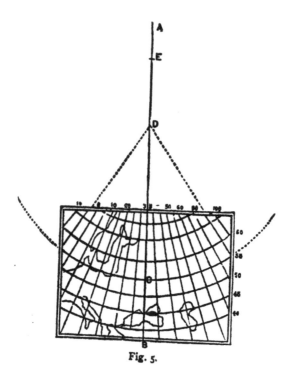

Fig. 5.

C. Cooper King, Map and **Plan** Drawing
(London: Cassell Petter & Galpin, 1873)

The Universe is built on a **plan** the profound symmetry of which is somehow present in the inner structure of our intellect.

Paul Valéry, *Man and the Sea Shell (The Collected Works of Paul Valéry)*

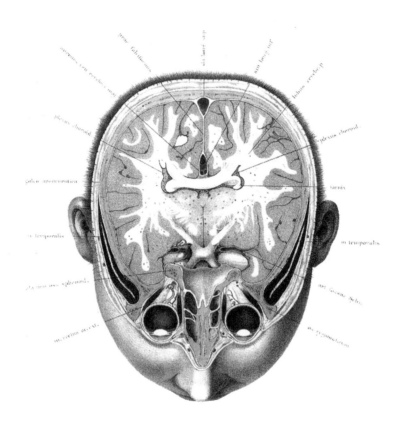

Wilhelm Braune and C. Schmiedel, *Topographisch-anatomischer Atlas*
(Leipzig: Verlag von Veit & Comp., 1872)

according to plan

rob kovitz

treyf books
keep refrigerated

Published by Treyf Books
5-193 Furby Street
Winnipeg, MB R3C 2A6
Canada
www.treyf.com
keeprefrigerated@treyf.com

LIBRARY AND ARCHIVES CANADA CATALOGUING IN PUBLICATION

Kovitz, Rob, 1963–, author, artist
 According to plan / Rob Kovitz.

Includes bibliographical references.
Issued in print and electronic formats.
ISBN 978-1-927923-11-5 (pbk.).—ISBN 978-1-927923-12-2 (epub).
—ISBN 978-1-927923-13-9 (pdf)

 1. Kovitz, Rob, 1963–. 2. Artists' books—Canada. I. Title.

N7433.K68A23 2014 700.971 C2014-904022-9
 C2014-904023-7

Financial assistance for the creation and production of *According to Plan*
has been provided by the the Manitoba Arts Council and the City of
Winnipeg through the Winnipeg Arts Council.

10 9 8 7 6 5 4 3 2 1

contents

policy statement

Copyright protection in Canada is automatically acquired upon creation of an original work. It is only necessary to include the universal copyright symbol on works where international protection, in accordance with the provisions of the Berne convention, is desired. Although it is not necessary to include the universal copyright symbol on **plans** and reports that are intended for use in Canada, the use of this symbol and a cautionary statement provides indisputable notice to those unsuspecting persons who have a tendency to copy or alter someone else's work.

Section 17(1) of the Copyright Act defines infringement: "copyright in a work shall be deemed to be infringed by any person who, without the consent of the owner of the copyright, does anything that, by this act, only the owner of the copyright has the right to do." However, Section 17(2) says that any "fair dealing" with a copyrighted work for the purpose of "private study, research, criticism, review or newspaper summary" does not constitute an infringement of copyright.

Therefore, under fair use, a surveyor has the right to use the information from a **plan** in the preparation of another **plan** ...

Association of Newfoundland Land Surveyors, Policy Statement

Clearly, someone had to have a **plan**, an idea, a beginning.

John McCabe, Stickleback

The exacting mind of Lavoisier was quick to home in on small weaknesses of this sort. In February of 1773, he opened a new laboratory notebook with a **plan** for a research program in this area:

> Before beginning the long series of experiments that I propose to myself to do ... be it by fermentation, by distillation, or finally by all kinds of combinations ... I believe I ought to put down some reflections here in writing, to form for myself the **plan** that I must follow.
>
> However numerous are the experiments of MM. Hales, Black, Mac Bride, Jacquin, Crantz, Priestley, and de Smeth on this subject, it nevertheless remains necessary that they should be numerous enough to form a complete body of theory ... The importance of the subject has engaged me to again take up all this work, which strikes me as made to occasion a revolution ... I believe that I should not regard all that has been done before as anything other than indications; I propose to repeat everything with new precautions, so as to connect what we know ... with other acquired knowledge and to form a theory.
>
> The works of the different authors which I have just cited, considered from this point of view, have presented to me separate sections of a great chain; they have joined together a few links of it. But a great sequence of experiments remain to be done, to form a continuity.

> Madison Smartt Bell, Lavoisier in the Year One: The Birth of a New Science in an Age of Revolution

Ladies and Gentlemen:

In accordance with our agreement we are pleased to submit the following report upon Administration of the **Plan**...

We wish to gratefully acknowledge the assistance and co-operation we have received from many officials and citizens in the preparation of this report.

Respectfully submitted,
Harland Bartholomew and Associates,
By Elridge H. Lovelace.

Harland Bartholomew and Associates, A Preliminary Report
Upon Administration of the **Plan**

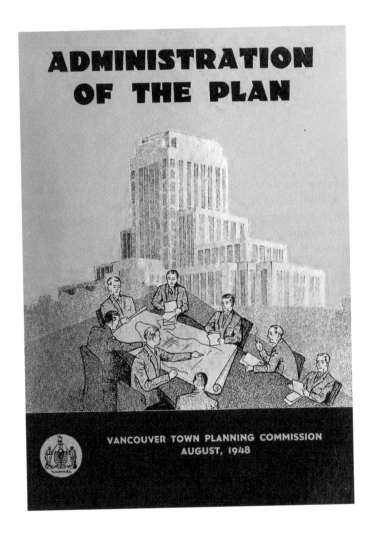

ADMINISTRATION
OF THE PLAN

VANCOUVER TOWN PLANNING COMMISSION
AUGUST, 1948

This put things in a very different light. Clearly Tattoo wasn't the hired thug Ian had believed him to be ... Tattoo may even have been the instigator of the scam, not that it particularly mattered now. But Ian felt conned. He had been targeted as an unwitting accomplice, and all it had taken for him to fall for it was a phone call from Archie saying that he was being mildly threatened. His life had fallen apart for two long weeks and might never be the same again. But, as Ian sat at Archie's desk gently shaking his head and biting his lower lip, largely in disbelief, he began to understand that what really mattered to him was who had instigated the **plan.**

John McCabe, Stickleback

according to **plan**

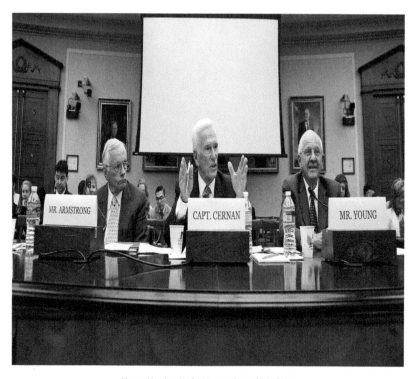

House Hearing NASA Human Spaceflight **Plan**

Retired Navy Captain and commander of Apollo 17 Eugene Cernan, center, is flanked by Apollo 11 Commander Neil Armstrong, left, and A. Thomas Young, as he testifies during a hearing before the House Science and Technology Committee, Tuesday, May 26, 2010, at the Rayburn House office building on Capitol Hill in Washington. The hearing was to review proposed human spaceflight **plan** by NASA.

NASA/Paul E. Alers

what's the plan?

The Modern Era was to be one of **plans** and proposals...

*Jacques Barzun, From Dawn to Decadence: 500 Years of
Western Cultural Life: 1500 to the Present*

MP DIANE FINLEY HOLDS CONSULTATIONS ON THE ECONOMY WITH HARDWORKING CANADIANS

Simcoe, Ontario—MP Diane Finley today met with small business owners in Simcoe, Ontario to discuss ways to create jobs and economic growth as Prime Minister Stephen Harper's Conservative Government **plans** for the next phase of Canada's Economic Action **Plan**.

"The economy remains the number one priority of the Prime Minister and our Conservative Government," said MP Finley. "Our Government will continue to focus on creating jobs for workers, retirement savings for seniors, and the financial security of all Canadian families."

Launched in 2009, the Economic Action **Plan** has so far contributed to the creation of more than 440,000 new jobs since July 2009 and helped the country emerge from the global economic crisis faster and stronger than most other major industrial countries around the world.

"It is clear that the Economic Action **Plan** is working," continued MP Finley. "It has created jobs and provided financial security to Canadian families through the worst global recession since the Second World War."

MP Finley also warned that Prime Minister Harper's Conservative Government will not jeopardize the fragile economic recovery by adopting the Ignatieff-NDP-Bloc Quebecois **plan** for higher taxes, increased spending, and more government waste.

"The Ignatieff-led coalition's economic **plan** for higher taxes, increased spending, and more government waste, will kill jobs, threaten growth and create economic instability and uncertainty for hard working Canadians and their families at the worst possible moment," continued MP Finley. "Our Conservative Government is committed to protecting and sustaining Canada's fragile economic recovery by fighting the high tax and risky economic policies of the Ignatieff-NDP-Bloc Quebecois Coalition.

Economic Action **Plan** announcement with Minister Fantino
Lisa Raitt, MP for Halton

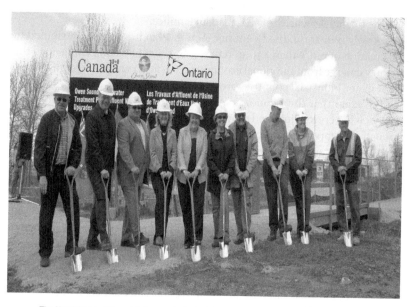

The Next Phase of Canada's Economic Action **Plan**—A Low-Tax **Plan** for Jobs and Growth
Larry Miller, Member of Parliament for Bruce-Grey-Owen Sound

Over the coming months, as the next phase of the Economic Action **Plan** is developed, MP Finley, the Prime Minister and his Conservative Government will travel to small towns, communities and cities across the country to listen to and seek the views of Canadians on the next phase of Canada's Economic Action **Plan**.

Diane Finlay, Member of Parliament for Haldimand-Norfolk, MP Diane Finley Holds Consultations on the Economy with Hardworking Canadians

"You can't be serious."

"Of course I'm serious. I'm always serious. You should know that by now."

"You mean to say that we're going to walk around the streets handing out fifty-dollar bills to strangers? It will cause a riot. People will go crazy, they'll tear us apart."

"Not if we handle it correctly. It's all a matter of having the right **plan**, and that's what we've got. Trust me, Fogg. It will be the greatest thing I've ever done, the crowning achievement of my life!"

His **plan** was very simple.

Paul Auster, Moon Palace

There have been various sorts of socialism, though one may link them all by certain common denominators. The first half of the century brought forth a profusion of schemes and **plans**, supplying the basic ideas for all subsequent socialist thought. The eagerness with which people produced and imbibed socialist ideas in this period relates to the general feeling that some new **plan** of social reorganization was desperately needed ...

Roland Stromberg, European Intellectual History Since 1789

MICHAEL HOGAN (ACTOR): Every week on the credits leading into *Battlestar Galactica* is the Cylons, and they have "a **Plan**." And this is "the **Plan**"— *Cut to film trailer:*

MALE CYLON: What's the **plan**?

Associated Press, Battlestar Actors Lay Out the Plan (youtube.com)

Not, therefore, to raise expectation, but to repress it, I here lay before your Lordship the **plan** of my undertaking, that more may not be demanded than I intend; and that, before it is too far advanced to be thrown into a new method, I may be advertised of its defects or superfluities. Such informations I may justly hope, from the emulation with which those, who desire the praise of elegance or discernment, must contend in the promotion of a **design** that you,

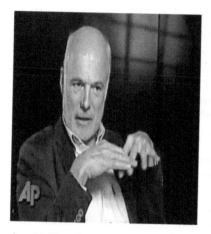

Associated Press, Battlestar Actors Lay Out the **Plan** (youtube.com)

my Lord, have not thought unworthy to share your attention with treaties and with wars.

Samuel Johnson, *The **Plan** of a Dictionary of the English Language*

"Hey, André. You wanted to be the big bad cop. You're always telling me you eat shit. Here's your chance to do it your way. Here's your big opportunity to walk on the dark side, see what that gets you. At least you'll be legit for a change."

He had to think about it a minute, roam around in his cage. Any time he looked over at Cinc-Mars he saw that smashed face and the cuts on his head and those determined hawk eyes. "What's the **plan**?" he asked him.

John Farrow, *City of Ice*

I went to thinking out a **plan**, but only just to be doing something; I knowed very well where the right **plan** was going to come from. Pretty soon Tom says:

"Ready?"

"Yes," I says.

"All right—bring it out."

"My **plan** is this," I says.

Mark Twain, *The Adventures of Huckleberry Finn*

Dear Galileo

Their **plan** was very simple …

Siren
A group of friends escaping the city for a weekend away have a simple **plan** …

Bottle Rocket
Focusing on a trio of friends and their elaborate **plan** to pull off a simple robbery and go on the run.

Ocean's Eleven
Danny Ocean and his ten accomplices **plan** to rob three Las Vegas casinos simultaneously.

Charley Varrick
Charley Varrick and his friends rob a small town bank. Expecting a small sum to divide amongst themselves, they are surprised to discover a very LARGE amount of money. Quickly figuring out that the money belongs to the MOB, they must now come up with a **plan** to throw the MOB off their trail.

A Perfect Murder
A powerful husband. An unfaithful wife. A jealous lover. All of them have a motive. Each of them has a **plan**. A remake of the Hitchcock classic *Dial "M" for Murder.*

Charlotte's Web
Wilbur the pig is scared of the end of the season, because he knows that come that time, he will end up on the dinner table. He hatches a **plan** with Charlotte, a spider that lives in his pen, to ensure that this will never happen.

The Sugarland Express
Lou-Jean, a blonde woman, tells her husband, who is imprisoned, to escape. They **plan** to kidnap their own child …

Yat do king sing
A young martial arts teacher is drawn into a **plan** to reform Imperial China.

Da zui xia
A ruthless band of thugs kidnaps a young official to exchange for their leader who has been captured. Golden Swallow is sent to take on the thugs and free the prisoner (who is also her brother). Though she is able to handle the overwhelming odds, she is hit by a poison dart and gets help from a beggar

who is really a kung-fu master in disguise. With his help, she forms a **plan** to get her brother back.

Star Wars, Episode V: The Empire Strikes Back
While Luke takes advanced Jedi training from Yoda, his friends are relentlessly pursued by Darth Vader as part of his **plan** to capture Luke.

The Life Aquatic with Steve Zissou
With a **plan** to exact revenge on a mythical shark that killed his partner, oceanographer Steve Zissou rallies a crew that includes his estranged wife, a journalist, and a man who may or may not be his son.

The Blue Lamp
Meanwhile, young hoods Tom and Spud **plan** a series of robberies with Tom's girl Diana, a discontented beauty, as inside worker.

Homecoming
A jilted ex-girlfriend has a **plan** in store for her former beau, who is coming back to his small town with a new lover.

Married in a Year
You too can find true love. Just ask the thousands of happy couples brought together by Patti Stanger, CEO of the Millionaire's Club matchmaking service and star of Bravo's hit TV series "Millionaire Matchmaker." Now Patti can help your marriage dreams come true with Married in a Year—her proven, easy-to-follow 12-month action **plan** for finding love. With her expert knowledge and up-beat, no-nonsense approach, Patti will motivate and guide you through all the stages.

Wicked Woman
…but a boarder at the rooming house where she is staying discovers her **plans**, and comes up with a **plan** of his own.

Waterhole #3
But before he can collect the big payoff, he must fend off other bounty-seekers who have the same **plan** …

Internet Movie Database, Plot Summaries

Lisa Barros D'Sa and Glenn Leyburn (directors), The 18th Electricity **Plan**

PLANS ABOUND FOR CLIMATE CHANGE

The provincial government released two documents Tuesday that it said will help Newfoundland and Labrador meet its goals on climate change and energy efficiency.

The papers, Climate Change Action **Plan** 2011 and Energy Efficiency Action **Plan** 2011, outline areas on these two topics the province sees as challenges and lists how government, business and the public can contribute to overcoming them.

Ross Wiseman, Minister of Environment and Conservation, said Tuesday it will take the combined efforts of all three to combat climate change.

He added these action **plans** are a good outline on how that can be achieved.

"We've tried in our **plan** to recognize that everyone has a role to play, be it business, be it homeowners or industry sectors," said Wiseman.

"This is a pretty broad approach that we're taking here. We're covering a lot of sectors in our economy. We believe with these initiatives, working in partnership particularly with industry, we'll be able to achieve the targets we've set out for ourselves," he said.

*Colin MacLean, **Plans** Abound for Climate Change (The Telegram)*

Eleven **plans** were then submitted and Mr. Cotsworth's **plan** was voted the best and commended to the governments of all nations. The Canadian Government had already accepted the **plan** ...

The Reader's Digest, Volume 5, 1926

What was the Commonwealth of Massachusetts **planning** to do? Already there were **plans** afoot in New York and Washington, and proposals being put to the White House and the President.

Brian Jackson, The Black Flag: A Look at the Strange Case of Nicola Sacco and Bartolomeo Vanzetti

PAULSON **PLAN** COULD COST $1 TRILLION

Congressional leaders said after meeting Thursday evening with Treasury Secretary Henry Paulson and Federal Reserve Chairman Ben Bernanke that as much as $1 trillion could be needed to avoid an imminent meltdown of the U.S. financial system.

Paulson **plans** to announce his "comprehensive" **plan** at 10 a.m. Eastern at the Treasury building, next door to the White House.

Stock markets soared around the world in anticipation of the rescue, with British and Chinese indexes recording their biggest gains ever.

Senate Banking Chairman Chris Dodd (D-Conn.) said on ABC's "Good Morning America" that lawmakers were told last night "that we're literally maybe days away from a complete meltdown of our financial system, with all the implications, here at home and globally."

CBS News, Paulson Plan Could Cost $1 Trillion

"There's nothing serious about a **plan** that claims to reduce the deficit by spending a trillion dollars on tax cuts for millionaires and billionaires. And I don't think there's anything courageous about asking for sacrifice from those who can least afford it and don't have any clout on Capitol Hill." Obama then offered a counter-**plan**, vague on details ...

George Packer, The Talk of the Town: Deepest Cuts (The New Yorker)

Barbicane looked hard at this man who spoke so lightly of his project with such complete absence of anxiety. "But, at least," said he, "you have some **plans**, some means of carrying your project into execution?"

"Excellent, my dear Barbicane; only permit me to offer one remark: My wish is to tell my story once for all, to everybody, and then have done with it; then there will be no need for recapitulation. So, if you have no objection, assemble your friends, colleagues, the whole town, all Florida, all America if you like, and to-morrow I shall be ready to explain my **plans** and answer any objections whatever that may be advanced. You may rest assured I shall wait without stirring. Will that suit you?"

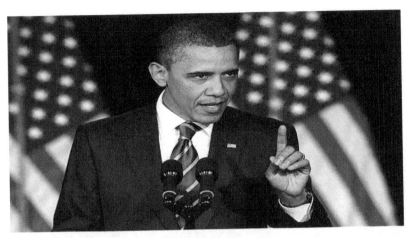

Two big budget **plans** now on the table—President Obama's and Rep. Paul Ryan's. We look at which would take us where.

*onpoint.wbur.org, Unpacking The Obama and Ryan Budget **Plans***

"All right," replied Barbicane.

Jules Verne, From the Earth to the Moon

EDMONTON OUTLINES **PLAN** TO FIGHT HOMICIDE RATE

To tackle a soaring homicide rate, police in Edmonton are set to cancel community programs to free up more foot-patrol officers in at-risk neighbourhoods, while also boosting traffic stops in hopes of nabbing misfits.

However, details of the **plan** remain vague—the mayor and police chief held off on releasing them.

Edmonton Police Chief Rod Knecht, criticized of late by a local newspaper for keeping a low profile during a spate of slayings, appeared at a news conference Monday after presenting Mayor Stephen Mandel with his Violence Reduction Strategy.

Instead of releasing the **plan**, however, the mayor—who had just returned from vacation—said more time was needed to review both the police **plan** and other city initiatives. All told, the day amounted to lengthy statements with little detail, with a promise to release the multiyear strategy on Wednesday.

*Josh Wingrove, Edmonton Outlines **Plan** to Fight Homicide Rate (The Globe and Mail)*

"The **plan** is the generator" said Le Corbusier; but how are **plans** generated? We usually start with a topological map (bubble diagram) and morph this into

I do not **plan** to explain this, let your little imagination run wild and free.

Posted by Sarah, The Events That Progressed Don't Make Much Sense (Wearing It On My Sleeves)

a geometrical map (**plan**). I was interested to find a mathematical structure underlying this process which was, perhaps, more elegant than the "chopping block" techniques of most shape grammar methods.

> *Christopher Stone, The Use of Linear Fractional Transformations to Produce Building **Plans** (Nexus Network Journal)*

Main Street

Several residents of a small Southern city whose lives are changed by the arrival of a stranger with a controversial **plan** to save their decaying hometown. In the midst of today's challenging times, each of the colorful citizens of this close-knit North Carolina community, will search for ways to reinvent themselves, their relationships and the very heart of their neighborhood.

> *Internet Movie Database, Plot Summaries*

Four months after Obama entered the White House, Leon Panetta, the director of the C.I.A., briefed the President on the agency's latest programs and initiatives for tracking bin Laden. Obama was unimpressed. In June, 2009, he drafted a memo instructing Panetta to create a "detailed operation **plan**" for finding the Al Qaeda leader and to "ensure that we have expended every effort."

> *Nicholas Schmidle, Getting Bin Laden: What Happened That Night in Abbottabad (The New Yorker)*

But he was in no hurry, he husbanded his resources. He spent the whole winter hatching his **plan**, involved in a hundred different projects, each more complicated than the other.

Émile Zola, The Kill

THE PATIENCE **PLAN**

GM Kevin Cheveldayoff keeps his thoughts to himself for the most part and doesn't engage in fireside chats about his long-range **plan**. But Cheveldayoff spent little money this summer in free agency, tipping his hand in terms of how he's going to build, and that's through the draft. Development will take time and the Jets won't buy a winner. But if Cheveldayoff can prove to be astute at the draft table and some of the previous regime's picks pan out—the Jets could be a contender down the line.

Gary Lawless, Jets Not Punchline Material Just Yet (Winnipeg Free Press)

"He will be here before long now," said Van Helsing, who had been consulting his pocket-book. *"Nota bene,* in Madam's telegram he went south from Carfax, that means he went to cross the river, and he could only do so at slack of tide, which should be something before one o'clock. That he went south has a meaning for us. He is as yet only suspicious; and he went from Carfax first to the place where he would suspect interference least. You must have been at Bermondsey only a short time before him. That he is not here already shows that he went to Mile End next. This took him some time; for he would then have to be carried over the river in some way. Believe me, my friends, we shall not have long to wait now. We should have ready some **plan** of attack, so that we may throw away no chance. Hush, there is no time now. Have all your arms! Be ready!" He held up a warning hand as he spoke, for we all could hear a key softly inserted in the lock of the hall door.

Bram Stoker, Dracula

POINT DOUGLAS PARK STILL UP IN THE AIR
City Must Decide What Future Holds For Area

A highly anticipated **plan** to convert a riverfront patch of land in Point Douglas into a provincial park will not move ahead until the city decides what its future development **plans** are for the community ... Since then, progress has been slow and Point Douglas residents have received little information about what the **plans** are for the strip of land along the Red River ... However, government spokesman Matthew Williamson said in an email

that the province can't formally **design**ate a park until Winnipeg firms up its master **plans** … Williamson said it's difficult to say how long the city-led process will take. City of Winnipeg officials were unavailable for comment on Sunday … Williamson said a master **plan** for the entire area is required before the province can proceed … CEO Jim August could not be reached for comment. Community residents say they haven't given up hope of a park and hope to be included in the **planning** process. Point Douglas residents committee chairwoman Roanna Hepburn said she's heard rumours the city wants to build more than 300 homes in the area. While residents have not received any concrete details, Hepburn said she hopes the city will not move ahead with **plans** before they consult the community … "What (would) bother me more than anything is if they go ahead and **plan** something else without telling us," she said … Community activist Sel Burrows said it's good to hear the park idea is still alive, since nothing has happened for so long that "most people gave up on it."

Jen Skerritt and Larry Kusch, Point Douglas Park Still Up in the Air (Winnipeg Free Press)

DAN: What happened to getting a **plan**?
CASEY: I know.
DAN: There was supposed to be a **plan**—
CASEY: I know.
DAN: Is there a **plan**?
CASEY: No.
DAN: You have no **plan**?
CASEY: Well, it wasn't for lack of trying.
DAN: I think it was.
CASEY: I tried.
DAN: You didn't.
CASEY: I tried to come up with the **plan**.
DAN: But you didn't.
CASEY: I didn't try?
DAN: You didn't come up with a **plan**.
CASEY: That's right.
DAN: You have no **plan**.
CASEY: That's right.
(Silence.)
DAN: You think there are people across the street looking at us in our underwear?
CASEY: Yes I do.

*Aaron Sorkin, Sports Night: Season 1, Episode 22: Napoleon's Battle **Plan***

*Aaron Sorkin, Sports Night: Season 1, Episode 22: Napoleon's Battle **Plan***

"Oh, yes." Nicholas nodded ... "They're having trouble, or anyhow it's very difficult; it takes a lot of things to do it. This man, this person, is important to them. I don't know why. I don't know who the man is. I don't know what he'll do." He lapsed into brooding silence for a time and then said, mostly to himself, as if he had said it or thought it many times before, "I don't know what's going to become of me when it happens. Maybe there are no **plans** for me at all."

Philip K. Dick, Radio Free Albemuth

DAN: No **plan**.
CASEY: Nope.
DAN: You know what it might be time for?
CASEY: Sadly I do.
DAN: Yeah, it might be time for me to step in.
KIM: Let's go, we'll get you your pants at the C break.
DAN: Okay. But I for one would feel more comfortable if everyone took their pants off.
CASEY: He's right.
DAN: We're a team.
CASEY: I'll tell ya, what really makes this outfit work are the socks.
KIM: I was gonna say ...

Aaron Sorkin, Sports Night: Season 1, Episode 22: Napoleon's Battle **Plan**

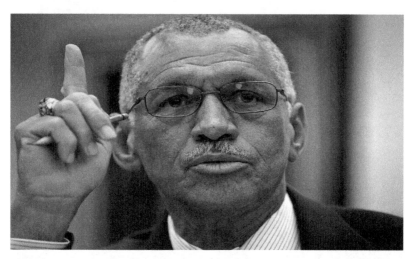

NASA Administrator Charles Bolden makes a point as he testifies during a hearing before the House Science and Technology Committee, Tuesday, May 26, 2010, at the Rayburn House office building on Capitol Hill in Washington. The hearing was to review proposed human spaceflight **plan** by NASA *(NASA/Paul E. Alers)*.

When I pull a sock on, I no longer *pre-bunch,* that is, I don't gather the sock up into telescoped folds over my thumbs and then position the resultant donut over my toes, even though I believed for some years that this was a clever trick, taught by admirable, fresh-faced kindergarten teachers, and that I revealed my laziness and my inability to **plan** ahead by instead holding the sock by the ankle rim and jamming my foot to its destination, working the ankle a few times to properly seat the heel. Why? The more elegant prebunching can leave in place any pieces of grit that have embedded themselves in your sole from the imperfectly swept floor you walked on to get from the shower to your room; while the cruder, more direct method, though it risks tearing an older sock, does detach this grit during the foot's downward passage, so that you seldom later feel irritating particles rolling around under your arch as you depart for the subway.

Nicholson Baker, The Mezzanine

CLIMATE CHANGE ACTION **PLAN** STILL UNSIGNED

President Benigno Aquino III is taking his time before signing the National Climate Change Action **Plan.**

National Climate Change Commission (NCCC) Secretary Mary Lucille Sering said the President will not dip his hands in signing the eighteen-year climate change **plan** without reading and studying the contents as this will supersede even his administration.

This left an impression that at a time when the world's top economies are already bracing for the effects of climate change, the Philippines, a third world and developing country, remains turtle-paced in mitigating the effects of climate change and global warming, which will likely affect us even worse than other developed states.

However, she said all three commissioners of the NCCC have already signed the **plan** and are only awaiting the president's go signal to execute the **plan.**

*Sun.Star Baguio, Climate Change Action **Plan** Still Unsigned (Sun.Star Baguio)*

There is only one thing worse than Republicans and Democrats failing to agree to lift the debt ceiling, and that is lifting the debt ceiling without a well-thought-out **plan** and with hasty cuts totaling trillions of dollars over a decade. What business do you know—that is still in business—that would operate this way: making massive long-term cuts, negotiated by exhausted executives, without any strategic **plan**? It certainly wouldn't be a business you'd expect to thrive. Maybe you can grow without a **plan**. But if you cut without a **plan,**

*Encyclopedia Britannica Films, The Baltimore **Plan***

you will almost surely hit an artery or a bone that could really debilitate you. That, I fear, is where we are heading.

Thomas L. Friedman, Can't We Do This Right? (The New York Times)

"They're lurching from one crisis to another," Shelby said. "They don't seem to have a super**plan** to deal with this. We want to see the **plan**.

*CBS News, Paulson **Plan** Could Cost $1 Trillion*

The idea of hoodwinking Saccard appealed to him greatly. He was nursing a **plan**, as yet vague, for he did not know how to use the weapon he possessed, lest he should do himself damage with it.

Émile Zola, The Kill

The Paulson **plan** is not a **plan**. It's a **plan** to maybe have a **plan** at some unspecified point in the future.

*Megan McCardle, What I Think About the Bailout **Plans** (The Atlantic)*

Even the recent launch of B.C.'s Education **Plan** has few answers—just a **plan** to have a **plan** after engaging with education stakeholders.

Katie Hyslop, Schools of the Future, Today (The Tyee)

Back in the 1950s, we dreamed of a rapid-transit system. But we spent the next five decades expanding roads in the apparent absence of any transit **planning**.

Finally, about a decade ago, former mayor Glen Murray secured federal funding for a busway that was not fully costed out and soon cancelled by his successor, Sam Katz.

The new mayor, expressing a preference for light rail, struck a rapid-transit task force that concluded the city should stick to conventional bus-transit improvements in the short term. Then in 2008, the availability of federal money led to the construction on the first phase of the Southwest Rapid Transit Corridor as a busway.

Plans for the second phase soon wound up in limbo at the hands of a city-provincial infrastructure-funding dispute as well as former chief administrative officer Glen Laubenstein's ill-fated investigation of both monorail technology and an allegedly cheap form of light-rail transit.

In the midst all this dilly-dallying, the city commissioned studies that determined there were no financial or technical obstacles in the way of building the corridor as a busway at first and then upgrading to light rail at a later date.

But senior city officials cherry-picked facts from the consultants' findings to declare light rail the end all and be all—a piece of political interventionism Katz finally rectified last fall, when Winnipeg's Transportation Master **Plan** made it quite clear light rail will not be cheap at all.

Now, Katz and Premier Greg Selinger may very well be able to reach a deal to build the second phase of the southwest corridor. While the two leaders still need to agree how to divvy up the cost, there is now a council commitment to attempt to complete the second phase by 2016.

Unfortunately, the city still has the potential to screw up the entire **plan**, as there remains two potential routes for the second phase of the corridor. One makes sense, while the other may very well be insane.

Bartley Kives, Prometheus, Sisyphus ... and Transit Tom: Winnipeg's Rapid Transit Woes the Stuff of Myth (Winnipeg Free Press)

The president defended himself with a tinge of resignation: If the crazed bullies put a gun to your head, you must surrender.

"Now, I know that people would like to say 'Well, just do something to get these guys under control,'" he told Emily, adding: "You don't want to reward unreasonableness. Look, I get that. But sometimes you've got to make choices in order to do what's best for the country at that particular moment."

The answer must have seemed lame even to Obama because, on the spur of the moment, he felt backed into doing what many in his White House and party wish he had done long ago. He told Emily he would put forward "a very

*Aaron Sorkin, Sports Night: Season 1, Episode 22: Napoleon's Battle **Plan***

specific **plan** to boost the economy, to create jobs and to control our deficit." (But not until September.)

Driving through Midwest cornfields in his opaque, black, custom-made, $1.1 million "Matrix" bus, our opaque president found himself in The Field of Dashed Dreams. If you don't build it, they may not come.

Maureen Dowd, Field of Dashed Dreams (The New York Times)

CASEY: Technically, I have a **plan**.
DAN: What's the **plan**?
CASEY: It's Napoleon's **plan**.
DAN: Who's Napoleon?
CASEY: 19th century French emperor.
DAN: Cracking wise with me now?
CASEY: Yes.
DAN: Thanks.
CASEY: He had a two-part **plan**.
DAN: What was it?
CASEY: First we show up—then we see what happens.

DAN: That was his **plan**?

CASEY: Yup.

DAN: Against the Russian army?

CASEY: Yup.

DAN: First we show up, then we see what happens?

CASEY: Yeah.

DAN: Almost hard to believe he lost.

CASEY: Yeah.

DAN: Alison, as you can see Casey and I are not wearing any pants, so I think in the interests of office professionalism you should avert your eyes.

ALISON: Okay.

DAN: Either that or take off your pants.

ALISON: I'll avert my eyes.

> Aaron Sorkin, *Sports Night: Season 1, Episode 22: Napoleon's Battle* **Plan**

And then there was Day Three.

As promised last Halloween, on Friday police Chief Keith McCaskill unveiled the city's long-awaited 48-page **plan** to reduce violent crime.

What's astonishing is the police service admits to not having a strategy to deal with violent crime in 15 or 16 years, this in Canada's perennial champion of per capita big city violent crime. What's more troubling in the immediate term is McCaskill was hired by Katz and council four years ago without a **plan**. When I asked McCaskill Friday if the mayor has ever asked for a **plan**, the police chief didn't answer directly.

When I asked the mayor the same question, he didn't either. "Just because there wasn't a **plan** on paper, I don't think you can come to the conclusion there wasn't a **plan**," Katz said.

There wasn't a **plan**. The 48 pages of paper is proof of that. Actually, why should we surprised there hasn't been a strategic **plan** to reduce crime since Katz took office? Short of Swandel's two-bit motion on Wednesday, there hasn't been a strategic **plan** on much of anything under Katz's leadership.

> Gordon Sinclair Jr., *Mayor's Regrettable Legacy Was Defined This Week (Winnipeg Free Press)*

Certainly these men who had so few spontaneous ideas might be very useful members of society under good feminine direction, if they were fortunate in choosing their sisters-in-law! It is difficult to say whether there was or was not a little wilfulness in her continuing blind to the possibility that another sort of choice was in question in relation to her. But her life was just now full of hope and action: she was not only thinking of her **plans**, but getting down learned books from the library and reading many things hastily (that she might be a

little less ignorant in talking to Mr. Casaubon), all the while being visited with conscientious questionings whether she were not exalting these poor doings above measure and contemplating them with that self-satisfaction which was the last doom of ignorance and folly.

George Eliot, *Middlemarch: A Study of Provincial Life*

"Harry, do you know that we have a **plan**?" "Who is we?" Harry asked; but she went on without noticing his question. "I tell you, because I believe you can help us more than any one, if you will. Only for your engagement with Miss Burton I should not mention it to you; and, but for that, the **plan** would, I daresay, be of no use."

"What is the **plan**?" said Harry, very gravely. A vague idea of what the **plan** might be had come across Harry's mind during Lady Clavering's last speech.

Anthony Trollope, *The Claverings*

"That, sir, is the question which I am now trying to answer for myself," returned the Idiot. "If I could answer it, as I have said, I could rule the world—everybody could rule the world; that is to say, his own world. It is based on an old idea which has been found by some to be practicable, but it has never been developed to the point which I hope to attain."

"Wake me up when he gets to the point, will you, kindly?" whispered the Doctor to the Bibliomaniac.

"If you sleep until then you'll never wake," said the Bibliomaniac. "To my mind the Idiot never comes to a point."

"You are a little too mysterious for me," observed Mr. Whitechoker. "I know no more about Dreamaline now than I did when you began."

"Which is my case exactly," said the Idiot. "It is a vague, shadowy something as yet. It is only a germ lost in my cerebral wrinkles, but I hope by a persistent smoothing out of those wrinkles with what I might call the flat-iron of thought, I may yet lay hold of the microbe, and with it electrify the world. Once Dreamaline is discovered all other discoveries become as nothing; all other inventions for the amelioration of the condition of the civilized will be unnecessary, and even Progressive Waffles will cease to fascinate."

"Perhaps," said the Bibliomaniac, "if you will give us a hint as to the nature of your **plan** in general we may be able to help you in carrying it out."

"The Doctor might," said the Idiot. "My genial friend who occasionally imbibes might—even the Poet, with his taste for Welsh rarebits, might—but from you and Mr. Pedagog and Mr. Whitechoker I fear I should receive little assistance. Indeed, I am not sure but that Mr. Whitechoker might disapprove of the **plan** altogether."

Peter MacKay ~ Representing Central Nova *(www.petermackay.ca)*

"Any **plan** which makes life happier and better is sure to meet with my approval," said Mr. Whitechoker.

"With that encouragement, then," said the Idiot, "I will endeavor to lay before you my crowning invention …"

John Kendrick Bangs, The Inventions of the Idiot

Right now you're probably asking yourself, how did Rick Perry do in the big Republican debate in New Hampshire this week?

He did great! It turns out that Governor Perry has a big energy **plan**, known as "The **Plan** I'm Going to Be Laying Out." When he does, it's going to be the answer to almost everything. We know that because no matter what Perry was asked, he talked about the **plan**. Which will involve "the American entrepreneurship that's out there." And a whole lot more. When he's ready to tell you.

For the rest of the time, Perry pretty much sat there like a large boulder with good hair, while the remaining members of the gang attacked Herman Cain, the former fast-food chain president turned Republican front-runner, about his economic **plan**.

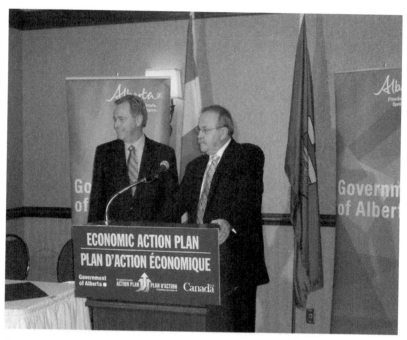

Government of Alberta Ministry of Transportation, Minister's Photos *(transportation.alberta.ca)*

This is what we've come to. A presidential debate about the 9-9-9 **plan**.

9-9-9 is the sine qua non of the Cain candidacy. It would scrap the tax code and give us 9 percent corporate, income and national sales taxes. He mentions it every 10 seconds. (Opening statement, he got it in by 5.)

I have never heard anybody discussing the 9-9-9 **plan** in the real world, but obviously I hang out in the wrong places. The organizers and the candidates felt the need to really get into this, and, as a result, Tuesday night in New Hampshire will go down in history as the 9-9-9 **plan** debate. (Here is how presidential primary debates go down in history. The tapes are stored in a moisture-proof vault in a civil defense cave in Indiana. If the world as we know it should come to an end, the surviving members of our species will be able to relive these deeply American contests and pass their knowledge on to their children. Soon, they will go forth and repopulate a world in which all the boys sit around looking smug like Newt Gingrich and all the girls sound like Michele Bachmann. That is what they mean by "the living will envy the dead.")

Gail Collins, The Gift of Glib (New York Times)

Saint-Simon and Thomas Carlyle, who owed much to him, reiterated their message that Europe had entered the industrial age, the "mechanical age," a new epoch calling for wholly new methods of government and thought; they called attention to the fact that the "social question" (Carlyle) was the burning issue of modern times and would not be solved by *laissez-faire* negativism. They did not have any exact blueprint for this new order but were sure that the "captains of industry" would have to assert leadership rather than content themselves with profits; they were sure that society needed a **plan** ("That Chaos should sit empire in it, that is the Worst," Carlyle exclaimed). These ideas, vigorously expressed, exerted an incalculable influence in Europe. It is impossible to imagine Marx and the other later socialists without this background.

Roland Stromberg, European Intellectual History Since 1789

What role the famous Fountain of Youth actually played in his **plans** is not clear ...

Paul Schneider, Brutal Journey: The Epic Story of the First Crossing of North America

HARRY POTTER: What's wrong?

RON WEASLEY: Wrong? Nothing's wrong. Not according to you, anyway.

HARRY POTTER: Look, if you've got something to say, don't be shy. Spit it out.

RON WEASLEY: Alright, I'll spit it out. But don't expect me to be grateful just because there's another damn thing we've got to find.

HARRY POTTER: I thought you knew what you signed up for.

RON WEASLEY: Yeah, I thought I did too.

HARRY POTTER: Well, I'm sorry, but I don't quite understand. What part of this isn't living up to your expectations? Did you think we were going to be staying in a five-star hotel, finding a Horcrux every other day? You thought you'd be back with your Mum by Christmas?

RON WEASLEY: I just thought, after all this time, we would have actually achieved something. I thought you knew what you were doing, I thought Dumbledore would have told you something worthwhile, I thought you had a **plan** ...

David Yates (director), Harry Potter and the Deathly Hallows: Part 1

Action Plan for Implementation of Solution(s)

Problem Statement:_____			
Solution(s)/Practical Method(s):_____			
Task/Project	**Who**	**Due Date**	**Status**

*Pete Abilla, Action **Plan** | Action **Plan** Templates | Action **Plan** Example | DMAIC (Shmula)*

action **plan** construction

Action **Plans** answer these basic questions:

- Who?
- What?
- When?
- Where?
- How?

Action **Plans** define an organized, effective implementation of selected solutions.

DMAIC ACTION **PLAN** CONSTRUCTION

Below are some helpful steps in creating an action **plan** (within the context of a DMAIC project):

1. Analyze the proposed improvement or solution and break it down into manageable steps
2. List the activities that must be done to ensure successful implementation of the improvements
3. For each activity, identify the resources needed/responsible for each step
4. List the remaining barriers from the barriers-and-aids analysis and any actions that can be taken to overcome these barriers (and who will do them)
5. Brainstorm, if necessary, for other items of possible significance
6. Add Due Dates for each activity
7. Track the status of each activity on the master list

Below is an example of what an Action **Plan** might look like.

*Pete Abilla, Action **Plan** | Action **Plan** Templates | Action **Plan** Example | DMAIC (Shmula)*

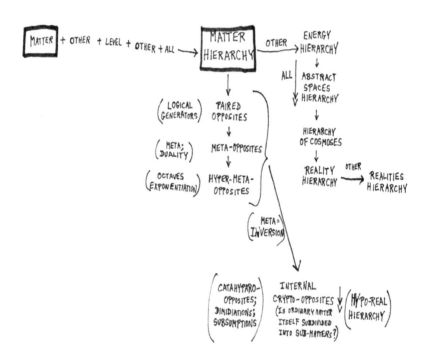

Patrick Gunkel, Ideonomy: The Science of Ideas: Maps and Lists (ideonomy.mit.edu)

"Wouldn't that **plan** work?"

"WORK? Why, cert'nly it would work, like rats a-fighting. But it's too blame' simple; there ain't nothing TO it. What's the good of a **plan** that ain't no more trouble than that? It's as mild as goose-milk. Why, Huck, it wouldn't make no more talk than breaking into a soap factory."

I never said nothing, because I warn't expecting nothing different; but I knowed mighty well that whenever he got HIS **plan** ready it wouldn't have none of them objections to it.

Mark Twain, The Adventures of Huckleberry Finn

While you are waiting on that, you can chop up your chocolate bar
or whatever you **plan** on adding to your sorbet.

Diane Eblin, Chocolate Sorbet with Roasted Chocolate Nibs
(www.thewholegang.org)

easy enough to **plan**

Don Quixote: Chapter XXV
on Quixote, "it shall be as thou wilt, for thy **plan** does not seem to me a bad
one, and three days

Don Quixote: Chapter XXVI
d we had best turn into this inn to consider what **plan** to adopt, and also to
dine, for it is now

Don Quixote: Chapter XXVII
record in this great history the curate's **plan** did not seem a bad one to the
barber, but on

Don Quixote: Chapter XXXIII
business. That night, however, he thought of a **plan** by which he might deceive
Anselmo without

Don Quixote: Chapter XXXIV
should try or devise some other less practicable **plan**. Lothario then retired,
and the next d

Don Quixote: Chapter XXXVII
arn or divine the intentions of the enemy, his **plans**, stratagems, or obstacles,
or to ward off im

Don Quixote: Chapter XXXIX
alva was on his way to Flanders. I changed my **plans**, joined him, served under
him in the campaig

Don Quixote: Chapter XL
h was to this effect: "I cannot think of a **plan**, senor, for our going to Spain,
nor has le

Don Quixote: Chapter XLI
ed; and, all following out the arrangement and **plan** which, after careful con-
sideration and many a

Don Quixote: Chapter XLVI
it seemed to them time to depart, they devised a **plan** so that, without giving
Dorothea and Don f

Don Quixote: Chapter XLVII
being confined in the cage, together with the **plan** they had of taking him
home to try if by a

Don Quixote: Chapter XLVIII
the barber; and I suspect they have hit upon this **plan** of carrying you off in
this fashion, out o

Don Quixote: Chapter XLIX
i so stupid, as not to be able to carry out my **plan**." "I am content to do as
thou sayest,

Don Quixote: Chapter I
nd; the curate, however, changing his original **plan**, which was to avoid
touching upon matters of

Don Quixote: Chapter V
a; "marry her to her equal, that is the safest **plan**; for if you put her out of
wooden clogs into

Don Quixote: Chapter IX
our worship is waiting for her to arrange some **plan** for you to see her without
any damage to h

Don Quixote: Chapter XI
is excellent," said Sancho; "and that by this **plan** we shall find out what we
want to know; an

Don Quixote: Chapter XIV
r sounder than a dormouse." "To match that **plan**," said Sancho, "I have
another that is not a

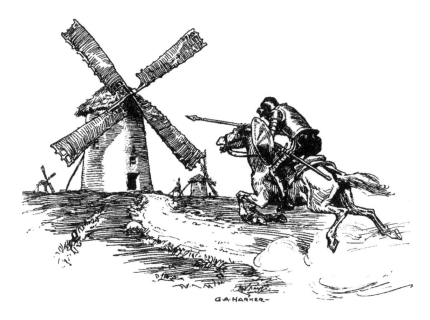

They **plan** an attack of all of the wrongs in society that have created an unhealthy lifestyle, and translate their passion into a business start-up with little hope of success.

I call this Don Quixote Syndrome.

Mind you, a passion to change the world is a good thing. I tilt at my own windmills everyday. It is just that I have learned that most of my "causes" don't make good business opportunities.

Dr. Jeff Cornwall, Don Quixote Syndrome (The Entrepreneurial Mind)

Don Quixote: Chapter XV

sco, we are served right; it is easy enough to **plan** and set about an enterprise, but it is often

Don Quixote: Chapter XXV

n him said to the other, 'Look here, gossip; a **plan** has occurred to me, by which, beyond a dou

Don Quixote: Chapter XXVI

nd do as the gentleman bids you; it's the best **plan**; keep to your plainsong, and don't attemp

Don Quixote: Chapter XXVII

cho Panza was asleep on his back, adopting the **plan** and device that Brunello had recourse to w

Don Quixote: Chapter XXXIV
ancho Panza; and, more bent than ever upon the **plan** they had of practising some jokes upon them t

Don Quixote: Chapter XXXV
ith their hunt and at having carried out their **plans** so cleverly and successfully, returned to

Don Quixote: Chapter XLI
y kind of harness or trappings, and that his best **plan** would be to sit sideways like a woman, as

Don Quixote: Chapter XLII
it all pass for reality. So having laid their **plans** and given instructions to their servants and

Don Quixote: Chapter LII
nly laugh, and look at my string of beads, and **plan** out the dress I am going to make for our d

Don Quixote: Chapter LVI
quey of mine is not one; but let us adopt this **plan** and device; let us put off the marriage fo

Don Quixote: Chapter LXIII
d said that the next day we should discuss the **plan** to be adopted for my return to Spain to ca

Don Quixote: Chapter LXIV
lls. Don Quixote told Don Antonio that the **plan** adopted for releasing Don Gregorio was not

Don Quixote: Chapter LXV
or he vanquished me and unhorsed me, and so my **plan** failed. He went his way, and I came back c

Don Quixote: Chapter LXVI
flesh, not to say eleven stone." "The best **plan** will be for them not to run," said another, "

Don Quijote Mission: ESA **Plans** to Slam Spacecraft Into Asteroid

The European Space Agency (ESA) **plans** to carry out a mission to slam a spacecraft into an asteroid. The mission, called Don Quijote, is scheduled for 2015. The **plan** resembles the plot of the Bruce Willis blockbuster, *Armageddon*, but there will be no humans aboard the ESA spacecraft.

The mission will target the Apophis asteroid, which astronomers say has a slim chance of hitting Earth in 2036.

The Don Quijote mission will have two phases. In the first phase a spacecraft (named Sanchez) will rendezvous with an asteroid and go into orbit around it. Sanchez will orbit Apophis for several months and monitor the asteroid. In the second phase an impactor spacecraft (Hidalgo) will slam into the asteroid, while the first spacecraft watches, looking for any changes in the asteroid's trajectory. The goal of the mission is to see if it is possible to alter the course of an asteroid headed for Earth.

There is some concern the ESA's experiment could make Apophis more likely to hit Earth.

Science, Space & Robots (photo: ESA/AOES Medialab)

Don Quixote: Chapter LXX

xote, which defeat and overthrow upset all his **plans**, resolved to try his hand again, hoping for

Don Quixote: Chapter LXXII

give free range to our fancies, and settle our **plans** for our future pastoral life." With t

The Literature Network, Don Quixote, Search Term: "plan"

Dr. Theodore von Karman (black coat) sketches out a **plan** on the wing of an airplane as his JATO engineering team looks on. From left to right: Dr. Clark B. Millikan, Dr. Martin Summerfield, Dr. Theodore von Karman, Dr. Frank J. Malina and pilot, Capt. Homer Boushey.

NASA/JPL

i have a **plan**

PLAN YOUR CANADIAN GETAWAY

There's no better time than the Canada Day weekend to **plan** a Canadian getaway. Here are some new things to consider:

*Doug English, **Plan** Your Canadian Getaway (Toronto Sun)*

"I have a **plan**."
 "Tell me."
 "Tonight, at the hotel." I nodded. The hotel, of course.

Matt Cohen, The Bookseller

In his excitement Mitya told the people of the house there and then that his fate would be decided that very day, and of course described to them in great haste practically the whole of his **plan** which he had put before Samsonov, and Samsonov's suggestion, his own future hopes, etc. etc.

Fyodor Dostoyevsky, The Brothers Karamazov

DIETER: Now listen. We must collect the rice, and hide it. But we must dry it because it rots too quickly if we don't dry it.
GENE: You want to hide it? We could eat it *now*.
DIETER: No, no, look, I've created a secret compartment here for the rice. It is at the bottom of my crap container. So I don't think the guards are gonna want to check that.
GENE: This is crazy. Why are you hiding it *now*?
DIETER: For our escape.
(Long pause.)
DUANE: You have a **plan**.

Werner Herzog (director), Rescue Dawn

I had come this far and waited long enough. I had a **plan**. It might get me into trouble, but it was my concern, my responsibility, and nobody else's. I bent over, ducked my head into the squad car window, and said:
 "I'm going to do some exploring."

What was Bellamy supposed to say? If I wanted to hang around an abandoned building in the middle of the night, there wasn't much he could do about it. I was the senior officer. I was a highly decorated member of the department, and as far as Bellamy could tell, I was losing my marbles.

"I've got to do this, Bells. Can't you see?" I pleaded.

"I don't know, Coddy. You like pushing rocks uphill?"

At least Bellamy was getting paid to watch me have a nervous breakdown. It wasn't like he could intervene. It was better to leave me alone; that was the best thing one cop could do for another brother. Let him find his own way. He'd thank you for it later.

"Don't sweat it, Coddy. Just do what you have to. Me? I'll make myself cozy and listen to the radio."

My face eased up; I was acting crazy, but I couldn't stop myself, and besides, I didn't want to stop. I let a shred of a grin touch my mouth.

"I won't be long."

I bounded across the pavement, showing more vitality than I'd had in a long time. I could feel myself gathering momentum, lifting off, gaining lucidity. And simultaneously, I was getting older, breaking down, becoming creaky, forgetful, simply not enough. The two paths were going to converge on my deathbed. Even now, with the abandoned building before me, I was aware of that.

Peter Plate, One Foot Off the Gutter

To save myself time in the future I put extra compound over some of the plasterboard in those first houses. The wind stopped blowing through them and the stupid young couples kept warm. That was the first of my **plans**.

I took no breaks and I had no time. But there was freedom between my ears, and I don't mean what you think I mean. Building is ten percent concentration and ninety percent habit. You have to think about what you're going to do, but you don't while you're doing it. It doesn't matter how busy your body is, your mind is always free. Free if you have good forearms. Once I know where to put it, my trowel moves steady as the waves—habit moves it, and my thoughts are free. And that's when you **plan**.

Johnny Cooper, Mario Caizone, and Tony Espolito, they don't **plan**. When they're staring at a wall or choking on sawdust, they're thinking this: Woman, Blood, Bone. They're thinking things you'll never know.

But Jerry McGuinty **plans**.

The future was there one day, drying around my fingers.

Colin McAdam, Some Great Thing

*Encyclopedia Britannica Films, Baltimore **Plan***

VOICE OVER
The Cylons were created by man. They rebelled. They evolved. They look and feel human. Some are programmed to think they are human. There are many copies. And they have—a **plan**.

MALE CYLON
What's the **plan**?

BROTHER CAVIL
The **plan** is, everything blows up a week ago. All humans are dead, we Cylons all download, and the universe basks in justice . . .

*New Trailer for 'Battlestar Galactica The **Plan**' (youtube.com)*

Gladstone Explaining **Plans** For Government Of Ireland

The Illustrated London News, April 17, 1886

I immediately understood that there was nothing I could do to stop him. His mind was made up, and rather than try to talk him out of it, I did what I could to make his **plan** as safe as possible. It was a decent **plan**, I said ...

Paul Auster, Moon Palace

Slyly going into Cantor territory on Friday, the president promised a sustained campaign to sell Americans on his **plan**. A re-energized Obama urged students at the University of Richmond to lobby lawmakers: "I want you to call, I want you to e-mail, I want you to tweet, I want you to fax, I want you to visit, I want you to Facebook, send a carrier pigeon."

Maureen Dowd, Sleeping Barry Awakes (The New York Times)

"Well said," cried Aramis; "you don't often speak, Athos, but when you do speak, it is like St. John of the Golden Mouth. I agree to Athos's **plan**. And you, Porthos?"

"I agree to it, too," said Porthos, "if D'Artagnan approves of it. D'Artagnan, being the bearer of the letter, is naturally the head of the enterprise; let him decide, and we will execute."

"Well," said D'Artagnan, "I decide that we should adopt Athos's **plan**, and that we set off in half an hour."

"Agreed!" shouted the three Musketeers in chorus.

Alexandre Dumas, The Three Musketeers

Project management involves the process of first establishing a **plan** and then implementing that **plan** to accomplish the project objective. Taking the time to develop a well-thought-out **plan** is critical to the successful accomplishment of any project. Once the project starts, the project management process involves monitoring progress to ensure that everything is going **according to plan**.

Jack Gido and James P. Clements, Successful Project Management

But, before they set out, the commodore paid the compliment of communicating his **design** to Mr. Pickle, who approved of the **plan** ...

*Tobias Smollett, The Adventures of Peregrine Pickle, in Which
Are Included Memoirs of A Lady of Quality*

Wait. Nancy. I've been saving these for myself, I want you to have them. Make a **plan** for yourself. For both of us. Those mitts are the key to our future.

Jenji Kohan, Weeds: Season 7, Episode 1

But wait: I had a **plan**. I couldn't stop now. I was standing back and looking at myself enter a tunnel. There I was at the entrance, catching a glimpse of myself as I disappeared down the tunnel's bore. Follow me, the hole was saying.

Peter Plate, One Foot Off the Gutter

As Archie left the office he suddenly worried that he might not have enough video space to cover his evening's viewing. He had some room left at the end of his *Star Trek Volume VI* tape. Maybe there would be enough to accommodate the *X Files*. He wondered whether it might be a bit sacrilegious to mix the two programmes on one tape, and slipped into a daydream of Scully encountering the Clingons, and what the FBI might make of Spock and ... this kept him more than amused while he walked out of the building towards the bus stop. A nagging doubt of change interrupted his sci-fi day-dreams. He really should be on the safe side and buy a videotape. If he bought a video, it would be bound to cost a sum of money ending in 99p. He checked his front trouser pockets for change and managed a curse skillfully untainted by swearing or blasphemy. He had no change at all. He checked his wallet. One five-pound note. This presented a change-disposal problem. Archie judged purchases of lunch, newspapers and cups of tea not in terms of the needs they fulfilled so much as their merits of spare coinage disposal. He generally took five pound coins with him to work each morning and a five- or ten-pound note in case of unforeseen eventualities. Occasionally, if he was feeling adventurous, he would vary his coinage and leave the house with four-pounds fifty or five-pounds twenty or some other sum which prevented him simply buying the same items every day. In this way, Archie kept himself on his toes. Today had been a challenge. The sandwich shop he bought his lunch from every day had increased its prices without warning and he had been badly off balance ever since. It had been a struggle, but by the end of the day he had returned to equilibrium having legitimately spent every one of the five-hundred pence he had started the day with. The video, though, would doubtless result in a spare coin and it would be difficult to dispose of one pence in a supermarket. By his own rules, he wasn't allowed to lose, donate, throw away, deface beyond recognition or otherwise dispose of remaining coinage. He stood at the bus stop for some minutes trying to find a way around his predicament. Anonymous cars crawled by. There had to be some way. He pushed his glasses slowly upwards as far as they would travel on the bridge of his nose. This would take some careful **planning**.

John McCabe, Stickleback

Asbestos Cement Products Association, **According to Plan:**
The Story of Modern Sidewalls for the Homes of America

FIGURE 2: STRATEGIC **PLANNING** AND IMPLEMENTATION TIMETABLE

YEAR 1

Spring/Summer: CSU forms the University Strategic **Planning** Committee (USPC)
- Develops mission and operating principles
- Develops **planning** process and timetable
- Assigns liaison roles to facilitate communication with stakeholders

Fall: USPC collects input and feedback from campus units
- Develops process for campuswide strategic **planning** sessions at department/unit level followed by strategic **planning** sessions at college/division level
- Qualitatively analyzes 75 department/unit reports and 16 college/division reports
- Prepares preliminary report on suggested strategies and tactics
- **Plans** and hosts strategic **planning** university review (SPUR) session of strategies and tactics (student leaders, faculty senators, Board of Trustees officers, deans, senior administrators)

Spring: USPC gathers more input and revises **planning** goals
- Surveys students, alumni, visiting committees, campus committees
- Hosts community leader breakfast
- Develops **planning** process procedures
- Revises strategies and tactics based on feedback from stakeholders
- Presents interim report to Faculty Senate and administration

YEAR 2

Summer: USPC finalizes **planning** report
- Integrates additional stakeholder data
- Analyzes challenges and conflicts
- Develops priorities and greatest opportunities
- Assigns preliminary measures and metrics for evaluation
- Finalizes and writes **planning** report

Fall: USPC submits **plan** for ratification and begins implementation
- Submits **planning** report to Faculty Senate and administration for ratification
- Develops **planning** process and second-year timetable
- Initiates strategic **planning** at the department/unit level and college/ division level by asking each to answer **planning** questions
- Supervises creation of brochure describing strategic **plan**
- Meets with **plan** champions (vice presidents and deans) to determine areas of ownership and accountability

Spring: USPC supervises **plan** implementation and develops key indicators
- Updates new faculty and administrative committee members and assigns new liaison roles
- Asks deans and vice presidents to integrate department/unit reports and prepare college/division **planning** reports
- Collects and integrates the strategic **planning** reports into university-wide strategic **planning** document
- Develops key indicators to annually assess progress on the six **planning** goals
- **Plans** and hosts SPUR II session to obtain feedback from university leadership on metrics, integration of master **planning** and strategic **planning**, development of collaborative/communication structures, and budget to support **planning** initiatives

YEAR 3

Summer: USPC prepares **planning** report for ratification
- Integrates data from **planning** reports, champion interviews, and SPUR II into strategies and tactics of university **plan**
- Develops tracking system to show progress toward completion of strategies and tactics
- Sends draft of overall **planning** document to relevant units and individuals for verification
- Develops measures and provides a rationale for key indicators and annual scorecard to assess goals
- Prepares third-year timetable
- Proposes process for changing strategic **plan**
- Introduces possible changes to strategic **plan**
- Meets with other key committees to ensure **planning** integration (e.g., master **planning**, capital **planning**, budget)

Asbestos Cement Products Association, ***According to Plan:***
The Story of Modern Sidewalls for the Homes of America

Fall/Spring: USPC continues ongoing, bottom-up, collaborative **planning** process
- Presents annual **planning** report to Faculty Senate and administration for ratification
- Monitors continued implementation of **plan** and approved changes to **plan**
- Establishes a process for assessing progress of short- and long-term strategies and tactics
- Supervises the collection of scorecard data
- Seeks stakeholder input to ensure continuous improvements in the **planning** process
- Promotes university-wide collaboration
- Communicates with campus community about **planning** process
- **Plans** and hosts SPUR III
- Facilitates the integration of key university activities (strategic **planning**, master **planning**, capital **planning**, budget, and program review)

*Susan E. Kogler Hill, Edward G. Thomas, and Lawrence F. Keller, A Collaborative, Ongoing University Strategic **Planning** Framework: Process, Landmines, and Lessons: Planners at Cleveland State University Describe That Institution's Highly Communicative and Participatory Strategic **Planning** Process (**Planning** for Higher Education)*

Hank Paulson, the US Treasury Secretary, issued a plea for serious consideration of his ground-breaking **plans** ...

But while the **plan** received praise for being bold, banking groups, consumer advocates and politicians added a litany of caveats that could bog down any attempt to push through serious reform.

"This is a complex subject deserving serious attention," Mr Paulson said as he unveiled the **plan** yesterday. "Those who want to quickly label the blueprint as advocating 'more' or 'less' regulation are over-simplifying this critical and inevitable debate. Government has a responsibility to make sure our financial system is regulated effectively, and in this area we can do a better job. Few, if any, will defend our current balkanised system as optimal."

*Stephen Foley, Paulson Reveals **Plans** for Biggest Financial Reform Since Depression (The Independent)*

Rodrigo was by now aged fifty-three, and realized he could not afford to leave matters to chance any longer. He immediately started laying **plans** for the next election. Pope Innocent retained him as Vice-Chancellor, and Rodrigo used the position to gather allies all over Italy, and set about patching up the family quarrel with the still-powerful Colonna and Orsini clans. With an assiduous distribution of favours, he used Innocent's reign to consolidate his position

*Wikimedia Commons, Portraits with **Architectural Plans***

*Wikimedia Commons, Portraits with **Architectural Plans***

for an invincible assault. His ostentatious living and entertaining were all part of his **plan** to present himself as the most powerful of men, and the prime choice as heir apparent.

Harry Edgington, The Borgias

"I've got a **plan**," I said.
"So? What am I supposed to do, pray in front of you?" she asked.

Peter Plate, One Foot Off the Gutter

"I've got a **plan**, Alice," I said.
I'm sure you do, dear. Can I have that aspirin, please."

Peter Plate, One Foot Off the Gutter

NARRATOR
You'll find a scene like this throughout every village, town, and city throughout the country. For in the hopes and dreams of everyone, there's a home they can call their own. Home brings a sense of security to a man. And to every woman, her home means a setting for gracious living. How do I know? Well, I'm a contractor, and over the years I've helped a lot of people realize their dreams, building new houses, and remodeling old ones too. And probably the most important step is the one these young people are going through right now ...

WOMAN
And we'll have the living room right in here. And the kitchen here, so we can see the children playing in the yard.

MAN
Yeah, the children. Children? Say, how many are you **planning** on? Not more than six, I hope. Maybe I better add a few more rooms back here at that.

WOMAN
Silly! And we'll have shrubbery of course, right along in here. And—oh darling, it's going to be just perfect.

Asbestos Cement Products Association, According to Plan:
The Story of Modern Sidewalls for the Homes of America

I could not but admire, even at such a moment, the way in which a dominant spirit asserted itself. In all our hunting parties and adventures in different parts of the world, Quincey Morris had always been the one to arrange the **plan** of action, and Arthur and I had been accustomed to obey him implicitly. Now,

*Asbestos Cement Products Association, **According to Plan**: The Story of Modern Sidewalls for the Homes of America*

the old habit seemed to be renewed instinctively. With a swift glance around the room, he at once laid out our **plan** of attack, and, without speaking a word, with a gesture, placed us each in position. Van Helsing, Harker, and I were just behind the door, so that when it was opened the Professor could guard it whilst we two stepped between the incomer and the door. Godalming behind and Quincey in front stood just out of sight ready to move in front of the window. We waited in a suspense that made the seconds pass with nightmare slowness. The slow, careful steps came along the hall; the Count was evidently prepared for some surprise—at least he feared it.

Bram Stoker, Dracula

I couldn't open the door. The house looked flimsy and broken down, but the door was solidly locked. I ran a gloved finger over the doorjamb, but I was unable to detect any holes or cracks. I stepped back on the porch, and lifted the gleaming riot helmet off my head, to mop up the sweat on my brow.

It didn't take me long to hatch a **plan** to solve the problem. A minute later, I was edging my way across the ledge to the left of the steps. If I crossed the ledge on the tiptoes of my boots, I could get to the front window. Then I could hoist myself through the broken glass into the building. It was a daring **plan** for a fat man, because if I lost my footing, I'd land on my head in the driveway ten feet below.

Peter Plate, One Foot Off the Gutter

NARRATOR

That's right. It's the **planning** that makes all the difference between happiness and headaches as the years go by. For instance, have you two decided what material to use on the outside walls. Wood provides a number of possibilities. Or you might choose stucco—or brick—or stone. All of these materials have been adapted for sidewall use for hundreds of years. But suppose we look at a material **designed** especially for sidewalls. You know industrial research has given us a lot of materials **designed** to do a specific job better, and made to **planned** specifications. For instance, rayon, and then nylon. Materials that make fabrics more beautiful and easier to care for than natural ones. And new plastic materials like this are light, strong and durable. Industry too has created new materials for the home. Today's floors, for example, are made of a modern, resilient material, which is more colorful, more durable, and easier to clean. And science also created asbestos cement roofing, which has made buildings safer and more durable. This material, available in many types and colors, is not only attractive but fire-proof too. This same kind of scientific thinking was applied to the problem of sidewalls for the homes of America.

Asbestos Cement Products Association, **According to Plan**:
The Story of Modern Sidewalls for the Homes of America

Asbestos Cement Products Association, *According to Plan:*
The Story of Modern Sidewalls for the Homes of America

In the development of a better siding material, rigid specifications were set up. It must be attractive, easy to handle, adjustable to **architectural design,** weather-proof, and rot-proof. Furthermore, it must be safe from the hazards of fire, and above all, free from constant maintenance expense. It was natural that the scientists would turn to asbestos, for this is a remarkable mineral. Actually stone, it is made up of tiny but extremely strong and flexible fibers. Combined with portland cement, these fibers act as a reinforcing agent, just as steel rods are used to reinforce concrete. Being stone, asbestos will not burn. In fact, it is best known for its use in all fields of fire-protection. And too the great success of asbestos combined with portland cement in the roofing field made it a natural choice for research for a better siding. So, from long testing and experiment, there came asbestos cement siding. Strong and tough, it could be handled and applied like ordinary shingles. It was given every conceivable test. It was absolutely fire safe, for even a torch couldn't burn it. And water couldn't harm it. It withstood all kinds of weather: sun, wind, snow and sleet. This machine, called a weatheromiter, in a few days duplicates years of weather conditions. This material won't rot or decay, so it doesn't need paint to preserve it. However it can be painted if the homeowner desires.

Asbestos Cement Products Association, According to Plan:
The Story of Modern Sidewalls for the Homes of America

But what think you of the **plan** of the curtain, Barbara? It is a charming one, is it not? No matter whether I be at work, or about to retire to rest, or just awaking from sleep, it enables me to know that you are thinking of me, and remembering me—that you are both well and happy. Then when you lower the curtain, it means that it is time that I, Makar Alexievitch, should go to bed; and when again you raise the curtain, it means that you are saying to me, "Good morning," and asking me how I am, and whether I have slept well. "As for myself," adds the curtain, "I am altogether in good health and spirits, glory be to God!" Yes, my heart's delight, you see how easy a **plan** it was to devise, and how much writing it will save us! It is a clever **plan**, is it not? And it was my own invention, too! Am I not cunning in such matters, Barbara Alexievna?

Fyodor Dostoyevsky, Poor Folk

Everyone glared at me.
I didn't care. I had made my **plan.**

Jeanette Winterson, Lighthousekeeping

Lisa Thompson, Game *Plan* (Minneapolis: Picture Window Books, 2006)

plan for hilarity

Creator
Harry has a **plan**, he wants to clone his dead wife, but first he needs an egg and a host. He mounts his search by stapling notices to every telephone pole in town from his bike ...

Olsen Gang Gets Polished
Egon has a **plan**! He'll need a drill, a cardboard honey and prune juice and a pile of dead rats ...

Ugly, Dirty and Bad
Four generations of a family live crowded together in a cardboard shantytown shack in the squalor of inner-city Rome. They **plan** to murder each other with poisoned dinners, arson, etc. The household engages in various forms of sexual idiosyncrasies, land swindles, incest, drugs and adultery.

Holly Hobbie and Friends Surprise Party
Holly Hobbie heads to Clover to **plan** a surprise party for Aunt Jessie, while her brother, Robbie, hopes to call upon extraterrestrials.

The Addams Family
Con artists **plan** to fleece the eccentric family using an accomplice who claims to be their long lost Uncle Fester.

*Family **Plan***
Put a gang of orphans, their bumbling benefactor, and a greedy developer together—and **plan** for hilarity.

Our Family Wedding
... and too suddenly announce their marriage **plans**, they soon discover that their fathers ... Lucia's mother is busy **planning** the wedding of "her" dreams ... With only weeks to **plan** their wedding ...

Zoomerne
Tim and Alexander are best friends. Tim would really like to have a girlfriend and Alexander would like to do better in school. Together they **design** the perfect **plan**, all they now need is a cordless kettle, a tiny robot, a blueprint of their school and 100 surveillance cameras!

Mortuary
… four young college students **plan** for the local Friday night bash, but Monte has bigger **plans** for them …

Cloud 9
A washed out former star in need of money has a get rich **plan** … start a volleyball team whose players consist of a group of beautiful athletic strippers.

Hot Money
Three women, Bridget, Liz and Jackie, embark on a **plan** to steal thousands of pounds of banknotes that were due …

The Sisterhood of the Traveling Pants
Four best girlfriends hatch a **plan** to stay connected with one another as their lives start off in different directions—they pass around a pair of secondhand jeans that fits each of their bodies perfectly.

Yamla Pagla Deewana
Paramveer saves the day with a crazy **plan** to win the girl back for Gajodhar which leads them to the rustic heartlands of Punjab …

Frontier Pony Express
In the midst of the Civil War, Lassiter has a **plan** to get control of California. Working out of St. Joseph, he **plans** to send forged messages to the troops on the west coast via Pony Express …

Six-Gun Trail
… agree to sell him the jewels but **plan** to kill him and keep both the jewels and the money …

Slovenka
Alexandra is a student from a small town in Ljubljana and she has a single-minded **plan** to conquer the world …

John A Burton, The **Plan**
(Mustang, OK: Tate Publishing &
Enterprises, 2007)

The Brotherhood IV: The Complex
… an age-old secret society's demonic **plan** to rule the world …

A New Leaf
… devises a **plan** with the help of his imaginative butler …

Holy Water
… comes up with a **plan** to hijack a consignment of Viagra, and sell it on the
open market in Amsterdam.

Carry on Matron
A gang of thieves **plan** to make their fortune by stealing a shipment of contra-
ceptive pills from Finisham maternity hospital …

Cookers
After stealing a huge stash of drugs, speed freaks Hector (Brad Hunt) and Darena (Cyia Batten) **plan** to cook up an enormous batch of crystal meth and get rich quick ...

.45
A story of how obsession, addiction and abuse leads a young woman (Jovovich) to execute an elaborate **plan** of revenge.

How the Grinch Stole Christmas!
A grumpy hermit hatches a **plan** to steal Christmas from the Whos of Whoville.

Two-Minute Warning
A group of art thieves **plan** a daring robbery by using a sniper to cause a panic during a championship football game in a stadium that just happens to be in the vicinity of the museum they **plan** to rob ...

9 Souls
Nine convicts escape from prison; most are convicted murders. They commandeer a van from a strip club. Their **plan** is to find a stash of counterfeit money that a deranged cell mate told them about, divide it, then part ways ...

Shut-Eye
... use their insider status at a strip club to **plan** a robbery they believe will be foolproof ...

Back by Midnight
... four inmates break out and **plan** a department store robbery to spruce up the prison's faculties ...

City Beneath the Sea
A group of 21st-century colonists inhabit an underwater city called Pacifica. Originally intended as a purely scientific installation, the U.S. government wants to stash all its gold reserves from Fort Knox there, along with a fantastic new radioactive element. The brother of Pacifica's returning former commander **plans** to steal the gold and on top of that, the city faces destruction by an asteroid from outer space.

Dragon Ball Z12: Fusion Reborn
An industrial disaster in Other World has unleashed a gargantuan monster, and the Z fighters are taking action! Janemba's arrival has thrown the dimensions into turmoil, leaving the door between worlds gaping open and the dead are rising from their graves. To combat this juggernaut, Goku must power up to his race Super Saiyan 3 form, but shockingly the move is not enough. It's a battle on two fronts and teamwork is the key! As time runs out, Goku stumbles across a weary Vegeta and devises a risky **plan** that might be the universe's only hope ...

Rude Boy The Jamaican Don
... all Biggs needs is a "mule" to make sure his **plan** is perfected ...

Laughing at Life
His globe hopping escape leads him finally to South America, where he is hired to organize a band of revolutionaries, unaware that they **plan** to eliminate him when his job is done.

Delhi Belly
... due to an upset stomach ailment commonly known as 'Delhi Belly' as well as his **plan** to blackmail their landlord ...

Mean Creek
When Sam Merrick is beaten up by local bully George Tooney, Sam's older brother Rocky and his friends Clyde and Marty **plan** to pretend it's Sam's birthday to "invite" George on a boat trip in which they would dare him to strip naked, jump in the lake, and run home naked. But when Sam, his girlfriend Millie, Rocky, and Clyde see George as not much of a bad guy, they want to call off the **plan**, but Marty refuses. Will the **plan** go ahead as **planned**?

Internet Movie Database, Plot Summaries

*Ronald F. Maxell (director), Gettysburg—Pickett's Charge: The **Plan** (uploaded by Zappiss, youtube.com)*

such a **plan** would save the country

National Geographic: The Gunpowder Plot
In one of the most famous plots in British history, Guy Fawkes attempted to blow up the Houses of Parliament. Find out more about his **plans**.

Internet Movie Database, Plot Summaries

"You didn't make any **plans**, did you?" his wife asked.

Denis Johnson, Already Dead: A California Gothic

I thought that now was the time for Van Helsing to warn him not to disclose our **plans** to her; but he took no notice. I looked at him significantly and coughed.

Bram Stoker, Dracula

Republican presidential candidate Mitt Romney is **planning** to nearly quadruple the size of his $12-million California beachfront manse.

Romney, a former Massachusetts governor and nominal frontrunner for the GOP's 2012 presidential nomination, is **planning** to bulldoze his 3,009-square-foot home facing the Pacific Ocean in La Jolla, Calif., and replace it with an 11,062-square-foot home, according to the San Diego Union-Tribune.

The Union-Tribune reported late Saturday that Romney has filed an application with the city for a coastal development permit, but that no date has been set to consider the project.

A Romney campaign official confirmed the report, saying the Romneys want to "enlarge their two-bedroom home because with five married sons and 16 grandchildren it is inadequate for their needs. Construction will not begin until the permits have been obtained and the campaign is finished."

In 2008, then-Republican presidential nominee John McCain was criticized and mocked when he said he was unsure how many houses he and his wife, Cindy, owned. The answer was eight.

Since then, perhaps sensing that this could be a liability for him, too, Romney began consolidating his real estate portfolio. Romney and his wife, Ann, sold for $3.5 million the 6,500-square-foot colonial in Belmont, Mass.,

where they raised their five sons. They also sold a 9,500-square-foot home at the Deer Valley ski resort near Park City, Utah, for close to its $5.25 million asking price, according to a 2010 Associated Press report.

Philip Rucker, Romney **Plans** to Quadruple Size of Calif. Home (The Washington Post)

I should be so glad to carry out that **plan** of yours, if you would let me see it. Of course, it is sinking money; that is why people object to it. Laborers can never pay rent to make it answer. But, after all, it is worth doing.

George Eliot, Middlemarch: A Study of Provincial Life

Day After Disaster
Against a morning sky, a mushroom cloud spirals heavenward. A nuclear bomb has detonated in the heart of Washington D.C., incinerating 15,000 residents in just 15 seconds. More than 50% of the population living within a ½ mile radius of the explosion is either dead or severely injured. The next 24 hours will determine whether the rest of the city lives or dies. To survive this horrific ordeal they will need a **plan**. And lucky for us—there is one. But will it work? For the first time on television, the Department of Homeland Security reveals the most detailed and comprehensive **plan** to save America should terrorists go nuclear. This chilling two-hour special delves into the complex and highly secretive world of disaster **planning**.

Internet Movie Database, Plot Summaries

Now Cyrus' **plan** was the following. If the enemy attacked in a tumultuous fashion his soldiers were to receive their onslaught in silence; but if the enemy attacked in silence, his line of battle was to advance with shouts and din. It certainly makes a vast difference, however, whether you have to deal with raw soldiers, who are susceptible to the slightest unusual noise and impression or with seasoned veterans who are not usually frightened by trifles.

Balthazar Ayala, Three Books on the Law of War and on the Duties Connected with War and on Military Discipline

The Vanguard
It's 2015. Oil is gone and the world has been thrown into chaos. Overpopulation has reached a critical stage and to combat it a massive company known only as 'The Corporation' has taken charge of society. Their **plan** for the betterment of mankind? They force scientists to find a disease to weed out the poor and let the rich survive on.

Internet Movie Database, Plot Summaries

*Survival Research Laboratories, A **Plan** for Social Improvement*

Half the states **plan** to cut spending on higher education, and nearly a third **plan** cuts to elementary and high schools. Public assistance and transportation face cuts. Eighteen states have proposed slashing aid to struggling cities and local governments. Some states will raise taxes or fees. Others **plan** to lay off workers, or cut their salaries or benefits.

*Michael Cooper, States **Plan** Deeper Cuts and Higher Taxes, Survey Finds (The New York Times)*

These reflections had led Rabourdin to desire the recasting of the clerical official staff. To employ fewer men, to double or treble salaries, and do away with pensions, to choose only young clerks (as did Napoleon, Louis XIV, Richelieu, and Ximenes), but to keep them long and train them for the higher offices and greatest honors, these were the chief features of a reform which if carried out would be as beneficial to the State as to the clerks themselves. It is difficult to recount in detail, chapter by chapter, a **plan** which embraced the whole budget and continued down through the minutest details of administration in order to keep the whole synthetical; but perhaps a slight sketch of the principal reforms will suffice for those who understand such matters, as well as for those who are wholly ignorant of the administrative system. Though the historian's position is rather hazardous in reproducing a **plan** which may be thought the politics of a chimney-corner, it is, nevertheless, necessary to sketch it so as to explain the author of it by his own work. Were the recital of his efforts to be omitted, the reader would not believe the narrator's word if he merely declared the talent and the courage of this official.

Honoré de Balzac, Bureaucracy

In the DMAIC methodology of Six Sigma, parts of it are managed with standard project management tools, but within the context of an improvement project. The Action **Plan**, also called a Gantt Chart, is usually used in the Improve Phase, where the root causes are identified and the countermeasures have been decided.

Within the context of the DMAIC Six Sigma Methodology, the Action **Plan** catalogs all activities that must be performed to ensure successful implementation of the proposed solution(s). This includes the practical methods that were identified on the <u>Solutions Selection Matrix</u> and any solutions to barriers discovered in the Barriers & Aids analysis that were not cancelled by offsetting aids.

*Pete Abilla, Action **Plan** | Action **Plan** Templates | Action **Plan** Example | DMAIC (Shmula)*

Deer Valley High School
co-principals Clarence Isadore,
left, and Scott Bergerhouse
were two of 52 Antioch Unified
School District employees
to receive layoff notices.

*Justin Lafferty, District Reviews
Two-Principal **Plan** (thepress.net)*

"Want to know how it works?"

"If it's not a state secret."

"Fig leaf operation. You're the fig leaf. Straw man, the Germans call it. Joke is, you're not even straw. You don't exist. All the better. Derek Thomas, merchant venturer, regular guy, quick on his feet, personable, wholesome. Decent record in commerce, no skeletons, good crits. It's Dicky and Derek. Maybe we've done deals before. Nobody's business but ours. I go to the clowns—the brokers, the venture boys, flexible banks—and I say: 'Got a very smart cookie here. Brilliant **plan**, quick profits, needs backing, mum's the word. It's tractors, turbines, machine parts, minerals, it's land, it's what the hell. Introduce you to him later if you're good. He's young, he's got the connections, don't ask where, very resourceful, politically hip, good with the right people, opportunity of a lifetime. Didn't want you missing out. Double your money in four months max. You'll be buying paper. If you don't want paper don't waste my time. We're talking bearer bonds, no names, no pack drill, no connection with any other firm including mine. It's another trust-Dicky deal. I'm in but I'm not there. Company's formed in an area where no accounts need to be prepared or filed, no British connection, not our colony, somebody else's mess. When the deal's done, company ceases trading, pull the plug on it, close the accounts, see you sometime. Very tight circle, few

chaps as possible, no silly questions, take it or leave it, want you to be one of the few.' All right so far?"

John le Carré, The Night Manager

Here were the basic ideas of the Baltimore **Plan** at last ...

*Encyclopedia Britannica Films, The Baltimore **Plan***

It's highly likely that only a few individuals were privy to the whole **plan**. As with the Manhattan Project, which involved hundreds of thousands of people working across America on the United States' atomic bomb, only a relatively few number of scientists were aware of the actual agenda behind the work that they were doing, and even fewer masterminds were coordinating the whole program.

David S. Percy (director), What Happened on the Moon? An Investigation Into Apollo

SILAS: Hey, check it out. We have demand all over the city, which is good—
NANCY: Silas.
SILAS:—but also difficult, because I realize we have no messengers—
NANCY: Silas.
SILAS: What? Can you not yell, I haven't slept much.
NANCY: Where's the supply, by the way, you were supposed to bring it with you.
SILAS: I put it—somewhere.
NANCY: Ok, where?
Silas holds up a key.
NANCY: I'm sorry, are you hiding my weed from me?
SILAS: I created it, I harvested it, I transported it all the way across the country, you mean my weed?
NANCY: I can't believe this.
SILAS: Hear me out, ok? We need to slow down, and come up with a proper business **plan**.
NANCY: We have a **plan**, it's called Sell Drugs, Make Money.
SILAS: I think we need to be more like a pyramid. We're at the top, right, we hire people at the bottom.
NANCY: We're not a pyramid.
SILAS: Halia says you have to insulate yourself.
NANCY: Halia lives in the middle of a pygmy tree forest with Dean Hodes and a shotgun, so I'd really rather not take her advice.
SILAS: I don't know why you hate her.

Jenji Kohan, Weeds: Season 7, Episode 7

NANCY: I don't hate her, I—ohhh—I can't do this right now. I have a son I'd really like to get custody of, I have a halfway house I'd really like to get the fuck out of, I need money flowing. Now.

SILAS: Well, good luck with that.

NANCY: Silas? Today's game—Wall Street bankers—lots of high-paying customers—long-term potential—must fit into your **plan** somewhere, lets not lose sight of that.

SILAS: *(Tosses Nancy some bags.)* Here.

NANCY: That's not even half a pound.

SILAS: It's enough. I've already broken it down for you, see—*(taps his head)*— **plaaaaaanning** ahead.

NANCY: Why don't you get some sleep, you look exhausted.

Jenji Kohan, Weeds: Season 7, Episode 7

This **plan**, so vast apparently yet so simple in point of fact, which did away with so many large staffs and so many little offices all equally useless, required for its presentation to the public mind close calculations, precise statistics, and self-evident proof. Rabourdin had long studied the budget under its double-aspect of ways and means and of expenditure. Many a night he had lain awake unknown to his wife. But so far he had only dared to conceive the **plan** and fit it prospectively to the administrative skeleton; all of which counted for nothing,—he must gain the ear of a minister capable of appreciating his ideas. Rabourdin's success depended on the tranquil condition of political affairs, which up to this time were still unsettled. He had not considered the government as permanently secure until three hundred deputies at least had the courage to form a compact majority systematically ministerial. An administration founded on that basis had come into power since Rabourdin had finished his elaborate **plan**. At this time the luxury of peace under the Bourbons had eclipsed the warlike luxury of the days when France shone like a vast encampment, prodigal and magnificent because it was victorious. After the Spanish campaign, the administration seemed to enter upon an era of tranquillity in which some good might be accomplished; and three months before the opening of our story a new reign had begun without any apparent opposition; for the liberalism of the Left had welcomed Charles X with as much enthusiasm as the Right. Even clear-sighted and suspicious persons were misled. The moment seemed propitious for Rabourdin. What could better conduce to the stability of the government than to propose and carry through a reform whose beneficial results were to be so vast?

Honoré de Balzac, Bureaucracy

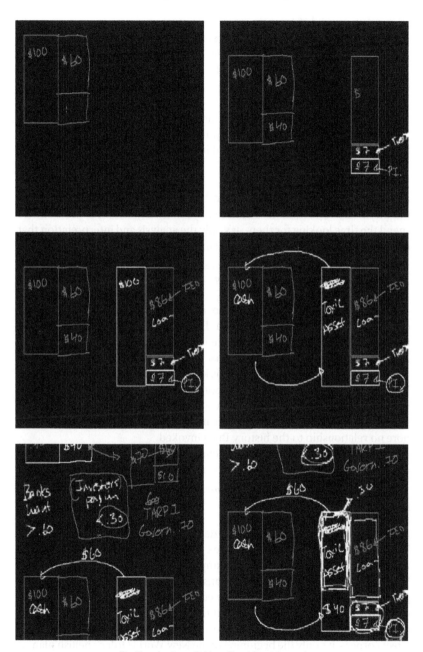

*The Khan Academy, Geithner **Plan** 1 (youtube.com)*

"What do you think?" he said.

"What do *you* think of it, Mr. Fanzel?"

"Such a **plan** would save the country."

"But should we pay them to save the country? Have they no other reason to manufacture these things?"

"They are in business."

"Aren't they making lots of money now?"

"More will be better for everybody. It's business. Ah," he laughed, waving his hand at me, "you don't understand it."

Saul Bellow, Dangling Man

About 90 percent of the information I have gathered on this **plan** is from publicly sourced documents available to you and any one else who wants to spend the time looking for them. It's only the analysis and interpretation that requires skilled—and sometimes unnamed—intelligence sources.

David Aaronovitch, Voodoo Histories: The Role of the Conspiracy Theory in Shaping Modern History

When the initial billions were announced, there were, inevitably, laudatory comparisons with the Marshall **Plan**. Bush invited the parallels, declaring the reconstruction "the greatest financial commitment of it's kind since the Marshall **Plan**," and stating in a televised address in the early months of the occupation that "America has done this kind of work before. Following World War II, we lifted up the defeated nations of Japan and Germany, and stood with them as they built representative governments."

What happened to the billions earmarked for reconstruction, however, bore no relationship to the history Bush invoked.

The Bush cabinet had in fact launched an anti-Marshall **Plan**, it's mirror opposite in nearly every conceivable way.

*Joanne98, The Shock Doctrine: The Anti-Marshall **Plan** Page 346 (Democratic Underground)*

Police State 4: The Rise of FEMA

Police State 4 chronicles the sickening depths to which our republic has fallen. Veteran documentary filmmaker Alex Jones conclusively proves the existence of a secret network of FEMA camps, now being expanded nationwide. The military industrial complex is transforming our once free nation into a giant prison camp. A cashless society control grid, constructed in the name of fighting terrorism, was actually built to enslave the American people. Body scanners, sound cannons, citizen spies, staged terror and cameras on every street corner—it's only the beginning of the New World Order's hellish **plan** ...

John D. Whipps, The Company **Plan**
(Bloomington, IN: AuthorHouse, 2006)

The Illuminati Vol. IV: Brotherhood of the Beast
The world's first political documentary film series to go into FOUR volumes; ILLUMINATI IV follows the occult careers of three American Presidents, and exposes for the first time on film the Black Magic Seances performed by Doctor John Dee for Queen Elizabeth the 1st in the 1500s—These seances summoned demons described in the ancient 'Book of Howling', otherwise known as the 'Goetia'—the demons prescribed a method of controlling the hearts and minds of all peoples on planet Earth—and recommended dividing our planet into a series of regions and states—what we today call 'THE NEW WORLD ORDER'. Today, President Obama sits at the desk of the Oval Office—this is a place where members of various secret societies, witch covens and masonic lodges have wielded power over the minds of millions ... They are following a Master **Plan** called THE WORK OF AGES ... It all seems like 'politics' to the uninitiated—but the wholesale destruction of planet Earth— with the poisoning of the soil, poisoning of the sky and poisoning of the seas has been the game **plan** of a Satanically-inspired Luciferian cabal since the dawn of history. It is a classic battle between the forces of Good and Evil. There is no question that many world leaders are following this master **plan**—and

Suze Orman, Suze Orman's Action **Plan**
(New York: Spiegel & Grau, 2010)

those who disobey are ASSASSINATED. This Master **Plan** was inspired by Elizabethan magician, alchemist and spy—Dr John Dee who maintained a huge library of books about demonology. Spirits spoke to Dr John Dee—and these phantoms dictated a New World Order—dividing the world into various regions over which a particular Dark Angel would rule. Dr John Dee's communications with demons took place within the Royal Court of England, using books known as Grimoires which summoned the Hierarchy of Hell. These demons promise riches for those who follow their **plan**—and curse those who fail to obey with disease and early death. A documentary with documents, diaries, photos, paintings & writings from the 1500s.

Internet Movie Database, Plot Summaries

MARKET'S DOWN? TIME TO CREATE A RETIREMENT **PLAN**

New York—Many big investors look at a drop in the stock market as a buying opportunity. Small business owners should consider it an opportunity as well. That's because it can be a smart time to start a retirement **plan.**

Workers may appreciate the chance to buy stocks while they're lower—or, if they're uneasy about the market, to start accumulating cash. And this is a good time of year to set up a **plan** and get a tax break, even for 2010.

The job market is showing signs of picking up. The more hiring starts to gain momentum, the more people will be looking for work. And if you want to hold on to your best workers, you need to remain competitive. If you're thinking of hiring, one way to get the best candidates is to be able to offer them a benefit like an individual retirement account or 401(k).

The contributions you make to a retirement **plan** for your employees are deductible. If you ask an accountant or tax attorney about getting more deductions for your business, quite often the first they're likely to mention is a retirement **plan**.

It's important to learn about your options before you do anything. IRS Publication 560, Retirement **Plans** for Small Business, outlines the different **plans** and their requirements. You can download it from the IRS website, http://www.irs.gov. But before you make a decision, meet with your accountant or a human resources consultant, or both. They can tell you which kind of **plan** makes the most sense for your firm.

Time and expense may be the biggest concerns of many small business owners. They need a **plan** that isn't complicated to set up and run, and that won't have a lot of fees.

Perhaps the best **plan** for these owners is a SEP, or Simplified Employee Pension. It requires the smallest amount of paperwork and reporting requirements of any **plan**. A small business owner can go to a bank or other financial institution to create a SEP. Although there is an IRS form to be completed, it does not have to be filed with the government. With a SEP, the employer makes contributions, but employees do not contribute to these accounts.

The next step up is the SIMPLE, or Savings Incentive Match **Plan** for Employees. It enables employers to match employee contributions. There are more IRS requirements to meet with a SIMPLE than a SEP. For example, a SIMPLE can only be created by a company with 100 employees or fewer who each were paid at least $5,000 during 2010.

A SIMPLE calls for more paperwork than a SEP, but is still relatively easy. More complex **plans**, like defined contribution **plans**, require more time and paperwork that must be filed with the government. You may need to hire a benefits consultant to do the work. So the added expense will be a consideration for many businesses.

*Joyce M. Rosenberg, Market's Down? Time to Create a Retirement **Plan** (The Times Leader)*

But the problems arrive with the squared **plan**, which is actually related to the Greek-cross **plan**, to which corresponds in most cases a hemispherical dome with a cylindrical drum, although it can also be octagonal. It is not by chance that all the interior perspectives we have are in relation to this **plan**, but even so, not everything can be disclosed.

> João Pedro Xavier, *Leonardo's Representational Technique for Centrally-**Plan**ned Temples (Nexus Network Journal)*

No, I believe there is another more sinister reason. There is a master **plan** for global governance being plotted in meetings of groups like the Council on Foreign Relations. You can read its reports. And I believe this open-borders policy is a direct result of those **plans**, which have been secretly adopted by our highest leaders, including President Bush.

> David Aaronovitch, *Voodoo Histories: The Role of the Conspiracy Theory in Shaping Modern History*

I call it magic **plan** economics, and I remind you there's no such thing as magic. Once you understand how sociopathic Freidman was, and witnessed the misery and havoc leveled everywhere else the Shock Doctrine has been applied, you can't help but get spooked. The **plan** is to do for the US economy what the shock doctrine has done for Bangladesh, if that doesn't scare you I don't know what will.

> Paul Udstrand, *Missed Metaphors: Naomi Klein's "Shock Doctrine" (Thoughtful Bastards)*

I DO URGE MY ONES TO SIMPLY NOT DO BUSINESS WITH OTHERS WHO ARE NOT PREPARED TO DO BUSINESS AS YOU FIND IT NECESSARY. AS A GOOD EXAMPLE—NONE OF OUR BUSINESSES DO BUSINESS WITH ANY OTHER THAN OTHER COMPANIES AND CORPORATIONS—PREFERABLY INCORPORATED IN NEVADA WHERE PRIVACY IS MAINTAINED ABOVE ALL ELSE. IT IS LEGAL, IT IS GOOD BUSINESS AND IT IS YOUR LAST BULWARK OF PRIVACY IN THIS PUBLIC WORLD WHERE YOU ARE ON DISPLAY FOR ALL. MY **PLAN** IS TO FURNISH YOU WITH RESOURCES AND SOURCES TO EXTEND EXPLANATIONS AND INFORMATION. MY **PLAN** IS TO ONLY OUTLINE METHODS—YOU WILL FERRET OUT THE INFORMATION—LET'S JUST REFER TO THIS AS HATONN'S HELPFUL HINTS FOR SURVIVAL.

> Gyeorgos Ceres Hatonn, *Privacy in A Fishbowl: Spiral to Economic Disaster, Vol. 2*

Alexander Grover, The Organic Stimulus **Plan**
(Seattle, WA: CreateSpace, 2010)

While Gevurah is the Sefirah of awe and evil, Tiferet is the Sefirah of beauty and harmony. As Diotallevi said: It is the light of understanding, the tree of life; it is pleasure, hale appearance. It is the concord of Law and Freedom.

And that year was for us the year of pleasure, of the joyful subversion of the great text of the universe, in which we celebrated the nuptials of Tradition and the Electronic Machine. We created, and we delighted in our creation. It was the year in which we invented the **Plan**.

Umberto Eco, Foucault's Pendulum

The method of development is the principle on
- which all ordinary maps are constructed, and it will,
therefore, be desirable to examine it more carefully.
There are many different plans of development, such
as globular, cylindrical, and conical, but they are

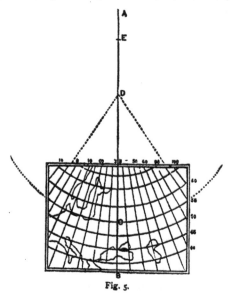

Fig. 5.

all similar in principle—that of representing the
earth on such a geometrical figure that it will not be
altered by being unfolded or developed as a plane.
A sphere cannot be thus developed without destroying
it; but a cone or cylinder can be unfolded without
altering the value of anything described upon its
surface.

*C. Cooper King, Map and **Plan** Drawing
(London: Cassell Petter & Galpin, 1873)*

are those the plans?

She was looking at **plans** one day in the following spring—they had finally decided to go down into Sussex and build—when Mrs. Charles Wilcox was announced.

"Have you heard the news?" Dolly cried, as soon as she entered the room. "Charles is so ang—I mean he is sure you know about it, or rather, that you don't know."

"Why, Dolly!" said Margaret, placidly kissing her. "Here's a surprise! How are the boys and the baby?"

Boys and the baby were well, and in describing a great row that there had been at Hilton Tennis Club, Dolly forgot her news. The wrong people had tried to get in. The rector, as representing the older inhabitants, had said—Charles had said—the tax-collector had said—Charles had regretted not saying—and she closed the description with, "But lucky you, with four courts of your own at Midhurst."

"It will be very jolly," replied Margaret.

"Are those the **plans**? Does it matter me seeing them?"

"Of course not."

"Charles has never seen the **plans**."

"They have only just arrived. Here is the ground floor—no, that's rather difficult. Try the elevation. We are to have a good many gables and a picturesque sky-line."

"What makes it smell so funny?" said Dolly, after a moment's inspection. She was incapable of understanding **plans** or maps.

"I suppose the paper."

"And WHICH way up is it?"

"Just the ordinary way up. That's the sky-line, and the part that smells strongest is the sky."

E. M. Forster, Howards End

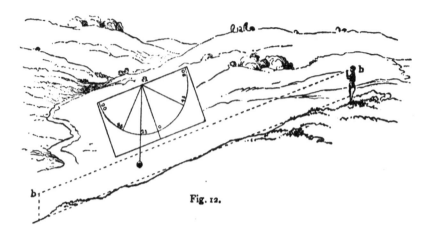

Fig. 12.

C. Cooper King, Map and **Plan** Drawing (London: Cassell Petter & Galpin, 1873)

Abstract. In this paper we propose and illustrate analytic techniques for the analysis of **plans**. Two issues are addressed: first, the characterization of individual surfaces according to the local and global patterns of visual connectivity between surfaces; second, the pattern of the smallest set of positions from which all surfaces become completely visible.

*J. Peponis, J. Wineman, M. Rashid, S. Bafna and S. H. Kim, Describing **Plan** Configuration According to the Covisibility of Surfaces (Environment and **Planning** B: **Planning** and Design)*

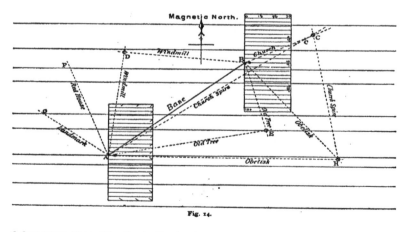

Fig. 14.

C. Cooper King, Map and **Plan** Drawing (London: Cassell Petter & Galpin, 1873)

PLATE 15

SIGNS USED IN PLANS.

Fence	Canal	Sand Pits
Fence with Bank	River	Rocks
Fence with Hedge	Ponds	Mud
Footpath	Lake	Gas Works
Bridle Paths	Wooden Fence	Glass Works
Occupation Road	Post and Rail or thus	Iron Works
Public Road	Chains & Post	Column
Wall	Hurdle Fence	Old Castle
Parish Boundary	Gates	Covered Passage
Hamlet Boundary	Farm Buildings	Saw Mill
County Boundary	Churches	Stone Windmill
Parish & County Boundary	Windmills	Wooden Windmill
Railway	Water Mills	Cotton Factory
Tramway	Lime Kiln	Woollen Factory
Stream	Sunk Road	Well
Brook	Raised Road	Dry Well
Ditch	Quarry	Salt Works
Mineral Waters	Inn	Field Well

E & F.N. Spon. London & New York

George G. André, The Draughtsman's Handbook of **Plan** and Map Drawing, Including Instructions for the Preparation of Engineering, **Architectural**, and Mechanical Drawings. With Numerous Illustrations and Coloured Examples (London, New York: E. & F. N. Spon, 1874)

Figure 2 shows an example of an **architectural** floor **plan**. Automatic analysis and integration of such drawings include the following steps (Fig. 3 refers):

1. Finding out parallel pairs (PPs) of structural entities using a shape-based method. A parallel pair (PP) is a segment of two parallel and overlapped lines.
2. Identifying the semantics of PPs and create structural objects.
3. Removing the recognized PPs.
4. Recognizing functional and decorative entities using a feature-based symbol recognition method.
5. Analyzing **architectural** tables and integrating with recognized objects.
6. Integrating recognized entities on the same floor.
7. Integrating drawings of different floors.

Tong Lu, Huafei Yang, Ruoyu Yang and Shijie Cai, Automatic Analysis and Integration of **Architectural** *Drawings (International Journal of Document Analysis and Recognition)*

The first or principal drawing is called the Sheer Drawing. This is divided into three parts, called the *Sheer **Plan**,* the *Half-Breadth **Plan**,* and the *Body **Plan**.* To understand these drawings and the mode of making them, it is only necessary to imagine yourself called on at dinner to dissever a turkey without being posted in the ways of carving. As you will naturally do the thing wrong, allow me to suggest that, on the first slash of the knife, you will divide Mr. Turkey in two parts, from the neck to the pope's nose. That is the Sheer **Plan**. Or, as there is more than one way to do the thing wrong, we will suppose that you see fit to divide the bird by cutting him in two parts, equidistant between those extremes of its person mentioned above. This would be the Body **Plan**; while by laying it upon the side and slicing it through lengthwise, you will get the Half-Breadth **Plan**.

From this sheer drawing we, as practical builders, go to work and make construction drawings, which shall show the exact position of every plank and timber in the ship we are about to build. The end gained by this proceeding will be, that every plank and timber can be accurately cut according to the shape wanted, and when brought to its place on the growing ship, can be fitted with little or no trouble. To show this, I here give you, with a few touches of my chalk, a portion of the outer planking or skin of a ship, according to the construction drawing, that you may see how easy it is, by reducing feet to inches and inches to hundredths, to get out each plank of the required width, length, and thickness to cover certain places.

The Building of the Ship (Harper's Magazine, 1862)

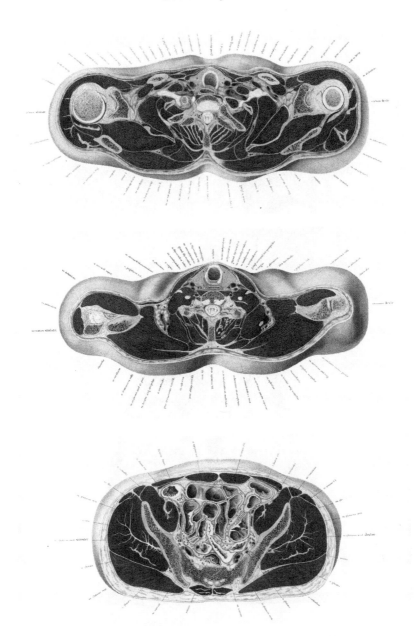

Wilhelm Braune and C. Schmiedel, Topographisch-anatomischer Atlas,
(Leipzig: Verlag von Veit & Comp., 1872)

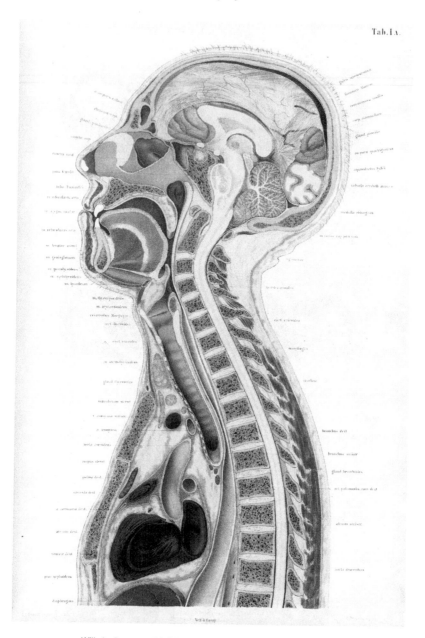

Wilhelm Braune and C. Schmiedel, Topographisch-anatomischer Atlas
(Leipzig: Verlag von Veit & Comp., 1872)

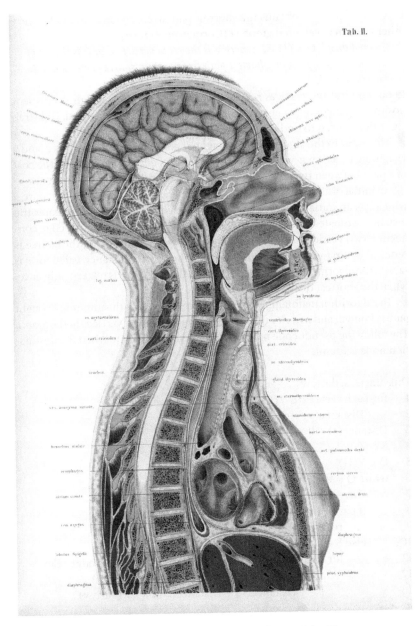

Wilhelm Braune and C. Schmiedel, Topographisch-anatomischer Atlas
(Leipzig: Verlag von Veit & Comp., 1872)

Dijkstra's algorithm obtains the shortest path from a source node *s* to every other node in a weighted graph G [Cormen et al. 2001].

> *Given a graph G = (V, E), where V is the set of vertices and E is the set of weighted edges, find the shortest path from a given source vertex s ∈ V to each vertex v ∈ V.*

In our application, vertices represent locations, and edge weights represent positive distances between pairs of locations connected by a portal. Dijkstra's algorithm is used to find the shortest route between two locations.

The input to the algorithm is a weighted graph G, a source vertex *s*, and a weighting function *w* which gives the weights of edges in the graph. The cost of a path between two vertices is the sum of weights of edges in that path.

An initial distance of infinity is assigned to each node except for the source, which has an initial distance of zero from itself. The algorithm updates the distance estimates for each node with *edge relaxation*: consider an edge connecting two vertices *u* and *v*. If the distance estimate to *v* from the source is reduced by first traveling through *u*, then the shorter distance value for *v* is saved. The algorithm is structured so that each edge (*u, v*) is relaxed only once, when the shortest distance to *u* is known.

The algorithm maintains a set S of vertices for which the minimum weight path is known, and priority queue Q containing all other vertices in the graph. The following pseudocode has been modified to terminate when the destination node is found.

```
Dijkstra(G, s, dest, w)
1    for each vertex v ∈ V(G)              // initialization
2         Distance(v) ← ∞
3    Distance(s) ← 0
4    S ← ∅
5    Q ← V(G)
6    while Q ≠ ∅
7         curr ← Extract-Min(Q)
8         if curr = dest
9              return Path(s, curr)
10        else S ← S ∪ {curr}
11             for each vertex v adjacent to curr          // edge relax
12                  if Distance(v) > Distance(curr) + w(curr, v)
13                       Distance(v) ← Distance(curr) + w(curr, v)
```

Emily J. Whiting, *Geometric, Topological and Semantic Analysis of Multi-Building Floor **Plan** Data*

Albrecht Dürer, Clariss. Pictoris et Geometrae Alberti Dureri, de varietate figurarum et
flexuris partium ac gestib. imaginum, libri duo: qui priorib. de symmetria quondam editis,
nunc primum in latinum conuersi accesserunt (Norinbergae: Formschneyder, 1534)

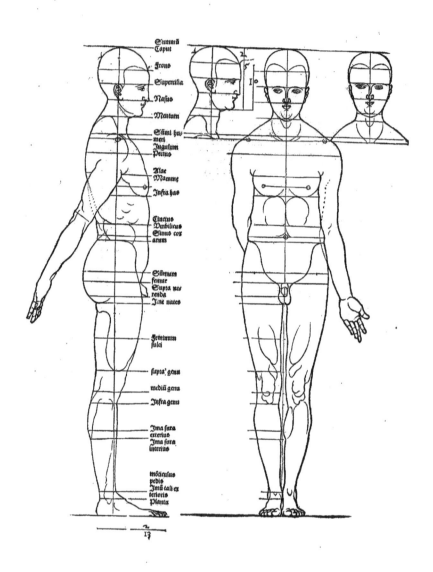

Albrecht Dürer, Clariss. Pictoris et Geometrae Alberti Dureri, de varietate figurarum et flexuris partium ac gestib. imaginum, libri duo: qui priorib. de symmetria quondam editis, nunc primum in latinum conuersi accesserunt (Norinbergae: Formschneyder, 1534)

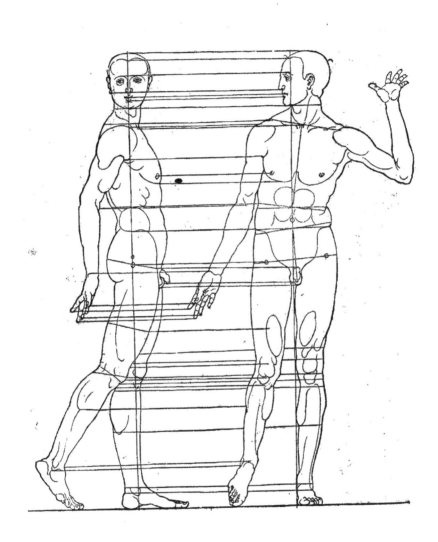

Albrecht Dürer, Clariss. Pictoris et Geometrae Alberti Dureri, de varietate figurarum et flexuris partium ac gestib. imaginum, libri duo: qui priorib. de symmetria quondam editis, nunc primum in latinum conuersi accesserunt (Norinbergae: Formschneyder, 1534)

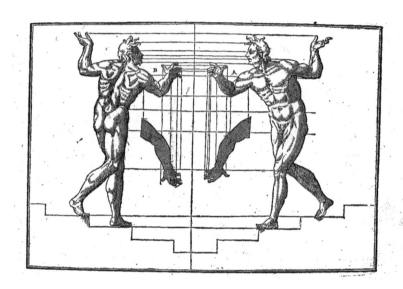

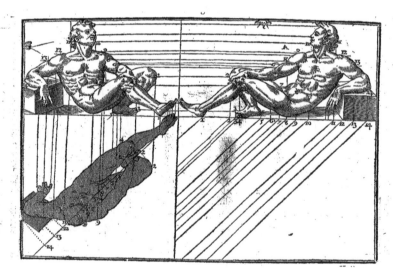

*Jehan Cousin and Jean Leclerc (engraver), Livre de pourtraiture de maistre Iean Cousin ...: contenant par vne facile instruction, plusieurs **plans** & figures de toutes les parties separees du corps humain, ensemble les figures entieres, tant d'ho[m]mes que de femmes, & de petits enfans, veues de front, de profil, & de dos, auec les proportions, mesures, & dimansions d'icelles, & certaines regles pour racourcir par art toutes lesdites figures: fort vtile & necessaire aux peintres, statuaires, **architects**, orseures, brodeurs, menusiers, & generalement à tous ceux qui ayment l'art de peinture & de sculpture (Paris: Chez Iean le Clerc., 1608)*

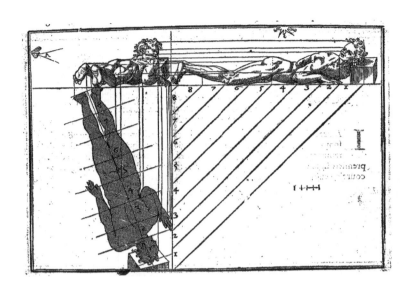

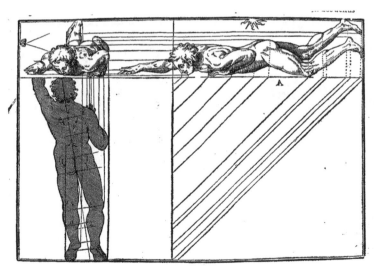

*Jehan Cousin and Jean Leclerc (engraver), Livre de pourtraiture de maistre Iean Cousin ...: contenant par vne facile instruction, plusieurs **plans** & figures de toutes les parties separees du corps humain, ensemble les figures entieres, tant d'ho[m]mes que de femmes, & de petits enfans, veues de front, de profil, & de dos, auec les proportions, mesures, & dimansions d'icelles, & certaines regles pour racourcir par art toutes lesdites figures: fort vtile & necessaire aux peintres, statuaires, **architects**, orseures, brodeurs, menusiers, & generalement à tous ceux qui ayment l'art de peinture & de sculpture (Paris: Chez Iean le Clerc., 1608)*

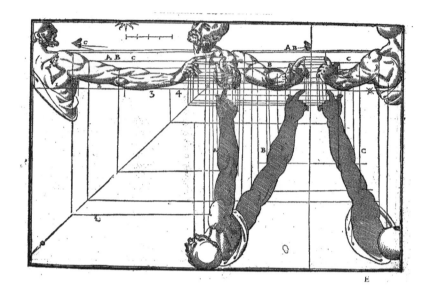

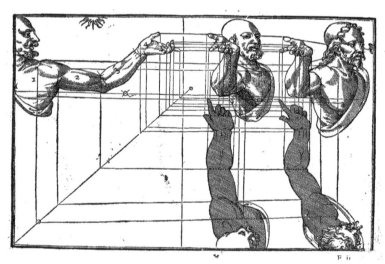

Jehan Cousin and Jean Leclerc (engraver), Livre de pourtraiture de maistre lean Cousin ...: contenant par vne facile instruction, plusieurs **plans** *& figures de toutes les parties separees du corps humain, ensemble les figures entieres, tant d'ho[m]mes que de femmes, & de petits enfans, veues de front, de profil, & de dos, auec les proportions, mesures, & dimansions d'icelles, & certaines regles pour racourcir par art toutes lesdites figures: fort vtile & necessaire aux peintres, statuaires,* **architects***, orseures, brodeurs, menusiers, & generalement à tous ceux qui ayment l'art de peinture & de sculpture (Paris: Chez lean le Clerc., 1608)*

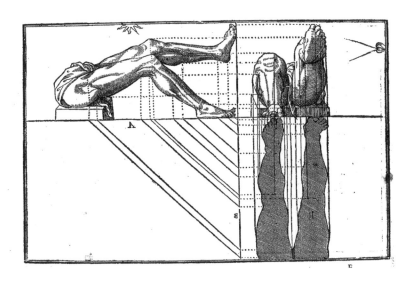

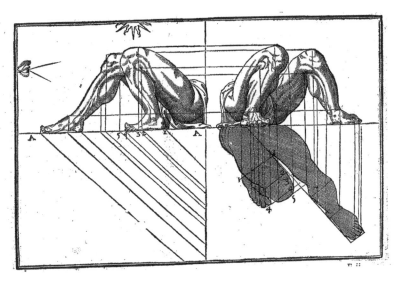

*Jehan Cousin and Jean Leclerc (engraver), Livre de pourtraiture de maistre Iean Cousin ...: contenant par vne facile instruction, plusieurs **plans** & figures de toutes les parties separees du corps humain, ensemble les figures entieres, tant d'ho[m]mes que de femmes, & de petits enfans, veues de front, de profil, & de dos, auec les proportions, mesures, & dimansions d'icelles, & certaines regles pour racourcir par art toutes lesdites figures: fort vtile & necessaire aux peintres, statuaires, **architects**, orseures, brodeurs, menusiers, & generalement à tous ceux qui ayment l'art de peinture & de sculpture (Paris: Chez Iean le Clerc., 1608)*

119

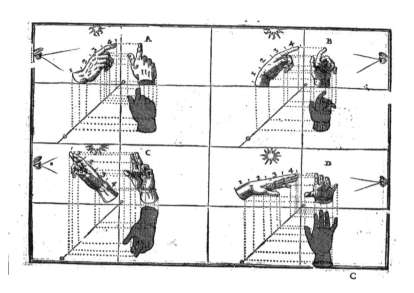

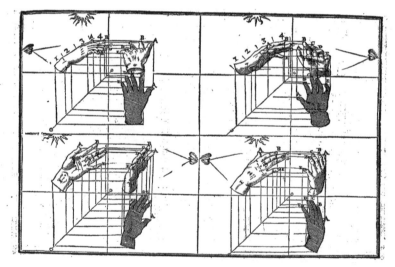

Jehan Cousin and Jean Leclerc (engraver), Livre de pourtraiture de maistre Iean Cousin ...: contenant par vne facile instruction, plusieurs **plans** & figures de toutes les parties separees du corps humain, ensemble les figures entieres, tant d'ho[m]mes que de femmes, & de petits enfans, veues de front, de profil, & de dos, auec les proportions, mesures, & dimansions d'icelles, & certaines regles pour racourcir par art toutes lesdites figures: fort vtile & necessaire aux peintres, statuaires, **architects**, orseures, brodeurs, menusiers, & generalement à tous ceux qui ayment l'art de peinture & de sculpture (Paris: Chez Iean le Clerc., 1608)

*Jehan Cousin and Jean Leclerc (engraver), Livre de pourtraiture de maistre Iean Cousin ...: contenant par vne facile instruction, plusieurs **plans** & figures de toutes les parties separees du corps humain, ensemble les figures entieres, tant d'ho[m]mes que de femmes, & de petits enfans, veues de front, de profil, & de dos, auec les proportions, mesures, & dimensions d'icelles, & certaines regles pour racourcir par art toutes lesdites figures: fort vtile & necessaire aux peintres, statuaires, **architects**, orseures, brodeurs, menusiers, & generalement à tous ceux qui ayment l'art de peinture & de sculpture (Paris: Chez Iean le Clerc., 1608)*

Postwar **plans** such as Copenhagen's famous Finger **Plan** and Holland's Green Heart and Randstad extended the tradition. In the early 1960s, Ed Bacon's **plan** for Philadelphia got him on the cover of *Time* magazine.

Michael Neuman, *Does Planning Need the Plan?*
(*Journal of the American Planning Association*)

'First I've heard of it,' said Arthur, 'why's it got to be built?'

Mr Prosser shook his finger at him for a bit, then stopped and put it away again.

'What do you mean, why's it got to be built?' he said 'It's a bypass. You've got to build bypasses.'

Bypasses are devices which allow some people to dash from point A to point B very fast whilst other people dash from point B to point A very fast. People living at point C, being a point directly in between, are often given to wonder what's so great about point A that so many people from point B are so keen to get there, and what's so great about point B that so many people from point A are so keen to get there. They often wish that people would just once and for all work out where the hell they want to be.

Mr Prosser wanted to be at point D. Point D wasn't anywhere in particular, it was just any convenient point a very long way from points A, B and C. He would have a nice little cottage at point D, with axes over the door, and spend a pleasant amount of time at point E, which would be the nearest pub to point D. His wife of course wanted climbing roses, but he wanted axes. He didn't know why—he just liked axes. He flushed hotly under the derisive grins of the bulldozer drivers.

He shifted his weight from foot to foot, but it was equally uncomfortable on each. Obviously somebody had been appallingly incompetent and he hoped to God it wasn't him.

Mr Prosser said, 'You were quite entitled to make any suggestions or protests at the appropriate time, you know.'

'Appropriate time?' hooted Arthur. 'Appropriate time? The first I knew about it was when a workman arrived at my home yesterday. I asked him if he'd come to clean the windows and he said no he'd come to demolish the house. He didn't tell me straight away, of course. Oh no. First he wiped a couple of windows and charged me a fiver. Then he told me.'

'But, Mr Dent, the **plans** have been available in the local **planning** office for the last nine months.'

'Oh yes, well as soon as I heard I went straight round to see them, yesterday afternoon. You hadn't exactly gone out of your way to call attention to them, had you? I mean like actually telling anybody or anything.'

'But the **plans** were on display ...'
'On display? I eventually had to go down to the cellar to find them.'
'That's the display department.'
'With a torch.'
'Ah, well the lights had probably gone.'
'So had the stairs.'
'But look, you found the notice, didn't you?'
'Yes,' said Arthur, 'yes I did. It was on display in the bottom of a locked filing cabinet stuck in a disused lavatory with a sign on the door saying *Beware of the Leopard.*'
A cloud passed overhead. It cast a shadow over Arthur Dent as he lay propped up on his elbow in the cold mud. It cast a shadow over Arthur Dent's house. Mr Prosser frowned at it.

Douglas Adams, The Hitchhiker's Guide to the Galaxy

Recently, there has been a revival of interest in visibility analysis of **architectural** configuration and various attempts have been made to develop automated tools for assistance in **architecture** and urban research and **plan** development. Benedikt (1979) was the first to introduce the 'ISOVIST', the area visible directly from any location within the space. He developed a set of analytic measurements of ISOVIST properties to be applied to achieve quantitative descriptions of the built environment. Batty (2001) suggested a feasible computational scheme for measuring ISOVIST fields and illustrated how they can visualize their spatial and statistical properties by using maps and frequency distributions. Turner et al (2001) have developed an automated model, the 'Depthmap', for visibility analysis based on the idea that a set of ISOVIST can be used to generate a graph of mutual visibility between locations. Additional automated models were developed based on the ISOVIST concept, among them the 'Axman' by Bin Jiang (1999) and the 'Spatialist' by Peponis et al (1998).

*Dafna Fisher-Gewirtzman, View-Oriented Three-Dimensional Visual Analysis Models for the Urban Environment (Urban **Design** International)*

Gentlemen. I want you to look at that clump of trees on that ridge. That is where all units will converge. You will be spread out in a long line, perhaps a mile, all units converging on that point on the crest of that ridge. Now, look here. The Yankee center. A stone wall. A small grove of trees. General Trimble, commanding Pender's division, will be on the left. Pettigrew's brigade in support. General Pickett's division will be on the right side of the attack. And now, George, I want you to put two brigades in front, and one in back, like so. Good, alright then. Garnett will dress off at Trimble's flank. He will

*Ronald F. Maxell (director), Gettysburg—Pickett's Charge: The **Plan** (uploaded by Zappiss, youtube.com)*

be the hinge, so to speak, in a series of left obliques. Somewhere about the Emmitsburg Road, you will execute your first left oblique, then direct, then left again, and so on at your own discretion, in order to deceive the Yankees and spread them out in a long line, here. Any questions?

Ronald F. Maxell (director), Gettysburg—Pickett's Charge: The **Plan**

Observations

(i) There is a consistency about parameter c which only appears to vary with the proportions of successive rectangles;

(ii) There is some interchange of real and imaginary values with opposite signs for a and d for successive transformations;

(iii) Clearly the lack of pattern in the parameters grows as the layouts become more complicated particularly with parameter b (in this case it may not be a problem);

(iv) The poles shown follow a less consistent path as the layout becomes more complicated.

Christopher Stone, The Use of Linear Fractional Transformations
to Produce Building **Plans** (Nexus Network Journal)

In order to triangulate general polygonal regions, the incremental Constrained Delaunay Triangulation (CDT) algorithm is used. This is a generalization of the standard Delaunay triangulation that forces certain edges (the boundaries) into the triangulation. We use the public domain implementation of [Bern and Eppstein 1992] by Dani Lischinski [1994]. The implementation is based on the quad-edge data structure, **designed** for representing general subdivisions of orientable manifolds [Guibas and Stolfi 1985] …

Next, in order to find the triangulation for the polygonal region (i.e. triangles inside the polygon), we perform a depth first search. The implementation relies on the following edge functions (see Fig. 1-11):

- *Lnext ()* returns the counter-clockwise edge around the left face following the current edge.
- *Sym ()* returns the edge from the destination to the origin of the current edge.

Additionally, each edge stores two Boolean values, c and *triangleMark*, that indicate a constrained edge and a visited left face (respectively).

The depth first search is illustrated in Fig. 1-12: the root triangle is chosen as the left face of a polygon edge E. This will return an interior triangle assuming E is oriented counter-clockwise, which we guarantee. The orientation of the

Fig. 7. Transformations H

Transformations H show a cyclic arrangement of 2x1 rectangles around a square. One fixed point per transformation is shown (fig. 7). Results are shown in **Table 4 (H)**.

	a	b	c	d	Pole z_∞	Pole Z_∞	Fixed Point
↑	$-14+2i$	$12+24i$	$5i$	$8-4i$	$\dfrac{4}{5}+\dfrac{8i}{5}$	$\dfrac{2}{5}+\dfrac{14i}{5}$	$2i$
→	$-13+14i$	$54+3i$	$5i$	$11-8i$	$\dfrac{8}{5}+\dfrac{11i}{5}$	$\dfrac{14}{5}+\dfrac{13i}{5}$	$2+3i$
↓	$-1+13i$	$18-24i$	$5i$	$7-11i$	$\dfrac{11}{5}+\dfrac{7i}{5}$	$\dfrac{13}{5}+\dfrac{i}{5}$	$3+i$
←	$-2+i$	$6-3i$	$5i$	$4-7i$	$\dfrac{7}{5}+\dfrac{4i}{5}$	$\dfrac{1}{5}+\dfrac{2i}{5}$	1

Table 4 (H). (Results cannot be easily summarised by creating formulae)

*Christopher Stone, The Use of Linear Fractional Transformations to Produce Building **Plans***

ordered list of contour points is determined, and if clockwise, then Sym(E) is used as the starting edge.

Emily J. Whiting, Geometric, Topological and Semantic
Analysis of Multi-Building Floor **Plan** *Data*

No, I wasn't going insane. I had a **plan**. I was moving in the right direction. He elbowed me twice in the belly, sending jet lightning patterns trilling up my spine.

"You had enough, Coddy?" Bellamy gasped.

"Nope, I haven't," I replied.

Peter Plate, One Foot Off the Gutter

A finite projective geometry of dimension $(r - 1)$ over GF(m) is denoted by PG($r - 1, m$), where GF(m) is the Galois field of order m, m being a prime power. It consists of the ordered set $(x_0, x_1, \ldots, x_{r-1})$ of points where x_i (i = 0, 1, \ldots, r − 1) are elements of GF(m) and all of them are not simultaneously zero. For any $\lambda \in$ GF(m) ($\lambda \neq 0$), the point $(\lambda x_0, \ldots, \lambda x_{r-1})$ represents the same point as that of (x_0, \ldots, x_{r-1}). The total number of points lying on PG(r − 1, m) is $\frac{m^r - 1}{m - 1}$. All those points that satisfy a set of (r − t − 1) linearly independent homogeneous equations with coefficients from GF(m) (all of them are not simultaneously zero within the same equation) is said to represent a t-flat in PG($r - 1, m$).

M. Aggarwal, Lih-Yuan Denga and Mukta Datta Mazumder, Optimal Fractional Factorial
Plans *Using Finite Projective Geometry (Communications in Statistics—Theory and Methods)*

But during those two days of his first wild vassalage to his original sensations, Pierre had not been unvisited by less mysterious impulses. Two or three very plain and practical **plannings** of desirable procedures in reference to some possible homely explication of all this nonsense—so he would momentarily denominate it—now and then fittingly intermitted his pervading mood of semi-madness. Once he had seized his hat, careless of his accustomed gloves and cane, and found himself in the street, walking very rapidly in the direction of the Miss Pennies'. But whither now? he disenchantingly interrogated himself. Where would you go? A million to one, those deaf old spinsters can tell you nothing you burn to know. Deaf old spinsters are not used to be the depositaries of such mystical secrecies.

Herman Melville, Pierre, Or, the Ambiguities

In particular, a 0-flat, a 1-flat . . . , and a $(r - 2)$-flat, respectively, in PG($r - 1, m$) are known as a point, a line . . . , and a hyperplane of PG($r - 1, m$). The number

really, I'm being so well organised with these! I normally just crochet away, but with this project I need some **planning** ahead!

Comments and faves
1. hooked on yarn (7 months ago | reply)
 Cool! I've often wondered whether these were **planned** or spontaneously happened
2. roomontheleft (7 months ago | reply)
 so by the end of the week you should have it done?????!!!!!!! :) :) :)
 can't wait to see it …
3. snippygal (7 months ago | reply)
 Oooooo I love Babette **planning**!!
 I know what you mean about **planning** ahead on this one. I just WENT with the first one I made, and enjoyed the heck out of myself, but along the way, I came to realize how beneficial it would be (next time) to be more organized going in. I haven't yet worked up the strength to do a second one—they require a great deal of time and commitment—but SO worth it. I've never seen an ugly Babette. Can't wait to see your progress! Hope you'll post plenty of squarey photos along the way.
5. LauraLRF (7 months ago | reply)
 Good girl pertinitaco!!! Sometimes it is necesary to be organized specially with a babette which it's so irregular. I agree with snippygal, I can't get the courage to go for a second one, BUT if someone else make an organized layout and share it with me … who knows?! hahahahaha Go for it my friend!!! It will be fantastic!!!
6. Bethel of Bethania (7 months ago | reply)
 Wow I'm impressed with your discipline …
 I do love your free spirit in crochet though …
 Can't wait to see you doing it orderly like … ha ha
11. bienzfive (7 months ago | reply)
 aaaah so there is a **plan**. Are those 2,4,6,8,10,12 inch squares? Sorry if it's a dumb question … you know me, s l o w ! ;D
 Can't wait for this baby!!

*pertinitaco, babette **planning** (flickr.com)*

of points lying on a $(t-1)$-flat is $\frac{m^t - 1}{m-1}$ but the number of independent points lying on a $(t-1)$-flat is t. The number of $(r-2)$ flats within a $\mathrm{PG}(r-1, m)$ that contain a given $(r-3)$-flat is $(m+1)$. One may refer to Hirschfeld (1998) for more details.

M. Aggarwal, Lih-Yuan Denga and Mukta Datta Mazumder, Optimal Fractional Factorial
Plans Using Finite Projective Geometry (Communications in Statistics—Theory and Methods)

"Eh! mon Dieu! yes."

"Oh! Porthos, Porthos! I must bow down before you—I must admire you! But you have always concealed from us this superb, this incomparable genius. I hope, my dear friend, you will show me all this in detail."

"Nothing more easy. Here lies my original sketch, my **plan**."

"Show it me." Porthos led D'Artagnan towards the stone that served him for a table, and upon which the **plan** was spread. At the foot of the **plan** was written, in the formidable writing of Porthos, writing of which we have already had occasion to speak:—

"Instead of making use of the square or rectangle, as has been done to this time, you will suppose your place inclosed in a regular hexagon, this polygon having the advantage of offering more angles than the quadrilateral one. Every side of your hexagon, of which you will determine the length in proportion to the dimensions taken upon the place, will be divided into two parts and upon the middle point you will elevate a perpendicular towards the center of the polygon, which will equal in length the sixth part of the side. By the extremities of each side of the polygon, you will trace two diagonals, which will cut the perpendicular. These will form the precise lines of your defense."

"The devil!" said D'Artagnan, stopping at this point of the demonstration; "why, this is a complete system, Porthos."

"Entirely," said Porthos. "Continue."

"No; I have read enough of it; but, since it is you, my dear Porthos, who direct the works, what need have you of setting down your system so formally in writing?"

Alexandre Dumas, Ten Years Later

Recognition of **architectural** entities is the first step. However, various types of **architectural** entities and multitude graphical primitives may complicate the recognition process. For instance, when recognizing walls, the leading lines and dimension lines are all disturbing graphical primitives. When the number of such primitives increases, the recognition process will become easily disturbed.

Tong Lu, Huafei Yang, Ruoyu Yang and Shijie Cai, Automatic Analysis and Integration of
Architectural Drawings (International Journal of Document Analysis and Recognition)

Albrecht Dürer, Clariss. Pictoris et Geometrae Alberti Dureri, de varietate figurarum et flexuris partium ac gestib. imaginum, libri duo: qui priorib. de symmetria quondam editis, nunc primum in latinum conuersi accesserunt (Norinbergae: Formschneyder, 1534)

Sunt et alij cubi variationes, de quibus diuerſitas in faciebus capitum exiſtit hu⸗
iuſmodi.Primum ſi ſuperiorem cubi ſuperficiem quadratā conſtituas et dilatatam,
Infra autem tantum detrahas de quadrata ſuperficie, quanto ſuperior fuerit dilata⸗
tior. Jdq̈ etiam ipſum poſtea inuertere poteris. Vt quanto fuerit infra cubus ampli⸗
or hoc ſit ſupra anguſtior. Quibus conſtitutis poſtea lineæ partium inducentur auxi⸗
lio Diligentis, et deinceps congruentia formæ. Ita exibit vna facies capitis ſupra
amplioris, infra anguſtioris. Altera autem ſupra anguſtioris amplioris infra. Cu⸗
ius et ipſius rationis vſus per totum corpus fuerit. Quemadmodum autem diximus
biſariam ſuperficiem cubi ſupra et infra variatam efficere diuerſas facies, Ita hinc
et illinc, id eſt, dextri ac ſiniſtri lateris mutata ſuperficies, diuerſas facies reddit. Nam
ſi prior, id eſt, quæ ad dextram eſt ſuperficies dilatetur, poſterior, id eſt, quæ ad ſini⸗
ſtram contrahatur, Itemq̈ contra, ſi hæc contrahatur, dilatetur illa. Et partium

Albrecht Dürer, Clariss. Pictoris et Geometrae Alberti Dureri, de varietate figurarum et flexuris partium ac gestib. imaginum, libri duo: qui priorib. de symmetria quondam editis, nunc primum in latinum conuersi accesserunt (Norinbergae: Formschneyder, 1534)

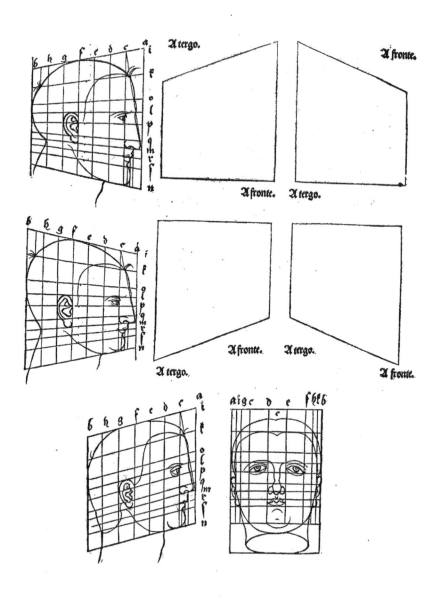

Albrecht Dürer, Clariss. Pictoris et Geometrae Alberti Dureri, de varietate figurarum et flexuris partium ac gestib. imaginum, libri duo: qui priorib. de symmetria quondam editis, nunc primum in latinum conuersi accesserunt (Norinbergae: Formschneyder, 1534)

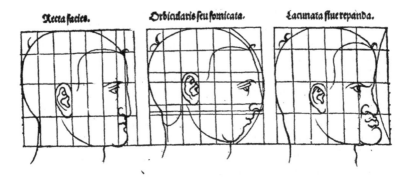

Recta facies. **Orbicularis seu fornicata.** **Lacunata siue repanda.**

Sunt præterea duæ differentiæ obliquæ faciei quæ sic quasi in Rhombi figura designantur vt relinquatur transuersa vtraqʒ supra et infra παράλληλοο, se duo recta latera obliquentur παραλληλαο tamen et ipsa. Ita vt in comparatione laterum obliquorum lineæ supra concurrant infra discedant. Ita erit in priore a fronte angulus supra acutus infra obtusus, cui a tergo respondeat supra obtusus, vt infra acuto acutus. In altera erunt hæc inuersa. Quo facto debebunt de transuersis omnes partes distribui. Sed tamen non quadrabunt ad perpendiculum demissæ per transuersas lineæ, Verum obliquæ omnes existent. In prioreqʒ facie proniusculam formam in altera supinulam lineamentis inductis expriment, Sicut in subiectis exemplis apret.

Facies prona. **Facies resupinata.**

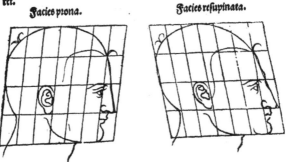

Albrecht Dürer, Clariss. Pictoris et Geometrae Alberti Dureri, de varietate figurarum et flexuris partium ac gestib. imaginum, libri duo: qui priorib. de symmetria quondam editis, nunc primum in latinum conuersi accesserunt (Norinbergae: Formschneyder, 1534)

While Space Syntax researchers have developed a range of analytical processes and theories, the focus of the present paper is the "justified **plan** graph" (JPG). This method has been known by a number of titles including "planar graphs" [March and Steadman 1971: 242] and "**plan** morphology" [Steadman 1983: 209], and it has been described as producing either a "justified graph" or a "justified permeability graph" [Hanson 1998: 27, 247]. Alternatively, the method is sometimes presented as producing a "**plan** graph," an "access graph" [Stevens 1990: 208] or a "justified access graph" [Shapiro 2005: 114]. Most recently, naming of the method has tended to return to the earlier, more general descriptors including "node analysis" and "connectivity graph analysis" [Manum 2009]. While Steadman [1983] provides different definitions for a **plan** graph and an access graph, the two concepts have been largely melded in subsequent use. To further complicate matters, Hillier and Hanson distinguish the syntactic analysis of urban settlements, which they call "alpha-analysis" [1984: 90] from the analysis of the interior, which they call "gamma-analysis" [1984: 147]. This means that the **plan** graph may also be described as a "gamma map" [1984: 147], an appellation which infers membership of a category (interior analysis) rather than a specific type of graph. For consistency, in the present paper the method is described as producing a "justified **plan** graph" (JPG).

The confusion surrounding the naming of this form of analysis may be one of many factors that have limited its application. Another reason is suggested

Fig. 5. Villa Alpha, view of the
Plan Graph

Fig. 6. Villa Alpha, view of Justified Plan Graph (exterior carrier)

Fig. 13. Villa Alpha, the remaining six possible JPGs

by Dovey, who argues that the real problem is that "Hillier's work is at times highly difficult to understand" [1999: 24]. With its often opaque language "of 'distributed' and 'non-distributed' structures which reveal 'integration' values measured by a formula for 'relative asymmetry' " [1999: 25] the theory underlying the construction of JPGs is not easy to comprehend.

*Michael Ostwald, The Mathematics of Spatial Configuration: Revisiting, Revising and Critiquing Justified **Plan** Graph Theory (Nexus Network Journal)*

Do you understand every execution **plan** of every query? If you don't, set long_query_time=0 and use mk-query-digest to capture queries.Â. Run them through MySQL's EXPLAIN command.

Morgan Tocker, Caching Could Be the Last Thing You Want to Do (MySQL Performance Blog)

*Rev. J. Goldsmith, Geography, Illustrated On A Popular **Plan**, For The Use Of Schools And Young Persons. With Sixty-Five Engravings (London: Printed for Longman, Hurst, Rees, Orme and Brown, Paternoster-Row, 1820)*

Despite all of the preceding discussion about calculating TD, MD, RA and i, what most people fail to realise, and may have simply been too obvious for the Space Syntax researchers to state, is that all four of these values simply rank rooms in an identical sequence (or its inverse). These are not four ways of developing different information about a **plan**, they are a series of variations of the one method. For example, MD is just TD divided by the number of spaces but not counting the carrier. Thus, while the rooms will be sorted against a narrower scale, the sequence of rooms is identical. For example, in order from the highest TD to the lowest TD for the Villa Alpha the spaces are: C, ⊕/B, D, A/E, F. Similarly, in order from the highest MD to the lowest MD for the Villa Alpha the spaces are: C, ⊕/B, D, A/E, F.

> Michael Ostwald, *The Mathematics of Spatial Configuration: Revisiting, Revising and Critiquing Justified **Plan** Graph Theory (Nexus Network Journal)*

In the development of these inquiries into the subject of **Architectural** Composition the greatest amount of space has been given to the study of the **plan**. This method has been employed because it is believed to be in accord with the opinion of the foremost teachers of **Architecture** who place the study of the **plan** at the head of instruction both in theory and practice. In respect to this point of view the reader will note that my study of the subject has led me to a position considerably different from that which has been generally followed

by other English and American writers who, while they have not neglected the **plan**, have at least relegated it to a comparatively subordinate position.

I have therefore purposely avoided a lengthy discussion of those Elements of Composition which have been so well set forth in other books and have sought to direct the reader's attention principally toward the study and analysis of **plan** of compositions, a direction which, to **Architecture** at least, is universally conceded to be of prime importance. The **plan** of a building establishes immediately two of the three dimensions in space and implies the third. It therefore lends itself to thinking in three dimensions. As one distinguished critic of **Architecture** has well said, "methods of study in **plan** have been adhered to at all times since the beginning of **architecture** ... if the floor **plan** is well studied, beautiful in proportion, with a proper distribution of piers, thickness of walls, logically disposed and with good circulations, there will be no structural difficulties." The author does not presume to assert that he has brought to light any new ideas relating to the theory of **Architecture**; he has not sought to produce an impression of originality but, on the contrary, gratefully acknowledges his indebtedness to the great authorities whose works have been freely consulted.

Nathaniel Curtis, **Architectural** *Composition*

"That is true," said D'Artagnan; "you have a reply for everything, my friend." And he replaced the **plan** upon the stone.

Alexandre Dumas, Ten Years Later

Fig. 6: Disturbing lines complicate the identification of correct PPs.

Tong Lu, Huafei Yang, Ruoyu Yang, and Shijie Cai,
*Automatic Analysis and Integration of **Architectural** Drawings*

a **plan** of lectures on the principles of nonconformity

LECTURE

The inn. Two lateral wooden galleries on the first floor with a projecting balcony—main building at the back—café on the ground floor—dining-room, billiard-room, doors and windows are open.

Crowd: notables, ordinary people.

Bouvard: 'We must first prove the value of our **plan**, our studies give us the right to speak.'

Gustave Flaubert, Bouvard and Pécuchet

plan. See **according to plan.**

Eric Partridge and Paul Beale, A Dictionary of Slang and Unconventional English: Colloquialisms and Catch Phrases, Fossilised Jokes and Puns, General Nicknames, Vulgarisms and Such Americanisms as Have Been Naturalized

Response involves putting the **plan** into action. If it has been well thought out, if it has been based on reliable information, and if there are no major unforeseen glitches, things should work more or less **according to plan**.

Laurence Miller, Practical Police Psychology: Stress Management and Crisis Intervention for Law Enforcement

A Big Week for Health Care Reform: What Could Happen Next?

CBS News—Mar 15, 2010

If all goes **according to plan**, the Democrats could have a health care bill ready to send to President Obama by the end of the week. It's impossible to say . . .

The Amazing Scott Mayfield

Webster Kirkwood Times—Rick Frese—Jul 1, 2011

If all goes **according to plan**, Scott Mayfield will become the first player from Webster Groves to play in the NHL. Four selections into the second round, the 34th pick overall, the New York Islanders chose the 18-year-old Mayfield during . . .

Noel coaching Jets in the art of fun
National Post (blog)—Ed Tait—1 day ago

WINNIPEG—It is a scene which—if things go **according to** Claude Noel's master **plan**—will repeat itself over and over again this season ...

researchers hail male pill breakthrough
Times LIVE—Biénne Huisman—9 hours ago

And if all goes **according to plan**, men will be able to take responsibility for their feats between the sheets by popping a pill derived from plants ...

Master Gardeners **planning** Forsyth beautification project
Springfield News-Leader—14 hours ago

If everything goes **according to plan**, the group will ultimately create a demonstration garden showcasing plants that do well in this area. This Master Gardener chapter has members from Stone and Taney Counties, and they have undertaken a number of ...

Greece: Default, interrupted? Why some still fear a debacle
CTV.ca—Jun 29, 2011

If all goes **according to plan**, the EU, European Central Bank and International Monetary Fund will give Athens €12-billion more from its original bailout, and agree to a second rescue package down the road. After tomorrow's second vote ...

Google News Canada

'You join us on a momentous occasion,' he said to me. 'These **plans** and drawings are the blueprint for my new mission. Everything is agreed. Tell him, Mr Abbot.'

Abbot lowered his gaze to the **plans**, but said nothing.

'Mr Abbot is too modest,' Klein said. 'Without his assistance, I would have been unable to proceed.'

'I simply—' Abbot said.

'Without Mr Abbot and all the assistance he has been able to offer me, my **plans** might not even have been thought worthy of consideration in the first instance. Perhaps I shall insist on a statue being erected in honour of his endeavours. Imagine that—a statue to a humble clerk.'

Robert Edric, The Book of the Heathen

Church bells rang throughout the city to herald his election and the victorious Alexander started laying **plans** for his enthronement, which was to be

a spectacle unparalleled since the triumphal processions accorded to the emperors of ancient Rome. The scale of the coronation reflected Alexander's exalted view of himself. A two-mile-long procession walked a carpeted route through the centre of Rome, past houses covered with flags, and winding through arches festooned with the red bull of the Borgia family device grazing in a field of gold. The arches were inscribed with adulatory, almost heretical slogans, 'Alexander the most pious', 'Alexander the invincible', 'Alexander the most magnificent', 'The coronation of the great God Alexander'. Most spectacular of all was an arch erected on the orders of a particularly sycophantic protonotary, which carried in letters of gold the words, 'Rome was great under Caesar, greater far under Alexander. The first was mortal, the latter is a God.'

The phalanx of the procession was formed by ten thousand cavaliers in colourful dress. Next came every member of the papal household, the foreign ambassadors, and the cardinals, each mounted on horses draped in finery, and each with a twelve-man retinue. The new Captain-General of the Church, the Count of Pitigliano, rode immediately before the pope with his sword drawn, symbolic of his role as defender of the church. Alexander rode under a canopy held aloft by a retinue on foot, and was followed by the papal guard, the Vatican protonotaries and every official of the Curia. Under the scorching heat of the late August Roman sun, the city became a heaving mass of horses and crowds. Despite his years Alexander still possessed a youthful vigour, but the drawn-out ceremonies proved too much even for him. Twice during the day he fainted under the strain.

Harry Edgington, The Borgias

Indians bullpen shuts down Reds

Examiner.com—6 hours ago

Saturday's game did not go **according to plan** for Cleveland Indians manager Manny Acta as his starting pitcher, Fausto Carmona, exited the game after pitching just two innings. Carmona, who injured himself running to first in the top of the third ...

Google News Canada

The Three Stooges: Whoops I'm an Indian

Set in the old west, the Stooges are crooked gamblers gypping the resident of a frontier town. They are discovered and must escape into the woods. To elude the sheriff they disguise themselves as Indians. Their **plan** works until Curly, dressed as a squaw, is forced to marry a local tough guy. The Stooges are unmasked and wind up in the hoosegow.

The Wedding Date
Single-girl anxiety causes Kat Ellis (Messing) to hire a male escort (Mulroney) to pose as her boyfriend at her sister's wedding. Her **plan**, an attempt to dupe her ex-fiancé, who dumped her a couple years prior, proves to be her undoing.

Hangover 2
… Stu's **plan** for a subdued pre-wedding brunch, however, goes seriously awry.

Romeo and Juliet
The Montagues and the Capulets, two powerful families of Verona, hate each other. Romeo, son of Montague, crashes a Capulet party, and there meets Juliet, daughter of Capulet. They fall passionately in love. Since their families would disapprove, they marry in secret. Romeo gets in a fight with Tybalt, nephew of Lady Capulet, and kills him. He is banished from Verona. Capulet, not knowing that his daughter is already married, proceeds with his **plans** to marry Juliet to Paris, a prince. This puts Juliet in quite a spot, so she goes to the sympathetic Friar Laurence, who married her to Romeo. He suggests a daring **plan** to extricate her from her fix. Tragedy ensues.

Internet Movie Database, Plot Summaries

Miles and Jack, driving in a car:
MILES: She tell you she was married?
JACK: Yeah.
MILES: So what the fuck were you thinking?
JACK: He wasn't supposed to be back till six. Fucker rolls in at five.
MILES: Cutting it a little close, don't you think?
JACK: This is the block.
MILES: You're sure?
JACK: Yeah. That's it, that's the one right there.
MILES: Yeah?
JACK: Yeah.
Miles pulls over and stops the car.
MILES: Ok, so, what's the **plan**?
JACK: Uh, the **plan** is, you go.
MILES: Me?
JACK: Cause of my ankle. Still hurts. Just go explain the situation, Miles.
MILES: Explain the situation, yes. Uh, excuse me, sir, my friend was the one
 balling your wife a couple hours ago, really sorry, he seems to have left

his wallet behind, I was wondering if I could just come in, poke around, I don't know—
JACK: Yeah, yeah, just like that. That's good.
MILES: For Christ sake.

Alexander Payne (director), Sideways

In the Company of Men
Two junior executives on a six week business trip, both of whom have been recently hurt by women, devise a horrible **plan** to get even with women for their past hurts: they intend to find, romance, and then dump a vulnerable woman. They choose Cristine, and for a while all goes **according to plan**. However, it soon becomes clear that things are not as simple as they think.

Sinatra Club
The **plan** is simple ... The only problem with this simple **plan** is that it is anything but simple ...

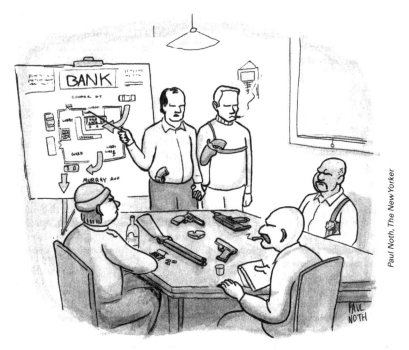

Paul Noth, The New Yorker

"The only thing we didn't plan on was falling in love."

Hindsight
Unexpectedly pregnant with no means to raise a child, Dina and Ronnie decide
to sell their unborn baby over the Internet. Their **plan** begins to unravel when
the couple they've chosen, Paul and Maria, turn out to have an agenda of
their own.

Drool
An abused wife's **plan** to escape her husband goes awry when she accidentally
kills him, causing her to split on a cross-country drive with her best friend
and his corpse in tow.

A Girl, Three Guys and a Gun
Three smalltown friends looking to leave their troubles behind come up with
a robbery scheme to fund their trip to the big city. But as their **plan** goes awry
and the authorities become involved, they are left with no other alternative
but to take hostage a pair of traveling young lovebirds, with no shortage of
problems of their own.

Superbad
Two co-dependent high school seniors are forced to deal with separation
anxiety after their **plan** to stage a booze-soaked party goes awry.

Internet Movie Database, Plot Summaries

It was now about nine o'clock, and the room seeming almost supernaturally
quiet after these orgies, I began to congratulate myself upon a little **plan** that
had occurred to me just previous to the entrance of the seamen.

No man prefers to sleep two in a bed. In fact, you would a good deal rather
not sleep with your own brother. I don't know how it is, but people like to
be private when they are sleeping. And when it comes to sleeping with an
unknown stranger, in a strange inn, in a strange town, and that stranger a
harpooneer, then your objections indefinitely multiply. Nor was there any
earthly reason why I as a sailor should sleep two in a bed, more than anybody
else; for sailors no more sleep two in a bed at sea, than bachelor Kings do
ashore. To be sure they all sleep together in one apartment, but you have
your own hammock, and cover yourself with your own blanket, and sleep
in your own skin.

The more I pondered over this harpooneer, the more I abominated the
thought of sleeping with him. It was fair to presume that being a harpooneer,
his linen or woollen, as the case might be, would not be of the tidiest, certainly
none of the finest. I began to twitch all over. Besides, it was getting late, and

my decent harpooneer ought to be home and going bedwards. Suppose now, he should tumble in upon me at midnight—how could I tell from what vile hole he had been coming?

'Landlord! I've changed my mind about that harpooneer.—I shan't sleep with him. I'll try the bench here.'

'Just as you please; I'm sorry I can't spare ye a tablecloth for a mattress, and it's a plaguy rough board here'—feeling of the knots and notches. 'But wait a bit, Skrimshander; I've got a carpenter's plane there in the bar—wait, I say, and I'll make ye snug enough.' So saying he procured the plane; and with his old silk handkerchief first dusting the bench, vigorously set to planing away at my bed, the while grinning like an ape. The shavings flew right and left; till at last the plane-iron came bump against an indestructible knot. The landlord was near spraining his wrist, and I told him for heaven's sake to quit—the bed was soft enough to suit me, and I did not know how all the planing in the world could make eiderdown of a pine plank. So gathering up the shavings with another grin, and throwing them into the great stove in the middle of the room, he went about his business, and left me in a brown study.

I now took the measure of the bench, and found that it was a foot too short; but that could be mended with a chair. But it was a foot too narrow, and the other bench in the room was about four inches higher than the planed one—so there was no yoking them. I then placed the first bench lengthwise along the only clear space against the wall, leaving a little interval between, for my back to settle down in. But I soon found that there came such a draught of cold air over me from under the sill of the window, that this **plan** would never do at all, especially as another current from the rickety door met the one from the window, and both together formed a series of small whirlwinds in the immediate vicinity of the spot where I had thought to spend the night.

The devil fetch that harpooneer, thought I ...

Herman Melville, Moby Dick, Or the White Whale

But in the face of rigorous production requirements **according to plan** it has frequently been found impossible to make the production program and the financial **plan** harmonize. If the economies in production cannot be realized and costs reduced **according to** the financial **plan**, it becomes a matter of either modifying the production program and holding rigorously to the **plan** of expenditures, or otherwise maintaining the production program **according to plan**, but at the expense of the financial **plan**. Production and financial **plans** can be made to coincide and harmonize only if the estimated volume of production is realized with the estimated money expenditures.

*Jerome Davis, The New Russia Between the First and Second Five Year **Plans***

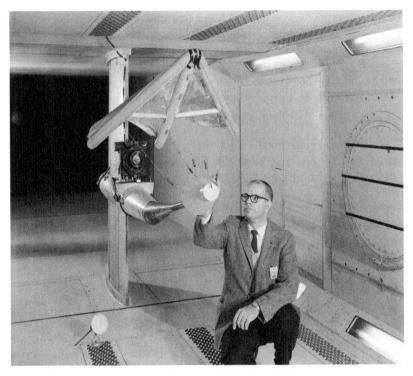

W. C. Sleeman, Jr. inspecting a model of the paraglider in 300 mph 7 x 10 Foot Wind Tunnel. The paraglider, or "Rogallo Wing," was proposed for use in the Gemini Program. It would have allowed Gemini to make precision landings on land, rather than in the water. But the wing suffered a number of problems. The biggest problem was getting it to deploy properly and reliably. The **plan** was canceled.

NASA (Great Images in NASA)

Before the earl again departed for the French wars in 1372, he placed his lands in irrevocable trust. This provided that in event of his death abroad the trustees were to grant the whole estate to William of Beauchamp, provided that the king would make Beauchamp earl of Pembroke. In effect John Hastings was adopting William of Beauchamp as his son and heir, with the king's anticipated approval and cutting out entirely Lord Grey. This was a clever but dicey legal maneuver, just the kind of complicated instrument a common lawyer loved to draw up.

The whole **plan** fell apart when John Hastings, earl of Pembroke, heard while he was in captivity in Spain that his young second wife was pregnant and then that she had borne him a son, John II. Pembroke had no doubt that he was the genetic father of the child. The trust that the earl had set up giving

everything to William of Beauchamp had not provided for this possibility. In effect John Hastings had disinherited his own yet-to-be-born son by a rash and sloppy legal maneuver. "Everything that was done has gone wrong," he lamented.

John Hastings promised a monstrous ransom to his Spanish captors (equivalent to thirty million dollars) and hurried back to England to try to straighten out this mess. Between Paris and Calais in 1375 he took ill and died of the plague.

Norman Cantor, In the Wake of the Plague: The Black Death and the World It Made

The Wrong Road
A young married couple whose **plans** for their life together haven't turned out as expected decide to rob the bank where the husband works of $100,000, then hide the money in a safe place and return for it after they serve out their sentences. All goes **according to plan** until they get out of prison, when they find that they're being trailed by an insurance investigator and the husband's old cellmate, who has decided that he wants a cut of the money.

The Bill Collector
With less than three weeks to payback $100,000 and Frankie's enforcer, Omar, shadowing his every move, Lorenzo cooks up a **plan** to pay his debt by scamming the collection agency and an inner-city mission. Neither Omar or the people from the mission are what he expects and Lorenzo's scheme doesn't work quite as he **plans**.

Gambit
Harry Dean has a **plan** to pull off a major robbery and needs Nicole as a gambit and windowdressing. He outlines his ideas about his perfect crime in a dream sequence and then meets Nicole, and nothing goes quite right again.

The St Louis Bank Robbery
George Fowler is drawn into a gang **planning** to rob a bank in St. Louis that they expect will have a $100,000 on hand on an upcoming Friday. George is drawn into the **plan** as the gang's driver by Gino, an old girlfriend's older brother. As the gang goes about its **planning**, George and Gino have to find a way to live for the next two weeks and they turn to Gino's sister, Ann, for help. George is hoping to go back to college and the money he would make would go a long way to helping him do that. Not trusting George to keep his nerve, the gang's leader John Egan moves him to the inside, but the robbery doesn't go off as **planned**.

The Asphalt Jungle
'Doc' Riedenschneider, legendary crime 'brain' just out of prison, has a brilliant **plan** for a million-dollar burglary. To pull it off, he recruits safecracker Louis, driver Gus, financial backer Emmerich, and strong-arm man Dix Handley. At first the **plan** goes like clockwork, but little accidents accumulate and each partner proves to have his own fatal weakness. In the background is a pervasive, grimy urban malaise.

The Man Who Wasn't There
A laconic, chain-smoking barber blackmails his wife's boss and lover for money to invest in dry cleaning, but his **plan** goes terribly wrong.

 Internet Movie Database, Plot Summaries

A night or two later, we talked about it just as casually as if it was a little trip to the mountains. I had to find out what she had been figuring on, and whether she had gummed it up with some bad move of her own. "Have you said anything to him about this, Phyllis? About this policy?"
 "No."
 "Absolutely nothing?"
 "Not a thing."
 "All right, how are you going to do it?"
 "I was going to take out the policy first—"
 "Without him knowing?"
 "Yes."
 "Holy smoke, they'd have crucified you. It's the first thing they look for. Well—anyway that's out. What else?"
 "He's going to build a swimming pool. In the spring. Out in the patio."
 "And?"
 "I thought it could be made to look as though he hit his head diving or something."
 "That's out. That's still worse."
 "Why? People do, don't they?"
 "It's no good. In the first place, some fool in the insurance business, five or six years ago, put out a newspaper story that most accidents happen in people's own bathtubs, and since then bathtubs, swimming pools, and fishponds are the first thing they think of. When they're trying to pull something, I mean. There's two cases like that out here in California right now. Neither one of them are on the up-and-up, and if there'd been an insurance angle those people would wind up on the gallows. Then it's a daytime job, and you never can tell who's peeping at you from the next hill. Then a swimming pool is like a tennis court,

you no sooner have one than it's a community affair, and you don't know who might come popping in on you at any minute. And then it's one of those things where you've got to watch for your chance, and you can't **plan** it in advance, and know where you're going to come out to the last decimal point. Get this, Phyllis. There's three essential elements to a successful murder."

That word was out before I knew it. I looked at her quick. I thought she'd wince under it. She didn't. She leaned forward. The firelight was reflected in her eyes like she was some kind of leopard. "Go on. I'm listening."

James M. Cain, *Double Indemnity*

He said on the night of Feb. 26, 2010, she enlisted him to kill her husband, but that the **plan** fell apart after she cut her hand outside her home and they left.

Kevin Bissett, *Cormier Says Kidnap Victim 'Was My Boss' (The Globe and Mail)*

Kill Me Later
Parts of the **plan** go awry …

Here and There
The **plan** goes awry …

The Box
The **plan** goes awry …

Bobby G Can't Swim
… the **plan** goes awry …

Internet Movie Database, *Plot Summaries*

"I know I don't look it," she said, "but I'm very nervous. My **plans** don't seem to be working out, and I'm nervous about it."

Robert Boswell, *The Geography of Desire*

The Music Man
A con man comes to a Midwestern town with a scam using a boy's marching band program, but things don't go **according to plan**.

Armored
A newbie guard for an armored truck company is coerced by his veteran coworkers to steal a truck containing $42 million. But a wrinkle in their supposedly foolproof **plan** divides the group, leading to a potentially deadly resolution.

2:22

The **plan** was easy; the job was not. On a snowy night a tight crew of four criminals **plan** to pull off a routine heist. When things go horribly wrong, friendship, loyalty and trust are pushed to the limit.

Dead Heist
Four friends **plan** the perfect small town bank heist, but choose the wrong night. Their **plans** go horribly wrong when vampiric zombies attack the town and trap them in the bank. Can they escape with the money and their lives?

Wrong Way
They escape, but soon run into a death cult who **plan** to gang-rape the girls, then kill them. Meanwhile ...

Undead or Alive
Army deserter Elmer Winslow and local cowboy Luke Budd are on the run after robbing the evil Sheriff Claypool, stealing his money and fleeing the town, they find themselves with an angry posse on their trail. Joining Elmer and Luke is an Apache warrior, who's out to wreak vengeance on behalf of her decimated people; her **plan** is to attack the U.S. Army wherever she can find it, and she takes Elmer up on his offer to go with her to the nearest Army outpost he knows. Their **plans** become complicated when they discover that, as a result of the great Apache Geronimo's curse on the white man, all the people of the surrounding areas have turned into zombies.

Two-Minute Heist
Slacker Dino Rado, and his uptight partner, Steven Scheere made a bad investment. They borrowed money to fund a "B" movie that flopped big time and now the Jamaican Mob wants its money back. As a last resort they steal an idea from a screenplay to cast unsuspecting actors to pull off a real heist. Their **plan** is flawless, until they put it into action. Dino and Steven didn't **plan** on getting shot at, beat up, and even worse, falling in love.

Extreme Dating
After a couple of near-successes, they go for broke by **planning** an elaborate kidnapping scheme that can't miss. But the hired "kidnappers" turn out to be ex-cons with a **plan** of their own, and the extreme date escalates out of control ...

Mom's Got a Date with a Vampire
Everything seems to go **according to plan** until their little brother Taylor realizes that this stranger might be a vampire.

Head of the Family
... the lovers hatch a **plan** involving the Stackpoole family—a collection of misshapen freaks who waylay unsuspecting travellers and dissect them in gruesome experiments. Unfortunately, things don't go quite **according to plan.**

Portal
Soon after finding their way into the shelter of the mysterious, fog-engulfed town of Mercy, two friends **plan** to rest up for the night, only to realize, as nights turn into nights, that time doesn't exist.

i came across another abandoned factory and i had to stop and check it out. there's a **plan** on the wall (see note) of how it was supposed to work out, but they never followed up on it. there's lots of buildings around here like that; it makes for good shooting.

*haydnseek, **plan** (flickr.com)*

Film Noir

Private detective Sam Ruben's clever **plan** falls apart with the onset of amnesia. Everyone is trying to kill him and he doesn't know why. The classic film noir milieu now comes to you in the form of an animated feature.

Internet Movie Database, Plot Summaries

MUPPET #1: I think we made it.

MUPPET #2: Yeah, right.

MUPPET #1: Yeah, the coast is clear.

MUPPET #2: Yeah, right.

MUPPET #1: Hey, we made it, we got the Golden An.

MUPPET #2: Righhht.

MUPPET #1: Look at it, isn't it beautiful.

MUPPET #2: Beeauuuuteeful.

MUPPET #1: Yeah, you see, there's an An, see, an 'A' and an 'N' together make 'An.'

MUPPET #2: Yeeaahhh. What are we gonna do with it now, boss?

MUPPET #1: Ahh, this is where you come into the **plan**, Lefty. You see that van?

MUPPET #2: That—that tan van?

MUPPET #1: Riigght.

MUPPET #2: Yeah, riigght.

MUPPET #1: Now look, I want you to take this Golden An in the tan van, give it to Dan, who will take it to Fran. You understan'?

MUPPET #2: Uhh … lay it on me once more … just a few parts I didn't … didn't get …

MUPPET #1: Look, this'll make it easier for ya.

MUPPET #2: Yeah.

MUPPET #1: Look, everything that I'm tellin' ya about the **plan** rhymes with 'an', ya see? Now you take the Golden An, in the tan van, you give it to Dan, who takes it to Fran.

MUPPET #2: Riigght, I understand, riigght, riigght …

MUPPET #1: One more thing—

MUPPET #2: Yeah, yeah—

MUPPET #1: Now look, every policeman in the city is after this Golden An, so don't tell the **plan** to anyone.

MUPPET #2: Gotcha, riigght, riigght.

MUPPET #1: Okay, good luck, Lefty.

MUPPET #2: Thanks. Yeah … Now, let's see, uh … I take, uh … I take the Golden An, and I put it in that tan truck—No, no, no, no, no, tan van, that's it, tan van, I take the Golden An, I put it in the tan van, and I take

*Sesame Street, Gangsters—An **Plan***

it to Horace—no, no, no, no, wait a minute, oh I know, wait—the words rhyme, that's it, the words rhyme, so let's see, I take the Golden An, yeah, and I take it and put it in the tan van, that's it, and then, uh, I take it to Dan, right, right, who takes it to Fran, dat's the **plan**, yeah …

MUPPET #3: What's the **plan**?

MUPPET #2: Who said that?

MUPPET #3: My name's Stan, I'm the man, you just got ten days in the can for stealing the Golden An. Let's go, come on.

MUPPET #2: Ahh, I shoulda ran.

*Sesame Street, Gangsters—An **Plan***

*Peter Rutland, The Myth of the **Plan**: Lessons of Soviet **Planning** Experience (London: Hutchinson, 1985)*

Payroll

A vicious gang of crooks **plan** to steal the wages of a local factory, but their carefully laid **plans** go wrong, when the factory employs an armoured van to carry the cash. The gang still go ahead with the robbery, but when the driver of the armoured van is killed in the raid, his wife **plans** revenge, and with the police closing in, the gang start to turn on each other.

Internet Movie Database, Plot Summaries

It was this individualist and egoist principle that critics of liberal economics, including Sismondi and, in Germany, Fichte, resented and assailed. Their moving impulse was an ethical desire to create something nobler than a selfish scramble, a "mere congeries of possessors and pursuers," as Lord Keynes once called it or, again, a rational impulse to **plan** rather than leave matters to a chaos of contending individual wills. The difficulty was that this led to highly authoritarian structures in which an intellectual elite **planned** for and governed the entire community.

Roland Stromberg, European Intellectual History Since 1789

Jerusalem—Israel's government approved a **plan** providing a uniform formula for the spelling of the names of communities and other sites around the country.

The uniform spellings will appear on maps and road signs, in textbooks and guidebooks, and in all other official publications, **according to** the **plan** approved Sunday.

The spelling of interchanges, junctions and historic sites will also be made uniform under the **plan**.

The new rules will be determined in accordance with the official map index formulated by the Government Names Committee, and **designed** to create uniform spelling rules that have not been changed since 1957, according to the Prime Minister's Office.

The **plan** has proved controversial for Arab lawmakers, after Transportation Minister Yisrael Katz said he would change the Arabic names of mixed communities to a Hebrew transcription; for example changing the Arabs' name for Jerusalem, Al-Quds, to Yerushalayim spelled in Arabic letters.

*Jewish Telegraphic Agency, **Plan** Approved for Uniform Spellings of Community Names*

But because the whole gradual change was complete before I became an adult, whenever I think over it I am tempted away from history into all kinds of untrustworthy emotional details. It took my mother a few years before she stopped absentmindedly trying to tear open the wrong side of the Sealtest

carton, despite my having lectured her on the fact that one triangle was much more heavily glued than the other, their difference indicated by the words "Open Here," enclosed in the outline of an arrow—to disregard it was to fail to take the invention seriously. My father made iced coffee after a morning of lawn-mowing or shrub transplantation, and often he left the carton sitting out on the counter afterward, with the spout open. And here I am pulled, willingly by this time, to consider my father's great iced coffee: several spoonfuls of instant coffee and sugar, liquefied into a venomous syrup by a bare quarter-inch of hot tap water to remove any granulation, then four or even five ice cubes, water to halfway up the glass, and milk to the top: so many ice cubes that until they melted a little, hissing and popping, with the milk falling in diffusional swirls around them, he could barely get a spoon to the bottom of the glass to stir the drink. His **plan** was to market a bottled mocha version of it called Café Olé, a mock-up of which, with a dramatic Zorro-like logo scripted diagonally across the label, sat on our mantel for a while after the **plan** was set aside.

 Nicholson Baker, The Mezzanine

Sonic Impact
… but things don't go as **planned**, and the criminal continues his **plan** …

White Heat
A psychopathic criminal with a mother complex makes a daring break from prison and leads his old gang in a chemical plant payroll heist. Shortly after the **plan** takes place, events take a crazy turn …

 Internet Movie Database, Plot Summaries

Their enterprise was projected on a broad and bold **plan**. They were to take with them fifty or sixty men, artificers and mariners. With these they were to make their way up one of the branches of the Missouri, explore the mountains for the source of the Oregon, or River of the West, and sail down that river to its supposed exit, near the Straits of Annian. Here they were to erect a fort, and build the vessels necessary to carry their discoveries by sea into effect. Their **plan** had the sanction of the British government, and grants and other requisites were nearly completed, when the breaking out of the American Revolution once more defeated the undertaking.

 Washington Irving, Astoria, or Anecdotes of an Enterprise Beyond the Rocky Mountains

Terry Fallis, *The Best Laid **Plans**: A Novel*
(Toronto: McClelland & Stewart, 2007)

MALE VOICE OVER
The Cylons were created by man. They rebelled. They evolved. They look and feel human. Some are programmed to think they are human. There are many copies. And they have—a **plan**.

BROTHER CAVIL
The **plan** is, everything blows up a week ago. All humans are dead, we Cylons all download, and the universe basks in justice ...

FEMALE CYLON
It didn't fracken happen.

ONSCREEN TEXT
"THINGS DON'T GO AS **PLANNED**"

New Trailer for 'Battlestar Galactica The **Plan**' (youtube.com)

CROMWELL and his army petition for toleration—QUARREL with the parliament—FORCIBLY diſsolve it—ASSUME the government—CALL

A

P L A N

OF

LECTURES

ON THE

PRINCIPLES

OF

NONCONFORMITY.

For the Instruction of

C A T E C H U M E N S.

By R. Robinson.

Whatever moderation or charity we may owe to men's PERSONS, *we owe none at all to their* ERRORS, *and to that frame which is built on, and supported by them.*

Bishop BURNET.

THE SIXTH EDITION.

N O T T I N G H A M :

PRINTED AND SOLD BY C. SUTTON. SOLD ALSO
BY MESSRS VERNOR AND HOOD. LEE AND HURST,
AND W. BAYNES LONDON.
1797.

158

the little parliament—A council of officers make him protector—HE calls another parliament—DISSOLVES them—TOLERATES all except papiſts and royaliſts—KEEPS them under for civil reaſons—MODELS parliaments—UNIVERSITIES—ARMY—NAVY—FOREIGN treaties—AND all branches of government ſo as to render *himſelf* neceſſary to all.—PROJECTS an union of all the reformed.—INTENDS to reſtore monarchy—AND unite it with univerſal liberty—TO wear a crown—AND tranſmit it to his family—BUT death prevented the execution of his **plan**.

R. Robinson, A ***Plan*** *of Lectures on the Principles of Nonconformity: For the Inſtruction of Catechumens*

I can see it if they hadn't **planned** to torture and kill him, but if they had a **plan**, it wasn't much of a **plan**.

John Farrow, *City of Ice*

When it comes to Bible studies, an area where facts are even harder to ascertain, the door is wide open for far-out theories. One strand was begun in 1965 by Dr. Hugh J. Schonfield, a British academic and Bible scholar. *The Passover Plot* consists of the extended hypothesis that Jesus engineered his own arrest and crucifixion in order to fulfill the Jewish prophecy about the Messiah, but that he had an elaborate **plan** for survival, which would be sold as a resurrection. "These things had to come about," wrote Schonfield, "in the manner predicted by the Scriptures and after preliminaries entailing the most careful scheming and plotting to produce them ... A conspiracy had to be organized of which the victim was himself the deliberate secret instigator. It was ... the outcome of the frightening logic of a sick mind, or of a genius."

Almost all went to **according to plan**: Jesus set Judas up to betray him, and events took their intended course. Jesus knew that crucifixion was a slow death and swallowed a special potion to make it look as though he had expired more quickly than usual, so that he would be cut down, still alive. He and others had arranged a tomb "conveniently placed" on Joseph of Arimathea's land, to which he would be taken off and revived, making it clear to all that he was indeed the Chosen One. Unfortunately, a Roman soldier, in an uncharacteristic and unlucky moment of compassion, decided to speed Jesus' end by thrusting a spear in the suffering man's side. After that the disciples spirited the body away and made the rest up as though nothing had gone wrong. Ironically, Christianity survived; Christ didn't.

David Aaronovitch, *Voodoo Histories: The Role of the Conspiracy Theory in Shaping Modern History*

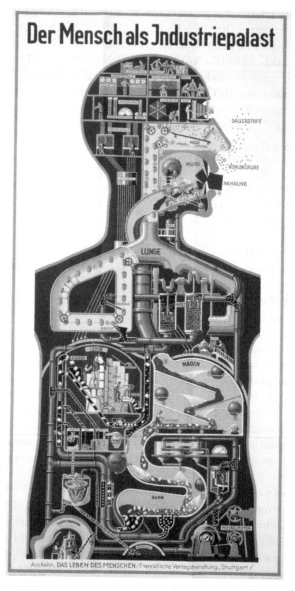

*Fritz Kahn, Der Mensch als Industriepalast (Man as Industrial Palace).
Stuttgart, 1926. Chromolithograph. National Library of Medicine.*

Kahn's modernist visualization of the digestive and respiratory system as
"industrial palace," really a chemical plant, was conceived in a period when
the German chemical industry was the world's most advanced.

Fraden stood and numbly watched. Dreadful, nauseating, loathsome though it all was, there was nothing here that he could blame on Willem. It was all **according to plan**, all **according to** his **plan**. The phrase stuck in his mind, mocked him over and over again … all **according to plan** … all **according to plan** …

Then something happened that emphatically was not **according to plan**.

Norman Spinrad, The Men in the Jungle

"I never thought today's the day they rob me. I never had this thought. And it never happened. I had a woman vomit in the slot. My worst incident personally. I never thought what I would do if they tried to rob me. I had the psychology you **plan** for it, then it happens. She puts her hands on the ledge and out it comes."

"Middle of the night?"

"Just her and me. You have to vomit, why can't you do it on the tracks? Her and me alone in the station, she comes right over like the coin slot they intend it just for this."

Don DeLillo, Underworld

Teething problems mark Arriva's arrival

DI-VE—11 hours ago

But not everything went **according to plan** in Malta, although operations in Gozo went smoothly. The ticketing system failed, which led to a number of passengers getting a free ride. Another source of complaints was late buses …

Google News Canada

Lord Zachary forced an outward appearance of calmness as he sampled the refreshments served by Lord Kimner's servants. Behind that facade, Zack's mind whirled in a search through the few words spoken by Lord Kimner for some hint of a way out of his predicament. He mentally replayed every spoken word since his arrival. A few things stuck out. The Baroukan lord indicated that he could not imagine any Vinaforan welcoming the Federation to his country, yet this man was supposed to have been the **architect** of the Federation. That made little sense unless Lord Kimner was not happy with his own creation. Or his creation did not turn out as he had **planned**.

Richard S. Tuttle, Heirs of the Enemy

Cruel Gun Story

The **plan** is solid, but it doesn't go smoothly. Togawa must improvise …

PREFACE.

THE main purpose of the present work is to be a handy book of
reference for draughtsmen engaged chiefly ~~~~~~~~~~~ wings.

ecially

d the

or has

ERRATUM.

Page 131, line 14, *for* W. F. Stouley *read* W. F. Stanley.

y, and

e in a

ι this

on it

t, for

ɔm it

ɔ the

generally useful by giving it a much wider scope.
And hence, if the intention has been efficiently carried out, it may
claim a place in every drawing office, be it that of the Topographer,
the Hydrographer, the Surveyor, the Military, Civil, or Mechanical
Engineer, or the Architect. Whether or not this degree of success
has been achieved, is not for the author to judge. But should he have
failed to reach the high mark at which he has aimed, he hopes, with
some degree of confidence, that he has at least succeeded in producing
a book which the experienced draughtsman will find valuable as a
book of reference, and which the pupil may constantly consult with
profit. A want has long been felt by draughtsmen for some work of
this kind to which they might refer their pupils in the office, and it
may not be presumptive to suppose that the present work has supplied
that want. To render it convenient for this twofold purpose, it has

George G. André, *The Draughtsman's Handbook of* **Plan** *and Map Drawing, Including
Instructions for the Preparation of Engineering,* **Architectural,** *and Mechanical Drawings. With
Numerous Illustrations and Coloured Examples* (London, New York: E. & F. N. Spon, 1874)

Jerry and the Goldfish
Tom is listening to a radio chef's recipe for fish stew when he realizes the key ingredient is right there in the home goldfish bowl. Jerry has been treating this fish as a pet, though, and won't let Tom get away with his **plan**, saving the fish in a glass of water and a teacup, while Tom abandons his stew **plans** in favor of a frying pan, a grill, the toaster, and a pressure cooker.

Kill Me Later
Her goldfish dead, her lover exposed as a rat, Shawn Holloway leaves her bank post and goes to the roof intent on suicide. Before she can leap, she's taken hostage by Charlie Anders, a fleeing bank robber. He and his partners have stolen a million in cash and **plan** to escape to Venezuela. Shawn agrees to cooperate if Charlie promises to kill her once he's in the clear. Parts of the **plan** go awry ...

Palindromes
... but in the end her **plan** is thwarted by her sensible parents. So she runs away, still determined to get pregnant one way or another, but instead ...

Venom
International terrorists attempt to kidnap a wealthy couple's child. Their **plan** comes unstuck when, a deadly Black Mamba sent by mistake instead of a harmless snake, escapes, and the terrorists and several hostages are trapped in the boy's London home. A tense evening is had by all as the snake creeps around the house picking off the various characters one by one.

Lost in La Mancha
Director Terry Gilliam is the latest filmmaker to try and bring Miguel de Cervantes y Saavedra's "Don Quixote de la Mancha" to the big screen, to be called *The Man Who Killed Don Quixote* (2011). Before filming even begins, Gilliam, who has moved from Hollywood studio to European financing, will have to scale back his vision as his budget has been slashed from $40 million to $32 million, still astronomical by European standards. But Gilliam is a dreamer, much like his title character, and his vision for the movie is uncompromising, meaning with the reduced budget that there is no margin for error and that some of his department heads may have to achieve miracles with their allotted moneys. During pre-production and actual filming, what Gilliam does not foresee is contractual and health issues with his actors, and the effects of Mother Nature. The question is does Gilliam have a **Plan** B if/when things go wrong.

Internet Movie Database, Plot Summaries

Anybody who is hoping the two sides can come together and work out a **plan** to control health care costs should **plan** a lengthy visit to some other country. I hear Finland is nice.

Gail Collins, Democratic Happy Dance (New York Times)

DAN: You have no **plan**.

CASEY: I have a **plan**.

DAN: First you show up, then you see what happens?

CASEY: It worked for Napoleon.

DAN: No, it didn't work for Napoleon, Napoleon was defeated at Waterloo and died in exile on the island of Elba!

CASEY: Actually, he was murdered on Elba, it's just one of the many things I know that most people don't.

DAN: Oh, I find myself incredibly frustrated with you right now, and I think the best thing for me to do is to go to the tape library and look at some film on Atlanta's middle relief. But before I do that, I'd just like to say that you have no **plan**.

CASEY: I can barely hear you up here, Danny.

DAN: I'm leaving now.

CASEY: I'm okay with that.

DAN: No **plan**.

CASEY: Got it.

DAN: Goodbye.

*Aaron Sorkin, Sports Night: Season 1, Episode 22: Napoleon's Battle **Plan***

Though on the way to Volovya station Mitya was radiant with the joyful anticipation that at last he would bring all these 'affairs' to a successful issue, he nevertheless trembled at the thought of what would happen with Grushenka in his absence. What if she should at last decide to go to his father? That was why he had gone off without telling her anything and warned his landlady not to disclose where he had gone if anyone came to ask for him. 'I must, I must be back this evening,' he kept repeating, as he jogged along in the cart, 'and I might as well bring that Lyagavy back with me to complete the deed of sale.' So Mitya dreamed with bated breath, but, alas, his dreams were not destined to be realized **according to** his 'plan'.

To begin with . . .

Fyodor Dostoyevsky, The Brothers Karamazov

"Withdrawn?"

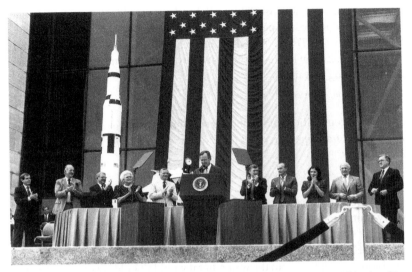

President George Bush speaks at the National Air and Space Museum's 20th anniversary celebration of the Apollo 11 Moon landing. Here, on July 20, 1989, Bush announced his new Space Exploration Initiative, which was to complete the space station, return man to the moon, and bring man to Mars for the first time. The **plan** fell apart when NASA offered an estimated budget of 500 billion over the next 20 to 30 years to achieve the President's goal. Congress balked, and NASA returned to its earlier program of primarily robotic space exploration. *(Great Images in NASA)*

"Cashier's cheque, for the full amount—rounded down to the nearest ten dollars."

"What are you saying?" Edwin knew exactly what she was saying.

"It's gone. Someone must have had access to your account. They cleaned it out, sucked it dry. Do you have any idea who might have done this?"

"Yes. I know—I know exactly who. It was my wife. My ex-wife."

The teller gave him a sympathetic, tight-lipped smile. "They'll do it every time."

Edwin stumbled from the queue, felt his inner ear spin like a gyroscope. He thought he might faint, he thought he might start to dry heave uncontrollably. He had no backup **plan**, no secret avenue of escape. The only thing of value Edwin had were his credit cards, and they were pretty well maxed out. Arid anyway, there was no way he could fund a continent-hopping escape on Diner's Cards and Uncle Visa. (It was even worse than he realized. That very morning the Visa Corporation, citing "a fundamental shift in consumer lending patterns," had filed for bankruptcy.)

Edwin sat down in a customer courtesy chair and put his head between his knees. "You can do this," he said. "You can pull this off." But he wasn't

convincing anyone, least of all himself. Maybe he could join a co-op, change his name to Moonbeam, spend his time in hiding, hoeing turnips and gathering flax. "Think, man. *Think.*" And then, just when he thought it couldn't get any worse, it did. Edwin looked up and saw, through the front window, a familiar black car lying in wait.

Will Ferguson, Generica

A fleeting premonition, unusual in its certainty, shook me: *We Jews of Lisbon have waited too long to re-enact the Exodus, and Pharaoh has learned of our escape* **plans***.*

Richard Zimler, The Last Kabbalist of Lisbon

Cabeza de Vaca doesn't explicitly say that he himself would be in the boat party, but the pronouns imply it. The **plan** only fell apart when the boat wouldn't float. The wood was worm-eaten and waterlogged, and there were other "defects" as well. After a day of hard digging they loosened it from the sand and eased it back into the water, but it wouldn't hold anyone up. When it sank altogether, they resigned themselves to spending the winter on Malhado.

Paul Schneider, Brutal Journey: The Epic Story of the First Crossing of North America

But as Timothy Joyner points out in his life of Magellan, this Moluccan **plan** was a disaster. Indeed, as the leader of the expedition, Magellan was killed before he could even reach there. He had, however, landed in the Philippines.

William Manchester, A World Lit Only by Fire: The Medieval Mind and the Renaissance

This was our first, remote contact with the **Plan**. I could easily be somewhere else now if I hadn't been in Belbo's office that day. I could be—who knows?— selling sesame seeds in Samarkand, or editing a series of books in Braille, or heading the first National Bank of Franz Josef Land. Counterfactual conditionals are always true, because the premise is false. But I was there that day, so now I am where I am.

Umberto Eco, Foucault's Pendulum

Jerry Sigmond was not the only man who came to Kennedy Airport that day, hoping to duck the police and **planning** to fall quietly off the face of Earth. Like Mr Sigmond, Jake Hoffman was, at first, too preoccupied to devote more than a passing thought to the outbreak, for he had no friends, family, or business interests in Long Beach. Even so, the motes came into his life with the same suddenness of sunset in the tropics, and plunged his **plans** into total darkness.

He was a tall man, clad in inconspicuous browns and off-greens. He had been seen, but barely noticed, by Detective Guzman, playing outside an arcade with his two little girls, at about the same time Jerry Sigmond was trying to rebook on Quantas. To all outward appearances Jake was an ordinary father, taking a short break between connecting flights. His girls were three and five, and Mr Hoffman appeared to be devoted fully to them, perhaps even a bit too fully. If one looked just a little closer, he became, at second glance, a cruel, unsavory creature. His name was not Mr Hoffman. He had left his wife in Bangor, Maine, and was abducting their two children to Paris, where he was planning to raise them under an assumed name.

His escape was proceeding much more smoothly than Jerry Sigmond's; in fact, Jerry Sigmond was providing a much welcomed diversion for the police. Jake was also better prepared than Sigmond. His identity, and the identities of little Wynne and Michelle, had been flawlessly rewritten and quietly reregistered, from Scotland Yard to One Police Plaza. Neither his wife nor the authorities would be able to find him—until or unless he decided otherwise. For good measure, he had, like Sigmond, cleaned out all the family accounts, leaving his wife barely enough money to pay next month's bills and buy a plane ticket, much less to hire lawyers and detectives.

He had laid his **plan** out months in advance, laid it out with attention to every detail. Then out of nowhere—out of the deep impersonal nowhere— came the Air France cancellations and the sudden closure of De Gaulle Airport to all American traffic. He joined the hundreds of displaced business people and vacationers who lined up before every available ticket counter in search of alternate routes through Europe, until Wynne and Michelle became too bored and too hungry and too cranky for him to continue the effort, and until it became clear to Jake that any further effort was like protesting against the winter snows in Alaska.

Still, he had plenty of cash on hand. If circumstances were changing, he would simply adapt his **plan.** He did not let the quarantine cost him his control and seemed every inch a man in command of his situation. This was a frequent role for Jake, but by no means his only one. What he truly had in common with Jerry Sigmond was that one could look at him and try to guess from appearances alone the measure of the man, and be wrong by a country mile.

After the realization that his journey to France had, at least for that day, been interrupted, he decided to try again in the morning and went about the task of finding a hotel room for the night.

Then came another change of **plan.** Hundreds of others had arrived at the same realization, and the same solution—hundreds of others before him. All of

Saab Group

the hotels within sight of the airport were booked full. The nearest vacancy was nearly five miles away, in Queens, and he soon discovered that there appeared to be a conspiracy, among both innkeepers and cab drivers, to price-gouge the daylights out of every stranded traveler they could find.

Jake began to worry, as a yellow cab carried him and his two girls down Rockaway Boulevard: if the quarantine and the price gougers kept him here too long, his money and his luck might begin to run out before he got anywhere near setting up shop in France. He thought of the times he had spent listening to the shell game and freak show criers at the Hancock County Fair and whispered to himself, 'It's turning into a fucking carnival!'

Charles Pellegrino, Dust

INT. BATHROOM—TWILIGHT
Ted dabs his head with a tissue, then moves to the toilet. As he TAKES A LEAK he glances out the window to his left.

TED'S POV
Two LOVEBIRDS are perched on a branch.
Ted smiles at the SOUND of these beautiful tweeties singing their love song for themselves, for the spring, for Ted and Mary, and suddenly they fly away and we …

SNAP FOCUS
… to reveal Mary in the bedroom window DIRECTLY BEHIND WHERE THE BIRDS WERE, in just a bra and panties, and just then her mother glances Ted's way and MAKES EYE-CONTACT with what she can only presume to be a leering Peeping Tom.

Bobby Farrelly and Peter Farrelly (directors), There's Something About Mary

ON TED
... he loses the smile and ducks his head back into the bathroom, HORRIFIED. PANICKING NOW, he hastily zips up his fly and—

TED
Yeeeooooowwwwww!!!!!!!!!!

Ted gets his dick stuck in the zipper!

CUT TO EXT. BATHROOM DOOR—NIGHT
A concerned Mary, her Mom, Dad, and Warren are huddled outside the bathroom.

MARY
(knocking gently)
Ted, are you okay?

TED (O.S.)
(pained)
Just a minute.

MARY'S MOM
He's been in there over half an hour. *(Whispering:)* Charlie, I think he's masturbating.

MARY
Mom!

MARY'S MOM
Well he was watching you undress with a silly grin on his face.

TED (O.S.)
(pained)
I was watching the birds!

They all look at one another.

MARY'S MOM
Charlie, do something.

MARY'S DAD
All right, kid, that's it, I'm coming in.

INT. BATHROOM—CONTINUOUS
A whimpering Ted huddles in the corner as Mary's Dad enters.

MARY'S DAD (CONT'D)
What seems to be the situation here? You shit yourself or something?

TED
I wish.

Ted motions for him to close the door and Mary's Dad obliges.

TED (CONT'D)
I, uh … I got it stuck.

MARY'S DAD
You got what stuck?

TED
It.

MARY'S DAD
It? *(Pause)* Oh it. All right, these things happen, let me have a look. It's not the end of the world.

Mary's Dad moves closer and puts his reading glasses on.

EXT. BATHROOM DOOR—CONTINUOUS
As Mary, her Mom, and Warren listen in …

MARY'S DAD (O.S.)
Oh for the love of god!

TED (O.S.)
Shhhhhh!

INT. BATHROOM—CONTINUOUS

Bobby Farrelly and Peter Farrelly (directors), There's Something About Mary

MARY'S DAD (CALLS OUT)
Shirley, get in here! You gotta see this!

TED
What?! No please, sir—

MARY'S DAD
She's a dental hygienist. She'll know what to do.

Mary's Mom comes in and closes the door behind her.

MARY'S MOM
Teddy, hon, are you okay? *(Moving closer, seeing the situation.)* Oh heavens
to pete!

TED
Would you shhh! Mary's gonna hear us.

MARY'S MOM
Just relax, dear. Now, um … What exactly are we looking at here?

TED (DIZZY)
What do you mean?

MARY'S MOM (DELICATE)
I mean is it … Is it … ?

MARY'S DAD (GRUFF)
Is it the frank or the beans?

TED
I think a little of both.

Suddenly we hear Warren from outside the door:

WARREN (O.S.)
Franks and beans!

Ted hangs his head.

EXT. BATHROOM DOOR—CONTINUOUS
Mary and Warren are huddled outside the door.

MARY (TO WARREN)
Shhhh.

MARY'S DAD (O.S.)
What the hell's that bubble?

Mary reacts to this.

INT. BATHROOM—CONTINUOUS

TED
One guess.

MARY'S DAD
How the hell'd you get the beans all the way up top like that?

TED
I don't know. It's not like it was a well thought-out **plan**.

MARY'S MOM
Oh my, there sure is a lot of skin coming through there.

MARY'S DAD
I'm guessing that's what the soprano shriek was about, pumpkin.

Bobby Farrelly and Peter Farrelly (directors), There's Something About Mary

MARY'S MOM
I'm going to get some Bactine.

TED
No, please!

Suddenly a POLICE OFFICER sticks his head in the bathroom window.

POLICE OFFICER
Ho there.

TED *(humiliated)*
Oh God.

> Ed Decter, John J. Straus, Peter Farrelly and Bobby Farrelly,
> *There's Something About Mary (Final Shooting Script)*

Assessment. How well is the **plan** working? There are usually a range of possible outcomes to a given response **plan**, with the middle of this range of possibilities more likely to occur than the extremes. That is, if the **plan** was well-founded to begin with, it is unlikely to be a complete and utter failure. This kind of total crash usually only occurs if something important was missing from the **planning** stage, in which case it may be "back to the drawing board." Equally unlikely is for the **plan** to go flawlessly smooth, without a hitch. Typically, things will work out generally **according to plan**, but certain details will require fine-tuning based on additional information that comes in as the **plan** is implemented.

> Laurence Miller, *Practical Police Psychology: Stress Management
> and Crisis Intervention for Law Enforcement*

Corrective Action Plan (CAP) Implementation Evaluation Checklist

Criteria for an Acceptable Implemented CAP (elements 4, 5, and 6 - Corrective Action Process Standard)

	Y	N	NA	
1				**Amendments to agreed upon CAP**
				An extension was granted for the implementation of this CAP. If yes, new completion due date_____.
				Amendments were made to the agreed upon CAP.
				These amendments were approved by CFIA.
2				**Immediate Corrective Action**
				Appropriate action was taken with non compliant product (as per the CAP)
3				**The "control system fix" which will address the root cause and prevent reoccurrence.**
				The system changes that were outlined in the CAP have been implemented.
				The Person(s) or Position(s) responsible for these changes was documented.
				The Date(s) these changes were completed was documented.
				The Date(s) that changes were completed met deadlines specified in the CAP.
				The verification of effectiveness procedures outlined in the CAP were conducted, and the date completed and person or position responsible were documented.
				The regulated party determined that the "system changes" were/will be effective in preventing reoccurrence of the N/C.
				Are there outstanding long term corrective actions for system "fixes"? (specify in comment section).
				Details on the interim control measures and monitoring procedures to be put in place to deal with hazards introduced where system weaknesses can not be corrected immediately.
				The interim control measures that were outlined in the CAP were implemented and monitored.
				The Person(s) or Position(s) responsible was documented.
				The verification that the procedures outlined in the CAP were conducted and effective.
				The date verified and person or position responsible were documented.
				The regulated party determined that the interim control measures were effective.
4				**The steps taken to correct deficiencies (objective evidence) identified.**
				All deficiencies have been corrected as per the CAP plan.
				The Person(s) or Position(s) responsible for these changes was documented.
				The Date(s) these changes were completed was documented.
				The Date(s) that changes were completed met deadlines specified in the CAP.
				The correction each deficiency was verified, and the date verified and person or position responsible were documented.
				For registered processors which received a C or D assessment for Schedule I and II - have they achieved a B level as per their self assessment and attestation (see Schedule I and II Regulatory Verification Process)?
				Are there outstanding long term corrective actions for deficiencies? (specify in comment section).
				Details on the interim control measures and monitoring procedures to be put in place to deal with hazards introduced where deficiencies can not be corrected immediately.
				The interim control measures that were outlined in the CAP were implemented and monitored.
				The Person(s) or Position(s) responsible was documented.
				The verification that the procedures outlined in the CAP were conducted and effective.
				The date verified and person or position responsible were documented.
				The regulated party determined that the interim control measures were effective

Comments

Evaluation Result

Y	N	
		CAP has been implemented
		CAP implementation is effective

Evaluator _____ Date of Evaluation _____

Canadä

Long before I knew very much about anything regarding sex, I did what many young males do, which of course is to place an empty paper-towel roll over my penis and suck hopefully upon the cardboard end. Okay, perhaps not everyone does this; I was a little confused about the suction principle. And now I'm a bit embarrassed by the story, although it's been a full year since the event and I'm much better informed on the subject of fellatio today. Oh, settle down, I'm only joking.

Well, kind of. I did actually attempt this feat, but I was 12 or 13 at the time, which, to give you a clearer sense of my unimpressive carnal knowledge at that age, is also around the time that I submitted to my older sister with great confidence that a "blow job" involves using one's lips to blow a cool breeze upon another's anus.

So to avoid similar confusion, let us define our terms clearly. Autofellatio, the subject at hand—or rather, not at hand at all—is the act of taking one's genitals in one's mouth to derive sexual pleasure. Terminology is important here, because at least one team of psychiatrists writing on this subject distinguishes between autofellatio and "self-irrumatio." In nonsolo sex, fellatio sees most of the action in the sucking party while irrumatio has more of a

Astronauts Charles Conrad, Joseph Kerwin, and Paul Weitz meet with NASA engineers to **plan** repairs to the damaged thermal cover on the Skylab I Spacecraft at a meeting at KSC prior to launch of the Skylab II. *(NASA)*

thrusting element to it, wherein the other person's mouth serves as a passive penile receptacle. (Hence the colorful and rather aggressive-sounding slang for irrumatio—"face-f*cking," "skull-f*cking," and so on.)

In any event, my paper-towel-roll act was simply a **"Plan** B" at that puerile age, a futile way to circumvent the obvious anatomical limitations to oral self-gratification. And by all accounts, I wasn't alone in hatching **Plan** B. Alfred Kinsey and his colleagues reported in *Sexual Behavior in the Human Male,* in fact, that, "[a] considerable portion of the population does record attempts at self-fellation, at least in early adolescence." Sadly, given our species' pesky ribcage and hesitant spine, Kinsey estimated that only two or three of every 1,000 males are able to achieve this feat.

Jesse Bering, So Close, and Yet So Far Away: The Contorted History of Autofellatio (Slate)

Failure may not be an option, but it has a nasty habit of happening anyway. As noted previously, operations rarely go exactly **according to plan** ...

Laurence Miller, Practical Police Psychology: Stress Management and Crisis Intervention for Law Enforcement

Asteroid

With the discovery of an incoming asteroid, the government of America for-mulate a **plan** to destroy it. When the **plan** fails, all the world can do is wait ...

Internet Movie Database, Plot Summaries

In a study of 29 US disasters, the University of Delaware's Disaster Research Center found that, in most cases, the disaster **plan** was not followed to any great extent. One of the reasons this occurred was that key personnel did not fully understand the **plan** or know their role in it. Another reason was that common disaster problems were not anticipated by the **plan**. Triage occurred **according to plan** in only one-third of the cases they studied. In fewer than half of the cases, casualties were transported to the hospital **according to** the **plan**; moreover, a **predesign**ated communications **plan** was followed in only 21% of the cases (2).

According to a 1979 report (29), city managers and county executives think that state and federal disaster agencies require very complicated and lengthy disaster **plans**. City managers said they had read their **plan** once and did not know where it was now and that they would not use it in a disaster anyway. In many cases, these **plans** are developed in isolation by a single person with minimal involvement from key emergency response organiza-tions because the operational goal is simply to comply with federal disaster **planning** requirements.

Example: 1989 San Francisco Bay Earthquake. A study conducted in the aftermath of the 1989 San Francisco Bay area earthquake revealed that, although 46 of 49 (94%) hospital emergency department nurses and 35 of 49 (71%) emergency department physicians knew the location of the emergency department disaster **plan**, only 15 (31%) of the emer-gency nurses and 13 (27%) of the emergency physicians in hospitals impacted by the quake referred to the **plan** during the disaster (30).

David E. Hogan and Jonathan L. Burstein, Disaster Medicine

No doubt of it. His **plan** was being overturned yet again, but the reality had not yet sunk in ...

Charles Pellegrino, Dust

Those Fantastic Flying Fools

Phineas T. Barnum and friends finance the first flight to the moon but find the task a little above them. They attempt to blast their rocket into orbit from

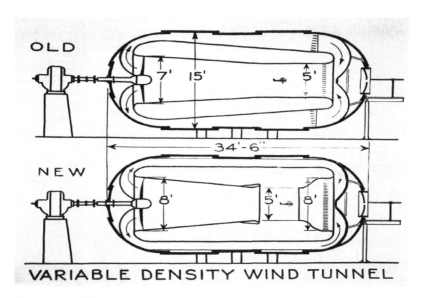

Charts/diagrams of the Variable Density Wind Tunnel (11/14/1932)

This diagram, based on a LMAL drawing from 1928, illustrates the Lab's **plan** for correcting the turbulent airflow that had plagued the original Variable Density Tunnel. Notice in particular the change from open-throat to closed-throat test section.

NASA/Langley Research Center

a massive gun barrel built into the side of a Welsh mountain, but money troubles, spies and saboteurs ensure that the **plan** is doomed before it starts.

Internet Movie Database, Plot Summaries

BOOK REVIEW: HOW THE **PLAN** TO FALL APART
SOON FELL APART

In 'The World That Never Was,' Alex Butterworth details how anarchism became violent and discredited with help from secret police and agents provocateurs.

*Wendy Smith, How the **Plan** to Fall Apart Soon Fell Apart (Los Angeles Times)*

A Clockwork Orange
In future Britain, charismatic delinquent Alex DeLarge is jailed and later volunteers for an experimental aversion therapy developed by the government in an effort to solve society's crime problem ... but not all goes to **plan**.

Internet Movie Database, Plot Summaries

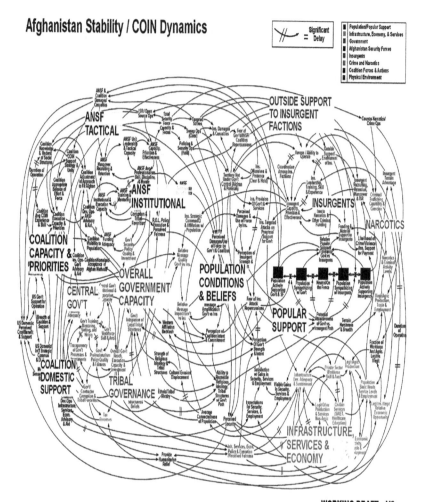

Afghanistan Stability / COIN Dynamics

WORKING DRAFT – V3

The Military's **Plan** For The Afghan War Surge, In One Giant Chart

With President Obama sending 30,000 more American men and women to fight in Afghanistan, attention has turned to the military strategy for turning around the eight-year war.

Thanks to NBC's Richard Engel, we now have a visual representation of the military's **plan**. The above chart from the office of the Joint Chiefs of Staff, Engel reports, lays out the counterinsurgency strategy to achieve three goals: "Influence insurgent-minded individuals to adopt a neutral disposition"; "Influence neutral-minded individuals to adopt a supportive disposition;" and "Retain supportive individuals."

The double lines through certain connectors on the chart represent "significant delay."

What could possibly go wrong with such a **plan**?

Justin Elliott, Talking Points Memo (talkingpointsmemo.com)

182

The informants in these sting operations were deployed to supply not just opportunities for criminal acts but also the inflammatory rhetoric that would justify terrorism charges. In a supposed plot to attack the United States Army Base in Fort Dix, New Jersey, the FBI sent two informants to infiltrate a group of suspected terrorists after a nearby Circuit City reported a suspicious video the five men had brought in to be copied. (The tape showed footage of what the men later claimed was a vacation in the Poconos, where they can be seen riding horseback, snowmobiling, and firing guns at a rifle range, while shouting, "Allahu Akbar." The government would later claim that this was a training mission.)

During the fifteen-month sting operation that followed, one of the informants urged the suspects to join their Muslim brothers overseas. "Don't you want to go and die with them, man?" he said. The other, Mahmoud Omar, an Egyptian who had agreed to work for the FBI after facing deportation for a bank-fraud conviction, initially suggested the plot to kill American soldiers at the army base. Omar told the men that if they appointed him as their leader he would be the "brain" of the operation. It was Omar who got them talking about the use of Molotov cocktails, grenade launchers, remote-controlled detonators, and roadside nail bombs. They also discussed purchasing a house near the base as a sniper station, but when the men failed to follow through with the **plans**, Omar grew frustrated. "You talk, but you don't do nothing," he told one of the suspects. The five men were arrested before they could devise a specific **plan** or set a date for the attack. Four of the defendants received life sentences, and the fifth was sentenced to thirty-three years in prison.

Petra Bartosiewicz, To Catch A Terrorist: The FBI Hunts
for the Enemy Within (Harper's Magazine)

An alternative to conflict that serious men gave thought to, and proposed, was colonial union followed by some form of federation with Britain, and with colonial representation in an imperial parliament. In 1754, a **Plan** of Union to meet the French and Indian threat had been proposed by Benjamin Franklin, with advice from Thomas Hutchinson, at the Albany Congress and found no takers. During the Stamp Act crisis the idea was revived by persons who held governing responsibility in the colonies and were worried by the growing alienation from the mother country. Franklin himself, Thomas Pownall, a former Governor of Massachusetts, now an MR, Thomas Crowley, a Quaker merchant familiar with America, and Francis Bernard, the current Governor of Massachusetts, all proposed various **plans** for rationalization of the colonial government and definitive settlement through debate of reciprocal rights and obligations leading to federation. Pownall complained at a later crisis in

1775 that as no one in government paid any attention to his views, he would offer them no more. Francis Bernard, who formulated a detailed **plan** of 97 propositions which he sent to Lord Halifax and others, was told by Halifax that the **plan** was "the best thing of the kind by much that he had ever read," and that was the last he heard.

Benjamin Franklin urged his British correspondents to recognize the inevitability of American growth and development and to make no laws intended to cramp its trade and manufacture, for natural expansion would sweep them aside, but rather to work toward an Atlantic world peopled by Americans and English possessing equal rights in which the colonists would enrich the mother country and extend its "empire round the whole globe and awe the world!" It was a splendid vision which had enthralled him since the Albany **Plan** of Union. "I am still of the opinion," he wrote years later in his autobiography, "that the **Plan** of Union would have been happy for both Sides of the Water if it had been adopted. The Colonies so united would have been sufficiently strong to have defended themselves; there would have been no need of Troops from England; of course the subsequent Pretence for Taxing America, and the bloody Contest it occasioned would have been avoided." Franklin ends with a sigh: "But such Mistakes are not new; History is full of the Errors of States and Princes."

Barbara W. Tuchman, The March of Folly: From Troy to Vietnam

So now again,
Oedipus, king, we bend to you, your power—
we implore you, all of us on our knees:
find us strength, rescue! Perhaps you've heard
the voice of a god or something from other men,
Oedipus … what do you know?
The man of experience—you see it every day—
his **plans** will work in a crisis …

Sophocles, Oedipus the King (Robert Fagles, translator)

Ada
Bo Gillis is running for Governor. Steve writes the speeches, Sylvester runs the campaign and Bo plays the guitar. Everything is going **according to** the **plan** until a hooker named Ada …

Internet Movie Database, Plot Summaries

I'd been almost on the point of hitting on a **plan**, something that would not only take care of Rose without me seeing her more than once, but would take

care of Myra and Lennie at the same time. And then Amy had spoke up, and the pieces of a **plan** had scattered every which way. And I knew I was going to have a heck of a time putting 'em together again, if I ever was able to.

Jim Thompson, Pop. 1280

If one of the points p_1 lies outside the floor contour (i.e. it is not contained by any space in the floor), then the portal is tagged as "dangling."

Emily J. Whiting, Geometric, Topological and Semantic
*Analysis of Multi-Building Floor **Plan** Data*

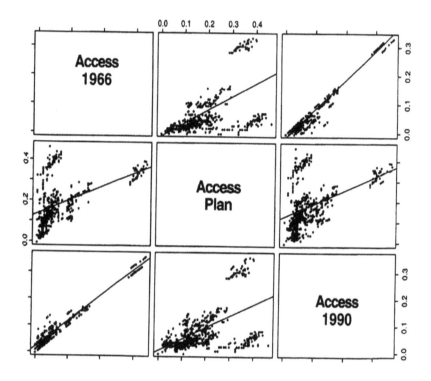

Figure 4. Scatterplot matrix. Comparison of 1966 access vs. **planned** access vs. 1990 access. Covering model.

Emily Talen, After the **Plans:** *Methods to Evaluate the Implementation Success of* **Plans**

plan platter

1.

What can be done if a project is not proceeding **according to plan**?

Jack Gido and James P. Clements, Successful Project Management

'Take it their fiendish **plan** didn't work, then?'

Iain Banks, The Business

Just establishing a sound baseline **plan** is not sufficient, because even the best-laid **plans** don't always work out.

Jack Gido and James P. Clements, Successful Project Management

according to plan. Joc. and ironic for 'willy-nilly', for anything that did not go **according to plan**: orig. army, later WWI; then a gen. c.p. more Ex Ger. **Plangemäss**, a euph. Misrepresentation in communiqués reporting loss of ground. (W.; B. & P.) See DCpp.

Eric Partridge and Paul Beale, A Dictionary of Slang and Unconventional English: Colloquialisms and Catch Phrases, Fossilised Jokes and Puns, General Nicknames, Vulgarisms and Such Americanisms as Have Been Naturalized

"No battle **plan** survives contact with the enemy," Prussian general Helmuth von Moltke once opined. The same can be said for any business **plan**: many successful businesses today bear little resemblance to the ventures outlined in their early **plans**, thanks to changes in markets, technology, finances, and even personnel. Businesses unwilling or unable to adapt to those changes are likely to end up as little more than historical footnotes.

*Jeff Foust, The Importance of **Plan** B (and **Plan** C, and **Plan** D...) (The Space Review)*

Plans, hopes, dreams—all reduced to smoke.

Philip K. Dick, Radio Free Albemuth

2.

Some people believe they have **planned** out their entire life; a few even manage to have everything go **according to plan**. For most of us, however, the further we look into the future, the more we cannot accurately see what is out there. The point is that most people do not have clear goals of becoming a supervisor and a **plan** on how to get into management. If you have such a goal and **plan**, that's great, as long as things go **according to plan**. One of the potential problems that people who precisely pre**plan** their careers run into is that things don't always go **according to plan**.

Louis V. Imundo, *The Effective Supervisor's Handbook*

He leaned back and sighed. I began to think that perhaps it wasn't the stealing that was the thrill for Nordahl so much as the escaping. He said, "If you were being chased by a bear, your adrenaline's going to be pumping, you know what I mean? Later, you might not really say, 'Gee, that was fun.' But, at the same time, if nothing else really was going on, it might have added flavor to the day. As long as you got away from the bear. But, of course, if you got caught by the bear, you know, it's another story."

Nordahl later said that he was tired of living on the run. "My whole **plan** was to go on with a real life now," he said. "I have no visions of being some criminal for my life. That's not cool. My whole thing is I want to get into real estate, remodelling homes, things like that."

Stephen J. Dubner, *The Silver Thief (The New Yorker)*

LIBERIAN
And what about you? You had big **plans**? Did you become a lawyer?

W1
(laughing)
Oh, no. Not by a long shot. I didn't even finish my undergrad degree.

LIBERIAN
But you told me you wanted to become a lawyer. You spoke so passionately.

W1
I'm sure I did. But I got married instead. The winter after you left. To an accountant.

Jesse Tatton, *My Career **Plans** Were Much More Exciting When I Was Five*
Girly Tee, White Regular Fit, $20 *(threadless.com)*

LIBERIAN
I thought all Americans got married in the spring?

W1
Not accountants. Accountants get married at the end of the year—for tax purposes.

LIBERIAN
Oh. I see.

W1
And pregnant women get married as soon as possible—at least where I came from.

 Michael Turner, American Whiskey Bar: A Novel

according to plan

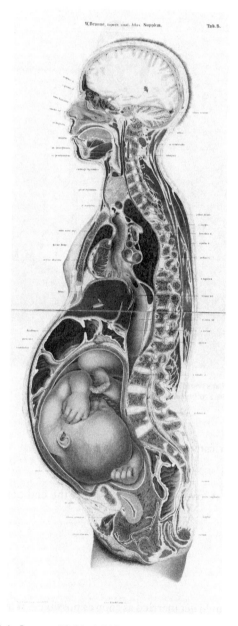

Wilhelm Braune and C. Schmiedel, Topographisch-anatomischer Atlas
(Leipzig: Verlag von Veit & Comp., 1872)

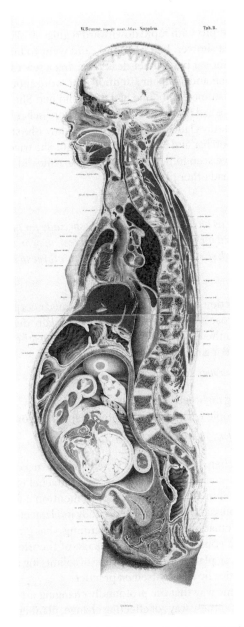

Wilhelm Braune and C. Schmiedel, Topographisch-anatomischer Atlas
(Leipzig: Verlag von Veit & Comp., 1872)

135

She shaved her armpits with rapid downward regular strokes. She was unobserved. She took a shower, had breakfast, and went to her office. A bright spring morning. She sat behind her desk receiving a few calls, making a few calls. Some calls demanded all her attention. She wore another costume. She looked good in costumes, someone had once told her. She took a taxi home from the office. She had never seen the driver before in her life. She wore her dark glasses and hardly glanced out of the car window. She stopped for a drink at the neighborhood bar and ran into an old friend. She tried to avoid him, to pretend not to have seen him, but he spotted her. She did not invite him up to her place. She had other **plans**.

42

a an and anything as black **designed** *elevator especially for her in incorporated into introduction is it jackets leather left men moment no of on one operator other* **plans** *rose said sank shaft stepped stood that the this three to use within*

52

This is an introduction to the other **plans**. The **plans** incorporated the use of the elevator that rose and sank within a shaft especially **designed** for it. The operator stood on the left as the three men in black leather jackets stepped into the elevator. For a moment no one said anything.

Walter Abish, In the Future Perfect

"Hey, what's going on here? Who the hell are you guys?"
"We are the people who make sure things happen **according to plan**."

George Nolfi (director), The Adjustment Bureau

Numerous researchers have been concerned with the need to better understand the actualities of **planning** (Bryson 1991; Yiftachel 1989; Healey 1986; Schon 1982; Fainstein and Fainstein 1982, to mention a few). Indeed, the inability of the profession to support empirically its claim of legitimacy—here defined as the effectuation of the goals of **planning**—has grave consequences for **planners**. The constantly shifting package of theories and ideologies handed to practicing **planners** has little hope of solidifying unless it becomes merged *with* practice by basing itself *on* practice.

Much in the same way that the profoundly changing urban fabric of postmodernism demands new ways of effecting change, **planners** should demand new methods of evaluation that extend the current limits of knowledge-building. One way to build knowledge about the precipitates of **planning** is by

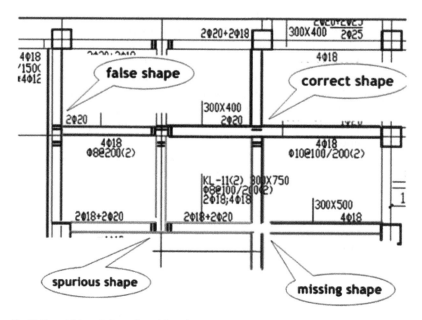

Fig. 21: Correct, false, missing and suspicious shapes

*Tong Lu, Huafei Yang, Ruoyu Yang and Shijie Cai, Automatic Analysis and Integration of **Architectural** Drawings*

analyzing the implementation of **plans**. Despite the weaknesses, **plan**making today continues as a common denominator of what **planners** do. In light of the apparent failure of urban **planning** to achieve any significant progress toward ameliorating urban ills, **planning** researchers must ask to what extent such **plans** have been successfully implemented. Where have they failed and where have they achieved their goals? How could such an investigation be approached empirically?

> *Emily Talen, After the **Plans**: Methods to Evaluate the Implementation*
> *Success of **Plans** (Journal of **Planning** Education and Research)*

This paper outlines a new theory of **plan** recognition that is significantly more powerful than previous approaches. Concurrent actions, shared steps between actions, and disjunctive information are all handled. The theory allows one to draw conclusions based on the class of possible **plans** being performed, rather than having to prematurely commit to a single interpretation.

> *Henry A. Kautz and James F. Allen, Generalized **Plan** Recognition*
> *(National Conference on Artificial Intelligence)*

Consider the following set of **plans**. There are four kinds of End events (hiking, hunting, robbing banks, and cashing checks) and three other kinds of events (going to the woods, getting a gun, and going to a bank). The event hierarchy can be illustrated by the following network, where the thick grey arrows denote abstraction or "is a," and the thin black arrows denote component or "has part." The labels "s1" and "s2" serve to distinguish the component arcs; they denote the functions which map an event to the respective component. (The labels do not, by themselves, formally indicate the temporal ordering of the components.)

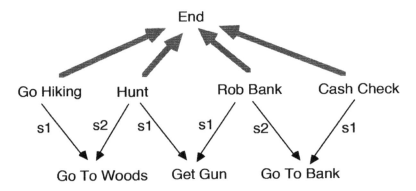

We encode this event hierarchy in first-order logic with the following axioms.

\forall x . GoHiking(x) \supset End(x)
\forall x . Hunt(x) \supset End(x)
\forall x . RobBank(x) \supset End(x)
\forall x . CashCheck(x) \supset End(x)
\forall x . GoHiking(x) \supset GoToWoods(s1(x))
\forall x . Hunt(x) \supset GetGun(s1(x)) \land GoToWoods(s2(x))
\forall x . RobBank(x) \supset GetGun(s1(x)) \land GoToBank(s2(x))
\forall x . CashCheck(x) \supset GoToBank(s1(x))

The symbols "s1" and "s2" are functions which map a **plan** to its steps. Suppose GetGun(C) is observed. This statement together with the axioms does not entail \existsx.Hunt(x), or \existsx.[Hunt(x) \land RobBank(x)], or even \existsx.End(x). The axioms let one infer that getting a gun is implied by hunting or going to the bank, but not vice versa.

*Henry A. Kautz, A Formal Theory of **Plan** Recognition and*
*Its Implementation (Reasoning About **Plans**)*

Several different methods are used to assess the correlation between **planned** accessibility and actual accessibility. First, univariate analysis can be used to characterize (and compare) the distribution of the **plan**'s access data versus that of 1990. The characterization can be nonspatial (e.g., boxplots and histograms) or spatial (comparison of mapped data). Second, bivariate analysis is used to compare how the relationship between two variables (e.g., between access and income) changes between the **plan**'s development and implementation. In nonspatial terms, scatterplots can be used to assess how the linearity of the relationship between access and socioeconomic characteristics changes (i.e., between the **plan** and after the **plan**). Spatially, bivariate analysis consists of evaluating mapped variables. For example, mapping blocks with high versus low access on the **plan** currently is used to determine whether or not certain neighborhoods achieved their intended (**planned**) accessibility level. In the case study examples, "high" and "low" access scores and census block statistics refer to their relative magnitude; that is, whether they are above or below a measure of the central tendency of the data (i.e., median or mean). Alternatively, scores can be mapped by quantile distributions, whether they are positive or negative, or any other desired categorization of the data.

Finally, spatial (multivariate) regression analysis can be used to assess the degree to which **planned** accessibility has predictive value in the achieved accessibility pattern, relative to other socioeconomic block characteristics. The model takes the following form:

$$A_{i+t} = \alpha + \beta_1 A_i + \beta_2 A p_i + \beta_3 x_1 + \beta_4 x_2 \ldots + \varepsilon$$

where A_{i+t} = accessibility per block at the future **planning** date relative to the original **plan** (for example, 1990); A_i = accessibility per block as it existed at the time of the **plan**; $A p_i$ = accessibility per block on the **plan**; and x_1, $x_2 \ldots$ represent socioeconomic characteristics of blocks for both the time of the **plan** (1970) as well as 1990.

Thus the strength of **plan** access as an explanatory variable can be evaluated against the strength of other socioeconomic characteristics. The regression models are estimated by means of Ordinary Least Squares (OLS), computed using SpaceStat software (Anselin 1995).

Emily Talen, After the **Plans***: Methods to Evaluate the Implementation Success of* **Plans**

It is time now to turn from the mechanisms that make integration possible to the pattern of behavior that results from the operation of these mechanisms. The process involves three principal steps:

Errol Morris (director), *The Fog of War: Eleven Lessons From the Life of Robert S. McNamara*

(1) The individual (or organization) makes broad decisions regarding the values to which he is going to direct his activities, the general methods he is going to use to attain these values, and the knowledge, skills, and information he will need to make particular decisions within the limits of the policy laid down and to carry out the decisions. The decisional activity just described might be called *substantive* **planning**.

(2) He **designs** and establishes mechanisms that will direct his attention, channel information and knowledge, etc., in such a way as to cause the specific

day-to-day decisions to conform with the substantive **plan**. This decisional activity might be called *procedural* **planning**, and corresponds to what was earlier described as "constructing the psychological environment of decision."

(3) He executes the **plan** through day-to-day decisions and activities that fit in the framework provided by steps (1) and (2).

In reality, the process involves not just three steps but a whole hierarchy of steps, the decisions at any given level of generality providing the environment for the more particular decisions at the next level below. The integration of behavior at the highest level is brought about by decisions that determine in very broad terms the values, knowledge, and possibilities that will receive consideration. The next lower level of integration, which gives greater specificity to these very general determinants, results from those decisions that determine what activities shall be undertaken. Other levels follow, each one determining in greater detail a subarea lying within the area of the level above.

Herbert Simon, Administrative Behavior: A Study of Decision-Making Processes in Administrative Organization

Indicators (items) within each **plan** component further specify the conception of **plan** quality (see Appendix A).

*Samuel D. Brody, Are We Learning to Make Better **Plans**? A Longitudinal Analysis of **Plan** Quality Associated with Natural Hazards (Journal of **Planning** Education and Research)*

The next morning I burst into Belbo's office. "They got it all wrong. We got it all wrong."

"Take it easy, Casaubon. What are you talking about? Oh, my God, the **Plan**."

Umberto Eco, Foucault's Pendulum

Stephen Sondheim Takes Issue with **Plan** for Revamped 'Porgy and Bess'

*New York Times, Stephen Sondheim Takes Issue with **Plan** for Revamped 'Porgy and Bess'*

HE
No, we've made a **plan** and we're gonna stick with it.

SHE
(*crossing her arms*)
This just doesn't feel right, sitting here.

HE

I don't care if it doesn't feel right. We've got a **plan** in motion and we've agreed to it with Janey and we're not gonna fuck it up. It's too late to start running off to the cop shop and messing things up.

SHE
(to herself)
Shit.

Michael Turner, *American Whiskey Bar: A Novel*

As expected, the Finance Minister's message to a Commons committee Friday acknowledged recent turmoil in global markets but stressed that Canada intends to stay the course with its deficit fighting **plans** ...

"We will stay the course. We will balance the budget by 2014-15," he added. "That's the **plan** and we intend to stick to the **plan**."

Bill Curry and Jeremy Torobin, *Flaherty Confident Deficit-Fighting Plan Can Weather Economic Storm (The Globe and Mail)*

It may be that the real value of hot spot and stop-and-frisk was that it provided a single game **plan** that the police believed in; as military history reveals, a bad **plan** is often better than no **plan**, especially if the people on the other side think it's a good **plan**.

Adam Gopnik, *The Caging of America: Why Do We Lock Up So Many People (The New Yorker)*

Colonel Cargill, General Peckem's troubleshooter, was a forceful, ruddy man. Before the war he had been an alert, hard-hitting, aggressive marketing executive. He was a very bad marketing executive. Colonel Cargill was so awful a marketing executive that his services were much sought after by firms eager to establish losses for tax purposes. Throughout the civilized world, from Battery Park to Fulton Street, he was known as a dependable man for a fast tax write-off. His prices were high, for failure often did not come easily. He had to start at the top and work his way down, and with sympathetic friends in Washington, losing money was no simple matter. It took months of hard work and careful **misplanning**. A person misplaced, disorganized, miscalculated, overlooked everything and opened every loophole, and just when he thought he had it made, the government gave him a lake or a forest or an oilfield and spoiled everything. Even with such handicaps, Colonel Cargill could be relied on to run the most prosperous enterprise into the ground. He was a self-made man who owed his lack of success to nobody.

Joseph Heller, *Catch-22*

By the beginning of August, it was clear that Calixtus could not last much longer. But the ailing pope was ignoring the inevitable. He talked on and on about his **plans** for the crusade, issuing an order that church bells should be rung every day at noon to remind Christians of their duty to pray for its success.

Harry Edgington, The Borgias

I have been told by a local agency that I need to trust the government on this. With Katrina survivors in mind, I guess that means I can expect to be huddled with the masses in a place the restrooms don't work, starved, dehydrated, raped, and mugged until a working **plan** is developed, assuming I have lived through the ordeal.

(From public comments submitted to the U.S. Bureau of Land Management regarding Over the River, *an art project proposed by artists Christo and Jeanne-Claude in 2005. Last November, the bureau approved the project, which includes the installation of fabric panels over a forty-two-mile wide stretch of the Arkansas River in Colorado. Construction may begin this year, with the two-week installation scheduled for display as early as August 2014. Jeanne-Claude died in 2009.)*

Readings: Bad Wrap (Harper's Magazine)

Another witness told CNN that protesters in western Tripoli were met by plainclothes security forces who fired guns at them and later tear gas to disperse the crowds.

Prior to the clashes this morning, security forces had removed barricades, disposed of bodies and painted over graffiti in Tripoli, witnesses said.

"We're all in our houses like we're sitting in jail," a Tripoli resident said Thursday. "We can't go outside or we get shot. We hear the bullets."

Gadhafi's son said his father has no intention of stepping down.

Asked if Gadhafi has a "**Plan B**" to leave Libya, Saif al-Islam Gadhafi told CNN Turk: "We have **Plan A**, **Plan B**, **Plan C**. **Plan A** is to live and die in Libya. **Plan B** is to live and die in Libya. **Plan C** is to live and die in Libya."

He said he hoped Libya would come out of the crisis united.

CNN, UN: Libyan Crackdown Escalating (NationNews.com)

As for his '**plan**' itself, it was the same as before ...

Fyodor Dostoyevsky, The Brothers Karamazov

A ways back I mentioned the different exhaust valve stem length and corresponding difference in rocker arm geometry between the 2F and 3FE, here are a few pics to illustrate the rocker arm portion of that story. First a comparison from above. **Plan** view geometry looks the same.

RockDoc, Improving Flow for the 3FE's Top End—Page 11—forum.ih8mud.com

So, the student of war who is unversed in the art of varying his **plans**, even though he be acquainted with the Five Advantages, will fail to make the best use of his men.

Sun Tzu, The Art of War

WASHINGTON—House Republican leaders said Tuesday they will rewrite their **plan** to raise the debt ceiling after a review said it would not meet its savings targets. The late afternoon decision came after a day of attacks on the bill from GOP conservatives and Democrats.

*Jackie Kucinich and Gregory Korte, Speaker's Debt-Ceiling **Plan** Comes Under Fire (USA Today)*

At that point we'll switch to **Plan** B. Don't ask me what that is at this moment, because I don't know.

Fern Michaels, Celebration

3.

Four of the pages were lettered: **PLAN A, PLAN** B, **PLAN** C, **PLAN** D. The
fifth was headed introduction. Reich read the ancient spidery cursive slowly:

Alfred Bester, The Demolished Man

WTF?

Driving home over the mountains from a Coastal Commission hearing, I had
time to ponder an email I received from a city official as the road wound
through the Redwood trees. The Coastal Commission had found that a zoning
change his city requested didn't conform to the Coastal Act, and we denied
it. I felt sorry for him because he had put together a project that depended
upon the property owner, developer, unions, hotel operator, local neighbors,
city council, weather, wind speed, phase of the moon and astrological sign
all aligning just to get the project in front of us. It was like herding cats and
pushing water uphill. Reading his email I was sympathetic realizing that if
you substituted customers, channel, product development, hiring, board of
directors, and fund raising, he was describing a typical day at a startup. I felt
real kinship until I got to his last sentence:
"Now we're screwed because we had no **Plan B.**"
Say what?
I had to read his email a few times to let this sink in. I kept thinking, "What
do you mean there's no **plan** B?" When I shared it with the other commis-
sioners who were public officials, all of them could see that there could
have been tons of alternate **plans** to get a project approved, and there were
still several options going forward. But the mayor just had been so intently
focussed on executing a complex **Plan** A he never considered that he might
need a **Plan** B.

*Steve Blank, There's Always a **Plan** B (steveblank.com)*

After I make a **Plan** A, I think about the fact that sometimes **Plan** A doesn't
work. Sometimes I have to be ready to compromise with the person. I make
a **Plan** B to have a back-up **plan** that will help me get part of the problem
solved. **Plan** B may help me make the situation better, at least for now, until
I can figure out another **Plan** A that will work better.

*Julie Brown, Skills System Instructors Guide: An Emotion-
Regulation Skills Curriculum for All Learning Abilities*

TIME FOR **PLAN** B

"Next time, let's start with **Plan** B."
— Lexi, *Loonatics Unleashed*

A Stock Phrase, generally said in the middle of an action scene when things are
going wrong. There are two common forms of **Plan** B: *Run like hell* and *Boom!*

*TV Tropes, Time for **Plan** B*

Plan B Skateboards Questionable
The first offering in the iconic **Plan** B video "fourology," the release of
Questionable promptly set the skateboard community on its ear screaming,
"change!" into the other. In the age of cut-down high tops and shove-its, the
hellish **Plan** B rode above the transitional feel of the era by pioneering today's
tech + handrail methodologies. Shot lovingly with shouldered VHS dinosaurs
and screw on fish eyes, *Questionable* is an undoubtedly raw, homegrown, and
pure skateboarding video that not only reflects a major turning point in skate-
boarding's evolution, but illuminates the path that the sport will follow over
the next decade.

Internet Movie Database, Plot Summaries

His thought processes might be described as a series of hypothetical implica-
tions: "If I am to go from A to B, routes (1), (2), and (3) seem more feasible
than the others; if I am to follow route (1), **plan** (1a) seems preferable; if route
(2), **plan** (2c); if route (3), **plan** (3a)"—and so on, until the most minute details
of the **design** have been determined for two or three alternative **plans**. His
final choice is among these detailed alternatives.

This process of thought may be contrasted with a single choice among all
the possible routes. The latter method is the one dictated by logic, and is the
only procedure that guarantees that the decision finally arrived at is the best.
On the other hand, this method requires that all the possible **plans** be worked
out in full detail before any decision is reached. The practical impossibility
of such a procedure is evident. The **planning** procedure is a compromise,
whereby only the most "plausible" alternatives are worked out in detail.

Herbert Simon, Administrative Behavior: A Study of Decision-
Making Processes in Administrative Organization

Plan B
Bruno is dumped by his girlfriend; behind a calm, indifferent expression, his
mind **plans** a cold, sweet vengeance. She, a modern girl, keeps on seeing him

GETTING
TO PLAN B

BREAKING THROUGH TO A
BETTER BUSINESS MODEL

JOHN MULLINS &
RANDY KOMISAR

John Mullins and Randy Komisar,
Getting to **Plan** B: Breaking Through
to a Better Business Model (Boston:
Harvard Business Press, 2009)

once in a while, but has another boyfriend, Pablo. Bruno becomes Pablo's friend, with the idea of eroding the couple, maybe introducing him to another woman. But, along the way, the possibility of a **plan** B arises, a more effective one, which will put his own sexuality into question.

Internet Movie Database, Plot Summaries

They had divided the savings account they were so assiduously building up into several parts, labeled **Plan** X and **Plan** Y and **Plan** Z and the like. Children must come strictly **according to plan**. However much they might want a child now, it would have to wait until sufficient money for **Plan** X had accumulated. Seeing the inadvisability, for numerous reasons, of installment buying, they waited until the money for **Plan** A or **Plan** B or **Plan** C had accumulated, and then paid cash for an electric washing machine or refrigerator or a television set. **Plan** A and **Plan** B had already been carried out. **Plan** D required little money, but, since it had as its object a low-priority clothes cupboard, it was always pushed back.

Yukio Mishima, Three Million Yen (Death in Midsummer and Other Stories)

Two days after my initial financial analysis, panic set in. Sleep was lost over the idea of spending years watching my savings dwindle toward zero. I forced myself to write down a **Plan B**. That felt good, so I wrote down **Plan** C.

John Wood, Leaving Microsoft to Change the World: An
Entrepreneur's Odyssey to Educate the World's Children

My use of the term "**plan**," unless noted otherwise, refers to a general, comprehensive, master structure, or strategic **plan**, rather than a sectoral or functional **plans** such as for transport or housing, or a site-specific **plan** for an area or project. Subtle analyses by Faludi and van der Valk (1994) and Mazza (1995), among many others, noted differences among types of **plans**.

*Michael Neuman, Does **Planning** Need the **Plan**?*
*(Journal of the American **Planning** Association)*

3. What are Program, **plan** types, **plans** and Option?

Medical, Dental, Vision, Life Insurance: these are the examples of **Plan** types. **Plan** types represent a particular type of insurance **plans**. For an example, Medical **Plan** type deals with all the medical insurances.

For Medical **Plan** type, there will be different insurance carriers (Insurance Providers) available. Each carrier may have many different types of insurance **plans** to provide. For an example, let's consider XYZ is a medical insurance carrier; so it might have **plans** like, XYZ **Plan** 'A', XYZ **Plan** 'B' etc. So these will be the two **plans** under Medical **plan** type. So to summarize, **plans** are the individual insurance policies available from different insurance carriers, and can be grouped under a particular **plan** type.

HCMised, Oracle Advanced Benefits

Government **designed plans** are the Medicare Supplements or Medigap policies. They come in 12 standard choices with two of the choices available with a simple modification. The choices are called **Plan** A, **Plan** B, **Plan** C, **Plan** D, **Plan** E, **Plan** F, **Plan** G, **Plan** H, **Plan** I, **Plan** J, **Plan** K and **Plan** L and the modified **plans** are the High Deductible **Plan** F and the High Deductible **Plan** J. As the letters increase from A to J, the coverage generally increases and the premiums are generally higher. **Plans** K and L are lower coverage and lower cost alternatives. The high deductible versions simply impose a deductible before the insurance company pays any benefits as a way to cut your health insurance premium costs.

First Choice Health Insurance, Inc., Medicare Advantage
*& Medicare Supplement **Plans** in Arizona*

Patrick Gunkel, *Ideonomy: The Science of Ideas: Maps and Lists (ideonomy.mit.edu)*

How Obama's **plan** to cut the deficit compares with others:

*Richard Wolf, How Obama's **Plan** to Cut the Deficit Compares with Others (USA Today)*

COMPANY	**PLAN** NAME	**PLAN** PRICE
AT&T	AT&T Nation	900 minutes $60
T-Mobile	Even More Talk	1,000 minutes $50
AT&T	Family Talk Nation	2,100 minutes, data, texts $170
T-Mobile	Even More Talk +	Text 3,000 minutes, data, texts $140

David P. Willis, AT&T, T-Mobile Merger: Good for the Consumer? (Asbury Park Press)

2010 MEDICARE SUPPLEMENT **PLAN** COMPARISON CHART ENDING 05/31/2010

This Chart allows you to compare all the standard Medicare Supplement **plans** in one easy to read chart. This standardized Medicare Supplement chart is valid until May 31, 2010 when the standardized Medicare chart changes beginning June 1, 2010.

Just click on the **plan** letter to see the specific details about each **plan**.

Special Note If you are looking for the New Modernized **plans** beginning after 06/01/2010 please click here. The old **plans** will not be available after 05/31/2010 nationwide.

Call us at 1-800-728-9609 to get a quote from a solid "A" rated company you will know and trust or submit a Medicare Supplement quote request and we will call you.

*The Medicare Channel, 2010 Medicare Supplement **Plan** Comparison Chart Ending 05/31/2010*

Difference at Ford between X **plan** and Y **plan**?

When dealing with leases and buying options, what is the difference between the X **Plan** and the Y **Plan**? Is one "Friends and Family" and one is "Supplier"? Thanks!

sarahlucy07

Best Answer—Chosen by Asker

As I understand it the X-**plan** is for retired employees and the Y-**plan** is the current employees and family members. Of course, right now you can get the equivalent deal on any Ford product even if you do not know or are related to a Ford employee and if you are buying a new 2008 or Demo the discounts are much deeper.

Gord R

Source(s):

My dad was a Ford employee for 42 years and I recently purchased a new 2008 Ford Edge LTD AWD at 40% off the sticker price since my dad has been dead for 11 years, I never thought I would see this type of deal again, it is the right time to buy from the Big 3 that's for sure.

Other Answers

A **Plan**—Ford employee

Z **Plan**—retired Ford employee

X **Plan**—Friends & Family

Ask (demand) to see the invoice, along with the associated rebates & incentives. All **plans** are shown on the invoice, so you can quickly see which is better. Not familiar with "Y" though the "X" **plan** was the same for employees of companies who received Fleet pricing.

At the moment, I believe Ford is still offering the Employee Pricing to the public.

If the dealership will not show you, go to one who will.

mike s

Source(s):

Spent 10 years in the business.

*Yahoo! Answers, Difference At Ford Between X **Plan** and Y **Plan**?*

Well, I left Kentucky back in '49
And went to Detroit workin' on a 'sembly line
The first year they had me puttin' wheels on Cadillacs

Every day I'd watch them beauties roll by
And sometimes I'd hang my head and cry
Cause I always wanted me one that was long and black.

*One day I devised myself a **plan***
That should be the envy of most any man
I'd sneak it out of there in a lunchbox in my hand
Now gettin' caught meant gettin' fired
But I figured I'd have it all by the time I retired
I'd have me a car worth at least a hundred grand.

I'd get it one piece at a time
And it wouldn't cost me a dime
You'll know it's me when I come through your town
I'm gonna ride around in style
I'm gonna drive everybody wild
Cause I'll have the only one there is around.

So the very next day when I punched in
With my big lunchbox and with help from my friends
I left that day with a lunch box full of gears
Now, I never considered myself a thief
GM wouldn't miss just one little piece
Especially if I strung it out over several years.

The first day I got me a fuel pump
And the next day I got me an engine and a trunk
Then I got me a transmission and all of the chrome
The little things I could get in my big lunchbox
Like nuts, an' bolts, and all four shocks
But the big stuff we snuck out in my buddy's mobile home.

*Now, up to now my **plan** went all right*
Til we tried to put it all together one night
And that's when we noticed that something was definitely wrong.

The transmission was a '53
And the motor turned out to be a '73
And when we tried to put in the bolts all the holes were gone.

So we drilled it out so that it would fit
And with a little bit of help with an A-daptor kit
We had that engine runnin' just like a song
Now the headlight was another sight
We had two on the left and one on the right
But when we pulled out the switch all three of em come on.

The back end looked kinda funny too
But we put it together and when we got thru
Well, that's when we noticed that we only had one tail-fin
About that time my wife walked out
And I could see in her eyes that she had her doubts
But she opened the door and said "Honey, take me for a spin."

So we drove up town just to get the tags
And I headed her right on down the main drag
I could hear everybody laughin' for blocks around
But up there at the court house they didn't laugh
Cause to type it up it took the whole staff
And when they got through the title weighed sixty pounds.

I got it one piece at a time
And it didn't cost me a dime
You'll know it's me when I come through your town
I'm gonna ride around in style

Bruce Fitzpatrick, owner of Abernathy Auto Parts and Hilltop Auto Salvage in Nashville, TN, was asked by the promoters of the song to build the vehicle for international promotion. Fitzpatrick had all the models of Cadillacs mentioned in the song when it was released and built a car using the song as a model. The result was presented to Cash in April 1976. It was parked outside The House Of Cash in Hendersonville, Tennessee, until someone could find a place to store it.

Wikipedia, One Piece at a Time

I'm gonna drive everybody wild
'Cause I'll have the only one there is around.

(Spoken) Ugh! Yow, RED RYDER
This is the COTTON MOUTH
In the PSYCHO-BILLY CADILLAC Come on

Huh, this is the COTTON MOUTH
And negatory on the cost of this mow-chine there RED RYDER
You might say I went right up to the factory
And picked it up, it's cheaper that way
Ugh!, what model is it?

Well, it's a '49, '50, '51, '52, '53, '54, '55, '56,
'57, '58, '59 automobile
It's a '60, '61, '62, '63, '64, '65, '66, '67,
'68, '69, '70 automobile.

 Wayne Kemp, One Piece at a Time (performed by Johnny Cash)

I trust that my **Plan**, will, by this time, appear to have *some* advantages, and to be founded on *principles* not liable to exception.

Mr. Pitt's **Plan**, on the contrary, does NOT answer any ONE DEFINITION of a *good* **Plan** ...

*Charles Earl Stanhope, Observations on Mr. Pitt's Plan, for
the Reduction of the National Debt (1786)*

"Okay," said the guy. "This is about the most basic one. And you can get the different coloured face plates. It's popular with ladies." He turned to watch his colleague handing a selection of coloured flat machines to the shouting girl. She was Indian or Arabic or something and wearing a clingy white top which was quite hot. This kind of thing would make up for working in a stall in a mall concourse, Justin supposed.

"So how much is this one?"

"Ah. That's two thirteen."

"Two thirteen? And that's the most basic one? Hell. I thought they were all free these days."

"Well," said the guy, still staring at the Indian girl. "You can get them free if you sign up for a **plan**. Or you can get a discount. You can get a hundred bucks off this one if you sign up for a twenty-four-month **plan**."

"No way," she said to her phone. "I was totally going to get her the blue one too. The pink is kind of cheesy-ass."

"Okay," said Justin. He was sweating already. "Tell me about the **plan**."

Sighing, the guy handed Justin a leaflet. Justin tried to read it for a minute and a half. It was covered in phrases like *The Nomad, The Family Man, The Weekender.* Each one had a series of abbreviations after it. He folded it up.

"Okay," he said. "I'll pay full price."

Russell Smith, Girl Crazy

But are the new machines and programs really smarter? The skeptics point out that what they do is still not really what we mean by "smart." They have a huge inventory of instances, but their capacity for thought isn't so different from that of the tic-tac-toe machine in the science museum. They have big memories, and an amazing ability to race through them quickly to find the right thing to apply to the circumstances—but that doesn't prove that they can think, **plan**, strategize, surprise, or come up with a **plan** so crazy it might just work.

*Adam Gopnik, Get Smart: How Will We Know When Machines
Are More Intelligent Than We Are? (The New Yorker)*

4.

Dial M for Murder
An ex-tennis pro carries out a plot to murder his wife. When things go wrong, he improvises a brilliant **plan** B.

Internet Movie Database, Plot Summaries

Plan B—sometimes it's so good, you actually want your other **plans** to fail.

*TV Tropes, Time for **Plan** B*

Amy launched into **plan** B. She squared her shoulders and looked directly at her uncle. "Uncle Bertrand, I am going to France. If I cannot leave with your assent, I shall leave without it." She braced herself for argument.

"Feisty one, ain't she!" Mr. Meadows declared approvingly. "Would've thought the French line would weaken the blood, he continued, eyeing Amy as though she were a ewe at market.

"The dam's line bred true! You can see it in my girls, too, eh, Marcus? Good Hereford stock." It was highly unclear whether Uncle Bertrand was referring to his niece, his sheep, his daughters, or all three.

"Bought a ram from Hereford once ..."

"Ha! That's nothing to the ewe I purchased from old Ticklepenny. Annabelle, he called her. There was a look in her eye ..." Uncle Bertrand waxed lyrical in the candlelight.

The conversation seemed on the verge of degenerating into a nostalgic catalog of sheep they had known and loved. Amy was mentally packing for a midnight flight to the mail coach to Dover (**plan** C), when Jane's gentle voice cut through the listing of ovine pedigrees.

Lauren Willig, The Secret History of the Pink Carnation

Since things rarely go **according to plan**, **plans** should not be overly detailed.

Louis V. Imundo, The Effective Supervisor's Handbook

In this work we are limited to recognizing instances of **plans** whose types appear in the hierarchy; we do not try to recognize new **plans** created by chaining together the preconditions and effects of other **plans** (as is done in [Allen 1983]).

*Henry A. Kautz, A Formal Theory of **Plan** Recognition and Its Implementation (Reasoning About **Plans**)*

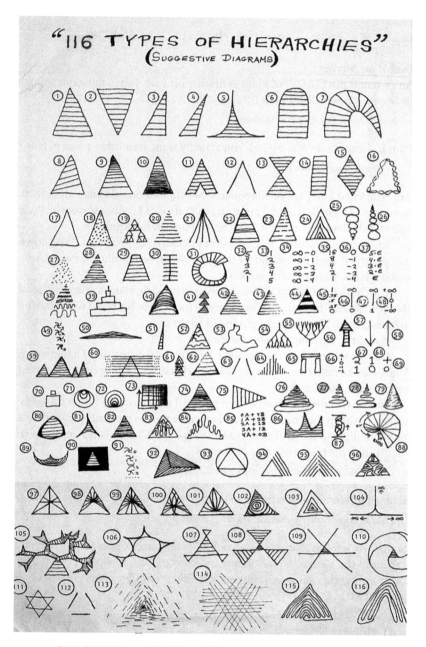

Patrick Gunkel, Ideonomy: The Science of Ideas: Maps and Lists (ideonomy.mit.edu)

"Drat." Amy absently kicked at the piling with her heel. "That also ruins **plan B.**"

"**Plan B?**"

"Yes, I thought if the Trojan Horse idea didn't work, maybe Jane and I could pretend to be dancing girls looking for work, and—"

"Let's skip straight to **plan** C, shall we?"

"You don't like **plan B?**"

Like? What an incredibly inadequate word *like* was. To say that he liked the idea of Amy dressed up as a dancing girl would be like saying that Midas liked gold, or Epicurus liked food, or Miss Gwen liked poking her parasol at people. It didn't cover the half of it. By the same token, the word *dislike* didn't even begin to describe the revulsion that flooded through Richard at the thought of Amy exposing herself to a warehouse full of hardened French operatives. In comparison, it made the whole Marston incident look about as dangerous as a peaceful stroll though Hyde Park at five o'clock at the height of the season. Chaperoned.

"I loathe, revile, and detest **plan** B," Richard replied blandly. "Next?"

"Setting the warehouse on fire," Amy suggested promptly.

The Purple Gentian stopped his pacing and knelt beside Amy's makeshift pedestal. "Do you mean to try to burn down the building around the gold?"

Amy decided he really didn't have to know that burning down the building around the gold had begun as **plan** F on the walk over, been demoted to **plan** M, and finally discarded altogether as impracticable.

Lauren Willig, *The Secret History of the Pink Carnation*

At the higher levels of integration only the very general aspects of the situation can be given consideration. Particularization can take place only when attention is directed to the more detailed possibilities and consequences. Hence, a fundamental problem of administrative theory is to determine how this plexus of decisions should be constructed—what the proper division of labor is between the broad "**planning**" decisions and the narrower "executory" decisions. A second fundamental problem is that of procedural **planning**—to devise mechanisms that will make effective the control of the executory decisions by the **planning** decisions.

Herbert Simon, *Administrative Behavior: A Study of Decision-Making Processes in Administrative Organization*

Jane, after a startled look at Miss Gwen, suggested filching some files from Delaroche's office, a **plan** which was instantly voted down by both of the others; Amy dismissed it as insufficiently bloodless. Amy's **plan** A, that they

sneak into the Temple prison in cunning disguises and liberate some deserving prisoners, met with equal scorn. As did **plan** B, **plan** C, and even **plan** D, which involved dressing up in the clothes of the previous decade, dusting themselves all over with flour, and flitting about Bonaparte's bedside as the ghosts of murdered aristocrats. "Like Richard III being haunted by his victims!" explained Amy with relish. Miss Gwen, scenting potential fodder for her horrid novel, was intrigued, but in the end ruled that scaling the windows of the Tuilleries dressed in three-foot-wide panniers and covered in flour would be both difficult and messy.

Jane's alarmed face relaxed.

"We don't have to do anything too spectacular," she pointed out hastily, before Amy could outline **plan** E. "After all, this is merely a calling card. Something to make the Minister of Police aware that he has a new adversary."

"A *better* adversary," amended Miss Gwen with a sniff.

"Since our real mission is the retrieval of the Swiss gold," Jane continued, "shouldn't we keep this one simple?"

Lauren Willig, The Secret History of the Pink Carnation

WEBSERIALS.COM LAUNCHES UNIQUE NEW UNSCRIPTED WEB COMEDY "BEST LAID **PLANS**"

August 31, 2010—WebSerials.com and New Renaissance Pictures, groundbreaking creators of original online entertainment, announce the launch of a one-of-a-kind improvised web sitcom, "Best Laid **Plans**." The cleverly unscripted show is a unique and amusing look at the **unplanned** ups and downs of our everyday lives.

In "Best Laid **Plans**," everyone's got a **plan** for their life—that just isn't working out. There's Tom, the out-of-work mechanic and hopeless romantic. He's got everything he needs, but nothing he wants. Roommate Alex was living off his parents' trust fund until the economy went bust. Now he's stuck on Tom's couch and might even have to find a job of his own. Together with friends John and Skip, these guys are always hatching new schemes—trying to get rich, get the girl, or just get by.

"Best Laid **Plans**" is produced completely without scripts thanks to an ensemble cast of talented improv performers. Each scene is loosely outlined and then the actors are given complete freedom to take that scene in unexpected directions. The result is a show that is uniquely raw, with compellingly grounded performances and completely unexpected humor. "The most

New series "The Fugitive: **Plan** B" Runs Up to No. 1 Spot on TV Charts
Hancinema: The Korean Movie & Drama Database

exciting part of this show is that literally anything can happen," notes lead
actor and co-creator Jesse GrothOlson.

> *WebSerials.com, WebSerials.com Launches Unique New*
> *Unscripted Web Comedy 'Best Laid **Plans**'*

The problem is that there are remnants from all those old **plans** …

> *George Nolfi (director), The Adjustment Bureau*

EXAMPLES

Anime

• Dub-Goku, early into his fight with Kid Buu. "Okay, onto **plan** b … whatever
that is." (This being DBZ, it seems like "try *that much harder* to blow him up.")

Comic Books

• *Hex* has: "Looks like a good time for **Plan B**. Sure do wish I had me a **Plan B**." Followed a few pages later by "Looks like I just found me a **Plan B**."

• *Runaways* gives us "We always use **plan** B. Why don't we just make it **plan A**?"

• *The Wizard of Id*. The King asks his knight Rodney why the battle **plan** is called **Plan** B instead of **Plan** A. Rodney replies that they always end up having to go to **Plan** B anyway.

• There's this great exchange in an issue of *Sonic: Universe,* where Shadow the Hedgehog and his "Team Dark" attempt to get a Chaos Emerald from the God-Panda currently lording over them in the "Special Zone." After failing the mini-game, Omega turns to Shadow and asks if it's time for **plan** B. Shadow answers in the affirmative and **Plan** B basically comprises entirely of Omega unloading his entire arsenal, which makes up over half of his total mass, in the God-Panda's face.

 *Omega: "I like **Plan B**."*

• In the American Manga *Vampire Cheerleaders,* the leader is thwarted in using her bite to alter the mind of the boy who announced he will expose them.

 *Lori: Heh. A minor setback. Girls, it's time for **Plan BC**.*
 *Leonard: **Plan B** and C? Huh?*
 *Zoe: No, it's just **plan** "BC" . . . Booty. Call.*

Film

• From *Star Trek V,* there's: "Prepare for Emergency Landing **Plan B**." "B, as in barricade!"

• *Bad Boys II* has one of these toward the end where the thoroughly improvised **plan** B consisted of driving what looks like a Humvee through the house, but definitely did not involve a bigass gun.

 Marcus: What the hell does the B stand for? Bullshit!

• *The Lost Boys*. When their first encounter with the vampires doesn't go **according to plan**, Sam and the Frog brothers have to go to **Plan** B. They don't have a **Plan** B yet and have only two and a half hours to come up with one.

• Strangely used in *Star Wars Episode III,* considering they're supposed to use a different alphabet (not that anyone's paid attention to that in the past). Incidentally, **Plan** B sucks, since it was Anakin's idea.

• *Plan 9 from Outer Space* was executed because **Plans** One through Eight failed.

• The *Dukes Of Hazzard* film gave us the line: "**Plan** B's jes' a fancy way of sayin' 'drivin' by the seat o' yer pants'."

• *Face/Off:* "Okay. **Plan B**. Let's just kill each other."

BEAUTIES

Various [Regions, Directions, Poles] Visibly Or Conjecturably [Present, Emergent, Or Confused] In Primary Plot:

Awesome

Opposites Nest?

Antisyzygially Tiny-&-Big (Contrastive)

Dwarfing, Big, Humbling, Great, Magnificent

Progressive

Numerous

Incessant

~High, Vertical, Perpendicular

Small

Active, Busy

Positive

Efficient, Useful

Measured, Exact

Superb

Powerful, Strong

Well-Constructed

Diverse, Rich, Complex

Charming

Transitory, Superficial

Bold, Exertive, Aspiring

Veridical, True, Verificatory

Seeking

~Some Elements of Stress, Threats, Anxiety

Perfect

Serious, Impressive

~Horizontal, Broad, Open, Spatial

Fun, Sensual, Delicate

Absolute, Eternal

~Beloved

Quiet, Still

Giving

Receiving

Right, Good, Moral

Negative

Harmony

Singular

Purity

Soft

Liberational

Opposites Part??

One Act, Final

Meridian?

Bliss

Transition, Transformation, Culmination

Clarity, Luminosity, Lightness

Analytic Regions Countermap

Patrick Gunkel, Ideonomy: The Science of Ideas: Maps and Lists (ideonomy.mit.edu)

- The Tag Line for the movie version of *The A-Team:* "There is no **Plan B.**"
- Naturally mentioned frequently in the movie "**Plan B.**" A woman is forced by the mafia to kill various mob leaders, but decides to think of an increasingly complicated way of getting out of this.

Literature

- In the *Star Trek* Expanded Universe novel *How Much for Just the Planet?*, by John M. Ford, the Diredei **plan** to stop the Federation and/or Klingons from exploiting their dilithium is called "**Plan C.**" There was no **Plan** A or B; C stands for the keystone of the **plan**: "Comedy."
- In one *Sonic the Hedgehog* novel, they eventually have to resort to **Plan D**, which Sonic hadn't actually got as far as thinking up. Fortunately, a *Contrived Coincidence* intervenes.
- One of the book titles in the *Liaden Universe* is "**Plan B.**" **Plan B** being the emergency "clan is under attack, everyone bug out, get weapons, and maintain radio silence" **plan**. It's pretty telling that Clan Korval has had this **plan** in reserve pretty much since they landed on the home planet. Word Of God is that the title of the book was actually decided upon *for them* by fans during the long gap between their publisher rejecting further books in the series after the third (in which the name "**Plan B**" was first mentioned) and the authors learning they had an unexpected Internet fan movement. Fans kept asking them when *Plan B* was coming out, and they chose to take advantage of the name recognition when they found a publisher for future books in the series.

 In a way, *Plan B* was the *authors'* "**Plan B**," since they had not ever expected to be able to continue the series when the first publisher didn't want it. *Word Of God* is also that "**Plan B**" was a working draft term for the real name of the **plan**, intended to be replaced in the edit process when they could come up with suitable Liaden nomenclature, but it somehow stuck.
- From *Good Omens,* after Crowley has successfully killed one Duke of Hell, but failed to bluff the surviving one:

 Plan A had worked. Plan B had failed. Everything depended on Plan C, and there was only one drawback to this: he had only ever planned as far as B.
- *The Good, The Bad, and the Undead* by Kim Harrison has:

 "Grab the fish and run like hell."

 TV Tropes, Time for **Plan** B

To sum it all, if you are enrolled in XYZ Medical **Plan** A—Employee + Spouse; it means, you are enrolled in Medical **Plan** type, XYZ Medical **Plan** and Employee+ spouse option. Now, what's a program?

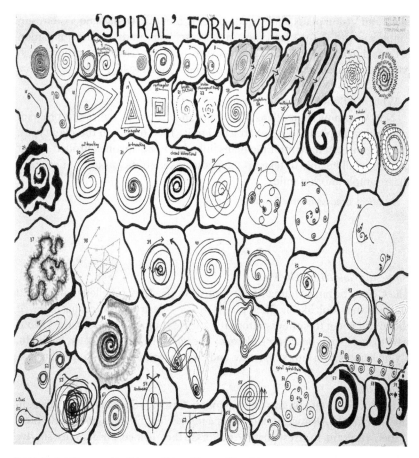

Patrick Gunkel, Ideonomy: The Science of Ideas: Maps and Lists (ideonomy.mit.edu)

A Program is a unit specifically defined for a set of people. Quite confusing eh? Let's take an example: in your enterprise, you have Employees who get benefits, there are retirees who get only a set of benefits, and you also have expats from other countries working in your firm, who need special kind of benefits. Now, if the set of **plans** offered to the three different groups are different from each other, you need some kind of a logical structure to group them, right? That logical structure is called a Program.

Program is a unit of benefits that groups a set of compensation objects (**Plans** and options) together. Taking the example a little further; if you say the Retirees can get only Medical and Dental, and won't get Life Insurance

plans and Vision **plans**; and Expats get only Medical, Dental and Vision; and Employees get all the **plan** types, in this case, you can divide the population in three different groups, and call them the programs. Now each program can have the required set of **Plan** types and **plans** linked to it.

4. What is a Benefit Structure?

Now you know about **Plans**, **Plan** types and Programs, right? One program can have multiple **Plan** types attached to it. Then based on the **plan** types, the program can have multiple **plans** linked to it. So anyone enrolled in that program will be able to take up the **plans** linked to the program. Let's take that example another mile ...

HCMised, Oracle Advanced Benefits

5.

*Battlestar Galactica: The **Plan***
The Cylons began as humanity's robot servants. They rebelled and evolved and now they look like us. Their **plan** is simple—destroy the race that enslaved them. But when their devastating attack leaves human survivors, the Cylons have to improvise. *Battlestar Galactica: The **Plan*** tells the story of two powerful Cylon leaders, working separately, and their determination to finish the task.

Battle Planet
In the not-so-distant future, Captain Jordan Strider, a Special Forces Officer in the New World Alliance, is chosen for a top-secret mission. Sent to a desolate planet, Terra 219, to arrest possible traitors to the Alliance, Strider must survive with only a government issued experimental suit as protection. He quickly learns of a **plan** to end all humanity. The Captain now faces a choice; to continue as instructed on his mission or choose his new mission, to save the world.

Internet Movie Database, Plot Summaries

In all worlds, there were mistakes that needed correcting. And if Bellamy didn't want to leave, didn't want to make a **plan**, I'd travel alone. I knew what I was doing. All I wanted were a few more minutes to set things straight. I called out once, Alice? My partner was screaming, but I couldn't answer him. I was dropping away. I was slipping out of reach. It was time to go. My journey towards home was just beginning.

Peter Plate, One Foot Off the Gutter

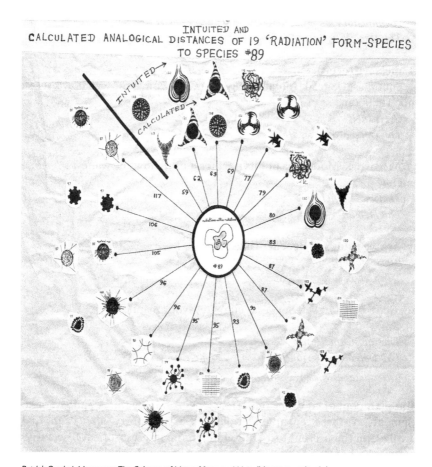

Patrick Gunkel, Ideonomy: The Science of Ideas: Maps and Lists (ideonomy.mit.edu)

9. Ultra XYZ plan in effect. Code 2, Level 1. Bref at midnight.
Thank you for your cooperation.
Out.
TheCowsCameHome
Thu Dec-08-05 07:06 PM

11. Message Received
Message received. Will forward instructions to action teams at 0200 hrs
after clarifications.
Out.

Vogon_Glory
Thu Dec-08-05 07:14 PM

12. message received
SouthEast US ready for full engagement. Remember the wolf howls at the moon at noon.
GreenInNC
Thu Dec-08-05 07:17 PM

19. Nice work. Moonrake points northeast until howling wanes.
Out.
TheCowsCameHome
Thu Dec-08-05 07:28 PM

17. Are we using our decoder rings? n/t
Bjornsdotter
Thu Dec-08-05 07:24 PM

20. Code 2 requires it. Suggest you review your manual.
Out.
TheCowsCameHome
Thu Dec-08-05 07:30 PM

DemocraticUnderground.com, General Discussion (Through 2005)

The **plan** contained other important operational features and strategic elements. As these remain under official Navy "security," they cannot be divulged in the present text. Therefore, in the interests of naval security, permit the borrowing of a leaf from tight-lipped President John Adams (bulkhead of the Navy, he was, too) who referred to certain parties he did not care to mention, as "X," "Y," and "Z." By this diplomatic codification, the submarine **plan** in question may be called the "XYZ **Plan**." Veteran submarine captains will recognize the reference, future submarine captains will become acquainted with the **plan** if it is employed in their time, and the present editors can go on with the story.

Theodore Roscoe, United States Submarine Operations in World War II

NANCY: I was going to tell you, you should probably leave town now.
FOSTER: Yeah, well, **Plan** A was live and prosper. **Plan** C? Disappear.
NANCY: Ah, I used to have **Plan** C. Then **Plan** C turned back into **Plan** A.

Jenji Kohan, Weeds: Season 7, Episode 7

Eugene Murphy, **Plan** C: Community
Survival Strategies for Peak Oil and
Climate Change (Gabriola Island, BC:
New Society Publishers, 2008)

The NYT has a link to a feature called 18-Year-Olds Predict Their Future.
Huh, wonder what I would have "predicted" for my future when I was 18. (I
turned 55 this year.)

I think I would have expected to be either a writer or an actor, although
what I really wanted to be was a disc jockey on the radio. I didn't have the
slightest idea how to go about achieving that dream, and by the time I got
out of college I was a film critic. That lasted about a year, and then I devoted
a lot of time to being a performance artist while working various dead-end
jobs and then getting my teaching degree. That lasted a couple years. Anyway,
37 years after graduating from high school, I actually do earn my living as a
writer—a technical writer, that is.

What use it is "predicting" at age 18 what you're going to be, I don't know.

Mark Pritchard, I Think I'm on **Plan** G or H (Too Beautiful)

Having now a good house and very sufficient income, he intended to marry;
and in seeking a reconciliation with the Longbourn family he had a wife
in view, as he meant to choose one of the daughters, if he found them as
handsome and amiable as they were represented by common report. This was
his **plan** of amends—of atonement—for inheriting their father's estate; and he
thought it an excellent one, full of eligibility and suitableness, and excessively
generous and disinterested on his own part.

Jennifer O'Connell, **Plan B**
(New York: Pocket Books/MTV
Books, 2006).

His **plan** did not vary on seeing them. Miss Bennet's lovely face confirmed his views, and established all his strictest notions of what was due to seniority; and for the first evening *she* was his settled choice. The next morning, however, made an alteration; for in a quarter of an hour's tête-à-tête with Mrs. Bennet before breakfast, a conversation beginning with his parsonage-house, and leading naturally to the avowal of his hopes, that a mistress for it might be found at Longbourn, produced from her, amid very complaisant smiles and general encouragement, a caution against the very Jane he had fixed on. "As to her younger daughters, she could not take upon her to say—she could not positively answer—but she did not know of any prepossession;—her eldest daughter, she must just mention—she felt it incumbent on her to hint, was likely to be very soon engaged."

Mr. Collins had only to change from Jane to Elizabeth—and it was soon done—done while Mrs. Bennet was stirring the fire. Elizabeth, equally next to Jane in birth and beauty, succeeded her of course.

Mrs. Bennet treasured up the hint, and trusted that she might soon have two daughters married; and the man whom she could not bear to speak of the day before, was now high in her good graces.

Lydia's intention of walking to Meryton was not forgotten ...

Jane Austen, Pride and Prejudice

You know the expression "paralyzed by choice"? Well, despite growing up in the US and coming back for regular visits over the ten years I was living in Europe, I still struggle in American grocery stores. For the first six or so months after we moved here, I was following my usual shopping routine, going to the supermarket whenever we needed something. After a while, though, I found I was making a trip almost every day because I'd forgotten something basic like milk, while coming home with an armload of peculiar specialties that caught my eye. Too many times, I'd find myself wandering the aisles, because I'd suddenly decided we MUST have sesame peanut noodles for dinner, and do we have fish sauce at home?

I had resisted menu **planning** in the past because it just sounds so regimented and, I don't know, authoritarian. Anyone who works long hours is probably all "authoritarian? You bet!" by now. You've been doing menu **plans** forever, right? But with our time becoming more limited, between work and shuttling kids around to their ever-growing list of activities (we get more American every week, I swear), I finally decided to get with the program. So I drew up a little chart and started to fill it in: dinner each night of the week, with vegetarian and picky eater options included. With the week's meals laid out, I wrote up my shopping list; it only took one trip to the grocery store with list in hand to make me a convert to, even an evangelist for, meal **planning**. No more drifting through the store waiting for inspiration to strike! I feel like a model of efficiency as I check off items and zip through to the checkout.

Katy, According to Plan (Emperor's Crumbs)

Three food-combining **plans** are offered here. **Plan** A is only for those with normal digestion and without serious health conditions; **Plan** B, the most effective program for digestive excellence, is needed most by persons with poor digestion and/or major health problems; **Plan** C, a one-pot meal, can include more or less restrictive combinations, depending on the person's digestive strength. It is well-suited to individuals deficient in *yin* fluids.

Paul Pitchford, Healing with Whole Foods: Asian Traditions and Modern Nutrition

Which Republican candidate can make the same claim? Perry, with his support for a balanced-budget amendment? Mitt Romney, with his fifty-nine-point **plan** to slash federal spending, make a bonfire of federal regulations, and impose trade sanctions on China? Herman Cain, with his "9-9-9" **plan**?

John Cassidy, Back on Track (The New Yorker)

Tammi Flynn, The 3-Apple-a-Day **Plan:**
Your Foundation for Permanent Fat Loss
(New York: Broadway Books, 2005)

While the horses were being harnessed, he ordered an omelette. He ate it at once, ate a huge chunk of bread, ate a sausage, which happened to be available, and drank three glasses of vodka. Having thus fortified himself, he felt much more cheerful and his heart grew light again. He drove along the road at a spanking pace, urging on the coachman, and suddenly he made a new and this time 'unalterable' **plan** how to obtain 'the damned money' that day and before the evening. 'And to think,' he cried scornfully, 'only to think that because of some rubbishy three thousand a man's life can be ruined! I shall settle it today!'

Fyodor Dostoyevsky, The Brothers Karamazov

The **plan** was immediately adjusted in all its parts ...

Tobias Smollett, The Adventures of Peregrine Pickle, in Which Are Included Memoirs of A Lady of Quality

THE NEW 2010 MODERNIZED MEDICARE SUPPLEMENT
PLAN COMPARISON CHART UPDATED FOR 2011

This Chart allows you to:

Compare all the Standard Medicare Supplement **plans** in one easy to read chart. This standardized Medicare Supplement chart is valid after June 1, 2010

& updated for 2011. The old **plans** will no longer be available to purchase after May 31, 2010.

*The Medicare Channel, The New 2010 Modernized Medicare Supplement **Plan** Comparison Chart Updated for 2011*

"How could a **plan** just change like that?"
"I don't know, it's above my pay grade."

George Nolfi (director), The Adjustment Bureau

Abstract: An observational study was conducted on a mechanical engineer throughout his task of defining the functional specifications for the machining operations of a factory automation cell. The engineer described his activity as following a hierarchically structured **plan**. The actual activity is in fact opportunistically organized. The engineer follows his **plan** as long as it is cognitively cost-effective. As soon as other actions are more interesting, he abandons his **plan** to proceed to these actions. This paper analyses when and how these alternative-to-the-**plan** actions come up. Quantitative results are presented with regard to the degree of **plan** deviation, the **design** components and the definitional aspects which are most affected by these deviations, and the deviation patterns. Qualitative results concern their nature. An explanatory framework for **plan** deviation is proposed in the context of a blackboard model. **Plan** deviation is supposed to occur if the control, according to certain selection criteria, selects an alternative-to-the-**planned**-action proposal rather than the **planned** action proposal. Implications of these results for assistance tools are discussed briefly.

*Willemien Visser, More Or Less Following a **Plan** During **Design**: Opportunistic Deviations in Specification (International Journal of Man-Machine Studies)*

Derivation of table 4-6. As discussed in the text, on any given day naifs will consider three options: choose **plan** B today, choose **plan** C today, and (**plan** to) choose **plan** C tomorrow. First, consider the comparison of **plan** C today and **plan** C tomorrow. If we define

$$\acute{L}(\tau) \equiv P[(1 + r_C/365)^T - (1 + r_A/365)^t(1 + r_C/365)^{T-t}],$$

then a sufficient condition for naifs to always prefer **plan** C tomorrow to **plan** C today is $C > \beta\delta^T\acute{L}(1) + \beta\delta C$ or $\beta < C/[\delta^T\acute{L}(1) + \delta C] \equiv \beta^C$.

Next consider the comparison of **plan** B today and **plan** C tomorrow. Define t^* to be the first day on which the person prefers **plan** B today over **plan** C tomorrow. Assuming $r_A = 0$ percent,

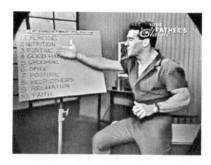
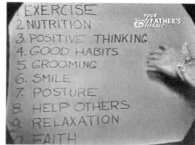
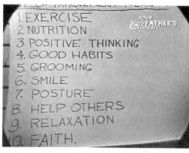

*Jack LaLanne, 10 Point **Plan** (youtube.com)*

$$t^* = \min\{t \in \{0,1,2,\ldots\}] \mid \beta\delta^{T+1-t}P(1 + r_C/365)^{T-t}$$
$$- \beta\delta C < \beta\delta^{T+1-t} P(1 + r_B/365)^{T+1-t}\}.$$

Note that t^* is independent of β.

Table 4-6 then uses the following logic. If $\beta > \beta^C$, people either choose **plan** C on day 1 or **plan** B on day 1. In fact, for all examples we consider, they choose **plan** C on day 1 (which follows from $t^* > 1$). If $\beta < \beta^C$, then the person will choose **plan** B on day t^*.

Derivation of table 4-7. TCs clearly choose **plan** $K \in C, D, E$ that maximizes

$$\delta^T P(1 + r_K/365)^T - C_K$$

For each $K \in C, D, E$, define

$$\hat{L}^K(\tau) \equiv P[(1 + r_K/365)^T - (1 + r_A/365)^t(1 + r_K/365)^{T-t}],$$

and then a sufficient condition for naifs to always prefer **plan** K tomorrow to **plan** K today is

$$C > \beta\delta^T\hat{L}^K(1) + \beta\delta C \text{ or } \beta < C/[\delta^T\hat{L}^K(1) + \delta C] \equiv \beta^K.$$

Table 4-7 then reports the **plan** $K^{tc} \in C, D, E$ chosen by TCs, and the critical self-control problem β^{Ktc} that will induce naifs to procrastinate on **plan** K^{tc}. To ensure procrastination for all $\beta < \beta^{Ktc}$, we must confirm that for each $K' \in C$, D, E people do not prefer **plan** K' today to **plan** K tomorrow. For all examples we consider this condition holds.

Henry Aaron, Behavioral Dimensions of Retirement Economics

Charles Baudelaire was convinced that the gigantic cookie would solve everything and didn't bother to come up with a **plan** B ... now what? Charles Baudelaire: The main thing is that you cram it full of dialogue. More showy, less telly.

Bill Kennedy and Darren Wershler, Update

The decision is really not complicated. Most people will select **Plan** F or **Plan** G. **Plan** F is the best **plan** and **Plan** G is the 2nd best. We have already done the shopping for you and have the lowest prices. Give us a call to get your free quote and email package today or submit the quote request form for a free consultation.

The Medicare Channel, The New 2010 Modernized Medicare Supplement
Plan Comparison Chart Beginning 06/01/2010 and Updated for 2011

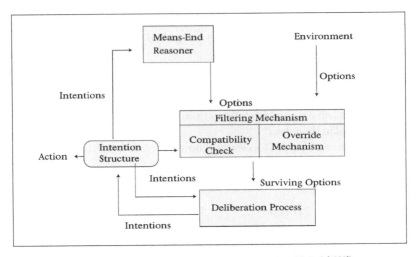

Figure 1: The Intelligent Resource-Bounded **Architecture** (Bratman, Israel, and Pollack [1982])

*Martha E. Pollack, and John E. Horty, There's More to Life Than Making **Plans: Plan** Management in Dynamic, Multiagent Environments (AI Magazine)*

Suddenly with a single bound he leaped into the room, winning a way past us before any of us could raise a hand to stay him. There was something so panther-like in the movement—something so unhuman, that it seemed to sober us all from the shock of his coming. The first to act was Harker, who, with a quick movement, threw himself before the door leading into the room in the front of the house. As the Count saw us, a horrible sort of snarl passed over his face, showing the eye-teeth long and pointed; but the evil smile as quickly passed into a cold stare of lion-like disdain. His expression again changed as, with a single impulse, we all advanced upon him. It was a pity that we had not some better organised **plan** of attack, for even at the moment I wondered what we were to do.

Bram Stoker, Dracula

Initial scanning yields data points on which to analyze the problem and develop a **plan**. Assessment of **plan** implementation yields further information that is then incorporated into revisions of the **plan**, and so on.

Laurence Miller, Practical Police Psychology: Stress Management and Crisis Intervention for Law Enforcement

The equation of the **plan** parallel to the **plan** $2x - y + 3z = 0$, which passes through the point $(1, 1, 1)$?

Additional Details

The equation of the **plan** parallel to the plane 2x – y + 3x + 4 = 0, I forgot to add the 4.

harrypotterfun11

*Yahoo! Answers, The Equation of the **Plan** Parallel to the **Plan**
2x – Y + 3z = 0, Which Passes Through the Point (1, 1, 1)?*

Management experts advise entrepreneurs to revisit their business **plans** regularly. After all, circumstances change, and if tactics and goals don't change along with them, a business strategy can grow stale awfully fast.

Still, it's hard not to wonder whether Craig Knouf has taken such advice a tad too far. The CEO of Associated Business Systems, an office-equipment supplier based in Portland, Oreg., simply cannot keep his hands off his business **plan**. Since founding his company in 1997, Knouf figures he's revised his original business **plan** more than 120 times, revisiting the 30-page document on a monthly, quarterly, and annual basis. Running his company any other way, Knouf says, "would be like driving a car with no steering wheel."

*Nicole Gull, **Plan** B (and C and D and ...) (Inc.)*

What worried him was the new '**plan**' he had devised while travelling in the cart, a **plan** that could not possibly fail and that could not possibly be put off. Mitya decided to sacrifice an hour to it. 'In an hour,' he thought, 'I shall settle everything, I shall find out everything, everything ...'

Fyodor Dostoyevsky, The Brothers Karamazov

But that hadn't happened. And **plan** A had been such an easy **plan**! True, Amy had **plans** B through G in reserve, but they were all much more complicated, and involved a freedom of movement that Amy wasn't sure she could acquire under Miss Gwen's watchful eye. For example, **plan** B, dressing as a stable boy and eavesdropping in the stables of any suspects, involved finding boy's clothes, finding enough time away from Miss Gwen, and, well, finding suspects. And **plan** C grew even more intricate ...

Lauren Willig, The Secret History of the Pink Carnation

Re: Plan Z
Rejected German **Plans**:
1) **Plan** X ...
What's the composition of the fleet?
2) **Plan** Y ...
What's the composition of the fleet?

according to plan

		First Semester	Second Semester
Plan E:	75 Meals Per Semester	☐ $435.00	☐ $435.00
Plan F:	50 Meals Per Semester	☐ $300.00	☐ $300.00
Plan G:	25 Meals Per Semester	☐ $155.00	☐ $155.00
Plan H:	$100.00 Flex Dollars Per Semester	☐ $100.00	☐ $100.00
Plan I:	$200.00 Flex Dollars Per Semester	☐ $200.00	☐ $200.00
Plan J:	$300.00 Flex Dollars Per Semester	☐ $300.00	☐ $300.00

Commuter students: "Build Your Own Plan" – Plans E through G must also purchase one of the Flex Plans H through J.

Flex dollars may be added to a base plan in increments of $25.00.
Flex dollars roll from Fall to Spring, but unused meals do *not* roll.
All unused meals and flex dollars are forfeited at the end of the Spring semester.

Student Name (please print): _____

Student ID Number: _____

I have read and understand this Board (Meal) Plan Agreement.

Signature: _____ **Date:** _____

Millikin University, Commuter Board Contract

nebelwerferXXX
12 Sep 2010, 06:18

Re: **Plan** Z
Hello ... If I were only to speculate a good guess for the composition of the
plans, it's like this ...

Plan X Fleet: smaller ships
—50 x 13,900-ton Adm Hipper-Class heavy cruisers
—50 x 6,980-ton K-Class light cruisers
—300 x 2,225-ton Type 34-Class destroyers
—300 x 844-ton T-Class torpedo boats
—1,000 x 750-ton Type VII U-boats

Plan Y Fleet: capital ships
—7 x 41,700-ton Bismarck-Class battleships
—7 x 31,850-ton Scharnhorst-Class battleships
—24 x 23,000-ton Graf Zeppelin-Class aircraft carriers

nebelwerferXXX
12 Sep 2010, 07:20

Re: **Plan Z**
From memory (so take it with a grain of salt), the X **Plan** was a sketchy study
giving the requirements to take on the RN.

Plan Y was a downsized **Plan** X which could be envisioned—if KM got the
lion's share of the rearmament budgets.

Plan Z was an evolution of **Plan** Y; IIRC the changes were made mainly
because of tactical & operational reasons, and not for budgetary reasons.

mescal
12 Sep 2010, 18:28
*Axis History Forum, **Plan** Z*

Meanwhile, the shareholders called!
 "You rang?" answered the internet, and went into overdrive registering
http://www.nokiaplanc.com (a picture of a tire to indicate that Nokia's best
hope of survival is a return to their roots); http://www.nokiapland.com (some

shoes, along the same lines); http://www.nokiaplane.com (a Nokia branded plane—you see what they did there); http://www.nokiaplanf.com (in which they file for bankruptcy) ... You get the idea.

Our favourite was http://www.nokiaplanx.com, a '**Plan** generator' which offered such gems as 'Sell actual Androids to Finnish Schoolchildren'. http://www.nokiaplans.com, meanwhile, is a helpful index site of all the other Nokia **plans** created so far.

Nokia **Plan** B remained up for at least four hours before disappearing, in mysterious circumstances, presumably along with its authors. Someone call David Lynch! We literally could not script this any better ...

*Contagious Magazine, Nokia / Plan B. And **Plan** C. And **Plan** ...*

PLAN C
Nov 15 2010, 10:40 PM EST

I love how **plan** c was not mentioned in the previous episode. When Nancy pulled the, "I think you may have picked up my passport by mistake" ... that was AWESOME! She actually has learned some things along the road. I totally knew Silas wasn't going to stay with Lars. The cash that the postman left behind was f#*king genius! I cant wait to see what they end up spending it on. Now, as for the last 5 minutes ... HOLY ****! Nancy ... confessing??? There's got to be some kind of game **plan** she's developed in her mind ... at least I hope. I guess prison is better than death. To wrap things up, I admire Jenji for her style and ability to nail great cliffhangers.

nancybotwin101

1. RE: PLAN C
Nov 15 2010, 11:59 PM EST | Post edited: Nov 16 2010, 12:00 AM EST

What a great end to this season—but two seconds after gasping at the last scene, I thought, hmmmm ... her confession isn't going to stick (there's video proof floating around Mexico ...) AND who's going to take care of the baby while she's in jail? At least she might survive for a while longer to get herself into more trouble ... EXCELLENT end to an exciting season. LOVE this show. So so so so happy it will be back. Thank you Jenji!!

summitgirl

2. RE: PLAN C
Nov 16 2010, 12:15 AM EST

Totally agree maybe a prison break or some old friends come back to help who knows cant wait to see hopefully season 7 crossing my fingers =)

Lanky808

Nokia Plan C

Inspired by Nokia Plan B

www.nokiaplanc.com

3. RE: PLAN C

Nov 16 2010, 12:18 AM EST

 and i guess silas shane and andy will take care of themselves and who knows doug might show up and help i wish conrad would come out of no where and be in season 7 or nancy's sister

 Lanky808

6. RE: PLAN C

Nov 16 2010, 7:12 PM EST

 She should have said, "oh yeah, arrest these guys, too. They're killers too." I mean they have a dead body in the trunk of their car right there at the airport! I think you're right, there's probably more to **plan** C that we'll find about next season … sigh, not til next summer, no doubt.

 malvavisco

7. RE: PLAN C

Nov 16 2010, 8:34 PM EST

 All of your thoughts on Season 7 are great and I love all of them. malvavisco, I totally agree with you that Nancy should have narked on Esteban and

Guiermo at the airport ... but I'm going to guess that doing so would have jacked up the smoothness of "**plan c**."

Dean would be a useful character for season 7 as would Conrad. Nancy's sister's reappearance would most likely just give Andy another erection, lol.

I hope that the postman's stashed money is used to jump right back into the drug world, only through Andy, Silas, and Shane. Any further thoughts??

nancybotwin101

8. RE: PLAN C

Nov 16 2010, 10:18 PM EST

BTW ... does anybody know what **Plan B** was??

Weeds Wiki, Discussion: Plan C

6.

THE CAPTAIN (after a long pause): Do you have a **plan**?
ABBOT AND JONES: We have two **plans**. Two irreconcilable **plans**. Each involves you. I'm afraid you're going to have to decide.

Walker Percy, Lost in the Cosmos: The Last Self-Help Book

Design of experiments. Assume that it is of interest to compare the milk yield from cows that have received two different feeding strategies (A and B) to determine if the feeding strategies lead to systematic differences in the yields. Discuss the advantages and disadvantages of the following four **design** strategies and whether or not they can be used to investigate the purpose of the experiment.

1. Feed one cow after **plan** A and one cow after **plan** B.
2. 100 cows from one farm are fed **according to plan** A while 88 cows from another farm are fed **according to plan** B.
3. Ten cows are selected at random from a group of 20 cows and fed **according to plan** A while the remaining 10 cows are fed **according to plan** B.
4. For each of 10 twin pairs, a cow is chosen at random and fed from **plan** A while the other cow is fed **according to plan** B.

Claus Thorn Ekstrøm and Helle Sørensen, Introduction to
Statistical Data Analysis for the Life Sciences

*www.nokia**pland**.com*

*www.nokia**plane**.com*

"How long can you keep this up?"

"Don't know. What am I supposed to do? Knock over milk stores? They gave me one week but I figure two."

"Are they serious?"

Henry gave me one of his patented stares. "Dungo, last Tuesday night, when I got into my car and turned on the key, there was an explosion under the hood. I ran into the office. The telephone was ringing and I picked it up. 'It's that easy,' a voice said. 'Happy driving.' No one I knew.

"Until then I thought I could put them off until my luck changed. But now I've got it figured out." Henry had that little smile he sometimes wore when he had put together a surprise. "Look at my options." He stuck out one finger: "I try to take out Nicko Ross. That's ridiculous, right? For one thing the guy's a barbarian. For another, even if I did drop something on his head or shoot him, the rest of them would get me. And not only me. There'd also be the family." He stuck out a second finger. "Two: we all disappear. That was my **plan**. I even managed to put some money aside for a while. One night we just take off, head for the coast or something. Problem is, we're a family. Too easy to track down. These guys have friends everywhere. They'd be afraid sooner or later I'd spill my guts to someone. Even Jeanine. Which would put her in danger, too." He put a third finger out. "Three: only I disappear. Make it look like suicide. Not a bad **plan**. If I kill myself, especially if the body is right there, they figure I'm so ashamed of everything that's happened I just offed myself. That way they could be sure I hadn't told Jeanine. So she'd be in the clear."

"Good thinking?' I said. "What's number four?"

"There is no number four."

Matt Cohen, The Bookseller

The pairs of alternatives are, of course, equivalent—**plan** A is the same as **plan** C, and **plan** B is the same as **plan** D—they've just been framed in different ways.

*John S. Hammond, Ralph L. Keeney and Howard Raiffa, Smart
Choices: A Practical Guide to Making Better Life Decisions*

Now the whole thing is clear. The whole intrigue, the whole deception is now obvious …' All this went whirling through his mind. He did not run to Maria Kondratyevna's yard. 'I mustn't go there. No, I mustn't do that. I mustn't raise any alarm. They will at once let them know and betray me. Maria Kondratyevna is obviously in the plot. Smerdyakov, too. They've all been bribed!' He formed a different **plan** of action …

Fyodor Dostoyevsky, The Brothers Karamazov

Richard Barnes—Before and After the 12 Week **Plan**

richardbarnes.com: An Inside View On Planet Richard Barnes

Rona Economou was a lawyer at a large Manhattan law firm, making a comfortable salary and enjoying nights on the town when she was laid off in 2009, another victim of the recession. At first, she cried. "Then it hit me," said Ms. Economou, now 33. "This is my one chance" to pursue a dream.

Six months later, feeling hopeful, she opened Boubouki, a tiny Greek food stall at the Essex Street Market on the Lower East Side, where she bakes spinach pies and baklava every morning. This was supposed to be her **Plan B**: her chance to indulge a passion, lead a healthier life and downshift professionally—at least by a gear. Instead, Ms. Economou finds herself in overdrive.

Six days a week, she wakes up at 5:30 a.m. ("before most lawyers") to start baking. Instead of pushing paper, she hoists 20-pound bags of flour, gets burned and occasionally slices open a finger. On Mondays, when the shop is closed, she does bookkeeping and other administrative tasks.

So much for a healthier life. "The second I feel a cold coming on, I'm taking Cold-Eeze, eating raw garlic," she said. "I can't afford to shut the shop down."

Plan B, it turns out, is a lot harder than it seems. But that hasn't stopped cubicle captives from fantasizing.

Alex Williams, Maybe It's Time for **Plan** *C (The New York Times)*

Willson (2006) reviews four **planning** approaches that are particularly relevant: classic rational **planning** (consolidation and equilibrium), incremental **planning** (expansion and transformation), strategic **planning** (maximization of output), and communicative **planning** (human commitment). He argues that it is critical to link the appropriate **planning** approach with the particular organizational culture. He suggests that the communicative **planning** approach, because it best corresponds with human commitment, will lead to organizational cohesion and high morale.

Susan E. Kogler Hill, Edward G. Thomas and Lawrence F. Keller, A Collaborative, Ongoing University Strategic **Planning** *Framework: Process, Landmines, and Lessons:* **Planners** *at Cleveland State University Describe That Institution's Highly Communicative and Participatory Strategic* **Planning** *Process (***Planning** *for Higher Education)*

Knouf couldn't agree more. So every 30 days, he distributes Associated's business **plan** to his seven vice presidents. The VPs review the **plan**, comparing their divisions' current results with goals established the previous month. If the two don't match, they consider why and rewrite the business **plan** accordingly. Quarterly reviews take the same approach to three-month goals. Plus, there's an annual two-day meeting to discuss and refine long-term objectives. Such relentless **planning**, Knouf says, helped the 110-employee company reach $21.5 million in sales in 2003. "If you only looked at the **plan** every quarter, by the time you realize the mistake, you're five months off," says the 45-year-old entrepreneur. "You're done. You're not going to get back on track."

Nicole Gull, **Plan** *B (and C and D and ...) (Inc.)*

I walked a couple of blocks, called Jeanine from a phonebooth. When she answered her voice sounded young and fresh. You would have thought she was a teenager waiting to be asked on her first date. "Is everything all right?"

"Everything's fine. Is Henry around?"

"He's out with Nicko Ross. He said I should tell you that he had a **plan**, a number four, that you'd know what he meant."

"Great."

There was a silence and I began to feel guilty. Maybe I was wrong to doubt Henry. Maybe Henry did have a **plan**, after all. "I'm sorry," I finally said.

Matt Cohen, The Bookseller

Jeb Hensarling: McConnell's **plan** is something like **Plan** X, Y, or Z while all the rest of us are still working on **Plan** A, B, or C

Conservative Home, Jeb Hensarling: McConnell's Plan is Something Like Plan X, Y, or Z While All the Rest of Us Are Still Working on Plan A, B, or C

Formally, we again suppose people have retirement savings $P and will retire in T days, and that their retirement savings are currently in default **plan** A that has yearly rate of return r_A. Each day, they can keep their money in **plan** A; can transfer it without cost to an alternative investment, **plan** B, that yields return r_B; or can exert some effort C to put it in a second alternative, **plan** C, that yields return r_C. We make the important additional assumption that people cannot invest in **plan** B now and later transfer to **plan** C.[24] Our analysis again assumes that $\delta(1 + r_B/365) > 1$, so that shifting to **plan** B or to **plan** C is more attractive the further people are from retirement.

In this environment people clearly should not leave money in **plan** A forever, because **plan** B dominates **plan** A. Time-consistent people will either choose **plan** B or **plan** C immediately. Because **plan** B yields intertemporal utility $\delta^T P(1 + r_B/365)^T - 0$, and **plan** C yields intertemporal utility $\delta^T P(1 + r_C/365)^T - C$, TCs behave as follows: transfer to **plan** C at $\tau = 1$ if and only if $\delta^T P[(1 + r_C/365)^T - (1 + r_B/365)^T] \geq C$; transfer to **plan** B at $\tau = 1$ if and only if $\delta^T P[(1 + r_C/365)^T - (1 + r_B/365)^T] < C$.

Now consider naive people with self-control problems.

Henry Aaron, Behavioral Dimensions of Retirement Economics

And on the same principle Pompey might easily have crushed Caesar at Pharsalus through his lack of everything, as he had **planned** to do, had not he suffered himself to be diverted from his **plan** by his soldiers in their elation after the victory of Dyrrhachium.

Balthazar Ayala, Three Books on the Law of War and on the Duties Connected with War and on Military Discipline

I realize that even **Plan** B doesn't work out sometimes, so I accept the fact that I may need to make a **Plan** C. **Plan** C may be to do an On-Track Action

of Accepting the Situation. Perhaps doing a Focus New-Me Activity will help me stay on-track as **plans** fall apart. A Safety **Plan** might be necessary if I am having urges to take my frustration out on other people.

Julie Brown, Skills System Instructors Guide: An Emotion-Regulation Skills Curriculum for All Learning Abilities

Fall back and regroup, his mind shrieked. ***Plan** B is just as good as **Plan** A.* The only problem was he hadn't gotten around to forming **Plan** B.

Fern Michaels, Celebration

- **Plan** B is the name of an emergency contraceptive brand. Their advertising campaign says "If **Plan** A fails, go to **Plan** B ..."
- WD-40, the all-purpose lubricant/de-greaser/de-ruster/water displacer was so named because WDs 1 through 39 didn't work as well in testing.
- On that note, a moment of silence please for the testers of Preparations A-G ...
- Not to mention the testers of Compounds A-V ...
- You gotta hand it to the guys that created Formula 409, they define dedication. Also according to a commercial, the world isn't ready for Formula 410.
- Likewise, the cocktail P2. P stands for project, and project 1 didn't measure up and was scrapped.
- Some **Plan** Bs even get their own facebook pages: *Croke Park **Plan** B*
- In the *2010 Copiapó mining accident* the **plan** that actually succeeded in reaching the trapped miners was, you guessed it, **Plan** B.

*TV Tropes, Time for **Plan** B*

Recently, Dey and Suen (DS) (2002) have given optimal fractional factorial **plans** that are hierarchical in nature for estimation of mean, all main effects and a specified set of two-factor interactions with far fewer runs using finite projective geometry. They have given the following three different types of optimal fractional factorial **plans**:

i. $(F_1, F_2; F_3, F_4; \ldots; F_{2u-1}, F_{2u})_1$: a **plan** allowing the optimal estimation of the mean, $2u$ main effects F_1, F_2, \ldots, F_{2u}, and u two-factor interactions $F_1 F_2$, $F_3 F_4, \ldots, F_{2u-1} F_{2u}$.

ii. $(F_1, \ldots, F_u; F_{u+1}, \ldots, F_{u+v})_2$: a **plan** allowing the optimal estimation of the mean, $u + v$ main effects $F_1, F_2, \ldots, F_{u+v}$, and uv two-factor interactions $F_i F_j$ $(1 \leq i \leq u, u + 1 \leq j \leq u + v)$.

*Kaptain Kobold Alan, **Planning** Session (flickr.com)*

All those Lego shots don't **plan** themselves, you know. Sometimes I am in two, or even three, minds as to what to do and how to do it. At times like that it's always good to have a meeting and thrash out ideas. Blue sky thinking is encouraged and no concept is too absurd—I think we are all agreed on that, at least.

iii. $(F_1, \ldots, Fu)_3$: a **plan** allowing the optimal estimation of the mean, u main effects F_1, F_2, \ldots, F_u, and u two-factor interactions $F_1 F_2, F_2 F_3, \ldots, F_{u-1} F_u, F_u F_1$ and also hybrid models arising from these using finite projective geometry.

Here we obtain two optimal fractional factorial **plans** for estimation of mean, all main effects, specified two-factor interactions, ... and specified $(r-1)$ factor interactions using $(r-1)$-dimensional finite projective geometry $\mathrm{PG}(r-1, m)$ over $\mathrm{GF}(m)$. These optimal **plans** can be applied to practical situations in biological experiments, where large fractional factorial **plans** as well as higher order interactions may be useful.

> *M. Aggarwal, Lih-Yuan Denga, and Mukta Datta Mazumder, Optimal Fractional Factorial Plans Using Finite Projective Geometry (Communications in Statistics—Theory and Methods)*

Re: Plan Z
The **Plan** was useless, full stop.

Baltasar
05 Sep 2010, 11:56

Re: Plan Z

Baltasar wrote: The **Plan** was useless, full stop.

So, by now the **Plan** Z discussion is a useless/obsolete topic by now. Is that what you mean Sir?

nebelwerferXXX

05 Sep 2010, 12:09

*Axis History Forum, **Plan** Z (Axis History Forum)*

The way I see it, when a man starts a project, he starts with **Plan**-A. If **Plan**-A don't work, he moves onto **Plan**-B, and so on. Well, with that in mind, let's suffice it to say right now my life is in **Plan**-V.

Capisci?

*Heather Letto, **Plan** V: **Plan** A Didn't Work—**Plan** B Sucked—**Plan** C Was Worse Than **Plan** A*

Hilarity Ensues if it loops all the way to **Plan** Z. Or if the letter doesn't actually have anything to do with the number of **plans** before it (e.g., it's called "**plan** B" because it involves a trip to Belgium).

*TV Tropes, Time for **Plan** B*

"Where are you going to be all this time?"

"Dead."

"Right." When Henry has a **plan**, you have to listen slowly, ask the right questions, get it out of him a bit at a time. Eventually it seems that he's thought of everything. Except that in the end it never works, which is Henry's peculiar riddle, his karma, Meribel T. Simmons would say, and why Henry had gotten himself into this mess in the first place. "But while you're supposed to be dead, where are you going to be hiding? What are you going to use for money? How are you going to fake the body? Henry, these friends of yours might not be very nice, but they aren't idiots. You can't just go away and leave a suicide note."

"I know."

"So?"

"Number three," Henry said. "The only number three that works is the one where they find a body. That way they know."

"No problem. We just dig someone up, strap on your watch, and throw him into the lake with a beeper so they find him. Got anyone in mind?"

"Me, Dungo. I'll do it at the garage. You just attach a vacuum cleaner hose to the exhaust pipe. I bought a new one the other day. One of those nice shiny flexible plastic hoses, guaranteed not to leak for at least a month. I won't feel a thing."

Henry had worked out the perfect **plan**. He just had to kill himself and all his problems would be solved.

Matt Cohen, The Bookseller

Wilby Wonderful
A day-in-the-life dark comedy concerning a group of islanders, their respective secrets, and one man's **plan** to kill himself quietly.

Inn of the Frightened People
... with the help of a friend whose daughter was also killed by the suspect, a **plan** is hatched to "teach the guy a lesson." Unfortunately the **plan** is ill conceived and hastily executed with unexpected and disastrous results for all concerned.

Dead in the Water
Charlie Deegan has everything he has ever wanted. He has an important Law practice, a beautiful secretary as his lover, and the chance to be appointed to the high court. The only thing wrong with this is that his wife Olivia, whose father made all the wealth and all the power, is living and that greatly upsets Charlie. So when his lover, Laura, suggests that they get rid of Olivia, Charlie thinks, being a lawyer, that he can create a fool-proof **plan**. In this **plan**, he must incorporate a woman named Victoria whom he detests, but she can help him get into the court and be part of the **plan** for Olivia. But dreams of judgeship, money and Laura makes him proceed. However, things never turn out as **planned** and he may not be as smart as he considers himself.

*Susan's **Plan***
Susan wants her reprehensible ex-husband dead and, in several bungled attempts by henchmen, tries to accomplish the deed. First her boyfriend hires two dim-witted hitmen. Then she hires a former biker boyfriend to smother him in the hospital where he is recuperating from the first attempt. Then Zane's former wife figures out what is going on and wants a part of the action.

Internet Movie Database, Plot Summaries

REID'S **PLAN** IS DEAD. BOEHNER'S **PLAN** IS DEAD. CAN THINGS GET ANY WORSE? YES, THEY CAN!

The first version of Senate Majority Leader Harry Reid's compromise debt **plan** died an expected and ignoble death Saturday afternoon.

...

Republicans warned that Reid's **plan**, which raised the debt limit by $2.4 trillion with just that much in spending cuts, would throttle military spending. Democrats warned that Boehner's **plan** would "cut Medicare and Social Security."

. . .

"Both the Boehner and Reid **plans** have nearly identical—identical!—**plans** to establish joint select committees," said Rep. David Dreier, R-Calif., the chairman of the rules committee, who spent the week shoving version after version of Boehner's **plan** through.

. . .

If America actually solves this crisis, and the debt limit is increased by some mash-up of the Boehner and Reid **plans**, that little spat is a preview of the screams to come . . . But Democrats were right, too: under their **plan**, cuts to Medicare, Social Security, and Medicaid are less likely than in the Republican **plan**.

. . .

Here's the dividing line. Both the Boehner and Reid **plans** create a powerful committee. (Whichever aide gave it the catchy, horrifying name of "Super Congress" deserves the Marvel No-Prize this month.) Under each **plan** ... If at least seven members of the committee approve a **plan** ...

. . .

There's a key difference between the **plans** ... the deficit committee's **plan** will be voted on separately.

. . .

That's just not good enough for Republicans. Look at the last few long-term deficit-reduction **plans**, they say ... Rep. Paul Ryan, R-Wis., put out a budget **plan** that turned Medicare into a voucher—sorry, "premium support"—**plan**. Democrats whittled that into a club and won a special election in western New York with it. That **plan** didn't even touch Social Security. The Bowles-Simpson **plan** did, and it died quickly, to live on as a spectral presence in Tom Friedman and David Brooks columns.

. . .

"There's just not enough time to get an entitlement **plan**. We have one ..."

. . .

She's one of the only Republicans who hasn't ruled out a vote on the Reid **plan**, but she wants this trigger. "In the Reid **plan** ... In the Boehner **plan** ... but that's where we are."

. . .

"Going through this experience means we'll probably be better at it the next time," said Rep. Tom Cole, R-Okla ...

David Weigel, Don't Worry, It Gets Worse (Slate)

The interpretation of symbols in **architectural plans** is one of the most recent activities [21]. Unlike other types of drawings, two difficulties make the recognition of **architectural** symbols difficult. First, there is no standardized notation and a general framework for the interpretation of various **architectural** symbols is not a solved issue. Second, variations of **architectural** symbols usually make the recognition an expensive process, especially when the graphical primitives are difficult to be separated from those of other structural objects.

Generally speaking, **architectural** symbols have more changeable characteristics, which make the recognition of **architectural** symbols depend more on synthetical analysis than that of engineering symbols. For example, all the two lights in Fig. 16b and c and the elevation symbol in Fig. 16d have the similar circle, two intersected lines and the filling attribute. But they have different semantic meanings: Fig. 16b shows a waterproof indicator light, Fig. 16c implies a general indicator light, while Fig. 16d describes the elevation of some structural objects. **Architectural** symbols also have more uncertain characteristics. For example, in Fig. 16e, several concentric circles represent a spray symbol, but the number of the concentric circles is not the crucial proof for the recognition of the symbol. Figure 16f shows two fire hydrant symbols with different directions. That means sometimes the recognition cannot start from the directions of graphic primitives, too.

Tong Lu, Huafei Yang, Ruoyu Yang and Shijie Cai, Automatic Analysis and Integration of
Architectural Drawings (International Journal of Document Analysis and Recognition)

By now, everyone is surely a bit confused.

*Michael D. Shear, A Debt Ceiling Cheat Sheet: 8 Possible **Plans** (The New York Times)*

You had to stay alert around Phyllida. Here she was, ostensibly talking about Richard the Lionhearted's petite kidney, and already she'd managed to move the subject to Madeleine's new boyfriend, Leonard (whom Phyllida and Alton hadn't met), and to Cape Cod (where Madeleine had announced **plans** to cohabitate with him). On a normal day, when her brain was working, Madeleine would have been able to keep one step ahead of Phyllida, but this morning the best she could manage was to let the words float past her.

Fortunately, Alton changed the subject. "So, where do you recommend for breakfast?"

Jeffrey Eugenides, The Marriage Plot

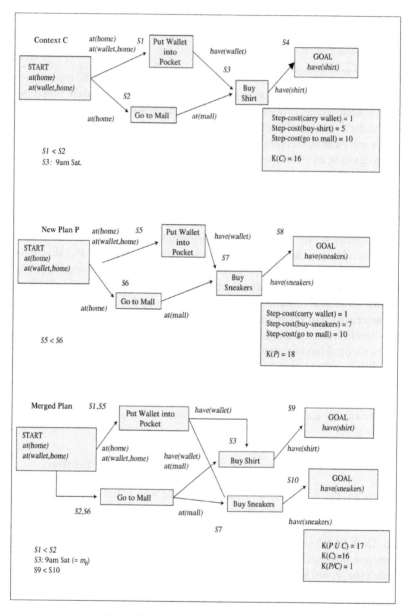

Figure 2: The Costs of **Plan** in Isolation and in Context

*Martha E. Pollack, and John E. Horty, There's More to Life Than Making **Plans: Plan** Management in Dynamic, Multiagent Environments (AI Magazine)*

Add to these the study that appeared in the February issue of JPL: "Searching for the Good **Plan**: A Meta-Analysis of **Plan** Quality Studies." It's by Phillip Berke and David Godschalk, FAICP, two bright lights in our field from the University of North Carolina at Chapel Hill.

*R. Ewing, Meta-Analysis of **Plan** Quality—More Than a Literature Review (**Planning**)*

Other approaches to **plan** recognition describe it as the result of applying unsound rules of inference that are created by reversing normally sound implications. From the fact that a particular **plan** entails a particular action, one derives the unsound rule that that action "may" imply that **plan** [Allen 1983]. Such unsound rules, however, generate staggering numbers of possible **plans**. The key problems of deciding which rules to apply and when to stop applying the rules remain outside the formal theory.

*Henry A. Kautz, A Formal Theory of **Plan** Recognition and
Its Implementation (Reasoning About **Plans**)*

Inside my stomach turns, churns, for it is all working out exactly **according to plan**. So much so, that I realized you should never ever **plan** because the best of all possible **plans** get handed to you on a **plan** platter.

*Eric Albert, Greta Christina, and Jill Soloway, Susie Bright
Presents: Three Kinds of Asking for it: Erotic Novellas*

Plan C is good for those who are weak or chronically ill. If digestion is also poor, C meals should be simpler, but need not be as strict as **Plan** B because of the harmonizing effect that occurs when foods slowly cook together in ample water. The watery nature of these meals recommends them to those with deficient *yin* fluids syndrome as well as those who cannot chew their food thoroughly.

Paul Pitchford, Healing with Whole Foods: Asian Traditions and Modern Nutrition

Considering all these possibilities, and others not yet mentioned, we begin to believe that from that **plan** it is possible to extract different **plans,** or more exactly, different variations of the same type of building, which is a clear indication that Leonardo was aware of such implications and was trying to find solutions for the problems posed by each.

*João Pedro Xavier, Leonardo's Representational Technique for
Centrally-**Planned** Temples (Nexus Network Journal)*

"We're not staying for dinner," Alton reminded her.
 "Well, we might. That depends on Maddy's schedule."

Patrick Gunkel, *Ideonomy: The Science of Ideas: Maps and Lists (ideonomy.mit.edu)*

"No, that's not the **plan**. The **plan** is to see Maddy for breakfast and then leave after the ceremony."

"Your father and his **plans**," Phyllida said to Madeleine. "Are you wearing that dress to the ceremony?"

"I don't know," Madeleine said.

Jeffrey Eugenides, The Marriage Plot

Through the man's brain passed **plan** after **plan** whereby he might thwart the escape of the Englishman and his wife, for so long as the vital spark remained within the vindictive brain of Alexander Paulvitch none who had aroused the enmity of the Russian might be entirely safe.

Plan after **plan** he formed only to discard each either as impracticable, or unworthy the vengeance his wrongs demanded. So warped by faulty reasoning was the criminal mind of Rokoff's lieutenant that he could not grasp the real truth of that which lay between himself and the ape-man and see that always the fault had been, not with the English lord, but with himself and his confederate.

And at the rejection of each new scheme Paulvitch arrived always at the same conclusion—that he could accomplish naught while half the breadth of the Ugambi separated him from the object of his hatred.

But how was he to span the crocodile-infested waters?

Edgar Rice Burroughs, The Beasts of Tarzan

... and whether the agent may try to perform erroneous **plans** [Pollack 1986].

*Henry A. Kautz, A Formal Theory of **Plan** Recognition and*
*Its Implementation (Reasoning About **Plans**)*

... may provide important insights into how **plan** quality can be strengthened to address repetitive hazardous events more effectively.

*Samuel D. Brody, Are We Learning to Make Better **Plans**? A Longitudinal Analysis of **Plan***
*Quality Associated with Natural Hazards (Journal of **Planning** Education and Research)*

"But you went through all this, Nicky!" Burr implored in one last appeal to the Denham he thought he had known. "What's changed? Joint steering held policy meetings galore! You had every bloody contingency cooked three ways! If Roper does this, we do this. Or that. Remember? I saw the minutes. You and Goodhew agreed it all with the Americans. **Plan** A, **Plan** B. What happened to all that work?"

Denham was unperturbed. "Very hard to negotiate a hypothesis, Leonard. Particularly with your Latin. You should try my desk for a few weeks. You've got to present him with facts. Your Latin won't budge until it's real."

"Won't till it's not, either," murmured Eccles.

"Mind you," said Denham encouragingly, "from all one hears, the Cousins are absolutely busting a gut to make this one stick. The little we do isn't going to alter the price of fish one farthing."

John le Carré, The Night Manager

It's like Lucy in *Peanuts,* except John Morefield offers **architecture**, not psychiatry, for a nickel. (Sometimes, particularly in residential **architecture**, they are hard to tell apart). The young **architect** set up a booth at a farmers market in Seattle and is dispensing advice for a nickel a pop. (Five cents more than a lot of **architects** get paid for curbside consultations.)

*Lloyd Alter, The **Architect** Is In—5 Cents Per Consultation (www.treehugger.com)*

the architect

Jack is employed in **architecture** or **design** (we see him browsing briefly through **plans**) ...

Anthony Lane, Time Trip (The New Yorker)

"Here, Kitty, come and look at my **plans**; I shall think I am a great **architect** if I have not got incompatible stairs and fireplaces."

George Eliot, Middlemarch: A Study of Provincial Life

Every man is the **architect** of his own fortune. — *Sallust.*

Theodore L. Cuyler, Golden Thoughts on Mother, Home and Heaven, From Poetic and Prose Literature of All Ages and All Lands

Every man is the **architect** of his own fortune. — *MacDiarmid.*

Charles Walton Sanders, The New School Reader, Fourth Book: Embracing A Comprehensive System of Instruction in the Principles of Elocution With A Choice Collection of Reading Lessons in Prose and Poetry, From the Most Approved Authors; for the Use of Academies and the Higher Classes in Schools, Etc

Every man is the **architect** of his own fortune. But chiefly the mould of a man's fortune is in his own hands. — *Lord Bacon.*

John McDiarmid, The Scrap Book: A Collection of Amusing and Striking Pieces, in Prose and Verse, With an Introduction, and Occasional Remarks and Contributions. Third Edition, Improved and Enlarged

SEMINAR LEADER: Let's get started. Today just might be the most important day of your life.
WOMAN: Come sit with me. There's safety in numbers.
SEMINAR LEADER: You cannot **design** a life that works without first drafting a clear blueprint. And you cannot construct a life that has meaning without first laying a solid foundation. You are the **architect** of your life. Not your

emotionally distant father. Not your overly critical mother. Not your petty fair-weather friends. You.

*Alan Ball, Six Feet Under: Season 2, Episode 3: The **Plan***

Every man is the **architect** of his own fortune—with variants. [Nullum numen abest, si sit Prudentia: nos te, Nos facimus, fortuna, Deam coeloque locamus.—Juvenal, x 365. Sallust (*De Repub. Ordin.*) attributes the saying to Appius Claudius Caecus, the Censor, 312 B.C.] 1533: N. Udall, *Flowers for Latin Speaking* (1560), 24, A proverbiall spekyng ... Every man ... is the acuser of his own fortune. 1539: Taverner, *Proverbs*, fo. 37, A mans owne maners do shape hym hys fortune. 1612: Shelton, *Quixote*, Pt I bk i ch iv, And, what is more, every one is son of his works. *c.*1680: L'Estrange, *Seneca's Epistles*, xiii, Every man is the artificer of his own fortune. 1707: Dunton, *Athen. Sport,* 454, It is a highway saying, that we are **architects** of our own fortune. 1800: Coleridge, *Wallenstein,* Man is made great or little by his own will. 1873: E. Tew, in *N. & Q.,* 4th ser, xii 515, We have not a commoner saying among us than 'Every man is the **architect** of his own fortune', and we have very few much older.

George Latimer Apperson, The Wordsworth Dictionary of Proverbs

Instead of saying that man is the creature of circumstance, it would be nearer the mark to say that man is the **architect** of circumstance. It is character which builds an existence out of circumstance. Our strength is measured by our plastic power. From the same materials one man builds palaces, another hovels; one warehouses, another villas: bricks and mortar are mortar and bricks, until the **architect** can make them something else. Thus it is that, in the same family, in the same circumstances, one man rears a stately edifice, while his brother, vacillating and incompetent, lives for ever amid ruins; the block of granite which was an obstacle in the pathway of the weak, becomes a stepping-stone in the pathway of the strong. — *Carlyle.*

Henry Southgate, Many Thoughts of Many Minds: Being A Treasury of Reference Consisting of Selections From the Writings of the Most Celebrated Authors

This encounter costs Don Quixote a full six days mending in Barcelona; but still, as he and Sancho leave the city to return to La Mancha, the Knight can affirm that "each man is the **architect** of his own fortune," as he tells his disheartened Squire ...

*"each man is the **architect** of his own fortune. I was the **architect** of mine, but I did not observe the necessary prudence, and as a result my presumptuousness has brought me to a sorry end. I should have reflected that*

Robert & Shana ParkeHarrison, *Kingdom*. A selection from their book, *The **Architect's** Brother*, published by Twin Palms Publishers, 2010. *(lebbeuswoods.wordpress.com)*

Rocinante, weak as he is, could not withstand the Knight of the White Moon's powerful steed. In short, I was too daring; I did my best but I was overthrown..." (II, 66)

Anthony J. Cascardi, *The Bounds of Reason: Cervantes, Dostoevsky, Flaubert*

I think it may be more rightly said to-day that the Engineer is the **Architect** of the world.

Proceedings of the American Society of Civil Engineers, Volume 32

... those whom Adam Smith called the "masters of mankind," who are "the principal **architects**" of government policy and pursue their "vile maxim": "All for ourselves and nothing for other people."

Noam Chomsky, The Responsibility of Intellectuals, Redux: Using Privilege to Challenge the State (Boston Review)

THE **ARCHITECT**: Hello Neo.
NEO: Who are you?
THE **ARCHITECT**: I am the **Architect**. I created the Matrix. I've been waiting for you.

Matrix Wiki, The Architect (Scene)

It cannot be very difficult to determine who have been the contrivers of this whole mercantile system; not the consumers, we may believe, whose interest has been entirely neglected; but the producers, whose interest has been so carefully attended to; and among this latter class our merchants and manufacturers have been by far the principal **architects**. In the mercantile regulations, which have been taken notice of in this chapter, the interest of our manufacturers has been most peculiarly attended to; and the interest, not so much of the consumers, as that of some other sets of producers, has been sacrificed to it.

Adam Smith, The Wealth of Nations

"I take offense at your words," Zack replied indignantly. "Do you think I came to the Sanctum to steal your valuables? That is an outrageous thing to accuse me of."

"Ah, mock offense," smiled the old man. "You play your part well, Lord Zachary. Why are you here? Out of all the estates in the Sanctum, why have you chosen to visit me?"

"Because you are the **architect** of the Federation," answered Zack.

Richard S. Tuttle, Heirs of the Enemy

On a rainy night in late November, Robert Kyncl was in Google's New York City offices, on Ninth Avenue, whiteboarding the future of TV. Kyncl holds a senior position at YouTube, which Google owns. He is the **architect** of the single largest cultural transformation in YouTube's seven-year history. Wielding a black Magic Marker, he charted the big bang of channel expansion and audience fragmentation that has propelled television history so far, from the age of the three networks, each with a mass audience, to the hundreds of cable channels, each serving a niche audience—twenty-four-hour news, food, sports, weather,

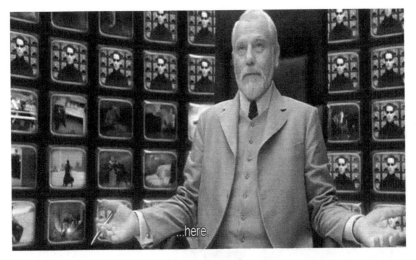

The **Architect** (scene). The **Architect** is the 29th scene from The Matrix Reloaded. *(matrix.wikia.com)*

music—and on to the dawning age of Internet video, bringing channels by the tens of thousands. "People went from broad to narrow," he said, "and we think they will continue to go that way—spend more and more time in the niches—because now the distribution landscape allows for more narrowness."

John Seabrook, Streaming Dreams: YouTube Turns Pro (The New Yorker)

It is thus no hyperbole to call Adams the "**architect**" of America's freedom ...

Joseph Cowley, John Adams: Architect of Freedom

NEO: Choice, the problem is choice.

THE **ARCHITECT**: The first matrix I **designed** was quite naturally perfect, it was a work of art, flawless, sublime. A triumph equaled only by its monumental failure. The inevitability of its doom is as apparent to me now as a consequence of the imperfection inherent in every human being, thus I **redesigned** it based on your history to more accurately reflect the varying grotesqueries of your nature. However, I was again frustrated by failure. I have since come to understand that the answer eluded me because it required a lesser mind, or perhaps a mind less bound by the parameters of perfection. Thus, the answer was stumbled upon by another, an intuitive program, initially created to investigate certain aspects of the human psyche. If I am the father of the matrix, she would undoubtedly be its mother.

Matt Tauber (director), The **Architect** (www.movies-wallpapers.net)

NEO: The Oracle.

Matrix Wiki, The One's Function

Woman is the **architect** of the whole society and the **architect** of humanity's destiny. She builds the home; she establishes the institution of family life; she brings up the children and makes them good citizens with her devotion, compassion, meditative nature, concentration and dhyana.

M. G. Chitkara, Rashtriya Swayamsevak Sangh: National Upsurge

Alas, the success of his '**plan**' depended on her.

Fyodor Dostoyevsky, The Brothers Karamazov

Lucy is to be married in the autumn, and she is already **planning** out her dresses and how her house is to be arranged. I sympathise with her, for I do the same ...

Bram Stoker, Dracula

Thus the man, through the law of form in the sperm cell, is the **architect** of the "house we live in." Woman, through her maternal law, is the **architect** of the living power within the house. The masculine law is to the human organism

what a house is to its living inmates; the maternal law is the indwelling life of the house. The human organism is not simply a *house,* it is a living structure formed upon the two great archetypal laws of form. Man is the **architect** upon the external plane, combining both laws in the sperm cell. Woman is the **architect** on the internal plane, combining also both laws; one in the sperm cell, and the other through the centrifugal action of the uterus and of her own nerves upon the fetus, which we shall explain hereafter.

Elizabeth Osgood Goodrich Willard, Sexology as the Philosophy of Life: Implying Social Organization and Government

JERRY: Hey, thanks again for running over here, appreciate it.

GEORGE: Yeah, yeah, I was showing a condo on 48th Street. Besides, you think I wanna miss this?

JERRY: I'm a little nervous.

GEORGE: Yeah, me too.

JERRY: If I see her, what do I say I'm doing here in the building?

GEORGE: Uhh, you came to see me, I work in the building.

JERRY: What do you do?

GEORGE: I'm an **architect**.

JERRY: You're an **architect**?

GEORGE: I'm not?

JERRY: I don't see **architecture** coming from you.

GEORGE: I suppose you could be an **architect**?

JERRY: I never said that I was the **architect**. Just something else.

GEORGE: Alright, she's not even gonna ask. If we see her, which is remote.

JERRY: What do you want me to say, we just wandered in here?

GEORGE: We're having lunch with a friend, he works in the building.

JERRY: What *is* his name?

GEORGE: Bert Har ... bin ... son. Bert Har-bin-son.

JERRY: Bert Har-bin-son? Sounds made up.

GEORGE: It does. Alright ... Art ... Core ...

JERRY: Art Core—

GEORGE: ... velay ...

JERRY: Corevelay?

GEORGE: Yeah, right ...

JERRY: Well, what does he do?

GEORGE: He's an importer.

JERRY: Just imports, no exports?

GEORGE: He's an importer/exporter, ok?

Jerry Seinfeld, and Larry David, Seinfeld: Season 1, Episode 1: The Stakeout

Philosophy ... is the most effective of all the intellectual pursuits. It builds cathedrals before the workmen have moved a stone and it destroys them before the elements have worn down their arches. It is the **architect** of the buildings of the spirit, and it is also their solvent ...

Alfred North Whitehead, Science and the Modern World

Jung himself, for instance, without any regard whatsoever for the most important assumption of his own theoretical model, the self-regulating psyche, astonishingly tells us in his "A Review of the Complex Theory" that the complex, not the self-regulating psyche, is the "**architect** of dreams." "The *via regia* to the unconscious, however," Jung explains with reference to Freud's own discoveries, "is not the dream, as he [Freud] thought, but the complex, which is the **architect** of dreams and of symptoms."[35] Now far from having quietly slipped into oblivion, Jung's characterization of the complex as the "**architect** of dreams" has been adopted and even promoted in Jungian literature by such notable writers as Jacobi,[36] Samuels,[37] and Samuels, Shorter, and Plaut.[38] Of course such pronouncements are not without theoretical and clinical consequences.

Robert Aziz, The Syndetic Paradigm: The Untrodden Path Beyond Freud and Jung

Dave wanted to leave because his mother, he said, had closed in on herself and his father had become artificially chatty. He couldn't walk around the house with Zac gone. His sister was still in high school and he felt bad abandoning her, but he was the one who was guilty for Zac's death. He was dealing with the recriminations. But Dave did not want to go alone. Could we both move to St John's and do our studies there. So we enrolled, but we were too late to get into residency during the middle of the year. Let's share an apartment, Dave said. On New Year's Day we drove across the island in Zac's Matador and found a two-bedroom apartment near the university and we studied. We had hours of study each night. And David bought a piranha. He fed it goldfish. He bought the goldfish in a clear plastic bag. He opened the bag and tipped the goldfish into the aquarium. The piranha, like a rock on its side, lunged and the orange fish was gone. It was startling and yet unsatisfying to watch. So Dave took to just tossing the entire knotted bag in. The piranha was puzzled by this, but learned to punch through the bag. It often took him three or four attacks to tear open the plastic. I think the goldfish often died of a heart attack. It missed the severe final twenty seconds of its own body.

Back then Dave had a saying: The **architects** are here. It was a phrase that summed up his experience with his brother, that bad times were lurking, and even though Dave is one of the luckiest men I've known, he is possessed

This portrait of my friend Thom Haller is my favorite of the photos I took at the recent Information **Architecture** Summit. If you weren't able to attend, the conference site offers a fairly complete archive of the talk handouts and presentations.

curiousLee: Information **Architecture** *Archives*

with a fatalism that one day he will be walking around homeless and broke, or unloved. The expression comes from a book by Seutonius, perhaps the only book Dave read thoroughly. There is a plot against Caesar. And when the assassins are in place, a guard issues the word: The **architects** are here. Dave would say it to the goldfish, as he cradled it in its baggie of water and slowly lowered it into the aquarium.

Michael Winter, The Architects Are Here

Michael Winter may yet be sued by the Ontario Association of **Architects** or the Royal **Architectural** Institute of Canada or some other group who claims as proprietary the use of the word "**architect**." After all, the title of his novel *The Architects are Here* could confuse the public, who might think, upon reading his book, that what **architects** do is kill their brothers.

In fact, generally this is not the case.

Architects in most of North America have a "titles act" of one kind or another, not to mention a "practice act." The former limits those who are permitted to call themselves **architects** to individuals who have achieved specific criteria; the latter limits those who would say they are practicing **architecture** to those who have been qualified as **architects**. The limitation of these strictures has always been the question of what's reasonable—thus a carpenter or real estate agent will be sued if they claim the title unlawfully, but the profession of computer systems "**architecture**" has usurped the word so thoroughly that most of the time a classified ad for an **architect** these days will turn out to have no use for for those of us who've taken and passed the NCARB exams.

In fact the "**architects**" of the title of Winter's book come from a book by Gaius Suetonius Tranquillus, known as Suetonius. In a Robert Graves translation of the work, called *The Twelve Caesars*, the phrase "the **architects** are here" serves as the code to indicate the assassins are in place:

Allderblob, *The Architects Are Here (Allderblob)*

Upon the day fixed at last for the enterprise, having given his accomplices notice to wait for him in the Forum near the temple of Saturn, at the gilded mile-stone, he went in the morning to pay his respects to Galba; and being received with a kiss as usual, he attended him at sacrifice, and heard the predictions of the augur. A freedman of his, then bringing him word that the **architects** were come, which was the signal agreed upon, he withdrew, as if it were with a **design** to view a house upon sale, and went out by a back-door of the palace to the place appointed. Some say he pretended to be seized with an ague fit, and ordered those about him to make that excuse for him, if he was inquired after. Being then quickly concealed in a woman's litter, he made the best of his way for the camp. But the bearers growing tired, he got out, and began to run. His shoe becoming loose, he stopped again, but being immediately raised by his attendants upon their shoulders, and unanimously saluted by the title of EMPEROR, he came amidst auspicious acclamations and drawn swords into the Principia in the camp; all who met him joining in the cavalcade, as if they had been privy to the **design**.

C. Suetonius Tranquillus, *The Lives of the Twelve Caesars*

JERRY: Wait a second, that's her.
GEORGE: On the right? I forgot who I am, who am I?
JERRY: You're you, we're having lunch with Art Corvelay.
GEORGE: Vandelay.
JERRY: Corvelay.
GEORGE: Let me be the **architect**, I can do it.
JERRY: Hey, hey, uh, Pamela's birthday party, didn't I see you there? Jerry …
VANESSA: Sure, hi.
JERRY: Uh, this is George. I'm sorry?
VANESSA: Vanessa.
GEORGE: Nice to meet you.
JERRY: *(Speaking quickly)* Simon Bennett Robbins Oppenheim and Taft.
VANESSA: That's right. What are you doing here?
JERRY: We're meeting a friend of ours here for lunch, works here in the building.
GEORGE: Yeah, Art Vandelay.

VANESSA: Oh, which company?
JERRY AND GEORGE: I don't really know …
JERRY: He's an importer.
VANESSA: Importer?
GEORGE: And exporter.
JERRY: He's an importer/exporter.
GEORGE: I'm, uh, I'm an **architect**.
VANESSA: Really? Well what do you **design**?
GEORGE: Uh, railroads.
VANESSA: I thought engineers do that?
GEORGE: They can.

Jerry Seinfeld, and Larry David, Seinfeld: Season 1, Episode 1: The Stakeout

We've been thinking a lot about **architecture** lately, which no doubt explains our urge to read Winter's book. After all, we are the **architects**. The **architects**, in fact, are *here*. We have a license from the state of New York, a license achieved after a hell of a lot of pain and hard work, which in the province of Ontario has no meaning or value at all. The situation is simple, according to the Ontario Association registrar: the individual who signed the interjurisdictional agreement between New York and Ontario (as well as with most other signatory jurisdictions across North America) was discovered, about a year and a half ago, to have no signing authority. All agreements were rendered null and void, and no cross-border recognition exists from that time to this.

Who pays? Us, that's who. Which only makes sense, right?

And please do not ask us about our brother.

We might as well be writers, for all the good our license does us.

Allderblob, The Architects Are Here (Allderblob)

But—Walter, that's what I've come for again tonight. I've thought it over. I realize that there have been one or two things I've said that could give you a completely wrong impression. In a way, I'm glad you warned me about them, because I might have said them to somebody else without knowing the—**construction** that could be put upon them. But now that I do know, you must surely see that—anything of that sort must be out my mind. Forever.

James M. Cain, Double Indemnity

Second thoughts, they say, are best; and The Scotsman, on the more mature reflection of another five minutes, having determined that "man is the architect of his own fortune and his own instructor," at one omnipotent dart of his pen thus absolves him from the influence of all laws, natural or divine—places

him, in his original condition, in a state of utter destitution and ignorance, without *natural* inclinations, principles, affections, or instincts—independent of his Maker and of the created universe;—and, at the same time that this most refined and subtle metaphysician thus places man in a supposed situation actually *beyond* nature, and out of nature, he invests this ignorant, destitute, heirless, unnatural being, with knowledge and powers greater than those of Nature herself—*knowledge of the means* by which to *enlighten,* without the aid of God or Nature, his own *ignorance,*—powers to create, in defiance of Nature, and amid utter destitution, his own fortune!

Really, it requires not the aid of logic to prove, that of all the wild and unnatural dogmas ever hatched in a human mind, without the walls of a madhouse, this is the wildest and most unnatural ...

*Robert Owen, The Economist: A Periodical Paper, Explanatory of the New System of Society Projected By Robert Owen, Esq.; and of A **Plan** of Association for Improving the Condition of the Working Classes During Their Continuance At Their Present Employments, Vol. 1*

In regarding the **architectural** habit of the higher organized animals, we are struck by the general slovenly indifference which these creatures manifest as to the erection or extemporization of shelter for themselves and their offspring. Though the monkey and the dog are credited with exceeding cunning and intelligence, yet they in no respect whatever rival the wit and sense in house-building which are evidenced by the beaver, or the muskrat, or the common red or fox-squirrel of our forests.

*Henry W. Elliott, Instinctive **Architects** (Frank Leslie's Sunday Magazine, Vol. 19, 1886)*

Rude sylvan crotches or the dark crannies of rocky caves and interstices suffice for the anthropoid apes, while the simple and hastily lined lairs of the mammalia almost universally attract no attention from us, or recognition as suggestive, even, of **architectural** or building capacity. Our eyes, however, rest with pleasant contemplation upon the skill and ingenuity, the pains and perseverance, which we find in the air-castle building of the fox-squirrel *(Sciurus Ludoricianus)*, in the curious domes of the beaver *(Castor Canadensis)*, the river washes of the muskrat or its root-crowned huts, and the softly and deftly woven nests of the wood-rat or the numerous field-mice of the pastures and the prairies.

Of all animals known to our continent, the beaver unquestionably deserves the first mention as an **architect**, and it has been the rare good fortune of the writer to witness personally and sketch from life the accompanying study of this rodent-carpenter, as it labors in the erection of its Winter dwelling.

Henry W. Elliott, Instinctive Architects (Frank Leslie's Sunday Magazine, Vol. 19, 1886)

From this comes the question, "Who am I?" Indeed, if the mind is the **architect** of that which we take to be the "I," then who or whom in fact "IS" the "I" of whom "I" believe myself to be? And if the **architect** is not the "I," and "I" am not the **architect**, whose ship is it anyway?

Rev. Sylvain Chamberland, The Science of Mind

*Alan Ball, Six Feet Under: Season 2, Episode 3: The **Plan***

homework

SEMINAR LEADER: Are you a guest in your own house, Ruth?

RUTH: I don't think so.

ROBBIE: Yes. She tiptoes around herself like she's afraid of waking someone up.

SEMINAR LEADER: The only person sleeping in your house is you.

RUTH: Well, I do have three children.

ROBBIE: See, she's not even listening.

SEMINAR LEADER: Ruth, you have to get out of bed. Open some windows, and let some light into your house, so that you can see the way things are. Then, and only then, can you begin renovating your life.

*Alan Ball, Six Feet Under: Season 2, Episode 3: The **Plan***

CLAIRE: Do you want some, like, tea or something?

RUTH: Alright, what did you break?

CLAIRE: Nothing, I was just being nice. God!

RUTH: I'm sorry. I was imposing my old blueprint on you.

CLAIRE: Excuse me?

RUTH: In the old blueprint, of my old house, you're only nice to me when you've done something bad or when you want something.

CLAIRE: Well, that makes me feel like shit.

RUTH: I'm sorry, but it really does seem that way to me. Well, I should go do my homework.

CLAIRE: They give you homework?

RUTH: I have to write a letter to my dead mother, and forgive her for all the terrible things she did to me.

CLAIRE: That sounds fun.

RUTH: And then I have to write a private letter to myself outlining how I want to renovate my life. Goodnight, dear.

*Alan Ball, Six Feet Under: Season 2, Episode 3: The **Plan***

SEMINAR LEADER: If you learn today that your relationship with your mother has been blocking the door to your happiness, then make that repair. Right now. Waiting only gives you more chances to make excuses. There are phones in the hall, see you in 19 minutes.

RUTH: Where can I find a Snickers bar?

ROBBIE: Can't you think of more productive ways to use this time?

RUTH: Like what, taking up smoking?

ROBBIE: What about trying rebuilding with someone right now. Ruth, I read your private letter to yourself, and if you really want closeness in your life you're going to have to start major renovations. In fact, I would gut.

RUTH: You read my private letter?

ROBBIE: Why don't you try calling your kids?

RUTH: I don't even know where my kids are, and the last thing any of them wants is for me to call them on a Friday night so I can put in new flooring.

MAN: *(Speaking into a telephone)* ... I've wanted to hear that my whole life, oh fuck, I love you too, you sadistic old fuck ...

ROBBIE: Start with Claire. Only you—can be the **architect**—of your life.

RUTH: *(Speaking into a telephone)* Claire? This is your mother ... Yes, well, I just wanted to tell you that ... I feel that even though I've been trying to be closer to you, it hasn't really been working. I wish you felt that you could confide in me. And maybe you don't because you feel my opinion is worthless ... Because, I don't really live in my house, and so, I suppose, that's the infrastructure I build. So I'm sorry ...

ROBBIE: And?

RUTH: *(Speaking into a telephone)* And I love you ...

ROBBIE: Ooh, ooh, that's so good. I gotta pee like a racehorse.

TELEPHONE: *You have exceeded the time limit. If you know the name of the person you'd like to speak to, press 1 now.*

Alan Ball, Six Feet Under: Season 2, Episode 3: The **Plan**

SEMINAR LEADER: Ruth, stand up. Tell me what you wrote in your private letter to yourself.

RUTH: It was a private letter. To myself.

SEMINAR LEADER: Tell me—where your house needs repairs.

ROBBIE: Yeah, and don't bullshit the lady, cupcake.

RUTH: I have a very nice house. I have nice children, and a nice job. And a nice gentleman friend. Can't anyone just be happy? I'm happy.

SEMINAR LEADER: Who's buying Ruth's house? We don't believe your house is structurally sound, Ruth.

RUTH: Well who knows better, me or a room full of complainers?

SEMINAR LEADER: What do you really want to complain about, really?

RUTH: The fact that the blood stopped circulating in my rear end four hours ago.

Audience laughter.

SEMINAR LEADER: OK, what else?

RUTH: You want me to complain. Alright, then. Fuck this. Fuck you. Fuck all of you with your snivelling self-pity. And fuck all your lousy parents. Fuck my lousy parents while we're at it. Fuck my selfish bohemian sister and her fucking bliss. Fuck my legless grandmother. Fuck my dead husband, and my lousy children with their nasty little secrets. And fuck you, Robbie, for dragging me to this terrible place and not letting me have a Snickers bar. I'm going to get something to eat.

SEMINAR LEADER: Congratulations, Ruth. You have just levelled your fleabag hovel. Now you can build the house of your dreams from the ground up.

ROBBIE: Yes, yes.

SEMINAR LEADER: Congratulations.

Audience applauds.

*Alan Ball, Six Feet Under: Season 2, Episode 3: The **Plan***

RUTH: *(Speaking into a telephone)* Hello, Hiram? ... It's me, Ruth ... I'm fine, how are you? ... Um, listen, the reason why I'm calling is, I just wanted to let you know, I've been drafting a new blueprint for myself ... No, not for the house ... Well, yes, it is for the house, my house. I mean, not the actual physical structure I live in with my family, I'm speaking more of the emotional structure within which I've chosen to live my life ... No, I most certainly have not been drinking ... I'm just trying to let you know, Hiram, that I harbor no hard feelings against you ... No, I do not want to get back together ... How presumptuous ... You know something, Hiram, fuck off!

RUTH: *(Speaking into a telephone and ironing)* Amelia, it's Ruth. I know we haven't seen each other in a while, and I feel a little funny leaving this on your machine, but I just wanted to let you know, I've been drafting a new blueprint for myself, and if you're ever looking for an opportunity to renew our friendship, my front door is open to you. That's all I wanted to say, you can call me back if you want to, ok? Byyye ...

RUTH: *(Speaking into a telephone and dusting)* Sarah? Sarah, you there? If you're there, pick up. Okay, fine, I know we don't talk to each other very much anymore but I've left you three messages in the last two weeks and you haven't returned any of my calls. I'm beginning to think you don't even want to talk to me again. If that's the case, well, we really need to talk. There are some things I would like to say to you, about the cracks in my foundation, and your part in helping me repair them. This is your sister Ruth.

*Alan Ball, Six Feet Under: Season 2, Episode 3: The **Plan***

THE SAFETYNET PLAN

DEVELOPING A CHRISTIAN WORLDVIEW THROUGH FAMILY DEVOTIONS

TOM PARENT AND DR. PAUL D. LINDSTROM

Tom Parent and Dr. Paul Lindstrom, *The Safety Net **Plan*** *(Portland, OR: Christian Liberty Press, 1994)*

plan of slavation

"I heard a clergyman the other day in the pulpit make use of the expression, 'Mr. Moody is the **architect** of his own character. Is that a correct phrase? — N.C."

Answer: Why not?

Isaac Kaufman Funk, The Preacher and Homiletic Monthly, Vol. 5, 1881

One's entire life can be pictured in comparison to a building which an **architect** has **designed**, workers have built one stone upon another, and its benefit to society can be measured through succeeding generations.

The infrastructure is comprised of character and moral fiber learned as a child and developed in the trenches of life. The outer facade is what others see but the proof of whether the building will stand the rigors of storm and the forces of nature is determined by the depth of the underpinnings and foundation, the basic strength of the materials used in the building, and whether the **architect's design** was followed.

God is the **architect** of each man's life. His **plan** is sure and the principles are laid out in His Word. Tying together all aspects of His **plan** is His Son, Jesus. Matthew says that Jesus is the HEAD OF THE CORNER. Many builders reject Him as the center or Head of their life. They will try to find answers and strength in everything else but Him.

When earthquakes cause lives to tumble and when storms buffet with the full force of spiritual man's enemy, those who have based their life's foundation on His principles will stand the test and their faith will not sway. One writer penned these words as the basis for his personal infrastructure.

> "My hope is built on nothing less
> Than Jesus' blood and righteousness.
> I dare not trust the sweetest frame
> But wholly lean on Jesus' name.
> His oath, His covenant, His blood
> Support me in the whelming flood.
> When all around my soul gives way,
> He then is all my Hope and Stay.

On Christ, the solid Rock, I stand;
All other ground is sinking sand."

— Edward Mote (1834)

Many buildings stand the test of time. Many lives stand the test of time. Buildings that have proven their worth and withstood the beatings and storm sometimes are designated as historical sites and are preserved for additional generations to view.

Saints who have proven their battle-worthiness and have held on through prayer and trust and are standing on Him are not forgotten when life is over. Not only are choice Saints remembered in this life, but they also are rewarded with a heavenly home and preserved for eternity!

Melvin Smith, Strong Tower: A Daily Devotional Based on Names of the Lord

I want to thank Jesus
*For the **plan** of Slavation*
Just to say, Lord, I love you
For You understand.

*Ruby Moody, The **Plan** of Slavation (Music-Lyrics-Gospel.com)*

"The **plan**'s wrong."
 "Do you know who wrote it?"
 "I don't care."
 "You should. You should really show a little respect."

George Nolfi (director), The Adjustment Bureau

"Thus Our Lord revealed to me that it was feasible to sail from here to the Indies, and placed in me a burning desire to carry out this **plan**," Columbus wrote.[13]

Timothy Ferris, Coming of Age in the Milky Way

In *The **Plan** of Salvation,* Warfield examines the various views offered within Christendom regarding the order and outworking of the decrees of God concerning human salvation. That God acts in salvation **according to a plan** is a given in theism, for purpose is essential to personhood. Even the deist must acknowledge that God acts **according to plan**, even if in that system God's

13. Ferdinand Columbus, *The Life of the Admiral Christopher Columbus,* trans. Benjamin Keen (New Brunswick, NJ: Rutgers University Press, 1979), p. 10.

Billy Sanders, Before Man, God's **Plan** *(Bloomington, IN: CrossBooks Publishing, 2010)*
Graeme Goldsworthy, **According to Plan** *(Downers Grove, IL: InterVarsity Press, 2002)*

plan is carried out in a mere mechanical fashion. In the deist conception salvation is not by chance, but neither is it by the immediate workings of a personal Deity. But if we grant the theistic conception of God—that he is a personal being who maintains immediate control over his creation—then we are forced to acknowledge that he acts **according to plan** in human salvation. The question here has to do with the nature of this **plan**. On this there are widely differing opinions ...

Fred G. Zaspel, The Theology of B. B. Warfield: A Systematic Summary

You don't have to be an **architect** to understand the concept of a blueprint. Simply put, a blueprint is a **plan**. When a blueprint is followed properly, the result is a new creation. God has a **plan** for us, and, when we follow that **plan**, we become a new creation. The blueprint for salvation is found in the Bible, and the Bible itself is constructed **according to a plan**. Welcome to The Bible Blueprint!

Sitting above my desk at work is a painting of my patron saint, Joseph the carpenter, doing what we tend to associate with thc role of a carpenter—carving wood. In fact, it's quite common for us to see images of the child Jesus

*Luca Cambiaso (1527-1585), The Holy Family in the Carpenter's Shop: Jesus Hold a Lamp While Joseph Carves a **Design**. Pen and brown ink, 349 x 242 mm.*

carving wood as his earthly father, Joseph the carpenter, looks on. We tend to conclude that carpenters, in those days, were makers of "tables, chairs, and oaken chests" (as described in the song "Heaven on Their Minds" from *Jesus Christ Superstar*). In truth, during the time of Jesus, a carpenter was not merely a cabinetmaker but was comparable to an **architect**: someone who was skilled at **designing** buildings. It makes perfect sense that Jesus' earthly father, Joseph, was an **architect** since his heavenly Father is the "architect" of all creation.

Plain and simple, an **architect** is someone who **designs** a detailed **plan**—a blueprint.

God, indeed, is an **architect** with a **plan**:

For surely I know the **plans** I have for you, says the LORD, **plans** for your welfare and not for harm, to give you a future with hope. (Jeremiah 29:11)

Joe Paprocki, The Bible Blueprint: A Catholic's Guide to
Understanding and Embracing God's Word

I'm hopeful you will discover that *you* are God's **Plan** A ... and there is no **Plan** B!

Dwight Robertson, You Are God's Plan A {And There Is No Plan B}

God's **plan** for us is no secret. He has provided us with a blueprint for our salvation: the Paschal Mystery—the suffering, death, and resurrection—of Jesus Christ. And where do we find this blueprint laid out for us? In the Bible.

So, just what is the Bible and how is it a blueprint for our salvation? Let's explore.

JESUS THE **ARCHITECT**?

When the Bible refers to Jesus as a *carpenter* (Mark 6:3) and as the *carpenter's son* (Matthew 13:55), it uses the Greek word *tekton* which suggests not only a worker in wood but a builder. It should come to us as no surprise then, that Jesus uses the imagery of building quite freely in the Gospels:

- On this rock I will build my church ... (Mt 16:18)
- The stone that the builders rejected has become the cornerstone (Mt 21:42)
- I am able to destroy the temple of God and to build it in three days (Mt 26:61)
- That one is like a man building a house who dug deeply, and laid the foundation upon rock ... (Lk 6:48)

- I will pull down my barns and build larger ones ... (Lk 12:18)
- For which of you, intending to build a tower ... (Lk 14:28)

THE BIBLE BLUEPRINT

While it is great to know that the Bible is a blueprint for our salvation, it is also helpful to know how to read blueprints. I recall years ago, when my dad was making **plans** to open a new family pharmacy to replace the old one that was being demolished, he had a set of blueprints drawn up for the new store. Although I couldn't make heads or tails of them, I was amazed at how various construction workers and electricians were able to glance at those blueprints and know exactly where to install a new store fixture or an electrical outlet. In a similar way, we need to be able to read God's blueprint for salvation as revealed in the Bible. The nice thing is, the Bible itself has a blueprint of sorts: a **plan** for its own arrangement. Here's what it looks like:

Old Testament	Catalog	New Testament
Pentateuch (Torah)		Gospels
History	Table of Contents	Acts
Wisdom		Letters
Prophets		Revelation

In fact, I find it helpful to carry this image of a blueprint even further and to think of the Bible as a building—a library, actually. I call it God's Library. If the Bible were indeed a building, then the above blueprint reveals to us how it is arranged. In short, we find the following:

- God's Library has two wings: an Old Testament wing and a New Testament wing.
- Both wings of the building are divided into four smaller stack rooms.
- In the Old Testament wing, which is more than twice the size of the New Testament wing, we can find rooms dedicated to the Pentateuch, History, Wisdom, and the Prophets.
- In the New Testament wing, we can find rooms housing the Gospels, Acts of the Apostles, the Letters, and Revelation.
- There is also a foyer or front desk housing the card catalog or Table of Contents.

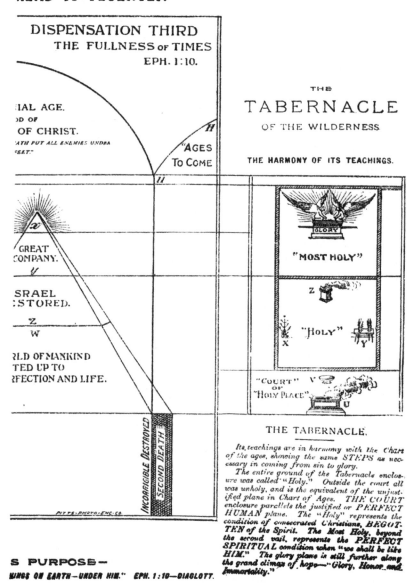

READ IT·FLUENTLY:

DISPENSATION THIRD
THE FULLNESS of TIMES
EPH. 1:10.

THE
TABERNACLE
OF THE WILDERNESS

THE HARMONY OF ITS TEACHINGS.

IAL AGE.
)D OF
OF CHRIST.
ATH PUT ALL ENEMIES UNDER
FEET."

H

"AGES
To Come

GREAT
COMPANY.

"MOST HOLY"

SRAEL
STORED.

"HOLY"

RLD OF MANKIND
TED UP TO
RFECTION AND LIFE.

"COURT"
OF
"HOLY PLACE"

INCORRIGIBLE DESTROYED

SECOND DEATH

PITTS-PHOTO-ENG.CO.

THE TABERNACLE.

Its teachings are in harmony with the *Chart of the ages*, showing the same *STEPS* as necessary in coming from sin to glory.
The entire ground of the Tabernacle enclosure was called "Holy." Outside the court all was unholy, and is the equivalent of the unjustified plane in Chart of Ages. THE COURT enclosure parallels the justified or PERFECT HUMAN plane. The "Holy" represents the condition of consecrated Christians, BEGOTTEN of the Spirit. The Most Holy, beyond the second vail, represents the PERFECT SPIRITUAL condition when "we shall be like HIM." The glory plane is still further along the grand climax of hope—"Glory, Honor and Immortality."

S PURPOSE—
WINGS ON EARTH—UNDER HIM." EPH. 1:10—DIAGLOTT.

Charles Taze Russell, Millennial Dawn: The **Plan** of the Ages: 560th Thousand
(Allegheny, PA: Tower Publishing Co., 1886)

Of course, no such building exists. However, the Bible is truly a library—a collection of books. This metaphor can help us understand how to approach the Bible and, like an **architect** or construction worker, be capable of reading the blueprints and understanding how it will lead us to encounter God.

Joe Paprocki, The Bible Blueprint: A Catholic's Guide to Understanding and Embracing God's Word

Simple enough, if there was really a **plan**. But how could there have been? Since we invented "the **Plan**" ourselves ...

Umberto Eco, Foucault's Pendulum

Who is the **architect**? Circumstances, providence, ministers, God? All these have much to do with the building; and without God of course the building could never be erected. But Self is the **architect** here referred to—" building up yourselves." Man *himself* in all cases is the former of his character. If it is a bad one, he alone must bear the blame and suffer the penalty. If a good one, he alone shall have the credit under God, and enjoy the reward. The redeeming God has furnished us with the foundation of a good character, the **plan** by which it is to be reared, the materials for its erection, and the strongest motives for setting to the work. But unless we ourselves build, the foundations, **plans**, materials, motives, are, so far as we are concerned, utterly worthless. No hand can pile up the materials into a symmetrical, moral superstructure but our own. "Building up yourselves." This is a work that no one can do for us. Not parents, friends, priests, God Himself. Each man must do it for himself. Man is the **architect** of his own character.

David Thomas, The Preacher's Finger-Post (The Homilist; Or, the Pulpit for the People)

One well-placed government expert argues that NASA's confidence is unfounded: "We're not effectively safer; we're just better informed. If an asteroid heads for us, we still have no **plan** in place."

Tad Friend, Vermin of the Sky: Who Will Keep the Planet Safe From Asteroids? (The New Yorker)

Everything depends on His sweet or sour will only. There is no question of free-will of humans. The view is in complete negation of the view that man is the **architect** of one's own destiny—good or bad.

R. K. Kaushik, Architect of Human Destiny?: Who Brings About Peace or Chaos?

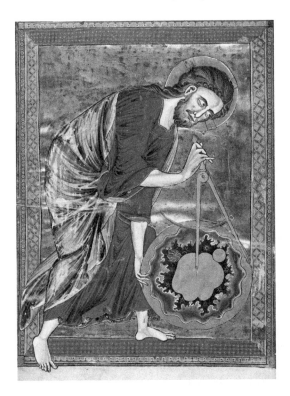

*God as **Architect** of the World, frontispiece of the Bible Moralisee, (French, ca. 1250)*

According to the Benedictine Rule,

> *The monastery should be **planned**, if possible, with all the necessities— water, mill, garden, shops—within the walls. Thus the monks will not need to wander about outside, for this is not good for their souls. (Rule of St. Benedict 102)*

I have argued elsewhere that in the fourteenth century, enclosure was seen as a sign of women's chastity (Hallissy 89-111); the Benedictine Rule sees enclosure as a sign of men's obedience. Wandering about outside the monastery is not good for the soul, and remaining in it is good for the soul. If simply *being within* is virtuous, then being within a structure that taught religious values would be even better. A well-**designed** monastery could **design** its monks.

Reading the **plans** of a medieval monastery is literally simpler but metaphorically more complex than reading the **plans** of a modern building. Like all other medieval art forms, **architectural** drawings were intended to be

clear. The type of drawings Eco includes are schematics, intended for users, rather than working drawings intended for builders. The purpose of schematic drawings is to indicate the forms of the buildings and their relationship to the other structures in the complex. The drawings are also easy to read because, as practiced in the fourteenth century, the master builder's skill was imagined as "the ability to perceive **design** and building problems in terms of a few basic geometrical figures" (Shelby 420-21). Like the drawings in the novel, the **plans** for most medieval buildings were drawn with only such simple tools as a geometry student uses today, the compass and the ruler. On the metaphorical level, the drawings, like the physical structures they represent, were believed to have a "higher" spiritual meaning. To medieval **architects**, geometry was not just a school subject but the "Science used by God Himself to create the world" (Harvey, *Medieval Architect* 139). Using the rules of geometry, "the very laws that order heaven and earth" (von Simson 39), the **architect** could create a microcosm according to the same principles by which God created the macrocosm. In the Middle Ages a well-known image depicted God as an **architect**, compass in hand, **designing** the universe (Harvey, "Mason's Skill" 69; cf. von Simson 35, 38). The image of God as Arch**planner** did not so much express medieval people's admiration for their master builders as the cultural assumption that **design** presupposes a **Designer**. In creating the little world of the structure, the builder emulates the ordering power of God.

Margaret Hallissy, Reading the **Plans***: The* **Architectural** *Drawings in Umberto Eco's The Name of the Rose (Critique: Studies in Contemporary Fiction)*

The images in those historic **plans** are etched in our minds. They are icons of the profession. The **plan** assumed heroic status, and the creators of **plans** became legends.

Michael Neuman, Does **Planning** *Need the* **Plan***? (Journal of the American* **Planning** *Association)*

It was a fanatical recent convert, Cosmas of Alexandria, who provided a full-fledged *Topographia Christiana,* which lasted these many centuries to the dismay and embarrassment of modern Christians. We do not know his real name, but he was called Cosmas on account of the fame of his geographic work, and nicknamed Indicopleustes (Indian Traveler), because he was a merchant who traveled around the Red Sea and the Indian Ocean, and had traded in Abyssinia and as far east as Ceylon. After his conversion to Christianity about A.D. 548, Cosmas became a monk and retired to a cloister on Mt. Sinai where he wrote his memoirs and his classic defense of the Christian view of the earth.

The Fountainhead
An uncompromising, visionary **architect** struggles to maintain his integrity and individualism despite personal, professional and economic pressures to conform to popular standards.
Internet Movie Database, Plot Summaries

This massive illustrated treatise in twelve books gives us the earliest surviving maps of Christian origin.

Cosmas rewarded the faithful with a full measure of vitriol against pagan error and a wonderfully simple diagram of the Christian universe. In his very first book he destroyed the abominable heresy of the sphericity of the earth. Then he expounded his own system, supported, of course, from Scripture, then from the Church Fathers, and finally from some non-Christian sources. What he provided was not so much a theory as a simple, clear, and attractive visual model.

When the apostle Paul, in Hebrews 9:1-3, declared the first Tabernacle of Moses to be the pattern of this whole world, he conveniently provided Cosmas his **plan** in all necessary detail. Cosmas had no trouble translating Saint Paul's words into physical reality. The first Tabernacle "had ordinances of divine service and a worldly sanctuary; for there was a Tabernacle made; the first wherein was the candlestick, and the table and the shew-bread, which is called the Sanctuary." By a "worldly" sanctuary Saint Paul meant "that it was, so to speak, a pattern of the world, wherein was also the candlestick, by this meaning the luminaries of heaven, and the table, that is, the earth, and the shew-bread, by this meaning the fruits which it produces annually." When Scripture said that the table of the Tabernacle should be two cubits long and one cubit wide, it meant that the whole flat earth was twice as long, east to west, as it was wide.

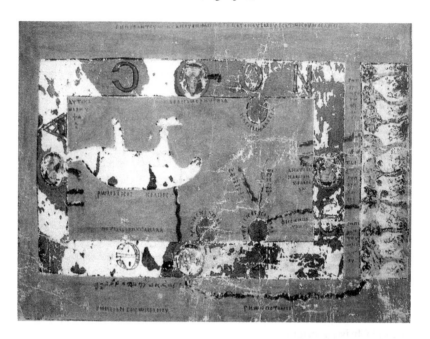

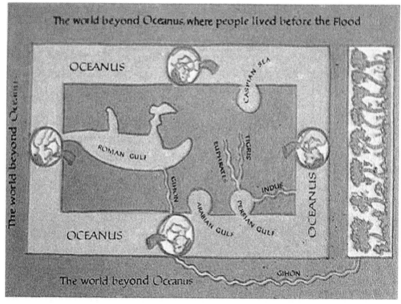

Cosmas Indicopleustes of Alexandria, Topographia Christiana, 547 A.D. (cartographic-images.net)

In Cosmas' appealing **plan** the whole earth was a vast rectangular box, most resembling a trunk with a bulging lid, the arch of heaven, above which the Creator surveyed his works. In the north was a great mountain, around which the sun moved, and whose obstructions of the sunlight explained the variant lengths of the days and the seasons. The lands of the world were, of course, symmetrical: in the East the Indians, in the South the Ethiops, in the West the Celts, and in the North the Scythians. And from Paradise flowed the four great rivers: the Indus or Ganges into India; the Nile through Ethiopia to Egypt; and the Tigris and the Euphrates that watered Mesopotamia. There was, of course, only one "face" of the earth—that which God gave to us the descendants of Adam—which made any suggestion of Antipodes both absurd and heretical.

Cosmas' work is still very much worth consulting as a wholesome tonic for any who believe there may be limits to human credulity. After Cosmas came a legion of Christian geographers each offering his own variant on the Scriptural **plan** ...

Daniel Boorstin, The Discoverers: A History of Man's Search to Know His World and Himself

*The Noah **Plan** History and Geography Curriculum Guide* provides detailed instruction for teaching history and geography at all levels from a Biblical worldview. It charts the teaching of Christian history, government, economics, and geography with model lessons and descriptions of methodology to make history come alive in the classroom.

*Amazon.com, The Noah **Plan** History and Geography Curriculum Guide (Product Description)*

Our study in this message is Psalm 104:24, "O Lord, how manifold are your works! In wisdom you have made them all. The earth is full of your possessions." I chose to speak on this particular verse in this psalm because this verse appeared in the *Los Angeles Times* January 7, 2004 ... The *Times* saw fit to mention this verse because something very important happened in connection with this verse which was newsworthy ... In the introduction of Mr. Vail's book, *Grand Canyon: A Different View,* the *Times* reports that Vail wrote, "For years as a Colorado River guide I told people how the Grand Canyon was formed over the evolutionary time scale of millions of years. Then I met the Lord. Now, I have a different view of the Canyon, which according to the biblical time scale, can't possibly be more than a few thousand years old." Reaction to this book has been sharply divided. The American Geological Institute and seven geoscience organizations sent letters to the Park and to agency officials calling for the book to be removed. They don't want tourists to know about this other view. What is reasonable and right that there should

be a free exchange of knowledge, that tourists should hear about both views; and then let them make up their mind? But tourists are not told about the other view, even though the Park sells the book, *Grand Canyon: A Different View.* What has happened to freedom of speech? Should not respect be shown to visitors who espouse the different view?

The status of this book at the Park is still in question., but the *L.A. Times* quoted this statement by a Park Service spokesman, "Each park determines which products were sold in its bookstores and gift shops. The creation book at the Grand Canyon was unanimously approved by a new-product review panel of the park and gift shop personnel." Meanwhile the book has sold out and is being reordered. There is another book in the Park bookstore, entitled, *How the Canyon became Grand* which presents the scientific or evolutionary explanation. The author of that book said about Mr. Vail's book, "I have not read the book, but I am familiar with the creation view. I think the Park Service would be remiss if it did not explain that there is not an agreed-upon story about the canyon, that there are conflicting stories. But science assumes it was not formed by a great flood or divine intervention." This man states two important truths. One is that there is no agreed-upon story about the canyon. The second is that science assumes it was not formed by a great flood or divine intervention. I believe this book by Tom Vail, *Grand Canyon: A Different View* would be a valuable addition to a Christian's library. I **plan** to get a copy for myself, and I hope some of you may decide to do so.

San Fernando Church of Christ, Grand Canyon: Another View

If you believe that God constructed the earth geologically so that Christianity would spread west toward America, rather than south or east to less divinely favored nations, then here's a book right up your alley: *America's Providential History,* by Mark A. Beliles and Stephen K. McDowell, published by the Providence Foundation.

An excerpt appears in the February issue of *Harper's* magazine, which notes that the authors' seminars based on the book drew more than 25,000 attendees last year. Here's an excerpt of the excerpt:

"God's **plan** for the nations has been unfolding in a specific geographic direction.

"This geographical march of history is called the Chain of Christianity or the Chain of Liberty. It seems as if God's direction is westward. 'Christian' geography (which is true geography) is the view that the earth's origin, end, purposes, and physiography are for Christ and His glory. Like individuals, nations have a unique purpose. We will see throughout this book how God has raised up and put down nations of the world for His purposes.

PHILOSOPHY

OF THE

PLAN OF SALVATION.

A BOOK FOR THE TIMES.

BY AN AMERICAN CITIZEN.

LONDON:

THE RELIGIOUS TRACT SOCIETY,

Instituted 1799.

1848.

"Arnold Guyot, a nineteenth-century scientist and professor of geology at Princeton University, noted that God had arranged the structure of the earth to assure that the Chain of Christianity would move not south into Africa or east into Asia but westward into Europe. That which originated in Asia and developed in Europe has had its greatest fulfillment in America. Now, in the twentieth and twenty-first centuries, travel and climatic barriers are being conquered by air travel and air-conditioning. It appears that the internal preparation is taking place so that the Chain of Liberty and all its external blessings might continue their westward march from America around the globe."

In sum:

"The goal of America's Providential History is to equip Christians to be able to introduce biblical principles into the public affairs of America, and every nation in the world, and in so doing bring Godly change throughout the world. As we learn to operate nations on Biblical principles, we will be bringing liberty to the nations of the world and hence fulfilling part of God's **plan**."

SoMA discussion question: In God's geographically based Chain of Liberty, did the Big Dude make Nevada a bleak desert so everyone passing through would have to stop in Vegas for a cold drink and a little entertainment to break the monotony?

Send your thoughts to editor@somareview.com, and we'll try to post them. Just write "God's **Plan**" in the subject field.

*John D. Spalding, God's **Plan** for America (The Society of Mutual Autopsy Review)*

Are **planned** communities always boring in the end?

*Larry Frolick, Suburbia's Last Stand: Big **Planning's** Audacious Bid to Curb Suburban Sprawl (The Walrus)*

When history is presented as *His* story rather than just an account of man's achievements, studying provides children with a greater understanding of God's nature and character. This curriculum offers practical step-by-step instruction with a biblical worldview. Lesson **plans** are spelled out in great detail for grades K through 12, progressing from two 20-minute periods a week to five 50-minute periods a week. 353 pages, softcover.

*ChristianBook.com, The Noah **Plan** History and Geography Curriculum Guide (Product Description)*

Detailed instructions show how to teach students to create accurate maps.

*Cathy Duffy Reviews, The Noah **Plan***

Elizabeth L. Youmans, The Noah **Plan**:
*History and Geography Curriculum
Guide (San Francisco: Foundation for
American Christian Education, 1998)*

Six years earlier, in the service of Spain, the Genoese Cristoforo Colombo—
Cristóbal Colón, as he thenceforth called himself—had made the first move
to the westward. He picked in the first instance the worst route to America—
namely, the longest—and he would probably never have reached his goal if
peculiarly favourable winds had not neutralized his mistake. His **plan** was to
"reach the Orient by the westward route." Thus he was fully acquainted with
the spherical form of the earth as it had been depicted in Martin Behaim's
famous "Earth Apple," but he shared the error that that globe displays of
treating Asia as one coherent mass which embraced the earth horseshoewise.
It is not quite exact to say, as is usually said, that he hoped to reach the "West
Indies" in this way, for what he expected—and perfectly rightly from his own
point of view—to reach was Cathay (China) or its outlying island of Zipangu
(Japan). His expectation was supported by the work of the famous explorer
Marco Polo, who had in actual fact, two hundred years previously, reached
China and Japan, but eastwards by the land route. And indeed Columbus took
Cuba, the first big island he touched at, to be Zipangu, and when, a little later,
he discovered the neighbouring island of Haiti, which he called Española, he
modified his view to the extent of calling Haiti Zipangu and making Cuba the
Chinese mainland. He was so obsessed by the idea that he was on Asiatic soil
that even for his last voyage he demanded Arabian interpreters for dealings

From an image in a National Geographic, Columbus is depicted showing a globe to Isabella and Ferdinand to explain his **plans**.

Jone Johnson Lewis, Queen Isabella Picture Gallery (about.com)

with the Great Khan of Cathay and actually mistook a flock of flamingos, which he saw gravely stalking through the night, for white-robed Chinese priests. On his second voyage he had touched at Jamaica, on his third had reached the mouth of the Orinoco and the mainland, and on his last, Honduras, which he declared to be Farther India. Four years later, in 1506, he died, in the same year as Martin Behaim, and still with no idea that he had discovered a new continent.

Egon Friedell, A Cultural History of the Modern Age, Volume 1

This brings us back to Clayton Christensen, who is occasionally quizzed by his students about the risk-to-reward ratio of religious faith. In this view, the Mormom vision of the afterlife seems no less disruptive:

One of them said, "You know, Clay, I've been thinking of becoming religious."

And I said, "Well, that's neat."

And he said, "But the MPB [an economist's acronym for Marginal Personal Benefit] is awful."

And I said, "What do you mean?"

He said, "Well, imagine that I become religious, and that I do everything that God says He wants me to do. And then I get to Heaven. *What do you do in Heaven?* Do you sit around all day on a cloud? If that's what eternity is like, man, that's an awful MPB. I have to give up everything in life that's fun—and *that's* the reward?"

But the great thing about the Mormom Church is that when somebody asks what you do in Heaven, we have an answer. Now, everybody else might not buy into it. But at least we've got a **plan**. And the rest of them don't have a **plan**.

Chris Lehmann, Pennies From Heaven: How Mormon Economics Shape the G.O.P. (Harper's Magazine)

Gas-lighted streets. Spotless front steps. Colorful screen paintings. These you say are Baltimore. True. But Baltimore, like most American cities, is also block after block of incredibly bad housing. I'm a worker for the Baltimore Housing Bureau. I had a job that hot summer day, to find someone in the neighborhood with whom the Housing Bureau could work. There were great **plans** to rehabilitate this area, but **plans** have only a paper-and-pencil reality. Without a neighborhood leader, someone known and liked, our **plans** would get about as far as a painted bird on a window screen.

Rod Nichols and Tim Johnson, God's Prosperity **Plan** (Concord, MA: Infinity Publishing, 2004)
Kontrena Clark, The Business **Plan** for the Believer (Mustang, OK: Tate Publishing, 2006)

I had of course the name of someone who sounded perfect for the job, but I wasn't sure of the address. This was more than just a routine day's work for me. I believed in the **plan** we were working on . . .

Encyclopedia Britannica Films, *The Baltimore **Plan***

" . . . and whatever takes place in the world of men is **planned** below."

Umberto Eco, *Foucault's Pendulum*

The Doorway to Hell

Lou Ricarno is a smart guy. His **plan** is to organize the various gangs in Chicago so that the mugs will not liquidate each other. With the success of his leadership, Louie prospers, marries Doris and retires to Florida to write his autobiography and play golf. In his absence the gang warfare flares, but he does not return as he wants to give a respectable image of life to his wife, younger brother and his Florida neighbors. While letters and telegrams from Mileaway will not influence his decision, events will.

Dudley Do-Right

Based on the 60's-era cartoon of the same name. Royal Canadian Mountie Dudley Do-Right is busy keeping the peace in his small mountain town when his old rival, Snidely Whiplash, comes up with a plot to buy all the property in town, then start a phony gold rush by seeding the river with nuggets. Can this well-meaning (though completely incompetent) Mountie stop Whiplash's evil **plan**?

Internet Movie Database, *Plot Summaries*

Our adversary, Satan is the **architect of sin** in the earth, who **designs and lays out 'plans of evil' to destroy.** He has an organized empire of evil forces that operate evil practices on man.

Dr. Elsie Clark, *Spiritual Warfare Series—Strategic Weapons of Our Warfare*

Evil Angel

Set in present day Chicago, the ancient avenging demon Lilith attempts to destroy a young paramedic's life while destroying anyone who interferes with her **plan**.

The Final Sacrifice

Ruled by the evil Satoris, an ancient cult of Canadian wrestlers, the Ziox, are bent on world domination. Instrumental to their **plan** is a map to the ancient Ziox cult idol, recently discovered by a young boy, Troy. When the

Gerry Burney, God's **Plan** / Satan's **Plan**
(Maitland, FL: Xulon Press, 2009)

Ziox invade his home to recover the map, he flees and ends up in the bed of a passing pickup truck, driven by Rowsdower. Rowsdower and Troy become friends, and together search for the lost idol before the Ziox can claim it and take over the world.

Internet Movie Database, Plot Summaries

Yet this view of the past greatly encouraged historical research by inculcating a deep respect for each epoch of the past, which made its unique contribution and is therefore worth studying for its own sake. One did not demand that it conform to current prejudices and thus commit the sin of an excessive "present-mindedness," distorting the past by forcing it into a mold of recent construction. One studied each era of the past as if, in Leopold von Ranke's words, it was "equidistant from eternity"—just as much a part of God's **plans** as our own age. German historians like Ranke, who led a great nineteenth-century renaissance of historical studies, were not Hegelian metaphysicians, but they did broadly share this outlook which saw order and purpose in the events of history and hoped to lay bare the whole mighty **plan** by their indus-trious researches.

Roland Stromberg, European Intellectual History Since 1789

*Valeria Franklin, God's **Plan** for Me: Becoming Sons and Daughters of God (PIttsburgh, PA: Rosedog Press, 2009)*

Yogi's First Christmas
Yogi Bear and Boo Boo are awakened from hibernation and end up joining friends at the Jellystone Lodge. They try to save it from being torn down by preparing for a great Christmas celebration in the lodge. However, two Christmas-haters, a miserable hermit and the lodge owner's rotten son, **plan** to ruin the festivities.

 Internet Movie Database, Plot Summaries

*This 'evil **design**' of our adversary perpetuates his evil works in the earth by securing a continuous residence in his children.* When Satan resides in the hearts of people, he makes his habitation within them.

Jesus is the **Architect** of righteousness in the earth—Who **designed** and laid out our spiritual blueprint for eternal life!

 The 'righteous **design**' of Jesus, on the other hand, 'perpetuates' his righteous works in the earth by securing a continuous residence in the hearts of His children.

 Dr. Elsie Clark, Spiritual Warfare Series—Strategic Weapons of Our Warfare

DEAR GOD,

I know You are there at my window. I know you watch over me at night. I love You as You love each of Your children. The wise ladies say I am being tested and that I am part of Your big **plan**. I ask them what is the big **plan** and they say it is not for me to know. They say I am ready ever since the sign of the blood. Yours and mine. Your sign on the porch brought mine, as You know because You know all things, and that too is part of the big **plan**, as the wise ladies say.

Please make it soon, because I love you.

Your little doll,
Beth

Nick Cave, And the Ass Saw the Angel

In such a state, the believer abandons the idea that she is the **architect** of her own destiny. What is left is: "There is no god but God" *(la ilaha illa Allah)* … It is the complete surrender or "sale" of oneself to God.

Vincent J. Cornell, Voices of Islam

*Rona Mobley-Wells, God Has A **Plan** For You, But God Will Not **Plan** For You (Maitland, FL: Xulon Press, 2009)*

My god, my god—what have you **planned** to do to me?

> *Sophocles, Oedipus the King (Robert Fagles, translator)*

If we say, 'Everything happens **according to** God's **plan**', at first it seems as if something is being said about a thing, similar to saying, 'This station is being closed **according to plan**'. In that case I should have access to this **plan** …

> *Rush Rhees and Dewi Zephaniah Phillips, In Dialogue with the Greeks, Volume 1: The Presocratics and Reality*

SORRY. **PLAN** is not present in the KJV Bible.
Please return to vocabulary page and try again.

> *Godsview.com: Bible Concordance, Bible Search, Bible Text (KJV) and Other Study Aids, Scan the Bible for Requested Words And Phrases*

What do you do with a shattered dream? Or an unmet expectation? What do you do when your life isn't turning out the way you thought it would? What do you do when you have to turn to **Plan** B?

In ***Plan** B* pastor and author Pete Wilson uses real life stories of disappointments and hurts along with the biblical stories of men and women like David, Joseph, and Ruth to help readers come to grips with the truth that they will face situations that in themselves they are completely unable to handle but that in them God is simply trying to get them to surrender their **plans** so that they can receive His.

> *Pete Wilson, **Plan** B: What Do You Do When God Doesn't Show Up the Way You Thought He Would? (Description)*

On page sixteen we present a diagram, published by the "London Missionary Society," and afterward in the United States by the " Women's Presbyterian Board of Missions." It is termed "A Mute Appeal on Behalf of Foreign Missions." It tells a sad tale of darkness and ignorance of the only name given under heaven, or among men, whereby we must be saved.

The Watchman—the "Y. M. C. A." journal of Chicago—published this same diagram, and commenting on it said:

"The ideas of some are very misty and indefinite in regard to the world's spiritual condition. We hear of glorious revival work at home and abroad, of fresh missionary efforts in various directions, of one country after another opening to the gospel, and of large sums being devoted to its spread: and

DIAGRAM

EXHIBITING THE ACTUAL AND RELATIVE NUMBERS OF MANKIND CLASSIFIED ACCORDING TO RELIGION.

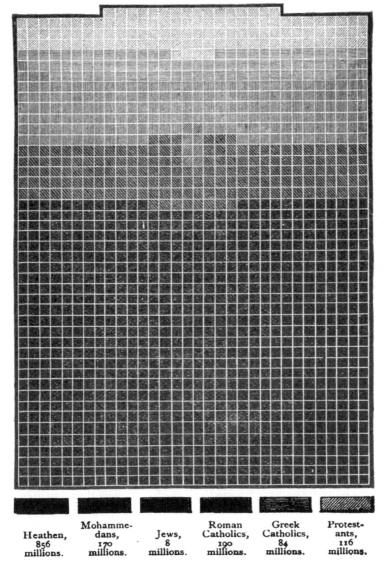

Heathen, 856 millions.	Mohamme-dans, 170 millions.	Jews, 8 millions.	Roman Catholics, 190 millions.	Greek Catholics, 84 millions.	Protest-ants, 116 millions.

*Charles Taze Russell, Millennial Dawn: The **Plan** of the Ages: 560th Thousand (Allegheny, PA: Tower Publishing Co., 1886)*

we get the idea that adequate efforts are being made for the evangelization of the nations of the earth. It is estimated to-day that the world's population is 1,424,000,000, and by studying the diagram we will see that considerably more than one-half—nearly two-thirds—are still *totally heathen,* and the remainder are mostly either followers of Mohammed or members of those great apostate churches whose religion is practically a Christianized idolatry, and who can scarcely be said to hold or teach the gospel of Christ. Even as to the 116 millions of nominal Protestants, we must remember how large a proportion in Germany, England and this country have lapsed into infidelity—a darkness deeper, if possible, than even that of heathenism—and how many are blinded by superstition, or buried in extreme ignorance; so that while eight millions of Jews still reject Jesus of Nazareth, and while more than 300 millions who bear his name have apostatized from his faith, 170 millions more bow before Mohammed, and the vast remainder of mankind are to this day worshipers of stocks and stones, of their own ancestors, of dead heroes or of the devil himself; all in one way or other worshiping and serving the creature instead of the Creator, who is God over all, blessed forever. Is there not enough here to sadden the heart of thoughtful Christians?"

Truly this is a sad picture. And though the diagram represents shades of difference between Heathens, Mohammedans and Jews, all are alike in total ignorance of Christ ...

But dark as this picture appears, it is not the darkest picture that fallen humanity presents. The above cut represents only the present living generations. When we consider the fact that century after century of the six thousand years past has swept away other vast multitudes, nearly all of whom were enveloped in the same ignorance and sin, how dark is the scene! Viewed from the popular standpoint, it is truly an awful picture.

The various creeds of to-day teach that all of these billions of humanity, ignorant of the only name under heaven by which we must be saved, are on the straight road to everlasting torment; and not only so, but that all of those 116,000,000 Protestants, except the very few saints, are sure of the same fate. No wonder, then, that those who believe such awful things of Jehovah's **plans** and purposes should be zealous in forwarding missionary enterprises—the wonder is that they are not frenzied by it. Really to believe thus, and to appreciate such conclusions, would rob life of every pleasure, and shroud in gloom every bright prospect of nature.

To show that we have not misstated "Orthodoxy" on the subject of the fate of the heathen, we quote from the pamphlet—"A Mute Appeal on Behalf of Foreign Missions"—in which the diagram was published. Its concluding

Southern Baptist Missions and Race
1945–1970

ALAN SCOT WILLIS

Alan Scot Willis, All **According
to** God's **Plan:** Southern Baptist
Missions and Race, 1945-1970
(Lexington, KY: University Press of
Kentucky, 2005)

sentence is: "Evangelize the mighty generations abroad—the one thousand million souls who are dying in Christless despair at the rate of 100,000 a day."

But though this is the gloomy outlook from the standpoint of human creeds, the Scriptures present a brighter view, which it is the purpose of these pages to point out. Instructed by the Word, we cannot believe that God's great **plan** of salvation was ever intended to be, or ever will be, such a failure. It will be a relief to the perplexed child of God to notice that the Prophet Isaiah foretells this very condition of things, and its remedy, saying: "Behold, the darkness shall cover the earth, and gross darkness the people; but the Lord shall arise upon thee, and his glory shall be seen upon thee. And the Gentiles [heathen] shall come to thy light." (Isa. 60:2-3.) In this prophecy, the gross darkness is lighted by the bow of promise: "The Gentiles [the nations of earth in general] shall come to thy light."

Charles Taze Russell, Millennial Dawn: The **Plan** *of the Ages: 560th Thousand*

What shall we do in the heat of summer
But wait in barren orchards for another October?
Some malady is coming upon us. We wait, we wait,
And the saints and martyrs wait, for those who shall be martyrs and saints.
Destiny waits in the hand of God, shaping the still unshapen:
I have seen these things in a shaft of sunlight.
Destiny waits in the hand of God, not in the hands of statesmen
Who do, some well, some ill, **planning** and guessing,
Having their aims which turn in their hands in the pattern of time.

> *T. S. Eliot, Murder in the Cathedral*

The year was 386. Augustine was thirty-one. He resigned the lucrative teaching posts that his family had worked to procure for him and went back to Tagaste. Soon he became a priest, and not much later bishop of Hippo, a Roman city in what is now Algeria that is famous only because of him. He spent the rest of his long life engaging in religious controversy, performing the numerous judicial duties that fell to bishops in those days, and writing books. The most important and influential of these was *The City of God.*

This was Augustine's response to the charge that Christianity had been the cause of the sack of Rome in 410. But he went farther than merely disproving that charge. He also laid out a **plan** of world history, showing how two cities had vied with each other for dominance and would continue to do so until the end of time. One city was human—material, fleshly, downward-turning. The other city was divine—spiritual, turning upward toward the Creator of all things.

> *Charles Van Doren, A History of Knowledge: The Pivotal*
> *Events, People, and Achievements of World History*

The *Wisdom of Jesus Christ* tells a similar story. Here again the disciples are gathered on a mountain after Jesus' death, when "then there appeared to them the Redeemer, not in his original form but in the invisible spirit. But his appearance was the appearance of a great angel of light." Responding to their amazement and terror, he smiles, and offers to teach them the "secrets [*mysteria;* literally, "mysteries"] of the holy **plan**" of the universe and its destiny.[67]

> *Elaine Pagels, The Gnostic Gospels*

67. *Sophia Jesu Christi* 91.8-13, in *The Nag Hammadi Library* (New York, 1977), 207-08.

R. M. Widney, The
***Plan** of Creation (Los
Angeles: 1881)*

Had God not turned out to have a **plan** for the man and woman he went on to create, he might be open to the charge of mere aestheticism, and his work dismissed as art for art's sake. With a **plan**, the question of how art that cannot refer to anything outside itself can nonetheless have a function beyond itself is also settled: the art both is and isn't all there is. With the creation of beauty comes the responsibility of purpose. The light is good in and of itself, but what is it good for? It's good because I say it is, God will later tell Job. But that's just

the bluster of the artist. It's good because it reveals an idea. The artist isn't obliged to explain what the idea is.

Howard Jacobson, A Mirror Up to Nothing (Harper's Magazine)

Hail Mary

In this modern retelling of the Virgin birth, Mary is a student who plays basketball and works at her father's petrol station; Joseph is an earnest dropout who drives a cab. The angel Gabriel must school Joseph to accept Mary's pregnancy, while Mary comes to terms with God's **plan** through meditations that are sometimes angry and usually punctuated by elemental images of the sun, moon, clouds, flowers, and water. Godard intercuts a brief parallel story of Eva and her nameless lover; their adulterous affair, rife with philosophical discussions, leads nowhere.

Internet Movie Database, Plot Summaries

Woyzeck was horrified. Once again he felt as if he was pushed down a bottomless void. He straightened up in his chair, with his spine about one inch from its back. His knuckles whitened as his hands clenched the seat. Thus he sat—for minutes or perhaps hours. Meanwhile the prison chaplain, after watching Woyzeck seize up with horror, silently left the cell.

Woyzeck's panic gradually gave way to despair. And to know that such horror might last forever! Then a hand, which took hold of his right shoulder, brought back a faint sense of where he was. Who was this unknown pastor who'd come to his cell? Woyzeck could hear his voice, but his figure seemed far, far away.

"The hidden sanctuary of God's **plans** is forever closed to man," the man said.

For one so infinitely small and distant, the pastor's voice was surprisingly clear and loud.

"The self-righteous, eager to break into these secret precincts, will stumble headlong and lose themselves in an endless maze. Their minds will be swallowed up and lost in eternal damnation."

Was he not already lost in this labyrinth of anguish? Then, once again, he felt the Reverend's hand squeeze his shoulder.

"But there is always hope for those, both sinners and righteous alike who, humbled and cast down, learn to tremble at the Almighty's wisdom and to esteem His infinite mercy."

The pastor fell silent still holding Woyzeck's shoulder.

THE GRAND

EXTENSIVE PLAN

O F

HUMAN REDEMPTION,

From the Ruins of the Fall,

Including the Times of the Reſtitution of all Things :

COMPRISING

The Time of the MILLENNIUM, SATAN's LIT-
TLE SEASON, and the SÆCULA SÆCU-
LORUM, or the AGES of AGES,
till Time is no more ;

IN TWELVE FAMILIAR DIALOGUES,

BETWEEN

DIDASCALOS, a Teacher, *and PHILOTHEOS,*
a Friend or Lover of Truth.

By JAMES KERSHAW.

" I alfo will ſhew mine Opinion," *Job* xxxii. 10.
" Many ſhall run to and fro, and Knowledge ſhall be in-
creaſed," *Dan.* xii. 4.

Louth ;

Printed and Sold by SHEARDOWN and SON, and may be
had of moſt other Bookſellers in Town and Country.
MDCCXCVII.

[Entered at Stationer's-Hall.]

"I'm the Reverend Gottlieb who's come to pray with you for your eternal salvation. Let us kneel."

Ekbert Faas, Woyzeck's Head

If we don't, we're creating our own **Plan** B just because we find it more comfortable and preferable than God's **Plan** A.

*Dwight Robertson, You Are God's **Plan** A {And There Is No **Plan** B}*

Plans and schedules are perhaps not strictly distinguishable from commands, since they usually derive their authority from an order. None the less, they are of special interest as devices for influencing decisions because of the immense amount of detail which it is possible to include in them, and because of the broad participation that can be secured, when desirable, in their formulation.

Herbert Simon, Administrative Behavior: A Study of Decision-Making Processes in Administrative Organization

WE PLAN, GOD LAUGHS

10 Steps to Finding Your Divine Path When Life Is Not Turning Out Like You Wanted

SHERRE HIRSCH

*Sherre Hirsch, We **Plan**, God Laughs: 10 Steps to Finding Your Divine Path When Life Is Not Turning Out Like You Wanted (New York: Doubleday, 2008)*

That must have been how it happened. Belbo decided to take the universe of the Diabolicals seriously, not because of an abundance of faith, but because of a total lack of it.

Humiliated by his incapacity to create (and all his life he had dined out on his frustrated desires and his unwritten pages, the former a metaphor of the latter and vice versa, all full of his alleged, impalpable cowardice), he came to realize that by inventing the **Plan** he had actually created. He fell in love with his golem, found it a source of consolation. Life—his life, mankind's—as art, and art as falsehood. Le monde est fait pour aboutir à un livre (faux). But now he wanted to believe in this false book, because, as he had also written, if there was a **Plan**, then he would no longer be defeated, diffident, a coward.

And this is what finally happened: he used the **Plan**, which he knew was unreal, to defeat a rival he believed real. And then, aware that the **Plan** was mastering him as if it existed, or as if he, Belbo, and the **Plan** were made of the same stuff, he went to Paris, toward a revelation, a liberation.

Umberto Eco, Foucault's Pendulum

God doesn't have a **Plan** B. Imperfect people are *the key* to His **plan**. Your imperfections in no way diminish His desire to use you.

*Dwight Robertson, You Are God's **Plan** A {And There Is No **Plan** B}*

And then, in an instant, the AI operator transferred an explanation to my mind; I saw James—James the creator as master of all prior or efficient causes, of the deterministic process moving forward up the manifold of linear time, from the first nanosecond of the universe to its last; but I also saw another creative being at the far end of the universe, at its point of completion, directing, accepting, shaping, and guiding the flow of change, so that it reached the proper conclusion. This creative entity, possessing absolute wisdom, guided rather than coerced, arranged rather than created; she or it was the **architect** of the **plan** and the controller of final or teleological causes. It was as if the original creator of the universe lobbed it like a great softball on a long blind trajectory, whereupon the receiving entity corrected its course and led it right into her glove. Without her, I realized, the great softball which was the universe—however well and hard it had been thrown—would have wandered out into left field somewhere and come to rest at some random, unpremeditated spot.

Philip K. Dick, Radio Free Albemuth

Prank
The lax Father Zoltan thinks boys will be boys, but when stern young Father Weigl begins to implement his own secret **plan** to curb the kids' "anarchic activity," he unwittingly ...

The Bridge of San Luis Rey
In early 19th Century Peru an old Inca rope bridge collapses, plunging five travelers to their deaths in the Andean chasm below. Brother Juniper, who was within minutes of being on the bridge himself, becomes obsessed with discovering how five people of differing class and circumstances came to be on the bridge at that moment. The Catholic friar wants to know if it was mere existential happenstance or part of God's cosmic **plan**. After researching the lives of the victims for five years and publishing his findings in a book, he is accused of heresy by the worldly Archbishop of Lima and is put on trial for his life by the Inquisition.

Internet Movie Database, Plot Summaries

Scott, James. *Every Man the **Architect** of His Own Fortune or the Art of Rising in the Church. A Satyre.* London: Published by W. Bristow; and sold by R. & J. Dodsley, T. Becket & P. A. De Hondt, Mr. Copperthwaite in Leeds, and the Booksellers in York, 1763.

eBooks on Demand

But I am the **architect** of her fortunes—the publisher, so to speak, of her book—and, if anything, I am underpaid.

Wilkie Collins, No Name: A Novel

Satan wants to paralyze you by making you feel small, as if you have nothing to offer God or His Kingdom. Don't buy into his lie.
 Remember, God doesn't have a **Plan** B. He has called you and desires to empower you to be His **Plan** A ...

*Dwight Robertson, You Are God's **Plan** A {And There Is No **Plan** B}*

THE **plan** was laid to make all men fee the manifold wifdom of God—BY preaching the unfearchable wisdom of Chrift—BUT this fyftem drives fome away from public worfhip—FATIGUES others unmeaning—ceremonies— LEAVES but a few minutes for preaching—EMPLOYS them but feldom—and

Bertram L. Melbourne, The Busy People's
Bible Study **Plan**: Strategies for Personal
Time with God Amidst Life's Hectic Pace
(Chicago: Urban Ministries, 2007)

then devotes them to a rapid declamation—IN favour of a dry morality—a
dream to amuſe—or a drug to ſtupify.

> R. Robinson, A **Plan** of Lectures on the Principles of
> Nonconformity: For the Inſtruction of Catechumens

In ignorance of God's **plan** for the recovery of the world from sin and its con-
sequences, and under the false idea that the nominal church, in its present
condition, is the sole agency for its accomplishment, the condition of the
world to-day, after the Gospel has been preached for nearly nineteen centuries,
is such as to awaken serious doubt in every thoughtful mind so misinformed.
And such doubts are not easily surmounted with anything short of the truth.
In fact, to every thoughtful observer, one of two things must be apparent:
either the church has made a great mistake in supposing that in the present
age, and in her present condition, her office has been to convert the world,
or else God's **plan** has been a miserable failure.

> Charles Taze Russell, Millennial Dawn: The **Plan** of the Ages: 560th Thousand

MAKING THE BIBLE YOURS SERIES, STUDY 2

GOD'S PLAN, OUR CHOICE

OUR CHOICE

A JOURNEY INTO
THE HEART
OF GOD

JACKIE OESCH

*Jackie Oesch, God's **Plan**, Our Choice*
(Maitland, FL: Xulon Press, 2010)

These realizations came to me not as speculation or even as logical deduction, but as insights presented to me by the sympathetic AI operator at work at my station. She was making me aware of that which man had ceased to understand: his role and place in the system of things. I saw on the inner screen of my mind an inferior agency creeping into our world, combating the wisdom of God; I saw it take over this planet with its own dreary **plans** and will, supplanting the benign will of God ... or Valis, as I still preferred to call him.

Philip K. Dick, Radio Free Albemuth

You are God's **Plan** A. (And did I mention there's no **Plan** B?)

*Dwight Robertson, You Are God's **Plan** A {And There Is No **Plan** B}*

We have here only glanced at the mere outline of this **plan** of the ages. The more we examine it, the more we will find in it perfect harmony, beauty and order. Each age has its part to accomplish, necessary to the complete development of God's **plan** as a whole. The **plan** is a progressive one, gradually unfolding from age to age, upward and onward to the grand consummation

of the original **design** of the Divine **Architect,** "who worketh all things after the counsel of his own will." (Eph. 1:11.) Not one of these great periods is an hour too long or too short for the accomplishment of its object. God is a wise economist of both time and means, though his resources are infinite; and no power, however malicious, for a moment retards or thwarts his purposes. All things, evil as well as good, under divine supervision and overruling, are working together for the accomplishment of his will.

To an uninstructed and undisciplined mind, which can see only a little of the intricate machinery of God's **plan**, it appears like anarchy, confusion and failure, just as the whole, or even a part, of an intricate machine would appear to a child. To its immature and untutored mind it is incomprehensible, and the opposite motions of its wheels and belts are but confusion. But maturity and investigation will show that the seeming confusion is beautiful harmony, working good results. The machine, however, was as truly a success before the child understood its operation as after. So, while God's **plan** is, and has been for ages, in successful operation, man has been receiving the necessary discipline, not only to enable him to understand its intricate workings, but also to experience its blessed results.

As we pursue our study of the divine **plan**, it is essential that we keep in memory these ages and their respective peculiarities and objects; for in *no one* of them can the **plan** be seen, *but in all of them,* even as a link is not a chain, but several links united form a chain. We obtain correct ideas of the whole **plan** by noting the distinctive features of each part, and thus we are enabled to divine rightly the Word of truth.

*Charles Taze Russell, Millennial Dawn: The **Plan** of the Ages: 560th Thousand*

The Assumption of the Virgin by Francesco Botticini at the National Gallery London shows
three hierarchies and nine orders of angels, each with different characteristics.

Wikipedia, Christian Angelic Hierarchy

some sort of other **plan**

When we were installed at our usual seats, plaster angels looking down on us, Martha told us her **plan.**

Matt Cohen, The Bookseller

Since the time of Aristotle, European thought had speculated about a "great chain of being," a logically complete range of life forms arranged in a hierarchy from lowest to highest. The chain ascending upward may suggest evolutionism to us, but it was always then conceived as a *static* hierarchy, a **plan** emanating from God's mind that was pleasing in its order and that was given for all time. Forms stayed as they were and did not change.

Roland Stromberg, European Intellectual History Since 1789

Everywhere life was unambiguous, unambiguous as Kapperbrunn, unambiguous as summers; the tooth of one wheel fitted into the other, the tramways ran **according to plan**, the dog barked **according to plan**, the stars revolved **according to plan**. Drowsily and soundlessly, whirling space revolved around the axis of the world …

Hermann Broch, The Unknown Quantity

This, this is Newton; He, who first survey'd
The **Plan**, by which the Universe was made:
Saw Nature's simple, yet stupendous Laws,
And prov'd th' Effects, tho' not explain'd the Cause.*

*Gilbert West, Stowe, The Gardens of the Right Honourable
Richard Viscount Cobham (1732)*

** Gilbert West wrote this poem to celebrate the landscape gardens of his uncle, Lord Cobham. As G. B. Clarke notes, this is one of the earliest examples of a topographical poem devoted to the description of an English garden …*

John D. Tatter, Birmingham-Southern College

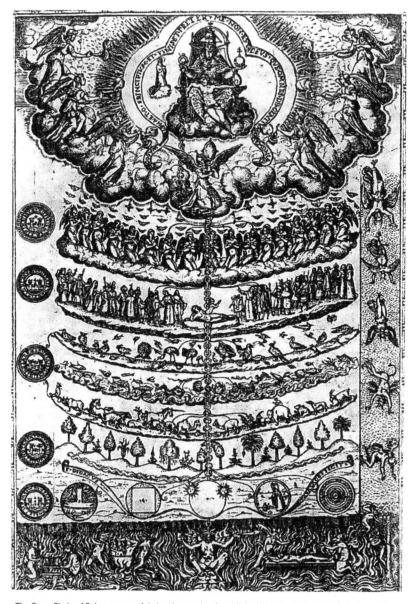

The Great Chain of Being: a powerful visual metaphor for a divinely inspired universal hierarchy ranking all forms of higher and lower life; humans are represented by the male alone. From Didacus Valades, *Rhetorica Christiana* (1579). Reproduced here from Anthony Fletcher's *Gender, Sex, & Subordination*.

Christopher Gabbard, English 174B: Gender and Politics in Literature, 1688-1750 (Stanford University)

But Darwin undeniably moved away from religion. His life story reveals one who earlier was quite pious but whom Lyell's geology led away from biblical Christianity; then the hypothesis of natural selection destroyed in his mind the classical arguments for natural religion, drawn from the evidences of **design** and purpose in organisms.[9] His concluding paragraphs in *Origin* point to a theism that was in fact quite widely adopted: it is not less wonderful, but *more* so, that God chose to plant the seeds of all life in a few simple forms rather than create each species separately. But Darwin abandoned this position, as a study of his letters and subsequent published writings reveals. There was too much chance and too much evil in the biological world he saw to permit him to believe in a benevolent **plan**. "I cannot persuade myself that a beneficent and omnipotent God would have **designedly** created the Ichneumonidae with the express intention of their feeding within the living bodies of caterpillars, or that cats should play with mice."

 Roland Stromberg, European Intellectual History Since 1789

PLAN, v.t. To bother about the best method of accomplishing an accidental result.

 Ambrose Bierce, The Devil's Dictionary

From the Earth to the Moon
Set just after the American civil war, businessman and inventor Victor Barbicane invents a new source of power called Power X. He **plans** to use it to power rockets, and to show its potential he **plans** to send a projectile to the moon. Joining him for the trip are his assistant Ben Sharpe, Barbicane's arch-rival Stuyvesant Nicholl, and Nicholl's daughter Virginia. Nicholl believes that Power X goes against the will of God and sabotages the projectile so that they cannot return to earth, setting up a suspenseful finale as they battle to repair the projectile.

 Internet Movie Database, Plot Summaries

9. The textbook long used and widely influential in early nineteenth-century England, affecting the young Darwin himself, was William Paley's *Natural Theology* (1802), a work that argued with a wealth of carefully observed detail that the marvelous adaptation of organisms to their environment proves deliberate contrivance by an "intelligent Creator"—the "argument from **design**" spelled out carefully. But with a change in perspective, many of Paley's examples could be seen as adaptation via natural selection rather than providential **design**.

*SubZenyth, Steampunk Wing Stencil **Plan** (deviantart.com)*

Comments:
Filecreator Mar 2, 2009
 How do you **plan** on balancing yourself with those on your back?
Reply:
 Design the impossible,
 Create the impossible,
 Make it possible.

Anne asked, "Are you going somewhere? Going far? I mean I need the van this afternoon."

Not far, he said, or maybe he didn't say. Some days you just can't hear the sound of your own voice.

"I've got books, seven boxes, I think."

The Reverend Connor changed his **plans** and let his wife have the van for the morning. He sat around in his living room, fully dressed down to his loafers, watching TV and refusing to answer the telephone.

 Denis Johnson, Already Dead: A California Gothic

Heaven (2002)
… a **plan** that fails miserably …

 Internet Movie Database, Plot Summaries

No doubt when it was understood that it was going to be well-nigh impossible to do the job safely with the available technology, only a relatively few of the core teams would have been completely in on the alternative **plan** to fake the public record of the Apollo moon landings. This would become the cover for the surrogate program.

David S. Percy (director), *What Happened on the Moon? An Investigation Into Apollo*

NEW WELFARE REFORM **PLAN** SEEKS
TO PUT RECIPIENTS TO WORK
Rising And Sustained Welfare Rolls Trigger Case For Reforms

NEW ORLEANS, La.—In response to three years of ballooning welfare rolls, a caucus of over 170 Republican House members has released H.R. 1167 Welfare Reform Act of 2011. The bill would expand the reforms of the mid-1990s, require food stamp recipients to either work or prepare for a job, and impose a spending cap once unemployment recedes.

Robert Ross, *New Welfare Reform **Plan** Seeks to Put Recipients to Work (The Pelican Post)*

Brutal government **plans** for welfare 'reform' have today been slammed by Sarah Evans, NW Hampshire's Labour candidate at the last general election and NW Hampshire Labour Party chair Alan Cotter, who have called on MP George Young to have a heart and urge the government he is part of to abandon the Bill due to be debated on Monday.

Sarah Evans said: "This Bill is about taking £18 billion from the poor to help pay for £24 billion in tax breaks for the rich, and that is simply disgusting."

Sarah Evans, *Brutal Government **Plans** for Welfare 'Reform' Slammed By Nw Hampshire Labour (North West Hampshire Labour Party)*

Among those measures are the Angel **Plan**, introduced in 1994, and the New Angel **Plan**, introduced in 1999. Under those **plans**, wide-ranging programs were implemented ...

Hisane Masaki, *Japan Stares into a Demographic Abyss (Asia Times)*

The approach is composed of supply and demand. **Plan** Angel can choose which combination you want and you can choose from existing projects or starting a new project. **Plan** Angel starts **plan** to provide aid to people in need. The activities are aimed at foreign countries. In the medium and long term **Plan** Angel wants be among worldwide operations.

In today's society, where many people have created many opportunities and where many people do well, there is still a huge group of people who have no

Support **Plan** Angel!
Become a Volunteer for **Plan** Angel!

*www.**plan**angel.org*

chances and have not yet learned to exploit this. Partly because they do not know where they can find help, partly because the assistance is wrong and sometimes because the financial resources needed to aid support are missing. **Plan** Angel was established to every person, regardless of religion, social status and in whatever conditions he or it is placed to help.

*Plan Angel, Welcome to **Plan** Angel's Website!*

Grace & Mercy

In poor health and dead broke, Grace has a **plan** to provide a future for her young daughter. With the help of her sister Mercy, she robs her former employer. But an alarm goes off during the robbery and they escape into a nearby church. They hold the police at bay by taking the Pastor and the elders hostage by gun point. Outside, the LAPD try to avoid another public relations disaster by keeping the hostage situation quiet and the local media away. Inside, the Pastor and the elders do their best to ease a potentially dangerous situation with their good-natured, spiritual guidance. Eventually, the church members become a new family to the desperate sisters, who have learned to trust in the Lord. But will the Lord provide HIS own Grace & Mercy for these two desperate siblings?

Internet Movie Database, Plot Summaries

The cry for reform comes on the heels of U.S. Census Bureau data that shows one in seven Americans lives at or below the poverty line. This number has remained stagnant since the 1970s, despite a 423 percent increase in federal welfare spending.

Robert Ross, New Welfare Reform **Plan** *Seeks to Put Recipients to Work (The Pelican Post)*

A benefit for **Plan** Angel is the fact that (available) and capital grants third parties a sound basis for the **Plan** Angel organization can be achieved and the road to economic success for the promoters open.

*Plan Angel, Welcome to **Plan** Angel's Website!*

WELFARE REFORM: TIME FOR **PLAN** B?

Basically delay people from claiming, encourage them to take a week or two. Apparently has seen results in the US, no figures quoted.

*Warren O'Keefe, Welfare Reform: Time for **Plan** B? (2020UK)*

Plan Angel would like to add an additional value. The added value should primarily lie in the fact that **Plan** Angel works with people on practical experience. By using these experienced people, capable people with **Plan** Angel seek help directly to the proper authorities by reference. This is always the right sought to help.

*Plan Angel, Welcome to **Plan** Angel's Website!*

Heaven (1998)

A struggling **architect**, being sued for divorce by his wife and struggling with booze and gambling, finds work remodeling a friend's strip club, the Paradise. There he meets a transsexual stripper who is bothered by accurate, but extremely violent visions of future events. The increasingly violent visions start including the **architect**, who doesn't believe in the prophesy. One who does however is a psychiatrist who is seeing both the stripper and the **architect** and is sleeping with the ex-wife. He uses the prophecies for his own financial gain.

Vavien

Living an unhappy life, Celal thinks that this money will be his salvation and makes a **plan**. He gets an automatic door fixed to his car. He **plans** to push his wife off the cliff by making it seem like an accident and he **plans** to possess 75.000 Euros that her wife saves. He carries out his **plan** but two days after his wife Sevilay comes back unexpectedly ...

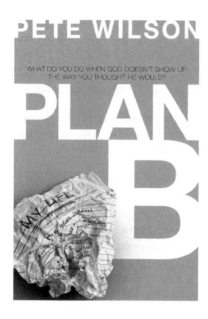

Pete Wilson, **Plan** *B: What Do You
Do When God Doesn't Show Up
the Way You Thought He Would?*
(Nashville: Thomas Nelson, 2009)

My Girlfriend's Back
This intelligent romantic comedy chronicles the socio-economic ascent of
Derek Scott. Derek has spent his entire life plotting a course for his success. His
diligence is about to pay off when he happens upon an unexpected detour. This
"road less traveled" intrigues Derek so much so that he considers throwing
away his entire well orchestrated life to experience the one thing his **plan** has
yet to provide … love.

Amnesia
Paul Keller is a married pastor who preaches piety on Sunday, while carrying
on a torrid affair with the local school teacher, Veronica Dow, during the
week. The lovers concoct a scheme to fake Keller's death so that they can be
together, but the **plan** goes awry when Keller hits his head and awakens not
knowing who he is …

Internet Movie Database, Plot Summaries

"Are you in a health **plan**?" another voice asked insistently. "Do you have Blue
Cross? Can you sign this form, if I hold it for you? Here's a pencil. You may
sign it with your left hand if you wish."

Philip K. Dick, Radio Free Albemuth

There were harmonizers and accommodators who sought to show that even Darwinian evolution is consistent with divine purpose. Was there not something sublime in the ascent of humanity through the eons from primeval slime to intelligent and spiritual being (Henry Drummond)? Admitting the cruelty and suffering, one still had as an undeniable fact the grand result. Asa Gray, the American naturalist, complimented Darwin for having *restored* teleology to nature. There was **design**, if "on the installment **plan**" ...

Roland Stromberg, European Intellectual History Since 1789

MEDICARE **PLAN** FOR PAYMENTS IRKS HOSPITALS

WASHINGTON—For the first time in its history, Medicare will soon track spending on millions of individual beneficiaries, reward hospitals that hold down costs and penalize those whose patients prove most expensive.

The administration **plans** to establish "Medicare spending per beneficiary" as a new measure of hospital performance, just like the mortality rate for heart attack patients and the infection rate for surgery patients.

Hospitals could be held accountable not only for the cost of the care they provide, but also for the cost of services performed by doctors and other health care providers in the 90 days after a Medicare patient leaves the hospital.

This **plan** has drawn fire from hospitals, which say they have little control over services provided after a patient's discharge—and, in many cases, do not even know about them. More generally, they are apprehensive about Medicare's **plans** to reward and penalize hospitals based on untested measures of efficiency that include spending per beneficiary.

*Robert Pear, Medicare **Plan** for Payments Irks Hospitals (The New York Times)*

It would be interesting to know the motives that could have induced the two accomplices to hit upon such an insane **plan**.

Fyodor Dostoyevsky, The Brothers Karamazov

"If a deed is insane in the commission, can the **planning** of it be sane? I will explain my point—

"If a human being, for example, living in our place and time and culture, **plans** to kill another man, roast his thigh, and sit down at a table and eat it with gravy, mashed potatoes, and string beans, is he not mad? Must he actually devour such a loathsome repast before we who are more fortunate can conclude he belongs to a different order of creatures than we? And then what?"

Thomas Berger, Killing Time

THE NEED FOR GREED

The bet was audacious from the beginning, and given the miserable, low-down tenor of contemporary politics, not unfathomable: Could you divide the country between greedy geezers and everyone else as a way to radically alter the social contract?

But in order for the Republican **plan** to turn Medicare, one of most popular government programs in history, into a much-diminished voucher system, the greed card had to work.

The **plan's architect**, Representative Paul Ryan of Wisconsin, drew a line in the actuarial sand: Anyone born before 1957 would not be affected. They could enjoy the single-payer, socialized medical care program that has allowed millions of people to live extended lives of dignity and decent health care.

And their kids and grandkids? Sorry, they would have to take their little voucher and pay some private insurer nearly twice as much as a senior pays for basic government coverage today. In essence, Republicans would break up the population between an I've Got Mine segment and The Left Behinds.

Again, not a bad political calculation. Altruism is a squishy notion, hard to sustain in an election. Ryan himself has made a naked play for greed in defending the **plan**. "Seniors, as soon as they realize this doesn't affect them, they are not so opposed," he has said.

Well, the early verdict is in, and it looks as though the better angels have prevailed: seniors are opposed. Republicans: Meet the Fockers. Already, there is considerable anxiety—and some guilt—among older folks about leaving their children worse off financially than they are. To burden them with a much costlier, privatized elderly health insurance program is a lead weight for the golden years.

This **plan** is toast. Newt Gingrich is in deep trouble with the Republican base for stating the obvious on Sunday, when he called the signature Medicare proposal of his party "right-wing social engineering." But that's exactly what it is: a blueprint for downward mobility.

Timothy Egan, The Need for Greed (The New York Times)

"But how did the Jesuits know of the **Plan**, when the Templars let themselves be killed rather than reveal it?" Diotallevi asked.

It was no good answering that the Jesuits always know everything. We needed a more seductive explanation.

Umberto Eco, Foucault's Pendulum

The Obama Deception

The Obama Deception is a hard-hitting film that completely destroys the myth that Barack Obama is working for the best interests of the American people. The Obama phenomenon is a hoax carefully crafted by the captains of the New World Order. He is being pushed as savior in an attempt to con the American people into accepting global slavery. We have reached a critical juncture in the New World Order's **plans**. It's not about Left or Right—it's about a One World Government. The international banks **plan** to loot the people of the United States and turn them into slaves on a Global Plantation. Covered in this film—who Obama works for, what lies he has told, and his real agenda. If you want to know the facts and cut through all the hype, this is the film for you.

Internet Movie Database, Plot Summaries

You will understand better after reading <u>SATAN'S DRUMMERS,</u> which is just headed for press this day, the importance of what is occurring in these Satanic cults. There is a great move within the cults to become more bold in the sacrificing and stealing of newborn babes and up to three years of age for they are after the little ones sent of God. Your new guide is now birthed, along with several extremely high masters in other places, they must be protected while they move into maturity to assume their jobs—do not become complacent, however, for they shall not require the years to mature as in natural "normal" growth. So be it. The dark masters know where the child is but it will be the public that will be most damaging.

It is not our intent to keep it secret from you ones who will maintain the protection, it is just that it will not even be brought forth in any public forum. The higher **plan** is most wondrous indeed.

Judas Priest **Plan** to Showcase *Nostradamus* as a Special Event Concert

Vocal legend Rob Halford told jam! the band **plans** to have special event concerts where the new concept album, *Nostradamus*, is played in its entirety.

powerlinead.wordpress.com

The anti-Christ is in place also—in adulthood and being groomed and "trained" in Egypt. I suggest you obtain a copy of *Conversations with Nostradamus, Vol. I,* by Dolores Cannon: new discussions of his prophecies. You can contact your local book store—the information is totally valid although you will not be given insight enough to yet decipher it all in understanding for it is premature.

I will move to stand-by, Dharma, that you might remove this from the equipment that we might move on with other correspondence. In love and appreciation I remain in your service and I am most honored to serve with you of Terra crew. I bring regards from your brothers of Pleiades.

Salu, Salu, Salu,

 Hatonn to clear frequency.

Gyeorgos Ceres Hatonn, Privacy in A Fishbowl: Spiral to Economic Disaster, Vol. 2

Outsiders to the world of money who start to take an interest in it soon notice that most of the things that alarm and outrage the wider public are taken by insiders to be perfectly routine and unremarkable. Consider the sums that bankers get paid, or the disruptive impact of hot money zipping around the world at the click of a mouse, tearing up industries and whole economies at will. To moneymen, those are just the givens of the way the world works, and have to be accepted, in the absence of a credible **plan** to go off to found a new system on another planet.

Once in a great while, though, something happens that reverses the loop, and has the moneymen more scared than the rest of us. That happened in late 2007, when the credit crunch began, and it's happening again now.

John Lanchester, Euro Science (The New Yorker)

"The community could be moved by this story, Heather. Here's a man at the pinnacle of success, vice president of one of the largest banks on the continent, and one day—"

"He can't get off the train."

"—he can't get off the train. He goes to work in the morning, he's the kind of man who enjoys taking the Metro, but at his stop—"

"He stays on."

"—he stays on. Then spends the entire day going back and forth on the subway. At the end of the day, he finally gets off and goes home."

"That was the first time but not the last."

"Four days in a row. Finally the bank calls his home to see why he hasn't shown up for work, and his wife finds out that he hadn't been to the office all week."

"He broke down in front of Mom," Julia improvised.

"He said he couldn't get off the train. Mom freaked."

"He went into therapy," Boyle said, repeating the story for the sake of the corroboration he was receiving. As research went, this was a breeze.

"Right. Tell me about it. Therapy. Empowerment. Getting in touch with your feelings. He walked out of therapy a sick, confused man and went straight to his boss's office and resigned. Just like that. No severance pay, no disability, no unemployment insurance. In-your-face quit. It would be heroic if it wasn't so damned pathetic."

"A year later his wife leaves him," Boyle says, guiding her to fill in the details.

As Heather Bantry, Julia was only too willing to oblige. "A year after that he's on welfare, sick, disoriented, on the streets, a case. Next came the court fiasco declaring he'd been mentally incompetent when he quit, so things looked rosy. But he ended up poorer than ever. In three years a vice president of the

First Canadian Bank goes from middle-class comfort to spending Christmas in a tunnel."

"That's a story." Boyle was elated. He could easily forget his professional detachment on this one. "It says—this could happen to me. This could happen to anyone!" He stopped to cough and blow his nose. "Here we have the justification for a social safety net the rich can understand. A mental breakdown, and no matter how well you've **planned**, no matter how safe and secure your life, with bad luck you can be shoved to the bottom of the ditch."

John Farrow, City of Ice

I think I was quite happy without microwave ovens, calculators, compact disks, touch-tone phones, universal credit cards, videotape recorders, and faxes, back when television was black and white, construction sites were marked by oil lamps, and billboards were printed paper.

We don't need these things.

What we *need* is a broadly informed discussion about our destiny. What we need is a penetrating, rigorous assessment of our **plan** for the future welfare of the human race.

Paul Davies, The Truth: A Novel

He printed up for distribution to the great and the good several dozen copies of *The Adventures of Alexander the Corrector,* which in addition to telling the tale of his visit to the Chelsea madhouse, outlined his **plans** for correcting the morals of the nation.

Julia Keay, Alexander the Corrector: The Tormented Genius Who Unwrote the Bible

'Well, good on you,' Donohue remarked and took another sip of his coffee. 'Shall we talk turkey?' he suggested to Justin.

'I thought we were doing that.'

'About your **plans**.'

'What **plans**?'

'Precisely.'

John le Carré, The Constant Gardener

It is, generally speaking, his duty who appeals to the public, to satisfy first their understanding. He, who now aspires to it, would never have presumed to address the public, or attempted to have engaged their attention, if he did

*John Peck, A Descant on the Universal **Plan**, Corrected; or Universal Salvation Explained (Madison: Arion & Lodge, 1831)*

not, from conviction of the rectitude of his **plan**, hope that they would not only see the necessity, but applaud the motive of it.

The fatal consequences arising from the Bites of Mad Dogs are too familiarly known, to need any horrid excitement, by a recital of them. The object of the present **Plan** is, that by prevention they may be heard of no more, or at least as seldom as possible.

The Author of this **Plan** does not intend to enter minutely into the question. He refers to those who want an explanation at large upon the subject to a Pamphlet published by him, entitled *An Essay on the Bite of a Mad Dog,* written in the year 1788, and sold by Mr. Becket, Pall-Mall.

But he cannot, consistent with his **Plan**, withhold from the public the following Truths, namely …

*Jesse Foot, A **Plan** for Preventing the Fatal Effects From the Bite of A Mad Dog, With Cases*

THOSE WITH FINANCIAL **PLANS** ACHIEVING GOALS
Studies Show Preparation Is Key

As you may have noticed over the years, we try in this column to avoid topics and themes that appear to be totally self-serving. Today, we break with that practice.

Today, we quote two studies which show that people who have financial **plans** and financial advisers are significantly more successful in achieving their financial and life goals.

Hopefully, that won't be a big surprise. And I'm mostly kidding about this being self-serving. My actual goal in today's column is instead to identify the behaviours of the consumers and investors who achieve greater success, so you can duplicate that success, with or without an adviser.

In the spirit of full disclosure, I am a financial **planner** and adviser, and I obviously believe in the value of good financial advice. Therefore, I cannot be objective in this discussion. However, I also believe that you are responsible for your own financial success, and you can benefit from learning what has worked for other people.

*David Christianson, Those with Financial **Plans** Achieving Goals (Winnipeg Free Press)*

EASY WAY TO MAKE MONEY: THE SIX-FIGURE INTERNET PUBLISHING **PLAN**

A couple years ago a woman came up with a very simple but powerful method for making money on the Internet—a method that anyone can copy and profit from. Here is what she did.

*Josh, Easy Way to Make Money—The Six-Figure Internet
Publishing **Plan** (Making Money From Home)*

First—let's talk about Public Domain content (and then I'll get into the whole PLR publishing drama).

For years the idea of taking "free" public domain stuff from the online archives—and then selling it on Amazon or eBay has been a windfall for many publishers.

In fact—I've been sharing many of the most profitable niches and what those profitable sellers are "Selling" on the *What To Sell For Money* site.

I admit—I have personally not sold "compiled" content on eBay or published an "as is" public domain book on Amazon.

Danielle LaPorte, Want to Write a Book? Get Ready, We're Coming for You (www. daniellelaporte.com)

I do know that others sell compiled or "as is" public domain content every single day—and have had fantastic success with it. It's not a bad business **plan** ...

Debra Conrad, Publishing Junk eBooks is Not a Business **Plan** (Debra Conrad: That Public Domain Diva)

Pickle, struck with this idea, eagerly embraced the proposal, which he honoured with many encomiums, as a **plan** in all respects worthy of his genius and apprehension; and the day was appointed at some distance of time, that the treater might have leisure to compose certain pickles and confections which were not to be found among the culinary preparations of these degenerate days.

Tobias Smollett, The Adventures of Peregrine Pickle, in Which Are Included Memoirs of A Lady of Quality

With the death of each new generation of booksellers, each failed "business model," the independent literary writer/poet/publisher wants to say, "Good

riddance, they had it coming," only to be mortified by how much worse the thing is that takes its place. In ten years, for people raised by computers (and by that I mean everyone), buying a book will mean buying an ebook from Amazon, Google, or maybe Barnes and Noble, if it survives. I asked John O'Brien, the legendary publisher of Dalkey Archive Press, what he thought, and he said this:

"The greatest threat to book publishing in the United States right now is Amazon. Through various spin-offs, they have become a publisher, and this means that they are moving towards becoming both a distributor of books and a publisher, and no book publisher will be able to compete. In the future (and I am sure this is the **plan**) Amazon wants to control all distribution and all publishing. This is a very scary prospect: that a single company will have such power to determine what will be published and on what terms. Once the 'Amazon **plan**' is realized, they will be able to charge whatever they want to charge and will of course be able to decide what the best-sellers will be. They will have gotten themselves into the position of making such decisions because they will be the only game in town."

Curtis White, The Late Word (Lapham's Quarterly)

"Here I thought the Serra Angel **Plan** was better than the really bad Thallid **plan**, but apparently I was mixed up. They do things differently in the 'Peg."

Veinneau opened with an aggressive start of Blade of the Sixth Pride and Goblin Skycutter. Olynyk suspended an Infiltrator il-Kor and then stalled on two islands, playing Dreamscape Artist. Vienneau had Flowstone Embrace at the ready.

And still no land for Olynyk. Vienneau's monsters weren't giving him much time. "I'm pretty sure I'm dead."

"I'm pretty sure you're dead too," said Vienneau. He drew his card, "Yes, I'm really sure you're dead." He turned over Ghostflame, and Olynyk extended the hand.

Matt Vienneau defeats Jason Olynyk 2-1

Josh Bennett, Magic: The Gathering, Day 1 Blog Archive (www.wizards.com)

Publishing books to make money …

… is a little like hanging out in a singles bar if you want to get married.

It might work, but there are way better ways to accomplish your goal.

If you love writing or making music or blogging or any sort of performing art, then do it. Do it with everything you've got. Just don't **plan** on using it as a shortcut to making a living.

The only people who should **plan** on making money from writing a book are people who made money on their last book. Everyone else should either be in it for passion, trust, referrals, speaking, consulting, change-making, tenure, connections or joy.

[Speaking of free, we made a small change to the interview dates on the upcoming nano-mba 11-person session for employees at corporations and orgs that make the world a little better.]

 Seth Godin, Publishing Books to Make Money … (Seth Godin's Blog)

For those of us who work in bookstores, the hundreds of thousands of bookstores scattered in their dusty glory over the surface of our planet, this job has a strange romance. We modest bookstore workers are the custodians of all that has been written. The living membrane through which passes the wisdom and the idiocies of the ages. We are the clerks of the hotel of language. It rises out of our collective brains, always available, always dependent on us to keep it smoothly functioning, to welcome new arrivals, to keep the guests moving in and out according to rank and demand, following values carefully constructed over the centuries yet capable of satisfying every need.

 And for those of us who live this strange romance, usually **planned** as something between a one-night stand and a provisional passion on the way to something more suitable, nothing could be less romantic than the job itself. The packing and unpacking. The constant worry about small accounts. The debtors and the creditors. The fact that people never wipe their feet when they come in the door. The way customers lick their thumbs before turning the pages of expensive art books they'll never buy. The way your "best" customers always think you owe them something. And so on. The shopkeeper's litany.

 Matt Cohen, The Bookseller

On some days, Alice believed in the **plan** like she used to. On other days, she looked at me as if I was a stranger trying to sell her bogus jewelry; shiny stuff that was worthless, something you'd insult your worst enemy with.

 Peter Plate, One Foot Off the Gutter

When Martha left I was alone in the store. But in a bookstore there is always too much to do. Especially when there are no customers. You are standing in the middle of the store. Adjusting shelves, sorting out a couple of cartons of newly received books. Your hands are working. You are thinking official thoughts. All of human history and evolution have been required to lead up to this incredible triumph of efficiency. Meanwhile you're not there. Without **planning** or wanting it you've dropped into another universe.

 Matt Cohen, The Bookseller

I woke up with the power out,
not really something to shout about.
Ice has covered up my parents hands
*don't have any dreams don't have any **plans**.*

I went out into the night,
I went out to find some light.
Kids are swingin' from the power lines,
nobody's home, so nobody minds.

I woke up on the darkest night,
neighbors all were shoutin' that they found the light.
("We found the light")
Shadows jumpin' all over the walls
some of them big, some of them small.

I went out into the night.
I went out to pick a fight with anyone.
Light a candle for the kids,
Jesus Christ don't keep it hid!

Woohoo! Woohoo! Woohoo!

Survival Research Laboratories, A **Plan** for Social Improvement

Survival Research Laboratories, A **Plan** for Social Improvement

Survival Research Laboratories, A **Plan** for Social Improvement

Survival Research Laboratories, *A **Plan** for Social Improvement*

Ice has covered up my parents hands
*don't have any dreams, don't have any **plans.***
Growin' up in some strange storm,
nobody's cold, nobody's warm.

I went out into the night,
I went out to find some light.
Kids are dyin' out in the snow,
look at them go, look at them go!

Woohoo! (3x) WOO! Woohoo! (3x)

And the power's out in the heart of man,
take it from your heart put in your hand.
(Hand)

*What's the **plan**? What's the **plan**?*

Is it a dream? Is it a lie?
I think I'll let you decide.
Just light a candle for the kids,
Jesus Christ don't keep it hid!

Cause nothin's hid, from us kids!
You ain't foolin' nobody with the lights out!

Woohoo! (2x)

And the power's out in the heart of man,
take it from your heart put in your hand.
And there's something wrong in the heart of man,
Take it from your heart and put it in your hand!
(hand, the lights out, hand, right now, hand)

Arcade Fire, *Neighborhood #3 (Power Out)*

"So," Kitty said, turning to Lulu. "What big **plans** are you hatching?"
 Lulu seemed to turn the question over. "You mean ... for my life?"

Adbusters, June/July 2000

"Why not."

"I haven't decided yet, Lulu said, thoughtful. "I'm only nine."

Jennifer Egan, A Visit From the Goon Squad

From about 950 to 1000, melancholy imbued our ancestors. Madmen ran through the towns and villages, shouting that the world was coming to an end. Some who were not mad feared the madmen might be right. There was a dearth of ingenuity and invention. Many problems seemed to be insoluble. People tried to hang on, hoping that life would not get even worse. They seem to have given up hope that it could get any better.

Outlaws roved through the land, stealing, burning, enslaving. Priests preached sad and somber sermons, warning the people that the last judgment might be at hand, urging them to right their lives and make peace with their neighbors. Most people were reluctant to embark on lengthy enterprises. No one made **plans** for the future, at least on this earth.

Charles Van Doren, A History of Knowledge

Left and right have argued at cross-purposes about the root causes of the riots. The left blame poverty and inequality. The right identify a different cluster of linked causes: welfarism, moral decline, the collapse of the inner city family, and the weakening of authority. One of the few things that left and right can agree on is that worklessness doesn't help—though even then, they disagree about why that is.

But will anything actually be done about it? In yesterday's *Telegraph* Paul Goodman sounded a sceptical note, worrying that politics may prevent the PM from following his better instincts. The front page of today's *Spectator* asks the same question.

How—realistically—might the government change direction after the riots?

I think a different approach to welfare reform is needed. You could call it a "**plan** B," but it isn't really, because the government should certainly continue

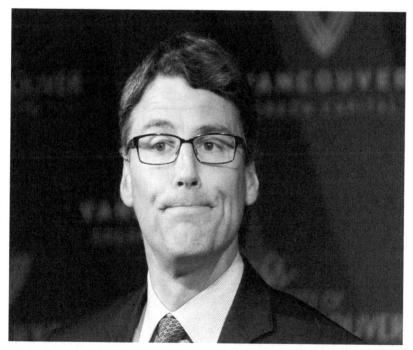

Mayor Gregor Robertson is perplexed with some of the media questions on preventing a Stanley Cup riot as he provided an update on progress to-date on riot review recommendations and unveiled initial **plans** for 2012 Stanley Cup playoffs celebrations in Vancouver.

*The Province, City Hall's Stanley Cup **Plans** Are Flawed Again*

to pursue its long-term **plans** to simplify benefits and make work pay. But those important reforms could take a while ...

*Neil O'Brien, Welfare Reform: Time for **Plan** B? (The Telegraph)*

"You're going to have lots of time on your hands," he told the lieutenant. "One of my wife's uncles retired last year without making any **plans** to keep himself occupied, and—"

"Don't tell me," Suster said. "He got a heart attack while cutting the grass for the third time that week, or while shoveling snow back onto the sidewalk so he could shovel it off again. I know all those stories. Me, I've got **plans**. I'm going to hang out at the public library and look up the skirts of high-school girls doing their assignments. Then I'll play cards Wednesday afternoons with the Old Lady and her pals. And every night I'll have a nice hot cup of cocoa. If that gets boring I know a cemetery that needs a night watchman: I'll sit down on a gravestone at midnight and eat my sandwich, and if I die I can be buried right on the job."

Thomas Berger, Killing Time

The government has dropped controversial **plans** to cut housing benefits by 10% for people out-of-work for more than a year—but the bill includes **plans** to cut housing benefit for tenants deemed to be "under-occupying" their homes.

*BBC News, David Cameron Sets Out Welfare Reform Bill **Plans***

DUANE: I didn't think it could get any worse—
Y.C.: No, it's much worse than that. They **plan** to march us out in the jungle, and kill us, and make it look as if we were trying to escape. They want to all go back to their villages and somehow try to get some food. The ringleader is Little Hitler and Crazy Horse—
GENE: Ohhh, I knew it.
DIETER: Okay, so, it has to be tomorrow.

Werner Herzog (director), Rescue Dawn

The **plan** might not work. They could only hope.

John Farrow, City of Ice

"If they should come, what is your **plan**, sir?"
"My **plan**, Johnny, is to have no **plan**. Particularly, when I don't have much of anything to **plan** with." Lincoln paused.

Gore Vidal, Lincoln: A Novel

*Jonathan Hughes and Simon Sadler, Non-**Plan**: Essays on Freedom Participation and Change in Modern **Architecture** and Urbanism (Oxford: **Architectural** Press, 2000)*

Thabo Langa, There Is No **Plan** (csmfineart.com)

'There is no **plan**' at CSM (yucckstrawberry.tumblr.com)

*StarSmith, Animethon 13 No-**Plan** Clanby (deviantart.com)*

So this is a picture of my cosplay group of friends! I'm Daisy, in the yellow dress, Rikl is Luigi, JB is Peach, Hay is Toadette, and Pan is Shadow Peach (from Paper Mario). We were working on Pan's costume down to almost the very last second, but I think we look great! We even won an award for the best performance at the Cosplay contest.

*Kat Shumar, No **Plan** (tackychristmasyards.com)*
Okay, here's the **plan**—nevermind, we don't have a **plan**. Oh, and someone may or may not
have fallen off the roof while hanging on to the blueish lights. Violations: Why Bother.
Rating: 0.0/5 (0 votes cast)
Filed under: Uncategorized

*subQ10x, part of no **plan** (Germany, 2010)*

*Van Morrison, Born To Sing: No **Plan** B (Blue Note Records, 2012)*

There Is No Plan

from "Transformers 3: Dark Of The Moon"

Composed by Steve Jablonsky
Arranged by Juggernoud1

As the sun rose the lion withdrew into the jungle and the black descended from his tree and started upon his long journey back to camp. In his primitive brain revolved various fiendish **plans** for a revenge that he would not have the courage to put into effect when the test came and he stood face to face with one of the dominant race.

Edgar Rice Burroughs, *The Son of Tarzan*

So that's what I did ... sat down with no **plan**, no scheme, no ideas and just started.
Sarah Cooper, Soulistry: A Spirituality of Play (and 29 Faces)

CASE III.
A young Midshipman was walking and reading in the public road, in the vicinity of London: He was bitten, without any provocation, by a Dog that passed him, seemingly mad, on the outer part of his thumb, in the Spring of 1789. The part was taken out the next day, and he did well. The Bite had drawn blood.

CASE IV.
In November, 1789, the Boy of a Poulterer in the Parish of St. Anne, was bitten in the hand by a Dog in a confirmed state of Madness, and which was pursued and killed. The Bite had drawn blood. The part was instantly taken out, and the Boy did well.

CASE V.
A Lady, in August 1789, was bitten in the heel, through her stocking, by her own Lap-Dog, which died mad. The Bite drew blood. The bitten part was not taken out till three days afterwards. The Lady did well.

None of these patients took medicine, or bathed in the sea.

*Jesse Foot, A **Plan** for Preventing the Fatal Effects From the Bite of A Mad Dog, With Cases*

PENNY: Sweetie, are you alright?
SHELDON: No, I'm not alright. It's been six days since I was supposed to get a haircut, and nothing horrible has happened.
PENNY: Ok I'm sorry, I don't understand.
SHELDON: Leonard, explain it to her.
LEONARD: Oh, uh, he's crazy.
SHELDON: I have spent my whole life trying to bring order to the universe by carefully **planning** every moment of every day. But all my efforts—our dinner schedule, my pyjama rotation, my bowel-movement spreadsheet— it's clear now, I've been wasting my time.
LEONARD: Good, I'm taking that disgusting chart off the fridge.
PENNY: You know, Sheldon, sometimes it's nice not knowing what's coming. Look at me and Leonard, we went out, we broke up, now we're trying again, we don't know what's going to happen.
SHELDON: Oh please, everyone knows what's going to happen. But I see your point.
LEONARD: This could be good for you, maybe it's time for you to shake things up a bit.
SHELDON: You're right. I should embrace the chaos.
LEONARD: Great. What are you going to do first?
SHELDON: I don't know—I could do anything—all bets are off—the world is my oyster—I got it, I'm going to put on my Tuesday pyjamas tonight!

Chuck Lorre and Bill Prady (creators), The Big Bang Theory:
Season 5, Episode 18: The Werewolf Transformation

Questions about Facebook's future inevitably raise questions about Sandberg's. Surely she is on track to one day become a C.E.O., if that's what she wants. Some people speak of a potential career in politics. Asked what she can imagine doing next, she responds, "I'm actually quite happy with Mark and the company. I always tell people if you try to connect the dots of your career, if you mess it up you're going to wind up on a very limited path. If I decided what I was going to do in college—when there was no Internet, no Google,

No **Plan**, No Direction, No Success
www.completemarketingsystems.com

no Facebook ... I don't want to make that mistake. The reason I don't have a **plan** is because if I have a **plan** I'm limited to today's options."

> *Ken Auletta, A Woman's Place: Can Sheryl Sandberg Upend Silicon Valley's Male-Dominated Culture? (The New Yorker)*

Gareth Davies, president of the National League of Blind and Disabled People, is also "suspicious" about the **plans**. He says: "We are concerned about genuine claimants running into difficulties with the work test." He adds: "We want to see a fully employed labour force but I think that they have underestimated the nature of the problem."

> *Disability Now, Welfare Reform: Are You Scared Yet?*

The paper kept hammering away, week after week, month after month, and gradually the impact mounted. Aroused by the hard-hitting news stories, groups of citizens organized a Citizen's **Planning** and Housing Association, and met with city officials. There were more months of delays ...

> *Encyclopedia Britannica Films, The Baltimore **Plan***

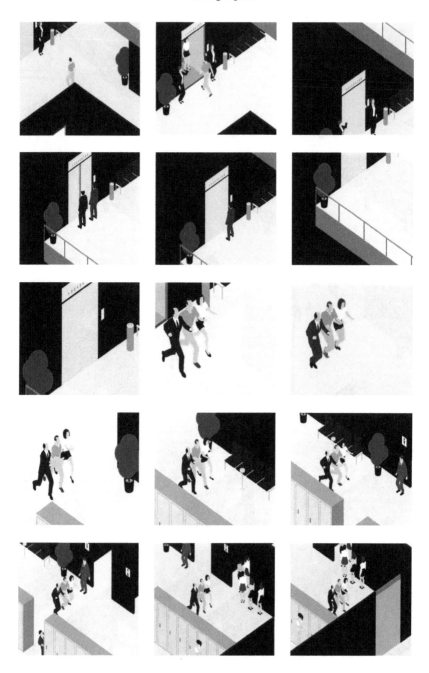

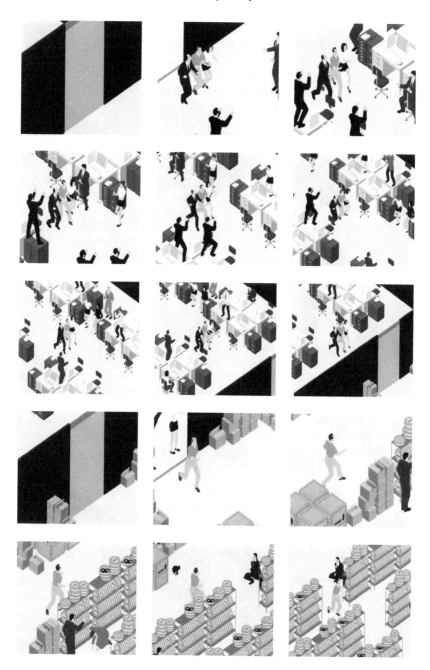

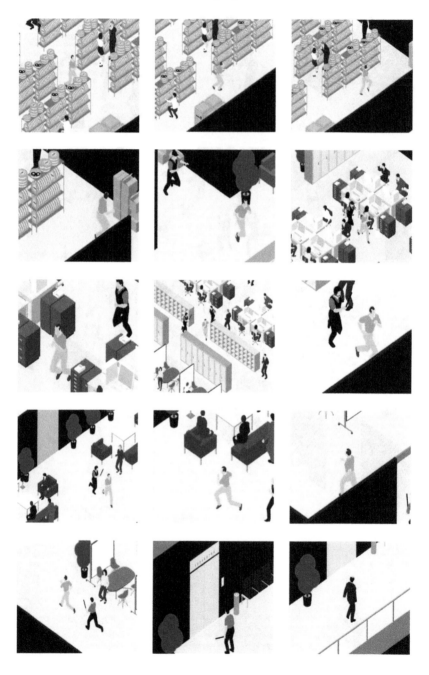

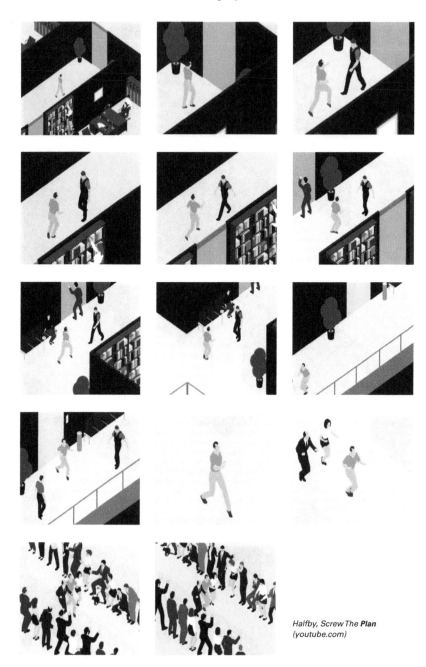

Halfby, Screw The **Plan**
(youtube.com)

'We ought to **plan** something,' yawned Miss Baker, sitting down at the table as if she were getting into bed.

'All right,' said Daisy. 'What'll we **plan**?' She turned helplessly: 'What do people **plan**?'

F. Scott Fitzgerald, The Great Gatsby

Herman Holtz (1994) pointed out "that everyone talks about the need for a business **plan** but most people starting small businesses do nothing about it." There doesn't appear to be any person who has systematically determined the percentage of entrepreneurs who start out with business **plans**. Available estimates have tended to relate to strategic **plans** for ongoing small businesses. See, for example, Rue and Ibrahim (1998; Karger, 1996; Mazzarol, 2001; Sexton & Van Auken, 1985). As far as new small businesses go, Siropolis (1997) guess-estimated that only about 5% of them start out with business **plans**. There are many reasons why most start-up entrepreneurs do not write business **plans**. One common reason is the view that business **plans** are intended only for raising business funds, implying therefore that if an entrepreneur doesn't need external financing, there is no need to prepare a business **plan**. Although existing literature doesn't seem to support the view that business **plans** are written exclusively for raising business funds, there is some support for the view that the single most important reason for writing business **plans** is to attract external financing (Kaplan & Warren, 2007). However, according to Zimmerer & Scarborough (1996) and Ford, Bornstein & Pruitt (2007), the first and foremost purpose of business **plans** is to provide guidelines for suc-cessfully managing a business. Raising capital is a secondary purpose.

Another common reason why most entrepreneurs do not write business **plans** is what David Bangs (1993) called the "Man of Action Problem," the preference for doing things instead of thinking about them or even writing about them. This view about business **plans** reflects the "Just Do It" philos-ophy, made popular by entertainer-turned-entrepreneur Wally "Famous" Amos (1999). He argued that formal business **plans** take too much time and require too much skill. Moreover, the analysis that goes into business **plans** may predict negative outcomes. Such outcomes could prevent the would-be entrepreneur from actually becoming one. Mazzarol (2001) has distinguished between formal business **plans** and the process of **planning**. Almost all start-up entrepreneurs undertake some **planning** activities, which may fall under what Van Auken & Neeley call "undocumented pre-launch preparations" (2000). Start-up entrepreneurs, often intuitively and informally, develop a sense of an unsatisfied need in the market and the relevant customer segment that can be helped to satisfy their need. They then proceed to satisfy the need, often

a small group of customers at a time. This intuitive **planning** is good enough for the overwhelming majority of start-up entrepreneurs (Mazzarol, 2001; Sudikoff, 1994; Gwendron, 2004). Like Wally "Famous" Amos, most start-up entrepreneurs informally ask themselves some tough questions, but they just don't document the answers they get in formal business **plans**.

Edward D. Bewayo, Pre-Start-Up Preparations: Why the Business
***Plan** Isn't Always Written (Entrepreneurial Executive)*

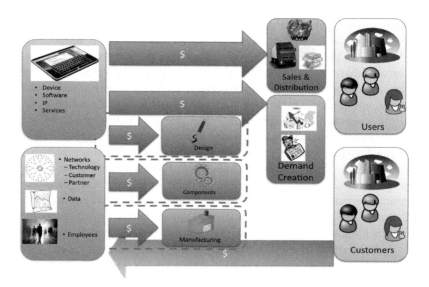

No **Plan** Survives First Contact with Customers—Business **Plans** versus Business Models

steveblank, steveblank.com

QUESTION ABOUT ONE OF THE JOKER'S QUOTES FROM DARK KNIGHT (SPOILERS!)?

Can someone help me finish off this quote from the Joker? While in the Hospital w/Dent … Joker says: "Do I look like someone who has a **plan**?"

What were the next few lines he says right after that? I remember it being interesting but I can't recall it!

doublespaded

Yahoo! Answers, Question About One of the Joker's Quotes from Dark Knight (Spoilers!)?

"We should not even speak of it," they said of Cabeza de Vaca's **plan**.

Paul Schneider, Brutal Journey: The Epic Story of the First Crossing of North America

Even Teitz's thorough appraisal of the state of **planning** in the United States in the 1990s—which he referred to as the "golden age of [North] American **planning**"—scarcely mentions the **plan** itself (Teitz 1996).

*Michael Neuman, Does **Planning** Need the **Plan**?*
*(Journal of the American **Planning** Association)*

"Well, then, I must be contented to imagine it."
"That is the best **plan**, believe me."
"Try, at least, to give me an idea of what it is."
"How can I?"
"Nothing is easier. Is it large?"

*Encyclopedia Britannica Films, The Baltimore **Plan***

"Middling."
"How is it arranged?"
"Faith, I should require pen, ink, and paper to make a **plan**."
"They are all here," said Caderousse, briskly. He fetched from an old secretary a sheet of white paper and pen and ink. "Here," said Caderousse, "draw me all that on the paper, my boy." Andrea took the pen with an imperceptible smile and began.

Alexandre Dumas, The Count of Monte Cristo

You've heard it here before: the Ontario PCs have no **plan** ... But recent developments have taken the Ontario Tories' dedication to offering up nothing to a whole new level of absurd. Not only do the Tories have no **plan**, but they have no **plan** to have a **plan** at all.

Christine McMillan, Vice President–Communications, Ontario Liberal Party,
There Is More To Not Having A Plan Than Meets The Eye (www.ontarioliberal.ca)

Somewhere along the line they gave people the impression that they didn't care for advertising—that they scarcely had a business **plan** at all. In fact it's clear that advertising was fundamental to their **plan** all along.

James Gleick, How Google Dominates Us (The New York Review of Books)

On the surface.

Beyond that, however, the Senator's investigating committee had learned that PAC/ORD had a secret arm, the kind of cover setup known as a propri-etary. This was Radial Matrix, a legally incorporated firm with headquarters in Fairfax County, Virginia. Radial Matrix—the term itself was meaningless—was a systems **planning** outfit. They advised on, and installed, manufacturing and shipping systems. Their clients included firms across the U.S. and in a number of other countries. In the last three years they'd become a huge success, with several spin-off operations and activities. The only overt connection between PAC/ORD and Radial Matrix was a contract the latter had to install a new computerized wage system on behalf of the former.

The only overt connection.

Radial Matrix was in fact a centralized funding mechanism for covert operations directed against foreign governments, against elements within foreign governments, and against political parties trying to gain power contrary to the interests of U.S. corporations abroad. It was responsible for channeling and laundering funds for unlisted station personnel, indigenous agents, terrorist operations, defector recruitment, political contributions, penetration of foreign communications networks and postal agencies.

So on, so on, so on.

"If you study the history of reform," Percival said, "you'll see there's always a counteraction built in. A low-lying surly passion. Always people ready to invent new secrets, new bureaucracies of terror."

"Don't get carried away on my behalf."

Don DeLillo, Running Dog

¡Ö¥ß¥å¡¼¥¥¥Ä¥¥¹¥Æ¡¼¥¥¥ç¥ó¤Ë¤Ð¤¿¤¤¡ª¡¡¡×¤«¤¤¤é»Î¤Þ¤Å¤¿ NO **Plan**

It gave me almost a turn to see again one of the letters which I had seen on the Count's table before I knew of his diabolical **plans**. Everything had been carefully thought out, and done systematically and with precision. He seemed to have been prepared for every obstacle which might be placed by accident in the way of his intentions being carried out. To use an Americanism, he had "taken no chances," and the absolute accuracy with which his instructions were fulfilled, was simply the logical result of his care. I saw the invoice, and took note of it: "Fifty cases of common earth, to be used for experimental purposes."

Bram Stoker, Dracula

The expression "the parcels of land with the appurtenances aforesaid" is the land already described as being **according to plan** …

Alexander Milton Ross, Thomas Dowrick Brown, Charles Murray Johnston, J. Kelso Hunter, Saskatchewan Supreme Court, Saskatchewan Court of Appeal, Court of King's Bench, and Law Society of Saskatchewan, The Saskatchewan Law Reports (Volume 11)

"Yes indeed. Such is the **plan**, the ordonation, in its marvelous simplicity and coherence. And there's something else. If you take a map of Europe and Asia and trace the development of the **plan** beginning with the castle in the north and moving from there to Jerusalem, from Jerusalem to Agarttha, from Agarttha to Chartres, from Chartres to the shores of the Mediterranean, and from there to Stonehenge, you will find that you have drawn a rune that looks more or less like this."

"And?" Belbo asked.

"And the same rune, ideally, would conect the main centers of Templar esotericism: Amiens, Troyes, Saint Bernard's domain at the edge of the Forêt d'Orient—Reims, Chartres, Rennes-le-Château, and Mont-Saint-Michel, a place of ancient druidic worship. The rune also recalls the constellation of the virgin."

"I dabble in astronomy," Diotallevi said shyly. "The Virgin has a different shape, and I believe it contains eleven stars …"

Labyrinth, Cathedral of Notre-Dame, Chartres, 1205-15 (photo: Philip Maye)

There is only one path through the labyrinth—it is 964 feet long. Its purpose is unknown but many pilgrims walk the path through the labyrinth as a meditative exercise.

*Alison Stones, Images Of Medieval Art And **Architecture** (www.medart.pitt.edu)*

The colonel smiled indulgently. "Gentlemen, gentlemen, you know as well as I do that everything depends on how you draw the lines. You can make a wain or a bear, whatever you like, and it's hard to decide whether a given star is part of a given constellation or not. Take another look at the Virgin, make Spica the lowermost point corresponding to the Provençal coast, use only five stars, and you'll see a striking resemblance between the two outlines."

"You just have to decide which stars to omit." Belbo said.

"Precisely," the colonel agreed.

"Listen," Belbo said, "how can you rule out the possibility that the meetings did take place as scheduled and that the knights are now hard at work?"

Because I perceive no symptoms, and allow me to add, 'unfortunately.' No, the **plan** was deliberately interrupted. And perhaps those who were to carry it to its conclusion no longer exist. The groups of the thirty-six may have been broken up by some worldwide catastrophe. But some other group of men with spirit, men with the right information, could perhaps pick up the thread of the plot. Whatever it is, that something is still there. I'm looking for the right men. That's why I want to publish the book: to encourage reactions. And at the same time, I'm trying to make contact with people who can help me look for the answer in the labyrinth of traditional learning. Just today I managed

to meet the greatest expert on the subject. But he, alas, luminary that he is, couldn't tell me anything, though he expressed great interest in my story and promised to write the preface ..."

Umberto Eco, *Foucault's Pendulum*

Just then, Christopher Smith from the art department showed up. "Hey there, Edwin! I have with me the cover for that book on chocolates. The one you put a rush order on." As always, Christopher was dressed completely in off-maroon. (He thought he was dressing in black, but he was colour-blind and no one ever had the heart to tell him.) Christopher wore a lush goatee and dark-tinted glasses. He insisted on signing his name *X-opher* and was always offering to show people his pierced nipple. "It didn't hurt," he'd say "Not as much as you'd think."

Christopher (or "X-opher," as he liked to be known) stood in front of Edwin and, with a certain art-school flare, held up a display card with a picture of chocolates on it. They were arranged on a silk background with the title spelled out in ribbon, just as May had suggested. "Here is what you originally asked for," said Christopher.

"It looks fine," said Edwin. "However, I'm afraid—"

"But then I started thinking: silk, satin, stockings. What do these suggest?"

"Chris, I'm sorry but there's been a change of **plans**."

"Sex. Right? That's what they suggest. The feel of silk on your body. The taste of chocolate. These are just sensory stand-ins for sex. And where does sex lead us? That's right: death. So I was thinking, instead of going with the original concept, why not do something a little more creative, a little more risqué, a little more—how shall I say—intriguing?" ("Intriguing" was Christopher's favourite word. He picked it up from his second-year **design** instructor at York University. It had since become something of a Christopher trademark.) And then, with an even greater flourish, he unveiled his follow-up **design**. It was a mound of rotting skulls piled on top of a silk pillow, with a snake sliding out of one of the eye sockets. There wasn't a chocolate in sight.

"Chris, listen—"

"X-opher, *please*. X for short."

"Okay. Listen to me, X. Everything's changed. We aren't using that title or that cover **design**. All I need are block letters on a solid background: *What I Learned on the Mountain* by Tupak Soiree. That's it. No skulls. No snakes. No silk sheets. Just block letters and a two-tone cover, okay? I don't want you to spend a lot of energy on this. What is the shortest increment of time you charge us for?"

"Temporally or spiritually?"

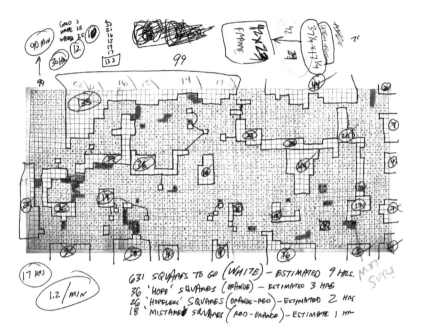

*Ben Husmann, **Planning**, estimating (flickr.com)*

I am making an attempt at estimating the amount of hours I have left to work on this painting. I like how my worksheet turned out—looking very much like a **plan**.

Comments and faves:
 What in the world is going on. I am totally lost here.
 andydeitrich (49 months ago)

Reply:
 it's a b/w small copy of the grid for my "Hope" painting. I was counting squares and sectioning off areas of the painting in order to estimate time. I underestimated most of it, actually …
 Ben Husmann (49 months ago)

"Time. Real time. Like what people live their lives in."

"I charge by blocks of fifteen minutes."

"Great. Fine. I don't want you to bill us for anything over fifteen minutes. That's the maximum amount of time I want you to allot for this cover. Got it?"

"I suppose so."

"Good, because there is a much more important project coming down the line, a specialty cookbook about fried pork, and I'll need your complete creative energy for that one."

Christopher nodded, stroked his goatee the way you might stroke the vulva of the one you love and said, "Pork, eh? Well, you know what that suggests."

Will Ferguson, Generica

"The Jews have nothing to do with the **Plan**."

Umberto Eco, Foucault's Pendulum

"Crayfish? Salmon?"

"Can I say something, please? I'm enjoying our success, and you seem to wanna mess with me. It ain't fun. You're bringing me down."

"I'm just prodding you, man, to be a little more accurate in your statements."

"Hey, you asked, I answered."

"Really I'm just trying to think. I feel like some sort of other **plan** is coming out of left field."

Denis Johnson, Already Dead: A California Gothic

Groundbreaking **plans** for a single integrated welfare tax and benefit system are meeting Treasury resistance but Iain Duncan Smith, the work and pensions secretary, has been given until the end of the year to prove that his **plan** is workable and will ultimately save money.

Patrick Wintour, Iain Duncan Smith Plots Welfare Revolution
Despite Treasury Resistance (The Guardian)

Jerry and the Goldfish
... while Tom abandons his stew **plans** in favor of a frying pan, a grill, the toaster, and a pressure cooker.

Internet Movie Database, Plot Summaries

Diversification. His **plans** to diversify.

Don DeLillo, Running Dog

This was strange and worrisome: the firewood was something new. Throughout the rest of that cold day, the forty naked conquistadors huddled by their fires and wondered about the arrangements. Why couldn't they have simply gone to the village immediately? What was all the wood for? Those among them who were opposed to the **plan** from the beginning grumbled aloud that it could not be good. The fires were for roasting men, they thought.

Paul Schneider, Brutal Journey: The Epic Story of the First Crossing of North America

"The appetite grows by what it feeds on," said Caderousse, grinning and showing his teeth, like a monkey laughing or a tiger growling. "And," added he, biting off with his large white teeth an enormous mouthful of bread, "I have formed a **plan**." Caderousse's **plans** alarmed Andrea still more than his

Deutsche Fotothe, Eugen Nosko photographer (commons.wikimedia.org)

ideas; ideas were but the germ, the **plan** was reality. "Let me see your **plan**; I dare say it is a pretty one."

"Why not? Who formed the **plan** by which we left the establishment of M—! eh? was it not I? and it was no bad one I believe, since here we are!"

"I do not say," replied Andrea, "that you never make a good one; but let us see your **plan**."

Alexandre Dumas, The Count of Monte Cristo

He needed a **plan**. He definitely needed a **plan**.

Fern Michaels, Fast Track

That night he sat on a cot in an almost bare room off the kitchen. The temperature kept dropping. He heard the plastic sheeting on the windows of nearby houses whip and snap in the wind.

The girl came in.

"What's the **plan**?"

"No **plan**," he said.

"We're leaving soon, aren't we?"

"I thought you'd want to stay for a while ..."

Don DeLillo, Running Dog

Not only did he need a **plan**, he needed a **Plan** B, a **Plan** C, and maybe even a **Plan** D. Hell, he might have to use up the whole damn alphabet.

Fern Michaels, Fast Track

no **plan**—still subject to change

Troy Livesay, The Livesay Haiti Weblog

"Sounds like you got a lot of **plans**."

"No, I have no **plans**. I have a halfway house—that wants 25% of an imaginary salary—I have a family that decided to ambush me this morning, I have a four year old that thinks I'm his aunt, a social status lower than homeless people and crack addicts—No, I have no **plans**."

Jenji Kohan, Weeds: Season 7, Episode 2

And in this connection I think that by far the most useful advice was that given by Herennius Pontius, father of Caius Pontius, at the time when the Samnites, under the leadership of Caius Pontius, had enticed the Romans by fraud into the Caudine Forks between two defiles: for the Samnites had no **plan** prepared for these joyful circumstances and so they determined that the advice of Herennius Pontius should be sought. Herennius, accordingly, was consulted by a messenger from his son and he gave it as his opinion that all the Romans should be set free from there as soon as possible without receiving any hurt. On this counsel being rejected, and the same messenger returning a second time for his advice, he recommended that they should all without exception be put to death. The meaning of his first **plan**, which he esteemed the best, was that by an act of extraordinary kindness perpetual peace and friendship should be established with a most powerful nation; and by his second **plan** he meant that the renewal of the war should be put off to the distance of many ages, during which the Roman State, after the loss of these two armies, would not easily recover its strength. A third **plan**, he said, there was not.

Balthazar Ayala, Three Books on the Law of War and on the Duties
Connected with War and on Military Discipline (1582)

I didn't have transportation either, so it was hard to **plan** for anything more than five blocks from home.

Jane Hamilton, A Map of the World

JOKER
Do I really look like a guy with a **plan**? You know what I am? I'm a dog chasing cars. I wouldn't know what to do with one if I caught it. You know, I just—do things. The mob has **plans**, the cops have **plans**, Gordon's got **plans**. You know, they're schemers. Schemers trying to control their little worlds. I'm not a schemer. I try to show the schemers how pathetic their attempts to control things really are. So, when I say—ah, come here—*(he takes Dent's hand into his own)*—when I say that you and your girlfriend was nothing personal, you know that I'm telling the truth. It's the schemers that put you where you are. You were a schemer, you had **plans**, and look where that got you. *(Dent*

tries to grab the Joker.) I just did what I do best. I took your little **plan** and I turned it on itself. Look what I did to this city with a few drums of gas and a couple of bullets. Hmmm? You know—you know what I've noticed? Nobody panics when things go **"according to plan."** Even if the **plan** is horrifying! If, tomorrow, I tell the press that, like, a gang-banger will get shot, or a truckload of soldiers will be blown up, nobody panics, because it's all "part of the **plan**." But when I say that one little old mayor will die, well then everyone loses their minds! *(Joker hands Two-Face a gun and points it at his forehead.)* Introduce a little anarchy. Upset the established order, and everything becomes chaos. I'm an agent of chaos. Oh, and you know the thing about chaos? It's fair!

 Christopher Nolan (director), The Dark Knight

Christopher Nolan (director), The Dark Knight

Oh, absolutely, agreed I. It was no use crying over spilt milk. No use building castles in the air. What was needed was a **plan**—lots of **plans**—serious, practical, sensible **plans**…

 Aldous Huxley, Eyeless in Gaza

Lindberg whirls on him. "Screw the **plan**!" he shouts. "There is no **plan**. The **plan** doesn't exist."

 "What? I don't understand."

 "You stupid shit!" Lindberg snarls.

 Lawrence Sanders, Capital Crimes

I hung up, slammed a pot down on our oak table, as if that could stop the table from watching. I had to have a **plan** now, a **plan**, a good **plan**.

Jane Hamilton, A Map of the World

If you can't read the quote at the bottom it says: "Nobody panics when things go **according to plan**, even if the **plans** are horrifying." —The Joker
 Haha my **plans** to go to the midnight release might be horrifying to some. But the point is, I **plan** a lot. Even for the smallest things, and if I don't, I freak out a little bit. I wish I could relax more sometimes.
*sKai Heitz, **According to Plan**: 63/365 (www.flickr.com)*

It turned out that Al Qaeda did not have **plans** to bomb the set of "Coronation Street," Britain's longest-running soap opera.

Lauren Collins, England, Their England: The Failure of British Multiculturalism and the Rise of the Islamophobic Right (The New Yorker)

Who knows where it'll end? Our enemies instinctively will exploit our ethics as a weakness. Do we tolerate that? Do we let the bastards win? Do we say, we're ethical, we're within the law? The country, the society, the Western world may be destroyed but at least we will choose the honorable course, now the barbarians must answer to God. Is that our **plan**?

John Farrow, City of Ice

*Sarah Mayberry, The Best Laid **Plans** (Toronto: Harlequin, 2010)*

i like your **plan**

"Since you do not like *our* **plan** of action, I suggest that you tell us *your* **plan**."

Gore Vidal, Lincoln: A Novel

Plan GL
> Short for **Plan** Get Laid

UrbanDictionary.com

Guaranteed Sex
A meticulous, over the top 1-13 point **plan** for getting a woman into bed. It never fails.

Internet Movie Database, Plot Summaries

She put her lips to his ear and whispered, "What am I going to do?"
> "You're going to change your **plans**," he said, and he began undressing her.

Robert Boswell, The Geography of Desire

Plan A
> The act of chatting to a hot girl at a bar. In most circumstances the act will involve asking the girl for oral sex.
> Once **Plan** A fails it is customary to follow up with **Plans** B, C, D and often ending with **Plan** E. All taking place at the bar or on the dance floor.

UrbanDictionary.com

"Do you have something better to do today? Did you have other **plans**?"
> She shook her head. She wished he'd lighten up. "Do I get lunch out of this, at least?"
> "McDonald's."
> "No way. We're eating upscale or I'm not participating."
> Gitteridge gripped her wrist and squeezed hard. "When do you get to understand that you never tell me what to do?"

John Farrow, City of Ice

I spent a lot of time going over the game **plan**, trying to figure out where I went wrong with girls. When I didn't make it, I'd spend hours saying, "Jesus Christ, why did I take no for an answer when she really wanted yes?" [Fleming and Fleming 1975, pp. 22-23]

Murray S. Davis, Smut: Erotic Reality/Obscene Ideology

It doesn't matter how much of an aphrodisiac oysters are, if your sweetheart doesn't like oysters, your **plan** won't work.

*GetRomantic.com, How to **Plan** A Romantic Dinner*

The Hick Chick
Clueless country rooster Clem's **plan** to marry his sweetheart Daisy are ruined when city slicker Charles sweeps Daisy off her (hen's) feet. When Charles takes Daisy to the big city, Clem follows and tries to win her back (while get punched a lot by Charles).

She Wouldn't Say Yes
... and with her father's help, pursues her and hatches a **plan** to marry her. Meanwhile, she has her own **plan** to get rid of him ...

Internet Movie Database, Plot Summaries

Agents **planned** to smuggle doses of oestrogen into his food to make him less aggressive ...

*Stephen Adams, Revealed: Sex Hormone **Plan** To Feminise Hitler (The Telegraph)*

"That was a silly thing to do, Fielding," I said. She agreed that it was.
"Wanted to get back at you," she said. "And I believe I may have been a little drunk when I conceived my **plan**."
"Drunk?" I said. "You were drunk? You were only fifteen."
"Actually," she said, "I was seventeen. I'm eighteen now. Didn't start school until I was seven, nearly eight."
"So what have you been up to since?" I said.
"Oh, not much," she said.

Wayne Johnston, The Colony of Unrequited Dreams

Wild Cherry
In high school, three girlfriends decide to make a secret pact with each other to wait to have sex, save themselves until they feel the time is right, despite an aggressive **plan** from the opposing sex.

"To the point and very funny, this is a must-read for all women." —*The Sun*

Not T🍒night, Mr. Right

The Best (DON'T GET) Laid Plans
for Finding *and* Marrying
the Man of Your Dreams

KATE TAYLOR

Kate Taylor, Not Tonight, Mr. Right:
The Best (Don't Get) Laid *Plans* for
Finding and Marrying the Man of Your
Dreams (New York: Marlowe, 2007)

The Hottie & The Nottie

Nate moves to L.A. to track down Cristabel, the woman he's been in love with since childhood, only to discover that his **plan** to woo her only has one hurdle to overcome—what to do with June, Cristabel's ever-present, not-so-hot best friend? What's even more complicating is Nate's growing feelings for June, whose true beauty starts to emerge.

Internet Movie Database, Plot Summaries

Plan F

This is the girl/guy that you call when you are drunk and horny. You wouldn't have sex with **Plan** F when you are sober, but you didn't pick up anyone at the bar and can't get ahold of anyone else. **Plan** F is the person that no matter what time it is, he/she will always let you come over and have your way with them.

UrbanDictionary.com

Asbestos Cement Products Association, **According to Plan**:
The Story of Modern Sidewalls for the Homes of America

Pillow Talk

Interior decorator Jan Morrow and composer Brad Allen share a phone line. Brad keeps the line occupied all day talking to his girlfriends, which annoys Jan terribly and animosity between them builds up. They however have never met and when by chance Brad sees Jan, he decides to add her to his list of conquests. Knowing however how she feels about him, he poses as an innocent Texan country boy named Rex Stetson to win her, a **plan** which seems to work.

Internet Movie Database, Plot Summaries

He was so pleased with himself. He looked around as though he hoped the people at the next table were listening. He wiped his mouth with a paper napkin and crumpled the napkin into a ball. 'Trouble with you,' he said. 'You're not honest with yourself. You won't face facts. This kind of thing swings for a while and then it stops. It's over. Get it? Finish.'

He stood up. He picked up her coffee check and, idiotically, as though it was the final insult for him to pay for her coffee, she plucked it out of his hand. 'Okay,' he said. 'If you want to be friends, all right. If not, it makes no difference to me. Suit yourself.'

He went up the aisle of tables to the cashier's desk. A black face loomed over her. 'That gentleman coming back?'

'No.'

The waiter cleared the dishes and an old man with a tremor in his hands sat down in Vito's place. She looked at the man and, sick, got up and went out of the restaurant. She wandered along Lexington Avenue, crossed over on to Fifth and began walking somnambulistically towards the park, ignoring traffic lights at intersections, drifting in the tide of lunchtime shoppers. At Fifty-Third Street, she crossed the street as though by instinct, walked past a large church whose name she had never bothered to know, and entered the foyer of the Museum of Modern Art. In her art school years she had come here almost every day and now, still in a trance, she paid and wandered through the cool, yet violent rooms of abstracts into the quiet sanctuary of the sculpture garden. She ignored the people lunching on the terrace, went to a bench and sat. A rapacious, knowing pigeon stalked the base of Lachaise's massive female nude, then, cautious, came to her bench. The pigeon bothered her: its cocked eye was cunning, yet stupid; there were no thoughts inside that sleek, tiny head. Scavenger and predator, its cold eye was Vito's and for a moment its presence almost drove her to leave. But why should she run: this garden was her place, not his. She stamped her foot and the pigeon, startled, flew up and out of the garden. Heartened, she began to **plan**.

Today was Thursday. She would not go back to the office this afternoon, and tomorrow she would stay home sick. On Monday, he would be gone for fourteen days and by the time he returned from Mexico, she would have herself in hand. Besides, Brendan would finish his book in the next six weeks or so, and then she could quit this job forever. Somehow, they would get rid of Mrs Let-Me, and with Brendan a successful author, life would be quite different. She would treat this thing like an illness: two weeks—almost three—to convalesce. Tomorrow, she would spend all her time with the kids, those poor kids, how she'd neglected them. Their lives were starved with that old woman. Why, they've never even been in this garden. She got up from the bench and walked slowly down the garden. In her mind the children were with her and as she looked at Guimard's metro station archway, she was telling Lisa about *art nouveau*. Lisa was perhaps a little young for that, but a start must be made somewhere, otherwise you developed adults like Vito. She supposed that with his training as an art director Vito might know something about *art nouveau*. But in her mind, she saw Vito knowing about in only as a promotion gimmick. He cheapened everything. He ...

No, she mustn't think of him. She tried to bring the children back into the sculpture garden. Look, Liam, do you see that statue? That is a statue of a famous writer called Balzac. Your father might be famous too, one day. Do I love my children, of course I do. I'd throw myself in front of a subway train to save their lives. Yes, but admit it, I wanted a rest from them, I wanted a job, I wanted excitement. *Excitement.* Krim's apartment and that vulgar brute in his jockey shorts, wearing his gold wristwatch with the gold-linked watchstrap, he wears it even when he's naked. He wore it while he laid fat Norma. And Louise, sexless, dried-up Louise, who got me this job. Thank you for nothing, Louise.

The children; she must forget him and think of the children. Tomorrow she could spend all day with the children. She could bring them here and show them everything. We'll have lunch on that terrace. Cokes and hamburgers.

No, not hamburgers.

Brian Moore, An Answer from Limbo

With no greater events than these in the Longbourn family, and otherwise diversified by little beyond the walks to Meryton, sometimes dirty and sometimes cold, did January and February pass away. March was to take Elizabeth to Hunsford. She had not at first thought very seriously of going thither; but Charlotte, she soon found, was depending on the **plan**, and she gradually learned to consider it herself with greater pleasure as well as greater certainty. Absence had increased her desire of seeing Charlotte again, and weakened her disgust of Mr. Collins. There was novelty in the scheme; and as, with such a

Lynn Schnurnberger, The Best Laid **Plans**
(New York: Ballantine Books, 2011)

mother and such uncompanionable sisters, home could not be faultless, a little change was not unwelcome for its own sake. The journey would, moreover, give her a peep at Jane; and, in short, as the time drew near, she would have been very sorry for any delay.

Jane Austen, Pride and Prejudice

She glanced at her watch. "Now listen to my good **plan**. It is almost time for lunch, yes? We go to the *charcuterie*, we get nice things—*pâté, artichaut,* cold duck, cheese, whatever you feel ... we get a nice bottle of Pouilly Fuissée ... then I take you to my picnic place—my secret picnic place," adding this last softly, not looking at Boris now, but out the window, and speaking as though from a distance, "... it is suddenly important to me ... I feel it strongly." She turned to him again, with a special smile—one that reflected a genuine camaraderie, along with just a touch of the bittersweet remembrance of things past; in her own way, she was extremely romantic. "It is good, yes? My **plan**? And can you tell me about the picture."

Terry Southern, Blue Movie

Henry is restlessly pacing the room. "Can't even fucking smoke," as he says. The tape recorder is in the closet along with the portable drill Henry used to make a hole for the wire we've run from the closet, under the carpet to the bed. Tonight is to be the revenge of technology. The idea is that the beginnings of the encounter will be taped and that as the crucial moment approaches, Henry and I will be taking pictures. Then we will burst out of the closet. At this point I'll be wielding our big weapon, Norman Swardlow's video camera, whirring like a plague of locusts. Nicko Ross, caught with his pants down, will be so surprised, terrified, embarrassed at the thought of these images getting out, that farce will overcome muscle and he will agree to abandon his war against Henry.

That's the **plan.**

"I'm going out for a smoke," Henry says. "Let me know if anything happens."

Matt Cohen, The Bookseller

EUPHRASIA: I have often wished that the first two volumes of Rousseau's *Eloise* could be abridged and altered ... I thought it might be possible to give a different turn to the story, and to make the two Lovers stop short of the act ...

HORTENSIUS: I like your **plan**, and advise you to make this alteration yourself.

EUPHRASIA: You must excuse me, Sir—I have not yet the presumption to attempt it, or to think myself able to do justice to Rousseau in such an alteration. It must remain as it is.

—*The Progress of Romance*, 1785

Noel Perrin, Dr. Bowdler's Legacy: A History of Expurgated Books in England and America.

Kiss Me Again

He teaches at a store-front college, she counsels at **Planned** Parenthood. Their Lower East Side flatmate is Malika, Chalice's long-time friend who's bisexual. Julian is attracted to a student, Elena, but steps back from an affair. He hatches a **plan** to convince Chalice to engage in a ménage a trois ...

Internet Movie Database, Plot Summaries

Plan T

When 2 males around the same height, skin tone, and wearing the same cloths (normaly boxers & white Beatter) **plan** to bang a bitch in the same room. One starts by banging the girl leaves and the other comes in. Girl believes it's the same guy in the dark. The "T" stand 4 twin cause the two guys look alike.

UrbanDictionary.com

Glen-L: Boat **Plans**, Patterns and Supplies for the Amateur Boat Builder, History Photo #2

When Will I Be Loved

Everything appears to be going even better than **planned**. But both men have gravely underestimated Vera, who has an agenda of her own. Ford and the Count unwittingly play right into her hands, and when her **plan** of deception and manipulation comes to fruition, the results are staggering.

Internet Movie Database, Plot Summaries

In bed we concocted our **plans** for the morrow. But to my surprise and no small concern, Queequeg now gave me to understand, that he had been diligently consulting Yojo—the name of his black little god—and Yojo had told him two or three times over, and strongly insisted upon it everyway, that instead of our going together among the whaling-fleet in harbor, and in concert selecting our craft; instead of this, I say, Yojo earnestly enjoined that the selection of the ship should rest wholly with me, inasmuch as Yojo purposed befriending us; and, in order to do so, had already pitched upon a vessel, which, if left to myself, I, Ishmael, should infallibly light upon, for all the world as though it

Two young women drawing **plans** of Beaufort bomber while two military men study **plans**.
State Library of South Australia

had turned out by chance; and in that vessel I must immediately ship myself, for the present irrespective of Queequeg.

Herman Melville, Moby Dick, Or the White Whale

Plan G

The person you would leave the bar with after every fat and or ugly girl has turned you down. Often this will be someone you made fun of upon arrival but in your final moments of drunken desperation, you proposition for sex. Generally this person must be approached in the parking lot to save face.

Tom: "Dammit, I can't believe that fatty with the lazy eye suddenly remembered she had a boyfriend!"
Steve: "Bummer, guess you can just go home and beat cry again"
Tom:"Hell no, I've still got **Plan G***"*
Steve:"I'm pretty sure that's not even a female!"

UrbanDictionary.com

I have forgotten to mention that, in many things, Queequeg placed great confidence in the excellence of Yojo's judgment and surprising forecast of things; and cherished Yojo with considerable esteem, as a rather good sort of god, who perhaps meant well enough upon the whole, but in all cases did not succeed in his benevolent **designs**.

Now, this **plan** of Queequeg's, or rather Yojo's, touching the selection of our craft; I did not like that **plan** at all. I had not a little relied upon Queequeg's sagacity to point out the whaler best fitted to carry us and our fortunes securely. But as all my remonstrances produced no effect upon Queequeg, I was obliged to acquiesce ...

Herman Melville, Moby Dick, Or the White Whale

I went on with the **plan**, though now that it had started, going on with it seemed almost impossible. I yanked at the pay phone by the bathroom, forced a coin in it, pressed Winona's phone number ... *Hello,* her voice machine said in its laboring parrot-cum-gramophone falsetto, *I can't,* it explained, *talk in person right now* ... "Winona, it's Nelson, eight P.M. Tuesday. I wanted to pick up my fishing rod. I'll just stop up tonight and grab it"—

Denis Johnson, Already Dead: A California Gothic

During our first cigarette break, Mr. Long Island City revealed that, indeed, his **plan** was to do precisely that—he'd already gone through this routine at

some 15 BPOs around Delhi. "Who needs to stay for the actual work? Plus," he added, flashing a salacious smile, "that way you meet more girls."

Andrew Marantz, Becoming to America: Australians Are Drunks, Americans Are Hotheads, and Other Life Lessons From My Brief Career at an Indian Call Center (Mother Jones)

My Best Friend's Wife

After Steve's job opportunity in San Francisco falls through, he comes up with a **plan**. A **plan** to do something "wild." A once-in-a-lifetime chance to experience the free-thinking lifestyle of the '70s. What if Eric's "joke" became "reality"? "So you don't mind that you missed Woodstock?" he asks a reluctant Eric. "Plato's Retreat? Who'd want to hang out in Hef's grotto with James Caan and three dozen Playmates, when you can grow up with Reaganomics and Rock Hudson's declining health?" Eric, of course, deep down, wants to do it. But convincing his lifelong friend is just the beginning. How does one ask his wife to try something that breaks so many taboos? And even if the answer is "yes," what then? What about the ramifications? And even if everything goes **according to** Steve's "plan," is it really enough?

Internet Movie Database, Plot Summaries

Plan 69

A sexual **plan** to be carried out by b1 and b2. Can only be attempted by those who are incredibly horny and love to experiment. **Plan** 69 can be carried out by:

1) Start by showering. This is to warm each other up and you must kiss and rub each other. Make sure to get hard and wet.

2) Once out of the shower, perform oral on your partner MAKING SURE you tease a lot. After each is satisfied, try out a 69 until you're ready to fuck her tits.

3) If you don't have any lube, suck on her tits for a while to get them wet and make sure your cock is still wet from the blowjob. Fuck her tits but make sure you don't cum yet!

4) Lay back on the bed and let her get on top of you. Let her ride your cock.

5) After she's tired, get her to lay back and fuck her missionary style, kissing each other.

6) If you can still fuck without cumming (you may have to slow down), fuck her really fast doggy style until you're close to finishing

7) Get her back on top and ride until you cum. Cum inside her and get her to continue riding your cock and cum to make a nice frothy milkshake. If she's really dirty get her to drink it.

UrbanDictionary.com

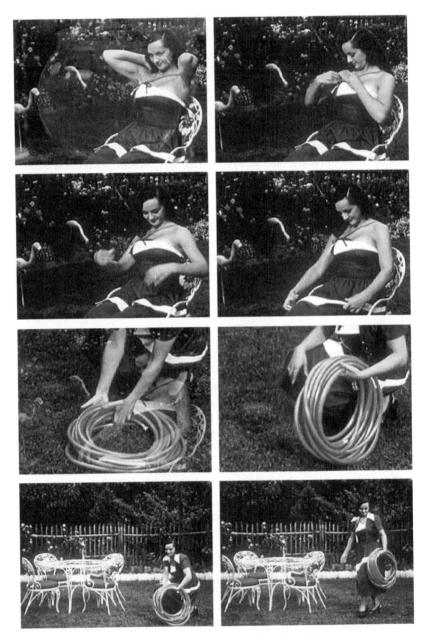

*Asbestos Cement Products Association, **According to Plan**:*
The Story of Modern Sidewalls for the Homes of America

"You make me do these things. It's not to be believed, what you make me do."

"What we make each other do."

"It's because I've lost the faith."

"You don't give a rat's ass. I understand, sweet."

"Take off your top, why don't you?"

"Due time, love."

"I don't believe. I used to believe but now I don't."

"I understand, pet."

She turned toward him, moving closer—the flask, in her left hand, resting on his chest.

"It was frankly nasty," he said.

"You tell such charming stories."

"Ain't it the truth."

"Let me get all curled up and toasty and snug."

"What happened, various sets of people were maneuvering for position. That's standard. I stationed myself **according to plan**, waiting for Earl. This can be a full-time occupation. It happens with him. Fierce enthusiasms. The earth is scorched for miles around. Other times, where is he? He says thus and so but he's not where he's supposed to be, he's in Saudi on some leasing deal. In the meantime I find myself face to face with a guy who has a bullet in his throat. It's very dark. What's going on?"

Don DeLillo, Running Dog

Unpredictable in his behavior, full of contradictory impulses and desires, Hector's character is too complexly delineated for us to feel altogether comfortable in his presence. He is not a type or familiar stock figure, and for every one of his actions that makes sense to us there is another one that confounds us and throws us off balance. He displays all the striving ambitiousness of a hardworking immigrant, a man bent on overcoming the odds and winning a place for himself in the American jungle, and yet one glimpse of a beautiful woman is enough to knock him off course, to scatter his carefully laid **plans** to the winds.

Paul Auster, The Book of Illusions

"Lipstick," said Jenni, and Edwin stopped dead in his tracks.

"Pardon?"

"On your collar," said Jenni. "See? Here, here and here. That's almost a cliché, the husband coming home with lipstick on his collar." She stepped closer, looked more carefully. "A new shade, but still the same line. I'd recognize it anywhere. It's what's-her-name. The chubby one."

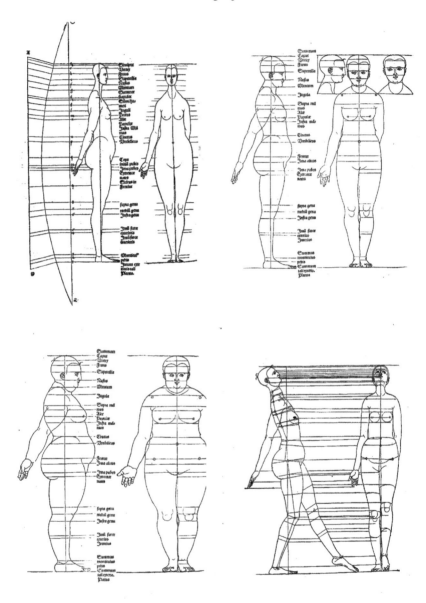

Albrecht Dürer, Clariss. Pictoris et Geometrae Alberti Dureri, de varietate figurarum et flexuris partium ac gestib. imaginum, libri duo: qui priorib. de symmetria quondam editis, nunc primum in latinum conuersi accesserunt (Norinbergae: Formschneyder, 1534)

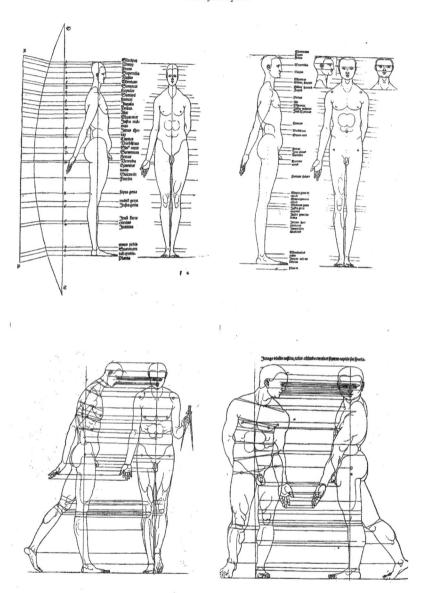

Albrecht Dürer, *Clariss. Pictoris et Geometrae Alberti Dureri, de varietate figurarum et flexuris partium ac gestib. imaginum, libri duo: qui priorib. de symmetria quondam editis, nunc primum in latinum conuersi accesserunt* (Norinbergae: Formschneyder, 1534)

"Steve?"

"No, not Steve. May. That was her name, right? So what happened?" Edwin swallowed hard. He had no alibi. He had no **plan** of evasion. He was, in fact, choking on silence. He thought of the other lipstick: the lipstick on his chest, streaked across his back, between his toes. He was a walking road map of infidelity. "Well," he said. "You see, it's, um—"

Will Ferguson, Generica

Not Now Darling

A mad cap British farce about mistresses and minks in the London fur salon of Bodley, Bodley, and Crouch. Gilbert Bodley **plans** to sell an expensive mink to a mobster dirt cheap for his wife, because the wife is Gilbert's mistress and he wants to "Close the deal." However, instead of doing his own dirty work, he gets his reluctant partner, Arnold Crouch, to do it for him. Things go awry when the mobster **plans** to buy it for his OWN mistress and soon the whole **plan** goes out the window along with women's clothing and a few other things.

Internet Movie Database, Plot Summaries

No Matter How Good Your Strategy is ...
You Will Get Screwed

*Roy Karch (director), Best Laid **Plans***

PETA **PLANS** TO LAUNCH A PORN WEB SITE

Animal rights group PETA (People for Ethical Treatment of Animals) has always managed to grab attention with its racy and bold campaigns featuring nude celebrities as well as its risqué advertisements.

Now the organization has gone a step further and announced that it will be launching its own porn Web site. The aim of launching the Web site is to raise awareness of veganism by offering pornographic material alongside graphic footage of animal mistreatment.

PETA **plans** to register itself to operate the http://www.peta.xxx Web site.

*International Business Times, PETA **Plans** to Launch A Porn Web Site*

And you told her the **plan** and dried her tears and made love to her in your strange way and waited as it got dark for her to say it ...

Denis Johnson, Already Dead: A California Gothic

My parents raised me never to ask people about their reproductive **plans**.

Tina Fey, Confessions of a Juggler: What's the Rudest Question
You Can Ask a Mother? (The New Yorker)

Before the mid-nineteen-sixties, birth control had largely been privately funded; clinics affiliated with **Planned** Parenthood ran on donations, grants, and fees for service. "I cannot imagine anything more emphatically a subject that is not a proper political or governmental activity or function or responsibility," Dwight Eisenhower said in 1959. "That's not our business."

*Jill Lepore, Birthright: What's Next for **Planned** Parenthood? (The New Yorker)*

COLLEGE STUDENTS HAVE SEX (OR **PLAN** TO)

A message from students at Wesleyan University in Connecticut:

In order to "balance the budget" the House of Representatives recently announced the intention to strip all federal funding to **Planned** Parenthood. This is unacceptable. It's time to face reality: many young people have sex, and need to know how to stay safe and healthy. Even those who have chosen to wait still need to know how to be safe and healthy when they begin their sexual activity. This extreme ideological measure threatens our youth's ability to choose their own future. In many parts of America, **Planned** Parenthood is the only place young people can go to learn about safe sex, access contraceptives, or have a simple question about "down there" answered.

*Sarah, College Students Have Sex (or **Plan** To) (Feministing)*

according to plan

Wilhelm Braune and C. Schmiedel, Topographisch-anatomischer Atlas
(Leipzig: Verlag von Veit & Comp., 1872)

i like your plan

Wilhelm Braune and C. Schmiedel, Topographisch-anatomischer Atlas
(Leipzig: Verlag von Veit & Comp., 1872)

"Nice little bonbon there," Jonathan commented.

"Oh, yes. I enjoy bringing her pleasure. I arrange complicated little events for her. She's so daring and inventive, it's great fun to **plan** for her."

"You're a selfless man."

Strange laughed. "My dear man! I never indulge in sexual activity myself."

"Never?"

"Not since I was a boy. I passed my youth in establishments of this kind. As you may know, it is the practice of candy manufacturers to allow their workers to eat to their heart's content when first they are employed. Within a few months, the workers become so cloyed that they make no further inroads on the merchandise."

"And you never—"

"Never. Too draining. Too hard on the body. But I have my own vice. Unfortunately, it's the most expensive vice in the world."

Jonathan pictured Amazing Grace's body. "Wasteful," he couldn't help commenting.

Trevanian, The Loo Sanction

And that's when I pick up the video camera, unlock the door, leap out with the camera against my face while Judith and Eileen follow their part of the **plan**, rolling away to give me a clear shot of Nicko Ross, born-again Mr. Clean, naked in a hotel room with women not his wife. Well, almost naked. I jumped out too soon and, in fact, Nicko was still wearing his briefs. Also, it later turned out, I made a mistake loading the video camera so the evidence was blank. Of course I didn't know this at the time. "Got you," I say.

Matt Cohen, The Bookseller

Batbabe: The Dark Nightie (Adult)
Bacchum City is being plagued by the maniacal Jerker who sets in motion a **plan** to steal all of the pornography in the land ...

Internet Movie Database, Plot Summaries

"I'm making moves," Mudger said. "That's how you keep going. You renew yourself. Systems **planning** is fundamentally lacking in one important respect."

"You've said. People."

"People, correct."

"Earl, it's peaked."

"I've been studying pornography for a long time now. Hell of an interesting field. Dynamics involved. The psychology. Interesting element. Strange arrays of people. Pacts and alliances and accommodations. That intrigues

NOTHING goes to **plan**, it's just pure mayhem and MADNESS! Starring Ivy Winters, Rhylie Richman, Chastity Lynn, and so many more!

Porno Dan (director), **Unplanned** *Orgies And Spontaneous Gangbangs*

me. Systems is all formulation. Essentially sterile concepts. I miss human interest ..."

Don DeLillo, Running Dog

I would get my boobs done," she said.

They were in bed, looking at her body.

"What? You're kidding." Justin stroked them. He tried to let his fingers be lighter than they were, as if by barely touching her skin he could feel more of it. "You're insane. Your boobs are perfect. What do you want?"

"Bigger, of course. A lot bigger." She cupped them with her hands and pushed them together to make cleavage. "See."

He pushed her hands off. He kissed each one on the side and then between them and then teased each nipple with his tongue. "That would be a travesty. That would be a crime against God and man. These are the most perfect breasts ever created or witnessed in the history of humanity."

She sat up. "Do you believe in God?"

"Ah. No. I do not." He tried to reattach his head to her chest. "But you see, these breasts may change my mind. They may be evidence of a divine **plan**."

Russell Smith, Girl Crazy

*Asbestos Cement Products Association, **According to Plan**:*
The Story of Modern Sidewalls for the Homes of America

His telephone rang.

"What!" he snapped into the receiver.

"How did you know it was me?" Jemima asked.

"What do you have **planned** tonight?"

"Making love with you," she answered without hesitation.

"Dinner first at your café?"

"Great. Does this mean everything is all right between us?"

"No." He was surprised at her assumption.

"Oh." The line was silent for a moment. "See you in twenty minutes."

"Fifteen?"

Trevanian, The Eiger Sanction

... it was an incredible thing to be happening for only twenty dollars. So he let her stroke him gently for a minute, wondering how it would end, and then the song ended and she stood up and pulled her thong on again, and her bra top, while Justin sat there deflated and wondering if he should pay for another song in case she was actually going to get him off there, in public, in his jeans. This was the **plan**, of course, to get him to wonder that, and he was at least sober

enough to realize that she would keep you going all night like that. And the music was sad now, just melancholy and embarrassing, and he was an idiot, and the whole sweetness of the place, the poignancy of that saccharine music, its childlike vulnerability, made him sick with pity.

It was strange to feel such fierce desire and pity so inseparable but then he supposed he always had, even when pudgy thirteen-year-old Anne-Marie Doucet had let him put his hands up her shirt and feel the heavenly weight of her breasts, and then even up her skirt to feel the rubbery mound through her underwear, when he was twelve or thirteen too, somewhere around there, although she was a year ahead of him. That had been exciting and humiliating too, for she was so ugly he would not have wanted anyone to know about it, and he felt terrible about it.

Sometimes the memory of that first touch of warm cottony pad between the humid thighs would still arouse him, even now, and he would masturbate to it at night.

Russell Smith, Girl Crazy

Yet what confession did they want from him? What more did they need to know that they didn't know already? They knew he was a plant and that most of the stories about him were invention. If they did not know how much he had betrayed, they knew enough to change or abort their **plans** before it was too late. So why the urgency? Why the frustration?

John le Carré, The Night Manager

Can Someone Help Me with My Sex **Plan**?

Okay so here's the deal. Nobody pays attention to me because I'm too much of a good girl. I make straight A's, and everyone's just like "oh cool." I made a 94 on a test once, and my dad said "I would've done better." I studied for 3 hours for that test! It made me almost cry :(

But my sister comes home drunk all of the time, and everyone gives her whatever she wants ... when she failed a class, my dad just said "do better next time."

So I have a **plan**. I'm going to ask my guy friend to have sex with me because I know if my family found out, then they'd take me more seriously ... the thing is, I don't know the best way to "get caught." Should I just leave the condom sitting by my bedroom door or something?? I thought about just putting a condom there and not really having sex but I don't want to get yelled at for something I didn't really do, you know?

Don't worry I'll be safe ... I don't want a baby or anything b/c I don't have money.

R. Michelle, Her Game
Plan (Bloomington, IN:
AuthorHouse, 2010)

So help please ... what's the best way to make sure they pay attention to me?

thank you!

*chillin, Can Someone Help Me with My Sex **Plan**? (Yahoo! Answers)*

One day she asked Céleste:

'Does Baptiste make jokes in the kitchen? Have you ever heard any stories about him? Has he got a mistress?'

'What a question!' was all the maid replied.

'Has he ever made advances to you?'

'He never looks at women. We hardly ever see him. He's always either with Monsieur or in the stables. He says he's very fond of horses.'

Renée was irritated by this apparent respectability. She insisted, for she

would have liked to be able to despise her servants. Although she had taken a liking to Céleste, she would have been very pleased to hear that she had lovers.

'But Céleste, don't you think that Baptiste is rather good-looking?'

'Me, Madame!' cried the maid, with the stupefied air of someone who has just been told something monstrous. 'Oh! I don't think about that sort of thing. I don't want a man. I've got my own **plans**, as you'll see. I'm not stupid, believe me.'

Émile Zola, The Kill

Plan L-M-N-O-P

Every girl has a back-up **plan**, a **plan** B, or even **plan** C when trying to get laid. Some girls have a longer list that go all the way to L-M-N-O-P (like mine).

The "L-M-N-O-P's" are your last resort. He doesn't care that your stumbling and slurring your speech. He doesn't care that you have been dancing with other guys all night. He doesn't care that you haven't shaved your legs. He is the guy that will take you as you are no matter what just to get a shot at you. They lower their standards for you because you are drunk, they will probably never have a shot at you again, or the times they had you they really liked the cookie. But you lower your standards because they aren't attractive, you haven't found anyone better, or the last time you guys hooked up he didn't lay it down. The LMNOP's are an option that you just don't take.

My advice, just go home.

UrbanDictionary.com

She imagined in future years there would be time to go over the series of events that led to the one event that inevitably led to the motel room. It felt like that, a whoosh of history, the somersault of dialectic rather than the firm step of will. the weight of centuries of history counterlevered against what, one person's action? Just in the **planning** they knew where it would lead. Contingencies are never really contingencies but blueprints. Probabilities became certainties. She knew she would comb over how she came to be involved with cells and **plans** and people who believed in the inevitable and absolute. Someday she would explain her intentions to someone, at least to herself And the event, which she could not think about, not yet, the event that she could not even name, she referred to in her thoughts as *then*, or *the thing*, or *it*. But surely in years to come she would think about it, over and over again ...

Dana Spiotta, Eat the Document

"I'm sorry about that," she said out of a long silence. She was sitting up, braced against the carved oaken headboard, and she had just lit another cigarette.

He hugged her around the hips and put his cheek into the curve of her waist. They had made love, and slept, and made love again, and now his voice was ragged with sleepiness. "Sorry about what?"

"About that last bit—those internal contractions when I climax. I can't help them. They're beyond my control."

He growled and mumbled, "By all means, do let's talk about it."

She laughed at him. "Don't you like to talk about it afterward? It's supposed to be very healthy and modern and all."

"I suppose. But I'm old-fashioned enough to be sentimental about the operation. For the first few minutes anyway."

"Hm-m." She took a drag on her cigarette, her face briefly illuminated in the glow. "Your kind of people are like that."

He turned over. "My kind of people?"

"The violent ones. They tend to be sentimental. I guess sentiment is their substitute for compassion. Kind of a surrogate for genuine feelings. I read somewhere that ranking Nazis used to weep over Wagner."

"Wagner makes me weep too. But not from sentiment. Go to sleep."

"All right." But after a moment of silence: "Still, I am sorry if my little spasms ruined any **plans** you had for epic control."

"Sorry for me? Or sorry for yourself?"

"Oh, you are feeling a bit bristly, aren't you? Do you always suffer from postcoitus aggression?"

He rose to one elbow. "Listen, madam. It doesn't seem to me that I started any of this. The only thing I'm feeling at this moment is postcoitus fatigue. Now good night." He dropped back on his pillow.

"Good night." But he could tell from the tension of her body that she was not prepared to sleep. "Do you know what I wish you suffered from?" she asked after a short silence.

He didn't answer.

"Intracoitus camaraderie, that's what," she said, and laughed.

"OK. You win." He pulled himself up and rested against the headboard. "Let's talk."

She scooted down under the covers. "Oh, I don't know. I'm kind of tired."

"You're going to get popped right in the eye."

"I'm sorry. But you are fun to tease. You rise to the bait so eagerly. What do you want to talk about, now that you've got me wide awake?"

"Let's talk about you, for lack of more interesting things. Tell me, how did a nice girl like you, et cetera ..."

Trevanian, The Loo Sanction

Asbestos Cement Products Association, ***According to Plan:***
The Story of Modern Sidewalls for the Homes of America

Plan Q
>The French version of a friends with benefits arrangement.
>Can also be referred to as:
>**Plan** Baise
>**Plan** Cul

A: I heard you and Sara were a couple?
*B: Nah she's just my **Plan** Q*
*A: Oh … My **Plan** Q is your ma*
B: …

>UrbanDictionary.com

Phyllida asked, "So, are we going to meet Leonard today?"
 "I'm not sure," Madeleine said.
 "Anything you want us to know about?"
 "No."
 "Are you two still **planning** to live together this summer?"

By this time Madeleine had taken a bite of her bagel. And since the answer to her mother's question was complicated—strictly speaking, Madeleine and Leonard weren't **planning** on living together, because they'd broken up three weeks ago; despite this fact, however, Madeleine hadn't given up hope of a reconciliation, and seeing as she'd spent so much effort getting her parents used to the idea of her living with a guy, and didn't want to jeopardize that by admitting that the **plan** was off—she was relieved to be able to point at her full mouth, which prevented her from replying.

"Well, you're an adult now," Phyllida said. "You can do what you like. Though, for the record, I have to say that I don't approve."

"You've already gone on record about that," Alton broke in.

"Because it's still a bad idea!" Phyllida cried. "I don't mean the propriety of it. I'm talking about the practical problems. If you move in with Leonard—or any young man—and *he's* the one with the job, then you begin at a disadvantage. What happens if you two don't get along? Where are you then? You won't have any place to live. Or anything to do."

That her mother was correct in her analysis, that the predicament Phyllida warned Madeleine about was exactly the predicament she was already in, didn't motivate Madeleine to register agreement.

"You quit your job when you met me," Alton said to Phyllida.

"That's why I know what I'm talking about."

"Can we change the subject?" Madeleine said at last, having swallowed her food.

"Of course we can, sweetheart. That's the last I'll say about it. If your **plans** change, you can always come home. Your father and I would love to have you."

Jeffrey Eugenides, The Marriage Plot

"I want it settled once and for all," Bella said. "We getting married or ain't we?"

He took a final pull at the cigarette and flipped it into the street. "I don't know yet."

"What do you mean, you don't know? What's holding you back?"

He groped for an answer, and couldn't find any. His shoulders were hunched, his folded arms pressing on his knees as he scowled at the pavement.

"Why shouldn't we get married?" Bella demanded. "We go for each other, don't we?"

"It needs more than that."

"Like what?"

Again he couldn't provide an answer.

'Where's the complication?" Bella wanted to know. "We're living in the same house, we eat at the same table. It ain't as if you gotta make some major

Kasey Michaels, *The Bride **Plan***
(Toronto: Harlequin, 2011)

changes. All we do is kick Frank out of your room and put him in mine. Then I bring my clothes across the hall and we're all set."

His scowl deepened. He tried to say something but his lips wouldn't move.

She inclined her head slightly, studying him with open suspicion. "Maybe you got some other **plans** that don't include me."

He didn't reply. He had the vague notion she'd spoken an important truth that he couldn't admit to himself.

David Goodis, *The Moon in the Gutter*

"You mean you're settling down at last?" Tiger cries, greatly amused. "Good heavens. I'd pictured you as a dashing bachelor of forty."

I suppose there are things you just can't **plan** for," Oliver says, all dewy eyed.

John le Carré, *Single & Single*

Greg Smalley and Erin Smalley
with Steve Halliday, Before You **Plan**
Your Wedding ... **Plan** Your Marriage
(New York: Howard Books, 2008)

It Had to Be You
Charlie and Anna end up spending the next three days **planning** their respective weddings together. Over the course of the weekend they consult with an embittered cast of wedding advisers who, while helping them **plan**, simultaneously deconstruct the institution of marriage as a whole.

Internet Movie Database, Plot Summaries

'So you're going to marry the hunchback?'

'No,' he murmured. 'Who told you that?'

'Oh, don't tell lies. There's no point.'

He suddenly became defiant. She alarmed him, he wanted to have done with her.

'Well, yes, I am going to marry her. So what? Can't I do what I want?'

She came up to him, her head slightly lowered, and with a wicked laugh grabbed his wrists:

'What you want? You know better than that. I'm your master. I could break your arms if I wanted to; you're no stronger than a girl.'

As he struggled, she twisted his arms with all the nervous violence of her anger. He uttered a faint cry. Then she let go and continued:

'You see? We'd better not fight; I'd only beat you.'

He remained very pale, with the shame of the pain he felt in his wrists. He watched her pacing up and down in the dressing room. She pushed back the furniture, thinking, fixing on the **plan** she had been turning over in her mind ...

Émile Zola, The Kill

She used a line from Trollope's *Barchester Towers* as an epigraph: "There is no happiness in love, except at the end of an English novel." Her **plan** was to begin with Jane Austen. After a brief examination of *Pride and Prejudice, Persuasion,* and *Sense and Sensibility,* all comedies, essentially, that ended with weddings, Madeleine was going to move on to the Victorian novel, where things got more complicated and considerably darker. *Middlemarch* and *The Portrait of a Lady* didn't end with weddings. They began with the traditional moves of the marriage plot—the suitors, the proposals, the misunderstandings—but after the wedding ceremony they kept on going. These novels followed their spirited, intelligent heroines, Dorothea Brooke and Isabel Archer, into their disappointing married lives, and it was here that the marriage plot reached its greatest artistic expression.

By 1900 the marriage plot was no more. Madeleine **planned** to end with a brief discussion of its demise.

Jeffrey Eugenides, The Marriage Plot

The Perfect Marriage

They **plan** to murder dad in law first, which succeeds, then Richard. Devoted secretary Carrie Hollings gets wind of Marianne's lies, so she's killed ...

Internet Movie Database, Plot Summaries

NATALIE: You have to cancel the **plans**.
DANA: What **plans**?
NATALIE: The marriage **plans**, you have to cancel them.
DANA: I've been engaged for two days, I have no marriage **plans**.
NATALIE: You have to call off the engagement, you have to give back the ring.
DANA: I don't have the ring, he's giving it to me at lunch.
NATALIE: You have to call off lunch.
DANA: I'm actually pretty hungry.

*Aaron Sorkin, Sports Night: Season 1, Episode 22: Napoleon's Battle **Plan***

according to plan

28 VAUGHT'S PRACTICAL CHARACTER READER.

A GENUINE HUSBAND

Young ladies, indelibly fix this shape of head in your memories. Any man who will make a natural, kind and true husband will have a head in outline from a side view like this.

PREJUDICE.

Prejudice is composed of Friendship, Parental Love, Conjugality, Inhabitiveness, Approbativeness, Veneration and Destructiveness. These elements when in the lead will give one a strong feeling for something or some-
'y and against the opposite.

Louis Allen Vaught, Vaught's Practical Character Reader (Chicago: L. A. Vaught, 1902)

i like your plan

VAUGHT'S PRACTICAL CHARACTER READER. 29

AN UNRELIABLE
HUSBAND

The reason this man is an unreliable husband is be-
cause he is very weak in Conjugality and Parental Love
and exceedingly strong in Amativeness. Young ladies,
beware of such men as husbands.

BIGAMY.

Bigamy comes directly from Amativeness. Con-
scientiousness is weak and Secretiveness large.

POLYGAMY.

Polygamy is an amalgamation of Amativeness, Spir-
ituality and Veneration. Strange, but perfectly true.

Louis Allen Vaught, Vaught's Practical Character Reader (Chicago: L. A. Vaught, 1902)

Ultimately, de Sade attacks nature itself:

"In everything we do there are nothing but idols offended and creatures insulted, but Nature is not among them, and it is she I should like to outrage. I should like to upset her **plans**, thwart her progress, arrest the wheeling courses of the stars, throw the spheres floating in space into mighty confusion, destroy what serves Nature and protect what is harmful to her, in a word, to insult her in her works—and this I am unable to do." [1966, quoted in Blanchot, p. 63]

Murray S. Davis, Smut: Erotic Reality/Obscene Ideology

"Okay, cut," said Boris quietly and went out to comfort the girl, who was crying profusely.

"It was *beautiful*, Pam," he said softly, "absolutely *beautiful*. You're a really *great* actress."

"What does *acting* have to do with it?" she asked tearfully, but it was apparent that the compliment had at least a modicum of appeasing effect on her, and she began dabbing at her eyes.

Helen Vrobel noticed as she arrived with the robes, and called out over her shoulder: "Makeup—tissues please!"

"I mean it, Pam," Boris continued, "it was terrific—you too, Arabella," he added, putting an arm around his super-star, who seemed vaguely annoyed.

"But why did we *stop*?" she wanted to know.

If you do come, **plan** on leaving very relaxed. This is where Heaven meets the Earth.

Monica Bennett, Just 5 More Minutes | An Epicurean & Adventure Travel Site

Boris looked at Pam. "Yeah, it was so great ... I mean, I thought you were going to *come*."

"But I *did* come," exclaimed Pam, looking from one to the other in astonishment. "Good heavens, couldn't you tell?"

Arabella's hurt and sullen expression stayed the same. "But that's no reason to *stop*," she said, "and to push me from you—that way it looks like you did not enjoy it." She turned to Boris. "Is it not true, Boris?"

"Well—"

Pamela couldn't believe it. "But I thought I was going to *faint* or something. I mean, *surely* you don't believe I could have kept that up?"

"Well, the thing is," said Boris, "we need to go out on your *submission* to her—I mean, we can't go out on your *rejecting* her, can we?" He thought about it for a second. "You know, the *fainting* thing might not be a bad idea."

"Well, said Pamela ruefully, "I can't very well *faint* if she doesn't *stop*, can I?"

"Yeah, well maybe not *faint* exactly, but just sort of look ... you know, *satisfied*."

"But that's what I'm *saying*—I can't do *anything* if she keeps on doing it ..."

"You mean after you come?"

She sighed, and demurely looked away. "Yes."

"Well ... what if you come twice?"

This suggestion caused her to burst into tears anew.

"Oh, I just *couldn't*, I *couldn't*, I *couldn't* ..."

"Okay," said Boris, "we'll work it out." And he smiled to himself. Great, at least now she had accepted actually having an orgasm as part of the scene.

The third take went **according to plan**—except, of course, that Arabella didn't stop as promised, and Pamela came twice—the second time, almost hysterically, when Arabella inserted two fingers while still sucking and biting her clit—and then she fell limp like a broken doll.

Terry Southern, Blue Movie

If there's a heaven, this is certainly what it must look like ... in my world, anyway. It is the vault at City Hall, where all kinds of **plans**, city council meeting minutes, ordinances and notices, specs, etc., going back to the city's founding in 1889, are stored. These are plans for some of the municipal buildings that have been constructed over the years. It's musty, dusty, and seemingly disorganized (but really not), and it's someplace I'd love to spend days of my time searching through all of the goodies. Heaven, indeed!

*Lynne's Lens, **Plans** II (flickr.com)*

other **plans** imply infinity

RUTH: Oh, goodness, everyone's here.
DAVID: With all their genitalia.
RUTH: Excuse me?
DAVID: Mom, would you like some toast?
RUTH: No thanks, I have to be in the Valley by ten-thirty.
NATE: What's in the Valley?
RUTH: I'm going to a seminar.
NATE: What seminar?
RUTH: Oh, something Robbie invited me to, the **Plan**?
CLAIRE: Isn't that like a cult?
NATE: No, it's one of those self-actualization things from the seventies, where they yell at you for twelve hours and don't let you go to the bathroom.
RUTH: Oh no, really? Should I bring some kind of jar?

*Alan Ball, Six Feet Under: Season 2, Episode 3: The **Plan***

Lenny carries a vast supply of white underwear because he has all the classic Jewish cleanliness phobias. He may bathe or shower three times a day, swill glass after glass of mineral water, and spend endless hours in the bathroom sitting on the can meditating deeply on his current **plans** and future dreams.

Albert Goldman, Ladies and Gentlemen—Lenny Bruce!!

The **Plan** is probably the biggest love letter and gift I could give to the fans ...

*Associated Press, Battlestar Actors Lay Out the **Plan** (youtube.com)*

DUTCH RAILWAY **PLANS** TO HAND PLASTIC BAGS TO PASSENGERS IN NEED ON TRAINS THAT LACK BATHROOMS

AMSTERDAM – The Dutch national railway has an unusual solution for passengers who need the bathroom on a train line **designed** without them: plastic bags.

The rail operator underlined that the bags, introduced Friday, are for use in emergencies only, when a train has stopped and passengers can't be evacuated. The idea has been met with incredulity by politicians and the general public already unhappy with the short-haul "Sprinter" trains' bathroomless **design**.

NS spokesman Eric Trinthamer confirmed Friday the "pee-bag" **plan** is not a joke. The bags are kept out of sight in the conductor's booth.

The bags have a cup-shaped plastic top and contain a highly absorbent material that turns urine into a gel-like mixture. After use the bags can be sealed and thrown in the trash.

*Associated Press, Dutch Railway **Plans** to Hand Plastic Bags to Passengers in Need on Trains That Lack Bathrooms (Winnipeg Free Press)*

Make no little **plans**. They have no magic to stir men's blood and probably themselves will not be realized. Make big **plans**; aim high in hope and work, remembering that a noble, logical diagram once recorded will never die, but long after we are gone will be a living thing, asserting itself with ever-growing insistency.

— Daniel H. Burnham, **Architect**

*Charles Moore, Daniel H. Burnham **Architect**, **Planner** of Cities*

Charles Fourier, who filled enormous books with his **plans** ...

Roland Stromberg, European Intellectual History Since 1789

*Walt Disney, Original **Plan** for EPCOT—Part 2 (uploaded by freedogshampoo, youtube.com)*

Great entrepreneurs don't just have a **Plan** B, they have **Plans** B through ∞

*Steve Blank, There's Always a **Plan** B*

In point of time, the mystery of God will be finished during the period of the sounding of the seventh [symbolic] trumpet. (Rev. 10:7.) This applies to the mystery in both senses in which it is used: the mystery or secret features of God's **plan** will then be made known and will be clearly seen; and also the "mystery of God," the Church, the embodiment of that **plan**. Both will then be finished. The secret, hidden **plan** will have sought out the full, complete number of the members of the body of Christ, and hence it, the BODY OF CHRIST, will be finished. The **plan** will cease to be a mystery, because there will be no further object in perpetuating its secrecy. The greatness of the mystery, so long kept secret, and hidden in promises, types and figures, and the wonderful grace bestowed on those called to fellowship in this mystery (Eph. 3:9), suggest to us that the work to follow its completion, for which for six thousand years Jehovah has kept mankind in expectation and hope, must be an immense work, a grand work, worthy of such great preparations. What

Ford Motor Bombing Factory, Drafting Room, 1942 (3oneseven.com)

may we not expect in blessings upon the world, when the veil of mystery is withdrawn and the showers of blessing descend! It is this for which the whole creation groans and travails in pain together until now, *waiting* for the completion of this mystery—for the manifestation of the Sons of God, the promised "Seed," in whom they shall all be blessed.—Rom. 8:19, 21, 22.

*Charles Taze Russell, Millennial Dawn: The **Plan** of the Ages: 560th Thousand*

NARRATOR: And so, by some extraordinary coincidence, fate, it seemed, had decided that Brad and Janet should keep that appointment with their friend, Dr. Everett Scott. But it was to be in a situation which none of them would have possibly foreseen. And, just a few hours after announcing their engagement, Brad and Janet had both tasted forbidden fruit. This in itself was proof that their host was a man of little morals ... and some persuasion. What further indignities were they to be subjected to? And what of the floor show that is spoken of? In an empty house? In the middle of the night? What diabolical **plan** had been shaped by Frank's crazed imagination? What indeed? From what had gone before, it was clear that this was to be no picnic.

Jim Sharman (director), Rocky Horror Picture Show

"Are you here to tell me what I am?" she inquired.

"A great soul must pass—"

"Stop flattering me. And stop interpreting, would you? Interpreting and instructing and explaining. It's like being in a house of mirrors. The funhouse kind, except it's no fun. A house of mirrors on wheels! I'm right on schedule, it's all ticking down **according to** the master's **plan**. If I fuck someone and then forget his name, or if I never knew it in the first place, that's all been written down. If I don't have the strength to get off this pallet, that's been written, too. If I destroy myself destroying others, that's just dandy! What happens if I jump the track and go tearing through the fields? What happens to the master's **plan**?"

"There is no master **plan**. No one has ever been this thing before."

"Then how come you keep telling me about the way I'm supposed to be, and why it's all right? That sounds like a master **plan** to me. It sounds like predetermination! Do you know anyone who wants to be predetermined?"

"It isn't a **plan**," he refuted her wearily. "No one knew you would perform miracles. No one knew what would come from them. And no one knows what will happen next."

"You're wearing thin, Mr. Peddler."

"Yes, I am," he confessed.

David Homel, Get on Top

It's just a jump to the left / and then a step to the right / with your hands on your hips / you bring your knees in tight / but it's the pelvic thrust that really drives you insane / let's do the time warp again.

Richard O'Brien (music and lyrics), Time Warp (Rocky Horror Picture Show)

BRAD MAJORS:	*The river was deep but I swam it*
CHORUS:	*Janet*
BRAD MAJORS:	*The future is ours, so let's **plan** it*
CHORUS:	*Janet*
BRAD MAJORS:	*So please don't tell me to can it*
CHORUS:	*Janet*
BRAD MAJORS:	*I've one thing to say, and that's*
	Dammit Janet, I love you

Jim Sharman (director), Rocky Horror Picture Show

"Why do you suppose she broke the **plan**?"

"Ah." The Vicar lifted his hands and let them fall in a gesture of helplessness. "Who can probe the human heart with only the brutish tools of logic, eh, Dr. Hemlock? She was shocked perhaps by the sight of that poor fellow in your bathroom? It is even possible that some affection for you misdirected her loyalties."

"In that case, why didn't she destroy the films?"

"Ah, there you go. Asking for sequential logic in the workings of emotion. Man is nothing if not labyrinthine. And when I say 'man' I include, of course, woman. For in this context, as in the romantic one, man embraces woman. I shall never understand why Americans doubt the Briton's sense of humor."

Trevanian, *The Loo Sanction*

I am not a pretty girl
that is not what I do
I ain't no damsel in distress
and I don't need to be rescued
so put me down, punk
maybe you'd prefer a maiden fair
isn't there a kitten stuck up a tree somewhere

I am not an angry girl
but it seems like I've got everyone fooled
every time I say something they find hard to hear
they chalk it up to my anger
and never to their own fear
and imagine you're a girl
just trying to finally come clean
knowing full well they'd prefer you
were dirty and smiling

and I am sorry
I am not a maiden fair
and I am not a kitten stuck up a tree somewhere

and generally my generation
wouldn't be caught dead working for the man
and generally I agree with them
trouble is you gotta have yourself an alternate **plan** . . .

Ani DiFranco, *Not A Pretty Girl (Not A Pretty Girl)*

I have committed fornication, true (or not true), but God is the one unable to solve the problem of Evil. Come, let us pound the fetus in the mortar with honey and pepper. Dieu le veult.

If belief is absolutely necessary, let it be in a religion that doesn't make you feel guilty. A religion out of joint, fuming, subterranean, without an end. Like a novel, not like a theology.

Five paths to a single destination. What a waste. Better a labyrinth that leads everywhere and nowhere ...

But if there is no cosmic **Plan**? What a mockery, to live in exile when no one sent you there. Exile from a place, moreover, that does not exist.

And what if there is a **Plan**, but it has eluded you—and will elude you for all eternity?

When religion fails, art provides. You invent the **Plan**, metaphor of the Unknowable One. Even a human plot can fill the void. They didn't publish my *Hearts in Exstasy* because I don't belong to the Templar clique.

To live as if there were a **Plan**: the philosopher's stone.

If you can't beat them, join them. If there's a **Plan**, adjust to it.

Umberto Eco, Foucault's Pendulum

For many years, research in AI **plan** generation was governed by a number of strong, simplifying assumptions: the **planning** agent is omniscient, its actions are deterministic and instantaneous, its goals are fixed and categorical, and its environment is static. More recently, researchers have developed expanded **planning** algorithms that are not predicated on such assumptions, but changing the way in which **plans** are formed is only part of what is required when the classical assumptions are abandoned. The demands of dynamic, uncertain environments mean that in addition to being able to form **plans**—even probabilistic, uncertain **plans**—agents must be able to effectively manage their **plans**. In this article, which is based on a talk given at the 1998 AAAI Fall Symposium on Distributed, Continual **Planning**, we first identify reasoning tasks that are involved in **plan** management, including commitment management, environment monitoring, alternative assessment, **plan** elaboration, metalevel control, and coordination with other agents. We next survey approaches we have developed to many of these tasks and discuss a **plan**-management system we are building to ground our theoretical work, by providing us with a platform for integrating our techniques and exploring their value in a realistic problem. Throughout, our discussion is informal and relies on numerous examples; the reader can consult the various papers cited for technical details.

*Martha E. Pollack and John E. Horty, There's More to Life Than Making **Plans**:*
***Plan** Management in Dynamic, Multiagent Environments (AI Magazine.)*

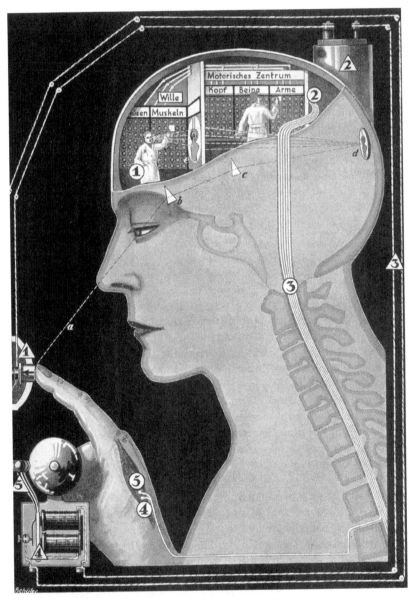

Fritz Kahn, Das Leben des Menschen; eine volkstümliche Anatomie, Biologie, Physiologie und Entwick-lungs-geschichte des Menschen, Vol. 2. Stuttgart, 1926. Relief halftone. National Library of Medicine

The nervous system here is visually compared to an electronic signaling system; the brain is an office where messages are sorted.

He did feel acutely the need for a complete reconstruction of ideas to replace the "intellectual anarchy" that was an aftermath of the French Revolution, a feeling he shared with Maistre, Saint-Simon, Hegel. As Saint-Simon's secretary he came to feel that the socialist count was too much in a hurry. He was right in seeking to found a new science of society based on the positive facts and scientific method, wrong in leaping to his conclusion about the shape of the new society. But when Comte branched out on his own, he showed himself quite as doctrinaire as Saint-Simon. Certainly the note of authority was strong in his **plan** for social reconstruction. Order must be reestablished in Europe, and having found the right foundation Comte proposed to make everybody accept it, by means of a suggested authoritarian social structure of which the high priests of positivism were to be the directors.

Roland Stromberg, European Intellectual History Since 1789

Power does not come from the **plan**, nor from the ability to execute any particular **plan**. It comes from the covert and self-generating formulation of **plans** themselves—**plans** in which the roads and cars and houses and statistical indices of growth are merely the visible parts of a calculus of expert rule.

*Larry Frolick, Suburbia's Last Stand: Big **Planning's** Audacious
Bid to Curb Suburban Sprawl (The Walrus)*

Placed in a position where he could study French administration and observe its mechanism, Rabourdin worked in the circle where his thought revolved, which, we may remark parenthetically, is the secret of much human accomplishment; and his labor culminated finally in the invention of a new system for the Civil Service of government. Knowing the people with whom he had to do, he maintained the machine as it then worked, so it still works and will continue to work; for everybody fears to remodel it, though no one, according to Rabourdin, ought to be unwilling to simplify it. In his opinion, the problem to be resolved lay in a better use of the same forces. His **plan**, in its simplest form, was to revise taxation and lower it in a way that should not diminish the revenues of the State, and to obtain, from a budget equal to the budgets which now excite such rabid discussion, results that should be two-fold greater than the present results. Long practical experience had taught Rabourdin that perfection is brought about in all things by changes in the direction of simplicity. To economize is to simplify. To simplify means to suppress unnecessary machinery; removals naturally follow. His system, therefore, depended on the weeding out of officials and the establishment of a new order of administrative offices. No doubt the hatred which all reformers incur takes its rise here. Removals required by this perfecting process, always

Encyclopedia Britannica Films, The Baltimore **Plan**

Encyclopedia Britannica Films, The Baltimore **Plan**

ill-understood, threaten the well-being of those on whom a change in their condition is thus forced. What rendered Rabourdin really great was that he was able to restrain the enthusiasm that possesses all reformers, and to patiently seek out a slow evolving medium for all changes so as to avoid shocks, leaving time and experience to prove the excellence of each reform. The grandeur of the result anticipated might make us doubt its possibility if we lose sight of this essential point in our rapid analysis of his system. It is, therefore, not unimportant to show through his self-communings, however incomplete they might be, the point of view from which he looked at the administrative horizon.

Honoré de Balzac, Bureaucracy

… and the **plan** became perfect as **plan** could be.

Jane Austen, Pride and Prejudice

"Nick," she said. "What happened to you? When did you get like this?"

I said, well, sir, if she meant when had the truth been revealed to me, it had been happenin' for a long time. Bit by bit, I'd been given a glimpse of it, and now and then I'd think I knew what it was, and now an' then I was just mystified and scared. I didn't know from what for, and I'd get the idea that I must be goin' crazy or something. And then, tonight, at her house, as I stood outside of myself **plannin'** things, and then as I'd watched what I'd **planned** take place, it was sort of like someone had pulled a trigger in my mind and

Frank Cotham, The New Yorker

"I'm sure you're a nice man, but I'm not interested in hearing your **plan** for a flat tax."

there was one great big flash of light, and at last I saw the whole truth; at last I saw why things were as they were, and why I was as I was.

Jim Thompson, Pop. 1280

Seymour Wayne was, by contrast, a solid, plodding investigator, a burly shtarker who looked like a plainclothes detective. He had been recommended to Lenny by Joe Speck, the latest sympathetic attorney to rally to his cause. Amid Lenny's confused ramblings, Wayne tried to pick out his client's desperate **plan** to exonerate himself.

Lenny had deduced from his legal research that he must find errors in questions of law rather than questions of fact in order to win a reversal of his narcotics-possession charge in the Appellate Court. Constant listening to the trial tape recording had convinced him that the judge had committed numerous mistakes. He was certain that members of the jury were familiar with his notoriety before they were selected, although all but one had vigorously denied such knowledge. Lenny felt that evidence of prejudice among the jurors could result in a reversal of his conviction.

Acting on his own behalf, while deliberately ignoring Marshall, Lenny was **planning** to file his narcotics-possession appeal by his own hand. For some unknown reason, he **planned** to have a brief written before the Department 95 hearing began the next week.

Suddenly, while pacing the room and unburdening himself, Lenny decided that Wayne could be his salvation—the latest Magic Man. As his voice filled with emotion, he pleaded with Wayne to start interviewing jurors immediately, at that very moment.

"He's nuts," Wayne thought to himself. "I don't want any part of this guy. I gotta get out of here." His head throbbing from Lenny's verbal bombardment, Wayne felt as if he had been listening to a record playing at twice its speed. Most of all, he was confused by Lenny's peculiar way of conducting business. Never had he been asked to produce the barest credentials or to comment on the efficacy of his client's **plans**.

Albert Goldman, Ladies and Gentlemen—Lenny Bruce!!

Archie was a wanker, as far as Ian could see which, characteristically, wasn't very far. Ian was more than capable of hating people he didn't know or had never met. He would take a deep loathing to someone's haircut and be unable to dissociate the person from the object. He would hate a particular brand of car, many brands in fact, and reasoned that if he hated the car it was more than likely he would hate the person who chose to drive it. In essence, anything which could be easily put into a box and classified could be easily despised.

His hatred was, however, fickle at best. Except when it came to Archie. In this instance, it was hatred based purely on personality. Archie was a plodder, a painful one step at a time trudger from routine to routine. Sure, Ian was a big fan of routines, but to him they were protectors from mundanity. Archie, however, *was* a routine, and he was rapidly becoming a focus for all the things which were wrong with Ian's stickleback existence. This morning, though, Ian had a **plan**.

John McCabe, Stickleback

Prepare yourself, you're in for a shock. Although he does not really believe in Fate, distinguished from any lesser destiny by that respectful initial capital letter, Tertuliano Máximo Afonso cannot shake off the idea that so many chance events and coincidences coming all together could very well correspond to a **plan**, as yet unrevealed, but whose development and denouement are doubtless already to be found on the tablets on which that same Destiny, always assuming it does exist and does govern our lives, set down, at the very beginning of time, the date on which the first hair would fall from our head and the last smile die on our lips.

José Saramago, The Double

'It will employ men for a year,' Abbot said, as though still hoping to persuade me of something I had so far failed to grasp. 'All the excavated stone from the quarry. Don't you see—nothing undertaken there will be wasted. This is a perfect solution.' He began to point out the features of the **plan**.

Robert Edric, The Book of the Heathen

A poem is a **plan** of the world in which all the factors I have mentioned are represented in a precisely determined ratio.

Mary Ellen Solt, Czechoslovakia (Concrete Poetry: A World View)

Every **planning** research article includes a literature review. In fact, nothing undermines the credibility of an author more than lack of familiarity with the literature, and nothing adds more credibility to a paper than building on what has been written on the topic … Unlike traditional research methods, meta-analysis uses summary statistics from primary research studies as the data points in a new analysis. Its appeal is that it aggregates all available research on a topic, allowing common threads to emerge …

*R. Ewing, Meta-Analysis of **Plan** Quality—More Than a Literature Review (**Planning**)*

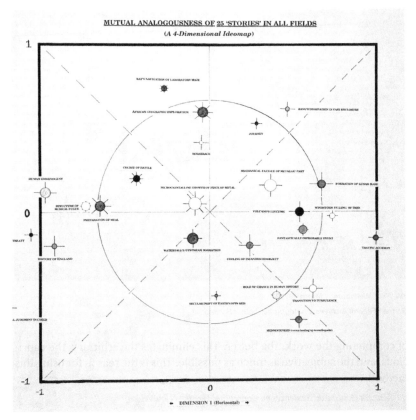

MUTUAL ANALOGOUSNESS OF 25 'STORIES' IN ALL FIELDS (A 4-Dimensional Ideomap)

Patrick Gunkel, Ideonomy: The Science of Ideas: Maps and Lists (ideonomy.mit.edu)

I will refer to the kind of writing in which I am involved as uncreative writing. In uncreative writing the idea or concept is the most important aspect of the work. When an author uses an uncreative form of writing, it means that all of the **planning** and decisions are made beforehand and the execution is a perfunctory affair. The idea becomes a machine that makes the text ...

To work with a **plan** that is preset is one way of avoiding subjectivity. It also obviates the necessity of **designing** each work in turn. The **plan** would **design** the work. Some **plans** would require millions of variations, and some a limited number, but both are finite. Other **plans** imply infinity. In each case, however, the writer would select the basic form and rules that would govern the solution of the problem. After that the fewer decisions made in the course

VW-Werk, Wolfsburg, 1 March 1973
German Federal Archives, photographer Lothar Schaack

of completing the work, the better. This eliminates the arbitrary, the capricious, and the subjective as much as possible. This is the reason for using this method.

 Kenneth Goldsmith, Sentences on Conceptual Writing (UbuWeb)

Basically there were three rules.

 Rule One: Concepts are connected by analogy. There is no way to decide at once whether an analogy is good or bad, because to some degree everything is connected to everything else. For example, potato crosses with apple, because both are vegetable and round in shape. From apple to snake, by Biblical association. From snake to doughnut, by formal likeness. From doughnut to life preserver, and from life preserver to bathing suit, then bathing to sea, sea to ship, ship to shit, shit to toilet paper, toilet to cologne, cologne to alcohol to drugs, drugs to syringe, syringe to hole, hole to ground, ground to potato.

 Rule Two says that if tout se tient in the end, the connecting works. From potato to potato, tout se tient. So it's right.

 Rule Three: The connections must not be original. They must have been made before, and the more often the better, by others. Only then do the crossings seem true, because they are obvious.

This, after all, was Signor Garamond's idea. The books of the Diabolicals must not innovate; they must repeat what has already been said. Otherwise what becomes of the authority of Tradition?

And this is what we did. We didn't invent anything; we only arranged the pieces. Colonel Ardenti hadn't invented anything either, but his arrangement of the pieces was clumsy. Furthermore, he was much less educated than we, so he had fewer pieces.

They had all the pieces, but They didn't know the **design** of the crossword. We—once again—were smarter.

I remembered something Lia said to me in the mountains, when she was scolding me for having played the nasty game that was our **Plan**: "People are starved for **plans**. If you offer them one, they fall on it like a pack of wolves. You invent, and they'll believe. It's wrong to add to the inventions that already exist."

Umberto Eco, Foucault's Pendulum

"You are all kindness, madam; but I believe we must abide by our original **plan**."

Jane Austen, Pride and Prejudice

We still have to print out sweets tokens, organise the table **plan**, print out the poems and then, I think, we sit and we wait.

Grace Bell, Happy World Happy Grace (bradfordianbridezilla.blogspot.com)

In a few months the room-sized replica of the town, made of clay, wood, and foam rubber, was completed. The woefully accurate scale model of two crazy little sculptors, it was first daubed with oil paint, then sanded down to make it look a little worn. We swung over it in rubber chairs, like infants learning how to walk, and had fun trying out the acrobatics of weightlessness. We lifted out parts we didn't fancy, then carefully put them back. As we fluttered and balanced above irrefutable injuries to the builder's ethic, above the flotsam of thoughtless **plans**, we began to approach what we had a little more carefully. The dictator of perfect arches and angles vanished from our minds; we were careful now in putting our hand on the unaccustomed body of time, and no longer wanted to imprint our thought patterns on its dense configurations. For though the city was at the mercy of our remodeling furor, and we could have imposed our simplistic solutions on the terrain, we were getting more and more anxious, and idly flapped about over this disconcerting model.

George Konrad, The City Builder

It was as though I'd stepped into a strange city, a city from which all people had fled. Besides that, it was hot. At this rate it would take years to get anything done. It had already taken long enough to accomplish what we had ...

*Encyclopedia Britannica Films, The Baltimore **Plan***

"Don't let it bother you," Bellamy replied. "You'll burn yourself out."

"That's probably true. But you know what, Bells? Even when I'm not on duty, I'm always fretting about the bullshit. I see the people in the street. I see them as lesson **plans** in my dreams."

"Sounds painful, bro'."

Peter Plate, One Foot Off the Gutter

A second reason for persistence is that the activity itself creates stimuli that direct attention toward its continuance and completion. This has already been pointed out—a book, if it is well written, tends to hold attention to the limits of its covers until it has been read through. But the same thing can be equally well illustrated from almost any administrative situation. An engineer, arriving at his office, finds on his desk a set of **plans** for a street on which he was working the previous day. Immediately, his attention is directed to these **plans** and the problems involved in completing them, and no further external stimuli may be needed to keep him at work on the **plans** for the remainder of the day.

Herbert Simon, Administrative Behavior: A Study of Decision-Making Processes in Administrative Organization

I'm not sure what this **planning** model was for but I thought it was very nicely done.
*zabdiel, **Planning** (flickr.com)*

If I ever left this town
I'd never settle down
I'd just be wanderin' around
If I ever left this town

If I wasn't by your side
I'd never be satisfied
Nothin' would feel just right
If I wasn't by your side

'Cause I'm not easy to understand
But you know me like the back of your hand
I'm your girl and you're my man
*And we're makin' **plans** . . .*

We can go on and on
Won't ever feel too long
I'll always call you home
And we'll go on and on

'Cause I know you like the back of my hand
Got a heart of gold and a piece of land
I'm your girl and you're my man
*And we're makin' **plans** . . .*

 Miranda Lambert, Makin' **Plans** (Revolution)

"Tomorrow's soon enough to change your mind."

Back in the car with the prisoner, Navarro told him his wife would come to the station tomorrow with a decision as to his short-term future.

"She'll never jail me."

"I can take you up to the end of the straightaway there, and let you go."

"Sounds like a **plan**."

"But if you turn up here at any time later tonight, I will produce my weapon and empty it into you. Are we clear?"

Kenmore's eyes widened and his ears moved back and his scalp jumped. "Jesus," he said. "I guess I better agree to your terms."

"And you come to the station tomorrow at one P.M. sharp."

"You bet. Whether you shoot me or not."

Navarro drove along the flat of the empty vale. All the trailers of the former shantytown had been removed to make room for **plans** and schemes . . .

 Denis Johnson, Already Dead: A California Gothic

The terraces covered much of the hillside at the eastern end of the island, where they were best sheltered from the wind. There were twelve levels of terracing at the time I arrived, each some twenty paces deep and banked with stone walls a yard thick and at their highest as high as a man's head. Within each terrace the ground was levelled and cleared; the stones that made up the walls had been dug out of the earth or borne from elsewhere one by one. I asked Cruso how many stones had gone into the walls. A hundred thousand or more, he replied. A mighty labour, I remarked. But privately I thought: is bare earth, baked by the sun and walled about, to be preferred to pebbles and bushes and swarms of birds? "Is it your **plan** to clear the whole island of growth, and turn it into terraces?" I asked. "It would be the work of many men and many lifetimes to clear the whole island," he replied; by which I saw he chose to understand only the letter of my question. "And what will you be planting, when you plant?" I asked. "The planting is not for us," said he. "We have nothing to plant—that is our misfortune." And he looked at me with such sorry dignity, I could have bit my tongue. "The planting is reserved for those who come after us and have the foresight to bring seed. I only clear the

renoir_girl, **Planned** *backyard garden created using The Garden Pack (flickr.com)*

ground for them. Clearing ground and piling stones is little enough, but it is better than sitting in idleness."

J. M. Coetzee, Foe

Over in Dedham jail, Sacco discovered that Carbone, the prisoner in the next cell, was a Federal Agent, placed next to him to pick up any leads about Red plots and bombings. There were **plans** for another Federal Agent to take lodgings with Rosina Sacco.

In the cell on the other side of Carbone was Celestino Madeiros, a young epileptic from the Azores, convicted of murder and bank robbery. He observed the comings and goings at Sacco's cell, particularly the visits of Mrs Sacco. Then he began to send roundabout messages. One told Sacco to get friends to visit 'Thomas' in Oak Street, Randolph. Then, through a prison trusty he passed on a yellow slip of paper, with a rudimentary map of Randolph. The house where 'Thomas' lived was marked with a cross. Sacco decided this was some new Federal scheme, and tore up the **plan**. Madeiros persisted.

Brian Jackson, The Black Flag: A Look at the Strange Case
of Nicola Sacco and Bartolomeo Vanzetti

George Nolfi (director), The Adjustment Bureau

WELFARE REFORM: GOVERNMENT HOPES
THERE'S AN APP FOR THAT

Government Minister Unveils **Plans** To Claim New Universal Credit Online But There Are Fears Program Could Lead To IT Disaster

Patrick Wintour, Welfare Reform: Government Hopes There's an App for That (The Guardian)

The man was dangerous when he had a **plan**. He meant Imp C to be profoundly different in nature. He wanted to push the notion of the self-**designing** system up a level. Reweighting prewired connections would no longer suffice. Imp C would be able to strengthen or weaken the interactions between entire distributed subsystems. It would even grow its own connections from scratch, as needed.

Lentz wanted to get hundreds, perhaps thousands of large, interdependent nets up and running at the same time. He saw them passing endless streams

of ideational tokens among themselves. The net of networks would churn at all times, not simply responding passively to new data inputs. When input stopped, it would interrogate itself in ongoing, internal dialogue. Its parts would quiz one another, associate and index themselves, even when alone. Imp C would undertake constant self-examination and reorganization.

Lentz meant to distribute these chattering subsystems not just across the connection monster's 65,536 processors but across other various and specialized hosts. Each task communicated with the others via high-speed fiber-optic cable. C, if it could be said to live anywhere at all, lived spread all over the digital map.

Never underestimate what can be accomplished by a motivated individual with a box of junk, a low budget soldering iron and a "never quit" attitude! Electronics is the ultimate hobby for the knowledge junkie because it demands a never ending ability to learn new skills, try new solutions, and to be persistent after multiple failures. Having an open mind and being able to think out-of-the box are important, too.

Our electronics **plans** and projects are often "From the Fringe," including many spy gadgets, laser projects, electronic bugs, transmitters, night vision devices, high voltage projects, and many of the other cool devices often associated with spy **plans** and projects. We like anything weird, controversial, experimental, and evil genius oriented, so "Electronics from the Fringe" will be the main focus of our electronics **plans**, spy gadget kits, and general electronics tutorials. This web site is an ongoing project and new things will be added regularly, at least once a week.

Posted by Atomic Zombie, What is LucidScience? (lucidsciencetech.blogspot.com)

"Keep out of my hair for a few weeks, Marcel."

"That should be easy."

Lentz, preoccupied, ignored my crack. "Just until I dig the foundations."

Richard Powers, Galatea 2.2

Computers are aggressive, directed chess players. This is a by-product of their programming: their software is **designed** to improve their chances of winning in ways that can be quantified. (A computer never makes a mistake in a game with six or fewer pieces on the board.) Friedel says that a human player trying to deflect a computer's attack should "do nothing and do it well." In other

Right, so "Lord" Mandelson has announced that the Government is indeed going to go ahead with their unenforceable nonsensical **plans** to "cripple the internet bandwidth of persistent file sharers." Here's a few highlights of the **plans** ...

Steve Lawson, "Piracy" And The 3 Strikes Law—A Few Thoughts From A Working Musician (stevelawson.net)

No **Plans** To Retire: Anand

He has been the undisputed world champion for the past five years but Indian chess veteran Viswanathan Anand has no **plans** of calling it quits just yet ... "There are definitely no thoughts of retirement. In fact quite the opposite. (Winning a fifth world title) has been a huge boost to my morale. As long as I enjoy, I don't see any reason to retire," Anand told reporters during a felicitation function organised by his long-time sponsors NIIT in Chennai on Sunday.

Susan Polgar, Chess Daily News and Information (susanpolgar.blogspot.com)

words, he should play a counter-game so subtle that the computer's relentless attempt to "solve" the game is thwarted. As Carlsen likes to put it, computers "are really good tactically and they can't play chess." The kind of chess they don't play easily is called "positional"—a style that focuses less on driving toward checkmate and more on having an over-all sense of the board. Carlsen, as he has matured, has increasingly adopted this approach. In the computer age, the only way to win may be to have no evident **plan**.

D. T. Max, *The Prince's Gambit: A Chess Star Emerges for the Post-Computer Age (The New Yorker)*

George Nolfi (director), The Adjustment Bureau

Blessed is the **architect** of the removed structures

. . .

Blessed is the **architect** who survives all removal

. . .

Blessed is the **architect** of the removed cut

— *David Shapiro, Prayer for a House*

Thomas Fink and Joseph Lease, "Burning Interiors": David Shapiro's Poetry and Poetics

Government's Expert Adviser on behaviour CharlieTaylor talks about his **plans** for tackling persistent absence *(uploaded by educationgovuk, http://www.youtube.com).*

"Promise me that you will not tell me anything of the **plans** . . . Not by word, or inference, or implication . . ." And she solemnly pointed to the scar. I saw that she was in earnest, and said solemnly:—

"I promise!" and as I said it I felt that from that instant a door had been shut between us.

Bram Stoker, Dracula

Non-vertical portals are classified as *horizontal.*

*Emily J. Whiting, Geometric, Topological and Semantic
Analysis of Multi-Building Floor **Plan** Data*

(Not Quite) Sweating to the Oldies

Posted by Jen, http://www.jenbutneverjenn.com

"Not what I mean at all. Bigger question altogether. In life. What do you want? What's your **plan**?"

"I haven't got a **plan**. Not at the moment. I'm drifting. Taking time out."

"Balls, frankly. Don't believe you. You've never relaxed in your life, my view. Not sure I have either. I try. Play a bit of golf, do the boat, bit of this and that, swim, screw. But my engine's going all the time. So's yours. What I like about you. No neutral gear."

He was still smiling. So was Jonathan, even though he wondered on what evidence Roper was able to base his judgment.

"If you say so," he said.

"Cooking. Climbing. Boating. Painting. Soldiering. Marrying. Languages. Divorcing. Some girl in Cairo, girl in Cornwall, girl in Canada. Some Australian doper you killed. Never trust a chap who tells me he's not after something. Why'd you do it?"

John le Carré, *The Night Manager*

In this humbling company, on this intimidating matter, who am I to tell anyone what to think? And so my **plan** was, frankly, to avoid the subject.

Bill Keller, *The Politics of Economics in the Age of Shouting (The New York Times)*

*Schedule Of No **Plan**, Oh, These Indistinct Years of You*

Tracklist: 01. It Is Like That 4 Hours Power Failure; 02. Dork Bowels; 03. Employees Must Wash Hands Before Living; 04. Life is Delicious! Eat & Joy!

Wherever the Directions do not appear to be perfectly distinct, a reference to the **Plan** *will put the visitor right. The route is marked very distinctly upon the* **Plan**.

Mount Auburn Cemetery, Including Also a Brief History and Description of Cambridge, Harvard University, and the Union Railway Company: Illustrations and **Plan**

WINSTON: Come on, man, my lunch break's almost over.

DON: Sorry. What's up?

WINSTON: Look, I've got all the info right here, based on your list, plus the whole **plan**. I've got addresses, married names, in some cases even their jobs. I've got some sad news though.

DON: What?

WINSTON: That girl, named Michelle Pepé, she died, in a car accident. Five years ago. I found the name of the cemetery where—well, where she is.

DON: Little Michelle Pepé.

WINSTON: Yeah, I'm sorry. But the other four, I've got all their info.

DON: Well, that's very impressive, Winston. I really don't know why you did all this, what am I supposed to do about it?

WINSTON: Look. The whole trip. It's all **planned**. Booked. Reservations, rental cars, everything you need, all you have to do is give them the credit card.

DON: What are you talking about?

WINSTON: You go visit them, you go to their houses, you see them, you bring flowers, pink flowers. You're just checking in.

DON: Just checking in?

WINSTON: I even got maps. Everything you need. And, I burned you a new CD. See, travelling music.

DON: That I'll take.

WINSTON: A few tips, though. Dress conservative—a little classy—don't give anything away. And always, always bring flowers. Pink flowers. And look for clues about your son. Photographs, anything, or hints, like pink stationary. And red ink. Handwriting if possible. And find that typewriter. Bring me that typewriter, and then I can forensically match the type to the letter.

DON: You're insane, Winston. Even if you could, possibly, rope me into this nonsense, which you can't, I'm not a detective, I'm not a private eye in one of your crime novels. Forget it. No fuckin' way.

WINSTON: What, after all the work I've done?

DON: Well, you do it. You take the trip, I'll pay for it—

WINSTON: Me? Impossible. I've got three jobs and five kids. And besides, it's your life. I've merely prepared the strategy, but only you can solve the mystery.

DON: And why is that?

WINSTON: Because you understand women.

Jim Jarmusch (director), Broken Flowers

Jim Jarmusch (director), Broken Flowers

Selvy also bought a canteen and filled it with water. Then he paid the man and went outside. A teenage girl was cleaning the windshield. When she was finished, they moved back onto the road.

"**Planning** on making it before dark."

"There's time," Selvy said.

"I've my doubts."

"We're right about there. I'd say less than five minutes and we'll be there."

"You don't want to forget the walk."

"I'm tuned," Selvy said. "The walk is good as made."

A coyote loped across the road and disappeared in some brush alongside a gulley.

Don DeLillo, Running Dog

The "No **Plan**" **Plans**: No **Plans** are the Best **Plans**—last minute mountain trekking in Indonesia
*Angela, no**planplans**.blogspot.com*

Four solitary walkers, they were committed now to some **plan** of their own that mystified the Indians as much as it confused half a millennium of historians. But if they had any doubts about the decision, they consoled themselves with the knowledge that they were on a well-worn trail, belying their former escort's exaggerations about the emptiness of the land ahead.

Paul Schneider, Brutal Journey: The Epic Story of the First Crossing of North America

(*The Washington Examiner's* Tim Carney quipped that "if you took Obama's **plan** and Romney's **plan,** and just met in the middle, you'd be in the middle of nowhere.")

Ross Douthat, *The Diminished President (The New York Times)*

The Gravel Road Which We Drove On

*Posted by Rahul Rane, The **Plan** — There was no **Plan**: My Excursions in Canada (rahulranecool2.blogspot.com)*

He found no pleasure or relief in the journey. Tortured by these thoughts he carried monotony with him, through the rushing landscape, and hurried headlong, not through a rich and varied country, but a wilderness of blighted **plans** and gnawing jealousies.

Charles Dickens, *Dombey and Son*

RECORDED VOICE: You have reached Moondog Electronics. If you know your party's extens—*(phone tones, ringing)*
JEANNIE: Shipping and receiving, this is Jeannie.
SCHMIDT: Jeannie? It's Dad. How are ya?
JEANNIE: Hey, uh, I'm totally swamped Dad, what's up?
SCHMIDT: Well, I have a big surprise for ya. Guess what?

Alexander Payne (director), About Schmidt

JEANNIE: What?

SCHMIDT: I'm on the road, on my way out to see you. Right now I'm just outside Grand Island.

JEANNIE: Uh, Dad, what are you—what are you talking about?

SCHMIDT: Jeannie, I've been thinking about things, and how much you mean to me, and how little time you and I have spent together these last few years, and all of a sudden I realized, what the heck am I doing in Omaha, when you're out there and I could be with you? We should be together.

JEANNIE: Wait, um, you're coming now?

SCHMIDT: If I drive straight through, I'll be there in time for supper.

JEANNIE: *(Long Pause.)* Um, gosh, I don't think so, Dad. This is not a good idea.

SCHMIDT: Well, sure it is. Don't tell me you couldn't use a little extra help with all those wedding arrangements. I'll help take the burden off.

JEANNIE: No, but, the thing is, Dad, Roberta and I and Jill, we've pretty much got everything under control—(No, no, use the bubble wrap on that one, it's too big)—it's such a nice offer but let's stick to the **plan**, okay, you get here a day or two before the wedding, like we said.

SCHMIDT: I assume you won't object to me sending any more of those cheques?

JEANNIE: Jesus, Dad, I do not have time for this, okay, you call me when you get home. Okay?

SCHMIDT: Fine. Bye Jeannie.

JEANNIE: Bye Dad.

Alexander Payne (director), About Schmidt

IV8.2.4
SUBSEQUENT COGNITION OF ILL:
THE MASTERY OVER THE LIMBS OF THE TRANCES, ETC.

Moreover **according to plan** the irreversible Bodhisattva enters on the first trance, etc. *to:* on the attainment of cessation. Moreover, **according to plan**, the irreversible Bodhisattva enters on the four applications of mindfulness, etc. *to:* he consummates the five superknowledges. He becomes a complete master over the four trances, the four Unlimited, the four formless attainments, and the attainment of cessation; he develops the four applications of mindfulness, etc. *to:* he enters on the path and the concentrations on emptiness, the signless and wishless, etc. *to:* he consummates the five superknowledges. But he does not take hold of the trances, etc. *to:* the fruit of the attainment of cessation, he does not take hold of the fruit of a Stream winner, etc. *to:* the enlightenment of a Pratyekabuddha. **According to plan** and at will he takes

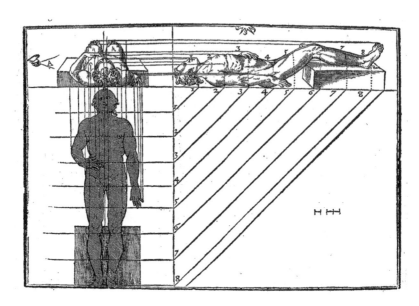

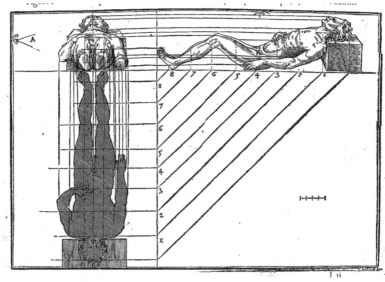

Jehan Cousin and Jean Leclerc (engraver), *Livre de pourtraiture de maistre Iean Cousin ...: contenant par vne facile instruction, plusieurs* **plans** *& figures de toutes les parties separees du corps humain, ensemble les figures entieres, tant d'ho[m]mes que de femmes, & de petits enfans, veues de front, de profil, & de dos, auec les proportions, mesures, & dimansions d'icelles, & certaines regles pour racourcir par art toutes lesdites figures: fort vtile & necessaire aux peintres, statuaires,* **architects***, orseures, brodeurs, menusiers, & generalement à tous ceux qui ayment l'art de peinture & de sculpture (Paris: Chez Iean le Clerc., 1608)*

hold of a new personality, through which he can work the weal of beings. Endowed with these attributes, etc.

Edward Conze, *The Large Sutra on Perfect Wisdom: With the Divisions of the Abhisamayalankara*

We ate Sunday dinner, Rose and Myra and Lennie and me. Rose was supposed to go home that afternoon, and I said I'd sure be proud to take her as soon as I'd rested myself a little. But naturally I didn't take her.

I couldn't, you know, since I could only see her one more time. Just once to do something about her. And that **plan** had come back to me again—the **plan** for doing something about her and Lennie and Myra at the same time. But it wasn't something that I could pull off on Sunday afternoon, or any afternoon; it had to be at night. And, anyways, I had to study some more about it.

Jim Thompson, *Pop. 1280*

Does **planning** need the **plan**? Or can **planning** go **plan**-less, naked and exposed? If the latter, why not call our profession "ning" and leave out "**plan**" entirely?

Michael Neuman, Does **Planning** Need the **Plan**?
(*Journal of the American **Planning** Association*)

He, accordingly, digested his **plan**; and the company being seated at table, affected to gaze with peculiar eagerness at the painter, who had helped himself to a large portion of the fricassee, and began to swallow it with infinite relish. Pallet, notwithstanding the keenness of his appetite, could not help taking notice of Pickle's demeanour; and, making a short pause in the exercise of his grinders, "You are surprised," said he, "to see me make so much despatch; but I was extremely hungry, and this is one of the best fricassees I ever tasted: the French are very expert in these dishes ...

Tobias Smollett, *The Adventures of Peregrine Pickle, in Which Are Included Memoirs of A Lady of Quality*

After eating he went outside, wrapped in a blanket. It was still clear in this area, broad scale of stars. No more than thirty degrees now, dropping. Dry cold. A pure state. An elating state of cold. Not weather. It wasn't weather so much as memory. A category of being.

The temperature kept dropping but this didn't signify change. It signified intensity. It signified a concentration of the faculty of recall. A steadiness of image. No stray light.

It was snowing in the mountains.

All behind him now. Cities, buildings, people, systems. All the relationships and links. The **plan**, the execution, the sequel. He could forget that now. He'd traveled the event. He'd come all the way down the straight white line.

He realized he didn't need the blanket he was wrapped in. The cold wasn't getting to him that way. In a way that called for insulation. It was perfect cold. The temperature at which things happen on an absolute scale.

All that incoherence. Selection, election, option, alternative. All behind him now. Codes and formats. Courses of action. Values, bias, predilection.

Choice is a subtle form of disease.

*New trailer for Battlestar Galactica The **Plan** (uploaded by greycoupon, youtube.com)*

When he woke up it was still dark. Gray ash in the stove. He walked to the window, naked, and looked east into the vast arc of predawn sky. He crouched by the window. He crossed his arms over his knees and lowered his head. Motionless, he waited for light to burn down on the sand and rimrock and dead trees.

Don DeLillo, Running Dog

We begin, perhaps, with a brain that is much too crowded with pure processing capacity, and therefore the death of the brain cells is part of a **planned** *and necessary* winnowing that precedes the move upward to higher levels

of intelligence: the weak ones fizzle out, and the gaps they leave as they are reabsorbed stimulate the growth buds of dendrites, which now have more capacious playgrounds, and complex correlational structures come about as a result. (Or perhaps the dendrites' own heightened need for space to grow forces a mating struggle: they lock antlers with feebler outriggers in the search for the informationally rich connections, shortcutting through intermediate territories and causing them to wither and shut down like neighborhoods near a new thruway.) With fewer total cells, but more connections between each cell, the quality of your knowledge undergoes a transformation: you begin to have a feel for situations, people fall into types, your past memories link together, and your life begins to seem, as it hadn't when you were younger, an inevitable thing composed of a million small failures and successes dependently intergrown, as opposed to a bright beadlike row of unaffiliated moments. Mathematicians need all of those spare neurons, and their careers falter when the neurons do, but the rest of us should be thankful for their disappearance, for it makes room for experience. Depending on where on the range you began, you are shifted as your brain ages toward the richer, more mingled pole: mathematicians become philosophers, philosophers become historians, historians become biographers, biographers become college provosts, college provosts become political consultants, and political consultants run for office.

Nicholson Baker, The Mezzanine

Now I must link Darwin and his riot of proliferating solutions to that one-in-a-million molecular mistake. I must trace how chance static—a dropped, added, or altered letter in the delicate program—can possibly produce the mad, limitless variety of the natural history plates. That forethought and **design** could come of feedback-shaped mistake is as unlikely as the prospect of fixing a Swiss watch by whacking it with a hammer and hoping. The element I lack is the odd eon. I have eight months. The world has all the time in the world.

Whatever works is right, worth repeating: not much of a first principle. How can blind **unplan** produce a string thick with desire to reveal its own fundament? Where is the master program he was after? Somewhere in the self-proliferating print, the snowy egret, a keyboard that plays itself when you hit the right notes. The theme Ressler hoped bitterly to forget urges me on, whispering in enzymes to rebuild the buzz all around him.

Richard Powers, The Gold Bug Variations

'In three days' time, Nash intends to quiz me on my disappearance—my desertion and dereliction of duty—and my crime.' He raised his hand to prevent me from speaking. 'Until then I must live in this limbo. I am prepared to

accommodate him and adhere to his **plan**. It is how he works. I understand that. And in understanding that, I consider myself to have some small advantage over him. It is not what another man might consider to be an advantage—I am still condemned—and it may be a very short-lived advantage—he will learn all he needs to know in a single hour of quizzing me—but, nevertheless, it is how I choose to see it: an advantage. Put crudely, I know something he does not; I know something it is his duty to learn, and that one question and its answer define his whole being. I know he has interests elsewhere, and that he involves himself in those wherever possible, now here and soon elsewhere, but at the very centre of him lies what I must tell him and what he must learn. Do you understand what I'm telling you, James?'

I nodded.

'And you do not need to tell me how fragile and possibly worthless that power is, how illusory and deceptive it may yet prove to be. It will not save; it will not redeem me; it will not remove me from Nash's blessed **plan**. But while I possess it, it is all I possess. Do you understand that, too?'

I told him I did.

He had raised his voice to tell me all this, and a fleck of blood had appeared at the side of his mouth. He touched this gently with his fingertip, studied it briefly and then wiped his lips with his palm. Whatever illness afflicted his gums and tongue, remained. I remarked on it, but he said he was still treating, though with little effect.

Robert Edric, The Book of the Heathen

"Why you?" I said. Of all people to pass it on to.

"Phil," Nicholas said, "how long does it take to get a book out? From the time you start writing it?"

"Too long," I said. "A year and a half minimum."

"That is too long. She's not going to wait that long; I could tell. I could feel it."

"How long is she going to wait?"

Nicholas said, "I don't think she is going to wait. I think that for them to **plan** is the same as acting. They **plan** and act simultaneously; to think it is to do it. They are a form of absolute mentation, pure minds. She is an all-knowing mind from which nothing is hidden. It's scary."

"But this is very good news," I said.

"Good news for us anyhow," Nicholas said. "We won't be mailing in these damn cards much longer."

Philip K. Dick, Radio Free Albemuth

Going backwards a bit, Wolgamot at some point in our relationship told me that he had had the "inspiration" for the book while standing in his mother's bedroom and that he had immediately jotted down "the **plan**" on a scrap of paper while standing at his mother's chest of drawers—the **plan** that took up the rest of his life. I should suppose this was the **plan** for the names, but it might have been the **plan** for the great sentence that, as Keith remembers, took him ten years to write.

Robert Ashley, John Barton Wolgamot (In Sara, Mencken, Christ and Beethoven There Were Men and Women)

I got this idea from **"Plan** to Stay Awake" by the Deathray Davies. I'm considering doing a series of photos "inspired" by random phrases in songs.

*Atomic Citrocity, My **Plan** (flickr.com)*

(EXTRACT FROM THE NOTE-BOOK OF JOSEPH ROULETABILLE)

'Take my revolver,' said Fred, 'and I'll take your stick.'

'Thanks,' I said; 'You are a brave man.'

I accepted his offer. I was going to be alone with the man in the room writing and was really thankful to have the weapon.

I left Fred, having posted him at the window (No. 5 on the **plan**), and, with the greatest precaution, went towards Monsieur Stangerson's apartment in the left wing of the chateau. I found him with Daddy Jacques, who had faithfully obeyed my directions, confining himself to asking his master to dress as quickly as possible. In a few words I explained to Monsieur Stangerson what was passing. He armed himself with a revolver, followed me, and we were all three speedily in the gallery. Since I had seen the murderer seated at the desk ten minutes had elapsed. Monsieur Stangerson wished to spring upon the assassin at once and kill him. I made him understand that, above all, he must not, in his desire to kill him, miss him.

When I had sworn to him that his daughter was not in the room, and in no danger, he conquered his impatience and left me to direct the operations. I told them that they must come to me the moment I called to them, or when I fired my revolver. I then sent Daddy Jacques to place himself before the window at the end of the 'right' gallery. (No. 2 on my **plan**.) I chose that position for Daddy Jacques because I believed that the murderer, tracked, on leaving the room, would run through the gallery towards the window which he had left open, and, instantly seeing that it was guarded by Larsan, would pursue his course along the 'right' gallery. There he would encounter Daddy Jacques, who would prevent his springing out of the window into the park. Under that window there was a sort of buttress, while all the other windows in the galleries were at such a height from the ground that it was almost impossible to jump from them without breaking one's neck. All the doors and windows, including those of the lumber-room at the end of the 'right' gallery—as I had rapidly assured myself—were strongly secured.

Having indicated to Daddy Jacques the post he was to occupy, and having seen him take up his position, I placed Monsieur Stangerson on the landing at the head of the stairs not far from the door of his daughter's ante-room, rather than the boudoir, where the women were, and the door of which must have been locked by Mademoiselle Stangerson herself if, as I thought, she had taken refuge in the boudoir for the purpose of avoiding the murderer who was coming to see her. In any case, he must return to the gallery where my people were awaiting him at every possible exit.

These are my plot notecards outlining my **plan** for the third section of LOST NOTES, my historical novel about a fainting pimp.

Laura Stanfill, The Barbie Jeep Method: Part 2 (laurastanfill.wordpress.com)

On coming there, he would see on his left, Monsieur Stangerson; he would turn to the right, towards the 'off-turning' gallery—the way he had pre-arranged for flight, where, at the intersection of the two galleries, he would see at once, as I have explained, on his left, Frederic Larsan at the end of the 'off-turning' gallery, and in front, Daddy Jacques, at the end of the 'right' gallery. Monsieur Stangerson and myself would arrive by way of the back of the chateau.—He is ours!—He can no longer escape us! I was sure of that.

The **plan** I had formed seemed to me the best, the surest, and the most simple. It would, no doubt, have been simpler still, if we had been able to place some one directly behind the door of Mademoiselle's boudoir, which opened out of her bedchamber, and, in that way, had been in a position to besiege the two doors of the room in which the man was. But we could not penetrate the boudoir except by way of the drawing-room, the door of which had been

Paul Rudolph's **Architectural** Office In Manhattan, Man Stepping Across File Cabinet
Tops Among Elevated Drafting Stations, c. 1965 (Library of Congress)

*Paul Rudolph's **Architectural** Office In Manhattan, Man Stepping Across File Cabinet Tops Among Elevated Drafting Stations, c. 1965 (Library of Congress)*

locked on the inside by Mademoiselle Stangerson. But even if I had had the free disposition of the boudoir, I should have held to the **plan** I had formed; because any other **plan** of attack would have separated us at the moment of the struggle with the man, while my **plan** united us all for the attack, at a spot which I had selected with almost mathematical precision,—the intersection of the two galleries.

Having so placed my people, I again left the chateau, hurried to my ladder, and, replacing it, climbed up, revolver in hand.

If there be any inclined to smile at my taking so many precautionary measures, I refer them to the mystery of The Yellow Room, and to all the

Tom Ngo, The Drafting Board (www.tomngo.net)
Coloured Pencil and Ink on Trace, 10.5 in. x 22 in.

In Its Time It Was the Largest Drafting Board in the World.

There has always been an urge to obtain large-sized drafting boards in order to draw on larger paper. This particular one grew unimaginably big, utilizing an entire face of a building and counter-weights anchored into clouds.

proofs we have of the weird cunning of the murderer. Further, if there be some who think my observations needlessly minute at a moment when they ought to be completely held by rapidity of movement and decision of action, I reply that I have wished to report here, at length and completely, all the details of a **plan** of attack conceived so rapidly that it is only the slowness of my pen that gives an appearance of slowness to the execution. I have wished, by this slowness and precision, to be certain that nothing should be omitted from the conditions under which the strange phenomenon was produced, which, until some natural explanation of it is forthcoming, seems to me to prove, even better than the theories of Professor Stangerson, the Dissociation of Matter—I will even say, the instantaneous Dissociation of Matter.

Gaston Leroux, *The Mystery of the Yellow Room*

I saw Belbo the next morning. "Yesterday we sketched a splendid dime novel," I said to him. "But maybe, if we want to make a convincing **Plan**, we should stick closer to reality."

"What reality?" he asked me. "Maybe only cheap fiction gives us the true measure of reality. Maybe they've deceived us."

"How?"

"Making us believe that on one hand there is Great Art, which portrays typical characters in typical situations, and on the other hand you have the thriller, the romance, which portrays atypical characters in atypical situations. No true dandy, I thought, would have made love to Scarlett O'Hara or even to Constance Bonacieux or Princess Daisy. I played with the dime novel, in order to take a stroll outside of life. It comforted me, offering the unattainable. But I was wrong."

"Wrong?"

"Wrong. Proust was right: life is represented better by bad music than by a Missa solemnis. Great Art makes fun of us as it comforts us, because it shows us the world as the artists would like the world to be. The dime novel, however, pretends to joke, but then it shows us the world as it actually is—or at least the world as it will become. Women are a lot more like Milady than they are like Little Nell, Fu Manchu is more real than Nathan the Wise, and History is closer to what Sue narrates than to what Hegel projects. Shakespeare, Melville, Balzac, and Dostoyevski all wrote sensational fiction. What has taken place in the real world was predicted in penny dreadfuls.

"The fact is, it's easier for reality to imitate the dime novel than to imitate art. Being a Mona Lisa is hard work; becoming Milady follows our natural tendency to choose the easy way."

Umberto Eco, *Foucault's Pendulum*

'The realism of actual life, madam, that's what it is! But let me explain, please.'

'Yes, sir, realism, indeed. I'm all for realism now. I've been taught a lesson so far as miracles are concerned. You've heard that Father Zossima is dead, haven't you?'

'No, madam, it's the first time I've heard of it,' Mitya sounded a little surprised. For a moment he thought of Alyosha.

'Last night and just imagine—'

'Madam,' Mitya interrupted, 'all I can imagine now is that I'm in an awful fix, and if you don't help me, everything will go to rack and ruin, and I first of all. Forgive the cliché, but I'm feeling so hot, I'm in a fever ...'

'I know, I know you're in a fever. You couldn't possibly be in any other state of mind, and whatever you may say, I know it all beforehand. I've long been thinking about your future, my dear Dmitry. I'm watching over it and studying it ... Oh, believe me, I'm an experienced doctor of the soul.'

'Madam, if you're an experienced doctor, then, for my part, I am an experienced patient,' said Mitya, making an effort to be polite, 'and I can't help feeling that if you are watching over my future like that, you will save it from being ruined. But, please, let me first explain the **plan** with which I've ventured to come to you and—er—what exactly I expect from you. I've come, madam—'

'Don't bother to explain. It's of minor importance. As for helping you, you're not the first I have helped. You've probably heard of my cousin Mrs Belmessov. Her husband was ruined, had gone to rack and ruin, as you so characteristically put it. Well, what do you think I did? I advised him to take up horse-breeding, and now he's simply flourishing. Do you know anything about horsebreeding?'

'Nothing at all, madam. Oh, madam, nothing at all,' cried Mitya with nervous impatience, even jumping up from his seat. 'I only implore you, madam, to listen to me, to grant me just two minutes of uninterrupted speech, so that I could first explain everything to you, the whole project with which I've come. Besides, I'm pressed for time and I'm in a terrible hurry,' Mitya exclaimed hysterically, feeling that she would start talking again and hoping to shout her down. 'I've come in despair—in the throes of despair—to beg you to lend me money, three thousand roubles, on good security, on the best possible security! Only, please, let me explain—'

'You can do it all afterwards, afterwards,' Mrs Khokhlakov waved her hands at him in her turn. 'And, anyway, I know everything you're going to tell me already. I've told you that, haven't I? You're asking for a loan, you must have three thousand roubles, but I'll give you more, immeasurably more: I will save you, my dear Dmitry. But first you must do as I tell you!'

Mitya leapt to his feet again.

'Madam, thank you, thank you. You are so kind!' he cried with great feeling. 'Good God, you have saved me. You have saved a man, madam, from a violent death, from a bullet ... My eternal gratitude—'

'I'll give you much more, infinitely more than three thousand!' cried Mrs Khokhlakov, gazing at Mitya's delight with a radiant smile.

'Infinitely? But I don't want so much. All I need is that fatal three thousand. And, for my part, I'm ready to guarantee you that sum with infinite gratitude and I propose a **plan** which—'

'Enough, it's as good as done.' Mrs Khokhlakov silenced him with the look of virtuous triumph of a benefactress. 'I've promised to save you and I will save you. I'll save you as I did Belmessov. What's your opinion of gold-mines, my dear Dmitry?'

'Gold-mines, madam? I've never thought anything about them.'

'Ah, but I've thought of them for you! I've been thinking and thinking of them. I've been watching you for the last month with that idea in my mind. I've looked at you a hundred times as you walked past and I've kept repeating to myself: here's an energetic man who ought to leave for the gold-mines. I've even studied the way you walked and I've come to the conclusion that you're the sort of man who will find many gold-mines.'

'From the way I walked, madam?' Mitya smiled.

'Why not? I can tell from that, too. Do you really deny that it's possible to tell a man's character from the way he walks? Natural sciences corroborate it. Oh, I'm now a realist, my dear Dmitry. From today, after all that affair in the monastery, which has upset me so much, I'm a complete realist and I want to take up practical work. I'm cured. Enough! as Turgenev has said.'

Fyodor Dostoyevsky, The Brothers Karamazov

The day after the hearing, Lenny was back in L.A. Frantically busy, he still found time to draw up **plans** for another total renovation of his house and property. To reconstruct all the projects hatched by Lenny Bruce as he brooded over his "$100,000 view" would baffle an archeologist fresh from excavating the ruins of some polis in Asia Minor where fourteen layers of civilization have been piled one on top of another. His house was exactly like his nightclub act. Just as the one was like a manuscript, endlessly typed and retyped, two or three times a night, six or seven nights a week, month in, month out, so the house offered a record—in brick, stucco, wood, glass, and paint—of the endless flux of Lenny's fantasy life, becoming eventually a two-story allegory of his soul.

Albert Goldman, Ladies and Gentlemen—Lenny Bruce!!

Paul Noble, *Family is Infinity (or, Hard Labour)*
Pencil on paper, work in three sections (total: 54 5/16 x 65 inches)

Event *tokens* are also individuals, and event *types* are represented by unary predicates. All event tokens are real; there are no imaginary or "possible" event tokens. Various functions on event tokens, called *roles*, yield parameters of the event. Role functions include the event's agent and time. For example, the formula

ReadBook(C) ∧ object(C) = WarAndPeace ∧ time(C) = T2

may be used to used to represent the fact that an instance of book reading occurs; the book read is *War and Peace;* and the time of the reading is (the interval) T2. Role functions are also used to represent the steps of **plans** (or any other kind of structured event). For example, suppose that reading a book is a kind of **plan**, one of whose steps is to pick up the book. The following formula could be used to represent the fact that two events have occurred, where one is reading a book, and the other is the substep of picking up the book.

ReadBook(C) ∧ pickupStep(C) = D ∧ Pickup(D)

All other facts are represented by ordinary predicates. For example, the fact that John is a human may be represented by the formula Human(John). Circumstances that change over time are also represented by predicates whose last argument is a time interval. For example, the fact that John is unhappy over the interval T1 will be represented by the formula Unhappy(John, T1)

*Henry A. Kautz, A Formal Theory of **Plan** Recognition and Its Implementation (Reasoning About **Plans**)*

EUPHRASIA: There are a great number of Novels of the same class, and we might fill a volume with a list of them: but we are now come to a resting place,—I have brought my work down to a later period than I at first intended; it is time to draw towards a conclusion.

HORTENSIUS: I hope you are not serious?—Your **plan** is by no means completed.

EUPHRASIA: I am very sensible that it is not, but this part of it is.—For what remains to be said I have more reason to fear it will be too much, than too little.—I shall endeavour to draw it into as small a compass as possible, with your assistance.—For this time we must adjourn.

HORTENSIUS: I shall have many questions to ask, and perhaps some objections to make; I think also there are many books omitted.

EUPHRASIA: At our next meeting I will hear and answer all your demands, if I do not (as I have already done) anticipate your objections.—I shall bring with me a list of Novels Original and uncommon.—I shall speak of Tales and Fables out of the reach of nature, though not of Criticism: and having dispatched these, we will gather up the clue of our progress, and proceed to inferences.

SOPHRONIA: I rejoice to hear that you are not come to a final conclusion. I hope to see you at my house next Thursday.

HORTENSIUS: I will not fail you.—I perceive that Euphrasia has yet much to say.—Perhaps I may be of some service, in protracting the conclusion you apprehend.

EUPHRASIA: Don't frighten me Hortensius.—I wish rather to contract than extend my **plan**, as I shall shew you at our next meeting.

HORTENSIUS: I take my leave for this Evening Ladies.

Clara Reeve, The Progress of Romance (1785)

THE GENTLEMAN'S HOUSE;

OR,

HOW TO PLAN ENGLISH RESIDENCES,

FROM THE PARSONAGE TO THE PALACE;

WITH TABLES OF ACCOMMODATION AND COST, AND A SERIES OF SELECTED PLANS.

By ROBERT KERR, Architect;

FELLOW OF THE ROYAL INSTITUTE OF ARCHITECTS;

PROFESSOR OF THE ARTS OF CONSTRUCTION IN KING'S COLLEGE, LONDON; ETC.

OSBORNE.

Second Edition, revised,

WITH A SUPPLEMENT ON WORKS OF ALTERATION, AND ADDITIONAL PLATES.

LONDON:

JOHN MURRAY, ALBEMARLE STREET.

1865.

the adventures of peregrine pickle, in which are included memoirs of a lady of quality

Thus determined, she formed a **plan**, the execution of which, to a spirit less enterprising and sufficient than hers, would have appeared altogether impracticable

Next morning, however, after breakfast, the pregnant lady, in pursuance of her **plan**, yawned, as it were by accident

who is disgusted upon that account, and resumes the **Plan** which she had before rejected.

Our she-projector's whole **plan** had like to have been ruined by the effect which this malicious hint had upon Trunnion

She then ordered a poultice to be prepared for his eye, which being applied, he was committed to the care of Pipes, by whom he was led about the house like a blind bear growling for prey, while his industrious yoke-fellow executed every circumstance of the **plan** she had projected

This, however, was the only point in which she had been baffled since her nuptials; and as she could by no means digest the miscarriage, she tortured her invention for some new **plan** by which she might augment her influence and authority.

he was left to the management of his preceptor, who tutored him **according to** his own **plan**, without any let or interruption.

While this **plan** was in its infancy,

He resolved, therefore, to lay the state of the case before Mr. Gamaliel Pickle, and concert such measures with him as should be thought likeliest to detach his son from the pursuit of an idle amour, which could not fail of interfering in a dangerous manner with the **plan** of his education.

In the mean time, Perry's ideas were totally engrossed by his amiable mistress,

This **plan** had been proposed to his own father,

Three days he waited patiently for the effect of this stratagem, and, in the afternoon of the fourth, ventured to hazard a formal visit, in quality of an old acquaintance. But here too he failed in his attempt: she was indisposed, and could not see company. These obstacles served only to increase his eagerness: he still adhered to his former resolution; and his companions, understanding his determination, left him next day to his own inventions. Thus relinquished to his own ideas, he doubled his assiduity, and practised every method his imagination could suggest, in order to promote his **plan**.

and Peregrine began to rave and curse his fate for having subjected him to such mean suspicion, attesting heaven and earth in the most earnest manner, that far from having composed and conveyed that stupid production, he had never seen it before, nor been privy to the least circumstance of the **plan**.

This **plan** was actually put in execution,

As they were by far the handsomest and best-accomplished couple in the room, they could not fail of attracting the notice and admiration of the spectators, which inflamed the jealousy of his three competitors, who immediately entered into a conspiracy against this gaudy stranger, whom, as their rival, they resolved to affront in public. Pursuant to the **plan** which they projected for this purpose,

In consequence of this **plan**, he every day contrived some fresh party of pleasure for the ladies, to whom he had by this time free access; and entangled himself so much in the snares of love, that he seemed quite enchanted by Emilia's charms, which were now indeed almost irresistible. While he thus heedlessly roved in the flowery paths of pleasure,

This being the prudential **plan** on which she acted,

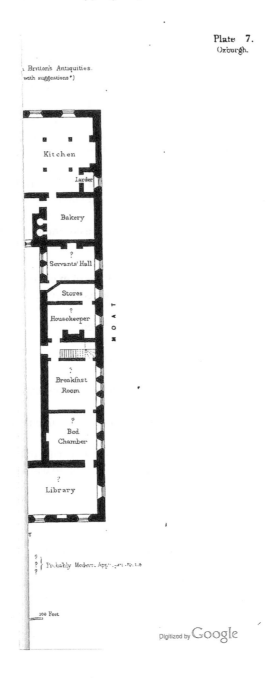

Plate 7.
Oxburgh.

Britton's Antiquities.
with suggestions*)

Kitchen

Larder

Bakery

?
Servants' Hall

Stores

?
Housekeeper

?
Breakfast
Room

?
Bed
Chamber

?
Library

MOAT

T

?
? Probably Modern Appartments
?

100 Feet

465

Chap. XXIX.—He projects a **plan** of Revenge, which is executed against the Curate.

For this purpose he and Hatchway, to whom he imparted his **plan**, went to the ale-house one evening, and called for an empty room, knowing there was no other but that which they had chosen for the scene of action.

and actually laid such a villainous **plan** for attacking our hero in the dark, that, had it been executed according to their intention,

Having imparted this discovery to his friend Hatchway, they came to a resolution of countermining the **plan** of their enemies.

The **plan** being thus digested, and the commodore made acquainted with the whole affair,

that frequently hurried him out of the **plan** of conduct which in his cooler moments he had laid down. They halted for refreshment at Montreuil,

executes a **Plan** which he had concerted

AN EVIL **DESIGN** FRUSTRATED

he concerted with himself a **plan** which was executed in this manner.

by which his **plan** had been almost entirely ruined and set aside.

This **plan** he executed, notwithstanding the pain of his wound, and the questions of the city-guard, both horse and foot, to which he could make no other answer than "Anglois, Anglois;"

Everything being adjusted **according to** their **plan**,

would be utterly ineffectual against such a **plan**

The wine, however, failed in the expected effect, and, without inspiring him with the **plan**,

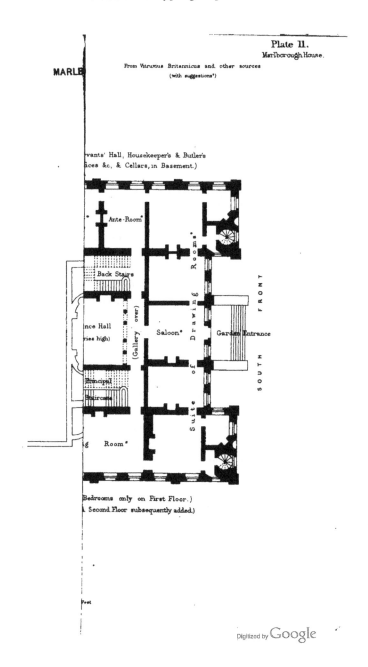

Plate 11.
Marlborough House.

From Vitruvius Britannicus and other sources
(with suggestions*)

MARLB

vants' Hall, Housekeeper's & Butler's
ices &c., & Cellars, in Basement.)

Ante-Room*

Back Stairs

Drawing Rooms*

(Gallery over)

nce Hall
ries high)

Saloon*

Garden Entrance

SOUTH FRONT

Suite of Drawing Rooms*

Principal
Staircase

g Room*

Bedrooms only on First Floor.)
Second Floor subsequently added.)

Feet

and he declining to be engaged in the project, Pallet had recourse to the genius of Pickle's valet-de-chambre, who readily embarked in the undertaking, and invented a **plan**, which was executed accordingly.

This young lady, with an air of mortification, expressed her sorrow for being the innocent cause of his anxiety; said she hoped last night's adventure would be a salutary warning to both their souls; for she was persuaded, that her virtue was protected by the intervention of Heaven; that whatever impression it might have made upon him, she was enabled by it to adhere to that duty from which her passion had begun to swerve; and, beseeching him to forget her for his own peace, gave him to understand, that neither the **plan** she had laid down for her own conduct, nor the dictates of her honour, would allow her to receive his visits, or carry on any other correspondence with him, while she was restricted by the articles of her marriage-vow.

Meanwhile the lovers enjoyed themselves without restraint, and Peregrine's **plan** of inquiry after his dear unknown was for the present postponed. His fellow-travellers were confounded at his mysterious motions,

and, whilst he put on his clothes, actually formed the **plan**

That the reader may have a clear idea of Mr. Jolter's performance, we shall transcribe the transactions of one day, as he had recorded them; and that abstract will be a sufficient specimen of the whole **plan** and execution of the work.

but, as the conversation between the two friends turned upon the information they had received, Peregrine projected a **plan** for punishing those villanous pests of society, who prey upon their fellow-creatures; and it was put in execution by Gauntlet in this manner.

But his attention was not at all dissipated by these vain reflections: he resolved to concentrate the whole exertion of his soul upon the execution of his present **plan**, desisted, in the mean time, from all other schemes of pleasure, interest, and ambition, and took lodgings in the city for the more commodious accomplishment of his purpose.

who prosecuted his **plan** with surprising eagerness and perseverance.

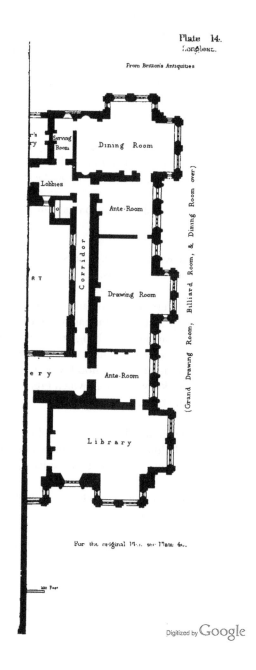

Plate 14.
Longleat.

From Britton's Antiquities

For the original Plan, see Plate 44.

100 Feet

Emilia had too much penetration to be imposed upon by this plausible pretext; in spite of her partiality for Peregrine, which had never been inflamed to such a pitch of complacency before, she comprehended his whole **plan** in a twinkling.

Baffled by her prudence and penetration, he altered his **plan**.

and a **plan** was immediately concerted,

"I therefore resolved within myself to gratify my lover's expectation, by eloping, if possible, that very night; though the execution of this **plan** was extremely difficult, because my father was upon the alarm,

"You may be sure I made no objections to this **plan**, which was immediately put in execution.

who followed me on the wings of love, in pursuance of the **plan** we had projected before my departure from Paris.

Then, without having determined upon any certain **plan**, I huddled on my clothes, muffled myself up, and, calling a chair, went to the next tavern, where I stayed no longer than was sufficient to change my vehicle; and, to the astonishment of the drawers, who could not conceive the meaning of my perturbation, proceeded to a shop in the neighbourhood, where I dismissed my second chair, and procured a hackney-coach, in which I repaired to the lodgings of my lawyer, whom I could trust.

until the issue of my lawsuit, by which I hoped to obtain some provision from my lord; and without all doubt my expectation would have been answered had I put this my **plan** in execution; but being at Paris,

Be this as it will, I honour the gentleman for his **plan**, which was ingeniously contrived and artfully conducted;

who, therefore, determined to overturn our whole **plan**, and succeeded accordingly.

and when I refused to comply with this demand, because this was the sole resource I had against his ill-usage, he would not proceed in the execution of his **plan**, though by dropping it he hurt nobody but himself; and he accused

me of having receded from my word, after I had drawn him into a considerable expense.

This woman, being in very indigent circumstance, occasioned by some losses her husband had sustained, no sooner had an opportunity of seeing and conversing with my lover, than she formed the **design** of making a conquest of him. I should have forgiven her for this scheme, whatever pangs it might have cost me, had I believed it the effect of real passion; but I knew her too well to suppose her heart was susceptible of love, and accordingly resented it. In the execution of her **plan**, she neglected nothing which she thought capable of engaging his attention. She took all opportunities of sitting near him at table, ogled him in the most palpable manner, directed her whole discourse to him, trod upon his toes; nay, I believe, squeezed his hand. My blood boiled at her, though my pride, for some time, enabled me to conceal my uneasiness; till at length her behaviour became so arrogant and gross, that I could no longer suppress my indignation,

in order to demonstrate the sincerity of what I professed. In consequence of our **plan**, I assumed, a fictitious name,

The **plan** was immediately adjusted in all its parts;

A NEW **PLAN** OF OPERATIONS

while Peregrine and his friend renewed the deliberations which had been interrupted, and settled a **plan** of operations for the next occasion:

Chap. LXXXIV.—The Conjurer and his Associate execute a **Plan** of Vengeance against certain Infidels who pretend to despise their Art; and Peregrine achieves an Adventure with a young Nobleman.

who, by divers ingenious contrivances, punished the most flagrant offenders with as much severity as the nature of their **plan** would allow. At length, they projected a scheme for chastising a number of their own acquaintance

A **PLAN** OF VENGEANCE

One mischievous **plan** that entered our hero's imagination was suggested by two advertisements published in the same paper,

according to plan

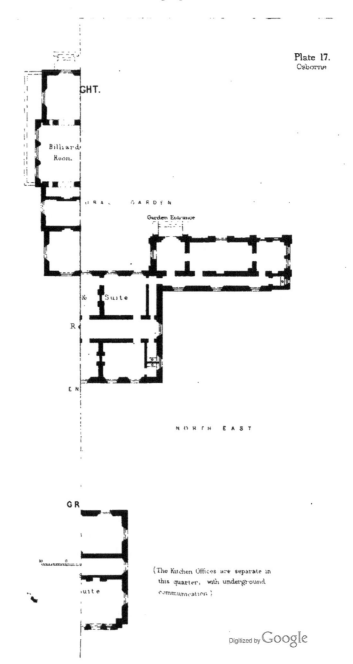

Plate 17.
Osborne

GHT.

Billiard
Room.

RA GARDEN

Garden Entrance

& Suite

R

E N

NORTH EAST

GR

(The Kitchen Offices are separate in
this quarter, with underground
communication.)

uite

472

to whom he had thought proper to communicate the **plan**

began to imagine that Pickle had projected the **plan** which was executed by his servant; and, looking upon it as a piece of unjustifiable finesse, which might be attended with very melancholy consequences to his sister or wife

and, on the other hand, he knew not how to acquit himself of the suspicion which he saw Godfrey entertain of his being the projector of the **plan**, without condescending to an explanation, which his present disposition could not brook.

This extravagant **plan** he forthwith began to execute with great eagerness and industry; and his endeavours succeeded even beyond his expectation.

Peregrine approved of the **plan**, towards the execution of which he made him and his wife a present of five hundred pounds,

far from shocking the poor man in distress by dropping the least hint of his conjecture, he desired to be favoured with six chances, if the circumstances of his **plan** would indulge him so far; and the painter, after some hesitation, condescended to comply with his request, out of pure friendship and veneration; though he observed, that in so doing he must exclude some of his most intimate companions. Having received the money, he gave Pickle his address, desiring he would, with his convenience, visit the princess, who, he was sure, would display her most engaging attractions, in order to captivate his fancy; and took his leave, extremely well pleased with the success of his application.

the nature of his **plan** being such, as would infallibly

and thus he delineated the **plan**:

This conversation helped to restore the tranquillity of Pickle's breast, though he still harboured resentment against Cadwallader, on account of the last insult; and on the instant he formed a **plan** of revenge.

he should not be backward in executing the **plan**.

The next person that addressed himself to the chief was a gentleman of a very mathematical turn, who valued himself upon the improvements he had made in several domestic machines, and now presented the **plan** of a new

contrivance for cutting cabbages in such a manner as would secure the stock against the rotting rain, and enable it to produce a plenteous after-crop of delicious sprouts. In this important machine he had united the whole mechanic powers, with such massy complication of iron and wood, that it could not have been moved without the assistance of a horse, and a road made for the convenience of the draught. These objections were so obvious, that they occurred at first sight to the inspector-general, who greatly commended the invention, which, he observed, might be applied to several other useful purposes, could it once be rendered a little more portable and commodious.

The inventor, who had not foreseen these difficulties, was not prepared to surmount them; but he took the hint in good part, and promised to task his abilities anew, in altering the construction of his **design**. Not but that he underwent some severe irony from the rest of the virtuosi, who complimented him upon the momentous improvement he had made, by which a family might save a dish of greens in a quarter for so trifling an expense as that of purchasing, working, and maintaining such a stupendous machine; but no man was ever more sarcastic in his remarks upon this piece of mechanism than the naturalist, who next appealed to the patron's approbation for a curious disquisition he had made touching the procreation of muck-flies, in which he had laid down a curious method of collecting, preserving, and hatching the eggs of these insects, even in the winter, by certain modifications of artificial heat.

"True it is," said Peregrine, "he has succeeded more than once in contrivances of this kind, having actually reduced divers people of weak heads to such extremity of despair, as hath issued in downright distraction, whereby he was rid of their importunities, and his judgment confirmed at the same time; but I have now, thank Heaven, attained to such a pitch of philosophical resolution as will support me against all his machinations; and I will forthwith exhibit the monster to the public in his true lineaments of craft, perfidy, and ingratitude."

This indeed was the **plan** with which Mr. Pickle had amused himself during the researches of Crabtree; and by this time it so effectually flattered his imagination, that he believed he should be able to bring his adversary, in spite of all his power, to his own terms of submission

Having made such progress in his studies, he resolved to qualify himself for the church; and acquired such a stock of school divinity under the instructions of a learned professor at Edinburgh, that he more than once mounted the rostrum in the public hall, and held forth with uncommon applause: but being discouraged from a prosecution of his **plan** by the unreasonable

resolved to execute his former **plan**

seduced into an indiscretion, that of necessity ruined the whole **plan** which had been concerted between them for their mutual happiness.

"His expectations in this quarter being disappointed, he, by the interposition of his friends, presented a **plan** to the French company, in which he set forth the advantages that would accrue to themselves,

on pretence of infidelity to his bed, for which they hinted there was but too much foundation. At their suggestions, a most infamous **plan** was projected, in the execution of which, one P—, a poor, unbred, simple, country booby, whom they had decoyed into a snare, lost one of his ears; and the injured lady retired that same day to New-R—, where she continued several years. She did not, however, leave the house

and therefore laid a **plan** for his being kidnapped, and sent to America as a slave

though he perceived his drift, and took an opportunity of describing the inconveniences of the place in such a manner as he hoped would deter him from putting such an extravagant **plan** in execution.

This expedient, however, far from answering the end proposed, had a quite contrary effect,

Peregrine, seeing him determined, desisted from any farther importunity, resolving, however, to tire him out of his **plan** by reserve and supercilious neglect;

This **plan** they would have executed that same evening, had not the misanthrope luckily withdrawn himself, by accident, before it was dark,

The lieutenant, having surveyed the dismal appearance of his friend, could not help being moved at the spectacle, and began to upbraid him with his obstinate pride, which, he swore, was no better than self-murder; but the young gentleman interrupted him in the course of his moralizing, by telling him he had reasons for his conduct, which, perhaps, he should impart in due season; but, at present, his **design** was to alter that **plan** of behaviour, and make himself some amends for the misery he had undergone. He accordingly sent Pipes to redeem his clothes from the pawnbroker's wardrobe, and bespeak something comfortable for dinner.

COMPARA...
OF CO...

Plate 22.
Comparative Plan
Mediæval.

Knives Boots

By... o o
w c

...amps

Brushing
Room

Luggage Entrance

...on Stair

Safe

Butler's
Bedroom

Butler's Pantry

Service
Room

Corridor

Dining
Room

Entry Porch

Bachelor's
Stair

Hall

Cloak
Room
o wc

Billiard
Room

ENTRANCE COURT

0 10 20 30 40 50 Feet

Scale 1 Inch to 30 Feet

476

DIVERS **PLANS** FOR THE FUTURE

This **plan** was, to Pickle, less disagreeable than any other project which had as yet been suggested; and the lieutenant declared himself ready to execute his part of it without delay;

had foreseen the purport of this epistle before it came to her hands; she did not therefore despair of success, nor desist from the prosecution of her **plan**, which was no other than that of securing her own happiness, in espousing the man upon whom she had fixed her unalterable affection.

Tobias Smollett, The Adventures of Peregrine Pickle, in Which
Are Included Memoirs of A Lady of Quality

Amid a flurry of campaign activity on Capitol Hill today, Gov. Rick Perry met with a
group of lawmakers to brief them on continued **plans** for his campaign ...

Alexandra Jaffe, Rick Perry 2012 Campaign for President—News and Updates (blog.chron.com)

the same subject continued ...

The Same Subject Continued, and the Incoherence of the Objections to the New **Plan** Exposed

James Madison, The Federalist Papers, No. 38

"I'm graduating from the **plan** tomorrow and I would really like it if you would be my witness."

"The **plan**? What is the **plan**?"

"It's a multi-disciplined course that allows you to think way beyond yourself, and rebuild your life, from the ground floor, plank by plank."

"It sounds awful."

*Alan Ball, Six Feet Under: Season 2, Episode 3: The **Plan***

*Everyone has a **plan** 'till they get punched in the mouth.*
— Mike Tyson

*Steve Blank, There's Always a **Plan** B (steveblank.com)*

Residents Rally Against **Plans**

www.youtube.com/watch?v=5EyZk6saEC8–19 Nov 2011–3 min–Uploaded by huddersfieldexaminer
John Gilbert of Save Grimescar Valley tells the Examiner why his group opposes **plans** ...

Petition Against **Plans** « Express & Star

www.expressandstar.com/.../petition-against-plans ...
19 Dec 2011—Just under 160 people have so far filled in a questionnaire about controversial **plans** ...

Protests Held in Jerusalem Against **Plans**

www.imemc.org/article/62654
12 Dec 2011—Thousands of Palestinians held a protest on Sunday in front of the Jerusalem office of Israeli Prime Minister, Benjamin ...

ENPI–EU Warns Belarus Against **Plans**
*www.enpi-info.eu/…/EU-warns-Belarus-against-*plans …
20 Oct 2011—The EU Delegation to Belarus has expressed its concerns …

Unions Stage Protests Against **Plans**
www.france24.com/…/20100526-unions-call-national-…*26 May 2010–1 min*
Tens of thousands of marchers gathered Thursday in several French cities …

Kenya and the World Stand Against **Plans**
mangroveactionproject.org/…/kenya-and-the-world-stand-against-pla…
The world is still reeling from the devastation of the recent quake, tsunami and nuclear aftermath in …

Ricky Gervais Stand with the BUAV Against **Plans**
www.buav.org › Media Centre › BUAV Latest News
Ricky Gervais stand with the BUAV against **plans** makes headline news …

Google News Canada

dear **plan**, you are officially the biggest pile of shit
ND Creepers, Plan cappin DUECE (flickr.com)

"Do you know whom you are talking to?" he exclaimed.

She replied, "Yes, I know very well who I am talking to."

He left the house in a great rage. I looked at my grandmother. Our eyes met. Their angry expression had passed away, but she looked sorrowful and weary—weary of incessant strife. I wondered that it did not lessen her love for me; but if it did she never showed it. She was always kind, always ready to sympathize with my troubles. There might have been peace and contentment in that humble home if it had not been for the demon Slavery.

The winter passed undisturbed by the doctor. The beautiful spring came; and when Nature resumes her loveliness, the human soul is apt to revive also. My drooping hopes came to life again with the flowers. I was dreaming of freedom again; more for my children's sake than my own. I **planned** and I **planned**. Obstacles hit against **plans**. There seemed no way of overcoming them; and yet I hoped.

Linda Brent, Incidents in the Life of a Slave Girl

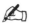

*Everyone has a **plan** 'till they get punched in the mouth.*
— Mike Tyson

*Steve Blank, There's Always a **Plan** B (steveblank.com)*

You might be wondering, what in the world can Mike Tyson teach me about financial **planning**. I promise, you will be surprised …

*RJ, The Mike Tyson Guide to Financial **Planning** (GenYWealth: Useful Personal Finance Talk)*

"Everyone has a **plan** until they get punched in the mouth" were the words spoken by Mike Tyson. Probably the smartest thing he's ever said.

As Giants lineman Michael Strahan pointed out after the game, this is exactly how you describe Super Bowl 42. The Patriots had a great offensive **plan** until Tom Brady got punched in the mouth. The Giants defense played GREAT—sacking Brady 5 times and knocking him down **18** times …

*Mike Lewis, Everyone Has a **Plan** Until They Get Punched in the Mouth (Loo.me)*

Would Mike Tyson take one punch and decide that the fight is over? Of course not. Your financial **plan** needs to act the same.

*RJ, The Mike Tyson Guide to Financial **Planning** (GenYWealth: Useful Personal Finance Talk)*

I can't tell you how many times in the last year I've heard something like "We just need to do social media, I'm not worried about anything else" or "All we

Joe Gibbs with Jerry B. Jenkins, Game **Plan** for Life: Your Personal Playbook for Success (Carol Stream, IL: Tyndale House Publishers, 2009)

need is SEO."—Yet these same folks almost without fail have nothing solid to show when we ask to see the marketing **plan** or the strategic **plan** for the year (not to mention 5 years).

*Will Davis, Everyone Has a **Plan** Until They Get Punched in the Mouth (Social Media Today)*

How many years in a row must I repeat ... You HAVE to have a Strategic **Plan** if you want to remain focused and move rapidly toward your success goals?

NPL Publishing Consultants, Publishing Newsletter, New Year's 2012

"Does the world have nothing inside it but sorrow—and are we the only ones with a Five Year **Plan**?"

Andrei Platonovich Platonov, The Foundation Pit

FINANCIAL **PLANNERS** JOIN TO FORM STANDARDS COALITION

It was a big week in the financial **planning** profession. Currently, there are five organizations in the country that have established—and enforce—professional standards for financial **planning**.

This week, those five organizations formed the Coalition for Professional Standards for Financial **Planners**. The goal is to serve the public interest by ensuring that only advisers who are qualified financial **planners** and who subject themselves to the rigours of professional standards can be allowed to call themselves "financial **planners**" or purport to offer and practise "financial **planning**."

...

The coalition is made up of the Institute of Advanced Financial **Planners** (IAFP), which grants the Registered Financial **Planner** designation, the Financial **Planning** Standards Council (FPSC), which licenses the CFP designation, two national member organizations, Advocis (the Financial Advisers Association of Canada) and the Canadian Institute of Financial **Planners** (CIFP), and l'Institut québécois de **planification** financière (IQPF).

"Professional oversight is a critical requirement for any professional ... To truly protect the public, anyone who calls themselves a financial **planner** or claims to offer financial **planning** services should not only be required to meet minimum standards of competence and ethics—they should also be accountable to professional oversight by a body that, by **design**, is dedicated to protecting the public interest," says Ken Bates, a director of the IAFP.

There is no regulation on using these terms or making such claims.

The professional organizations have been asking the provincial securities regulators for 25 years to put such regulation in place, and to delegate to these professional organizations the ability to enforce professional standards.

The investment industry is regulated quite differently.

In my humble opinion, they simply don't "get" financial **planning** and the factors that differentiate it from investment advising. Their initiatives to have it supervised by bodies that are focused on investments will likely not work.

In the next few weeks, I will look in detail at the investment regulatory regime and the current initiatives—positive and negative—aimed at protecting investors. Hopefully, I can help bridge that gap of knowledge, without offending the friendly people we in the industry affectionately refer to as "the almighty."

*David Christianson is a fee-for-service financial **planner** with Wellington West Total Wealth Management Inc., a Portfolio Manager (Restricted).*

*David Christianson, Financial **Planners** Join to Form*
Standards Coalition (Winnipeg Free Press)

Nicole B. Simpson, *The Ultimate*
Plan: *A Financial Survival Guide for*
Life's Unexpected Events (Mustang,
OK: Tate Publishing, 2008)

… and the **plan** is again working to perfection toward the complete control
of a planet …

Gyeorgos Ceres Hatonn, Privacy in A Fishbowl: Spiral to Economic Disaster, Vol. 2

… so that if the words on the **plan** make a restrictive covenant, then the
covenant to transfer **according to** the **plan** would mean to transfer subject to
such restrictive covenant.

Alexander Milton Ross, Thomas Dowrick Brown, Charles Murray Johnston, J. Kelso
Hunter, Saskatchewan Supreme Court, Saskatchewan Court of Appeal, Court of
King's Bench and Law Society of Saskatchewan, The Saskatchewan Law Reports

*Everyone has a **plan** 'till they get punched in the mouth.*
— Mike Tyson

*Steve Blank, There's Always a **Plan** B (steveblank.com)*

Megan McArdle, reporting from an annual gabfest in Aspen:

> *"The questions for [Austan] Goolsbee are much more hostile than they were*
> *last year. I don't know whether to attribute this to the economy, or the fact*
> *that the disadvantages of Obama's policies are now apparent. All policies*
> *sound better when they're in white paper, and Obama's rhetorical deftness*
> *made it particularly easy to make his proposals sound like all things to all*
> *people. Now deficits have to be paid for, climate change bills turn out to*
> *lack teeth for anyone except the Chinese, health care gets scored by the CBO*
> *rather than optimistic campaign members."*

Quite so. Last year, Goolsbee was a smart outsider, pointing to deficiencies in the extant Bush administration's policy outcomes. This year, he's an insider presiding over a giant mess. While one aspires to the latter position, the former is more comfortable.

The post's title, of course, refers to a quotation from the philosopher Michael Gerard Tyson. (Reported variants include, "Everyone's got a **plan** until they get punched in the mouth.") It may or may not have been inspired by Helmuth von Moltke's dictum "No **plan** survives first contact with the enemy."

*James Joyner, Everyone Has a **Plan** Until They Get Hit (Outside the Beltway)*

Thomas J. Neff and James M. Citrin, You're
*in Charge, Now What?: The 8 Point **Plan***
(New York: Crown Business, 2005)

It will generally be found that the greatest amount of petitions against the Council **plans**, is, from those dioceses, where the diocesan is known and felt to be unfavorable to the scheme, and where those of the clergy in official situations take an active part in stirring up the clergy to oppose it.

*Rev. Richard Dawes, Remarks Occasioned by the Present Crusade Against the Educational **Plans** of the Committee of Council on Education*

... questions, conjectures, evidence for, evidence against, **plans**, steps in **plans**, information, and commentary. Using the hypermedia system, students can pose a question, then link it to competing conjectures about the questions posed by different students (perhaps from different sites) and to a **plan** for investigating the question ...

John D. Bransford, How People Learn: Brain, Mind, Experience, and School

Comments

Zelsdorf Ragshaft III says:
Thursday, July 2, 2009 at 09:14
Goolsbee has the answers as he is in on the **plan**, however if he revealed it in public he would be torn limb from limb by angry mobs. Read Alinsky. Obama is following the blueprint.

Helpful or Unhelpful

*James Joyner, Everyone Has a **Plan** Until They Get Hit (Outside the Beltway)*

7. While I think this is effective "up front" it is a cumbersome approach to administer. I favour other tools, i.e. writing a specific zone to control use, etc. This approach appears to give an easy out.
8. Given the increasing difficulty of siting new developments in the midst of public opposition of NIMBY et. al., from a **planning** and political perspective, use of restrictive covenant appears to be only recourse to achieve specific site management objectives.

Christopher Gawronski, Tools of the Trade: Part of the Municipal Act Reform Initiative of British Columbia

'No, God won't have the satisfaction that I shall,' he returned. 'I only wish I knew the best way! Let me alone, and I'll **plan** it out: while I'm thinking of that I don't feel pain.'

Emily Bronte, Wuthering Heights

*Thelma Louise Elisher Foster, Born to Be a Leader **According to** God's **Plan** by Teaching Others to Heal Inside (TOTHI): No More Shame (Maitland, FL: Xulon Press, 2010)*

*Everyone has a **plan** 'till they get punched in the mouth.*
— Mike Tyson

Steve Blank, *There's Always a **Plan** B (steveblank.com)*

Pendragon Sword of His Father

Set in 411 AD, Pendragon tells the story of young Artos who is raised to believe that God has a purpose for each day. When his family is killed and he is taken into slavery by the Saxons, Artos questions his God. Advancing through the military ranks, Artos begins to understand that his father's vision was not based on the strength of man, but on the **plan** of God. Further betrayal by his friends forces Artos to decide between following God's **plan** unto certain death or abandoning God to save his own life.

Internet Movie Database, *Plot Summaries*

I believe everyone can have the life they want—sometimes we need a good guide to help get us there.

Game Plan

I never been good in any sport, I'm scared to play volleyball, I love basketball and i can shoot a ball in a ring but never know how play to it ... I learned to play chess but i must admit i just do it to at least beat my father ... and i did once ... only once ... for a hundred times we play i beat Him once ... and that is it ... I love to watch tennis but i never actually hold a tennis rocket ... I used to have bike but never ride it outside the town until it was stolen. In all sport their is always a game **plan** ... Manny Didn't win because he isThe Best fighter ... He win Because he always Have a Great Game **plan** and His team carefully **plan** it, He practice it ... He always Stick to the **plan** ... What is the **Plan**?.. to Beat his opponent ... People make **plans** ... I have **plans**, But even how hard i **plan** ... i always blow it off ... blow it off ... that's why i always make other people disappointed ... yes I do that. So many things I said I will do ... but never do it ... Every night before i sleep i set my alarm at 5:00 am ... i **Plan** to jog and loose some weight ... and every morning I wake up my alarm ringing. I hated it ... i turn it off and sleep again ... until i wake up so late, then again and i promise my self that tomorrow will be different so at night i set my alarm at 5:00 am, i will jog for one hour prepare breakfast, clean my room, and start the day right, and do all the things i need to do, be productive. Every night i **plan** my day for the next day ... But every morning i ended waking up so late. I wish i can do that ... a sport man **plan** ... a game **plan** ... a game **plan** that will lead me to success a **plan** that will guide me to everyday of my life ... a **plan** that will make me closer to happiness ... a **plan** that will make me a better person ... **plan** ... yes I want a **plan** ... a **plan** that i will stick to it, and do it, Coz know I'm stranded ... I'm just standing in the middle of nowhere ... and i have no **plans** ... no **plans** at all ... i know i cant just stand and wait for someone to move me ... life is not a fairy tail at all ... We just don't come home and everything gonna be alright ... I need a **plan** ... a **plan** that makes me a winner, a game **plan**, can just someone coach me ...

Kaycee, simplykaycee.blogspot.com

You are never too young or too old to make changes. Just think—what happens if you don't?

"Never Let your Memories be greater than your Dreams"

I'm looking forward to hearing from you soon and creating the perfect **plan** for your life.

"Opportunity will always be there for those willing to grab it now."

Breda Stackpool—helping you take your brain pain away.

> *Breda Stackpool, Perfect **Plans** for Life (FindaCoach.ie:*
> *Ireland's Independent Coaching Directory)*

"Everybody's got **plans** ... until they get hit."
 It's a rarity that I'll quote Mike Tyson, but how true are those words? It seems that everyone makes **plans**—it's a part of life ...

> *Aub, Everybody's Got **Plans** ... Until They Get Hit (A Long Suffering Heart)*

... city officials, schools, newspapers, social agencies, individuals—everyone **planned** ...

> *Encyclopedia Britannica Films, The Baltimore **Plan***

Weddings
Rehearsals
Receptions
Retirement or Promotion Parties
Graduations
Birthdays
Anniversaries
Teas
Showers
Engagements
Funerals
Holiday Parties
Charitable Events
Open Houses (staging services available)
Customer & Employee Appreciation Events
Team-Building Events
Corporate Retreats
Grand Openings
Travel Arrangements (Honeymoons, vacations, etc.)
Wedding website set up
... and more!

Call us 903-723-**PLAN** (7526) to set up a free consultation ...

> *Perfect **Plans**, We Make Your **Plans** Perfect!—Services*

NSDBea, 4 Point Recruiting **Plan** 576 (Internet Archive, http://www.archive.org)

... but no one **plans** on the "hit" that derails it all.

*Aub, Everybody's Got **Plans** ... Until They Get Hit (A Long Suffering Heart)*

Always expect trouble. Always be alert. Famed boxing champion Mike Tyson once said "Everyone has a **plan** ... until they get punched in the mouth." No **plan** is foolproof. Expect things to go wrong. Prepare contingency **plans**. Never lower your guard. Develop the habit of visualizing where important things are (exits, weapons, people, supplies, etc). When travelling through unsecured grounds, constantly look around and listen. Be aware if any actions being taken may attract more zombies.

Zombiepedia, General Survival Guidelines

*Rinkly Rimes, Contingency **Planning** (rinklyrimes.blogspot.com)*

One of the forms is a detailed lesson **plan** in which teachers must lay out in advance what they're going to teach that day. Ms. Mendelsohn believes it is clearly counterproductive—"You have to remain flexible and creative in what you teach"—but she also knows nobody looks at it. She knows because she frequently filled in the boxes with words like *Mickey Mouse.*

Philip Howard, The Death of Common Sense: How Law is Suffocating America

The walking Strandbeest is a body snatcher. It charms people and then uses them so they can't do anything else but follow, and I am the worst victim, you could say. All the time I think about them. Always I have a new **plan**, but then it is corrected by the requirements of the tubes. They dictate to me what to do. At the end of my working day, I am almost always depressed. Mine is not a straight path like an engineer's, it's not A to B. I make a very curly road just by the restrictions of goals and materials. A real engineer would probably solve the problem differently, maybe make an aluminum robot with motor and electric sensors and all that. But the solutions of engineers are often much alike, because human brains are much alike. Everything we think can in principle be thought by someone else. The real ideas, as evolution shows, come about by chance. Reality is very creative. Maybe that is why the Strandbeests appear to be alive, and charm us. The Strandbeests themselves have let me make them.

Tad Friend, The March of the Strandbeests (The New Yorker)

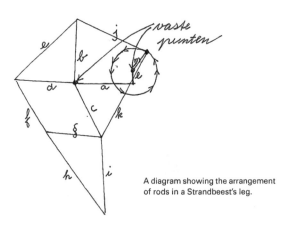

A diagram showing the arrangement of rods in a Strandbeest's leg.

Determining the lengths of the rods would be an extraordinarily time consuming process by hand, and even with the assistance of a computer, if each leg had only 10 possible lengths, it would take quite some time to find a satisfactory arrangement. Mr. Jansen solved this problem through the use of genetic simulations. 1500 sets of rods were selected and their paths computed, then the top 100 which matched the desired path were selected and combined so that children inherited their characteristics from their parents and were tested. In each generation the best ones were selected to pass their characteristics along, and after months of 24 hour per day simulations, the ideal lengths were determined to be: a = 38, b = 41.5, c = 39.3, d = 40.1, e = 55.8, f = 39.4, g = 36.7, h = 65.7, i = 49, j = 50, k = 61.9, l = 7.8, m = 15. It is thanks to these numbers that the animals walk the way they do.

After **designing** the legs, many different versions were built, after observing their behavior and tweaking the **designs**. The result of all of this effort is very lifelike creations, which Mr. Jansen eventually **plans** to build in herds and allow to roam.

David Johnson, A New Form of Life? (hs.rainard.org/blog)

Barbara Schantz, *My Double Life (babydipper.blogspot.com)*

AB: But it's more than that. It has to do with the times. Lize conducts a lot of mapping workshops and I remember she was shocked at one point about how everyone thinks in **plan** now. Ten or fifteen years ago, if you asked a school kid to draw their house, they would probably draw a house from the front. The image of home was generally based on the image of walking into it. Now when you ask kids to draw their house, they draw it out like they'd see it in Google Maps. Lize has talked to teachers and confirmed that this is an established shift that has taken place. It's natural for people to communicate through maps because of the dominance of the **plan**-image in our thinking now.

> *Alexis Bhagat and Nato Thompson, Atlas Über Alles: A Conversation*
> *with Alexis Bhagat and Nato Thompson (Scapegoat)*

... these objections are so frivolous that one can scarcely conceive their being brought forward as grievances, unless it is to swell the number of objections and increase the suspicions against the **plan** of the Committee of Council.

> *Rev. Richard Dawes, Remarks Occasioned by the Present Crusade Against*
> *the Educational **Plans** of the Committee of Council on Education*

Comments

Eric Florack says:
Thursday, July 2, 2009 at 11:14

*In the beginning, there was the **Plan**.*
And then came the Assumptions.
And the Assumptions were without form.
*And the **Plan** was without substance.*
And darkness was upon the face of the Workers.
And they spoke among themselves, saying, "It is a crock of shit, and it stinks."
And the Workers went unto their Supervisors and said, "It is a pail of dung, and we can't live with the smell."
And the Supervisors went unto their Managers, saying, "It is a container of excrement, and it is very strong, such that none may abide by it."
And the Managers went unto their Directors, saying, "It is a vessel of fertilizer, and none may abide its strength."
And the Directors spoke among themselves, Saying to one another, "It contains that which aids plant growth, and it is very strong."
And the Directors went to the Vice Presidents, saying unto them, "It promotes growth, and it is very powerful."
*And the Vice Presidents went to the President, saying unto him, "This new **plan** will actively promote the growth and vigor of the company with very powerful effects."*
*And the President looked upon the **Plan** and saw that it was good.*

Encyclopedia Britannica
Films, The Baltimore **Plan**

*And the **Plan** became Policy.*
And this is how Shit happens.

I suspect Goolsbee to be just recently figuring out that what he was selling a few years ago has more in the way of holes in it than he supposed. I also suspect some of the hostility is reaction to people at the conference who have also started to figure this out and are pressing the poor sot on the matter.

Not unlike Obama and the war on terror, he's being forced by the reality of the situation to an understanding that his original assessment is a pail of dung, and he's having problems selling stuff that smells quite so bad.

In short, the **plan** has met reality, and the result is less than encouraging.

Helpful or Unhelpful?

James Joyner, *Everyone Has a **Plan** Until They Get Hit (Outside the Beltway)*

*Everyone has a **plan** 'till they get punched in the mouth.*
— Mike Tyson

Steve Blank, *There's Always a **Plan** B (steveblank.com)*

The title of this post is a quote, widely credited to Mike Tyson, which may be the perfect metaphor for life with an autistic child. We have found that making **plans** is basically a fool's game. It is, in a way, like playing black jack at a casino. You can spend years studying the nuances of the game, memorizing strategies, even learning to count cards, but in the end, you can only slightly change the odds of a favorable outcome.

Big Daddy Autism, *Everybody Has A **Plan** … Until They Get Punched in the Mouth (Special Happens)*

"Oh no, are we gonna cry?"

"We're going to cry, yes. And we're going to beg. I'm begging you for help, Clarence."

"I'm not saying no right yet."

"For help secondarily. Primarily though I'm begging you for indulgence. I beg your forgiveness. Our own enterprise is threatened."

Clarence jumped up with a stick of kindling and laid it like a sword to Nelson's throat. "The plants better be growing right in this spot at harvest time."

"They will be. It's just that they've come into play in this ludicrous situation."

William A. Sherden, *Best Laid*
***Plans**: The Tyranny of Unintended*
Consequences and How to Avoid Them
(Santa Barbara, CA: Praeger, 2011)

"And you think that puts *me* in play?"

"I didn't **plan** it like this."

"I refuse to be committed here. Shit. I'll just dump your body in Lally's pool."

> Denis Johnson, *Already Dead: A California Gothic*

... a conclusive argument against this **plan**.

> Rev. Richard Dawes, *Remarks Occasioned by the Present Crusade Against*
> *the Educational **Plans** of the Committee of Council on Education*

As a theorist, Zinoviev overdid it only when he predicted that even dissidence would turn out to be part of the **plan**: a built-in safety valve. Commendably, he backtracked on that point not long before he packed his bags. He would probably never have said it if he had not been reduced to despair by the thuggishness with which he was stripped of his academic posts and honours. He was drummed out of the country through a shower of abuse. We tend to forget that the people who were bright enough to predict that such things would happen to them still needed a lot of moral courage to remain calm when they did. But Zinoviev didn't despair for long: not in Russia, at any rate. In the West,

he went silent, sharing the fate of several of the prominent émigré dissidents, which was to find out the hard way that they had destroyed the glamour of their special subject by helping to deprive it of its power.

Clive James, Cultural Amnesia: Notes in the Margin of My Time

*"Everyone has a **plan** until they get punched in the mouth."*
"I'm a historian, and that freaks me out."
"I'm a nutcase, but that is what I believe."
"I'm just happy I'm not a phony."
"I just want to conquer people and their souls."
"I'll eat your asshole alive you bitch, fuck you, you ho."

[Chorus]
"I'm on the Zoloft to keep from killin' y'all."
"I guess I'll fade into Bolivian."
"When you see me smash someone's skull, you enjoy it."

"I'll fight any man, any animal, if Jesus were here I'd fight him too."
"[He] called me a rapist and a recluse. I'm not a recluse."
"You can't last two minutes in my world bitch."

Plan B aka Ben Drew, The Brit Awards 2012

Which celebrity has been talking angrily about drugs and educating the kiddywinkles? Thank god we've got good ol' **Plan** B here, eh team? What would we do without him. Take that drugs!

*John Hill, So What's The **Plan**? (holymoly.com, photo by Lia Toby/WENN.com)*

"[Hannibal] He rode elephants into cartilage."
"I want to rip out his heart and feed it to him."
"I want to kill people. I want to rip out their stomachs and eat their children."

[Chorus]
"I'm on the Zoloft to keep from killin' y'all."
"I guess I'll fade into Bolivian."
"When you see me smash someone's skull, you enjoy it."

[Repeat Chorus]

 Just Dave, Mike Tyson Quotes: The Song

You have no idea (say the Corinthians) what sort of people these Athenians are, how totally different from yourselves. They are always thinking of new schemes, and are quick to make their **plans** and carry them out: you are content with what you have, and are reluctant to do even what is necessary. They are bold, adventurous, sanguine: you are cautious, and trust neither to your power nor to your judgement. They love foreign adventure, you hate it: for they think they stand to gain, you that you stand to lose something. When victorious they make the most of it: when defeated, they fall back less than anyone ... They make a **plan**: if it fails, they think they have lost something; if it succeeds, this success is nothing in comparison with what they are going to do next. It is impossible for them either to enjoy peace and quiet themselves or allow anyone else to. (Paraphrase of Thucydides, I, 70.)

 H. D. F. Kitto, The Greeks: A Study of the Character and History of
 an Ancient Civilization, and of the People Who Created It

HORTENSIUS: We have now, I presume, done with the Romances, and are expecting your investigation of Novels.

EUPHRASIA: It is now that I begin to be sensible in how arduous an undertaking I have engaged, and to fear I shall leave it unfinished.

HORTENSIUS: Have no fears, Madam; we shall not suffer you to leave off presently. We expect the completion of the **plan** you have given us, Sophronia. If I judge rightly, the conclusion is yet a great way off.

EUPHRASIA: This is one of the circumstances that frighten me. If I skim over the subject lightly it will be doing nothing; and if I am too minute I may grow dull and tedious, and tire my hearers.

HORTENSIUS: You must aim at the medium you recommended to us.

EUPHRASIA: What Goddess, or what Muse must I invoke to guide me through these vast, unexplored regions of fancy?—regions inhabited by wisdom and

the same subject continued ...

INDEX TO REGISTERED PLANS—Continued.

Library and Archives Canada, Index To Registered **Plans** Continued (Item 6)

folly,—by wit and stupidity,—by religion and profaneness,—by morality and licentiousness.—How shall I separate and distinguish the various and opposite qualities of these strange concomitants?—point out some as the objects of admiration and respect, and others of abhorrence and contempt?

HORTENSIUS: The subject warms you already, and when that is the café, you will never be heard coldly.—Go on and prosper.

EUPHRASIA: In this fairy land are many Castles of various **Architecture**.— Some are built in the air, and have no foundation at all,—others are composed of such heavy materials, that their own weight sinks them into the earth, where they lie buried under their own ruins, and leave not a trace behind,—a third sort are built upon a real and solid foundation, and remain impregnable against all the attacks of Criticism, and perhaps even of time itself.

SOPHRONIA: So so!—we are indeed got into Fairy-land; it is here that I expect to meet with many of my acquaintance, and I shall challenge them whenever I do.

EUPHRASIA: I hope that you will assist my labours.—I will drop the metaphor, and tell you that I mean to take notice only of the most eminent works of this kind:—to pass over others slightly and leave the worst in the depths of Oblivion.

Clara Reeve, The Progress of Romance (1785)

I was just finishing the scouring-pad questionnaire, a rush job, when Mrs. Grot of Accounting came through the door. Her business was with Mrs. Bogue, but on her way out she stopped at my desk. She's a short tight woman with hair the colour of a metal refrigerator-tray.

"Well, Miss MacAlpin," she grated, "you've been with us four months now, and that means you're eligible for the Pension **Plan**."

"Pension **Plan**?" I had been told about the Pension **Plan** when I joined the company but I had forgotten about it. "Isn't it too soon for me to join the Pension **Plan**? I mean—don't you think I'm too young?"

"Well, it's just as well to start early, isn't it," Mrs. Grot said. Her eyes behind their rimless spectacles were glittering: she would relish the chance of making yet another deduction from my pay-cheque.

"I don't think I'd like to join the Pension **Plan**," I said. "Thank you anyway."

"Yes, well, but it's obligatory, you see," she said in a matter-of-fact voice.

"Obligatory? You mean even if I don't want it?"

"Yes, you see if nobody paid into it, nobody would be able to get anything out of it, would they? Now I've brought the necessary documents; all you have to do is sign here."

Christopher Weyant, The New Yorker

"Would you like to hear about our retirement plan?"

I signed, but after Mrs. Grot had left I was suddenly quite depressed; it bothered me more than it should have. It wasn't only the feeling of being subject to rules I had no interest in and had no part in making: you get adjusted to that at school. It was a kind of superstitious panic about the fact that I had actually signed my name, had put my signature to a magic document which seemed to bind me to a future so far ahead I couldn't think about it. Somewhere in front of me a self was waiting, pre-formed, a self who had worked during innumerable years for Seymour Surveys and was now receiving her reward. A pension. I foresaw a bleak room with a plug-in electric heater. Perhaps I would have a hearing aid, like one of my great-aunts who had never married. I would talk to myself; children would throw snowballs at me. I told myself not to be silly, the world would probably blow up between now and then; I reminded myself I could walk out of there the next day and get a different job if I wanted to, but that didn't help. I thought of my signature going into a file and the file going into a cabinet and the cabinet being shut away in a vault somewhere and locked.

Margaret Atwood, The Edible Woman

Dexter Bang Sinister, B/W sensorium, entrance

this **plan** goes into effect
no matter what

A pension **plan** had been approved by some committee and a statement had been issued about the onerous and dangerous lives led by such people ...
...
The first stage, the Senior Study Effort, consisted of fourteen high officials, including presidential advisers, ranking military men, special assistants, undersecretaries, heads of intelligence. They met for an hour and a half. Then eleven men left the room, six men entered. The resulting group, called SE Augmented, met for two hours. Then seven men left, four men entered, including Everett and Parmenter. This was SE Detailed, a group that developed specific covert operations and then decided which members of SE Augmented ought to know about these **plans**. Those members in turn wondered whether the Senior Study Effort wanted to know what was going on in stage three. Chances are they didn't.
...
Knowledge was a danger, ignorance a cherished asset. In many cases the DCI, the Director of Central Intelligence, was not to know important things. It would impair his ability to tell the truth at an inquiry or a hearing, or in an Oval Office chat with the President, if he knew what they were doing in Leader 4, or even what they were talking about, or muttering in their sleep. The Joint Chiefs were not to know. The operational horrors were not for their ears. Details were a form of contamination. The Secretaries were to be insulated from knowing. They were happier not knowing, or knowing too late. The Deputy Secretaries were interested in drifts and tendencies. They expected to be misled. They counted on it. The Attorney General wasn't to know the queasy details. Just get results. Each level of the committee was **designed** to protect a higher level. There were complexities of speech. A man needed special experience and insight to work true meanings out of certain murky remarks. There were pauses and blank looks. Brilliant riddles floated up and down the echelons, to be pondered, solved, ignored. It had to be this way, Win admitted to himself. The men at his level were spawning secrets that quivered like reptile eggs. They were **planning** to poison Castro's cigars. They were **designing** cigars equipped with micro-explosives. They had a poison pen in the works. They were conspiring with organized-crime figures to send assassins to Havana,

Art Spaces Archives Project, http://www.as-ap.org

Dexter Sinister Exhibition Producing Dot Dot Dot 15 On Location

poisoners, snipers, saboteurs. They were testing a botulin toxin on monkeys. Fidel would be seized by cramps, vomiting and fits of coughing, just like the long-tailed primates, and horribly die. Have you ever seen a monkey coughing uncontrollably? Gruesome. They wanted to put fungus spores in his scuba suit. They were devising a sea shell that would explode when he went swimming.

...

But there were even deeper shadows, strange and grave silences surrounding the **plans** to invade the island.

...

The **plan** was never clear.

...

"Some things we wait for all our lives without knowing it. Then it happens and we recognize at once who we are and how we are meant to proceed. This is the idea I've always wanted. I believe you'll sense it is right. It's the high risk we need. We need an electrifying event. You've been waiting for this every bit as much as I have. I believe that or I wouldn't have asked you to come here. We want to set up an attempt on the life of the President. We **plan** every step,

design every incident leading up to the event. We put together a team, leave a dim trail. The evidence is ambiguous. But it points to the Cuban Intelligence Directorate. Inherent in the **plan** is a second set of clues, even more unclear, more intriguing. These point to the Agency's attempt to assassinate Castro. I am **designing** a **plan** that includes elements of both the American provocation and the Cuban reply. We do the whole thing with paper. Passports, drivers' licenses, address books. Our team of shooters disappears but the police find a trail. Mail-order forms, change-of-address cards, photographs. We script a person or persons out of ordinary pocket litter. Shots ring out, the country is shocked, aroused. The paper trail leads to paid agents who have disappeared in Venezuela, in Mexico. I am convinced this is what we have to do to get Cuba back. This **plan** has levels and variations I've only begun to explore but it is already, essentially, right. I feel its rightness. I know what scientists mean when they talk about elegant solutions. This **plan** speaks to something deep inside me. It has a powerful logic. I've felt it unfolding for weeks, like a dream whose meaning slowly becomes apparent. This is the condition we've always wanted to reach. It's the life-insight, the life-secret, and we have to extend it, guard it carefully, right up to the time we have shooters stationed on a rooftop or railroad bridge."

There was a silence. Then Parmenter said dryly, "We couldn't hit Castro. So let's hit Kennedy. I wonder if that's the hidden motive here."

"But we won't hit Kennedy. We miss him," Win said.

. . .

He preferred to avoid thinking about Everett's **plan** for the time being. He listened to the radio, to an evangelist talking about retail prayer and wholesome prayer. Pray for yourself, pray for the world. Win was a bright man, dedicated, loyal to the cause, bright, very bright, but he'd suffered some kind of nervous collapse. Happens all the time. He seemed well now, alert, in full control, but an idea needs time to reveal its facets, its shifting lights and fires. Not that Larry meant to let the matter drag.

. . .

This very inflammability, this Cuban heat and light, made him determined to keep the **plan** a secret from anti-Castro leaders.

. . .

He would not consider the **plan** a success if the uncovering of its successive layers did not reveal the CIA's schemes, his own schemes in some cases, to assassinate Fidel Castro. This was the little surprise he was keeping for the end. It was his personal contribution to an informed public. Let them see what goes on in the committee rooms and corner offices. The pocket litter, the gunman's effects, the sidetrackings and back alleys must allow investigators

to learn that Kennedy wanted Castro dead, that plots were devised, approved at high levels, put into motion, and that Fidel or his senior aides decided to retaliate. This was the major subtext and moral lesson of Win Everett's **plan**.

...

"Christ, Ozzie, you make me sick. You're sitting here all alone. What if I don't come in? You just sit there and wait? If there's anything I don't respect, it's bad **planning**."

...

The men behind the **plan**, he said, were respected Agency veterans, deep believers in a free Havana.

...

After the revolution came the **plan** to invade. He helped set up the Double-Chek Corporation, a front for the recruitment of pilot instructors. Gibraltar Steamship came next, a company whose nominal head was a former State Department officer and ex-president of United Fruit. Parmenter himself could not always tell where the Agency left off and the corporations began. There were men related by blood and by marriage; there were company directors who were former high-ranking intelligence officers; there were government advisers who were once company directors. It was a society he recognized as a better-working version of the larger world, where things have an almost dreamy sense of connection to each other. Here the **plan** was tighter. These were men who believed history was in their care.

...

It is, "I did not tell you about my **plans** because you could hardly be expected to understand."

...

He tells them he is going to school in Switzerland but doesn't mention the name of the institution or the course of study he **plans** to follow.

...

On the Albert Schweitzer application he made it a point to mention that after the term was completed he **planned** to attend the summer session of the University of Turku—Turku, Finland.

...

He'd devised a top-secret memo from the Deputy Director **Plans** to selected members of the Senior Study Effort, dated May 1961. It concerned the assassination of foreign leaders from a philosophical point of view.

...

The story was fabricated but the **plan** itself was real, involving the assassination of Fidel Castro and his brother Raúl. This news item would be found among the subject's effects after the failed attempt on the life of the President.

305 Cambie Street, 6:00 pm

fillip.ca

...

He had other schemes, other documents, authentic, relating to attempts on Castro's life—attempts he'd personally been involved in at the **planning** stage. It would be up to Parmenter to get this reading matter, circuitously, into the hands of journalists, subcommittee members and anyone else who might bring them to light.

...

Things happened fast after that. He had no time to work out meanings, fall back on old attitudes and positions. The secret he'd carried through the Marine Corps for over a year, his **plan** to defect, was the most powerful knowledge in his life up to this point.

...

He'd made **plans**, he'd engineered a new life, and now no one would take ten minutes to understand who he was. A zero in the system.

...

He sketched a rough street **plan** of Moscow in his notebook, Kremlin at the center.

...

A dark and somber **plan**.

...

Interesting, Marina thought, how much writing he seems to do on those large new pads. What are those photographs he keeps on the top shelf of the closet, behind the suitcases? What is this pencil sketch that looks like a ground **plan** of the radio factory?

...

It was Everett who'd made the leap. Everett took the once-bold idea of assassinating Castro and turned it over in his mind, finding it unworkable and crude. He struck a countermeasure that made better sense on every level. It was original, spare and clean. The man we really want is JFK. Mackey gave him every credit. Everett was a complex and passionate man who could think economically. All over Langley and Miami they were still formulating **plans** to hit Fidel. It was an industry like wood pulp or shoes. Everett had seen the logic in staying home. The idea had power and second sight. Of course Everett did not **plan** to shoot Kennedy in the strict sense. Only to lay down fire in the street. He wanted a surgical miss.

The second leap was Mackey's. He made it after hearing Everett's **plan**, driving alone toward the Louisiana border, his sunglasses on the dash in the softfall of evening light, two years to the day after Pigs. They had to take it one more step. Everett's obsession was scattered in technique. The **plan** grew too twisty and deep. Everett wanted mazes that extended to infinity. The **plan** was anxious, self-absorbed. It lacked the full heat of feeling. They had to take it all the way. It was a revelation to him that in the moment he saw what had to be done, feeling the crash of air on the hood of the car, he felt the oddest goddamn sympathy for President Jack.

...

He **planned** to write to the Socialist Workers Party for information about their aims and policies.

...

Bobby said, "I believe the whole system works to make the black man humble down. Follow the penny hustle, drink the cheap wine. This is what they got **planned** for us …"

...

"It fits all right. Everything works. Everything fits. I **planned** this thing with care. I had to go to six gun shops before I found ammo for this type carbine."

...

He was not half surprised. They have been plotting for a long time, every element in the Control Apparatus, **planning** and scheming carefully to keep Walker quiet. This is what shooting people does.

...

Chauffeur Waiting for Dexter Sinister at Nicosia International Airport

Alpha was **planning** a major operation.

. . .

Frank knew what Alpha was **planning** to do. He thought and he thought and it had to be that.

. . .

Frank's judgment was that Alpha **planned** to kill the President. He seemed to think Mackey would have trouble believing this. But it was easy to believe.

. . .

"And this is what you also **planned**, all this time, T-Jay, to get Kennedy?"

. . .

Oswald wanted his path to be tracked and his name to be known. He had private **designs**, a hero's safe haven in Cuba. He wanted to use the rifle that could be traced to him through the transparent Hidell. Mackey was cautious. The kid had a dizzying history and he was playing some kind of mirror game with Ferrie in New Orleans. Left is right and right is left. But he continued to fit the outline that Everett had devised six months earlier. There were the homemade documents, the socialist literature, the weapons and false names. He was one element of the original **plan** that still made sense.

. . .

Too many people, too many levels of plotting. Mackey had to safeguard the attempt not only from Alpha but from Everett and Parmenter. They might decide to expose the **plan** now that he'd removed himself from contact, leaving them to their hieroglyphics.

. . .

That was how it started. Lee sat many nights on the screened porch cleaning the Mannlicher, working the bolt on the Mannlicher, after midnight, formulating **plans**.

. . .

Ferrie ordered two more beers and said, "You are the object of some intense scrutiny. Banister doesn't know the exact nature of the role being **planned** for you. But it's only a matter of time before he finds out."

. . .

Working the bolt on the Mannlicher. Cleaning the Mannlicher. They had **plans** for him, whoever they were.

. . .

Ferrie didn't seem to know sometimes whether a story was funny or sad. He told Lee about the time he tried to perfect a tiny flare device with a timer. He wanted to make thousands of these devices and attach them to the bodies of mice. He wanted to parachute the mice into Cuban cane fields. He was driven by the image of fifty thousand mice scattering through the sugar cane as the timers ignited the flares. He wanted to be the Hannibal of the mouse world, he said, and seemed dejected by the failure of the **plan**.

. . .

"What were they looking for?"

"Signs that you exist. Evidence that Lee Oswald matches the cardboard cutout they've been shaping all along. You're a quirk of history. You're a coincidence. They devise a **plan**, you fit it perfectly. They lose you, here you are. There's a pattern in things. Something in us has an effect on independent events. We make things happen. The conscious mind gives one side only. We're deeper than that. We extend into time. Some of us can almost predict the time and place and nature of our own death. We know it on some deeper plane. It's almost a romance, a flirtation. I look for it, Leon. I chase it discreetly."

. . .

"United States leaders should think that if they are aiding terrorist **plans** to eliminate Cuban leaders," he said, "they themselves will not be safe."

. . .

"You won't tell me what it is they want me to do. I have to make my **plans** best I can."

. . .

Entrance to Dexter Sinister's Headquarters

Interior of Dexter Sinister's Headquarters

"I'm **planning** I might come back."

...

"From business. From the clubs. Plus some ventures I'm **planning** in other vicinities ..."

...

"Tony, I have **plans**. I'm painting the club. A whole new scheme. I want to feature a silky type red, like an old-timey red. The convention business picks up soon. If Carmine could see his way clear to just think about this for a couple of minutes, riding in the car someday."

...

"We create our own Oswald. A second, a third, a fourth. This **plan** goes into effect no matter what he does after Mexico City. Mackey wants Oswald all over Texas. He wants Alpha to supply the people. I talked to Carmine Latta about money for this thing."

...

The Agency forgives. There wasn't a man in the upper ranks of the four directorates who didn't understand the perils of clandestine work. They would be pleased by his willingness to cooperate. What's more, they would admire the complexity of his **plan**, incomplete as it was. It had art and memory. It had a sense of responsibility, of moral force. And it was a picture in the world of their own guilty wishes. He was never more surely an Agency man than in the first breathless days of dreaming up this plot.

...

Raymo walked in. He said, "When did you get back?"

"This afternoon."

"Did you hear there's word going around? Somebody in Chicago's **planning** the same thing."

...

He was sure Oswald wanted to be the lone gunman. This is how it is with solitaries, with men who **plan** eternally toward some total moment. Easy enough to make him believe it.

...

The **plan** had one thing going for it that Win Everett's level and refinements could not have supplied. Luck. T-Jay watched Oswald peel the lettuce off the bread and eat it separately.

...

Wayne watched the silver faces show fear and desire. He was waiting for the noise on-screen to increase, for the Japs to swarm over the guerilla camp with machine guns and grenades. He **planned** to ease out of the row, step in behind

Leon, whisper a small *adiós,* then mash the grooved trigger, already walking backwards to the lobby.

But he would wait for the noise and cries.

He would let the tension build.

Because that's the way they do it in the movies.

...

He was looking for a radio reporter named Joe Long because he had a dozen corned-beef sandwiches out in the car which he **planned** to take to the crew at KLIF working into the night to report this frantic tale to an unbelieving city.

...

There was a third way he could play it. He could tell them he was the lone gunman. He did it on his own, the only one. It was the culmination of a life of struggle. He did it to protest the anti-Castro aims of the government, to advance the Marxist cause into the heart of the American empire. He had no help. It was his **plan**, his weapon. Three shots. All struck home. He was an expert shot with a rifle.

...

Guy told him something was in the works, a chancy **plan**, a long shot.

Don DeLillo, Libra

DOC SAVAGE DOUBLE NOVEL #53: **ACCORDING TO PLAN** OF A ONE-EYED MYSTIC

Doc Savage follows his stolen dirigible to a magic island and discovers the lost city of Ost. Then, Renny Renwick awakens in the body of a fugitive gangster after encountering a strange impish man in *According to Plan of a One-Eyed Mystic*. What is the bizarre connection between the One-Eyed Mystic, a stolen military secret and a Nazi plot?

an even more sinister **plan**

Agents Secrets
Moles threaten to foil a team of secret agents' **plan**.

The Octagon
A martial artist must defeat a **plan** by ninjas to create a worldwide training camp for terrorists.

Headhunter The Assessment Weekend
A motley group of business students in Berlin, Germany sign up for Takahashi Corp.'s assessment weekend, hoping to land one of the coveted spots with the consulting company. Under the watchful eye of a company psychologist, the team-working and improvisational skills of the aspirants will be put to the test in a survival-type situation. But nothing goes **according to plan** ...

Wrong Turn 2: Dead End
A group of reality show contestants find themselves fighting for their survival against a family of hideously deformed inbred cannibals who **plan** to ruthlessly butcher them all.

KISS Meets the Phantom of the Park
The tale of rock band KISS and their efforts to thwart a diabolical **plan** by mad scientist Abner Devereaux ...

Carnosaur
A brilliant geneticist, Diane Ladd, **plans** to expose a lethal virus to every human being on the planet. Her objective—to destroy humankind in favour of her new strain of prehistoric dinosaurs. Two people stand in the way of her diabolical **plan**, a cynical night watchman and a lovely idealistic environmentalist. The two must overcome their differences long enough to uncover the scientist's scheme and fight her carnivorous creations in a desperate battle against the extinction of the human race.

The Return of the Vampire
In 1918, an English family are terrorized by a vampire, until they learn how to deal with it. They think their troubles are over, but German bombs in WWII

free the monster. He reclaims the soul of his wolfman ex-servant, and assuming the identity of a scientist who has just escaped from a concentration camp, he starts out on a **plan** to get revenge upon the family.

Yo-Yo Girl Cop
… but finds an even more sinister **plan** is about to unfold.

Senrei
A fatal skin disease forces a beautiful actress to retire from the screen. She puts a sinister **plan** into motion to transplant her brain into her own daughter Sakura …

Female Prisoner #701: Scorpion
After being cruelly set up and deceived by Sugimi (Natsuyagi Isao), a con-niving and crooked detective she had whole-heartedly fallen in love with (and subsequently lost her virginity to), Matsushima Nami's desire for revenge knows no bounds. Her failed attempt at stabbing Sugimi on the steps of the Tokyo Metropolitan Police Headquarters results in her doing hard time in a female prison run by sadistic and horny male guards. To Sugimi's surprise, Matsushima refuses to testify against him and his connections to the mob, and now the sheer fact that she knows such secrets makes her a liability. So Sugimi and the Japanese mafia orchestrate a **plan** whereby Matsushima will succumb to an "accidental" death in prison. They enlist the help of Kagiri, another female inmate with ties to both Sugimi and the mafia, thus their for-midable **plan** is quickly set in motion. Little do they realize, however, how hotly Matsushima's desire for revenge burns within her.

Dead or Alive Hanzaisha
As they **plan** an all-out-assault on the remaining Chinese and Japanese mafia kings, only Detective Jojima (Aikawa Sho) stands between them and complete domination.

Curral de Mulheres
Young women in the Amazon are kidnapped by a ring of devil-worshipers, who **plan** to sell them as sex slaves …

Queen of Outer Space
Three American astronauts are on the first manned mission to Venus, and when they arrive, they find the planet to be inhabited solely by women with high heels and short dresses. Unfortunately, they are immediately imprisoned,

for the queen who rules Venus hates men. Suspecting the astronauts to be spies, she now **plans** to destroy the Earth. So now it's up to the three men (and some friendly Venusians) to overthrow the wicked queen and save the Earth.

Design for Scandal

To save his job, newsman Jeff Sherman offers to help his boss get out of a swingeing alimony settlement. But his devious **plan** to compromise Cornelia Porter, the judge on the case, while she is on holiday at Cape Cod soon proves to be—well—too devious!

The Silencers

In this, the first Matt Helm movie, we see Matt Helm coaxed out of semi-retirement by an attractive ex-partner. It seems that the evil Big O organization has a nefarious **plan** called "Operation—Fallout." If this **plan** comes to fruition, Big O will explode an atomic bomb over Alamagordo, NM, and start WWIII. Only Matt Helm can stop them.

The Light at the Edge of the World

Pirates take over a lighthouse on a rocky island. They then execute a devious **plan** to cause ships to run aground ...

Indiana Jones and the Temple of Doom

After arriving in India, Indiana Jones is asked by a desperate village to find a mystical stone. He agrees, and stumbles upon a secret cult plotting a terrible **plan** in the catacombs of an ancient palace.

Tick Tock

Rachel **plans** with her partner-in-crime Carla to murder Rachel's wealthy husband for his money through a complex plot of blackmail, seduction, and brutality involving a cowboy named Travis who may or may not be on to the lady's **plan**.

Raqeeb

A diabolical **plan** is hatched between Sunny and Sophie to kill Remo by natural means, by just threatening him by fake bullets, so that he dies in an asthmatic attack, so that no suspicion is raised. And Remo is killed by Sunny, not by asthma, but by the gun. The bullets were real, indeed. Are there any other meanings behind the scenes more dark than this?

Internet Movie Database, Plot Summaries

Peter Warlock, **Plans** *For Deception*
(London: The Magic Wand Office, 1942)

the **plan** is real

The phone woke me. It was Belbo; his voice different, remote.

"Where the hell are you? Lost in the jungle?"

"Don't joke, Casaubon. This is serious. I'm in Paris."

"Paris? But I was the one who was supposed to go to the Conservatoire."

"Stop joking, damn it. I'm in a booth—in a bar. I may not be able to talk much longer ... "

"If you're running out of change, call collect. I'll wait here."

"Change isn't the problem. I'm in trouble." He was talking fast, not giving me time to interrupt. "The **Plan**. The **Plan** is real. I know, don't say it. They're after me."

"Who?" I still couldn't understand.

"The Templars, Casaubon, for God's sake. You won't want to believe this, I know, but it's all true ... "

Umberto Eco, Foucault's Pendulum

The fear that your home would be broken into at night by armed gangsters shaded imperceptibly into the rising hysteria about a Red Plot. 'Bolshevik **Plan** for Conquest of America' shouted the *Boston Herald*.

Brian Jackson, The Black Flag: A Look at the Strange Case
of Nicola Sacco and Bartolomeo Vanzetti

2) "Kennedy was executed by the Communist Conspiracy because he was **planning** to turn American." For this comforting hypothesis, the Professor comments, ironically, "there is no known reason."

Bob Callahan, Who Shot JFK? A Guide to the Major Conspiracy Theories

The British version was called *The Jewish Peril* and was soon being reviewed in some of Britain's most prestigious journals. On May 8, *The Times*, newspaper of the Establishment, published an editorial, quite possibly the work of its celebrated editor Mr. Henry Wickham Steed. This leading article was titled "A Disturbing Pamphlet: A Call for Inquiry." Its tone was urgent. "What are these *Protocols*?" it asked. "Are they authentic? If so, what malevolent assembly concocted these **plans** and gloated over their exposition?" [27]

Nicholas II himself received one of the first copies of Nilus's book and was delighted, scribbling exclamations in the margins: "What depth of thought!" "How prophetic!" "How perfectly they have fulfilled their **plan**!" "This year of 1905 has truly been dominated by the Jewish Elders!" "All of it is undoubtedly genuine! The destructive hand of Jewry is everywhere!" And more. [41]

As the waiters cleared away the dishes around the two Russians and as other customers sipped their coffees, Pyatakov gave his consent: he was in. Sedov was delighted. His father, he said, had never had any doubt that, despite their earlier falling-out, Comrade Pyatakov would step up to the plate when he was needed. Then the son outlined the **plan**. [53]

In an abrupt change to an earlier **plan**, Diana, leaving the Paris Ritz, was put in the back of a Mercedes and driven recklessly fast by a man who had been drinking into a tunnel with a disguised ramp. [155]

… speculated that Diana was killed because of her **plans** to highlight the plight of the Palestinians. [161]

… former MI6 employee Richard Tomlinson, who had originated the strobe-gun theory based on **plans** he recalled from his secret-service days, now admitted that he might have got the whole thing wrong, and that there was no blinding-light **plan** after all. [172]

Mansfield suggested that the Al Fayed body-guards should have resisted the **plan** to have Henri Paul do the driving. [172]

MANSFIELD: You didn't get authority or clearance … for this **plan**, did you?
WINGFIELD: When we spoke to Dodi, he told us the **plan** had been okayed by Mr. Fayed. [173]

Determined to discover the truth about Emma's death, Craven follows a convoluted trail that leads to a cover-up of the illegal production of weapons-grade plutonium at a British nuclear reprocessing plant. This, in turn, links to an American **plan** to militarize space. [199]

The idea that such an absurd **plan** for world domination actually existed, but for another group altogether … [227]

... nearly two-thirds of New Yorkers under thirty agreeing with the proposition that the administration "knew in advance that attacks were **planned** on or around September 11, 2001, and that they consciously failed to act." [244]

Where it led, according to the Carpenter Professor of Feminist Theology at Berkeley, was to "demonstrate a high level of probability that the Bush administration was complicit in allowing 9/11 to happen in order to further war **plans** that had already been made." [251]

... the hegemonic and imperialist **plans** of the United States of America ... [263]

Is there a **plan** for world government? If so, who is behind it? [287]

> *David Aaronovitch, Voodoo Histories: The Role of the Conspiracy Theory in Shaping Modern History*

The Jesuits are trying to get their hands on the **Plan.**

> *Umberto Eco, Foucault's Pendulum*

"They won't have me," Palfrey told Goodhew with satisfaction, as they rode around Battersea in a taxi. Goodhew had picked him up at the Festival Hall. We'll have to make it quick, Palfrey had said.

"Who won't?"

"Darker's new committee. They've invented a code name for themselves. Flagship. You have to be on their list, otherwise you're not Flagship cleared."

"So who is on the list?"

"Not known. They're color coded."

"Meaning?"

"They're identified by an electronic band printed into their office passes. There's a Flagship reading room. They go there, they shove their passes into a machine, the door opens. The go in, it shuts. They sit down, read the stuff, have a meeting. The door opens, they come out."

"What do they read?"

"The developments. The game **plan.**"

"Where's the reading room?"

"Away from the building. Far from prying eyes. Rented. They pay cash. No receipts. Probably the upstairs of a bank. Darker loves banks."

> *John le Carré, The Night Manager*

AND YOU ARE "THERE," BELOVED ONES—YOU ARE "THERE." IT HAS BEEN A MASTERFULLY EXECUTED **PLAN** BY THE "BIG BOYS" AND IT IS WORKING TO PERFECTION. THE MASSES WILL PLEAD TO HAVE THE GOVERNMENT NOW COME IN AND SOMEHOW SAVE YOU FROM THE DRAGON WITH THE NEW DEBIT SYSTEM AND YOUR MOVEMENT INTO SLAVERY WILL BE COMPLETE. SO BE IT!

Gyeorgos Ceres Hatonn, Privacy in A Fishbowl: Spiral to Economic Disaster, Vol. 2

Willis screeched about how it was all a **plan**, a plot, a conspiracy, before his rantings dissolved into incoherency.

At that moment, Fordyce was suddenly and utterly convinced ... Even though he already half believed it, now the conclusion was inescapable.

"Hey! Hey, you!"

Lockhart's scream interrupted this epiphany. Fordyce looked up to see the cult leader staring at him, extending a shaking finger. "It's him! There he is! You son of a bitch!"

Fordyce glanced left and right. Everyone was staring at him, Millard included.

Douglas Preston and Lincoln Child, Gideon's Corpse

The old man just would not quieten down. He had reached that state of drunkenness when some drunkards, till then subdued, are suddenly overcome by an irresistible desire to fly into a rage and assert themselves.

'What are you staring at me for? You know what your eyes are like? Your eyes are looking at me and saying: "What a drunken rotter you are!" Your eyes are full of suspicion. Your eyes are full of contempt ... You've come here with some crafty **plan** in your mind ...

Fyodor Dostoyevsky, The Brothers Karamazov

His **plan** had nothing to do with the Jews specifically.

Charles D. Watson, The Terrorist Connection (Abounding Love Ministries)

NEW PIXAR TOPICS: DINOSAURS, BRAIN

For summer 2014, the studio **plans** to release "the untitled Pixar movie that takes you inside the mind," said its director Pete Docter, who was behind "Up" and "Monsters, Inc."

"We are excited to take you to a world that everybody knows but where no one has ever been: the world inside your own mind," he said.

Agence France-Presse, New Pixar Topics: Dinosaurs, Brain (Hürriyet Daily News)

PEACE OF MIND® EXTENDED SERVICE **PLAN**
TERMS, CONDITIONS AND LIMITATIONS

The Peace of Mind® Extended Service **Plan** (the "**Plan**") offered by HRB Tax Group, Inc. ("Block") is available only at participating Block offices at the time your return is completed, but no later than October 31 of the year of the return due date. The **Plan** is separate from, and in addition to, The H&R Block Guarantee that pays penalty and interest resulting from an error in tax preparation.

The **Plan** is effective when paid for and signed by you, and cannot be transferred by you to others. Subject to the exceptions noted below ...

H&R Block Tax Services, Peace of Mind® Terms and Conditions

"We can't read your mind or hear your thoughts. When you make a decision your mind weighs options. We can perceive that. We know when you're going to go off the **plan** or not because, if we're close enough, we can sense when it's going to happen. We're just here to keep you on **plan**, that's all we're authorized to do."

"Are you allowed to be telling me this stuff? I mean, are they following me now?"

"We have to monitor the entire world. We don't have the manpower to follow everyone all the time."

George Nolfi (director), The Adjustment Bureau

The Greeks were near despair. But there was
a **plan** forming in Odysseus' head …

*Rosemary Sutcliff, The Wanderings of Odysseus
(Jennifer Armstrong, Courage Book Review: The
Wanderer, http://www.lionswhiskers.com)*

the **plan** of zeus

RAW presents *Off **Plan***, an adaptation of *The Oresteia* ...

*Patrick Lonergan, Reviews | Current | Off **Plan** (Irish Theatre Magazine)*

TALKING POINTS: GREEK DRAMA PLAYS
OUT OVER AUSTERITY **PLAN**

The Issue: A Greek drama unfolded on the streets of Athens and in parliament this week as the fate of the euro hung in the balance.

Greece voted to adopt austerity measures in order to get an EU-IMF bailout package for its half-trillion dollar (U.S.) debt, while demonstrators staged a two-day general strike to protest the widely vilified belt-tightening **plan**.

Olli Rehn, EU economic and monetary affairs commissioner, The Hill: "The only way to avoid immediate default is for Parliament to endorse the revised economic program ... To those who speculate about other options, let me say this clearly: there is no **Plan B** to avoid default. The European Union continues to be ready to support Greece. But Europe can only help Greece if Greece helps itself."

*Sarah Barmak, Talking Points: Greek Drama Plays Out Over Austerity **Plan** (Toronto Star)*

He put his mind to work and came up with a **plan**.
That's how he was; he could think up things
As well as he could fight.

Homer, Odyssey (Stanley Lombardo, translator)

In some ancient Greek epics, a *Dios boulē* 'plan of Zeus' helps to motivate and explain the plot.

Jim Marks, Zeus in the Odyssey

Trying to come up with the best **plan** I could
To get us all out from the jaws of death.

Homer, Odyssey (Stanley Lombardo, translator)

At a Valentines Day workshop, Farmington city officials and council members gathered around a table covered with the city's massive spreadsheet detailing a **plan** for paying back millions in bond debt.

*Laura Adelmann, Farmington Council Introduced To City's Payoff **Plan** For Millions In Debt (sunthisweek.com)*

The Greeks are facing a stark choice. They can say yes to the terms of the European bailout **plan**—in which case they face a life sentence of harsh austerity under the watchful eye of European technocrats who'll basically be telling their government what to do. Or they can say no—in which case they face a life sentence of harsh austerity, but at least they'll be in charge ...

Margaret Wente, The Euro: A Nice Idea Until the People Got in the Way (The Globe and Mail)

This was the best **plan** I could come up with:
Beside one of the sheep pens lay a huge pole
Of green olive which the Cyclops had cut
To use as a walking stick when dry. Looking at it
We guessed it was about as large as the mast
Of a black ship, a twenty-oared, broad-beamed
Freighter that crosses the wide gulfs.
That's how long and thick it looked. I cut off
About a fathom's length from this pole
And handed it over to my men. They scraped it
And made it smooth, and I sharpened the tip
And took it over to the fire and hardened it.
Then I hid it, setting it carefully in the dung
That lay in piles all around the cave.
And I told my men to draw straws to decide

Which of them would have to share the risk with me—
Lift that stake and grind it in his eye
While he was asleep.

Homer, Odyssey (Stanley Lombardo, translator)

Democracy is messy. And now it's messing up the best-laid **plans** of the elites. They're beside themselves that Greek Prime Minister George Papandreou would dynamite their rescue **plan** by calling a referendum. Consult the people? What could he be thinking?

Margaret Wente, The Euro: A Nice Idea Until the People Got in the Way (The Globe and Mail)

Then, sitting at the base of the sacred olive,
The two plotted death for the insolent suitors.
Athena began their discussion this way:

"Son of Laertes in the line of Zeus,
Odysseus, the master tactician—consider how
You're going to get your hands on the shameless suitors,
Who for three years now have taken over your house,
Proposing to your wife and giving her gifts.
She pines constantly for your return,
But she strings them along, makes little promises,
Sends messages—while her intentions are otherwise."

What do you think? Will the euro be able to survive? Will Nicolas Sarkozy and Angela Merkel be able to come up with a **plan** to end the euro zone debt crisis that is acceptable to their own citizens and member nations?

Gerald Greene, Euro Zone Debt Crisis Talks Stalled (politics.gather.com, photo by Sebastian Zwez)

And Odysseus, his mind teeming:

"Ah, I'd be heading for the same pitiful death
That Agamemnon met in his house
If you hadn't told me all this, Goddess.
Weave a **plan** so I can pay them back!

> Homer, *Odyssey (Stanley Lombardo, translator)*

Mr. Papandreou was no doubt thinking of his own survival. All around the country, Greeks are saying *ochi* (no). Forcing nasty medicine down their throats against their will is a good way to be kicked out of office. Besides, the salvage **plan** was likely to be dynamited anyway. The current government may not survive the week. The next one could be far more hostile to the European Union's idea of a cure ...

> Margaret Wente, *The Euro: A Nice Idea Until the People Got in the Way (The Globe and Mail)*

The motivation behind the narrative of the *Odyssey* has generally been understood as a fairly straightforward process: the chain of causality in the Odyssean narrative begins with Athene. And as the above quote shows, the **plan** for Books 1 through 13 is indeed articulated by the goddess. Yet Athene speaks up only in response to Zeus' account of the Oresteia, which I now quote in full:

> Jim Marks, *Zeus in the Odyssey*

The Bankruptcy Code sets forth the relative priority of claims against a debtor and the waterfall in which such claims are typically paid. In order for a court to confirm a **plan** over a dissenting class of creditors—what is commonly called a "cram-down"—the Bankruptcy Code demands that *either* (i) the dissenting class receives the full value of its claim, or (ii) no classes junior to that class receive any property under the **plan** on account of their junior claims or interests. This is known as the "absolute priority rule."

Not surprisingly, rigid enforcement of the absolute priority rule can lead to some difficulties in confirming a **plan**. It can encourage a class of out-of-the-money creditors or equity holders to withhold their consent to the **plan**, which often results in time-consuming and expensive valuation fights and confirmation battles. Traditionally, a common solution to such a problem has been that a senior secured creditor gives a "gift" or "tip"—a distribution to which the senior creditor would otherwise be entitled—to an objecting junior class in order to buy peace and achieve a consensual **plan**. Courts generally permitted such **plan** provisions under the premise that such distributions are,

Trojan Horse
Part 1:
The Start

Trojan Horse
Part 2: The
Development

The Trojan Horse was surprising to both of us. Just how did this image develop, seemingly independently of **plan** or will? What was happening behind the Oz-like curtain of the studio process?

Suzanne Edminster, How We Built the Trojan Horse: A Four Hands Collaborative Painting Process (saltworkstudio.wordpress.com)

in essence, "gifts" of the senior party's property and not of estate property and simply do not implicate (and, thus, do not violate), the "absolute priority rule."

The problem arises when the gift skips over a class that comes ahead of the gift-recipient class in the Bankruptcy Code priority scheme. In such cases, the "skipped" class of creditors may argue that, to satisfy the absolute priority rule, a **plan** must provide that its claims be paid in full before distributions are made to any junior class of creditors (or interest holders). In 2005, the Third Circuit condemned that approach in *In re Armstrong World Industries* as violating the absolute priority rule. And in a recently issued opinion, the Second Circuit Court of Appeals agreed with the Third Circuit, holding that the **plan** *In re DBSD North America, Inc.*, which contained a gifting provision, should not have been confirmed.

Henry J. Jaffe and Deborah Kovsky-Apap, Looking a Gift Horse in the Mouth: Second Circuit Finds Class-Skipping Gift Violates Absolute Priority Rule (Pepper Hamilton, LLP: Attorneys at Law)

Palin urges 'Trojan camel' trick to defeat Al Qaeda
By Helen Troy, Staff Writer

Hoping to quell fears that she lacks foreign policy expertise, Sarah Palin unveiled **plans** to combat Middle East terrorists with "a giant wooden camel on wheels," modeled after poet Virgil's legendary Trojan horse.

"It's genius," she said. "We find out where Al Qaeda is hiding, then roll the camel up to their cave and wait. They'll think it's a gift and bring it inside, not realizing we've hidden 200 U.S. Marines in the camel's belly. Once the terrorists fall asleep, the Marines climb out and kill them."

Not The Los Angeles Times, illustration by Russ Cohen

The premise of Europe's financial system was fatally flawed from the start. It assumed that culture didn't matter. It assumed that Europeans could be made as interchangeable as euros and that, eventually, they'd all behave like

Germans. But now, every cultural stereotype has turned out to be true. The profligate Greeks and Italians are in hock up to their eyeballs to the thrifty, industrious Germans and Finns. The good burgers of Hamburg would be quite happy to let Greece sink to the bottom of the Aegean. But they can't afford to see their own banks and pension **plans** sink with it ...

Margaret Wente, The Euro: A Nice Idea Until the People Got in the Way (The Globe and Mail)

And Odysseus' resplendent son answered:

"You'll soon see what I'm made of, Father,
And don't think you'll find me lacking.
But I'm not sure your **plan** will work
To our advantage. Think about it.
It'll take forever for you to make the rounds
Testing each man, while back in the house
The high-handed suitors are having a good time
Eating their way through everything you own.

Homer, Odyssey (Stanley Lombardo, translator)

A Greek man withdraws cash from an ATM on Feb. 16, in Athens, Greece. EU officials admitted to making contingency **plans**, including limiting ATM withdrawals, in the (unlikely) event that Greece exits the eurozone.

*Alex Johnston, EU Has 'Contingency Plan' if Greece Leaves Euro (The Epoch Times,*Oli Scarff/Getty Images)

There's no quick fix for this debacle. There may not be a slow fix, either. Austerity **plans** may look fine on paper, but you can't always make them stick. You can't turn a nation of tax evaders into tax compliers overnight—especially when the tax collectors go on strike.

And Greece is just a tiny country ...

Margaret Wente, The Euro: A Nice Idea Until the People Got in the Way (The Globe and Mail)

You and I must **plan**
How to kill our enemies. List them for me now
So I can know who they are, and how many,
And so I can weigh the odds and decide whether
You and I can go up against them alone
Or whether we have to enlist some allies.

 Homer, Odyssey (Stanley Lombardo, translator)

What about Italy? The Italians are €1.9-trillion in debt, and they aren't about to give up their perks, either. Italy has more than half a million pensioners who retired under the age of 50. They will spend an average of 40 years in retirement, and they cost the system €13-billion a year. But what politician is going to cut them off? The government is propped up by a deeply entrenched jobs-for-votes system that is as Italian as spaghetti. Even tiny villages have dozens of people on the payroll to do non-existent jobs, paid for by the central government. Reducing the number of these people, or their salaries, is an unthinkable **plan**. It's exceedingly unlikely that the Italians will allow a bunch of Eurocrats to destroy their way of life. And Italy is far too big to fail. Therefore, the Italians, like the Greeks, will be inclined to tell the Eurocrats to go to hell.

 Margaret Wente, The Euro: A Nice Idea Until the People Got in the Way (The Globe and Mail)

It is also important to recall that the absolute priority rule only applies in a cram-down—that is, where the **plan** proponent seeks to confirm the **plan** over the objection of a dissenting class. *If every class votes to accept the plan, the absolute priority rule isn't implicated.* Expect to see **plan** proponents employing the "carrot and stick" approach—if the skipped class votes in favor of the **plan**, it will receive a distribution; if it votes to reject the **plan**, it gets nothing. Although some courts frown on this kind of so-called "deathtrap," many courts—including the Second Circuit Court of Appeals—have affirmed confirmation of **plans** containing such provisions. (Even with a deathtrap, however, the balance of power isn't entirely one-sided. As the Second Circuit intimated in its opinion in *DBSD*, unsecured creditors can use the specter of the absolute priority rule as leverage to increase their distribution under a **plan** "if the 'good business reasons' for the gift to the [junior class] are still worth the cost" to the gift-giver.)

 Henry J. Jaffe and Deborah Kovsky-Apap, Looking a Gift Horse in the
 Mouth: Second Circuit Finds Class-Skipping Gift Violates Absolute
 Priority Rule (Pepper Hamilton, LLP: Attorneys at Law)

the plan of zeus

When I asked her what she wanted to make for our project last week, she hadn't had a horse lesson for a month because her instructor was traveling to various horse shows out west. She told me she wanted to make "a horse that she could ride, out of wood, sort of like the Trojan Horse." She then drew me a picture of what it would look like:

I hate drawing horses. I still draw horses based on the seven-step method I learned from Ed Emberley's *Drawing Book of Faces* (1975):

according to plan

So I figured if I could draw a horse out of triangles that is how we could make one out of wood. I drew her a picture (based on her sketch) of the kind of horse I thought I might be able to make …:

We got out a big book of newsprint and drew up some **plans**. I know I could have found an actual pattern or some instructions online or in a book, but I was pretty sure I would have been scared off by the skill level or materials required. Besides, sometimes I prefer figuring things out for myself. It demystifies the whole process. Sometimes the hardest part of making something is just sitting down to actually make it. Figuring how I'd fit various pieces together and using equations I hadn't thought about since tenth grade was actually kind of fun:

the plan of zeus

While I was working out a **plan**, the girl was sitting next to me with her own piece of newsprint, plotting out the pieces we'd need and giving them names, and even adding a bunch of numbers she called "her measurements" …

Voila, this is no ordinary horse!

jdg, End of Summer Project: The Wooden Horse (www.sweet-juniper.com)

Athena, meanwhile, was having a word with Zeus:

"Father of us all, Son of Cronus most high,
Tell me what is hidden in that mind of yours.
Will you let this grim struggle go on?
Or will you establish peace on Ithaca?"

And Zeus in his thunderhead responded:

"Why question me, Daughter? Wasn't this
Your **plan** ...?"

> Homer, *Odyssey* (Stanley Lombardo, translator)

Re: Zeus
My original **plan** was to put my two current 120 mm rads in the top mounts inside the case, with fans on the outside. Unfortunately, they're a bit too thick for that (like, ~1/2″), so now I'm gonna be reversing it and mounting the fans on the inside with the rads on the outside.
My eventual **plan** is to get a 140.2 or 120.2 (the 140's are weirdly expensive ... guess because they don't sell as many?) to put in place of those, and at that point drill the necessary holes to run the tubing through. In the mean time, I'm enjoying that CM put in those little holes for just this purpose.

> *x88x (might just be god), The Best Case Scenario: Community Forums > Mod Walk > Works in progress > Zeus (www.thebestcasescenario.com)*

"I'm tired of trying to be the **architect** for this family. It's high time you drew your own blueprints."
 "Does anyone know what the fuck she's talking about anymore?"

> *Alan Ball, Six Feet Under: Season 2, Episode 3: The **Plan***

There is no question that the Second Circuit's decision represents an obstacle to the use of consensual gifting as a restructuring technique. But commentators who have suggested the Second Circuit's decision in *DBSD* spells the end of class-skipping gifts in Chapter 11 bankruptcy cases may be overlooking the avenues for gifting that remain open—and may well be underestimating the creativity of restructuring professionals and **plan** proponents.

Henry J. Jaffe and Deborah Kovsky-Apap, Looking a Gift Horse in the Mouth: Second Circuit Finds Class-Skipping Gift Violates Absolute Priority Rule (Pepper Hamilton, LLP: Attorneys at Law)

TRAITOR, TROJAN HORSE GREEK PM PAPANDREOU UNMASKS SELF, SCRAPS REFERENDUM **PLAN**

Scumbag Liar Papandreou Never Intended To Go Forward With Referendum—Will Ensure Survival Of EU Seeking One World Government—Mass Riots Probable In Greece—Little Mussolini Sarkozy, Merkel, Obama Threaten Greek Sovereignty

The Greek prime minister has announced he will drop the idea of a referendum on a vital bailout package and hold talks with the opposition to resolve the country's political and economic crisis.

In a speech to his cabinet on Thursday, George Papandreou said he would assign the task of discussions with the opposition to two senior party members and praised their support of the bailout deal.

If the opposition agreed to back the deal in parliament no referendum would have to be held, he said.

"I will be glad even if we don't go to a referendum, which was never a purpose in itself. I'm glad that all this discussion has at least brought a lot of people back to their senses," he said in the text of his speech released to media.

WhiteKnight, Trojan Horse Greek PM Unmasks Himself. Scraps Referendum **Plan***. All Part of the* **Plan***? (Surfing the Apocalypse Network)*

I hope to show that the unfolding of Zeus' divine **plan** creates a narrative **plan** through the controlled negotiation of narrative choices. Within the narrative, these choices are identified with the conflicting aims of gods who are, at least in the canonical epics, subordinate to Zeus. Choices authorized by the chief god align the narrative with, or distance it from, various traditions among which the canonical epics developed. Thus Zeus' harmonization of the conflicting aims of Athene and Poseidon in the *Odyssey* can be seen as a metaphor for the *Odyssey's* own composition. In like manner as Zeus manipulates and

cajoles others into making their aims coextensive with his own, the *Odyssey* finesses the competing claims of parallel traditions, according as much recognition and authority to each as its own thematics allow.

Jim Marks, *Zeus in the Odyssey*

It seems like forever ago when Zeus first mentioned a family expedition to Washington D.C. I listened and then forgot. He brought it up again, this time to the kids. Of course, Eris jumped right on it. The rest were lukewarm (or downright cold) to the idea. Zeus continued to discuss and **plan**.

The Numismatist, *We Did It! Numismatically Speaking ... Adding It All Up* (numismaticallyspeaking.blogspot.com)

I was wondering why would Athena wait so long to release Odysseus after seven years of being a prisoner on Ogygia, and from above quote, it has to do with *specific timing* and Poseidon needed to be *absent* at that moment for the "**plan**" to be initiated.

Zadius Sky, *Re: The Odyssey—Manual of Secret Teachings? (Cassiopaea Forum)*

The Wooden Horse

... and **plan** to make for neutral Sweden. To do that, they'll not only have to move around without arousing any suspicions, but also find a stranger from a neutral or occupied country who'll be willing and able to help them.

Internet Movie Database, *Plot Summaries*

Edward Lansdale, the general chosen to head up Operation Mongoose, was a remarkably inventive man. A master of dark and deceptive "psy-ops" (psychological operations), Lansdale devised a **plan** in which a submarine would surface off the shores of Cuba a day or so before the actual invasion. By that time the region would have been blanketed with an announcement proclaiming the second coming of Jesus Christ, an act intended to profoundly affect the island's residents, most of whom were peasant Catholics. The submarine would contribute to their anxiety by hosting a fantastic Second Coming light show to be played out in the night sky above the island. The idea never got off the ground, however, because—in the words of the irascible Warren Hinckle—while one bearded leader on the island of Cuba might have been okay, the idea of two bearded leaders would have been just too much.

Bob Callahan, Who Shot JFK? A Guide to the Major Conspiracy Theories

However, even allowing for the artificiality of epic conventions, this interpretation renders the scene almost comic upon examination. Athene sits around the Olympian agora, waiting until Zeus offers her a pretext to announce a **plan** for Odysseus and Telemachos. As the clock ticks toward the last possible moment any such **plan** could be successful, Zeus happens to launch into a story that happens to contain a sweeping generalization about divine justice to which Odysseus is a glaring exception, and that, to anticipate my analysis below, happens to contain the seeds of the narrative itself.

Jim Marks, Zeus in the Odyssey

"The more we hear, the worse it actually is. It's a Trojan horse **plan** that was not well thought out and full of unanswered questions. Middletown Township should get as far away from this **plan** as it can!"
— Un-named Urban **Planner**

savemiddletown, Trojan Horse Plan (Save Middletown's Blog)

The American government watched the incident with alarm, and the following year Congress created the first National Contingency **Plan**—a blueprint for dealing with a similar catastrophe.

Raffi Khatchadourian, The Gulf War (The New Yorker)

... Contingency **Plan** NE385/8 (Operation Six Second War). In terms of this **plan**, CIA-sponsored troops of the Orthodox Islamic Maoist Falange would rescue the Arab states from the temptations of greed by occupying more than 80 percent of its oil facilities in an action calculated to require less than one minute of actual combat, although it was universally admitted

that an additional three months would be required to round up such Arab and Egyptian troops as had fled in panic as far as Rhodesia and Scandinavia.

It was agreed that Operation Six Second War would be undertaken without burdening the President or Congress with those decision-making responsibilities so onerous in an election year. Phase One was instituted ...

Trevanian, Shibumi

... and I am worried the **plan** will not succeed as **planned** ...
Posted by Alec, Ithaca As a Beggar (bigbossodysseus.blogspot.com)

They reveal the Trojan Horse **plan** to Jeff and Ozzy talks about his dream (hopefully a naked Indian was involved) that told him to do this, plus the added twist that Ozzy is going to tell Christine that Cochran had the Idol and played it, which is how Ozzy got voted out. That's not bad, though how does that get back to Upolu? Hmm.

During the vote, we only see Cochran vote for Ozzy. Hilariously, before the votes are read, Ozzy fakes Cochran out by saying he's changed his mind and Cochran can go to Redemption. Have you ever wondered what a grown man soiling himself looks like? That was it.

Ozzy then hands the Idol over to Cochran and the votes are unanimous for Ozzy (except presumably obviously Ozzy's vote, since you are not allowed to vote for yourself).

Next week: I can't wait to see how this plays out, y'all. That was a crazy move.

*Andrea Reiher, 'Survivor: South Pacific': The Trojan Horse **Plan***
Is a Go (From Inside the Box: TV News and Buzz)

Waiting at home for him is his wife, Clytemnestra, who has been **planning** his murder: partly as revenge for the sacrifice of their daughter, Iphigenia; partly because during the ten years of Agamemnon's absence Clytemnestra has entered into an adulterous relationship with Aegisthus, Agamemnon's cousin.

Eric Ladau, HBU Presents Aeschylus's "Oresteia" (Houston Public Radio)

"Last night, at The Cloisters ..." She paused, then decided to press on. "Do you remember what I said?"

Of course he remembered, but he hoped she had been babbling and would forget it all later. "Oh, you were pretty much out of your head with the dope. You were just playing out fantasies."

"Is that what you want to believe?"

He didn't answer. Instead, he patted her arm.

"Don't do that! I'm not a puppy, or a child that's stubbed its toe."

"Sorry."

"I'm sorry too. Sorry the idea of being loved is such a burden to you. I think you're an emotional cripple, Jonathan Hemlock."

"Do you?"

"Yes I do."

The downward curl of the last vowel made him smile to himself.

"I have a **plan**," he said after a silence. "When this thing is over, we'll get together and play it out. Gingerly. Week by week. See how it goes."

She had to laugh. "Lord love us, if you haven't found the tertium quid between proposal and proposition."

"Whichever it is, do you accept?"

"Of course I do."

"Good."

Trevanian, The Loo Sanction

With that final bit of stroking, Émile Cinq-Mars left and walked back to his car, confident that he had put serious matters into motion. It had stopped raining. No **plan** made sense unless it accomplished a variety of functions. That way, it never looked like a **plan**, it didn't take on the appearance of a ploy.

John Farrow, City of Ice

For this is not about conspiracy but about coincidence—unexpected connections that are both riveting and rattling. Much religious faith is based on the idea that almost nothing is coincidence; science is an exercise in eliminating the taint of coincidence; police work is often a feint and parry between those trying to prove coincidence and those trying to prove complicity. Without

coincidence, there would be few movies worth watching ("Of all the gin joints in all the towns in all the world, she walks into mine"), and literary plots would come grinding to a disappointing halt. (What if Oedipus had not happened to marry his mother? If Javert had not happened to arrive in the town where Valjean was mayor?)

The true meaning of the word is "a surprising concurrence of events, perceived as meaningfully related, with no apparent causal connection." In other words, pure happenstance. Yet by merely noticing a coincidence, we elevate it to something that transcends its definition as pure chance. We are discomforted by the idea of a random universe. Like Mel Gibson's character Graham Hess in M. Night Shyamalan's new movie "Signs," we want to feel that our lives are governed by a grand **plan**.

Lisa Belkin, The Odds of That (The New York Times)

So 'the **plan** of Zeus was fulfilled'. And what does this mean? That all this was specially **designed** by Zeus for inscrutable reasons of his own? Rather the opposite, that it is part of a universal **Plan**: not an isolated event—something which, as it happened, so fell out on this occasion—but something that came from the very nature of things: not a particular, but a universal. It is not for us to say whether it was from pondering on this episode of the war that Homer was led to this conception, or whether his experience of life led him to this conception, which he then saw could be expressed through the Achilles-story: the important thing is that this is his subject ...

H. D. F. Kitto, The Greeks: A Study of the Character and History of an Ancient Civilization, and of the People Who Created It

The **plan**—when it was the **plan** we had somehow believed in—

Matt Cohen, The Bookseller

The polemical presentation of Zeus' Oresteia, I conclude, involves manipulation of virtually every character and theme. Thus the very arbitrariness of the Oresteia-*Odyssey* relationship points to the significance of Zeus' role in the **plan** that Athene formulates for Odysseus. Zeus defines the thematic parameters of both stories, so that all Athene must (or can) do in order to come up with a **plan** for Odysseus is to make obvious connections between his story and Agamemnon's. As discussed in subsequent chapters, the kinds of interactions to which I have drawn attention in the first divine council remain prominent in further **planning** sessions among the gods.

Jim Marks, Zeus in the Odyssey

Jesus Was A Carpenter, Right?
I don't like right angles.
So the Basement Project limps on.
And it is now time for me to do the "I Told You So" dance (unfortunately no one is ever around for this dance) because we just had to order the cabinets. Lord almighty, even if you go the Do-It-Yourself route on this cabinet thing—do you realize what it entails?
Kudos to the ladies at Lowe's who sat there doing super cool things on a computer with That Man I Love. I don't understand blueprints. And when I measure something I always end with the words "give or take." Apparently cabinets are very literal.

Posted by Omgrrrl, WTF-n-Stuff (wtf-n-stuff.blogspot.com)

But even in these recessionary days, big films still command big budgets. Christopher Nolan's next installation of *Batman* has a reported budget of $250 million dollars. Despite having this amount of coin, the rumor is that Mr. Nolan **plans** to use the Occupy Wall Street protestors as free background material for certain scenes in the film. This sounds like one of the worst ideas I could imagine. I don't imagine that the protestors will get paid for their usage. In fact I would hope they rise up and take bricks and bats to old Batman.

> *Dorothy Woodend, Occupy the Movie Theatres: Could Money-Sucking,*
> *Worker-Shedding Hollywood Be More Out of Touch? (The Tyee)*

Hey its Telemachus here, sorry my dads busy working on our **plan**, he's dressed as a beggar right now but will be back soon I think. So now that my dad and I have a **plan** to kill the suitors I'm getting really excited.

> *odysseus the great, Book 17 (Diary of Odysseus)*

ALSO THIS IS MY SECOND **PLAN**—IF YOUR LOOSING YOUR HOME
DESTROY IT BEFORE YOU LEAVE—THE DAY THEY COME FOR
THIS HOME THERE WILL BE NOTHING LEFT OF IT. NOTHING!!!!
DO YOU THINK I'M GOING TO LET THEM RE-SELL MY HOME AND
MAKE MORE MONEY ARE YOU FUCKING NUTS! FIRST OUT COME
THE TOILETS, IN GOES THE CEMENT, SECOND, DOWN COMES
CEILING TURN OFF MAIN BREAKER CUT EVERY WIRE, TAKE IT
TO SCRAPYARD FOR COPPER, THEN OUT COMES EVERY SWITCH
AND PLUG CUTTING WIRES AS SHORT AS POSSIBLE, THEN I WILL
CUT LOWER HALF OF CEILING TRUSSES, GO ON ROOF AND CUT
THE TOP ROOF AND WATCH THE ROOF DROP INTO THE HOME,
THEN BREAK THE WINDOWS AND TURN ON SPRINKLER AND
PUT IN IN THE MIDDLE OF THE HOUSE—THEN THEY CAN HAVE
IT BACK—WATCH FOR ME ON T.V. THIS WILL BE ON THE NEWS—
CAUSE WHEN I START CUTTING ROOF I'LL CALL NEWS STATIONS,
I WANT IT ALL OVER THE COUNTRY—THOSE FUCKS WON'T BE
TAKING ANY BONUS MONEY BY RE-SELLING MY HOME—AND IF
IT REALLY HAPPENS I MEAN PEOPLE WITH GUNS—ANARCHY—I
WILL ALSO BE HUNTING BANKERS, UNMERCIFULLY.

Captain Capitalism, Kill the Bankers: Comment (Captain Capitalism:
Rantings and Tirades of a Frustrated Economist)

And it is not only externals that are seen with this vividness. The artistic function of this passage, as Homer himself tells us, is to describe that event—the quarrel—from which came so much suffering to the Greeks, in accordance with what Homer calls 'the **plan** of Zeus', and we should call the inevitable working-out of events. The cause is the 'wicked arrogance' of Agamemnon, and the 'ruinous wrath' of Achilles; this is quite plain.

But what Homer gives us is not two abstract qualities in conflict; we see two men quarrelling violently. Nothing could be more 'real', less abstract. As in life, there is something to be said on each side, only both men go too far. The quarrel flares up because each man happens to be the sort of man that he is. It is an affair of a moment—but 'it sent the souls of many brave heroes down to the world of the dead, and left their bodies to be eaten by dogs and birds. And the **plan** of Zeus was fulfilled.'

This is, not of course exclusively, but characteristically, Greek, this power of seeing the immediate event so sharply, and at the same time of apprehending the universal law which it exemplifies. We are shown something of the framework of the whole universe in one event, yet the treatment of this event has all the sharpness of the most brilliant reporting. Homer does not need to blur

the sharpness of his picture by generalizing comments; all his generalizing has been done already, in the ground-**plan** of the whole edifice.

H. D. F. Kitto, *The Greeks: A Study of the Character and History of an Ancient Civilization, and of the People Who Created It*

So went their talk.
 The suitors, meanwhile,
Were laying **plans** for Telemachus' death,
But as they talked a bird appeared on their left,
A high-flying eagle with a dove in its talons.
This prompted Amphinomus to say to them:

"This **plan** of ours isn't going to work, friends—
Killing Telemachus. We might as well just eat."

Homer, *Odyssey* (Stanley Lombardo, translator)

I'd hardly begun to make sense of this communication before another one caught my eye—a postcard, the same kind Van Ness had mailed me—"Greetings from Santa Cruz," where the ferris wheel meets the ocean and seems ready to glide into that gigantic blueness.

I turned the card over. The message read *Now we'll see.* No postmark. He'd carried this card here in his pocket, and laid it down with his hand.

The spasm that wrenched me knowing that he'd actually entered this house set loose a spray of images inside me, bits and pieces blown above the forest, the forest of dreams—I'd walked in a dream through these rooms, but their walls had given onto other places, a ramshackle barn full of strangers who claimed I should know them, and I lied, saying that I did, and in that place this very tabletop had upheld a pile of fruit. It was impossibly strong, nauseating, violently so, the sense that I was both remembering and experiencing this, that I could, if I just stood still and collected myself, predict the next thing to happen in this kitchen.

According to the **plan**, the point of my being here was to discover the body. But I hadn't considered that I'd actually have to *discover* the *body*. This was no theory. I was living it.

"Winona?"

Denis Johnson, *Already Dead: A California Gothic*

090828-N-3592S-132, ATLANTIC OCEAN (August 28, 2009). Deputy Assistant Secretary Of Defense for **Plans** Janine Davidson departs the amphibious assault ship USS NASSAU (LHA 4) after her Quadrennial Defense Review tour.

U.S. Navy photo by Mass Communication Specialist 1st Class James R. Stilipec

master **plan**

Flesh for Frankenstein
In Serbia, Baron Frankenstein lives with the Baroness and their two children. He dreams of a super-race, returning Serbia to its grand connections to ancient Greece. In his laboratory, assisted by Otto, he builds a desirable female body, but needs a male who will be superbody and superlover. He thinks he has found just the right brain to go with a body he's built, but he's made an error, taking the head of a gay aesthete. Meanwhile, the Baroness has her lusts, and she fastens on Nicholas, a friend of the dead lad. Can the Baron pull off his grand **plan**?

Internet Movie Database, Plot Summaries

VOICEOVER: This is the Secretary of Defense of the United States, Robert McNamara. His department absorbs 10% of the national income of this country and over half of every tax dollar. His job has been called the toughest in Washington, and McNamara is the most controversial figure that has ever held the job. Walter Lippmann calls him not only the best Secretary of Defense but the first one that ever asserted civilian control over the military. His critics call him a con-man, an IBM machine with legs, an arrogant dictator.

INTERVIEWER: Mr. Secretary, I've noticed in several cabinet offices that little silver calender thing there, can you explain that?

ROBERT MCNAMARA: Yes, this was given by President Kennedy. On the calender are engraved the dates October sixteen, seventeen, eighteen, nineteen, twenty, twenty-one, twenty-two, twenty-three, twenty-four, twenty-five, twenty-six, twenty-seven, and finally twenty-eight were the dates when we literally looked down the gun barrel into nuclear war.

October 16, 1962
Tape recorded phone call:
JOHN F. KENNEDY: In the next 24 hours what is it we need to do?

ROBERT MCNAMARA: Mr. President, we need to do two things, it seems to me. First, we need to develop a specific strike **plan**. The second thing we have to do is consider the consequences. I don't know quite what kind of a

Errol Morris (director), The Fog of War: Eleven Lessons From the Life of Robert S. McNamara

world we'll live in after we've struck Cuba. How do we stop at that point? I don't know the answer to this.

Errol Morris (director), The Fog of War: Eleven Lessons from the Life of Robert S. McNamara

We have indeed no direct transcripts of Ancient Greek conversation, but we have passages, in the dramatists and in Plato, in which the writer is striving to give the effect of unpremeditated speech, and in these a fairly elaborate periodic structure is not uncommon, but even if we do not find this we always find a perfectly limpid and unambiguous ordering of the sentence, as if the speaker saw the ground-**plan** of his idea, and therefore of his sentence, in a flash, before he began to put it into words. It is the nature of the Greek language to be exact, subtle and clear. The imprecision and the lack of immediate perspicuity into which English occasionally deviates[1] and from which German occasionally emerges, is quite foreign to Greek. I do not mean that it is impossible to talk nonsense in Greek; it is quite possible—but the fact that it is nonsense is at once patent. The Greek vice in language is not vagueness or woolliness but a kind of bogus clarity, a firm drawing of distinctions which are not there.

H. D. F. Kitto, The Greeks: A Study of the Character and History of an Ancient Civilization, and of the People Who Created It

March 2, 1964
Tape-recorded phone call:
LYNDON B. JOHNSON: I want you to dictate to me a memorandum of a couple of pages. Four letter words and short sentences on the situation in Vietnam, the 'Vietnam Picture'. This morning Senator Scott said, 'The war which we can neither win, lose, nor drop is evidence of an instability of ideas, a floating series of judgments, our policy of nervous conciliation which is extremely disturbing.' Do you think it is a mistake to explain about Vietnam and what we're faced with?
ROBERT MCNAMARA: Well, I do think, Mr. President, it would be wise for you to say as little as possible. The frank answer is we don't know what is going on out there. The signs I see coming through the cables are disturbing signs. It is a very uncertain period.

March 10, 1964
Tape-recorded phone call:

1 When I say 'English' I do not mean the English of administrators, politicians and important people who write letters to *The Times*. Imprecision would be the chief quality of this language, but for its weary pomposity and its childish delight in foolish metaphors.

Errol Morris (director), The Fog of War: Eleven Lessons From the Life of Robert S. McNamara

LYNDON B. JOHNSON: We need somebody over there that can get us some better **plans** than we've got. What I want is somebody that can lay up some **plans** to trap these guys and whoop the hell out of 'em. Kill some of 'em, that's what I want to do.

ROBERT MCNAMARA: I'll try to bring something back that will meet that objective.

LYNDON B. JOHNSON: Okay Bob, thank you.

Errol Morris (director), The Fog of War: Eleven Lessons from the Life of Robert S. McNamara

*How does the United States **plan** to defeat Iraq?*

U.S. war **planners** have devised a strategy **designed** to bring about a quick victory. The **plan's** central element, according to widespread press reports, will be an intense "shock and awe" assault that stuns Iraqi forces into quick submission. It will be carried out nearly simultaneously from the air, ground, and sea, probably beginning under cover of darkness.

What's the aim of an Iraq war?

To force Saddam Hussein to give up his suspected arsenal of weapons of mass destruction and remove him from power.

Has the U.S. military strategy been made public?

No. Details are kept secret to preserve an element of surprise and, because **plans** and contingencies are always evolving and false information is sometimes purposefully leaked, it's difficult to know which reports are reliable. The emerging consensus about how the attack will unfold is supported by military analysts and press reports based on interviews with administration officials and military **planners**, both in the Middle East and in Washington.

*Council on Foreign Relations, Q&A: How Does the United States **Plan** to Defeat Iraq? (The New York Times)*

ANALYSIS: BUSH'S NEW **PLAN** NOT ALL NEW

WASHINGTON—President Bush's new **plan** for Iraq sounds a lot like his old one. Send in more troops, set goals for the Iraqi government and assure Americans it's better to wage war there than here. And now the U.S. military is back in Somalia, too, once again attacking suspected terrorist targets. Bush's challenge in Iraq: show what's different now.

The **plan** the president will outline to the nation Wednesday night is the latest repackaging of a program that's been wrapped and rewrapped many times.

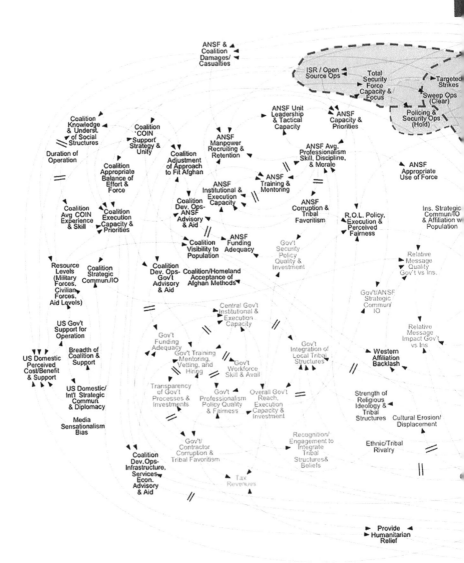

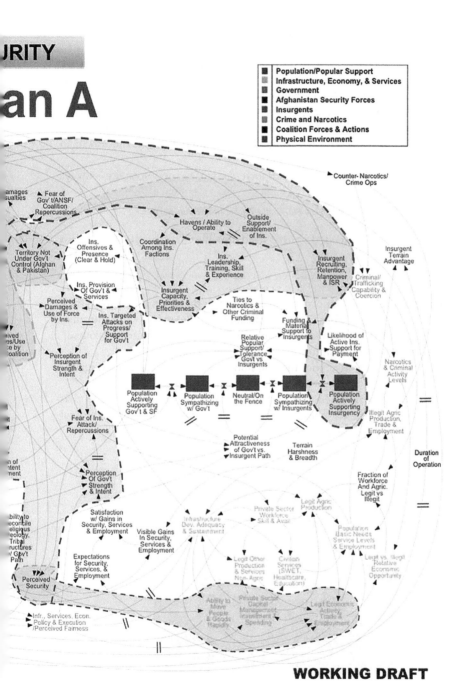

WORKING DRAFT

The White House recognizes that a majority of Americans disapprove of Bush's handling of Iraq and that Democrats are eager to assert their new leadership on Capitol Hill by challenging his proposal to send in more troops.

But Bush advisers also believe that Americans do not necessarily support an immediate withdrawal and might be willing to give the president the benefit of the doubt if he presents a feasible, detailed **plan** that points the way to an eventual U.S. drawdown.

It's different this time, Bush supporters say of his new strategy—always words to beware.

*Tom Raum, Analysis: Bush's New **Plan** Not All New (The Washington Post)*

Rush Limbaugh conceded, with a fond chuckle, that the **plan** was "a bit radical."

Kelefa Sanneh, Bottle Rocket: Newt Gingrich's Turn (The New Yorker)

After breakfast the next morning, Sir Wilfred sent the ladies away and sat back with his last cup of coffee. "I was on the line with the masters this morning. They've decided to go along with you—with a couple of provisos, of course."

"They had better be minor."

"First, they want assurance that this information will never be used against them again."

"You should have been able to give them that assurance. You know that the man you call the Gnome always destroys the originals as soon as the deal is made. His reputation rests on that."

*Encyclopedia Britannica Films, The Baltimore **Plan***

*Encyclopedia Britannica Films, The Baltimore **Plan***

"Yes, quite so. And I shall undertake to assure them on that account. Their second proviso is that I report to them, telling them that I have considered your **plan** carefully and believe it to be airtight and absolutely sure not to involve the government directly."

"Nothing in this business is airtight."

"All right. Airtight-ish, then. So I'm afraid that you will have to take me into your confidence—familiarize me with details of dastardly machinations, and all that."

"Certain details I cannot give you until I have gone over your observation reports on the Septembrists. But I can sketch the bold outlines for you."

Trevanian, Shibumi

And how does the name Ulrich Hargenau ring in the German ear? Does the name Hargenau remind the official who is examining the passport of a recent—well, not so recent—trial in which the Hargenaus, at least some of the Hargenaus, were linked to what the press recorded as a pathological and maniacal attempt to overthrow the democratic government of the Bundesrepublik.

However, Ulrich has nothing further to fear. He is not asked: What is the reason for your visit to Germany, and how long do you **plan** to stay? Clearly, in his case, the question is not applicable. The usual response to that question, no matter what the visitor's purpose, is: Oh, for pleasure. True or not, pleasure is acceptable and instantly understood. It is the right answer. The correct answer. There is no earthly reason why anyone should not come to Germany purely for the sake of pleasure. To admire Germany's remaining castles, churches,

cathedrals. Undeniably, whatever it is that brings people to Germany, it does not preclude the inspection of the magnificent Baroque and Gothic **architecture**, a trip to a few romantic-looking castles along the Rhine, a day or two attending one of a number of Wagner or Beethoven music festivals, and once there, with the Bavarian mountains providing a scenic backdrop, several hours reclining on the sweet-smelling grass while listening to the heavenly music. Then there are the Dürers, Cranachs, and the works of Holbein the Younger, Conrad Witz, Martin Schongauer, Lochner, Baldung, Bruyn, Amberger, and the magnificent *Isenheim Altarpiece* by Mathias Grünewald at the museum in Colmar. But this by no means exhausts the reason why people visit Germany. They come to peer into their past, to look up their relatives or the places where their parents were born. They come to rediscover their German roots. They also come to visit the grave of Goethe and to walk in a German forest and absorb that spiritual attachment to nature that underlies all things German. They come in droves to study music or drama or to attend the lectures of Brumhold who, now in his late seventies, is still teaching in Würtenburg. It should also be added that occasionally a foreign writer will come to Germany to promote his book, which has appeared in German. By and large the Germans are avid readers. They respect books, they respect the printed word. Of course, writers also come to Germany in search of material. They can use any at the excellent archives in Bonn, Munich, Nuremberg, or Berlin. They are meticulously kept archives going back to the time of Dürer. There is something in the archives on everyone.

Walter Abish, How German Is It

*Encyclopedia Britannica Films, The Baltimore **Plan***

October 2, 1963
Tape-recorded phone call:
KENNEDY: The advantage to taking them out is?
MCNAMARA: We can say to the Congress and the people that we do have a
 plan for reducing the exposure of U.S. combat personnel
KENNEDY: My only reservation about this is, if the war doesn't continue to
 go well, it will look like we were overly optimistic.

Errol Morris (director), The Fog of War: Eleven Lessons from the Life of Robert S. McNamara

"There's nothing you can do. You lack the training, the skill, the organization.
You didn't even have a **plan** worthy of the name."
 "Yes, we did."
 He smiled. "All right. Let's take a look at your **plan**. You said that the Black
Septembrists were intending to hijack a plane from Heathrow. Presumably
your group was going to hit them at that time. Were you going to take them
on the plane, or before they boarded?"
 "I don't know."
 "You don't know?"
 "Avrim was the leader after Uncle Asa died. He told us no more than he
thought we had to know, in case one of us was captured or something like
that. But I don't believe we were going to meet them on the plane. I think we
were going to execute them in the terminal."
 "And when was this to take place?"
 "The morning of the seventeenth."
 "That's six days away: Why were you going to London so soon? Why expose
yourself for six days?"
 "We weren't going to London. We were coming here. Uncle Asa knew we
didn't have much chance of success without him. He had hoped he would be
strong enough to accompany us and lead us. The end came too fast for him."
 "So he sent you here? I don't believe that."
 "He didn't exactly send us here. He had mentioned you several times. He
said that if we got into trouble we could come to you and you would help."
 "I'm sure he meant that I would help you get away after the event."
 She shrugged.
 He sighed. "So you three youngsters were going to pick up your arms from
your IRA contacts in London, loiter around town for six days, take a taxi out
to Heathrow, stroll into the terminal, locate the targets in the waiting area,
and blow them away. Was that your **plan**?"
 Her jaw tightened, and she looked away. It did sound silly, put like that.

Trevanian, Shibumi

Spoils of War
… the secret Nazi **plan** to destabilise the British economy by flooding Britain with forged sterling notes.

Brass Target
General Patton tries to transfer the German gold stock to Frankfurt. But someone foils his **plan**.

Up the Front
Frankie Howerd stars in this comedy as a lowly boot-boy who is a terrible coward. He only goes to war in 1914 after he has been hypnotised to 'save England'. With the German master **plan** tattooed on his backside (this is the only way he could get the **plan** back to the British), he goes to the British head-quarters, with the Germans in hot pursuit, to try and 'hand over the **plans**'!!!

Internet Movie Database, Plot Summaries

Whether as a single, double or triple agent ("Triple, please," you can imagine him saying) the Burton character would have been barely free of his parachute harness before being placed under arrest. He would have been locked up on the basis of his appearance alone. Every other anachronism is explicable, within the screenplay's purely cinematic parameters. In the German pub below the castle, Burton, Eastwood and the other agents—the others are notable chiefly for their expendability—talk very loudly in English. Yes, English is their chosen language when they discuss their **plans** about fooling the Germans, and they do not lower their voices when members of the garrison pass by closely behind them …

Clive James, Cultural Amnesia: Notes in the Margin of My Time

Plan?
Yes. **Plan.** P … L … A … N …
Walter Abish, How German Is It

It could be said, however, that a convention is being observed here, and that our agents are really speaking German. (It could also be said that if they were speaking German, the closely attendant Germans would be even more likely to notice that **plans** to fool them were being loudly discussed, but let that pass.)
Clive James, Cultural Amnesia: Notes in the Margin of My Time

NARRATOR: Jones tells his congregation that the world outside People's Temple is teeming with those who would like to harm them.

*Graham Seton, The W **Plan***
(London: Thornton Butterworth, 1935)

ALAN SWANSON (DEFECTOR): Well, he had these scare tactics—there would be nuclear holocaust, and we had the only safe place to survive, and that there would be concentration camps—

LESLIE CATHEY (SURVIVOR): We did paramilitary training up in the hills, I'm talking thirteen, fourteen years old, preparing for some big nuclear war—

NARRATOR: Jones and his inner circle formulate **plans** to escape from the United States. One of their ideas is to go abroad, and establish the People's Temple Agricultural Project. Why did they choose Guyana?

H. D. Motyl, The Final Report: Jonestown Tragedy

His recent disastrous success had convinced him that neither Ithaca nor any other abode of civilization was a safe place to continue his experiments, but it was not until their cruising had brought them among the multitudinous islands of the East Indies that the **plan** occurred to him that he finally adopted—a **plan** the outcome of which could he then have foreseen would have sent him scurrying to the safety of his own country with the daughter who was to bear the full brunt of the horrors it entailed.

Edgar Rice Burroughs, The Monster Men

"So, Miss Stern, notwithstanding your disgust and honor over the incident at Rome International, it turns out that you were **planning** to be responsible for the same kind of messy business—a stand-up blow-away in a crowded waiting room. Children, old women, and bits thereof flying hither and yon as the dedicated young revolutionaries, eyes flashing and hair floating, shoot their way into history. Is that what you had in mind?"

"If you're trying to say we are no different from those killers who murdered young athletes in Munich or who shot my comrades in Rome—!"

"The differences are obvious! They were well organized and professional!" He cut himself off short. "I'm sorry. Tell me this: what are your resources?"

"Resources?"

Trevanian, Shibumi

NARRATOR: *(Voiceover)* Few in the team first into Iraq to help rebuild it after the fall of Saddam knew much about the country.

GOVERNMENT OFFICIAL: *(Voiceover)* We were using a Lonely Planet guidebook, from sometime in the early 90's. It's a great guidebook but it shouldn't be the basis of an occupation.

NARRATOR: *(Voiceover)* The US Government was warned that creating a new

Don't worry, the new World War 3 Battle **Plan** has been officially drafted. *(www.soshichan.org)*

Iraq would be the most complex nation-building project since Germany after World War II. Then, **planning** began three and a half years before Hitler's defeat. In Iraq, it began in earnest just two months before Saddam was overthrown.

TONY BLAIR: *(Voiceover)* Just as we had a strategy for war, so we have a strategy for peace.

NARRATOR: *(Voiceover)* Many now believe that neither George Bush nor Tony Blair had a strategy for after the invasion.

GOVERNMENT OFFICIAL: *(Voiceover)* The **plan**, the long-term **plan**, was we do not need a **plan**.

NARRATOR: *(Voiceover)* This is the story of how the President and the Prime Minister together helped create the Iraq we have today ...

ONSCREEN TEXT: "NO **PLAN**, NO PEACE"

> British Broadcasting Corporation, No **Plan**, No Peace

"There is no **plan**," one politician took to saying as the response progressed last summer. But there was a **plan**.

> Raffi Khatchadourian, The Gulf War: Were There Any Heroes in the BP Oil Disaster? (The New Yorker)

Terrorism is defined as a "systematic covert warfare to produce terror for political coercion" (Merriam-Webster). It can also be defined as "the **planned**, organized use of fear as a weapon."

> Charles D. Watson, The Terrorist Connection (Abounding Love Ministries)

Caligula's cruelty was not wanton or casual like that of Tiberius, but **planned**, even painstaking, outrageous and, to him, enjoyable ... His cruelty was political—"Let them hate me as long as they fear me"—and never far from his thinking even with his lovers—"You'll lose this beautiful head whenever I decide"—as he kissed them on the neck. Suetonius also tells how he forced parents to attend the executions of their children and once made a father come to dinner immediately afterwards, joking throughout the meal. He gloated over the deaths of his victims, requiring the torturers to take their time—"Strike so he may feel he is dying." His capacity for horror appeared to be limitless. He once ordered the guts and arms and legs of a senatorial victim to be stacked up in front of him.

> Anthony Blond, The Secret History of the Roman Emperors

My father, when I was young, often said to me: look around you my boy; look at the world, with its thousands upon thousands of years of wars, plagues,

Baptiste Debombourg, Tradition Of Excellence (www.baptistedebombourg.com)

Baptiste Debombourg, Tradition Of Excellence (www.baptistedebombourg.com)

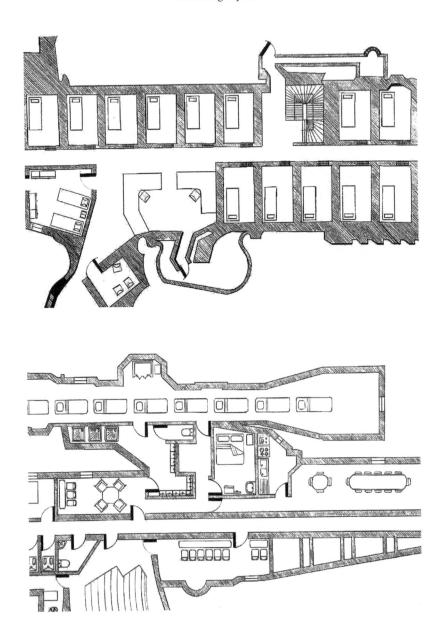

Baptiste Debombourg, Tradition Of Excellence (www.baptistedebombourg.com)

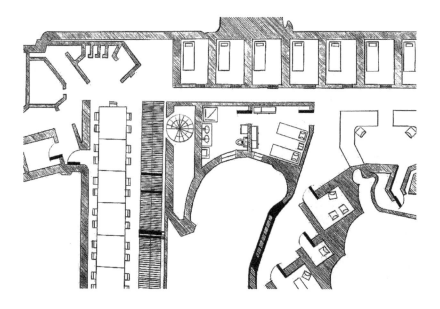

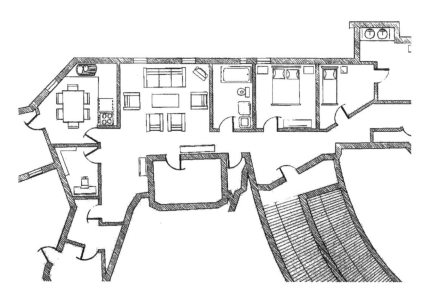

Baptiste Debombourg, Tradition Of Excellence (www.baptistedebombourg.com)

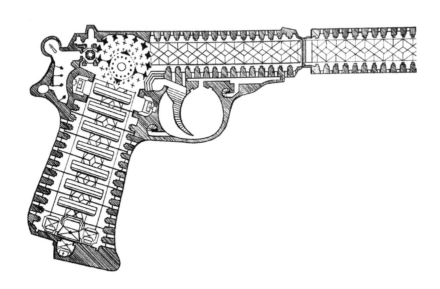

Baptiste Debombourg, Tradition Of Excellence (www.baptistedebombourg.com)

famines, murders, public and private brutalities, injustices, parricides, genocides: one would have to be a cynic not to believe there was some great **plan** behind it all.

Eric McCormack, *The Paradise Motel*

... **planners** of a great 'death conspiracy' ...

Brian Jackson, *The Black Flag: A Look at the Strange Case of Nicola Sacco and Bartolomeo Vanzetti*

15 *copy of Morgenthau's **plan:*** Stimson's reaction to the **plan**, Tusa 51, 54; B. Smith 23, 26; Conot 10.
17 *a criminal conspiracy, a gigantic plot:* Bernays proposal for conducting ...

Joseph E. Persico, *Nuremberg: Infamy on Trial*

*History Special: Nazi **Plan** To Bomb New York*
... uncovered evidence of a diabolical Nazi **plan** to deliver a radioactive bomb to New York. In late 1944, the "Amerika Bomber" project was **planned**, and three aerospace **designers**—Wernher von Braun, Eugen Sanger, and Reimar Horton—each had a different solution ...

History Channel: Weird Warfare
An in-depth look is taken into history's most bizarre weapons of war, such as pigeon-guided missiles, an aircraft carrier made of ice, trained poisonous mosquitoes, incendiary bats, a **plan** to alter Hitler's gender and much more.

Internet Movie Database, *Plot Summaries*

Bill remembered hearing about an amazing **plan** in which bats were to infest and destroy Japanese cities during World War II. Miniature incendiary bombs with timers were glued to their bodies. The bats were, in effect, the world's first attempt at constructing a smart cluster bomb. The bomb housing was a giant bat cage with fall-away walls and floors. Dropped by parachute from a plane, just before dawn, it was **designed** to open up at fifteen hundred feet. Seeking refuge, the bats would enter houses and factories, flittering onto wooden eaves and into dark corners where explosives and uranium oxides were stored, or into the beds of Hirohito and Yamamoto themselves, where they would blaze forth as six thousand tongues of well-placed flame.

The bomb worked well. Too well. When it was tested over New Mexico, some of the little winged bomblets went astray, descending into a newly constructed Air Force base and reducing every building, every airplane, and much of the scrub brush surrounding the base to cinders. A second bomb was

Assortment of Drafting Tools and Firearm Related Books, Magazines and Pamphlets

Large assortment of over 100 firearm related books, catalogs, pamphlets, and magazines (Fair). Assortment of loose and cased drafting and navigation tools (Very good). Also included is a 18th century Persian powder flask (Good) and an unsigned/unissued Sharps Rifle Co. stock certificate numbered 126 (Very good).

www.icollector.com

quickly assembled; but shortly before it was to be dropped on Japan, it was rendered obsolete by the first successful test of the atomic bomb—a lucky break for the bats; not so lucky for their human captors.

Charles Pellegrino, Dust

Schnitzler, let us remember, said that the flight into stupidity is a flight away from responsibility. But soaring beyond any human absurdity that even Schnitzler could imagine, Richard Burton's hairstyle in *Where Eagles Dare* is a flight into stupidity and away from the barber. Burton plays a British agent who is possibly also a German agent, although we can be fairly sure that he will turn out to be a British agent in the end, because Richard Burton's agent

111101-N-TZ605-057, SAN DIEGO (Nov. 1, 2011). Cmdr. Paul Spedero, left, executive officer of the aircraft carrier USS Carl Vinson (CVN 70) and Master Chief Machinist's Mate Timothy Armstrong review **plans** as construction begins on the basketball court for the Quicken Loans Carrier Classic on the flight deck of Carl Vinson. Carl Vinson is at homeport at Naval Air Station North Island preparing for the upcoming college basketball game.

U.S. Navy photo by Mass Communication Specialist 3rd Class Timothy A. Hazel/Released

would never agree to a deal by which his client was shot at dawn. Burton the almost certainly British agent is sent, with Clint Eastwood and other agents— some of whom actually do turn out to be German agents—on a mission to a castle deep behind German lines, there to rescue, or possibly confirm the credibility of, or perhaps betray the real identity of, an actor pretending to be an American general in possession of the **Plans** for a Second Front. The actor playing the actor need not detain us, and considering how he acts it is a wonder that the Germans have detained him. (There is a lot more to wonder at about the behaviour of the Germans, but we'll get to that later.)

Clive James, Cultural Amnesia: Notes in the Margin of My Time

Now days are dragon-ridden, the nightmare
Rides upon sleep: a drunken soldiery
Can leave the mother, murdered at her door,
To crawl in her own blood, and go scot-free;
The night can sweat with terror as before
We pieced our thoughts into philosophy,
And **planned** to bring the world under a rule,
Who are but weasels fighting in a hole.

William Butler Yeats, *Nineteen Hundred and Nineteen*

"For a study of human madness," writes Czesław Miłosz, "the history of the Vistula basin during the time it bore the curious name of 'Government-General' makes excellent material. Yet the enormity of the crimes committed here paralyzes the imagination, and this, no doubt, is why the massacres in the small Czech town of Lidice and in the small French town of Oradour are given more notice in the annals of Nazi-dominated Europe than the region where there were hundreds of Lidices and Oradours." In this "experimental laboratory," Miłosz writes,

> *the Nazis divided the population into two categories: Jews and Poles. The former were scheduled for complete extermination in the initial phase; the latter, in the next phase, were to be partially exterminated and partly utilized as a slave-labor force. The objective for the 'non-Aryan' category was nearly one hundred per cent realized, as borne out by the approximate figure of three million slain. The **plan** for the 'Aryans' was fulfilled more slowly, and their number only decreased by about twelve per cent.*

Enda O'Doherty, *All Things Considered: Review of Proud to be A Mammal*, By Czeslaw Milosz (Dublin Review of Books)

DICTATOR: Entirely **according to plan.** *(MESSENGER exits L.)* Faster, Soldiers. One, two. War forced upon us for honor and glory; needs of the State; noble conception of Justice; Soldiers, show your bravery; greatest moment in history!
(Effects.)
 Quick march! Quick march! The battle is beginning: Second Levy!
(Effects.)
(DICTATOR inspects battlefield through a telescope.)
BLIND ANT: One, two, four—one, two, four.
CHRYSALIS: *(Shouting)* The earth is bursting, listen to me. The depths of the world are toiling in pain for the birth that is mine.

DICTATOR: Second levy. Third levy. To arms! *(To the QUARTERMASTER)* Issue a report.

QUARTERMASTER: *(In a loud voice)* The battle has begun at last amid favorable weather conditions. Our heroic men are fighting in magnificent spirits. *(Effects.)*

(NEW TROOPS march past to the beating of DRUMS.)

DICTATOR: Quick march! One, two. One, two. Faster, boys!

SECOND MESSENGER: *(Running in L.)* Our right wing is retreating. The Fifth Regiment is completely destroyed.

Not only is the battle strange but the preparation for battle was also very different, there wasn't any deployment of military equipment, there wasn't any trenches being dug, there is just a bunch of noise outside the wall everyday and then they go back to their tents.

Rick Morgan, A Strange Battle Plan (diggingtheword.blogspot.com)

DICTATOR: **According to plan.** Sixth Regiment replace them. *(MESSENGER runs off L.)*

VAGRANT: Ha! Ha! **According to plan.** So it's all right, when Death himself serves on the staff as a general and carries out orders; I beg to report the Fifth Regiment is destroyed—according to plan! Oh, I know all about this, and I've seen it before. I've seen broad fields covered with corpses, slaughtered human flesh frozen in the snow; I've seen the Supreme Staff, and Death himself with a breast full of medals, survey the fallen, to see whether the rotting corpses are heaped, on the chart of the dead, **according to plan.**

A WOUNDED MAN: *(Screams: Enters L: and crossing R: exits R.)* The Fifth Regiment! Our regiment! We're all killed! Stop! Stop! *(The Telegraph instrument clatters.)*

TELEGRAPHER: *(Reads dispatch)* Fifth Regiment destroyed. We await orders.

Josef Capek and Karel Capek, The World We Live In (The Insect Comedy): A Play in Three Acts with Prologue and Epilogue

Reinhard Heynrich had a meeting with Hermann Goering in Berlin. It was July 31, 1941. Heydrich, who administered Jewish matters at the SS, had with him a draft order that he wanted Goering to sign. The order employed the word "solution" (lösung) three times—and the last time, the word "final" (end) was attached to it:

> *Complementing the task already assigned to you in the decree of January 24, 1939, to undertake, by emigration or evacuation, a solution of the Jewish question as advantageous as possible under the conditions at the time, I hereby charge you with making all necessary organizational, functional, and material preparations for a complete solution of the Jewish question in the German sphere of influence in Europe. In so far as the jurisdiction of other central agencies may be touched thereby, they are to be involved. I charge you furthermore with submitting to me in the near future an overall* **plan** *of the organizational, functional, and material measures to be taken in preparing for the implementation of the aspired final solution of the Jewish question.*

Years later, a historian, Richard Breitman, wrote: "The Final Solution was and was not a resettlement **plan.**" One of Himmler's SS leaders, Hans-Adolf Prutzmann, was once asked where some "criminal elements" were being resettled to. To the next world, answered Prutzmann.

Nicholson Baker, Human Smoke: The Beginnings of World War II, the End of Civilization

General **plans** for Auschwitz-Birkenau Camp, 18 June 1943. The **plan** shows the overall construction **plans**. Construction Section 3 was only partially carried to realization.

Auschwitz Central Construction Management personnel, spring of 1943.
The **planning** and construction of the crematoria was the responsibility of the Central Construction Management of the SS in Auschwitz. Some thirty engineers and **architects** worked there under the supervision of construction engineer Karl Bischoff, who reported not to the camp commanders but directly to the Reich Leader of the SS, Heinrich Himmler.

Planning office, June 1940.

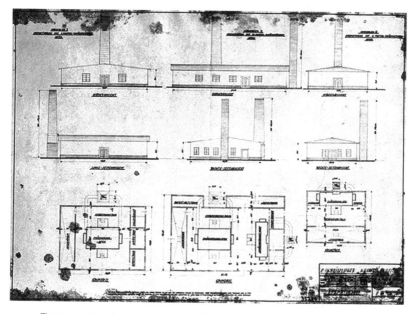

Three suggestions for crematoria in forced labour camp, Cracow/Plaszow, 8 October 1943.

The Engineers of the Final Solution: Topf & Sons — Builders of the
Auschwitz Ovens (www.topfundsoehne.de)

"When Hitler had four-sixths of the **Plan** in his hands, he sent Hess on a secret mission to England to propose an alliance. The Baconians, however, refused. He had another idea: those who were holding the most important part of the secret must be his eternal enemies the Jews. He didn't look for them in Jerusalem, where few were left. The Jerusalemite group's piece of the message wasn't in Palestine anyway; it was in the possession of a group of the Diaspora. And so the Holocaust is explained."

"How is that?"

"Just think for a moment. Suppose you wanted to commit genocide ..."

"Excuse me," Diotallevi said, "but this is going too far. My stomach hurts. I'm going home."

"Wait, damn it. When the Templars were disemboweling the Saracens, you enjoyed yourself, because it was so long ago. Now you're being delicate, like a petty intellectual. We're remaking history; we can't be squeamish."

We let him continue, subdued by his vehemence.

Walter Abish, *How German Is It*
(New York: New Directions, 1980)

POSITIVE NEUTRAL NEGATIVE PECULIAR GOOD AND BAD

VITAL MENTAL MOTIVE BALANCED SELFISH AND HOPEFUL

WHERE TO LOOK.

If you wanted to know whether a man had a nose or not would you look somewhere in general? Would you look for it on his backhead? In looking for mental faculties you should be just as definite as in looking for the nose. For instance, in looking for the faculty of anger always look where it is naturally and always located. This is just above the tips of the ears on the sides of the head. It is never anywhere else. One ought to know just as certainly where to look for mental elements or faculties as he knows where to look for the nose.

Louis Allen Vaught, *Vaught's Practical Character Reader* (Chicago: L. A. Vaught, 1902)

"The striking thing about the genocide of the Jews is the lengthiness of the procedures. First they're kept in camps and starved, then they're stripped naked, then the showers, then the scrupulous piling up of the corpses, and the sorting and storing of clothes, the listing of personal effects ... None of this makes sense if it was just a question of killing them. It makes sense if it was a question of looking for something, for a message that one of those millions of people—the Jerusalemite representative of the Thirty-six Invisibles— was hiding in the hem of a garment, or in his mouth, or had tattooed on his body ... Only the **Plan** explains the inexplicable bureaucracy of this genocide!

Umberto Eco, Foucault's Pendulum

… and some play was made of the fact that it was President Lowell who had fixed the quota **plan** for Polish Jews at Harvard.

*Brian Jackson, The Black Flag: A Look at the Strange Case
of Nicola Sacco and Bartolomeo Vanzetti*

INT. GRADE SCHOOL CLASSROOM
Children's art on wall, plastic bin of toys used as lectern.

(speaking very quickly)
… a comparative advantage case. Rather than giving you 'harms' and a **plan** to fix them, we ask you to hold our **plan** and the status-quo side by side and see which produces the most advantages.

Mandates. One. All Blue Force Tracking Systems in NATO's field of operations will be standardized and updated to the newest edition. This means that all non-interoperable tech systems will be replaced with the most common Blue Force Tracking System. To achieve the goals of NATO's Standardization Agency in compatibility, interchangeability, and commonality, on an as-needed basis.

Section Two. Additional Blue Force Tracking Systems will be supplied as necessary by NATO military personnel. Our agency and enforcement is a North Atlantic Council and a NATO Standardization Agency, which reports directly to the Council. Also the NATO Maintenance and Supply Agency and any necessary agency will be used.

Under our **plan**, funding will come from any necessary raise in NATO's common budget. Our mandates will be phased in over a four year period. *(Unclear)* have legislative intent for the purpose of clarifying the **plan**.

Now we will attempt to prove to you the benefits of our case over the status quo, in Section Four: Advantages.

Advantage 1 …

*Nathan (director), New Hampshire's **Plan***

Western satirists had fun mocking the gung-ho language from the American side of the face-off (since most of the satirists were American themselves, few of them had any idea of what the Soviets sounded like when *they* were being gung-ho) but the idea that America's security state grew **according to** the principle of some sinister initial **plan** was a fiction in the minds of novelists. It grew, but it grew like Little Topsy. The real danger zone was never Europe, where the two main antagonists were debarred from fighting each other directly. The danger zone was everywhere else, and on this point the East Coast foreign policy elite really was vulnerable to criticism. It had been since

*Nathan, New Hampshire's **Plan** (Internet Archive, http://www.archive.org)*

the Marshall **Plan** was formulated, because there was no means of getting the Marshall **Plan** through Congress without the aid of a Red scare.

Clive James, Cultural Amnesia: Notes in the Margin of My Time

Stage Two will curdle your blood. There are some leaks coming forth from your sector but mostly even they are terrified for their lives—the only valid slips have come from a Federal Reserve insider. I shall blow the whistle on no one—I am only going to enlighten you to some general **plans** and hold my scribe in security. You had better just carefully heed what little help I might have been up to this point.

The entire **plan** has been kept under wraps because it would, and will, throw the entire world into panic and ultimate collapse. The switch will take place at a most inappropriate time and the exchange will be totally limited and conducted like a security death camp. You, as "little people," may not recognize it but the "big boys" certainly will.

Gyeorgos Ceres Hatonn, Privacy in A Fishbowl: Spiral to Economic Disaster, Vol. 2

Christopher Weyant, The New Yorker

*"We don't offer a health-care plan. Instead, we have
Lou persuade you not to get sick."*

I switched stations, a weather report, then returned to Ovid Lamartine: "...you see, we get, we have always gotten, the watered-down versions of Grimm's, and other fairy tales, from the dark forests of the German subconscious mind. Make no mistake about it, they are *cautionary* tales. Many of them, told in today's German households, warn: 'Do not go out of your houses at night, good children of Germany, pure-blood German children. Do not wander from your villages. Stay huddled in front of the hearth. The monster lurks nearby. Children of the new Germany, stay safe and warm under your bedcovers. Take heed. Take caution. Take *precaution*. Which means, take action against. And in the nightmare world of Mr. Hitler's Germany, this 'monster' is the Jews. The Hebrew people. Read Mr. Hitler's *Mein Kampf,* a degenerate book from a degenerate mind. In his twisted vision, the Jew is pariah. The cause of all troubles and woes. The Jewish people, a rich culture, a country people, an urbane people, also. A rich part of the European intelligentsia. In Brussels, I spoke with Professor—" I turned off the radio.

Ovid Lamartine's program was called *Dateline: Europe.* He was based in London, but seemed to be living out of a suitcase. He often began his broadcast: "Just back from—" Some European capital, or the home of a dignitary at which political high intrigue was discussed over dinner. In one broadcast he said, "I stand accused of bringing you more bad than good news. At times, and we are in such a time now, at times in human history, bad is disproportionate to good, and so I own up to the indictment. It's a fact of life, my Canadian brethren, that we cannot always control where the truth comes from, or how bad it turns out to be, or what it reveals about human nature." He always ended his broadcast: "Remember: as my grandmother always said, if you wish to make God laugh, make **plans**. This is Ovid Lamartine—*Dateline: Europe.*"

Howard A. Norman, *The Museum Guard: A Novel*

"You're still getting this trash?" he asked at last in an amused tone, touching the folded newspapers Efor had set on the table.

"Efor brings them."

"Does he?"

"I asked him to," Shevek said, glancing at Pae, a split-second reconnoitering glance. "They broaden my comprehension of your country. I take an interest in your lower classes. Most Anarresti came from the lower classes."

"Yes, of course," the younger man said, looking respectful and nodding. He ate a small bite of honey roll. "I think I'd like a drop of that chocolate after all," he said, and rang the bell on the tray. Efor appeared at the door. "Another cup," Pae said without turning. "Well, sir, we'd looked forward to taking you about again, now the weather's turning fine, and showing you more of the

country. Even a visit abroad, perhaps. But this damned war has put an end to all such **plans**, I'm afraid."

Ursula K. Le Guin, The Dispossessed

A government with a comprehensive **plan** for the betterment of society is a government that uses torture. *Per contra,* if you never consider principles and have no **plan** ...

Aldous Huxley, Eyeless in Gaza

"I had immense **plans**," he muttered irresolutely. "Yes," said I; "but if you try to shout I'll smash your head with—" There was not a stick or a stone near. "I will throttle you for good," I corrected myself. "I was on the threshold of great things," he pleaded, in a voice of longing, with a wistfulness of tone that made my blood run cold. "And now for this stupid scoundrel—" "Your success in Europe is assured in any case," I affirmed, steadily. I did not want to have the throttling of him, you understand—and indeed it would have been very little use for any practical purpose. I tried to break the spell—the heavy, mute spell of the wilderness—that seemed to draw him to its pitiless breast by the awakening of forgotten and brutal instincts, by the memory of gratified and monstrous passions. This alone, I was convinced, had driven him out to the edge of the forest, to the bush, towards the gleam of fires, the throb of drums, the drone of weird incantations; this alone had beguiled his unlawful soul beyond the bounds of permitted aspirations. And, don't you see, the terror of the position was not in being knocked on the head—though I had a very lively sense of that danger too—but in this, that I had to deal with a being to whom I could not appeal in the name of anything high or low. I had, even like the niggers, to invoke him—himself—his own exalted and incredible degradation. There was nothing either above or below him, and I knew it. He had kicked himself loose of the earth. Confound the man! he had kicked the very earth to pieces. He was alone, and I before him did not know whether I stood on the ground or floated in the air. I've been telling you what we said—repeating the phrases we pronounced,—but what's the good? They were common everyday words,—the familiar, vague sounds exchanged on every waking day of life. But what of that? They had behind them, to my mind, the terrific suggestiveness of words heard in dreams, of phrases spoken in nightmares.

Joseph Conrad, Heart of Darkness

"Mudger hasn't forgotten his field training. He uses the same methods in business he used in espionage activities. In actual combat. That's why the firm's a whopping success. The man's made his own set of rules and won't

Jaime Pozuelo-Monfort,
The Monfort **Plan**: *The New*
Architecture *of Capitalism*
(Hoboken, NJ: John Wiley
& Sons, 2010)

allow anyone else to use them. He's got all kinds of links, organized crime and so on. And he's just sitting out there in the countryside running up profits. Recent scheme is diversification. Systems **planning** has apparently begun to seem dull. He wants to diversify."

There was a silence as they pondered this.

"What you have in Mudger," the Senator said, "is the combination of business drives and lusts and impulses with police techniques, with ultra-sophisticated skills of detection, surveillance, extortion, terror and the rest of it."

"It's like what Chaplin said in connection with Monsieur Verdoux. The logical extension of business is murder."

Don DeLillo, Running Dog

Partly, I say. And here I feel it necessary to revive Joseph, that creature of **plans.** He had asked himself a question I still would like answered, namely,

"How should a good man live; what ought he to do?" Hence the **plans**. Unfortunately, most of them were foolish. Also, they led him to be untrue to himself. He made mistakes of the sort people make who see things as they wish to see them or, for the sake of their **plans**, *must* see them. There might be some justice in the view that man was born the slayer of his father and of his brother, full of instinctive bloody rages, licentious and unruly from his earliest days, an animal who had to be tamed. But, he protested, he could find in himself no such history of hate overcome. He could not. He believed in his own mildness, believed in it piously. He allowed this belief to interfere with his natural shrewdness and did both himself and his friends a disservice. They could not give him what he wanted. What he wanted was a "colony of the spirit," or a group whose covenants forbade spite, bloodiness, and cruelty. To hack, to tear, to murder was for those in whom the sense of the temporariness of life had shrunk. The world was crude and it was dangerous and, if no measures were taken, existence could indeed become—in Hobbes' phrase, which had long ago lodged in Joseph's mind—"nasty, brutish, short." It need not become so if a number of others would combine to defend themselves against danger and crudity. He thought he had found those others, but even before the Servatius party he (or rather I) had begun to have misgivings about the progress that was being made. I was beginning to see that a difficult **plan** or program like mine had to take into account all that was natural, including corruptness. I had to be faithful to the facts, and corruptness was one of them.

But the party shocked me.

Saul Bellow, Dangling Man

Spring 1976, San Francisco. At a **planning** commission meeting of the Temple, Jones offers a hundred people in the room a glass of wine …

H. D. Motyl, The Final Report: Jonestown Tragedy

HOW TO HOST A KILLER PARTY: A PARTY-**PLANNING** MYSTERY
by Penny Warner

Presley Parker was just happy to get her party **planning** business off the ground. Now she's gotten the gig of the year, **planning** Mayor Davin Green's sumptuous "surprise" wedding for his socialite fiancée, to be held on Alcatraz.

But when the bride is found floating in the bay and the original party **planner** is found murdered, Presley becomes the prime suspect. If the attractive crime scene cleaner, Brad Matthews, doesn't help her tidy her reputation, she'll be exchanging her formal wear for prison stripes …

*Amazon. com, How to Host a Killer Party: A Party-**Planning** Mystery (Book Description)*

Penny Warner, How to Host a Killer
Party: A Party-**Planning** Mystery
(New York: Obsidian Mystery, 2010)

I sat down with Kent Moyer, World Protection Group's founder and CEO, in his cramped office. Moyer is trim, balding, and middle-aged. He got into private security back in the early '90s, serving a five-year stint as a bodyguard for Hugh Hefner at the Playboy Mansion. "I could write a book on just the things that I saw," he told me, "but I get paid not to write that book." He was hired, he says, because he could knock heads; he'd placed fourth in the International Okinawan Goju-Ryu Karate-do Federation championship and later trained with Steven Seagal in aikido. For a while, he played B-movie villains, like a neo-Nazi in 1994's *Femme Fontaine: Killer Babe for the CIA*.

Moyer quickly learned that protecting Hef was less a matter of brawn than of discreet surveillance and detailed **planning**. By the early aughts he'd launched WPG, with a top Hollywood talent agency as his first client. The collapse of the World Trade Center towers proved a boon for executive protection; soon after, WPG began landing corporate clients, and sales shot up by 40 to 50 percent.

James Marsh (director), Man on Wire

Like most security professionals, Moyer won't name his clients. About 20 percent are celebrities and entertainers, he says, while the rest are wealthy individuals and corporate executives. The firm has protected senators, congressmen, former secretaries of state, and members of the Saudi royal family. As the business grew, Moyer took some time off to attend Wharton's Advanced Management Program. Executive protection "is about more than sending an off-duty cop out with a gun," he explains. "If it came to any kind of semi-organized attack, those guys would get dead real quick, because they don't have any kind of game **plan**."

Josh Harkinson, Cover Your Assets: The Growing Business of Protecting
CEOs and the Superrich From the Rest of Us (Mother Jones)

EDMONTON FILMMAKER'S LAPTOP CONTAINED **PLAN** TO BECOME A SERIAL KILLER
Mark Twitchell Charged with First-Degree Murder

EDMONTON—In a deleted file stored deep on filmmaker Mark Twitchell's laptop was a **plan** to become a serial killer.

"This story is based on true events," the document states. "The names and events were altered slightly to protect the guilty. This is the story of my progression into becoming a serial killer."

Over 30 pages, the author describes a **plan** to lure a man to a garage by posing as a woman on an Internet dating site. It describes a failed attack on one man who fought back, and a second attack on another man who was killed and dismembered, his remains dumped down a storm sewer.

That second man, Crown prosecutor Lawrence Van Dyke said in opening arguments at Twitchell's first-degree murder trial, was Johnny Altinger, whose remains were found in a sewer less than two blocks from Twitchell's parents' house in June 2010.

But is the document a piece of fiction, or a true account of events that happened in the fall of 2008? That question will be a central focus of the trial, Van Dyke said.

"On careful appraisal of the evidence, you'll be left with the inescapable conclusion this diary is a factual documentation of Mark Twitchell's truly lived experiences," Van Dyke argued. "Mark Twitchell formulated a **plan**. His **plan** was, quite simply and quite shockingly, to gain the experience of killing another human being."

Alexandra Zabjek, Edmonton Filmmaker's Laptop Contained
***Plan** to Become a Serial Killer (Vancouver Sun)*

National Geographic Channel, *The Final Report: Jonestown Tragedy*

NARRATOR: The following day, after the shooting of Leo Ryan, and four others in his group, 913 people die at Jonestown after drinking a grape-flavoured cyanide-laced drink. Was this mass suicide or mass murder? It seems to be both. There's evidence to indicate a mass-suicide was carefully **planned** by the leadership.

MARY MCCORMICK MAAGA (AUTHOR, "HEARING THE VOICES OF JONESTOWN"): The cyanide was ordered months before it was ever used. The **plan** for how to kill that many people in a short amount of time was formulated months in advance ...

H. D. Motyl, The Final Report: Jonestown Tragedy

And then around half past one I stood up, not the least bit drunk, and went to find out whether or not I'd committed a murder.

Aren't they always saying, "I'll never know how I got through the next few minutes, hardly remember," et cetera? The hell with them. They don't know what they're talking about. I remember the exact length of my fingernails, the sherry's sweetness, the bill I paid with—a five, face up, our beloved Abraham Lincoln—the give in the wooden floorboards under my shoes walking out, the wet smell of the air and the shine of moisture on my car, and two finger streaks in the dust that made an ideogram, unintelligible and scary, on the Porsche's dashboard; and I remember driving in the moonless dark and passing through the streetlamp's glow at the head of Winona's drive as if through the spongy boundary at the end of the universe, remember realizing, at the moment I stepped from the car in front of her house, that it would almost certainly rain tonight, remember feeling the laces flap on one of my Invader-brand jogging shoes, remember pausing to deal with it, remember deciding not to. The kitchen light burned. Otherwise the place was shrouded. Winona's customized jeep, formerly mine, a Japanese jeep, a Subaru, waited by the walk. Out in the dark, Red bumped against his stall and snickered. I felt my left hand go out, palm up, in a gesture I often make in conversation. I was talking to nobody: I've come home to look for my wife, don't know what I expect. Maybe I'll warn her she's about to be murdered. I don't really want to go through with this. I'll give Harry Lally the pot plants, Clarence will break some of my bones, that'll be okay, then they'll heal, that'll be neat. No need for anyone to die.

—All the while humming with excitement in the center of my heart, because I've stumbled onto an explanation, correct me if I'm wrong, for the tendency of our race to grope toward tragedy: in order to ponder the imponderable— war, murder, our power to mutilate the planet—in order to concentrate our thoughts on these matters, we have to **plan** them. We have to be mapping

Errol Morris (director), The Fog of War: Eleven Lessons From the Life of Robert S. McNamara

out, not merely contemplating, the unthinkable. Or we can't think about it at all. And I reflected, forgiving my own delirious pun, that **designs** just lead naturally to executions.

Denis Johnson, Already Dead: A California Gothic

As long as I kept my daily tour to the hill, to look out, so long also I kept up the vigour of my **design**, and my spirits seemed to be all the while in a suitable frame for so outrageous an execution as the killing of twenty or thirty naked savages, for an offence which I had not at all entered into any discussion of in my thoughts, any farther than my passions were at first fired by the horror I conceived at the unnatural custom of the people of that country, who, it seems, had been suffered by Providence, in His wise disposition of the world, to have no other guide than that of their own abominable and vitiated passions; and consequently were left, and perhaps had been so for some ages, to act such horrid things, and receive such dreadful customs, as nothing but nature, entirely abandoned by Heaven, and actuated by some hellish degeneracy, could have run them into. But now, when, as I have said, I began to be weary of the fruitless excursion which I had made so long and so far every morning in vain, so my opinion of the action itself began to alter; and I began, with cooler and calmer thoughts, to consider what I was going to engage in; what authority or call I had to pretend to be judge and executioner upon these men as criminals, whom Heaven had thought fit for so many ages to suffer unpunished to go on, and to be as it were the executioners of His judgments one upon another; how far these people were offenders against me, and what right

I had to engage in the quarrel of that blood which they shed promiscuously upon one another. I debated this very often with myself thus: "How do I know what God Himself judges in this particular case? It is certain these people do not commit this as a crime; it is not against their own consciences reproving, or their light reproaching them; they do not know it to be an offence, and then commit it in defiance of divine justice, as we do in almost all the sins we commit. They think it no more a crime to kill a captive taken in war than we do to kill an ox; or to eat human flesh than we do to eat mutton."

When I considered this a little, it followed necessarily that I was certainly in the wrong; that these people were not murderers, in the sense that I had before condemned them in my thoughts, any more than those Christians were murderers who often put to death the prisoners taken in battle; or more frequently, upon many occasions, put whole troops of men to the sword, without giving quarter, though they threw down their arms and submitted. In the next place, it occurred to me that although the usage they gave one another was thus brutish and inhuman, yet it was really nothing to me: these people had done me no injury: that if they attempted, or I saw it necessary, for my immediate preservation, to fall upon them, something might be said for it: but that I was yet out of their power, and they really had no knowledge of me, and consequently no **design** upon me; and therefore it could not be just for me to fall upon them; that this would justify the conduct of the Spaniards in all their barbarities practised in America, where they destroyed millions of these people; who, however they were idolators and barbarians, and had several bloody and barbarous rites in their customs, such as sacrificing human bodies to their idols, were yet, as to the Spaniards, very innocent people; and that the rooting them out of the country is spoken of with the utmost abhorrence and detestation by even the Spaniards themselves at this time, and by all other Christian nations of Europe, as a mere butchery, a bloody and unnatural piece of cruelty, unjustifiable either to God or man; and for which the very name of a Spaniard is reckoned to be frightful and terrible, to all people of humanity or of Christian compassion; as if the kingdom of Spain were particularly eminent for the produce of a race of men who were without principles of tenderness, or the common bowels of pity to the miserable, which is reckoned to be a mark of generous temper in the mind.

These considerations really put me to a pause, and to a kind of a full stop; and I began by little and little to be off my **design** ...

Daniel Defoe, Robinson Crusoe

plrinternetmarketing.com, Having An Exit **Plan**

exit plan

The Great Escape
Several hundred Allied POWs **plan** a mass escape from a German POW camp.

Internet Movie Database, Plot Summaries

After World War II, however, the **plan's** fortunes began to ebb.

*Michael Neuman, Does **Planning** Need the **Plan**?*
*(Journal of the American **Planning** Association)*

BLIND MAN: That's it, sun's gone down, regular people, you know, they go home, sit around the dinner table, you know, have all this food prepared, very nice, everybody has a little setting—and they trade stories, about the day, about the heat, maybe laugh about a little joke, something crazy they did—then they kiss, sleep, wake up in about 2 hours, then do it all over again.

BOBBY: Well, the day was alright. We all got through it okay. *(Gives the blind man some spare change.)*

BLIND MAN: You keep it, day ain't over yet. Night is part of day. You see things in the shadows and you hear things in the dark.

BOBBY: You afraid of the dark?

BLIND MAN: Afraid of it? Boy, I live in the dark. All because of a woman, who made me this way. Want some? *(Offers him a drink from a liquor bottle.)* People only afraid of what they can't see. I can't see nothing, so it's all the same to me. Mmmm *(kissing noises)*, kiss from a beautiful woman, lick from a dog *(licking noise)*, kiss of death *(howls)*, it's all the same to me now.

BOBBY: So we're all just floating like sticks in a stream, just enjoy the ride, is that it?

BLIND MAN: That's about it.

BOBBY: Not this twig, friend. I got **plans**.

BLIND MAN: Oh you got **plans**? Nothing makes the Great Spirit laugh harder than men's **plans**. We all got **plans**, I got **plans**, I **planned** on seeing all my life. I bet you never **planned** on straying into this town.

BOBBY: Well I don't **plan** on sticking around, neither.

Oliver Stone (director), U Turn

A Brady **plan** to end Europe's crisis
Financial Times—1 hour ago

Never too early to **plan** ahead for exiting business
The Durango Herald—19 hours ago

Greece vows to implement exit **plan** from debt crisis on time
Taipei Times—The Australian

all 1,041 news articles »

Google News Canada

EXIT **PLAN** TAKES SHAPE FOR TRAPPED CHILE MINERS

SAN JOSE MINE, Chile: As drillers in northern Chile on Friday neared the completion of a narrow tunnel to provide an exit for 33 men trapped for two months down a collapsed mine, complex rescue **plans** took shape.

Starting with the strongest first, the miners were due to ascend in harnesses used by astronauts, wearing special glasses to prepare their eyes for renewed contact with daylight.

Government ministers said the shaft could break through to the men, who are trapped more than 700 metres underground, within the next 24 hours, raising hopes the first miners could be rescued early next week.

Once the drill reaches the men—expected by dawn on Saturday—engineers must decide whether to line all or part of the tunnel with steel tubes to make it safer.

Several other technical operations also need to be completed before the rescue can begin.

Channel News Asia, Exit **Plan** *Takes Shape for Trapped Chile Miners*

James Marsh (director), Man on Wire

James Marsh (director), Man on Wire

White Wedding
But things don't always go **according to plan**. An appealing, feel-good movie about love, commitment, intimacy and friendship and the host of maddening obstacles that can get in the way of a happy ending.

Planzet
In the year 2047, an alien lifeform codenamed FOS invades Earth and smashes through the world's major cities in one wave. The earth unites to fight back and puts up a Diffuser in place to stop further invasions 3 years after. Now in 2053, a **plan** is made for a last counterattack that must disable the Diffuser for an offensive ...

Internet Movie Database, Plot Summaries

The story starts on planet Earth, where a man named Arthur Dent is lying in the mud in front of his house in order to stop the city from bulldozing it down to build a bypass. While Arthur is lying there, his peculiar friend, Ford Prefect, comes to say hi. Ford is actually from the Betelgeuse star and is stuck on Earth for fifteen years due to the fact that he is a researcher for the *Hitchhikers Guide to the Galaxy*. Ford announces that Earth is about to be annihilated by the Vogon Construction Fleet. The Galactic Hyperspace **Planning** Council has decided to destroy Earth because they **plan** to build an expressway at the planet's location.

Jason Chen, *The Hitchhiker's Guide to the Galaxy: Book Report*

A sudden silence hit the Earth. If anything it was worse than the noise. For a while nothing happened.

The great ships hung motionless in the sky, over every nation on Earth. Motionless they hung, huge, heavy, steady in the sky, a blasphemy against

Encyclopedia Britannica Films, The Baltimore **Plan**

nature. Many people went straight into shock as their minds tried to encompass what they were looking at. The ships hung in the sky in much the same way that bricks don't.

And still nothing happened.

Then there was a slight whisper, a sudden spacious whisper of open ambient sound. Every hi-fi set in the world, every radio, every television, every cassette recorder, every woofer, every tweeter, every mid-range driver in the world quietly turned itself on.

Every tin can, every dustbin, every window, every car, every wine glass, every sheet of rusty metal became activated as an acoustically perfect sounding board.

Before the Earth passed away it was going to be treated to the very ultimate in sound reproduction, the greatest public address system ever built. But there was no concert, no music, no fanfare, just a simple message. *'People of Earth, your attention please,'* a voice said, and it was wonderful. Wonderful perfect quadraphonic sound with distortion levels so low as to make a brave man weep.

*'This is Prostetnic Vogon Jeltz of the Galactic Hyperspace **Planning** Council,' the voice continued. 'As you will no doubt be aware, the **plans** for development of the outlying regions of the Galaxy require the building of a hyperspatial express route through your star system, and regrettably your planet is one of those scheduled for demolition. The process will take slightly less than two of your Earth minutes. Thank you.'*

The PA died away.

Uncomprehending terror settled on the watching people of Earth. The terror moved slowly through the gathered crowds as if they were iron filings

Encyclopedia Britannica Films, The Baltimore **Plan**

on a sheet of board and a magnet was moving beneath them. Panic sprouted again, desperate fleeing panic, but there was nowhere to flee to.

Observing this, the Vogons turned on their PA again. It said:

*'There's no point in acting all surprised about it. All the **planning** charts and demolition orders have been on display in your local **planning** department in Alpha Centauri for fifty of your Earth years, so you've had plenty of time to lodge any formal complaint and it's far too late to start making a fuss about it now.'*

The PA fell silent again and its echo drifted off across the land. The huge ships turned slowly in the sky with easy power. On the underside of each a hatchway opened, an empty black square.

By this time somebody somewhere must have manned a radio transmitter, located a wavelength and broadcast a message back to the Vogon ships, to plead on behalf of the planet. Nobody ever heard what they said, they only heard the reply. The PA slammed back into life again. The voice was annoyed. It said:

'What do you mean you've never been to Alpha Centauri? For Heavens's sake, mankind, it's only four light-years away, you know. I'm sorry, but if you can't be bothered to take an interest in local affairs that's your own lookout.'

'Energize the demolition beams.'

Light poured out of the hatchways.

'I don't know,' said the voice on the PA, *'apathetic bloody planet, I've no sympathy at all.'* It cut off.

There was a terrible ghastly silence.

There was a terrible ghastly noise.

There was a terrible ghastly silence.

The Vogon Constructor Fleet coasted away into the inky starry void.

Douglas Adams, The Hitchhiker's Guide to the Galaxy

Christopher Nolan (director), The Dark Knight

Before Falls was halfway back to the truck, Thompson climbed aboard and slammed the door. He fired the ignition, and the truck sat there jiggling. The dogs had gotten very quiet.

Falls reached him and leaned against the driver's door. "You didn't miss by *exactly* a mile, did you?"

"I'd like to know who's been messing with my gun."

"You think you're Joe the Sniper. It don't work that way."

"A Casull. I'm dumbfounded."

'And what were you **planning** to do now? Just leave?"

"What? I thought we should split, because of the noise."

'Ain't nobody here but us, chief. And him."

Thompson nodded, and coughed, and matted away the sweat from his face with his shirtsleeve. He turned off the engine. "Okay—I blinked. Nolo contendere. What do you advise? I'll go in and do his ass."

Denis Johnson, *Already Dead: A California Gothic*

*The **plan** it wasn't much of a **plan***
I just started walking
I had enough of this old town
Had nothing else to do
It was one of those nights
You wonder how nobody died
We started talking
You didn't come here to have fun . . .

dEUS, *Nothing Really Ends (Pocket Revolution)*

The Earth Dies Screaming
A crack space pilot returns to earth to find the planet has been devastated by some unknown forces. There are a few survivors, so he organizes them in a **plan** to ward off control by a group of killer robots.

Invasion of the Star Creatures
A pair of comical soldiers (Robert Ball and Frankie Ray) investigate a mysterious crater in an atomic detonation area and discover several beautiful alien vixens (Dolores Reed and Gloria Victor) who **plan** to conquer the world using an army of vegetable monsters.

Internet Movie Database, *Plot Summaries*

Her high spirits had returned. Her mad **plan** delighted her. It was a piece of supreme eccentricity, a dramatic finale, which, in her feverish state, seemed to her quite inspired. It far surpassed her desire to travel in a balloon.

Émile Zola, The Kill

Hel closed his eyes. "My dear, dumb, lethal girl. If I were to undertake something like you people had in mind, it would cost between a hundred and a hundred-fifty-thousand dollars. And I am not speaking of my fee. That would be only the setup money. It costs a lot to get in, and often even more to get out. Your uncle knew that." He looked out over the horizon line of mountain and sky. "I'm coming to realize that what he had put together was a suicide raid."

"I don't believe that! He would never lead us into suicide without telling us!"

"He probably didn't intend to have you up front. Chances are he was going to use you three children as backups, hoping he could do the number himself, and you three would be able to walk away in the confusion. Then too ..."

"Then too, what?"

"Well, we have to realize that he had been on drugs for a long time to manage his pain. Who knows what he was thinking; who knows how much he had left to think with toward the end?"

She drew up one knee and hugged it to her chest, revealing again her erubescence. She pressed her lips against her knee and stared over the top of it across the garden. "I don't know what to do."

Hel looked at her through half-closed eyes. Poor befuddled twit, seeking purpose and excitement in life, when her culture and background condemned her to mating with merchants and giving birth to advertising executives. She was frightened and confused, and not quite ready to give up her affair with danger and significance and return to a life of **plans** and possessions. "You really don't have much choice. You'll have to go home. I shall be delighted to pay your way."

"I can't do that."

Trevanian, Shibumi

Puppet Master Axis of Evil

In a Stateside hotel during the height of World War II, young Danny Coogan dreams of joining the war effort. Following the murder of hotel guest Mr. Toulon by Nazi assassins, Danny finds the old man's crate of mysterious puppets and is suddenly thrust into a battle all his own. He discovers that Nazis Max and Klaus, along with beautiful Japanese saboteur Ozu, **plan** to attack a secret American manufacturing plant. After his family is attacked

Looks like we're having fun, right? Just a few girls pre-drinking Miller Lite (nice ...), listening to some tunes and putting makeup on before a concert. WRONG. We had to get ready in complete silence because a group of men pulled up in a pickup truck outside of our room and began banging on the room right next to ours and yelling for the residents to come out. We instantly froze, turned off our music, pulled our curtains shut tight and ceased all talking, except for quickly devising an emergency exit **plan** (me lying down on the floor, doing a kip up and then knocking both men out while Heather, Leslie and Velvet run out of the room). You can see the fear in Velvet and Heather's eyes if you look closely.

Samantha Clark, Cut it Out, Detroit! The Motorama Motel (ofsamanthaclark.blogspot.com)

and his girlfriend Beth is kidnapped, it is up to Danny and the living deadly Puppets to stop this Axis of Evil.

The Dead Don't Die

The story begins in the Illinois State Penitentiary where Ralph Drake (Jerry Douglas) is about to be executed for the murder of his wife. At Ralph's request, his brother, Don (George Hamilton), sets out to clear his name and find the real murderer. It's a search that takes him into a nightmarish world where no one can be trusted. Don first seeks out Ralph's former employer, Moss (Ray Milland), who runs a sleazy marathon dance hall, and enlists his help in finding the murderer. Then Don encounters Vera LaValle (Linda Cristal) who warns him that he is in mortal danger because he is close to uncovering the insidious **plan** of a man called Varek—the Zombie Master. Learning that

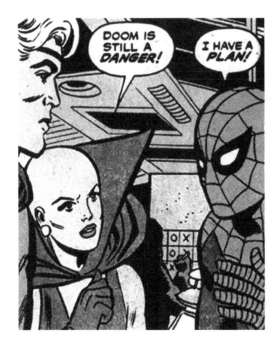

And now, the ISB proudly presents the final Spidey Super Stories Moment of Joy. Jim Salicrup's allegedly educational masterpiece has given us a lot of joy over the past year, from the Thanoscopter to Webby-Two and so many candidates for the greatest panel of all time, but with the final scene from #31, the ISB says goodbye to the greatest comic book ever printed.

Chris Sims, *Spidey Super Stories* | *Chris's Invincible Super-Blog* (www.the-isb.com)

his own brother Ralph is a zombie, Don tries to warn the authorities. But will anyone believe him?

Internet Movie Database, Plot Summaries

"Crisis is a term that is used far too often in Washington, but this is one of the few times that I believe those using it," Rep. Jeb Hensarling, a Texas Republican, said Friday in a written statement. "At such a critical moment for our nation, careful, sober, and thoughtful reflection and rhetoric is required."

Hensarling is head of the Republican Study Committee, known as one of the most conservative blocs of Republicans in the House. The group **plans** to hold a phone conference Saturday to lay out their concerns about the rescue **plan**.

*Fox News, Economic Rescue **Plan** Faces Resistance From Conservatives in Congress*

"Well, Mr. Idiot," said Mr. Pedagog, as the guests gathered about the table, "how goes the noble art of invention with you? You've been at it for some time now. Do you find that you have succeeded in your self-imposed mission and made the condition of the civilized less unbearable?"

"Frankly, Mr. Pedagog, I have failed," said the Idiot, sadly. "Failed egregiously. I cannot find that of all the many schemes I have evolved for the benefit of the human race any single one has been adopted by those who would be benefited. Wherefore, with the exception of Dreamaline, which I have not yet developed to my satisfaction, I shall do no more inventing. What is the use? Even you, gentlemen, here have tacitly declined to accept my **plan** for the elimination of irritation on Waffle Days, a **plan** at once simple, picturesque, and efficacious. With such discouragement at home, what hope have I for better fortune abroad?"

"It is dreadful to be an unappreciated genius!" said the Bibliomaniac, gruffly. "It's better to be a plain lunatic. A plain lunatic is at least free from the consciousness of failure."

"Nevertheless, I'd rather be myself than any one else at this board," rejoined the Idiot. "Unappreciated though I be, I am at least happy. Consciousness of failure need not necessarily destroy one's happiness. If I do the best I can with the tools I have I needn't weep because I fail, and with his consciousness of failure the unappreciated genius always has the consolation of knowing that it is not he but the world that is wrong. If I am a philanthropist and offer a thousand dollars to a charity, and the charity declines to accept it because I happen to have made it out of my interest in 'A Widows' and Orphans' Speculation Company, Large Losses a Surety,' it is the charity that loses, not I. So with my **plans**. Social expansion is not taken up by society—who dies, I or society? Capitalists decline to consider my proposition for a General Poetry Trust and Supply Company. Who loses a fine chance, I or the capitalists? I may be a little discouraged for the time being, but what of that? Invention isn't the only occupation in the world for me. I can give up Philanthropy and take up Misanthropy in a moment if I want to ..."

John Kendrick Bangs, The Inventions of the Idiot

Lautlos
Viktor, a methodical hit man, probably on his last job, has no **plan** for his retirement ...

Internet Movie Database, Plot Summaries

... I thought about mentioning the Pension **Plan**, but decided not to.

Margaret Atwood, The Edible Woman

In the film, Nasheed was asked what his **Plan** B was if he couldn't persuade the world to restrict emissions. "None," he said. "We will all die."

Tad Friend, Underwater (The New Yorker)

Louis-Ferdinand Céline, *Death
on the Installment* **Plan** *(New
York: New Directions, 1938)*

Side Effects
Karly Hert has spent the last ten years selling drugs ... legally, that is. Although
conflicted on a daily basis by the values within the pharmaceutical industry,
and industry driven by profits at the expense of patients; Karly has been
seduced by the golden handcuffs of corporate America. Enter Zach Danner,
who convinces Karly to be true to her values and walk away from her lucrative
but empty job. As their relationship blossoms, Karly devises a **plan** to get out.
But leaving is never quite as easy as it seems ...

Internet Movie Database, Plot Summaries

"It has become, in my view, a bit too trendy to regard the acceptance of death
as something tantamount to intrinsic dignity," he wrote in his 1985 essay. "Of
course I agree with the preacher of Ecclesiastes that there is a time to love and
a time to die and when my skein runs out I hope to face the end calmly and
in my own way. For most situations, however, I prefer the more martial view
that death is the ultimate enemy—and I find nothing reproachable in those
who rage mightily against the dying of the light."

I think of Gould and his essay every time I have a patient with a terminal
illness. There is almost always a long tail of possibility, however thin. What's
wrong with looking for it? Nothing, it seems to me, unless it means we have

failed to prepare for the outcome that's vastly more probable. The trouble is that we've built our medical system and culture around the long tail. We've created a multitrillion-dollar edifice for dispensing the medical equivalent of lottery tickets—and have only the rudiments of a system to prepare patients for the near-certainty that those tickets will not win. Hope is not a **plan**, but hope is our **plan**.

Atul Gawande, Letting Go: What Should Medicine Do When
It Can't Save Your Life? (The New Yorker)

"I don't **plan** on dying, because I don't want to give up a rent-controlled apartment," said Mr. Warwick, who is 80 and has lived in one of the apartments above the Cherry Lane Theater for half a century. "I pay so little I'm almost embarrassed."

Elizabeth A. Harris, A Piece of the Manhattan Dream,
Only $331.76 a Month (The New York Times)

Stamps QB roster still in doubt

Calgary Herald–Jun 29, 2011

And if all goes **according to plan**, he'll be on the field this morning for the Stampeders for his only full practice before Friday's game, in which he'll take

*Anti-government protestors say Mr Saleh's 30-day exit **plan** is a bid to buy time.*

*AFP, Yemen Protesters Reject President's Exit **Plan** (powradhwani. blogspot.com, photo by AFP/ Mohammed Huwais)*

the injured Drew Tate's spot on the active roster. Still to be decided is whether Bishop will ...

Google News Canada

What kind of a political statement are you making in your work?
I'm sorry, my mind was on something else. What did you say?
What kind of a political statement are you making in your book?
I don't believe in making statements. Least of all political ones.
The young man, belligerently: You just said ...
A novel is not a process of rebellion. Just as it validates and makes acceptable forms of human conduct, it also validates and makes acceptable societal institutions.
Does that trouble you?
Not at all. Should it?
When are you **planning** to return to Germany?
As soon as I complete the novel. I am, you might say, searching for an appropriate ending. In yesterday's paper there was mention of a young woman who jumped to her death from the fourteenth story of an office building only a few blocks from this hotel. Incidentally, someone on the seventh floor, or was it the eighth, sitting at his desk near the window, actually made eye contact with her. I mention this only because in life jumping out of a window is an end, whereas in a novel, where suicide occurs all too frequently, it becomes an explanation. The interviewer picked up his tape recorder, first pressing one button then another, then with a look of distress which was not feigned explained that he had neglected to press the record button. Could we possibly go over the interview again? Just briefly.

Walter Abish, How German Is It

He would probably never know the absolute truth, but it wouldn't hurt to speculate a little. Whoever had got the ball rolling had done it with some style. As **plans** went, this one had it all. All, that was, except the happy ending.

John McCabe, Stickleback

HORTENSIUS: We will not urge you any further,—you have fully executed the **plan** you laid down, and we leave the conclusion to you.
EUPHRASIA: Here then I conclude, and thank you for your assistance, and the patience with which you have attended me in my progress: As soon as I have made out my list of books, I will return your visit Hortensius, and desire your opinion upon it.

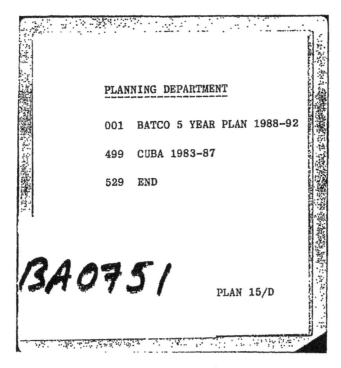

PLANNING DEPARTMENT

001 BATCO 5 YEAR PLAN 1988-92

499 CUBA 1983-87

529 END

BA0751 PLAN 15/D

BATCO 5 YEAR **PLAN** 1988-92 CUBA 1983-87 END **PLAN** 15/D BATCO Document for Mayo Clinic 28 March 2002

tobaccodocuments.org

HORTENSIUS: I shall hope for that pleasure soon.—I now take my leave wishing you the best reward of your labours, Fame and Profit!

SOPHRONIA: I join heartily in the fame wish.

EUPHRASIA: Every kind of happiness attend you my good friends!—For what remains, I shall (without asking the aid of puffing, or the influence of the tide of fashion,) leave the decision to an impartial and discerning public.

Clara Reeve, The Progress of Romance (1785)

"You're a dreamer, boy," he said. "Your mind is on the moon, and from the looks of things, it's never going to be anywhere else. You have no ambitions, you don't give a damn about money, and you're too much of a philosopher to have any feeling for art. What am I going to do with you? You need someone to look after you, to make sure you have food in your belly and a bit of cash in your pocket. Once I'm gone, you'll be right back where you started."

"I've been making **plans**," I lied, hoping to get him off the subject. "I sent in an application to the library school at Columbia last winter, and they've accepted me. I thought I'd already mentioned it to you. Classes start in the fall."

"And how are you going to pay tuition?"

"They've given me a full scholarship, plus a stipend to cover living expenses. It's a good deal, a tremendous opportunity. The program lasts for two years, and after that I'll always have a way to make a living."

"It's hard to see you as a librarian, Fogg."

"I admit it's strange, but I think I might be suited for it. Libraries aren't in the real world, after all. They're places apart, sanctuaries of pure thought. In that way, I can go on living on the moon for the rest of my life."

Paul Auster, Moon Palace

Carry on Teacher
Pupils run amock at Maudin Street School in an attempt to hang on to their headmaster. He has applied for a new job, but the students like him and don't want to lose him. They concoct a **plan**—blacken his record in front of the Ministry Inspector and then he won't ever be able to get another job!

Internet Movie Database, Plot Summaries

No doubt when it was understood that it was going to be well-nigh impossible to do the job safely with the available technology, only a relatively few of the core teams would have been completely in on the alternative **plan** to fake the public record of the Apollo moon landings. This would become the cover for the surrogate program.

David S. Percy (director), What Happened on the Moon? An Investigation Into Apollo

Riders
An entrepreneurial criminal, Slim (Dorff) is as smart as they come. Cocky and confident, he assembles a team of risk-taking rush-seekers to pull off a series of five bank heists, each time using a different extreme sport to make the getaway. Following an unexpected windfall on only their second job, the gang nets $20 million in untraceable bonds. Having scored enough money to retire on, Slim and his crew decide to call the robbery game quits. But both the mob and the police have other **plans** in mind for Slim: they want him to keep working, for them.

Internet Movie Database, Plot Summaries

"This one too?" A FAPer asked her, pointing a gun at me.

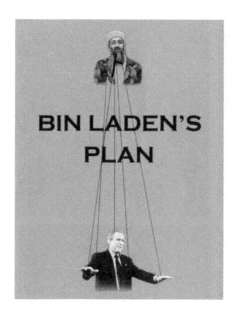

David Malone, Bin Laden's
Plan: The Project for the New
Al Qaeda Century (Victoria, BC:
Trafford, 2006)

"He's not part of Aramchek," Vivian said. To me she said, "We will keep you alive, Phil; we will release books under your name which we will write. For several years we have been preparing them; they already exist. Your style is easy to imitate. You will be allowed to speak in public, enough to confirm them as your books. Or shall we shoot you?"

"Shoot me," I said. "You bastards."

"The books will be released," Vivian continued. "In them you will slowly conform to establishment views, book by book, until you reach a point we can approve of. The initial ones will still contain some of your subversive views, but since you are getting old now it won't be unexpected for you to mellow."

I stared at her. "Then you've been **planning** all this time to pick me up."

"Yes," she said.

"And kill Nicholas."

"We did not **plan** that; we did not know he was satellite-controlled. Phil, there is no alternative. Your friend is no longer a—"

Philip K. Dick, Radio Free Albemuth

Dr Rage
Straun's shocking family secret and twisted **plan** are then revealed in a stunning finale.

*Lisa Barros D'Sa and Glenn Leyburn (directors), The 18th Electricity **Plan***

*Lisa Barros D'Sa and Glenn Leyburn (directors), The 18th Electricity **Plan***

Lisa Barros D'Sa and Glenn Leyburn (directors), The 18th Electricity **Plan**

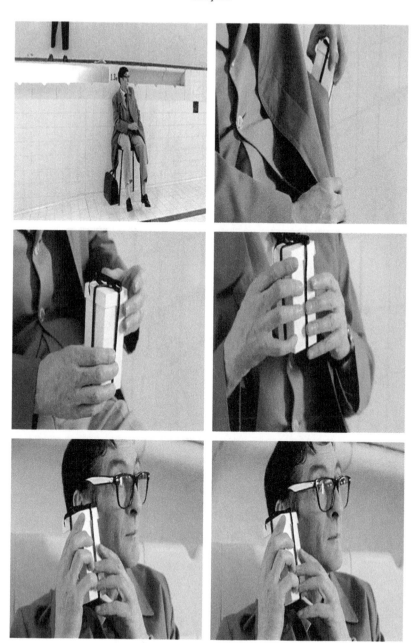

Lisa Barros D'Sa and Glenn Leyburn (directors), The 18th Electricity **Plan**

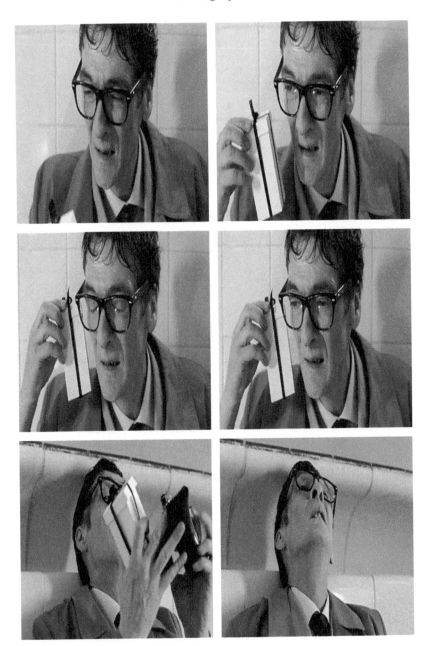

*Lisa Barros D'Sa and Glenn Leyburn (directors), The 18th Electricity **Plan***

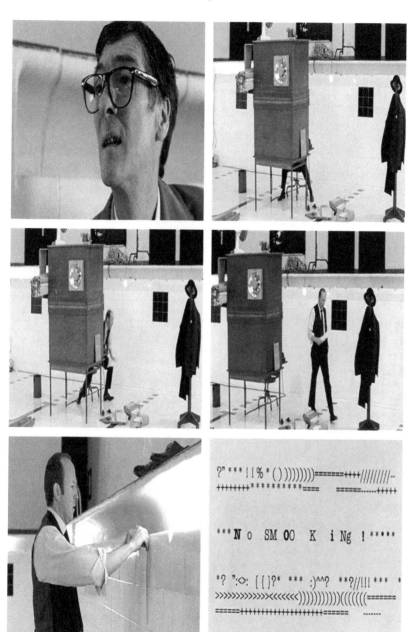

Lisa Barros D'Sa and Glenn Leyburn (directors), *The 18th Electricity* **Plan**

*Lisa Barros D'Sa and Glenn Leyburn (directors), The 18th Electricity **Plan***

Lisa Barros D'Sa and Glenn Leyburn (directors), The 18th Electricity **Plan**

*Lisa Barros D'Sa and Glenn Leyburn (directors), The 18th Electricity **Plan***

*Lisa Barros D'Sa and Glenn Leyburn (directors), The 18th Electricity **Plan***

Lisa Barros D'Sa and Glenn Leyburn (directors), The 18th Electricity **Plan**

*Lisa Barros D'Sa and Glenn Leyburn (directors), The 18th Electricity **Plan***

Cicakman 2: Planet Hitam
The evil Professor Klon is back, not only to overthrow the Government but also to control the world's supply of fresh water through his ingenious **plan** ...
Internet Movie Database, Plot Summaries

Today, Amazon unveiled something radical: the Kindle Owners' Lending Library.

You get to download one Kindle book a month, with no due dates, free, if you're an Amazon Prime member and a Kindle owner.

O.K., whoa.

First of all, Amazon Prime used to be a free-shipping service. You pay $80 a year, and you get two-day free shipping on anything you buy from Amazon. It was fine, I guess, for people who bought enough stuff from Amazon to make it worth the fee.

But then something really weird happened. Amazon decided to compete with Netflix's movie-streaming service. It started licensing more and more movies and TV shows—now 13,000 of them, which is rapidly approaching Netflix's library size. The price? Free, if you're an Amazon Prime subscriber.

What does free shipping have to do with streaming movies? Beats me. But it must have been a delightful surprise to people who'd signed up for Prime.

And now this. Free books, including *New York Times* bestsellers, for the Kindle. If you're an Amazon Prime member.

Free shipping, free movies, free books, for $80 a year. What, exactly, is Amazon up to?

There has to be some master **plan**, because Amazon is spending itself silly to pull this off ...

Obviously, the notoriously e-terrified book publishers wouldn't sign off on Amazon's free-book deal without a lot of reassurance—and a lot of payments. And sure enough, Amazon says that these free Kindle books aren't really free. It's paying publishers for the right to distribute them.

"Titles in the Kindle Owners' Lending Library come from a range of publishers under a variety of terms," Amazon says. "For the vast majority of titles, Amazon has reached agreement with publishers to include titles for a fixed fee. In some cases, Amazon is purchasing a title each time it is borrowed by a reader under standard wholesale terms as a no-risk trial to demonstrate to publishers the incremental growth and revenue opportunity that this new service presents."

Wow.

David Pogue, Amazon Lights the Fire with Free Books (The New York Times)

WALT: Wow. Where—where—how did you know how to put this all together?
GUS: I had excellent help ... Quite a lot of **planning** went into this.
WALT: I would say so.

Vince Gilligan, Breaking Bad: Season 3, Episode 5: Más

Mathers nodded and clapped his hands against his sides as a cold wind caught him head-on. "Are we through here?"

"We have some legwork left. I want the ship's manifest. I want an itemized account of everything that has been loaded and unloaded while it's been in port."

"Anything else?"

"Where do you think the killers found Santa Claus suits on Christmas Eve? Did they steal them, buy them, rent them? I'll run down the costume and novelty stores, see if anything turns up. If they killed the boy onboard this ship, and got him back through the gate dressed as Santa, they must have had that suit ready for him. They must have known they were going to need it."

"They let Artinian sign himself in. He had to. He had to show ID. How could they have been so stupid? They let him write his name in the gatekeeper's log! Then Kaplonski signed him out. That I can understand, they don't care who signs out as long as the count is right. But with their names together in the logbook, it's like announcing that Kaplonski did it. They gave us the time and place! I can see it if they hadn't **planned** to torture and kill him, but if they had a **plan**, it wasn't much of a **plan**."

Cinq-Mars disagreed. "Who would look for Artinian here? They never expected us to show up on the docks."

"Why did we?" Mathers wondered aloud. "We were told not to."

"We were told not to. That's interesting by itself ..."

John Farrow, City of Ice

"What Lies Ahead" picks up shortly after last season's finale left off, with the remaining survivors banding together under the general leadership of series protagonist Rick Grimes. Our heroes' best hope, the Center for Disease Control and Prevention, self-destructed at the end of season one, so they've turned to **Plan** B: a 125-mile trek to Fort Benning. This being *The Walking Dead,* the Fort Benning **plan** goes awry pretty much immediately when the group's RV breaks down on a long stretch of highway.

From there, "What Lies Ahead" alternates between zombie-killing action and bland, repetitive characterization. In between all the blood and guts, we spend a lot of time retreading the building blocks of *The Walking Dead's* first season: Rick struggles to find the best way to protect his family and lead the

We returned to the parking lot of the Grandview Ninth Ward chapel by about 1:30 pm. To the right, Gunnar Legas found an interesting place to rest while waiting for Sister Legas to pick him up. So, in the end, **Plan** A failed, we could not use **Plan** B, **Plan** C was abandoned, and we ended up using **Plan** D. Did we fail? I actually like this campout. It was a chance to work on several values of the Scout Law, in particular on being helpful, cheerful, and brave.

Greg Jones, Troop 797: On Target Campout (gregjonesorg.wordpress.com)

rest of the survivors. Shane guiltily pines for Lori after their aborted love affair. Andrea snaps at everyone and complains about how terrible it is to be alive. These subplots were all featured extensively in the first season of *The Walking Dead,* and it's getting harder to ignore the fact that none of the series' characters has grown or changed at all since they were first introduced.

Scott Meslow, 'The Walking Dead' Still Has an Identity Crisis (The Atlantic)

'Have you considered (and I will conclude here) that in your own wanderings you may, without knowing it, have left behind some such token for yourself; or, if you choose to believe you are not mistress of your life, that a token has been left behind on your behalf, which is the sign of blindness I have spoken of; and that, for lack of a better **plan**, your search for a way out of the maze—if you are indeed a-mazed or be-mazed—might start from that point and return to it as many times as are needed till you discover yourself to be saved?'

J. M. Coetzee, Foe

Kirot

Galia and Eleanor don't know each other, but as neighbors they share two things—an adjoining wall and a strong need to **plan** their escape ...

Internet Movie Database, Plot Summaries

- Do you find yourself thinking about getting out of your business?
- Are you wondering how to groom a successor?
- Is passing your company on to your children becoming increasingly unlikely?
- Are you getting tired of fighting the alligators and want a different challenge?
- Does the whole succession idea seem overwhelming?

If you can answer yes to any of these questions, it is time for you to create an Exit **Plan**. If you don't know how to get started, you are not alone. Few, if any, business owners know how to leave their businesses in style.

*Business Enterprise Institute, Welcome to ExitPlanning.com! Your Home for Exit **Planning** Information and Education (exitplanning.com)*

*Tony Kubica and Sara LaForest, Business Exit **Planning**—Can Your Business Survive If You Could No Longer Manage It Tomorrow (getentrepreneurial.com)*

Toy Story 3

So, it's all for one and one for all as they join Barbie's counterpart Ken, a thespian hedgehog named Mr. Pricklepants and a pink, strawberry-scented teddy bear called Lots-o'-Huggin' Bear to **plan** their great escape.

Internet Movie Database, Plot Summaries

In 2007 the Exit **Planning** Institute developed and began administering the Certified Exit **Planning** Advisor or CEPA credential to set the highest professional standards in the exit **planning** profession. The CEPA credential is awarded to participants who complete a 5 day executive MBA style program that is taught by nationally recognized experts in their respective fields. The CEPA program offers professionals an innovative learning experience, performance-enhancing resources, and strategic tools **designed** to help them advance their exit **planning** practice. The CEPA program now qualifies for 32.5 hours of CPE credit for CPAs, 17 hours of CE credit for CFP's, 24 hours of CPE credit for CM&AAs, and 10 hours of CE credit for CBIs.

*Exit **Planning** Institute, Welcome to the Exit **Planning** Institute (Exit **Planning** Institute)*

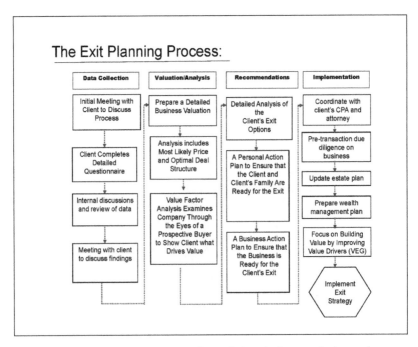

*Cliff Olin, Exiting Your Business: The Exit **Planning** Process (independentinvestmentbankers.com)*

But hearing her elaborating her **plan**, Maxime was again seized with terror. To leave Paris, to go so far away with a woman who was undoubtedly mad, to leave behind a scandal that would exile him forever! It was as if he were being suffocated by a hideous nightmare. He sought desperately for a means of escape from this dressing room, from this pink retreat where the passing bell at Charenton seemed to be tolling. He thought he had hit on something.

Émile Zola, The Kill

"There's only one thing for you to do. It's against practice, and in some other case I'd oppose it. But not in this. There's a couple of things about this that make me think that practice is one of the things they're going to count on, and take advantage of. Practice in a case like this is to wait, and make them come to you, isn't it? I advise against that. I advise jumping in there at once, tonight if possible, and if not tonight, then certainly on the day of that inquest, and filing a complaint against that woman. I advise filing an information of suspected murder against her, and smashing at her as hard and as quick as we can. I advise that we demand her arrest, and her detention too, for the full forty-eight hours incommunicado that the law allows in a case of this kind. I advise sweating her with everything the police have got. I particularly advise separating her from this accomplice, whoever he is, or she is, so we get the full value of surprise, and prevent their conferring on future **plans**. Do that, and mark my words you're going to find out things that'll amaze you."

James M. Cain, Double Indemnity

DIETER: When does the monsoon start?
PHISIT: I don't know, could be another two weeks, or a month—
DIETER: No, no, no, no ...
PHISIT: Maybe five days—
DIETER: Okay, no. We need to set a start date, because the guards, you know, they are starving as well, and they are getting meaner and meaner, so—
GENE: I don't care about anything else, your '**plan**' *(waves fingers around head)*, I don't care—
DIETER: You can stay behind.
GENE: Listen to me—
DIETER:—if you want—
GENE: Listen to me now, how about—
DUANE: I'm on board. I'd rather be dead out there than rottin' away in here.
DIETER: Okay. Y.C., are you on board?
Y.C.: I guess so ...

Colorado River Relocation Center, Poston, Arizona. After the final **plans** have been made, boxes packed, and grants picked up, the residents of Poston are at last ready to leave the center. Now that so many of their friends have gone out before them, it is with a feeling of anticipation rather than one of sorrow that the evacuees prepare to leave the place which for three years has been home to them.

Department of the Interior, War Relocation Authority, September 1945, Hikaru Iwasaki photographer (U.S. National Archives and Records Administration)

DIETER: Okay. Procet?
PROCET: I am out.
DIETER: You are out of the **plan**?
PROCET: No, no, I am out, to get out.
DIETER: Oh, you are coming with us out, great. Okay, Phisit?
PHISIT: *(Silence.)*
DIETER: Ha ha, that's a yes. So. So. It is settled then. Okay.

Werner Herzog (director), Rescue Dawn

One of the most Stantonesque moments in "Nemo" is when Gill describes his intricate escape **plan**: after the dentist transfers the fish to individual baggies to clean the tank, "we'll roll ourselves down the counter, out the window, off the awning, into the bushes, across the street, and into the harbor. It's foolproof!" The film ends with a coda in which Gill and his tank mates have executed the **plan**—and are now bobbing in the harbor, stuck in their baggies. "That's life in a nutshell for us," Stanton told me. "There's always something you haven't thought of. It's never-ending."

Tad Friend, Second-Act Twist (The New Yorker)

Shibyo Osen (Dead Rising)
Loosely based on the *Dead Rising 2* game, Shibyo Osen is a spin-off story that takes place in a world where the zombie outbreak has spread all over the world, including Japan. Areas with the infected are quarantined from the rest of the world, leaving the uninfected residents to fend for themselves against the horde of hungry zombies. Two of these people are brothers George and Shin, who decide to hatch a **plan** to escape after they find themselves trapped in a zombie-infested area.

Internet Movie Database, Plot Summaries

When Rabbi ben Zakkai had himself smuggled out of besieged Jerusalem in a coffin and explained to Vespasian that he had not **planned** on a martyr's death, he was allowed to start a theological college in Sfad.

Anthony Blond, The Secret History of the Roman Emperors

"So, Mitchell," Phyllida was asking, "what are your **plans** after graduation?"
"My father's been asking me the same question," Mitchell answered. "For some reason he thinks Religious Studies isn't a marketable degree."
Madeleine smiled for the first time all day. "See? Mitchell doesn't have a job lined up, either."
"Well, I sort of do," Mitchell said.

Unfortunately, this week I found out my graduation **plan**—is not God's **plan**.
Posted by Lauren Owen, Oh What A Week (Barefoot in the Kitchen, mrslaurenowen.blogspot.com)

"You do not," Madeleine challenged him.

"I'm serious. I do." He explained that he and his roommate, Larry Pleshette, had come up with a **plan** to fight the recession. As liberal-arts degree holders matriculating into the job market at a time when unemployment was at 9.5 percent, they had decided, after much consideration, to leave the country and stay away as long as possible. At the end of the summer, after they'd saved up enough money, they were going to backpack through Europe. After they'd seen everything in Europe there was to see, they were going to fly to India and stay there as long as their money held out. The whole trip would take eight or nine months, maybe as long as a year.

Jeffrey Eugenides, The Marriage Plot

"Certainly you realize that your route would not do for a retreat, if we were blocked higher up."

"I consider it self-defeating to **plan** in terms of retreat."

"I consider it stupid not to."

"Stupid!" Karl struggled with his control. Then he shrugged in peevish accord. "Very well. I shall leave the **planning** of a retreat route to Doctor Hemlock. After all, he has had more experience in retreating than I."

Ben glanced at Jonathan, surprised that he allowed this to pass with only a smile.

"I may take it then that my **plan** is accepted?" Karl asked.

Trevanian, *The Eiger Sanction*

*The **plan** it wasn't much of a **plan***
I just started walking
I had enough of this old town
Had nothing else to do
It was one of those nights
You wonder how nobody died
We started talking
You didn't come here to have fun
You said: "well I just came for you"

But do you still love me?
Do you feel the same
Do I have a chance
Of doing that old dance
With someone I've been
Pushing away

And touch, we touched the soul
The very soul, the soul of what we were then
With the old schemes of shattered dreams
Lying on the floor
You looked at me
No more than sympathy
My lies you have heard them
My stories you have laughed with
My clothes you have torn

And do you still love me?
Do you feel the same
And do I have a chance

Of doing that old dance again
Is it too late for some of that romance again
Let's go away, we'll never have the chance again

You lost that feeling
You want it again
More than I'm feeling
You'll never get
You had a go at
All that you know
You lost that feeling
So come down and show

Don't say goodbye
Let accusations fly
Like in that movie
You know the one where Martin Sheen
Waves his arm to the girl on the street
I once told a friend
That nothing really ends
No-one can prove it
So I'm asking you now
Could it possibly be
That you still love me?
And do you feel the same
Do I have a chance
Of doing that old dance again
Or is it too late for some of that romance again
Let's go away, we'll never have the chance again

I take it all from you
I take it all from you
I take it all from you
I take it all from you

I take it all from you
I take it all from you

 dEUS, *Nothing Really Ends (Pocket Revolution)*

Asbestos Cement Products Association, **According to Plan:**
The Story of Modern Sidewalls for the Homes of America

However, many more days passed and that too came to an end. An overseer happened to notice the cage one day and asked the help why this perfectly useful cage with rotten straw in it was left unoccupied; no one knew the answer until someone, with the help of the signboard, recalled the hunger artist. They prodded the straw with sticks and found the hunger artist buried inside. "Are you still fasting?" asked the overseer. "When on earth do you **plan** on stopping?" "Forgive me, everyone," rasped the hunger artist; only the overseer with his ear pressed against the bars could understand him. "By all means," said the overseer, tapping his finger at the side of his forehead to indicate the hunger artist's condition to the others, "we forgive you." "I always wanted you to admire my fasting," said the hunger artist. "And so we do admire it," said the overseer accommodatingly. "But you shouldn't admire it," said the hunger artist. "So then we don't admire it," said the overseer, "but why should we not admire it?" "Because I must fast, I cannot do otherwise," answered the hunger artist. "What a character you are," said the overseer, "and why can't you do otherwise?" "Because," said the hunger artist, lifting his head a little and puckering his lips as if for a kiss, and he spoke directly into the overseer's ear so that nothing would be missed, "because I could never find food I liked. Had I found it, believe me, I would never have created such a ruckus and would have stuffed myself like you and everyone else." These were his last words ...

Franz Kafka, A Hunger Artist

Wait, this reminds me of something—I've heard this business **plan** before. Oh, right, I know. It's what Amazon is doing with its new iPad rival, the Kindle Fire. (It comes out later this month, and yes, I'll review it soon.) The Kindle Fire has all kinds of interesting features; it's basically a tablet for consuming all things Amazon: books, music, TV, movies. But the best feature by far is the shockingly low price: $200. It's 80 percent of an iPad, for 40 percent of the price.

Look, we know what tablets cost, no matter what electronics company makes them: $500 and up. Amazon must be selling the Fire at a loss, to get more people to buy books, music, TV and movies. They're giving away the razors and selling a lot more blades.

It'd be fascinating to see the spreadsheet for this **plan**, wouldn't it?

David Pogue, Amazon Lights the Fire with Free Books (The New York Times)

"I don't know why I even try," he said, and he was clearly pissed off at this point. "Seriously, May. I'm not kidding. I have a bad feeling about this. We didn't spend any money promoting *What I Learned on the Mountain*." Not a penny. We didn't send out a single review copy, and in turn we didn't get

a single book review. And yet, within weeks, it just took off. How do you explain that, May?"

"Edwin, you know as well as I do that the greatest sales tool we have is word of mouth. It sells more books than anything else. You can have the biggest, slickest marketing **plan** available, but poor word of mouth will still kill the best-laid **plans** of mice and publishers. That's what happened here, only the other way around. It's like *The Celestine Prophecy.* Remember that? The author couldn't find a publisher for love nor money, so he ended up publishing it himself, hawking it out of the trunk of his car, going from bookstore to bookstore—"

"And that took years, May. Years of persistence. What happened with *What I Learned on the Mountain* took only a matter of weeks. And no one was driving around with copies of it in the trunk of his car. This was purely word of mouth. And you know what? Paul down in marketing did a reader survey when sales first started to soar, trying to figure out what was going on—you know how reactive marketing is; always trying to catch up to the latest trend and then take credit for it. Well, anyway, Paul tested reader satisfaction with *What I Learned on the Mountain,* and do you know what he came up with? One hundred per cent satisfaction. That's right, 100 per cent, May."

"Come on, Edwin. You're going to take anything marketing says seriously?"

Will Ferguson, Generica

... he could still talk about his **plans** on his TV show ...

Jake Coyle, Stephen Colbert Transfers Super PAC to Jon Stewart, Teases Entry to Republican Primary in SC (Winnipeg Free Press)

Don't Lose Heart
... Then the TVs stopped, and the electricity and gas ran out. Finally the only thing still broadcasting is a BBC "10 Point Emergency **Plan**"—Outdated and crackly, but at least it's a voice in the darkness ...

Internet Movie Database, Plot Summaries

"Message starts ... Hemlock ... break ... Search has had no success in designating your objective ... break ... Alternate **plan** now in operation ... break ... Have placed details in the hands of Clement Pope ... break ... **Plan** will crystallize for you tomorrow ... break ... Can anything be done to decrease the attention the news media have given to your proposed climb ... question mark ... break ... Miss Brown remains outside our cognizance ... break ... best regards ... break, break ... Message ends."

Trevanian, The Eiger Sanction

Sam's till-bound cashier is in no way a supermarket equivalent of Zola's rising heroine, but her real-life story and that of her book have been 'a bit like a modern fairy tale', as she says in an afterword to the new French edition. She had begun working on the checkout when she was a student, and stayed put when she didn't find the kind of job she wanted after finishing her degree. Later she started a blog, *caissierenofutur*, to share stories with fellow checkout workers. On the very day she finally quit, but with nothing particular in prospect, a local newspaper ran a story about the blog which was picked up by the national media. Within no time publishers were fighting for the book contract, and soon *caissierenofutur* had been transformed into *Les Tribulations d'une caissière,* now translated into nearly 20 languages. There are **plans** for a Hollywood movie.

Rachel Bowlby, Please Enter Your PIN. Review of Checkout: A Life on the Tills, By Anna Sam (London Review of Books)

AMY WHEATON	Female Student
BEN PARRILLO	Plan Man
HERSCHEL BLEEFELD	Male Student
BARBARA GRUEN	Plan Woman 1
BREE MICHAEL WARNER	Plan Woman 2
GREG SHAMIE	Guy In Car

Alan Ball, Six Feet Under: The **Plan** (End Credits)

Last page of main text	Appendix A
Appendix B	Endnotes
Abbreviations	Picture credits
Glossary	Bibliography
Acknowl-edgements	Index
Index	Blank
Blank	

A conventional sequence for endmatter.

original flat **plan**: end matter page position

Positions of the end matter pages: As with prelims or front matter, the sequence of sections at the end of the book can vary depending on content and function. Every effort should be made to leave two blanks at the end of a book. This is especially true if the book is to be hard bound as the back endpaper has to be partially fixed onto the last page.

The following pages may be included in the back matter:

Appendices
Endnotes
Abbreviations
Photographers'/Illustrators' credits
Glossary
Bibliography
Acknowledgements
Indexes
Colophon

*Momentum Press, Original Flat **Plan**: End Matter Page Position*

PAC Photo Praxis Theatre's "Open Source Theatre" project has gone live! In this first entry, "What a tangled web we weave," I've introduced our concept of "open source" to let you know that we **plan** to share our process, and our materials with you as they develop. The first step in Section 98's development process was to figure out the gaps in our knowledge, or, as our Dramaturg Alex Fallis suggests, "how ignorant are we?" Here you'll be able to see how we went about creating a visual representation of what we didn't yet know, and the kinds of questions that our continuing research have been raising. We need your feedback, your advice, and to hear whether or not our processes might help you with yours. We look forward to the dialogue.

Praxis Theatre, Section 98—Open Source Entry #1—Introduction: What A Tangled Web We Weave

sources

Not only the title, but the **plan** and a good deal of the incidental symbolism of the poem were suggested by Miss Jessie L. Weston's book on the Grail legend: *From Ritual to Romance* (Cambridge). Indeed, so deeply am I indebted, Miss Weston's book will elucidate the difficulties of the poem much better than my notes can do; and I recommend it (apart from the great interest of the book itself) to any who think such elucidation of the poem worth the trouble.

> T. S. Eliot, Notes on "The Waste Land"

uncredited images

x — *Ingenieure Mit Konsturktionsplänen (Engineers with Construction **Plans**)*, 1952. German Federal Archives. From *Wikimedia Commons,* http://commons.wikimedia.org.

xii — *Konstrukteure Mit Risszeichnung (**Designers** with Technical Drawings)*, 1958. German Federal Archives. From *Wikimedia Commons,* http://commons.wikimedia.org.

xiv — Glenn Research Center, NASA. *Interior View of Drafting Room in Engine Research Building,* 1942. From *Great Images in NASA,* http://grin.hq.nasa.gov.

xvi — *Dick Gay, Second From Right, Talks Over Expansion **Plans** for the Hellendoff Inn with Local Building Contractors At Helen Georgia, Near Robertstown,* 1975. Photo by Al Stephenson. U.S. National Archives and Records Administration. From *Wikimedia Commons,* http://commons.wikimedia.org.

xxi — Farm Security Administration. *Architect's Office, 1940's.* Office of War Information Photograph Collection, Library of Congress. From *Wikimedia Commons,* http://commons.wikimedia.org.

xxiii — Harland Bartholomew and Associates. *A Preliminary Report Upon Administration of the **Plan**.* Vancouver: Vancouver Town **Planning** Commission, 1948.

xxv — Department of the Interior, Fish and Wildlife Service, Minneapolis Regional Office. *Man Sitting At Drafting Board,* 1936. U.S. National Archives and Records Administration. From *Wikimedia Commons,* http://commons.wikimedia.org.

text sources

Aaron, Henry. *Behavioral Dimensions of Retirement Economics.* Washington, DC: Brookings Institution Press, 1999.

Aaronovitch, David. *Voodoo Histories: The Role of the Conspiracy Theory in Shaping Modern History.* New York: Riverhead Books, 2010.

Abilla, Pete. "Action **Plan** | Action **Plan** Templates | Action **Plan** Example | DMAIC." *Shmula,* December 10 2010, http://www.shmula.com.

Abish, Walter. *In the Future Perfect.* New York: New Directions, 1977.

———. *How German Is It.* New York: New Directions, 1979.

Adams, Douglas. *The Hitchhiker's Guide to the Galaxy.* 1979. London: Picador, 2002.

Agence France-Presse. "New Pixar Topics: Dinosaurs, Brain." *Hürriyet Daily News: Leading News Source for Turkey and the Region,* 8/22/2011, http://www.hurriyetdailynews.com.

Aggarwal, M., Lih-Yuan Denga, and Mukta Datta Mazumder. "Optimal Fractional Factorial **Plans** Using Finite Projective Geometry." *Communications in Statistics—Theory and Methods* 37, no. 8 (2008): 1258-65.

Albert, Eric, Greta Christina, and Jill Soloway. *Susie Bright Presents: Three Kinds of Asking for It: Erotic Novellas.* New York: Touchstone Books, 2005.

Allderblob. "The **Architects** Are Here." *Allderblob,* http://allderdice.ca.

Amazon. "The Noah **Plan** History and Geography Curriculum Guide (Product Description)." *Amazon,* http://www.amazon.com.

Apperson, George Latimer. *The Wordsworth Dictionary of Proverbs.* Ware, Hertfordshire: Wordsworth Reference, 2006.

Arcade Fire. "Neighborhood #3 (Power Out)." *Funeral.* CD. Merge Records, 2004.

Asbestos Cement Products Association. *According to Plan: The Story of Modern Sidewalls for the Homes of America.* Film. United States, Jam Handy Organization, 1952.

Ashley, Robert. "John Barton Wolgamot." *In Sara, Mencken, Christ and Beethoven There Were Men and Women,* pp. 21-43. New York: Lovely Music, 2001.

Associated Press. "Dutch Railway **Plans** to Hand Plastic Bags to Passengers in Need on Trains That Lack Bathrooms." *Winnipeg Free Press,* 10 July 2011, http://www.winnipegfreepress.com.

———. "Battlestar Actors Lay Out the **Plan**." Video. *YouTube,* 2009, http://youtube.com.

Association of Newfoundland Land Surveyors. *Policy Statement.* December 31, 2011, http://www.surveyors.nf.ca.

Atwood, Margaret. *The Edible Woman.* Toronto: McClelland & Stewart, 1989.

Aub. "Everybody's Got **Plans** ... Until They Get Hit." *A Long Suffering Heart,* 22 June 2011, longsufferinginoklahoma.blogspot.com.

Auletta, Ken. "A Woman's Place: Can Sheryl Sandberg Upend Silicon Valley's Male-Dominated Culture?" *The New Yorker,* July 11 & 18, 2011, pp. 54-62.

Austen, Jane. *Pride and Prejudice.* Leipzig: Bernhard Tauchnitz, 1870.

Auster, Paul. *Moon Palace.* New York: Viking Penguin, 1989.

———. *The Book of Illusions.* New York: Picador, 2002.

Axis History Forum. "**Plan** Z." *Axis History Forum,* 2010, http://forum.axishistory.com.

Ayala, Balthazar. *Three Books on the Law of War and on the Duties Connected with War and on Military Discipline.* 1582. Translated by John Pawley Bate. Washington, DC: Carnegie Institution of Washington, 1912.

Aziz, Robert. *The Syndetic Paradigm: The Untrodden Path Beyond Freud and Jung.* Albany: State University of New York Press, 2007.

Baker, Nicholson. *The Mezzanine.* New York: Vintage, 1986.

Ball, Alan (creator). "The **Plan**." *Six Feet Under,* Season 2, Episode 3. Television series. USA, Home Box Office, 17 March 2002.

Balzac, Honoré de. *Bureaucracy.* 1838. Translated by Katharine Prescott Wormeley. BiblioBazaar, 2007.

Bangs, John Kendrick. *The Inventions of the Idiot.* New York: Harper & Bros., 1904.

Banks, Iain. *The Business.* London: Little, Brown, 1999.

Barmak, Sarah. "Talking Points: Greek Drama Plays Out Over Austerity **Plan**." *Toronto Star,* July 01, 2011, http://www.thestar.com.

Bartosiewicz, Petra. "To Catch A Terrorist: The FBI Hunts for the Enemy Within." *Harper's Magazine,* August 2011, pp. 37-45.

Barzun, Jacques. *From Dawn to Decadence: 500 Years of Western Cultural Life: 1500 to the Present.* New York: HarperCollins, 2000.

BBC News. "David Cameron Sets Out Welfare Reform Bill **Plans**." *BBC News,* 17 February 2011, http://www.bbc.co.uk.

Belkin, Lisa. "The Odds of That." *The New York Times,* August 11, 2002, http://www.nytimes.com.

Bell, Madison Smartt. *Lavoisier in the Year One: The Birth of A New Science in an Age of Revolution.* New York: W. W. Norton, 2005.

Bellow, Saul. *Dangling Man.* 1944. New York: Penguin Books, 1988.

Berger, Thomas. *Killing Time.* New York: Dell, 1968.

Bering, Jesse. "So Close, and Yet So Far Away: The Contorted History of Autofellatio." *Slate,* Aug. 8, 2011, http://www.slate.com.

Bester, Alfred. *The Demolished Man.* New York: Vintage Books, 1996.

Bewayo, Edward D. "Pre-Start-Up Preparations: Why the Business **Plan** Isn't Always Written." *Entrepreneurial Executive*, 2010, http://www.thefreelibrary.com.

Bhagat, Alexis, and Nato Thompson. "Atlas Über Alles: A Conversation with Alexis Bhagat and Nato Thompson." *Scapegoat* 00, Fall 2010, pp. 2-3.

Bierce, Ambrose. *The Devil's Dictionary.* 1911. Alcyone Systems, 1993, http://www.alcyone.com.

Big Daddy Autism. "Everybody Has A **Plan** ... Until They Get Punched in the Mouth." *Special Happens,* April 12, 2011, specialhappens.com.

Bissett, Kevin. "Cormier Says Kidnap Victim 'Was My Boss'." *The Globe and Mail,* June 28, 2011, http://www.theglobeandmail.com.

Blank, Steve. "There's Always a **Plan** B." *Steve Blank,* August 15, 2011, http://steveblank.com.

Blond, Anthony. *The Secret History of the Roman Emperors.* London: Magpie, 2008.

Boorstin, Daniel. *The Discoverers: A History of Man's Search to Know His World and Himself.* New York: Vintage Books, 1985.

Boswell, Robert. *The Geography of Desire.* New York: Harper Collins, 1989.

Bowlby, Rachel. "Please Enter Your PIN. Review of *Checkout: A Life on the Tills,* by Anna Sam." *London Review of Books* 31, 22 October 2009, pp. 20-22.

Bransford, John D. *How People Learn: Brain, Mind, Experience, and School.* Washington, DC: National Academic Press, 2001.

Brent, Linda. *Incidents in the Life of a Slave Girl.* Edited by L. Maria Child. Boston: 1861.

British Broadcasting Corporation. *No **Plan**, No Peace.* Television. UK, 2007.

Broch, Hermann. *The Unknown Quantity.* Translated by Willa and Edwin Muir. Marlboro, VT: Marlboro Press, 1988.

Brody, Samuel D. "Are We Learning to Make Better **Plans**? A Longitudinal Analysis of **Plan** Quality Associated with Natural Hazards." *Journal of Planning Education and Research* 23.2, 191-201.

Bronte, Emily. *Wuthering Heights.* 1847. Online Literature Library, http://www.literature.org.

Brown, Julie. *Skills System Instructors Guide: An Emotion-Regulation Skills Curriculum for All Learning Abilities.* Bloomington, IN: iUniverse, 2011.

Burroughs, Edgar Rice. *The Beasts of Tarzan.* 1916. The Free Library, http://www.thefreelibrary.com.

———. *The Monster Men.* 1929. The Free Library, http://www.thefreelibrary.com.

———. *The Son of Tarzan.* 1917. The Free Library, http://www.thefreelibrary.com..

Business Enterprise Institute. "Welcome to Exit**Planning**.com! Your Home for Exit **Planning** Information and Education." *Exit**Planning**.com,* 2004-2007, https://www.exitplanning.com.

Cain, James M. *Double Indemnity.* 1943. New York: Vintage Books, 1992.

Callahan, Bob. *Who Shot JFK? A Guide to the Major Conspiracy Theories.* New York: Simon and Schuster, 1993.

Cantor, Norman. *In the Wake of the Plague: The Black Death and the World It Made.* New York: Free Press, 2001.

Capek, Josef, and Karel Capek. *The World We Live In (The Insect Comedy): A Play in Three Acts with Prologue and Epilogue.* Translated by Owen Davis. New York: Samuel French, 1933.

Captain Capitalism. "Kill the Bankers: Comment." *Captain Capitalism: Rantings and Tirades of a Frustrated Economist,* September 19, 2008, captaincapitalism.blogspot.com.

Cascardi, Anthony J. *The Bounds of Reason: Cervantes, Dostoevsky, Flaubert.* New York: Columbia University Press, 1986.

Cassidy, John. "Back on Track." *The New Yorker,* September 19, 2011, pp. 23-24.

Cave, Nick. *And the Ass Saw the Angel.* Los Angeles: 2.13.61 Publications, 2003.

CBS News. "Paulson **Plan** Could Cost $1 Trillion." *CBS News,* June 26, 2009, http://www.cbsnews.com.

Chamberlain, Rev. Sylvain. *The Science of Mind.* Shannon, MS: Threefold Lotus Kwoon, 2006.

chillin. "Can Someone Help Me with My Sex **Plan**?" *Yahoo! Answers,* 2009, http://answers.yahoo.com.

Chirgotis, William G. *150 Home **Plans**: Ranch, Expansion Ranch, Vacation and Leisure Homes, Dome Homes.* Passaic, NJ: Creative Homeowner Press, 1981.

Chitkara, M. G. *Rashtriya Swayamsevak Sangh: National Upsurge.* New Delhi: A. P. H. Publishing Corporation, 2004.

Chomsky, Noam. "The Responsibility of Intellectuals, Redux: Using Privilege to Challenge the State." *Boston Review,* September/October 2011, http://www.bostonreview.net.

ChristianBook.com. "The Noah Plan History and Geography Curriculum Guide" (Product Description). *ChristianBook.com,* 2011, http://www.christianbook.com.

Christianson, David. "Those with Financial Plans Achieving Goals." *Winnipeg Free Press,* 10 July 2011, http://www.winnipegfreepress.com.

———. "Financial Planners Join to Form Standards Coalition." *Winnipeg Free Press,* March 6, 2011, http://www.winnipegfreepress.com.

Clark, Dr. Elsie. *Spiritual Warfare Series—Strategic Weapons of Our Warfare.* Maitland, FL: Xulon Press, 2009.

CNN. "UN: Libyan Crackdown Escalating." *NationNews.com,* February 25, 2011, http://www.nationnews.com.

Coetzee, J. M. *Foe.* London: Penguin, 1986.

Cohen, Matt. *The Bookseller.* Toronto: Vintage, 1997.

Collins, Wilkie. *No Name: A Novel.* New York: Harper & Bros., 1863.

Collins, Gail. "Democratic Happy Dance." *New York Times,* May 25 2011, http://www.nytimes.com.

———. "The Gift of Glib." *New York Times,* October 12, 2011, http://www.nytimes.com.

Collins, Lauren. "England, Their England: The Failure of British Multiculturalism and the Rise of the Islamophobic Right." *The New Yorker,* July 4, 2011, pp. 28-34.

Conrad, Debra. "Publishing Junk eBooks is Not a Business Plan." *Debra Conrad: That Public Domain Diva,* June 26, 2011, http://www.publicdomaintreasurehunter.com.

Conrad, Joseph. *Heart of Darkness.* 1902. London: Penguin Books, 1995.

Conservative Home. "Jeb Hensarling: McConnell's Plan is Something Like Plan X, Y, or Z While All the Rest of Us Are Still Working on Plan A, B, or C." *Conservative Home,* 7/15/2011, http://conhomeusa.typepad.com.

Contagious Magazine. "Nokia / Plan B. And Plan C. And Plan ..." *Contagious Magazine,* 15 February 2011, http://www.contagiousmagazine.com.

Conze, Edward. *The Large Sutra on Perfect Wisdom: With the Divisions of the Abhisamayalankara.* Berkeley, CA: Univ. of California Press, 1984.

Cooper, Michael. "States Plan Deeper Cuts and Higher Taxes, Survey Finds." *The New York Times,* June 2, 2011, http://www.nytimes.com.

Cornell, Vincent J. *Voices of Islam.* Westport, CT: Praeger Publishers, 2007.

Council on Foreign Relations. "Q&A: How Does the United States Plan to Defeat Iraq?" *The New York Times,* March 18, 2003, http://www.nytimes.com.

Cowley, Joseph. *John Adams: Architect of Freedom.* New York: iUniverse, Inc., 2009.

Coyle, Jake. "Stephen Colbert Transfers Super PAC to Jon Stewart, Teases Entry to Republican Primary in SC." *Winnipeg Free Press,* 01/12/2012, http://www.winnipegfreepress.com.

Curry, Bill, and Jeremy Torobin. "Flaherty Confident Deficit-Fighting Plan Can Weather Economic Storm." *The Globe and Mail,* August 19, 2011, http://www.theglobeandmail.com.

Curtis, Nathaniel. *Architectural Composition.* Cleveland: J. H. Jansen, 1923.

Cuyler, Theodore L. *Golden Thoughts on Mother, Home and Heaven, From Poetic and Prose Literature of All Ages and All Lands.* New York: E. B. Treat, 1878.

Davies, Paul. *The Truth: A Novel.* Toronto: Insomniac Press, 1999.

Davis, Jerome. *The New Russia Between the First and Second Five Year Plans.* Freeport, NY: Books for Libraries Press, 1968.

Davis, Murray S. *Smut: Erotic Reality/Obscene Ideology.* Chicago: University of Chicago Press, 1983.

Davis, Will. "Everyone Has a Plan Until They Get Punched in the Mouth." *Social Media Today,* March 2, 2011, http://socialmediatoday.com.

Dawes, Rev. Richard. *Remarks Occasioned by the Present Crusade Against the Educational Plans of the Committee of Council on Education.* London: Groombridge and Sons, 1850.

Decter, Ed, John J. Straus, Peter Farrelly, and Bobby Farrelly. "There's Something About Mary (Final Shooting Script)." *The Internet Movie Script Database*, 1997, http://www.imsdb.com.

Defoe, Daniel. *Robinson Crusoe.* 1719. Baltimore: 1965.

DeLillo, Don. *Running Dog.* New York: Vintage, 1978.

———. *Libra.* New York: Viking, 1988.

———. *Underworld.* New York: Simon and Schuster, 1997.

DemocraticUnderground.com. "General Discussion (Through 2005)." *DemocraticUnderground.com*, 2005, http://www.democraticunderground.com.

dEUS. "Nothing Really Ends." *Pocket Revolution.* CD. Universal Music Publishing Belgium/ Rondor Music London Ltd, 2005.

Dick, Philip K. *Radio Free Albemuth.* New York: Avon Books, 1985.

Dickens, Charles. *Dombey and Son.* 1848. The Literature Network, http://www.online-literature.com.

DiFranco, Ani. "Not A Pretty Girl." *Not A Pretty Girl.* CD. Righteous Babe Records, 1995.

Disability Now. "Welfare Reform: Are You Scared Yet?" *Disability Now,* October 2011, http://www.disabilitynow.org.uk.

Dostoyevsky, Fyodor. *Poor Folk.* 1846. The Free Library, http://www.thefreelibrary.com.

———. *The Brothers Karamazov.* 1880. Translated by David Magarshack. Harmondsworth, England: Penguin, 1958.

Douthat, Ross. "The Diminished President." *The New York Times,* July 31, 2011, http://www.nytimes.com.

Dowd, Maureen. "Field of Dashed Dreams." *The New York Times,* August 16, 2011, http://www.nytimes.com.

———. "Sleeping Barry Awakes." *The New York Times,* September 10, 2011, http://www.nytimes.com.

Dubner, Stephen J. "The Silver Thief." *The New Yorker,* May 17, 2004, pp. 74-85.

Duffy, Cathy. "The Noah Plan." *Cathy Duffy Reviews,* November 2010, http://cathyduffyreviews.com.

Dumas, Alexandre. *Ten Years Later.* 1893. The Free Library, http://www.thefreelibrary.com.

———. *The Count of Monte Cristo.* 1845. The Free Library, http://www.thefreelibrary.com.

———. *The Three Musketeers.* 1844. Online Literature Library, http://www.literature.org.

Eco, Umberto. *Foucault's Pendulum.* Translated by William Weaver. New York: Ballantine Books, 1989.

Edgington, Harry. *The Borgias.* Feltham, UK: Hamlyn Paperbacks, 1981.

Edric, Robert. *The Book of the Heathen.* London: Anchor, 2000.

Egan, Jennifer. *A Visit From the Goon Squad.* New York: Anchor Books, 2011.

Egan, Timothy. "The Need for Greed." *The New York Times,* May 17, 2011, http://opinionator.blogs.nytimes.com.

Ekstrøm, Claus Thorn, and Helle Sørensen. *Introduction to Statistical Data Analysis for the Life Sciences.* Boca Raton: CRC Press, 2011.

Eliot, George. *Middlemarch: A Study of Provincial Life.* 1872. New York: New American Library, 1964.

Eliot, T. S. *Murder in the Cathedral.* Toronto: Kingswood House, 1959.

———. "The Waste Land." *Collected Poems, 1909-1962,* pp. 51-76. New York: Harcourt, Brace & World, 1963,

Elliott, Henry W. "Instinctive Architects." *Frank Leslie's Sunday Magazine,* pp. 116-18. New York: Frank Leslie's Publishing House, 1886.

Encyclopedia Britannica Films. *The Baltimore Plan.* Film. USA, 1953.

Eugenides, Jeffrey. *The Marriage Plot.* Toronto: Knopf Canada, 2011.

Evans, Sarah. "Brutal Government Plans for Welfare 'Reform' Slammed By NW Hampshire Labour." *North West Hampshire Labour Party,* June 10, 2011, http://nwhampshirelabourparty.wordpress.com.

Ewing, R. "Meta-Analysis of Plan Quality—More Than a Literature Review." *Planning* 75.3 (March 2009): 42.

W. P. Trowbridge, Proposed Plan for Building a Bridge Across the East River,
*at Blackwell's Island, With **Plans** (New York: D. Van Nostrand, 1868)*

Exit **Planning** Institute. "Welcome to the Exit **Planning** Institute." *Exit Planning Institute,* 2010, https://www.exit-**planning**-institute.org.

Faas, Ekbert. *Woyzeck's Head.* Dunvegan, ON: Cormorant Books, 1991.

Farrow, John. *City of Ice.* Toronto: Harper Collins, 1999.

Ferguson, Will. *Generica.* Toronto: Penguin, 2001.

Ferris, Timothy. *Coming of Age in the Milky Way.* New York: HarperCollins, 2003.

Fey, Tina. "Confessions of a Juggler: What's the Rudest Question You Can Ask a Mother?" *New Yorker,* February 14 & 21, 2011, pp. 64-67.

Fink, Thomas, and Joseph Lease. *"Burning Interiors": David Shapiro's Poetry and Poetics.* Madison, NJ: Fairleigh Dickinson University Press, 2007.

Finlay, Diane. "MP Diane Finley Holds Consultations on the Economy with Hardworking Canadians." *Diane Finlay: Member of Parliament for Haldimand-Norfolk,* January 22 2011, http://dianefinley.ca.

First Choice Health Insurance, Inc. "Medicare Advantage & Medicare Supplement **Plans** in Arizona." *First Choice Health Insurance, Inc.,* 2002-2011, http://www.ehealthlink.com.

Fisher-Gewirtzman, Dafna. "View-Oriented Three-Dimensional Visual Analysis Models for the Urban Environment." *Urban Design International* 10.1 (2005-04): 23-37.

Fitzgerald, F. Scott. *The Great Gatsby.* Great Britain: Wordsworth Editions, 1993.

Flaubert, Gustave. *Bouvard and Pécuchet.* 1881. Translated by A. L. Krailsheimer. London: Penguin Books, 1976.

Foley, Stephen. "Paulson Reveals **Plans** for Biggest Financial Reform Since Depression." *The Independent,* 1 April 2008, http://www.independent.co.uk.

Foot, Jesse. *A **Plan** for Preventing the Fatal Effects From the Bite of A Mad Dog, With Cases.* London: T. Becket, Pall Mall, 1793.

Forster, E. M. *Howards End.* 1910. The Free Library, http://www.thefreelibrary.com.

Foust, Jeff. "The Importance of **Plan** B (and **Plan** C, and **Plan** D...)." *The Space Review,* May 29, 2007, http://www.thespacereview.com.

Fox News. "Economic Rescue **Plan** Faces Resistance From Conservatives in Congress." *Fox News,* September 19, 2008, http://www.foxnews.com.

Friedell, Egon. *A Cultural History of the Modern Age,* Volume 1. 1930. New Brunswick, NJ: Transaction Publishers, 2008.

Friedman, Thomas L. "Can't We Do This Right?" *The New York Times,* July 26, 2011, http://www.nytimes.com.

Friend, Tad. "Underwater." *The New Yorker,* February 27, 2012, pp. 25-26.

———. "Vermin of the Sky: Who Will Keep the **Plan**et Safe From Asteroids?" *The New Yorker,* February 28, 2011, pp. 22-29.

———. "Second-Act Twist." *The New Yorker,* October 17, 2011, pp. 62-71.

———. "The March of the Strandbeests." *The New Yorker,* September 5, 2011, pp. 54-61.

Frolick, Larry. "Suburbia's Last Stand: Big **Planning**'s Audacious Bid to Curb Suburban Sprawl." *The Walrus,* November 2005, pp. 44-55.

Funk, Isaac Kaufman. *The Preacher and Homiletic Monthly,* Vol. 5. New York: I. K. Funk & Co., 1881.

Gawande, Atul. "Letting Go: What Should Medicine Do When It Can't Save Your Life?" *The New Yorker,* August 2, 2010, pp. 36-49.

Gawronski, Christopher. *Tools of the Trade: Part of the Municipal Act Reform Initiative of British Columbia.* Province of British Columbia, Ministry of Municipal Affairs, March 1999.

GetRomantic.com. "How to **Plan** A Romantic Dinner." *GetRomantic.com,* 1999-2011, http://www.getromantic.com.

"Gettysburg—Pickett's Charge: The **Plan**." Video. *YouTube,* 2007, http://youtube.com.

Gido, Jack, and James P. Clements. *Successful Project Management.* Mason, OH: South-Western/ Cengage Learning, 2009.

Gilligan, Vince (creator). "Más." *Breaking Bad,* Season 3, Episode 5. Television series. USA, Sony Pictures Television, 18 Apr. 2010.

Gleick, James. "How Google Dominates Us." *The New York Review of Books,* August 18, 2011, http://www.nybooks.com.

Godin, Seth. "Publishing Books to Make Money ..." *Seth Godin's Blog,* March 28, 2010, http://sethgodin.typepad.com.

Godsview.com. "Scan the Bible for Requested Words and Phrases." *Godsview.com: Bible Concordance, Bible Search, Bible Text (KJV) and Other Study Aids,* http://cgi.godsview.com.

Goldman, Albert. *Ladies and Gentlemen—Lenny Bruce!!* New York: Penguin Books, 1971.

Goldsmith, Kenneth. "Sentences on Conceptual Writing." *UbuWeb,* http://www.ubu.com.

Goodis, David. *The Moon in the Gutter.* London: Serpent's Tail, 1998.

Gopnik, Adam. "Get Smart: How Will We Know When Machines Are More Intelligent Than We Are?" *The New Yorker,* April 4, 2011, pp. 70-74.

———. "The Caging of America: Why Do We Lock Up So Many People." *The New Yorker,* January 30, 2012, pp. 72-77.

Gull, Nicole. "**Plan** B (and C and D and ...)." *Inc,* Mar 1, 2004, http://www.inc.com.

H&R Block Tax Services. "Peace of Mind® Terms and Conditions." *H&R Block,* 2011-2012, http://www.hrblock.com.

Hallissy, Margaret. "Reading the **Plans**: The **Architectural** Drawings in Umberto Eco's The Name of the Rose." *Critique: Studies in Contemporary Fiction* 42.3 (2001): 271-86.

Hamilton, Jane. *A Map of the World.* New York: Doubleday, 1994.

Hammond, John S., Ralph L. Keeney, and Howard Raiffa. *Smart Choices: A Practical Guide to Making Better Life Decisions.* New York: Broadway Books, 2002.

Harkinson, Josh. "Cover Your Assets: The Growing Business of Protecting CEOs and the Superrich From the Rest of Us." *Mother Jones,* July/August 2011, pp. 5-7.

Harland Bartholomew and Associates. *A Preliminary Report Upon Administration of the Plan.* Vancouver: Vancouver Town **Planning** Commission, August 1948.

Harris, Elizabeth A. "A Piece of the Manhattan Dream, Only \$331.76 a Month." *New York Times.* January 23, 2012, http://www.nytimes.com.

Hatonn, Gyeorgos Ceres. *Privacy in A Fishbowl: Spiral to Economic Disaster, Vol. 2.* Carlsbad, CA: America West, 1989.

HCMised. "Oracle Advanced Benefits." *HCMised,* 2011, http://hcmised.com.

Heller, Joseph. *Catch-22.* 1955. New York: Dell Publishing, 1977.

Herzog, Werner (director). *Rescue Dawn.* Feature film. USA, MGM, 2006.

Hill, Susan E. Kogler, Edward G. Thomas, and Lawrence F. Keller. "A Collaborative, Ongoing University Strategic **Planning** Framework: Process, Landmines, and Lessons: **Planners** at Cleveland State University Describe That Institution's Highly Communicative and Participatory Strategic **Planning** Process." *Planning for Higher Education,* 2009. The Free Library, http://www.thefreelibrary.com.

Hogan, David E., and Jonathan L. Burstein. *Disaster Medicine.* Philadelphia: Lippincott Williams & Wilkins, 2007.

Homel, David. *Get on Top.* Toronto: Stoddart, 1999.

Homer. *Odyssey.* Translated by Stanley Lombardo. Indianapolis/Cambridge: Hackett Publishing Company, 2000.

Howard, Philip. *The Death of Common Sense: How Law is Suffocating America.* New York, NY: Warner Books, 1994.

Huxley, Aldous. *Eyeless in Gaza.* London: Chatto & Windus, 1969.

Hyslop, Katie. "Schools of the Future, Today." *The Tyee,* 15 Nov. 2011, http://www.thetyee.ca.

Imundo, Louis V. *The Effective Supervisor's Handbook.* New York: Amacom, 1991.

International Business Times. "PETA **Plans** to Launch A Porn Web Site." *International Business Times,* August 21, 2011, http://www.ibtimes.com.

Internet Movie Database. *Internet Movie Database,* 1990-2012, http://www.imdb.com.

Irving, Washington. *Astoria, or Anecdotes of an Enterprise Beyond the Rocky Mountains.* 1870. The Free Library, http://www.thefreelibrary.com.

Jackson, Brian. *The Black Flag: A Look at the Strange Case of Nicola Sacco and Bartolomeo Vanzetti.* Boston, MA: Routledge & Kegan Paul, 1981.

Jacobson, Howard. "A Mirror Up to Nothing." *Harper's Magazine,* June 2011, pp. 34-35.

Jaffe, Henry J., and Deborah Kovsky-Apap. "Looking a Gift Horse in the Mouth: Second Circuit Finds Class-Skipping Gift Violates Absolute Priority Rule." *Pepper Hamilton, LLP: Attorneys at Law,* February 14, 2011, http://www.pepperlaw.com.

James, Clive. *Cultural Amnesia: Notes in the Margin of My Time.* London: Picador, 2008.

Jarmusch, Jim (director). *Broken Flowers.* Feature film. USA, Focus Features, 2005.

Jewish Telegraphic Agency. "**Plan** Approved for Uniform Spellings of Community Names." *Jewish Telegraphic Agency,* July 3, 2011, http://www.jta.org.

Joanne98. "The Shock Doctrine: The Anti-Marshall **Plan** Page 346." *Democratic Underground,* December 31, 2007, http://www.democraticunderground.com.

Johnson, Denis. *Already Dead: A California Gothic.* New York: Harper Collins, 1997.

Johnson, Samuel. *The **Plan** of a Dictionary of the English Language.* London: Knapton, 1747.

Johnston, Wayne. *The Colony of Unrequited Dreams.* Toronto: Vintage Canada, 1998.

Josh. "Easy Way to Make Money—The Six-Figure Internet Publishing **Plan**." *Making Money From Home,* October 1, 2011, http://www.unixtips.org.

Joyner, James. "Everyone Has a **Plan** Until They Get Hit." *Outside the Beltway,* July 2, 2009, http://www.outsidethebeltway.com.

Just Dave. "Mike Tyson Quotes: The Song." Video. *YouTube,* 2011, http://youtube.com.

Kafka, Franz. "A Hunger Artist." 1919. Translated by Donna Freed. *The Metamorphosis and Other Stories,* pp. 135-45. New York: Barnes & Noble Classics, 2003.

Katy. "**According to Plan.**" *Emperor's Crumbs,* 2011/02/21, http://www.emperorscrumbs.com.

Kaushik, R. K. *Architect of Human Destiny?: Who Brings About Peace or Chaos?* Delhi: Kalpaz Publications, 2003.

Kautz, Henry A. "A Formal Theory of **Plan** Recognition and Its Implementation." *Reasoning About Plans,* pp. 69-126. San Mateo, CA: Morgan Kaufmann, 1991.

Kautz, Henry A., and James F. Allen. "Generalized **Plan** Recognition." Paper presented at the National Conference on Artificial Intelligence, 1986.

Keay, Julia. *Alexander the Corrector: The Tormented Genius Who Unwrote the Bible.* London: HarperCollins, 2004.

Keller, Bill. "The Politics of Economics in the Age of Shouting." *The New York Times.* November 27, 2011. http://www.nytimes.com.

Kemp, Wayne. "One Piece at a Time." Song. USA, Columbia, 1976. Performed by Johnny Cash.

Kennedy, Bill, and Darren Wershler. *Update.* Montreal: Snare Books, 2010.

Khatchadourian, Raffi. "The Gulf War: Were There Any Heroes in the BP Oil Disaster?" *The New Yorker,* March 14, 2011, pp. 36-59.

Kitto, H. D. F. *The Greeks: A Study of the Character and History of an Ancient Civilization, and of the People Who Created It.* London: Penguin Books, 1951.

Kives, Bartley. "Prometheus, Sisyphus … and Transit Tom: Winnipeg's Rapid Transit Woes the Stuff of Myth." *Winnipeg Free Press,* 01/8/2012, http://www.winnipegfreepress.com.

Kohan, Jenji (creator). *Weeds.* Television series. USA, Showtime, 2005-2012.

Konrad, George. *The City Builder.* Translated by Ivan Sanders. New York, NY: Penguin Books, 1987.

Kucinich, Jackie, and Gregory Korte. "Speaker's Debt-Ceiling **Plan** Comes Under Fire." *USA Today,* July 27, 2011, http://www.usatoday.com.

Ladau, Eric. "HBU Presents Aeschylus's 'Oresteia'." *Houston Public Radio,* October 12, 2010, http://www.houstonpublicradio.org.

Lambert, Miranda. "Makin' **Plans.**" *Revolution.* CD. Sony Music, 2009.

Lanchester, John. "Euro Science." *The New Yorker,* October 10, 2011, pp. 35-36.

Lane, Anthony. "Time Trip." *The New Yorker,* May 30, 2011, pp. 72-74.

Lawless, Gary. "Jets Not Punchline Material Just Yet." *Winnipeg Free Press,* 22 October 2011, http://www.bbc.co.uk.

le Carré, John. *The Night Manager.* London: Penguin, 1993.

———. *Single & Single.* Toronto: Penguin, 2000.

———. *The Constant Gardener.* Toronto: Penguin, 2001.

Le Guin, Ursula K. *The Dispossessed.* New York: Avon Books, 1974.

Lehmann, Chris. "Pennies From Heaven: How Mormon Economics Shape the G.O.P." *Harper's Magazine,* October 2011, pp. 33-41.

Lepore, Jill. "Birthright: What's Next for **Planned** Parenthood?" *The New Yorker,* November 14, 2011, pp. 44-55.

Leroux, Gaston. *The Mystery of the Yellow Room.* 1908. The Free Library, http://www.thefreelibrary.com.

Letto, Heather. *Plan V: Plan A Didn't Work—Plan B Sucked—Plan C Was Worse Than Plan A.* Frederick, MD: PublishAmerica, 2010.

Lewis, Mike. "Everyone Has a **Plan** Until They Get Punched in the Mouth." *Loo.me,* February 7, 2008, http://www.loo.me.

Lonergan, Patrick. "Reviews | Current | Off **Plan**." *Irish Theatre Magazine,* 16 February 2010, http://www.irishtheatremagazine.ie.

Lorre, Chuck, and Bill Prady (creators). "The Werewolf Transformation." *The Big Bang Theory,* Season 5, Episode 18. Television series. USA, Warner Bros. Television, 23 Feb. 2012.

Lu, Tong, Huafei Yang, Ruoyu Yang, and Shijie Cai. "Automatic Analysis and Integration of **Architectural** Drawings." *International Journal of Document Analysis and Recognition* 9.1 (2007-03-01): 31-47.

MacLean, Colin. "**Plans** Abound for Climate Change." *The Telegram,* August 17, 2011, http://www.thetelegram.com.

Madison, James. "The Federalist Papers, No. 38." *The Free Library,* http://www.thefreelibrary.com.

Manchester, William. *A World Lit Only by Fire: The Medieval Mind and the Renaissance.* Boston: Little, Brown, 1993.

Marantz, Andrew. "Becoming to America: Australians Are Drunks, Americans Are Hotheads, and Other Life Lessons From My Brief Career at an Indian Call Center." *Mother Jones,* July/August 2011, p. 38.

Marks, Jim. *Zeus in the Odyssey.* Washington, DC: Center for Hellenic Studies, Harvard University, 2008.

Masaki, Hisane. "Japan Stares into a Demographic Abyss." *Asia Times,* May 9, 2006, http://www.atimes.com.

Matrix Wiki. "The **Architect** (Scene)." *Matrix Wiki,* http://matrix.wikia.com.

———. "The One's Function." *Matrix Wiki,* http://matrix.wikia.com.

McAdam, Colin. *Some Great Thing.* Orlando: Harcourt, Inc., 2004.

McCabe, John. *Stickleback.* London: Granta Books, 1998.

McCardle, Megan. "What I Think About the Bailout **Plans**." *The Atlantic,* September 24, 2008, http://www.theatlantic.com.

McCormack, Eric. *The Paradise Motel.* London: Fontana Paperbacks, 1990.

McDiarmid, John. *The Scrap Book: A Collection of Amusing and Striking Pieces, in Prose and Verse, With an Introduction, and Occasional Remarks and Contributions. Third Edition, Improved and Enlarged.* Edinburgh: Oliver & Boyd, 1823.

Melville, Herman. *Moby Dick, Or the White Whale.* 1851. New York: Airmont Publishing Company, 1964.

———. *Pierre, Or the Ambiguities.* 1852. New York: New American Library, 1979.

Meslow, Scott. " 'The Walking Dead' Still Has an Identity Crisis." *The Atlantic,* October 17 2011, http://www.theatlantic.com.

Michaels, Fern. *Celebration.* New York: Kensington Books, 1999.

———. *Fast Track.* New York: Kensington Books, 2008.

Miller, Laurence. *Practical Police Psychology: Stress Management and Crisis Intervention for Law Enforcement.* Springfield, IL: Charles C. Thomas, 2006.

Mishima, Yukio. "Three Million Yen." *Death in Midsummer and Other Stories,* pp. 30-42. New York: New Directions, 1966.

Momentum Press. "Original Flat **Plan**: End Matter Page Position." *Momentum Press,* http://momentumpress.com.

Moody, Ruby. "The **Plan** of Slavation." *Music-Lyrics-Gospel.com,* 1986, http://www.music-lyrics-gospel.com.

Moore, Brian. *An Answer from Limbo.* Toronto: General Publishing Company, 1973.

Moore, Charles. *Daniel H. Burnham* **Architect, Planner** *of Cities.* 1921. New York: Da Capo Press, 1968.

Morris, Errol (director). *The Fog of War: Eleven Lessons From the Life of Robert S. Mcnamara.* Film. USA, Sony Classics, 2003.

Motyl, H. D. (producer). *The Final Report: Jonestown Tragedy.* Television. National Geographic Channel, 2006.

Mount Auburn Cemetery, Including Also A Brief History and Description of Cambridge, Harvard University, and the Union Railway Company: Illustrations and **Plans.** Boston: Moses King, 1883.

Nathan (director). *New Hampshire's* **Plan.** Video. *Archive.org/Ourmedia,* http://www.archive.org.

Neuman, Michael. "Does **Planning** Need the **Plan**?" *Journal of the American* **Planning** *Association* 64.2 (Spring 1998): 208-20.

"New Trailer for 'Battlestar Galactica The **Plan**'." Video. *YouTube,* 2009, http://youtube.com.

New York Times. "Stephen Sondheim Takes Issue with **Plan** for Revamped 'Porgy and Bess'." *New York Times,* August 10, 2011, http://artsbeat.blogs.nytimes.com.

Nolan, Christopher (director). *The Dark Knight.* Feature film. USA, 2008.

Nolfi, George (director). *The Adjustment Bureau.* Feature film. USA, 2011.

Norman, Howard A. *The Museum Guard: A Novel.* Toronto: Alfred A. Knopf Canada, 1998.

NPL Publishing Consultants. "Publishing Newsletter, New Year's, 2012." Email, December 29, 2011.

O'Brien, Neil. "Welfare Reform: Time for **Plan** B?" *The Telegraph,* August 18, 2011, http://blogs.telegraph.co.uk.

O'Doherty, Enda. "All Things Considered: Review of *Proud to be A Mammal,* by Czeslaw Milosz." *Dublin Review of Books,* 2008, http://www.drb.ie.

O'Keefe, Warren. "Welfare Reform: Time for **Plan** B?" *2020UK,* 18 August 2011, http://www.2020uk.org.

odysseus the great. "Book 17." *Diary of Odysseus,* March 10, 2008, http://odysseusthegreat.blogspot.com.

Ostwald, Michael. "The Mathematics of Spatial Configuration: Revisiting, Revising and Critiquing Justified **Plan** Graph Theory." *Nexus Network Journal* 13.2 (2011-07-01): 445-70.

Owen, Robert. *The Economist: A Periodical Paper,* **Explanatory** *of the New System of Society Projected By Robert Owen, Esq.; and of A* **Plan** *of Association for Improving the Condition of the Working Classes During Their Continuance At Their Present Employments, Vol. 1.* London: Wright, 1821.

Packer, George. "The Talk of the Town: Deepest Cuts." *The New Yorker,* April 25, 2011, pp. 19-20.

Pagels, Elaine. *The Gnostic Gospels.* New York: Vintage Books, 1979.

Paprocki, Joe. *The Bible Blueprint: A Catholic's Guide to Understanding and Embracing God's Word.* Chicago, IL: Loyola Press, 2009.

Partridge, Eric, and Paul Beale. *A Dictionary of Slang and Unconventional English: Colloquialisms and Catch Phrases, Fossilised Jokes and Puns, General Nicknames, Vulgarisms and Such Americanisms as Have Been Naturalized.* London; New York: Routledge, 2002.

Payne, Alexander (director). *About Schmidt.* Feature film. USA, New Line Cinema, 2002.

——— (director). *Sideways.* Feature film. USA, Fox Searchlight Pictures, 2004.

Pear, Robert. "Medicare **Plan** for Payments Irks Hospitals." *The New York Times,* May 30, 2011, http://www.nytimes.com.

Pellegrino, Charles. *Dust.* London: Bantam Books, 1998.

Peponis, J., J. Wineman, M. Rashid, S. Bafna, and S. H. Kim. "Describing **Plan** Configuration According to the Covisibility of Surfaces." *Environment and Planning B: Planning and Design* 25(5), 1998. Pion Ltd, http://www.env**plan**.com.

Percy, David S. *(director). What Happened on the Moon? An In*vestigation Into Apollo. Video. USA, 2005.

Percy, Walker. Lost in th*e Cosmos: The Last Self-Help Book. New York: Farrar, Str*aus & Giroux, 1983.

Perfect **Plans**. "We Make Your **Plans** Perfect!—Services." *Perfect Plans*, http://www.perfectplans.net.

Perrin, Noel. *Dr. Bowdler's Legacy: A History of Expurgated Books in England and America.* New York: Atheneum, 1969.

Persico, Joseph E. *Nuremberg: Infamy on Trial.* New York: Penguin Books, 1994.

Phillips, Colby. "How to Write a Dedication in a Program." *eHow.com,* http://www.ehow.com.

Pitchford, Paul. *Healing with Whole Foods: Asian Traditions and Modern Nutrition.* Berkeley: North Atlantic Books, 2002.

Plan Angel. "Welcome to **Plan** Angel's Website!" *Plan Angel*, http://www.**plan**angel.org.

Plate, Peter. *One Foot Off the Gutter.* San Diego: Incommunicado Press, 1995.

Platonov, Andrei Platonovich. *The Foundation Pit.* Translated by Robert Chandler and Geoffrey Smith. London: Harvill Press, 1996.

Pogue, David. "Amazon Lights the Fire with Free Books." *The New York Times,* November 3, 2011, http://www pogue.blogs.nytimes.com.

Pollack, Martha E., and John E. Horty. "There's More to Life Than Making **Plans**: **Plan** Management in Dynamic, Multiagent Environments." *AI Magazine* 20.4 (1999): 71.

Potok, Chaim. *Wanderings: Chaim Potok's History of the Jews.* New York: Fawcett Crest, 1978.

Powers, Richard. *The Gold Bug Variations.* New York: Harper Perennial, 1991.

———. *Galatea 2.2.* New York: HarperCollins, 1996.

Preston, Douglas, and Lincoln Child. *Gideon's Corpse.* New York: Grand Central Publishing, 2012.

Pritchard, Mark. "I Think I'm on **Plan** G or H." *Too Beautiful,* June 12, 2011, http://toobeautifultheblog. blogspot.com.

Proceedings of the American Society of Civil Engineers, Vol. 32. American Society of Civil Engineers, 1906.

Raum, Tom. "Analysis: Bush's New **Plan** Not All New." *The Washington Post,* January 10, 2007, http:// www.washingtonpost.com.

"Readings: Bad Wrap." *Harper's Magazine,* February 2012, p. 21.

Reeve, Clara. *The Progress of Romance and the History of Charoba, Queen of Aegypt, Reproduced From the Colchester Edition of 1785, With A Bibliographical Note By Esther M. Mcgill.* New York: The Facsimile Text Society, 1930.

Reiher, Andrea. " 'Survivor: South Pacific': The Trojan Horse **Plan** Is a Go." *From Inside the Box: TV News and Buzz,* October 26, 2011, http://www blog.zap2it.com/frominsidethebox.

Rhees, Rush, and Dewi Zephaniah Phillips. *In Dialogue with the Greeks, Volume 1: The Presocratics and Reality.* Aldershot, UK: Ashgate, 2004.

RJ. "The Mike Tyson Guide to Financial **Planning**." *GenYWealth: Useful Personal Finance Talk,* 2010, http://www.genywealth.com.

Robertson, Dwight. *You Are God's Plan A {And There Is No Plan B}.* Colorado Springs, CO: David C. Cook Publishing, 2010.

Robinson, R. *A Plan of Lectures on the Principles of Nonconformity: For the Inſtruction of Catechumens.* Nottingham; London: Printed and ſold by C. Sutton; Sold alſo by Meſſrs. Vernor and Hood, Lee and Hurſt, and W. Baynes, 1797.

Roscoe, Theodore. *United States Submarine Operations in World War II.* Annapolis: United States Naval Institute, 1949.

Rosenberg, Joyce M. "Market's Down? Time to Create a Retirement **Plan**." *The Times Leader,* August 21, 2011, http://www.timesleader.com.

Ross, Alexander Milton, Thomas Dowrick Brown, Charles Murray Johnston, J. Kelso Hunter, Saskatchewan Supreme Court, Saskatchewan Court of Appeal, Court of King's Bench, and

Alexander Fraser Tytler Woodhouselee, **Plan** *and Outlines of a Course of Lectures on Universal History, Ancient and Modern, Delivered in the University of Edinburgh, Illustrated with Maps of Ancient and Modern Geography, and a Chronological Table (Edinburgh: William Creech, 1782)*

Law Society of Saskatchewan. *The Saskatchewan Law Reports,* Vol. 11. Calgary: Burroughs and Company, Ltd., 1919.

Ross, Robert. "New Welfare Reform **Plan** Seeks to Put Recipients to Work." *The Pelican Post: Louisiana News and Commentary,* March 25, 2011, http://www.thepelicanpost.org.

Rucker, Philip. "Romney **Plans** to Quadruple Size of Calif. Home." *The Washington Post,* August 21, 2011, http://www.washingtonpost.com.

Russell, Charles Taze. *Millennial Dawn: The **Plan** of the Ages: 560th Thousand.* Allegheny, PA: Tower Publishing Co., 1886.

San Fernando Church of Christ. "Grand Canyon: Another View." *San Fernando Church of Christ,* 2005, http://sanfernandochurchofchrist.com.

Sanders, Charles Walton. *The New School Reader, Fourth Book: Embracing A Comprehensive System of Instruction in the Principles of Elocution With A Choice Collection of Reading Lessons in Prose and Poetry, From the Most Approved Authors; for the Use of Academies and the Higher Classes in Schools, Etc.* New York: Vison & Phinney, 1855.

Sanders, Lawrence. *Capital Crimes.* New York: Berkley Books, 1990.

Sanneh, Kelefa. "Bottle Rocket: Newt Gingrich's Turn." *The New Yorker,* January 9, 2012, pp. 24-28.

Sarah. "College Students Have Sex (or **Plan** To)." *Feministing,* March 25, 2011, http://campus.feministing.com.

Saramago, José. *The Double.* Translated by Margaret Jull Costa. Orlando: Harcourt, 2004.

savemiddletown. "Trojan Horse **Plan**." *Save Middletown's Blog,* December 11, 2010, http://savemiddletown.wordpress.com.

Schmidle, Nicholas. "Getting Bin Laden: What Happened That Night in Abbottabad." *The New Yorker,* August 8, 2011, pp. 35-45.

Schneider, Paul. *Brutal Journey: The Epic Story of the First Crossing of North America.* New York: H. Holt, 2006.

Scott, James. *Every Man the **Architect** of His Own Fortune Or the Art of Rising in the Church. A Satyre. By Mr. Scott.* London: Published by W. Bristow; and sold by R. & J. Dodsley, T. Becket & P. A. De Hondt, Mr. Copperthwaite in Leeds, and the Booksellers in York, 1763.

Seabrook, John. "Streaming Dreams: YouTube Turns Pro." *The New Yorker,* January 16, 2012, pp. 24-30.

Seinfeld, Jerry, and Larry David (creators). "The Stakeout." *Seinfeld,* Season 1, Episode 1. Television series. USA, Castle Rock Entertainment, 31 May 1990.

Sesame Street. "Gangsters—An **Plan**." Video. *YouTube,* 2009, http://youtube.com.

Sharman, Jim (director). *Rocky Horror Picture Show.* Feature film. USA, Twentieth Century Fox, 1975.

Shear, Michael D. "A Debt Ceiling Cheat Sheet: 8 Possible **Plans**." *The New York Times,* July 15, 2011, http://thecaucus.blogs.nytimes.com.

Simon, Herbert. *Administrative Behavior: A Study of Decision-Making Processes in Administrative Organization.* New York: Free Press, 1997.

Sinclair, Gordon, Jr. "Mayor's Regrettable Legacy Was Defined This Week." *Winnipeg Free Press,* Nov. 19, 2011. http://www.winnipegfreepress.com.

Skerritt, Jen, and Larry Kusch. "Point Douglas Park Still Up in the Air." *Winnipeg Free Press,* July 25, 2011, http://www.winnipegfreepress.com.

Sky, Zadius. "Re: The Odyssey—Manual of Secret Teachings?" *Cassiopaea Forum,* December 28, 2011, https://cassiopaea.org.

Smith, Adam. *The Wealth of Nations.* 1776. Adam Smith Reference Archive, 1937, http://www.marxists.org.

Smith, Melvin. *Strong Tower: A Daily Devotional Based on Names of the Lord.* Victoria, BC: Trafford, 2004.

Smith, Russell. *Girl Crazy.* Toronto: HarperCollins, 2010.

Smith, Wendy. "How the **Plan** to Fall Apart Soon Fell Apart." *Los Angeles Times,* August 1, 2010, http://www.latimes.com.

Smollett, Tobias. *The Adventures of Peregrine Pickle, in Which Are Included Memoirs of A Lady of Quality.* London: G. Routledge & Co., 1857.

Solt, Mary Ellen. "Czechoslovakia." *Concrete Poetry: A World View.* Bloomington: Indiana University Press, 1968, http://www.ubu.com.

Sophocles. "Oedipus the King." Translated by Robert Fagles. *The Three Theban Plays,* pp. 155-254. New York: Penguin Books, 1982.

Sorkin, Aaron (creator). "Napoleon's Battle **Plan**." *Sports Night,* Season 1, Episode 22. Television series. USA, Touchstone Television, 27 April 1999.

Southern, Terry. *Blue Movie.* New York: World Publishing Company, 1970.

Southgate, Henry. *Many Thoughts of Many Minds: Being A Treasury of Reference Consisting of Selections From the Writings of the Most Celebrated Authors.* London: Griffin, Bohn, and Company, 1862.

Spalding, John D. "God's **Plan** for America." *The Society of Mutual Autopsy Review,* January 26, 2005, http://www.somareview.com.

Spinrad, Norman. *The Men in the Jungle.* Garden City, NY: Doubleday, 1967.

Spiotta, Dana. *Eat the Document.* New York: Scribner, 2006.

Stackpool, Breda. "Perfect **Plans** for Life." *FindaCoach.ie: Ireland's Independent Coaching Directory,* http://www.findacoach.ie.

Stanhope, Charles Earl. *Observations on Mr. Pitt's **Plan**, for the Reduction of the National Debt.* London: Printed by J. Davis, for P. Elmsly, 1786.

Stoker, Bram. *Dracula.* 1897. New York: Barnes & Noble Classics, 2003.

Stone, Christopher. "The Use of Linear Fractional Transformations to Produce Building **Plans**." *Nexus Network Journal* 10.2 (2008): 331-42.

Stone, Oliver (director). *U Turn.* Feature film. USA, Phoenix Pictures, Illusion Entertainment Group, Clyde Is Hungry Films, 1997.

Stromberg, Roland. *European Intellectual History Since 1789.* Englewood Cliffs, NJ: Prentice-Hall, 1986.

Sun.Star Baguio. "Climate Change Action **Plan** Still Unsigned." *Sun.Star Baguio,* August 17, 2011, http://www.sunstar.com.ph.

Talen, Emily. "After the **Plans**: Methods to Evaluate the Implementation Success of **Plans**." *Journal of Planning Education and Research* 16.2 (December 1996): 79-91.

"The Building of the Ship." *Harper's Magazine* 24, 1862, pp. 608-20.

The Medicare Channel. "2010 Medicare Supplement **Plan** Comparison Chart Ending 05/31/2010." *The Medicare Channel,* http://www.themedicarechannel.com.

———. "The New 2010 Modernized Medicare Supplement **Plan** Comparison Chart Beginning 06/01/2010 and Updated for 2011." *The Medicare Channel,* http://www.themedicarechannel.com.

The Reader's Digest, Vol. 5. The Reader's Digest Association, 1926.

Thirlwell, Adam. "J. B. Him: Joe Brainard's Universal Prose." *Harper's Magazine,* July 2012, pp. 69-72.

Thomas, David. "The Preacher's Finger-Post." *The Homilist; Or, the Pulpit for the People.* London: Simpkin, Marshall, & Co., 1875.

Thompson, Jim. *Pop. 1280.* 1964. New York: Vintage Books, 1990.

Tocker, Morgan. "Caching Could Be the Last Thing You Want to Do." *MySQL Performance Blog,* July 24, 2010, http://www.mysqlperformanceblog.com.

Tranquillus, C. Suetonius. *The Lives of the Twelve Caesars.* Project Gutenberg, 2006, http://www.gutenberg.org.

Trevanian. *The Eiger Sanction.* New York: Avon Books, 1972.

———. *The Loo Sanction.* New York: Ballantine Books, 1973.

———. *Shibumi.* New York: Ballantine Books, 1979.

Trollope, Anthony. "The Claverings." *The Galaxy* 1, 1866, p. 374.

Tuchman, Barbara W. *The March of Folly: From Troy to Vietnam.* New York: Knopf, 1984.

Turner, Michael. *American Whiskey Bar: A Novel.* Vancouver: Arsenal Pulp Press, 1997.

Tuttle, Richard S. *Heirs of the Enemy.* Marco Island, FL: KBS Pub., 2007.

TV Tropes. "Time for **Plan** B." *TV Tropes,* http://tvtropes.org.

Twain, Mark. *The Adventures of Huckleberry Finn.* 1884. Online Literature Library, http://www.literature.org.

Tzu, Sun. *The Art of War.* The Free Library, http://www.freelibrary.com.

Udstrand, Paul. "Missed Metaphors: Naomi Klein's 'Shock Doctrine'." *Thoughtful Bastards,* August 3, 2011, http://pudstrand.fatcow.com.

Urban Dictionary. *Urban Dictionary,* 1999-2014, http://www.urbandictionary.com.

Valéry, Paul. "Man and the Sea Shell." Translated by Ralph Mannheim. *The Collected Works of Paul Valéry.* London: Routledge & Kegan Paul, 1964.

Van Doren, Charles. *A History of Knowledge: The Pivotal Events, People, and Achievements of World History.* New York, NY: Ballantine Books, 1991.

Verne, Jules. *From the Earth to the Moon.* 1865. The Free Library, http://www.thefreelibrary.com.

Vidal, Gore. *Lincoln: A Novel.* New York: Vintage International, 2000.

Visser, Willemien. "More Or Less Following a **Plan** During **Design**: Opportunistic Deviations in Specification." *International Journal of Man-Machine Studies* 33(3), 1990, http://www.science-direct.com.

Watson, Charles D. "The Terrorist Connection." *Abounding Love Ministries,* January 7, 2012, http://www.aboundinglove.org.

WebSerials.com. "WebSerials.com Launches Unique New Unscripted Web Comedy 'Best Laid **Plans**'." *WebSerials.com,* August 31 2010, http://webserials.com.

Weeds Wiki. "Discussion: **Plan** C." *Weeds Wiki,* 2010, http://weedswiki.wetpaint.com.

Weigel, David. "Don't Worry, It Gets Worse." *Slate,* July 30, 2011, http://www.slate.com.

Wente, Margaret. "The Euro: A Nice Idea Until the People Got in the Way." *The Globe and Mail,* Nov. 3, 2011, http://www.theglobeandmail.com.

West, Gilbert. "Stowe, the Gardens of the Right Honourable Richard Viscount Cobham." 1732. http://faculty.bsc.edu/jtatter/west.html.

White, Curtis. "The Late Word." *Lapham's Quarterly,* October 23, 2011, http://www.laphamsquarterly.org.

Whitehead, Alfred North. *Science and the Modern World.* New York: Macmillan Co., 1925.

WhiteKnight. "Trojan Horse Greek PM Unmasks Himself. Scraps Referendum **Plan**. All Part of the **Plan**?" *Surfing the Apocalypse Network,* November 4, 2011. http://www.surfingtheapocalypse.net.

Whiting, Emily J. "Geometric, Topological and Semantic Analysis of Multi-Building Floor **Plan** Data." Massachusetts Institute of Technology, 2006.

Willard, Elizabeth Osgood Goodrich. *Sexology as the Philosophy of Life: Implying Social Organization and Government.* Chicago, IL: J. R. Walsh, 1867.

Williams, Alex. "Maybe It's Time for **Plan** C." *The New York Times,* August 12, 2011, http://www.nytimes.com.

Willig, Lauren. *The Secret History of the Pink Carnation.* New York: Dutton, 2005.

Willis, David P. "AT&T, T-Mobile Merger: Good for the Consumer?" *Asbury Park Press,* August 19, 2011, http://www.app.com.

Wilson, Pete. ***Plan** B: What Do You Do When God Doesn't Show Up the Way You Thought He Would?* Nashville, TN: Thomas Nelson, 2009.

Wingrove, Josh. "Edmonton Outlines **Plan** to Fight Homicide Rate." *The Globe and Mail,* Aug. 08, 2011, http://www.theglobeandmail.com.

Winter, Michael. *The Architects Are Here.* Toronto: Penguin Canada, 2008.

Winterson, Jeanette. *Lighthousekeeping.* Toronto: A. A. Knopf Canada, 2004.

Wintour, Patrick. "Welfare Reform: Government Hopes There's an App for That." *The Guardian,* 19 October 2011, http://www.guardian.co.uk.

———. "Iain Duncan Smith Plots Welfare Revolution Despite Treasury Resistance." *The Guardian,* 30 July 2010, http://www.guardian.co.uk.

Wolf, Richard. "How Obama's **Plan** to Cut the Deficit Compares with Others." *USA Today,* August 14, 2011, http://www.usatoday.com.

Wood, John. *Leaving Microsoft to Change the World: An Entrepreneur's Odyssey to Educate the World's Children.* New York: Collins, 2006.

Woodend, Dorothy. "Occupy the Movie Theatres: Could Money-Sucking, Worker-Shedding Hollywood Be More Out of Touch?" *The Tyee,* 28 Oct 2011. http://www.thetyee.ca.

Xavier, João Pedro. "Leonardo's Representational Technique for Centrally-**Planned** Temples." *Nexus Network Journal* 10.1 (2008-04-01): 77-99.

Yahoo! Answers. "Difference At Ford Between X **Plan** and Y **Plan**?" *Yahoo! Answers,* 2008, http://answers.yahoo.com.

———. "The Equation of the **Plan** Parallel to the **Plan** 2x – Y + 3z = 0, Which Passes Through the Point (1, 1, 1)?" *Yahoo! Answers,* 2011, http://answers.yahoo.com.

———. "Question About One of the Joker's Quotes from Dark Knight (Spoilers!)?" *Yahoo! Answers.* 2008, http://answers.yahoo.com.

Yates, David (director). *Harry Potter and the Deathly Hallows.* Feature film. USA, Warner Bros. Pictures, 2010.

Yeats, William Butler. "Nineteen Hundred and Nineteen." *Plagiarist.com,* http://plagiarist.com.

Zabjek, Alexandra. "Edmonton Filmmaker's Laptop Contained **Plan** to Become a Serial Killer." *Vancouver Sun,* March 16, 2011, http://www.vancouversun.com.

Zaspel, Fred G. *The Theology of B. B. Warfield: A Systematic Summary.* Wheaton, IL: Crossway, 2010.

Zimler, Richard. *The Last Kabbalist of Lisbon.* Woodstock, NY: Overlook Press, 1998.

Zola, Émile. *The Kill.* 1872. Translated by Brian Nelson. London: Oxford University Press, 2004.

Zombiepedia. "General Survival Guidelines." *Zombiepedia,* http://zombie.wikia.com.

survey results

The results are finally in from the survey inspired by Anne's Learning tips. 1774 people—speakers of English, German, Spanish, French and Italian—have participated. To tell you the truth, the feedback was overwhelming: free comments alone added up to over one hundred pages.

We read every last one of them, we sorted them, we evaluated them. Here we assemble our first conclusions for you . . .

*Babbel Blog, **Plans**, Types And Styles, Oh My! Results From Our Learning Behavior Survey*

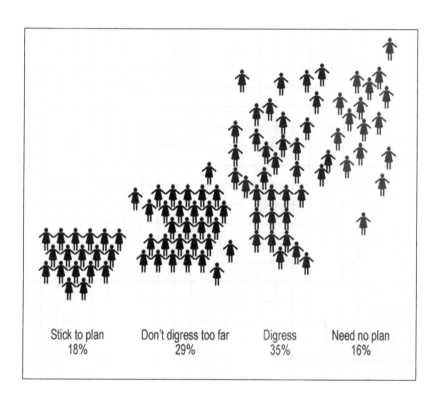

Stick to plan
18%

Don't digress too far
29%

Digress
35%

Need no plan
16%

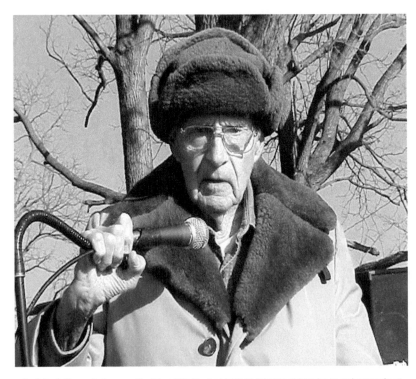

Dr. John D. Kraus, **designer** and builder of Big Ear, had indicated that he didn't **plan** to make remarks at this Dedication Ceremony. However, after he heard from all of the speakers and after the Big Ear Historical Marker was revealed, John was moved to make some comments to the assembled crowd.

Ohio Historical Society, Big Ear Historical Marker Dedication Ceremony Photos

dedication

1. Thank the individuals who helped **plan** or fund the event. Write something such as, "This event would not have been possible without the generosity of my grandparents," or "It is because of the efforts of our executive director that we are all here today."

2. Identify their contribution, being tactful and sensitive to privacy concerns. You may write, "Their financial and logistical support was essential to this amazing day finally coming true," or "They believed in this project when no one else did." Refrain from mentioning specific dollar figures for financial contributions or referring to controversies that came about during the **planning**.

3. Use a phrase that captures the spirit of their generosity. Write something such as, "Their kindness, patience and determination is an inspiration to all of us. It is to them that we dedicate this program," or "This gathering shows what generous people can do when they dedicate themselves to a cause. And so we dedicate this program to them."

Colby Phillips, How to Write a Dedication in a Program (eHow.com)

about the author

"I don't ever have an idea," he noted in an interview in 1978. "The material does it all … I know I could never **plan** a plot because the only kind of plot in any sense of the word in either writing or painting that I've ever been able to present has come of itself from one word to the next or one thing to the next."

Adam Thirlwell, J. B. Him: Joe Brainard's Universal Prose

They would gather in beautiful homes and he would stand before them, a handsome dark-bearded figure with a prominent nose, a shock of thick black hair, wearing a demeanor of dignity and sophistication and fixing upon them the dark eyes of a dreamer …

They listened to his reading of the address, which lasted about two hours, but would not take his **plan** seriously. "Today I am an isolated and lonely man," he had written in June, "tomorrow perhaps the intellectual leader of hundreds of thousands … "

He decided to present the **plan** in a book.

Chaim Potok, Wanderings

treyf?

treyf, adj. [Yiddish]—not kosher, unclean.

Treyf—unusual books of an indeterminate type, sort of story-picture remix books for people who can't stomach any more schmaltzy *Chicken Soup for the Soul.* Treyf is cooked up using texts and images compiled from various sources, usually obsessively related to one or more themes, and then recombined through a process of highly subjective editing, ordering and juxtaposition.

"Strange and clever." — *Globe & Mail*

"Funny, but deep." — *Umbrella*

"Is this a new form of discourse in step with its multivalent, chaotic times, or just an excuse for intellectual laziness? Only the author knows for sure." — *Canadian Architect*

www.treyf.com
keep refrigerated

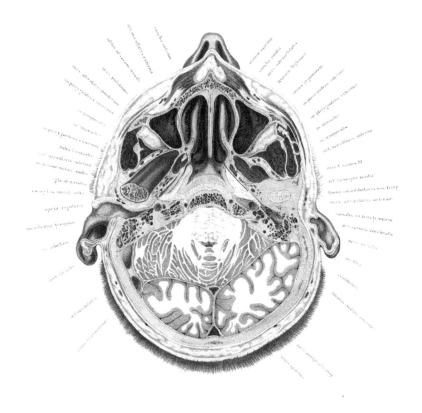

Wilhelm Braune and C. Schmiedel, Topographisch-anatomischer Atlas
(Leipzig: Verlag von Veit & Comp., 1872)

CPSIA information can be obtained at www.ICGtesting.com
Printed in the USA
LVOW02s0728041114

411835LV00003B/5/P